The Material Landscapes of Scotland's Jewellery Craft, 1780–1914

Material Culture of Art and Design

Material Culture of Art and Design is devoted to scholarship that brings art history into dialogue with interdisciplinary material culture studies. The material components of an object – its medium and physicality – are key to understanding its cultural significance. Material culture has stretched the boundaries of art history and emphasized new points of contact with other disciplines, including anthropology, archaeology, consumer and mass culture studies, the literary movement called 'Thing Theory', and materialist philosophy. **Material Culture of Art and Design** seeks to publish studies that explore the relationship between art and material culture in all of its complexity. The series is a venue for scholars to explore specific object histories (or object biographies, as the term has developed), studies of medium and the procedures for making works of art, and investigations of art's relationship to the broader material world that comprises society. It seeks to be the premiere venue for publishing scholarship about works of art as exemplifications of material culture.

The series encompasses material culture in its broadest dimensions, including the decorative arts (furniture, ceramics, metalwork, textiles), everyday objects of all kinds (toys, machines, musical instruments) and studies of the familiar high arts of painting and sculpture. The series welcomes proposals for monographs, thematic studies and edited collections.

Series Editor:
Michael Yonan, University of California, Davis, USA

Advisory Board:
Wendy Bellion, University of Delaware, USA
Claire Jones, University of Birmingham, UK
Stephen McDowall, University of Edinburgh, UK
Amanda Phillips, University of Virginia, USA
John Potvin, Concordia University, Canada
Olaya Sanfuentes, Pontificia Universidad Católica de Chile, Chile
Stacey Sloboda, University of Massachusetts Boston, USA
Kristel Smentek, Massachusetts Institute of Technology, USA
Robert Wellington, Australian National University, Australia

The Material Landscapes of Scotland's Jewellery Craft, 1780–1914

Sarah Laurenson

BLOOMSBURY VISUAL ARTS
NEW YORK • LONDON • OXFORD • NEW DELHI • SYDNEY

BLOOMSBURY VISUAL ARTS
Bloomsbury Publishing Plc
1385 Broadway, New York, NY 10018, USA
50 Bedford Square, London, WC1B 3DP, UK
29 Earlsfort Terrace, Dublin 2, Ireland

BLOOMSBURY, BLOOMSBURY VISUAL ARTS and the Diana logo
are trademarks of Bloomsbury Publishing Plc

First published in the United States of America 2023

Cover design: Irene Martinez Costa
Cover image: Bracelet of six moss agates from Burn Anne, in Ayrshire, mounted in gold,
c. 1840–1860. Agate and gold, 206 × 54 mm. NMS, A.1891.344
© National Museums Scotland

Library of Congress Cataloging-in-Publication Data
Names: Laurenson, Sarah, author.
Title: The material landscapes of Scotland's jewellery craft,
1780–1914 / Sarah Laurenson.
Description: London ; New York : Bloomsbury Visual Arts, [2023] |
Series: Material culture of art and design | Includes bibliographical references and index.
Identifiers: LCCN 2022048236 (print) | LCCN 2022048237 (ebook) |
ISBN 9781501358005 (hardback) | ISBN 9798765104972 (paperback) |
ISBN 9781501357992 (epub) | ISBN 9781501357985 (pdf) | ISBN 9781501357978
Subjects: LCSH: Jewelry–Scotland–History–19th century. | Jewelry–Social aspects–
Scotland. | Jewelry making–Scotland. | Scotland–Social life and customs–19th century.
Classification: LCC NK7345.A1 L38 2023 (print) |
LCC NK7345.A1 (ebook) | DDC 739.2709411–dc23/eng/20221115
LC record available at https://lccn.loc.gov/2022048236
LC ebook record available at https://lccn.loc.gov/2022048237

ISBN: HB: 978-1-5013-5800-5
 ePDF: 978-1-5013-5798-5
 eBook: 978-1-5013-5799-2

Series: Material Culture of Art and Design

Typeset by Integra Software Services Pvt. Ltd.
Printed and bound in Great Britain

To find out more about our authors and books visit www.bloomsbury.com
and sign up for our newsletters.

Contents

List of illustrations

Plates

Figures

List of abbreviations

AAGM	Aberdeen Archives, Gallery and Museums
CUP	Cambridge University Press
EUP	Edinburgh University Press
Incorporation	Incorporation of Goldsmiths of the City of Edinburgh
MUP	Manchester University Press
NGS	National Galleries of Scotland, Edinburgh
NLS	National Library of Scotland, Edinburgh
NMS	National Museums Scotland, Edinburgh
NMSE	National Museums Scotland Enterprises, Edinburgh
NRS	National Records of Scotland, Edinburgh
ODNB	Oxford Dictionary of National Biography
OUP	Oxford University Press
PKCA	Perth and Kinross City Archives
PMAG	Perth Museum and Art Gallery
SAS	Society of Antiquaries of Scotland, Edinburgh
YUP	Yale University Press

Acknowledgements

This book has been 'in the making' in the broadest sense for about a decade now, from when I began studying material cultures of the past at the University of Edinburgh under the supervision of Stana Nenadic. I am grateful to Stana for nurturing my curiosity then, for her continued support and friendship since and for shaping the way I think about the material past. My research on jewellery specifically started with my doctorate, supervised by Stana as part of a major project, 'Artisans and the Craft Economy in Scotland, c.1780–1914' between 2013 and 2017. That project was funded by the Leverhulme Trust, and I will be forever grateful, as it opened up insights into the world of craft – past and present – that are central to this book. Trevor Griffiths has also been generous in support of my research and career during and since that project. The others on the project – namely Sally Tuckett and Keren Protheroe – helped me see craft from a range of angles, alongside a host of craft producers we had the privilege of talking with: stonemasons, blacksmiths, jewellers, silversmiths, taxidermists, weavers and knitters.

Most of the thinking through of the objects at the core of this book has been carried out during my time at National Museums Scotland, which has provided a hugely supportive environment for such research. Day-to-day curatorial work with the museum's unrivalled collections of Scotland's human and natural history together with access to an astonishing breadth of material – from ancient tools, the stuff of modern technologies and geological specimens that never fail to blow my mind – has been fundamental to the writing. I am so very grateful for my excellent and supportive colleagues and friends. David Forsyth, Xerxes Mazda, Sam Alberti and especially Stuart Allan were all endlessly supportive and made sure I was able to carve out the time to do research and writing alongside the pressures of a busy curatorial job.

The best thing about working in the Department of Scottish History and Archaeology is the way that conversations and questions about the stuff of the past cut across time periods. This would have been a very different book without input from colleagues specializing in the material world from prehistory to the present. Special thanks are due to Alice Blackwell, Martin Goldberg,

Fraser Hunter, Matthew Knight, Lyndsay McGill, Calum Robertson, Georgia Vullinghs and Rosie Waine. I was lucky to have Patrick Watt as a colleague and a friend at both the University of Edinburgh and then the museum, and he deserves special thanks for reading drafts and sharing his thoughts. Katie Stevenson, former Keeper of Scottish History and Archaeology, deserves a special mention for being a trusted friend and mentor these past years. I've also benefitted hugely from conversations with collaborators on museum projects. Hugh Cheape and Dòmhnall Uilleam Stiùbhart of Sabhal Mòr Ostaig, University of the Highlands and Islands, brought new insights from a Scottish Gaelic perspective. Indeed, this is a perspective which could yet open up further, deeper insights into the links between land, materials and making in modern Scotland.

I have accrued debts to curators and archivists as well as makers, collectors and dealers of jewellery. John Faithfull of the Hunterian Museum has been beyond helpful in discussing Scotland's geology and mineralogy with me, and for reading draft chapters. I am also grateful to colleagues too numerous to name at Perth Museum and Art Gallery, Glasgow Museums, Aberdeen Art Gallery and Museum, the V&A, Montrose Museum, Dumfries Museum, the Incorporation of the City of Edinburgh and the Royal Collection Trust. Many a jeweller has shared insights on the making of jewellery, and even helped me to learn a bit of the craft myself. Those insights into skill, tools and materials today have been crucial to unpicking the ways in which work was made in the past. Special thanks to Colin Fraser for alerting me to shiny things in all sorts of unusual places and for sharing his knowledge of goldsmiths past, through his work at Lyon & Turnbull and R. L. Christie. Lyon & Turnbull also generously provided images and information.

Between the lines of this book are many miles trodden with friends and enlisted experts to and in the landscapes that feature throughout, sometimes to visit places in the sources or hunt for materials, sometimes just to walk and think. Special thanks to Georgia Vullinghs, who has stomped with me in the very highest places, indulging in conversations about the relationship between Scotland's past and landscape across the modern period while swooning at the views.

Writing material culture history relies on images, but purchasing and printing the ones that appear here simply would not have been possible without a generous grant from The Strathmartine Trust along with support from National Museums Scotland. I would happily have included twice as

many pictures and more, but alas. I also gratefully acknowledge funding for research trips and conferences from the University of Edinburgh, the Design History Society and the Costume Society.

It is a privilege to be part of this series on the Material Culture of Art and Design. I am grateful for the support of Michael Yonan as series editor, for his encouragement, and to Stephen McDowall, who first suggested I place the book here and helped me form ideas about what shape it would take. Freya Gowrley has been an enormously supportive series buddy. Sincere thanks are also due to my PhD examiners, Annie Tindley and Christopher Breward, who encouraged me to write this book in the first place. The work of Laura Scobie, whose fascinating doctoral research I supervise along with Stana and Trevor, has also developed my own thinking on matters of landscape. And thanks for their friendship and support in research, book drafting and the rest of life to Sophie Cooper (who also read and commented on many a draft), Anna Feintuck and Felicity Loughlin.

Most of all, thank you to my lovely family – especially to my husband and the two little women who appeared in our lives during the making of this book. Our girls have been my biggest distraction and my most powerful driving force. While I don't expect my children will ever actually read this book in its entirety, I hope that the early exposure to the stuff of Scotland's past will play some part in making them curious about how the material landscapes of the period have shaped the world around them.

Introduction

Revealing craft: Between nature and culture

On the front cover of this book is an image of a bracelet. It is made up of a row of six slivers of agate, the light pouring through the translucent stone and illuminating mossy patterns in earthy greens, reds and ochres. Each slice is framed by a delicate gold setting with unfurling foliage at the tops and bottoms, tiny beads of gold granulation cascading down the sides and two small flowers linking one piece to the next. The fastening is attached via a fine bar, gently curved to mirror the shape of the stone's edge, allowing it to slot into its partner on the other end and become almost invisible when worn. It is a piece that has been cleverly crafted to display the stones to maximum effect. These agates – or 'pebbles', as they were known – were sourced from Burn Anne in south-west Scotland, where, in 1792, it was noted that 'the Burn Anne throws up at times some good pebbles, which are supposed to come from the sides of the Mol-mount-hill, where it is said they abound'.[1] This particular source of pebbles did indeed 'abound' and would become one of the most productive and well-known in relation to Scottish jewellery. Burn Anne was one of many spots in the Scottish landscape that provided jewellers with the natural materials – precious gold and silver, an array of stones and gems, and freshwater pearls – that would come to define the country's jewellery craft during the industrial age.

This is a book about the journey of matter on its transformation from raw materials to finished luxury goods. It tracks metals, stones and a range of gems as they were crafted on the benches of Scotland's jewellers for wear on the bodies of an ever-expanding number of consumers. But it is not solely about jewellery made from Scottish materials. Rather, it is an exploration of the world of jewellery making in Scotland during the long nineteenth century, and of how craft skill itself was shaped and reshaped, as seen through the lens of objects. For example, these steel-hard agates were gathered from the hill as rough rocks by people

with detailed knowledge of the land, then sliced thinly by a specialist lapidary, who worked closely with the jeweller to shape the stones for the setting, tapering their edges, smoothing off corners and curves, creating subtle little peaks. The final thing constituted a display of interesting patterns set off by the play of light within natural materials, as well as a range of skills executed by different hands. It functioned as an object of dress and, effectively, as a wearable curiosity cabinet displaying specimens of geological process and mineralogical wonders tied to ideas of place, landscape and the passing of time. These native materials may have defined the image of Scotland's jewellery craft, but many of the objects considered in these pages were made from recycled or imported materials that came to jewellers through established international supply networks.

What all of the objects within share is a connection to a highly respected area of skilled making that was long established, world renowned and connected to complex global webs of supply and production. Through these pieces – alongside a range of other visual and documentary sources – I consider how the people with knowledge, skills and tools in common who made up Scotland's jewellery craft acquired, learned, developed and passed on their skill. I explore how they understood and valued their skill across time, against the backdrop of profound economic, social, cultural and technological change. And I question how they engaged with nature, local environments and ideas about landscape via their material supplies and their practice. Ultimately, I question how the jeweller's skill evolved across more than a century and, crucially, how those jewellers brought about change through the things they made, by driving new techniques and technologies, shaping perceptions of skill, and creating new ways of seeing and engaging culturally with the Scottish landscape. By asking 'what did it mean to be a jeweller in nineteenth-century Scotland?', this book reveals a picture of the jeweller as a cultural agent who both responded to and brought about change in the world. That picture stands in contrast to the dominant image of the craftsperson in the 'Age of Industry', more often than not framed as being at the mercy of that change.

The long nineteenth century in Britain was marked by deep and wide-reaching economic, social and cultural change characterized by industrialization, urbanization, population growth, an unprecedented rise in wealth, increasing social mobility, the emergence of the middle classes and decline of the aristocracy, and the rise of modern consumerism.[2] These shifts

were swift, transforming the world contemporaries were experiencing and generating new material landscapes through the proliferation of goods. It was against this backdrop that the powerful narrative that industrialization was destroying craft skill, replacing skilled people and their time-tested tools and hand techniques with machines, emerged and took root. That narrative continues to persist even now, despite decades of scholarship illustrating the contrary, and, on the ground, the continuation of skilled craft producers to the present day.[3] Indeed, Glenn Adamson has argued that this was the period in which craft – as a concept – was invented, emerging as an area of intense cultural value precisely as a result of the forces of industrialization said to be bringing about the destruction of skilled handwork.[4] Furthermore, the many objects that survive from this period show us – clearly – that, far from declining, particular skills flourished, with skilled hands adapting tools and techniques to produce new goods for a rapidly shifting world. *The Material Landscapes of Scotland's Jewellery Craft, 1780–1914* examines the jeweller's skill in Scotland within this cultural context, and, crucially, it does so through the material manifestations of that skill: through the things they made.

Scotland provides a rich area of focus. The country has a long history of quality craft production in jewellery and silverware, with the geological and natural diversity of the region providing jewellers with precious metals, a variety of stones and freshwater pearls. The embedded nature of skilled metalworking in Scotland's towns, alongside the availability of jewellery materials, offers insights into making processes and the life cycles of jewellery objects – the transformation from, and interplay between, natural to cultural – that are otherwise difficult to get at. As such, this book focuses on poesis. It foregrounds the coming-into-being of jewellery objects, situating historical analysis of a key facet of Britain's specialist craft sector within a growing field of scholarship that integrates the study of making and meaning through close attention to materiality.[5] As will become clear in this introduction, it does so through an interdisciplinary methodology, building on recent studies of early modern craft that examine the role of matter in shaping the ways in which things were made, consumed and perceived, and the personal, social and cultural meanings assigned to them.[6] Honing in on the haptic and visual skills applied to manipulate raw materials into finished jewellery objects, it opens up new ways of looking at the history of material culture and forges new approaches to the study of material things.

Materializing jewellery

The beauty and enduring draw of jewellery has meant that there is no shortage of books on the topic including shiny catalogues and collectors' guides, surveys of particular assemblages, firms or materials. In the later nineteenth century, jewellers themselves – from Tiffany's gemmologist in New York to the owner of Edinburgh's top jewellery firm – published accounts of the mythical meanings of their materials and the history of their craft.[7] Internationally, jewellers and curators contributed to trade publications such as *The Watchmaker, Jeweller and Silversmith* with snapshots of historical detail including articles on ancient and revived techniques, alongside technical information and tips. Accounts of the production of jewellery were printed for a general readership, including an in-depth account of the industry in Scotland, published in *The Scotsman* in 1868.[8] That essay, by the journalist David Bremner, was later published within a volume illuminating a plethora of *Industries of Scotland*, from fishing to shipbuilding to weaving. It frames the organization of labour and detailed descriptions of jewellers' making processes within a narrative about the long history of metal working in the country. Significantly, it opens with a nod to materials found in Scotland, tracing a line from early producers to the present day: the 'native gold in use by the early inhabitants of Scotland', found in 'the river beds of their own rugged country' and formed with 'stone hammers' into 'rude ornaments for the decoration of their persons'.[9] Bremner's survey was one of many works on production printed during the second half of the nineteenth century that point to a surge of interest in skill – and a shift in the value placed on it – provoked by contemporaries' sense of the rapid tides of industry reshaping the world around them.[10] What characterizes these writings on jewellery is the strong temporal dimension, the emphasis on prehistoric materials, ancient skills and their continuation through to the present.

The physical longevity of jewellery materials and the ideas of timelessness they evoke have played a key role in shaping a broad range of historical works. Shiny metal things thousands of years old can come out of the ground looking much the same as when they went in, still clinging to their significance as objects of status, power and wealth. Jewellery survives in documentary records, too. As objects of high value, and often tied to rites of passage – birth, coming of age, marriage, death – they were recorded and described in inventories and wills. And, of course, jewellery was depicted in paintings. Over the last two decades,

art historians have overlaid the biographies of objects with the biographies of their owners and wearers, from courtesans in Renaissance Italy to eighteenth-century British aristocrats.[11] These studies reveal the personal, symbolic and cultural significance of jewellery and its role in creating social bonds, fashioning identities, asserting status and delineating highly gendered dimensions of property relations. The theoretical frameworks underpinning this approach are drawn from anthropology, specifically the hugely influential work of Arjun Appadurai, based on the notion that objects have agency and social lives, building biographies and becoming embedded with social and cultural meanings and associations as they move between people and across time.[12] Appadurai and others have since argued that the way this now widely applied cultural biography approach privileges human interaction in creating the meanings of things has led to the field of material culture studies neglecting the object, producing research that is 'more about culture than about material'.[13] With jewellery, the material is critical. Associations of permanence embedded in shining metals and sparkling precious stones enabled jewellery objects to become layered with memories of the people who interacted with and exchanged them, to create powerful symbols of personal ties.[14] The same was true of jewellery crafted from non-precious matter, such as human hair and jet, which materialized emotional links between bodies and souls across time and place.[15]

It may seem obvious that metals and gems sparkle, shine and dazzle, and reflect, refract and harness light, producing fleeting effects that draw the eye, capturing the viewer's attention and imagination, provoking wonder. But the difficulties of dealing with these physical and visual properties – and their role in creating and communicating historically contingent symbolic meanings – are very real for the historian of jewellery. Marcia Pointon's *Brilliant Effects* marks a turning point in the study of jewellery through the way it attends to ephemeral visual effects in jewellery materials. Drawing from objects, artistic depictions, contemporary novels, advertisements, bills and inventories, Pointon explores 'the force of jewels and jewellery as image and metaphor', through a thematic, cultural approach that takes in a broad chronological sweep, from the Renaissance to the twenty-first century.[16] Pointon highlights the necessity of understanding materials and methods, but makes clear that, for the purposes of her research, this is a means to an end.[17] Similarly, Jean Arnold's book on the representation of jewels and their use as metaphor in fiction opens up new ways of seeing jewellery as objects that created and shaped identities during the

nineteenth century. Focusing on the Victorian period, Arnold highlights how the proliferation of jewellery, including that made from inexpensive materials such as paste that mimicked precious stones to shells and non-precious stones, meant that 'women's practices of wearing jewellery became so widespread that jewels served as a focal point in novelistic narratives'.[18] Those narratives, from Wilkie Collins's *The Moonstone* to the jewel mysteries of Sherlock Holmes, provide a glimpse into how jewels were read in society, and what they meant to the people who exchanged and wore them, as well as the people who lost or stole them. For example, in *The Moonstone* and Anthony Trollope's *The Eustace Diamonds*, sparkling diamonds acted as so-called 'boundary troublers' which simultaneously built and distorted social relationships.[19] The narratives of both these works revolve around diamonds, but novels from this period more widely are punctuated with gems and jewellery objects, revealing how they functioned as symbols of power and wealth, a facet of gendered property relations and as deeply symbolic markers of personal ties.

By thinking with and through matter, it is clear in both scholarly studies and fictional narratives that materials, making process and makers were key to the meanings of jewels and jewellery. The jeweller had the power to shape, reshape or (through recycling or reset) obliterate the embedded meanings and associations of jewels. Yet questions remain around the coming-into-being of jewellery, and particularly on the relationship between jewellers, their work and the cultural worlds they inhabited. From an anthropological perspective, Igor Kopytoff and Alfred Gell have both argued, albeit in different ways, that makers' skill and workmanship were core to an object's agency – that the ways in which materials and methods were combined to create an object were central to its ability to provoke reactions, emotions and actions.[20] A now rich area of scholarship has evolved with a focus on understanding ways of making things, and how materials themselves guided the mind and hand of the maker as they responded to the challenges – and opportunities – posed by raw matter.[21] These works are based on the notion that the interlinked physical, visual and symbolic properties of matter are key to shaping human interaction with things – how they were made and used – and thus central to creating the personal, social and cultural meanings assigned to those objects. This book builds on this area, employing a cultural biography approach with a focus on materiality. Making and process are foregrounded to explore the ways in which producers harnessed the interlinked physical and symbolic dimensions of materials to generate and layer up meanings, including associations that enabled finished goods to

connect people to place and act as receptacles of collective as well as individual memory.[22]

So often, the jewellery that survives in physical form or through traces in the written record are spectacular examples of valuable materials: gold and precious stones passed through family lines. The high quality and the 'beautifully made' overwhelmingly outlive the poorly produced, the low-value and the quotidian. Many existing studies focus on the bodies of elite women for this very reason.[23] But the nineteenth century saw an array of new materials put to work in jewellery, which was worn by men as well as women of all classes, thereby creating a new 'language' of modern jewellery.[24] These categories of goods are also preserved in the collections of museums, documenting shifts in aesthetics, design or manufacture. The jewellers with which this book is concerned were not known for their work with precious diamonds, though they certainly made with and sold them. Rather, they developed a reputation for specialist skills in working semi-precious and non-precious materials, such as the aforementioned agates as well as 'cairngorm' crystals associated with Scotland's mountain environments, and Scottish freshwater pearls found in rivers and streams. The image of Scotland's jewellery craft – and the skills of those who were part of that web of production – swirled around these materials. In terms of contemporary design, their work was deemed interesting and often remarkable in terms of innovation, ingenuity and making. For that reason, Scottish jewellery of semi- and non-precious materials is fairly well represented in public and private collections. Yet there is a slim scholarly literature on the topic. There are a number of reasons for this, foremost among them the baggage of '"biscuit-tin" kitsch' identified as having led to a reluctance among historians to engage seriously with distinctively Scottish material cultures.[25] The few existing books dedicated to the subject are excellent, though characterized by catalogue-type approaches accompanied by summary essays rather than focussed on deep historical analysis.[26] In almost every book on Victorian jewellery design, Scottish examples feature somewhere, underlining its importance as a facet of wider design shifts of the period, but the material is invariably discussed in relation to Queen Victoria and her love of Scotland with little further detail or analysis.

That said, an essay on Scottish jewellery by Judy Rudoe – which marks the only focussed examination through the lens of cultural history to date – rightly places this category of goods in an international context.[27] It sits within a groundbreaking volume by Rudoe and Charlotte Gere, *Jewellery in the Age of Queen Victoria,* which examines museum collections along with a range of other

sources to show the impact of tourism, an interest in science and nature, along with a 'Victorian sense of humour' embedded in objects, arguing that 'jewellery, more than any other branch of the applied arts, reflected the preoccupations of its owners'.[28] Scottish jewellery is framed alongside other 'national revivals' of Scandinavian, Italian, Assyrian, Egyptian and Irish jewellery. Deploying ideas of 'invented tradition', what is termed 'recognizably Scottish' jewellery, including that of historicist design and native materials, is submerged in a narrative about the surge of interest in Highland dress most often associated with tartan, kilts and plaid brooches.

Given that these works begin during, and focus on, the Victorian period, a great chunk of the story is quite simply missing.[29] The longer view, from the late eighteenth century, and seen from the perspective of the jeweller's bench, presents a rather different side of the picture. That picture is characterized by the long evolution of skills and design with complex roots in localized and regional cultural practices that were then adapted alongside much broader international aesthetic, economic and cultural shifts. By foregrounding landscapes of production – in terms of the social embeddedness of the jewellery craft across rural and urban spaces, alongside the use of native materials – this book seeks to untangle that longer, messier narrative to explore the mutability of skill, design and meanings of matter.

Landscapes of production

For its size, Scotland is the most geologically diverse country in the world, and, as such, displays one of the most varied natural landscapes.[30] The country's mineralogical and organic resources provided a range of materials for jewellery. The (often informal) paths those materials took from countryside source to town jeweller are less visible in the historical record than the established global supply routes, such as precious metals and gems from India and South America via the European capitals of Amsterdam, Antwerp, Paris and London.[31] Getting to grips with the use of native materials requires engaging with ideas about how rural landscapes provided both supplies and design inspiration for jewellers. It also requires thinking through how those landscapes were exploited to provide luxuries that both relied on and fed Romantic ideas of Scotland – and the Highlands in particular – as wild, untouched landscapes.[32] The exploitation of peoples and landscapes in pursuit of jewels and jewellery on a global scale is well

documented. Scotland was not immune from those issues. Indeed, as ground-breaking new work has shown, this was the period in which the proceeds of vast fortunes made through the slavery system were invested heavily in Scotland's estates: the Scottish landscape was inextricably bound with colonialism and empire.[33] It was precisely the ideas of 'wildness', 'romance' and 'timelessness' that made Scottish land and property so attractive to those looking to change the nature of their slavery-derived wealth and, in turn, transform their image. What, then, of the things made from jewellery materials replete with temporal meanings derived from that land, and particularly of worn objects made from gold, crystals and freshwater pearls examined in Chapters Three to Five, which were worn to communicate the wearer's ties to and ownership of landed property?

Simon Schama's *Landscape and Memory* remains the key work on how landscapes 'carry the freight of history', fusing nature and human perception.[34] He writes that, 'Before it can ever be a repose for the senses, landscape is the work of the mind. Its scenery is built up as much from strata of memory as from layers of rock.'[35] Exploring ideas of cultural memory embedded in the Scottish landscape in the modern period, Charles Withers shows how the legacies of historical events – namely poverty and eviction – that took place in the Highlands during the nineteenth century were carried through generations, shifting ways of seeing the land.[36] Exploring the roots of 'green consciousness' in the Highlands of Scotland, James Hunter's work on the relationship between nature and people builds on environmental histories to show, through a cultural approach, that there was a long history of deep respect and appreciation for the land and landscape that long predates the modern period.[37] Art historical works by Ann McLeod and Viccy Coltman on depictions of landscapes in the Highlands and Islands have shown how visual sources document shifting ideas about Scotland as a wild, timeless place and were key to the construction of 'Scottishness' in the historical imagination.[38] And the flourishing of environmental history has opened new avenues for considering the ways in which landscapes were changed through commercial activity over time.[39] Together, these works about the connections between people, land and the environment offer a foundation for exploring the cultural dimensions to the production of jewellery made from the stuff of the land.[40] How did jewellers and consumers – including locals, tourists and international markets – use that jewellery to express cultural identities and ties to place? And, a question curiously missing from the existing literature, how did ideas about and connections to particular landscapes shape

the world of goods beyond the commercial supply and transportation of natural resources?

Many of the big shifts that characterize Britain's industrial growth in the modern period emerged slightly later in Scotland than in England and played out differently in the former, with the 'speed, scale and intensity' of economic and social change after 1790 outstripping anything seen elsewhere in Western Europe.[41] The country's distinct geology and geography played an important part in the nature and pace of industrial change, for example in terms of the minerals required for iron production, coal-mining and the related production of ships and railways.[42] But this picture of wide-scale transformation and heavy industry has primarily been focused on economics and large-scale labour movements, rather than on work and skill.[43] Furthermore, the historiographical emphasis on large industries, technological innovation and urban production has obscured the smaller trades, eclipsed the continuity of craft skills and overshadowed provincial – never mind rural – economies. This powerful narrative about big industries and rapid change – in particular the increasing visibility of heavy industries, large factories and innovative machinery in urban areas – stimulated influential writings by Karl Marx, John Ruskin and, later, William Morris, all of whom argued in different ways that craftspeople were being dehumanized and deskilled as a result of industrialization.[44] The myth of industrialization as the destroyer of hand work still has significant power today. But as Raphael Samuel argued in the 1970s, the adoption of machinery was uneven between industries in Britain – partly due to a growing preference for the handmade, and tied to aspects of place and geography – and the production of small metalwares is just one example where small workshops persisted until at least 1880.[45] Following the Marxist 'history from below' approach put forward by E. P. Thompson in the 1960s, Samuel argued that it is important to analyse what industrialization actually meant for workers: to learn 'how the furnaces were declinkered, or the iron steam ships coaled', rather than seeing production at second or third remove.[46] Recovering the historical experience of producers by examining their processes is central to this book, but the focus is turned away from ideas about the manipulation of workers that dominates earlier studies towards analysis of how they saw themselves and produced cultural knowledge.

As demonstrated in both older economic works (if not always explicitly) and new studies on the handmade, place was fundamental to the production of consumer goods.[47] Across the world, localized hubs of jewellery making

and associated craft skills flourished from the late eighteenth century, in one example of many trades that clearly show how mass production did not destroy the craft economy.[48] By the late eighteenth century, the craft of jewellery-making in Britain was a complex industry in its organization, characterized by intricate webs of subcontracting.[49] Producers were, however, extremely effective in portraying an image rooted in the timelessness and venerability of materials and skills, cloaking their work in an air of mystery that maintained those notions about the industry and reflected them back on finished goods that were treasured as special things replete with meaning. In other words, the image of the industry itself was carefully crafted to mask the complex reality. Drawing on economic models of 'flexible specialization', Francesca Carnevali's hugely important work shows how factories and small workshops in 'industrial districts' became interdependent during the nineteenth century in order to adapt and survive, highlighting interlinked shifts in training, the organization of production as well as the nature of retailing and consumer demand.[50] Specialty producers were clustered in Birmingham and London in the UK, Pforzheim in Germany and Philadelphia in the United States. While these frameworks clearly show up the persistence of small producers and provide valuable insights into how they worked, craft communities which did not fit the fairly rigid economic model of the 'industrial district' – but, like those in Scotland, often intersected with them – remain out of view. Overall, very little is known about the impact of cultural shifts on reshaping industry dynamics, jewellers' relationship to their work or the way they saw themselves and their skill in light of the growing demand for things made by hand.

The dovetailing of different sectors and specialisms within Scotland's jewellery craft and its reach across geographies is perhaps best expressed in Bremner's 1868 report, which stated, in Edinburgh, 'All the work done is of a superior kind, no attempt being made to vie with Birmingham in the production of cheap and showy articles, the beauty of which is as transient as that of a flower.'[51] He asserted, 'The city [of Edinburgh] is not likely to become a manufacturing centre in the common meaning of the term, nor in some respects would that be desirable.'[52] While London was held up as the centre for quality production, Bremner stressed that the output of Edinburgh jewellers was of an equally high standard: 'Workmen trained in Edinburgh are highly valued by the London manufacturers of plate and jewellery, and some of the best work done in the metropolis is by their hands.'[53] In other words, Edinburgh's reputation centred

on the skilled production of high-quality goods while being bound with supply and production in London and Birmingham. In turn, all three were enmeshed with international supply and production. Labour too moved between centres of production, with highly trained Scottish goldsmiths a dominant feature of London's jewellery world, to the point of satire, from at least the mid-eighteenth century.

While Bremner refers to Edinburgh's image specifically, his report offers useful insights into the ways in which the interlinked jewellery and goldsmithing trade in other parts of urban Scotland – which unarguably revolved around that of the capital – was perceived. The smaller towns of Aberdeen and Inverness were established centres of silver production by the eighteenth century and served wealthy elites in the north of Scotland, in areas that were geographically removed from the capital.[54] These northern towns were also popular destinations for growing numbers of tourists visiting the Cairngorms, Highlands and Islands during the nineteenth century. Similarly, Perth had a reputation for quality silver production.[55] The town's location – right in the centre of the Scottish mainland and the heart of leafy Perthshire – meant that producers catered to wealthy elites from the surrounding area, and the town became a hub for tourists exploring the local countryside and travelling further north. Neither Glasgow nor Dundee had an especially strong reputation in the silver craft in the same way that these other towns did, though they were home to skilled makers. Both were small port towns in the eighteenth century and expanded rapidly, if along different lines, during the nineteenth. In the west, Glasgow ballooned as a result of rapid industrial development and, around the middle of the nineteenth century, outgrew Edinburgh, just 40 miles away, in terms of population.[56] On the east coast, Dundee's port made the town a centre for the import and export of materials and goods – particularly from the mid-nineteenth century – and these shipping and trade links were central to the development of other industries.[57] The rapid development of both saw a rise in the professional and wealthy middle classes, and an increase in shops selling fashionable luxuries.[58] By taking one craft – that of jewellery making – and viewing it across a country over time, a picture emerges of how geographical and cultural variations were inextricably linked to the ways in which that craft evolved in particular places, while remaining tied up with shifts in international production and consumption.

The jeweller's skill

How, then, does the historian go about excavating and examining the jeweller's skill across time and place? Jewellers are often portrayed as possessing a strong sense of self, rooted in the elevated status that came with being skilled in creating beautiful objects from intrinsically valuable materials.[59] By piecing together studies on the historical meanings of work, it is possible to see that the ways in which artisans more broadly – that is, skilled manual workers – understood their skill and workmanship changed over time, bringing about corresponding shifts in their sense of occupational identity. It is argued that, in the early modern period, craft skill was understood as collective property, and 'the sense of a property of skill was then deeply embedded in the culture and consciousness of the artisan, as was the assumption of the respect of others for it'.[60] The argument continues that a collective craft consciousness was destabilized when respect for hand skill was arguably diminished during the early nineteenth century, which in turn led to the property of skill being articulated rather than just assumed, and propelled further changes.[61] The backlash to this perceived loss of respect for skill can be seen in the writings of Ruskin and Morris, and was manifested most clearly in the Arts and Crafts Movement's self-conscious embrace of hand work. Despite this, changes in the wider market in the later decades of the century, from about 1870, undermined the role of established production methods in many industries and brought about further shifts in the identity of the working classes.[62] And it has been argued that by the late nineteenth century, business acumen had come to replace a pride in craft skill as the most important trait of the successful craftsman, which led to producers experiencing an 'embattled' sense of identity.[63] It is important to get a sense of the complex wider forces that were seen as distancing artisans from their property of skill – forces which were underpinned by the perceived shift towards mechanical modes of production – and the response, but also to understand that the meanings of skill mutated in uneven ways across industries and regions.

So, how did the jeweller's world and skill evolve specifically? The traditional approach to considering particular categories of workers is through guild records that document 'common concerns'. James Farr, however, has convincingly argued that understanding how artisans saw themselves requires moving beyond this approach towards a cultural analysis.[64] For a start, guilds went into terminal decline during the early modern period and,

on the whole, lacked power and authority by the nineteenth century.[65] That said, goldsmiths' institutional bodies – the Goldsmiths' Company in London and the Incorporation of Goldsmiths of the City of Edinburgh (hereafter the Incorporation) – retained more power and control over the labour market than other guilds. It is worth noting here that 'goldsmith' was an all-encompassing occupational title used by producers of both jewellery and silverware. While the skills used to make these goods were distinct, there was significant overlap, and they were usually retailed together. In Scotland, the Incorporation has survived from the sixteenth century to the present day, and its register of marks and online archive provide an indispensable resource for identifying makers and digging for biographical and business details.[66] Outside of Edinburgh, goldsmith-jewellers were usually members of the Hammermen guilds, along with other types of metalworkers who wielded the hammer, including cutlers, watch and clockmakers, locksmiths, blacksmiths, pewterers and tinsmiths. There are two main reasons for the survival of the Incorporation. Firstly, its responsibility for the Assay office in Edinburgh meant that it was enmeshed in the trade and of practical relevance to makers and markets. Such relevance also saw an Assay Office set up in Glasgow in 1819, though it was to be short-lived.[67] Assaying and hallmarking provided consumer protection while simultaneously allowing producers to assert ownership over their work and generating tax revenues for the Crown.[68] Indeed, the practice of marking objects has been cited as a central pillar of the jeweller's highly developed sense of self.[69] This idea is problematic because marks materialized the reputation of upper-middle-class business owners rather than artisans who worked under them and because smaller jewellery objects were exempt from the laws around assaying. This aspect renders guild records a fundamentally distorted lens through which to explore the jewellery craft in Scotland, as membership was dominated by wealthier jewellers, and was exclusively male.

Therein lie the issues of class and gender that are central to the study of craft, and which this book seeks to cut across. Uncovering the historical experiences of artisans is tricky, even more so when it comes to considering women in what was a male-dominated craft. The hard metals and manual work required to make jewellery were overwhelmingly associated with men. Indeed, artisanship itself was tied in with masculinity and the male life cycle. Apprenticeship, years of travel as a journeyman and the money required to establish a business enterprise posed significant obstacles for women, who were unable to travel alone and were obliged to take career breaks for pregnancies.[70] But that is not to say that women

jewellers did not exist, and I have highlighted them where they appear to render them more visible and reintegrate them into the narrative so far as is possible. Partly to guide that inclusive approach, I have adopted Crossick's definition of a craft as 'a body of producers tied together by a set of techniques and knowledge which could be acquired only through the practice of the occupation itself over time'.[71] This book conceptualizes Scotland's jewellery craft as a group of producers with skills, knowledge, materials, tools and markets in common, so as to include groups that are often excluded – including women – as well as the suppliers, dealers and shopkeepers that dovetailed with workshop production. Uncovering these aspects of production requires looking at the inner workings of industry. As existing studies have highlighted, however, the historian is often shut out of the secretive world of the workshop because producers actively tried to preserve the mysteries of their work in order to protect their property of skill until this became futile from around the 1860s, in the face of rapid industrial shifts.[72] From that point, there was an increased level of openness, carefully balanced with hidden activities.[73] That increased visibility runs along a parallel timeline to more visible signs of women producers in the sources, as census recording shifted and new forms of training, namely art schools, came into play.

This book peers inside the workshop to reveal its secrets using the objects made within them as a lens. Since the 1970s, feminist art-historical works on the Arts and Crafts Movement have explored the role of women jewellers in Britain during the late nineteenth century, many of whom were trained and worked in Scotland.[74] These works have rarely overlapped with social history because they are concerned with middle-class 'artist-craftspeople' trained through art schools, rather than apprentice-trained workshop producers (mainly men). More recent works have provided a glimpse at collaboration between art and industry.[75] What these studies have always explored are the direct links and relationships between producers, the things they made and the wider cultural context. This element is missing from economic and social histories of production that rely overwhelmingly on documentary sources and thus separate producers from the material manifestations of their skill, time and labour. Drawing these methods together, this book teases out the historical experience of understudied makers from the objects they produced. It also draws out the continuities between the way in which the Arts and Crafts Movement harked back to a pre-industrial past, and the way in which artisans and workshops throughout the century represented an imagined golden age for people who felt that they were living through a period of unprecedented change.[76]

The study of production has gradually merged with a parallel body of work that has shown consumption to be one of the key drivers of historical change.[77] Crucially, key studies in consumption proceed from the idea that understanding how luxury goods were consumed requires analysis of how they were designed and made.[78] By looking at production through the lens of consumption, works in this area have stimulated a deepened engagement with the physical qualities of consumer goods. Helen Clifford's groundbreaking work on silverware forged new ways of looking at shifting perceptions of skill and workmanship through objects and the materials from which they were made: silver and silver-plated base metals.[79] Clifford argues that the ingenuity and innovation involved in the production of electro-plated silverware meant that these goods were embedded with their own distinct values and meanings, rather than being perceived as lesser-grade versions of intrinsically valuable objects made from precious metal. Similarly, by looking at a specific type of goods, Kate Smith's work on eighteenth-century ceramics has shown how shifting perceptions of the potter's skill and workmanship impacted on consumption and on the cultural meanings owners assigned to objects.[80] Jewellery has not yet received focussed attention as to the relationship between skill and materiality. That said, Pamela Smith's work on sixteenth-century goldsmiths explores making processes to argue that artisans were deeply engaged with nature through their materials and, by applying embodied skills in metalworking, produced knowledge that broke away from the workshop and entered into the realms of philosophy and science.[81]

These works are so important in shifting the ground on which studies of modern production are built. It is telling, however, that they are overwhelmingly concerned with the early modern period, reflecting that there remains an underlying assumption that supply, production and retail were essentially industrial or commercial after 1830, and certainly after 1850. This is where the work of Adamson has been fundamental in proposing an alternative take, by integrating the study of making and meaning to show that, while handwork has often been viewed as an 'antidote to modernity', nineteenth-century industrial capitalism was responsible for transforming craft skills from the norm into something 'special'.[82] Adamson's study moves deftly between different objects, skills and sectors across time to argue that craft has always been a mutable concept, and was invented as industrialization's 'other' during the nineteenth century.[83] Other highly influential works, namely Richard Sennet's *The Craftsman*, revolve around the notion that skill must be seen as an embodied form of haptic knowledge that is distinct from but entangled with formal

knowledge of the sort that can be communicated in words.[84] The limitations of language, Sennett argues, have created a false separation between the head and hand. And Lara Kriegel's study of British artisans' role in nineteenth-century design reform reveals the intersections between economics, aesthetics and museum cultures.[85] Together, Adamson, Sennett and Kriegel have forged new ways of analysing nineteenth-century producers not just as makers of things, but as drivers of cultural change. Fusing these ideas, this book seeks to unveil how the haptic skill, knowledge, experience and creativity of jewellers in nineteenth-century Scotland were materialized in the goods they made, to explore their role as cultural actors who shaped their own worlds.

The present study

Every object contains clues about its making and use. The jewellery artefacts considered in this book are interpreted using established material culture and dress history methodologies – the latter an important lens, given that jewellery objects were made to be worn.[86] The fundamental relationship between jewellery and the body underpins this book, keeping in mind that jewellery is dress, and that making jewellery was a profoundly physical experience that required haptic skill, close sight and a high level of hand-eye coordination. By conceptualizing jewellery as worn objects, this study gets right to the intersections between the lives of people – both producers and consumers – and things, to integrate analysis of making and meaning.

Touch and sight are central to the study of this material. Telling real gold from good pinchbeck, learning to spot a Scottish freshwater pearl and understanding how the shape of an object has been dictated by inclusions in the stone relies on a sensory understanding of the materiality of jewellery. This knowledge has been built up by handling hundreds of objects in museums – including at National Museums Scotland, where it is my job to care for and be curious about these things – as well as in other public private collections and auction rooms. Only a small proportion of those objects are included here, each one selected to give particular insights, with no attempt made to present an exhaustive catalogue. The difficulties in understanding materials – many of which, such as pinchbeck and paste, were intended to deceive the eye by imitating intrinsically valuable materials – have opened up research questions about, for example, how the gulf between the knowledge of producers and consumers was manipulated and

overcome. It is important to note that the challenges posed by jewellery objects are compounded by representation. Still images of jewellery objects cannot communicate their mutable effects as a result of the play of light, and issues of scale mean that every miniature object pictured here is made giant, with the tiniest details magnified. When I look at the bracelet on the cover of this book I see an infinite number of pictures as it moves under the light. I feel its weight and its temperature, the cool smoothness of the stones, the way it sits in the hand, and the quality and bounce of the clasp. By handling it I understand, on a sensory level, how it would have sat close to the skin, clasped to the lower arm. Much like the limitations of language in describing objects and their effects, a still image conveys only a static glimpse or fragment of the thing itself. Images and words in combination have to do a lot of work for the reader in a book like this, and yet still give a partial picture of the object.

I look at each object as a miniature vault containing a wealth of evidence about its making and culture. But uncovering the biographies of individual objects and understanding them in relation to their wider context necessarily involves deploying complementary sources which, for this period, are plentiful – if a little uneven.[87] Add to that the fact that, by their very nature, jewellery objects were vulnerable to loss as they were melted down and reformed in line with changing fashions. Such recycling causes issues with dating jewellery objects, as older stones were often reworked into new pieces. Alteration, loss and recontextualization place the theme of absence at the heart of material culture studies and the gaps where objects once existed are considered through the surviving material that surrounds them.[88] This range of other sources spans the visual and documentary. In the course of these chapters, I employ paintings, engravings, newspapers, private letters, wills, inventories of big houses and of bankrupt workshops, business directories and exhibition catalogues. I consider design sketches, pattern books and fragments of tracing paper containing rubbings of objects now lost to explore the design processes used to create them. Novels, travel and nature writing, and works of literary geology are employed throughout, with the literature-based studies outlined above providing a useful model for unpicking language. Contemporary images and texts are analysed both to understand jewellery on its own terms and to explore the ways in which the material, visual and textual, collapsed into one another.

In doing so, this book undertakes a 'craft-based reading' of jewellery production in Scotland, working across scholarly boundaries in pursuit of new and deeper understandings of history through objects and poesis.[89] I employ a mixed

methodology, drawing on social and economic history methods which have underpinned the development of material culture studies alongside interpretive frameworks drawn from histories of art, design and dress. At its core, this is a material culture study that fuses a cultural biography approach with a focus on materiality to explore the role of matter and making processes in shaping the social and cultural meanings of Scottish-made jewellery. The study traces the life cycle of jewellery made in Scotland, from raw matter in the landscape, through the hands of jewellers in the workshop, across displays in shops and exhibitions, and on to the bodies of wearers. But it does not do so in this order, as a march through process. Instead, it employs a thematic approach between chapters and a broadly chronological structure within each of those chapters. The view that then emerges of the objects themselves reflects the fact that jewellery objects could move back and forth on a spectrum of made to un-made as materials were recycled and reset.

Chapter One takes a tour of the workshop, opening with a close look at the apprenticeship system and at visual representations of making spaces to examine the organization of skill and labour within the jewellery trade. It then moves to the bench itself to examine ways of making things by interrogating surviving jewellery objects along with letters and craft manuals to reveal the historically contingent ways in which jewellers learned, adapted and passed on their skills and knowledge, and to explore jewellers' sense of belonging to their craft. Chapter Two continues this thread of learning and driving skills, examining the different methods by which jewellers created new things from older objects. The focus is on how jewellers adapted – and asserted ownership over – the designs of past makers to create new products, and in turn cemented a collective image and identity of themselves as venerable producers tied in to a long line of makers stretching back into prehistory. The book then hones in on different categories of materials, drilling down to take a closer look at the relationship between matter and meaning with an emphasis on making processes. Chapter Three considers precious metals to explore how their natural origins in the Scottish landscape gave them the power to act as receptacles for individual and collective memories, and posed challenges for producers that required them to adapt methods of transport, design, making and marketing. Chapter Four examines colourful jewellery made from crystal 'pebbles' to examine the ways in which a cultural preoccupation with scientific and Romantic ideas about geology and mineralogy stimulated the development of specialist lapidary skills. Through its focus on coloured objects, the chapter extends analysis to the related craft of enamelling, to reflect on the dynamism of craft skill. Scottish freshwater pearls

are the subject of Chapter Five, alongside other types of organic matter such as shells, taxidermy and hair. The focus is on how the cycles of natural supply intersected with market demand to show that evolving ideas about the living world continually reshaped the meanings of materials derived from animals and had a direct bearing on the look and feel of the jewellery objects made from them, as well as the image and reputation of jewellery firms in different towns. The concluding chapter summarizes some key findings, picking up and reflecting on threads that have emerged throughout to underline the value of a materiality-based approach to the historical study of craft. I also propose new avenues for research as well as for the collecting and display of objects in museums of the twenty-first century, with a particular focus on responding to the evolution of environmental thought since the nineteenth century.

At the core of this book, then, is the constellation of relationships between materials, makers and making processes, and the social and cultural meanings of things. It is an exercise in reading objects and in gathering sources – material, visual and documentary – to unearth the history of a craft during a period of profound social, cultural and technological change. By examining these processes and materials, the book reveals how Scotland's jewellers continually adapted their skill to create powerful objects that both reflected and shaped cultural ideas about workmanship, history and landscape. The materiality-based approach to jewellery employed provides hitherto unrecognized insights into the making and remaking of the material world during the long nineteenth century. As such, it presents new methods for bridging documentary, visual and material sources to examine the relationship between economics and aesthetics, landscapes and bodies, and craft and culture.

Making things: The materiality of skill in the jeweller's workshop

Workshops are notoriously mysterious places. They are spaces of transformation, of manipulation and of secrets: craft secrets, the knack, tricks of the trade. This is particularly true of jewellers' workshops, where precious materials loaded with myth and symbolism are manipulated into miniature luxuries that are considered special, often treasured. Treasured for their preciousness, for their beauty and for their role as objects that bind people. The small scale of objects, the layered symbolism and high monetary value of materials, the metamorphic nature of metals – that movement between solid and liquid states – all serve to heighten the sense of the jeweller's bench as a space shrouded in secrecy. At least, to an outsider, that is how it might appear.

Inside the nineteenth-century jeweller's workshop, things looked rather different: knowledge was shared, produced through collaboration between makers. It evolved and was passed around. Becoming skilled in the craft of jewellery making involved building a knowledge and understanding of materials, tools and techniques, all of which were developed over time through a process of problem-solving and physical practise. But for much of the nineteenth century the manual, productive labour or 'informal' knowledge of the hand was seen as the poor relation of intellectual, scholarly or 'formal' knowledge of the head. Recent influential works on craft have asserted the notion that 'making is thinking', that craftsmanship involves a relationship between head and hand.[1] Artisanal labour combined theoretical knowledge of the sort that can be codified in words and text, and haptic knowledge that is difficult to express in formal ways but is known in the body.[2] The knowledge and skill of makers – their workmanship – became embedded in objects, and materialized in their quality. While inseparable from materials and their monetary value, workmanship was to do with the skill and dexterity used to transform raw matter into quality objects. The finished object was the

physical manifestation of that workmanship. In the words of David Pye, 'Good workmanship will make something better out of pinchbeck than bad will out of gold.'[3]

The idea that this relationship between head and hand is fundamental to making is not new. Writing in 1792, Scottish philosopher Dugald Stewart argued, 'When theoretical knowledge and practical skill are happily combined in the same person, the intellectual power of man appears in its full perfection.'[4] These words were quoted in a speech given in London in 1823, to mark a vote to establish a technical school there.[5] The proposed school was much like and modelled on those already operating in Edinburgh and Glasgow. Indeed, the man who gave the speech was George Birkbeck, who had played a central role in establishing talks and lectures for Glasgow's artisans at the Andersonian Institute, founded in the 1780s.[6] The way in which these words were deployed, to frame the importance of combining formal and tacit knowledge in the mind of the artisan, is evidence in itself of the imbalance between the two. Across the period, value placed on skill and workmanship fluctuated – not just over time but also between different areas of craft and industry.

This chapter explores the ways in which jewellers learned and developed skills, and applied head and hand to transform raw materials into finished objects. It does so against the backdrop of the changing value and meanings of skill and workmanship. Across the nineteenth century, the numbers of jewellers and jewellery firms increased in all of Scotland's towns, reflecting broader demographic shifts.[7] This growth, together with a parallel increase in goods retailed by jewellery firms, has partly obscured the craft dimension to the broader industry in the historical record. Recent works have argued that moving beyond the myth of modern industry as the destroyer of craft production, towards an understanding of the 'shift to craft *within* industry', requires viewing skill not as something that can be lost forever, but as a form of social and cultural capital that is learned and passed on, 'redistributed or redeployed or reformed'.[8] Working from that idea, this chapter closely examines processes of learning and making. So much of the debate around skill – and the relationship between head and hand – is rooted in rhetoric, detached from the embodied experience of makers, from the physicality of objects and from workmanship itself.[9] In looking at these processes, we can better understand the evolving ways by which craft jewellers gained, applied, valued and passed on their property of skill as the wider industry grew and

morphed around them over time, and how what it actually meant to be a jeweller was reshaped in the process.[10]

So, how are we to excavate the knowledge that circulated within the workshop and get inside the minds of jewellers past? The day-to-day of the workshop – the activity that went on within the space, and within the jeweller's head – is not the sort of information that readily survives in documentary sources, rendering the historian an 'outsider' and effectively maintaining the secrecy of the workshop space across time. Getting a glimpse inside requires drawing together a range of sources, including the objects themselves. Given that skill and workmanship are manifest in the goods makers' produced, a series of surviving objects forms the bones of the chapter. Rings, brooches and buttons are examined for evidence of tools, techniques and ways of working, interrogated for signs of how they were made, in order to understand the ways in which artisanal skill and knowledge were applied in the workshop, and how the craft dimension to making jewellery changed over the period. Letters and contemporary craft manuals are employed to unveil processes used to make those things, and to explore the ways in which artisanal knowledge was codified and transmitted between producers. That information is often fragmentary, though by looking at objects together with the documentary it is possible to piece it together.

But first, a look inside the workshop and at the apprenticeship system by which most jewellers entered the craft during the late eighteenth and early nineteenth century sets the scene and provides a touchstone for the following analysis of jewellery objects. Throughout, this chapter attends to the ways in which the shifting value placed on workmanship interacted with the changing shape of the industry, in terms of its class and gender dimensions. Learning is a thread that runs through the whole, showing that while the apprenticeship system upheld by patriarchal institutions was the way to become a jeweller in the late eighteenth century, the disintegration of this system (so often a byword for a perceived decline in skilled metalworking during the period) was paralleled by other routes in and other structures of learning. Those alternative entry points to becoming a jeweller opened up opportunities – albeit limited – to those who had previously been excluded: namely women. Seen in this light, the implicit gender dimension to the very notion of the decline of craft comes into sharp relief. Ultimately, the chapter drills down into the often overlooked area of the materiality of skill and its inseparability from the social and cultural dimensions of the workshop.

Learning by doing

A discussion of workmanship must begin with an examination of forms of learning and making 'at the bench', in order to understand the social and cultural contexts in which skills were acquired, as well as how training shaped the collective norms and values of groups of producers.[11] What did the jeweller's workspace look like, how were skills learned and applied, and how did the career of the jeweller unfold? Across Europe, there were distinct elements to the workshop that changed little over time. Those elements were sometimes recorded in visual evidence that offers a starting point for thinking about making spaces and the constellations of knowledge produced within. These images require viewing with care, of course, as they were constructed to present skilled production in a particular light. Nevertheless, they offer useful insights as to the defining features of particular areas of craft, in terms of the workshop space, key tools, and the organization of people, tasks and labour.

Denis Diderot's *Encyclopédie* is a famous, much-studied work which sought to represent thought and knowledge of the eighteenth century – including tacit or informal knowledge – with detailed engravings of working producers.[12] The depiction of Parisian jewellers and goldsmiths at work highlights the interconnected nature of the production and retail of jewellery and silverware (Figure 1.1). On the left-hand side four craftsmen dressed in smock-like overalls are making jewellery at their distinctive benches, characterized by the semi-circular cut-out to facilitate close-up work, with leather suspended underneath to catch precious dust and filings for recycling. The benches are directly underneath large windows, crucial for seeing and executing fine work. In the back corner is the kiln, where raw materials were treated with heat. In the centre of the image is a man at the anvil and block – that symbolic main tool of metalworking – his arm raised, ready to drop the hammer with a clang. On the right-hand side, the door to the shop is open and a male customer is seated in front of the counter attended by a female worker. A display case full of silver lines the back wall. In the foreground, another worker directs a flame through a blow pipe. He wears a frock coat, a marker of respectability and authority that was suggestive of a master, or a worker who oversaw and directed the work of others.

While shop and workshop are represented as one space, a line on the floor hints at separation. In reality, the clanging of metal on metal, the roar and heat of the kiln, and the dust and smoke – plus the high value of materials – meant

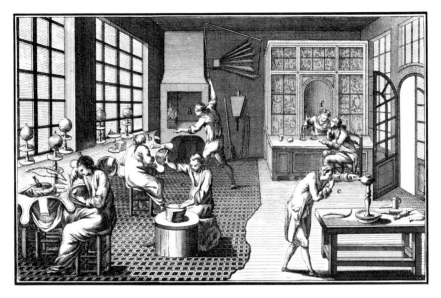

Figure 1.1 'Orfèvre-bijoutier', in Denis Diderot and Jean Le Rond d'Alembert, *Encyclopédie ou Dictionnaire Raisonné des Sciences, des Arts et des Métiers*, Volume 8 (plates) (Paris, 1771) © Bridgeman Images.

that the workshop was almost always separate from the shop space by the late eighteenth century.[13] While production and retail were physically removed from one another, they were intimately bound. Indeed, it was in producers' interests to present a picture that disguised the complex subcontracting systems that underpinned the industry.[14]

Jewellery production was characterized by the subdivision of labour, which, as previous studies have recognized, had a more pronounced effect on the industry than mechanization.[15] Themes of specialization and the division of labour are prominent in images from Britain and France. In one such engraving from Paris (Figure 1.2), not one but two anvil and blocks occupy the centre of the image, with five men carrying out distinct tasks at the bench, and another at the kiln. Standing above all this is the master, cutting an authoritative figure in his dark frock coat, overseeing and directing work. These illustrations of hands engaged in different types of activity with eyes focused on work too small for us to see emphasize the close-up, delicate nature of work making miniature objects. Detailed illustrations of tools and finished jewellery objects – pins, a ring and earring – and hand tools frame the scene, giving a sense of the physical movement of these objects, through the various hands that made them and on

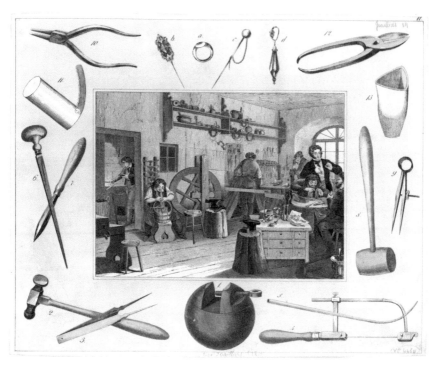

Figure 1.2 'Workshop and main tools of jewellery', French School, 1810. Engraving. Musee de la Ville de Paris, Musee Carnavalet, Paris, France/Bridgeman Images, XIR3247626 © Granger/Bridgeman Images.

to their finished state, at which point they would be moved to a separate shop space.

There were hierarchies within the workshop, with business owners at the top then masters (sometimes owner and master were the same person), then artisans, journeymen and apprentices of various skill levels and, at the very bottom, 'boys' or 'lads' who ran errands and swept floors. An 1818 publication aimed at informing young people in Britain about manual occupations gives important detail on this point.[16] A jeweller is depicted working at the bench under a window, surrounded by tools (Figure 1.3). Like the master in the Paris image, he wears a dark frock coat over his apron. There is an empty place next to him at the bench, and the text draws attention to the fact that this was a shared workspace, and describes how rates of pay corresponded to the hierarchical structure of work. At the top were business owners with the: 'capital required to carry on a business of this kind, [which] must be very great; a single diamond being sometimes valued at twenty thousand pounds'. Under those who made

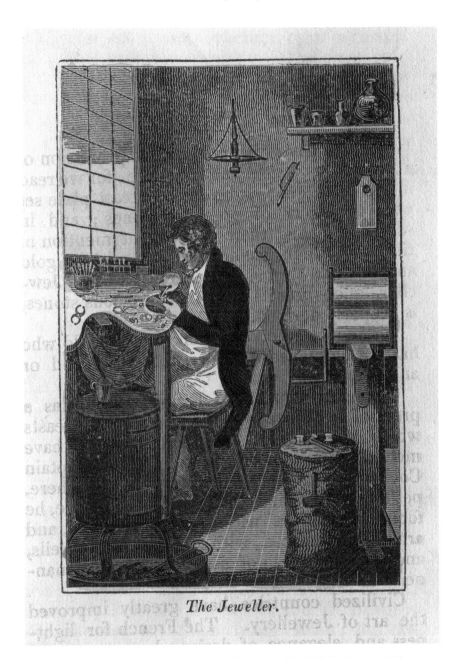

Figure 1.3 'The Jeweller' in John Souter, *The Book of English Trades: And Library of the Useful Arts: With Seventy Engravings* (London: Richard Phillips, 1818) © Universal History Archive/UIG/Bridgeman Images.

their money from trading goods, there were jewellers who earned through their labour. Within the latter group were journeymen, who were not necessarily attached to a particular firm but worked under small masters, paying rent for their place at the bench and supplying their own tools, and might earn up to 'four guineas a week'. Then there were artisans employed by a firm and given a fixed wage, 'the general run of wages, is about twenty eight or thirty shillings'.[17] Despite the gap – sometimes gulf – in authority and earnings between these workers, they all identified as jewellers and, given the small workshop setting that characterized the craft, often worked in close proximity to one another. As we shall see, the relationships between individuals in small firms was complex, with personal and kinship ties both reinforcing and cutting across the hierarchy.

Ownership of materials was a defining feature of the jewellers' position within this hierarchy and is embedded in the workshop itself. For example, even the metal grates on the floor were a key feature of the workshop, as seen in Diderot's image and the accompanying list of integral tools and equipment. They were taken up regularly and sweepings put in the crucible, ensuring precious dust was recycled and reused, thereby remaining the property of the owner rather than carried out of the workshop on the soles of workers' shoes. Workers' aprons, often made of leather, as well as the leather piece suspended underneath the cut-out of the bench to catch small pieces and dust, remained on the premises and were burned when worn out to recycle trace metals. Materials constituted a significant proportion of the capital of jewellery businesses. Money could be tied up in works-in-progress and stock of finished goods for some time. It is important to remember that while the industry, the firms within it, and the products were comparatively small, the monetary value of materials and the risks and rewards for business owners were high. In short, capital was key.

So, what was the route to becoming a jeweller? In eighteenth-century Scotland, like much of the rest of Europe, the primary approach was through an apprenticeship.[18] There are few studies on apprenticeship as a form of learning in Scotland but the general consensus in a well-established literature on English apprenticeship is that the government-regulated system enshrined in the Elizabethan law, the Statute of Artificers, was gradually eroded from the seventeenth century and had almost entirely collapsed by 1780.[19] While the Statute never applied in Scots law, the fact that it was essentially defunct by the turn of the nineteenth century underlines the fact that, across Britain, there was no central governing body responsible for training artisans. Rather, there was a system of formal contracts regulated by individual guilds, which

were themselves losing their teeth, as well as informal contracts that operated outside of institutional control.[20] Nevertheless, in the late eighteenth century apprenticeship was 'still the rule' for certain areas of production, particularly those which, like the jewellery trade, were highly skilled and which were run by wealthy guilds that retained just enough power, for a little longer than others at least, to enforce the system.[21] Parallel to this gradual but terminal loss of institutional control, there were growing objections to apprenticeship on the basis that it constituted a barrier to free trade. Adam Smith argued that the system denied the craftsman the right to exercise his skill and labour as he saw fit and was, therefore, 'a plain violation of his most sacred property' – that is, the property of skill.[22] Smith viewed long apprenticeships as unnecessary on the basis that 'dexterity of the hand' could only be acquired through physical practise and proposed that basic instruction in tool use and construction followed by independent work – where journeymen were responsible for their own materials – would be a 'more effectual' and 'less tedious' way of learning.[23] Smith also highlighted masters' vested interest in maintaining the system because it saved them the cost of a workman's wages for seven years and enabled them to keep the number of competitors in check by exerting significant control over the labour market.[24]

Nowhere are these vested interests clearer in the records of the Incorporation of Goldsmiths of the City of Edinburgh, which show an ancient institution – and one enmeshed with political power structures – attempting to prop up a system being dismantled by profound social and economic change. The rules they attempted to assert, tighten and reassert, and the points of tension recorded in the minutes, highlight exactly how the system worked and how it was being transformed. Recording is generally loose, and variable across time with flashpoints of more stringent recording at times of heightened concern around control, but shows that in both theory and reality, apprenticeships did run for seven years and were, unsurprisingly, an exclusively male affair. When the indentures were signed off, the newly trained man-boy went off with a 'burgess ticket' in hand, which gave him the right to practice his trade as a journeyman, and could later apply to become a 'freeman', enabling him to start his own jewellery business in the city and, crucially, take on his own apprentices.[25] In 1799 it was stated that all new apprentices were to be under twenty years of age and could not have held an apprenticeship previously (a defensive measure to hinder this form of training being used as a loophole to business partnership between freemen and owners of firms who had not been through the system,

usually termed 'unfreemen').[26] In 1825, this was tightened further with all boys having to be between the ages of ten and sixteen when the seven-year term of the apprenticeship commenced.[27] In the years between 1822 and 1860, the average age of new apprentices recorded was fourteen years.[28] It is worth remembering that these were children, young boys entering a contract which placed the responsibility for their occupational training as well as their accommodation, food and clothing to the master for seven years. And it is important to view the context of their training and their socialization into the workshop through this lens. The apprenticeship linked boyhood with life as an adult man in possession of a respectable trade and (all going well) an enviable, and potentially lucrative, set of skills that would go on to define his wealth, status and sense of self. Artisanship was inseparable from masculinity; apprenticeship was the rite of passage that fused them, forging masculine identities in a trade that, for the most part, excluded women – though, as we shall see, women did operate as jewellers and were becoming more visible within the craft towards the end of the nineteenth century.

The Incorporation was a powerful organization, with its members holding positions of significant political authority in Scotland's capital. A famous painting of Edinburgh's Parliament Square (Figure 1.4) from the eighteenth century shows St Giles' Cathedral in full view, lit up in golden sun, with a row of luxury shops – including jewellers' – huddled along its southern flank. The Goldsmiths' Hall is enveloped in shadow on the left, the signage proudly marking out (just visible to the viewer) its prominent position in this space of urban power. In the absence of images of the inside of Scotland's jewellery workshops at this date, the painting opens up a view of the urban spaces those jewellers and silversmiths inhabited. This was the area that came to be most closely associated with the craft, with shops and workshops clustered in and around this square until the early nineteenth century, at which point jewellers gravitated steadily northwards to fancy spaces in the Georgian New Town. Training and working here in Parliament Square and thereabouts, the jewellers under study were acutely aware of how their craft dovetailed with the enmeshed power structures of church, law, politics and business. And, of course, the customers who frequented this space were overwhelmingly moneyed elites: the aristocracy of Edinburgh and central Scotland, and increasingly a growing group of moneyed middle-class consumers, including visitors as tourism evolved from the later decades of the eighteenth century. The sense of status and pride in craft skill was inseparable from the physicality of the city itself. Though the space was much changed

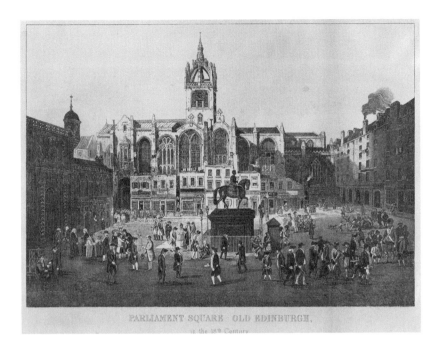

Figure 1.4 David Wilkie, 'Parliament Square, Old Edinburgh in the 18th Century', 1845. Aquatint, 22.3 × 29.1 cm. © City of Edinburgh Council – Edinburgh Libraries.

during those early years of the nineteenth century, the unshakeable reputation of this area as the seat of Scotland's luxury trade has seen the cobbled square in front of the cathedral – and the adjacent High Street – retain strong associations with jewellery and silversmithing to the present day.

A rare surviving indenture paper from 1793 lays out the terms of the apprenticeship. The paper was printed as a standardized contract with blank spaces for names, dates and occupational details (see handwritten detail in italics):

> And the said *Alexr Spence* binds and obliges himself, his heirs and successors, to teach, learn, and instruct or to cause teach, learn, and instruct the said *John Duffus* in his foresaid art and *Trade as a Goldsmith* with the parts and practiques thereto belonging, and to entertain and sustain his said apprentice in meat, drink, bedding, and clothing, sufficiently, during the whole space foresaid.[29]

As well as teaching the apprentice the 'art' of processes and techniques, the inclusion of the word 'trade' suggests that the master had a contractual

responsibility to share his knowledge of business, such as evaluating and buying materials, and dealing with customers and suppliers.[30] Alexander Spence was experienced, having completed his training and opened his own business in the early 1780s.[31] As was often the case, his apprentice, John Duffus, was the son of another Edinburgh goldsmith, Thomas Duffus.[32] The whole system constituted a network of enmeshed kinship ties, with makers training sons of family members, friends and fellow producers. While set fees were paid to the Incorporation and other legal and administrative functions when apprenticeship commenced, the payment given to the master jeweller was negotiated on an individual basis, given that it constituted both economic contract and personal agreement, sometimes between friends and family.

There was some flexibility in these contracts. For example, John Duffus's indentures were transferred to another Edinburgh firm three years into his apprenticeship.[33] He passed through the system successfully, serving his time as a journeyman before becoming a 'freeman' in 1810. Becoming a freeman involved applying to the Incorporation (and paying a hefty fee) and, if the petition was approved, producing an essay piece to prove that he had 'rendered and confirmed himself more perfect in the Art'.[34] The essay piece was assigned by the members of the Incorporation: often a plain gold ring, set with stones or hair, and was made in an appointed workshop on a fixed date, supervised by two experienced masters.[35] Duffus made a box hair ring and a plain ring.[36] The crafted objects were then presented to the Incorporation and, if they passed examination, the freeman was admitted and took an oath that reflected the embodied, tacit nature of his craft knowledge, to 'maintain and defend the liberties thereof my body and goods'.[37] The transition to freeman was a crucial one in the jeweller's life cycle, giving him the right to operate his own business under his own name within the city – these were the businessmen who had monopolistic privileges over production, and the market. In this light, we see that attempts to cling to the Incorporation's control were about preserving commercial advantages by keeping others out.

Many new freemen took on apprentices fairly quickly. The fees paid and the additional pair of hands were useful in a new business and, moreover, having an apprentice was an important source of craft pride that reflected freeman status.[38] A degree of flexibility within the apprenticeship contract is glimpsed through further records relating to Alex Spence, who also trained his son, John Spence.[39] When the Incorporation objected to John's application for freeman in 1817, his response was firm: 'I have to state that during the whole course of my

apprenticeship I served my father in every thing that he required of me, both in his sale shop and workshop.'[40] Clearly, then, John had received training in both retail and making, unlike many apprentices in Europe who complained that they were unable to gain experience in the professional or non-practical skills that enabled them to progress to management positions.[41] Tellingly, he went on to justify his pursuit of a formal education alongside technical training, stating:

> It is true that during my apprenticeship, time was allowed me by my father to attend to my education and other studies, but I understand that every master has it in his power to give his apprentice what liberty he thinks proper.[42]

Clearly, the Incorporation had a problem with this. Furthermore, Spence argued, he had been working informally for his father 'for some time before I was entered on your books as his apprentice and that in return for it I continued to assist him in the shop a considerable time after the termination of my apprenticeship'.[43] That Spence bookended his apprenticeship term with work for his father indicates that there was room for negotiation where time served was concerned, at least in the eyes of makers, if not the Incorporation's members.

Exposure to day-to-day workshop activities and proximity to other workers can be understood as a sort of 'pre-apprenticeship' that equipped future apprentices with an understanding of processes as well as the social and cultural dimensions of a trade.[44] In this sense, apprenticeships were not just about acquiring and practising manual skills but about learning the hidden rules of the workshop, adjusting to a way of life, fitting in with other workers and forming social ties.[45] Indeed, a surviving contract from Aberdeen in 1766 shows that James Gordon's apprentice – and later brother-in-law – George Roger (son of a stabler) was bound and obliged to protect the hard-won craft knowledge passed on to him, 'His Masters [*sic*] Careful Secrets not to reveal'.[46] In 1784, 'having mutual trust and confidence in each other', the two went into business partnership, with Roger given responsibility for 'overseeing, managing and carrying on' the firm and for ensuring that 'the Company Books are to be Balanced at the end of each year'.[47] In this case, apprenticeship was not just a system for learning: it was a contractual gateway to multifaceted opportunities for both master and apprentice, a way of cementing kinship ties to ensure the security and stability of the firm. Within this web of ties were women like Gordon's sister, who later became Roger's wife. The combination of marriage and business partnership created the double bond of family and business that, among other things, provided some security for women within the family network who

were deprived of the right to own the firm or go into business partnership of this sort in their own right. While records of this kind offer important context and intriguing glimpses of the webs of people and relationships around the apprenticeship system, they cannot provide evidence of what went on inside the workshop day-to-day, nor of informal apprenticeships that were never officially 'booked'.[48] Understanding the more complex story at play requires a closer look inside, through the lens of the luxury goods made within.

Forming small luxuries, setting stones

The making of the essay piece marked a transitional moment in a jeweller's working life. The jeweller was assigned the essay, essentially tasked by experienced masters to make a piece that involved applying a range of fundamental skills and techniques to an acceptable standard of workmanship. Gold rings, often set with stones or hair, were commonly chosen because they combined a range of complex processes. A gold and hair ring made in the early nineteenth century offers a look at exactly this type of object (see Plate 1.1). The ring itself is unexceptional. It survives in museum collections because, unusually for an object of this type and size, it carries a maker's mark. That mark makes it rather interesting, as it identifies the maker as Robert Keay, who was admitted freeman to the Hammermen of Perth in 1791 after making a plain gold ring as an essay and, remarkably, went on to train twenty-four apprentices – an exceptionally high number that points to a significant level of output – over the following thirty years.[49] Also unusually, extensive papers surviving from Keay's firm give fascinating insights into how knowledge was produced and shared between jewellers, and transmitted through business and kinship ties. One of his many apprentices was his namesake and nephew, Robert Keay Jnr, who trained for five years from 1815 and made a gold set pin with a stone as an essay.[50] That Keay Jnr's apprenticeship was two years short of the norm suggests he may be an example of an apprentice who had prior skills and experience, perhaps through being socialized into the workshop before starting his formal training. The two entered partnership as R. & R. Keay in 1825 and Keay Jnr took over the business in 1839 when his uncle died, running it until his own death in 1856.[51]

For such a small thing, the ring feels weighty in the hand. The high density of gold gives objects on this scale an unmistakeable heft that declares a high content of the precious metals. A fairly chunky 'D-shaped' band – flat on the

inside, the crisp edge giving way to a gently domed outside – meets at an oval-shaped setting, or bezel, framed by a small neo-classical decoration at either side. These little flourishes – the tiny tear and curly C shapes – are both decorative and functional. They provide a visual linkage between the band and bezel and equalize the height difference between the two parts. They also reinforce and hide the joint where the bezel is soldered to the band. Under the crystal, human hair has been carefully organized into smooth, flat strips and woven, creating four interlinked triangle shapes. The crystal has been specially cut to fit, and a fine gold collet – or collar – is fitted on top of its tapered edge, tension holding the pieces in place and creating a seal. The crystal is scuffed and scratched and the band misshapen indicating this was a well-worn piece, likely a sign of its sentimental value and its place as something worn daily rather than on occasion. Indeed, damage through wear-and-tear has been exacerbated by issues with the fit between the crystal and collet, which, judging by the brighter, more yellow shade of gold in the collet, appears to have been repaired. A similar ring, also by Keay, in Perth Museum's collections contains all of the same main parts, but is slightly different. The subtle differences in appearance and construction suggest that the company made this type of ring in quantity, and highlight how different hands applied to the same task produced different results.

Making a ring like this started with acquiring tools and materials. It is often assumed that tools were made in larger centres of production such as Birmingham and London. Broadly speaking, that was the case, but evidence of specialist makers reflects Edinburgh's place as a specialist centre in fine metalworking of jewellery, timepieces and scientific instruments. One Giacomo Visconti, from Lombardy in Italy, operated in the city in the 1790s, supplying Scotland's 'principal watch makers, jewellers and smiths', 'making fine Tools, such as are used in the Manufactures of Gold, Silver, Brass, Steel & other Metals, and … is possessed of Methods of tempering & making those Tools, little if at all known in this Country'.[52] Suppliers of tools and materials were often trusted contacts who also undertook subcontracted work. For example, Keay was supplied by Edinburgh goldsmith and bullion dealer, John Blackwood Caw, who trained in the capital and became a freeman in 1815 after making a pearl ring and a plain gold ring as an essay.[53] In 1834, Caw billed Keay for 'pliars' [sic], engine turning, 60 oz Sterling silver and an ounce of fine gold.[54] Caw was still supplying similar goods in 1848 (nearly a decade after Keay Snr's death) when he sent a bill for duties, fine gold, silver and copper, and for fashioning teaspoons.[55] Fine gold was mixed with other metals – usually

silver and copper – to create an alloyed metal suitable for working, and the fact that Keay was purchasing these materials shows that the process was carried out in-house. Keay also commissioned/subcontracted Caw to make finished jewellery objects. In 1834, a gold bracelet costing £1 10s was sent from one of Caw's workmen to Perth with a note saying: 'The above is lighter than the pattern. It is not any easy matter to match the weighte [*sic*] of an article of this Kind exactly. And J.B.C. [John B. Caw] was anxious to have it rather within than over the weight.'[56] The challenge of using the correct amounts of gold is a reminder of the jeweller's need to adapt processes to control the use of valuable materials.

Mixing metals was a skilled technique in its own right – raw materials were only made good through the jeweller's processes.[57] In 1822, a craft encyclopaedia *The Technical Repository* described recipes using salt, gold, and copper or silver for gilding articles and remarked:

> It is a very curious circumstance, that the best workmen in this branch of jewellery have at this day no other menstrum for giving the last high finish in colour to their beautiful articles, than the employment of the compound salts of alum, nitre, and common salt.[58]

Although methods changed little over a long period, understanding the techniques and amounts of materials required was hard-won knowledge. In 1848, Caw sent supplies to Keay along with a letter offering advice on creating 'the colour [of gold] generally approved of' while achieving the right balance of malleability and strength:

> Now be pleased to observe that to mix the metals properly, and to make malleable gold you must melt them together twice – and don't put any borax, but the second melting – you may put a little the first – but put a very little nitre, or salt petre, just before you pour your melting. In fact I believe the whole secret in making tough gold has been in this simple affair. At last I have found it so after a very great deal of labour to discover what is of so much importance to me. And I trust you will be so good as to keep the thing to yourself, for you are the first I have communicated the fact to. No doubt there are many others who makes there [*sic*] gold perfectly malleable but I have never learned the method they employ. And there are great many who have very great difficulty with this at the present day.[59]

Caw's excitement at his discovery at making *just* the right colour of gold is palpable in his writing and highlights a pride in craft skill. He underlined the

key methods and quantities, and emphasized the 'very great deal of labour' taken to refine his recipe.

Caw asked Keay to keep the information to himself – the technique would make working the metal easier and, in turn, drive up standards to create a higher-quality end product, thus giving the men a commercial advantage over competitors.[60] That Caw shared his craft secret is indicative of a level of trust, and an awareness of the mutual benefit to be gained through collaboration. Solving material problems was central to good workmanship, though hidden – invisible to the naked eye – in finished objects, discernable only in their overall quality. Instructions for creating the desired colour of gold were communicated through trade manuals into the later part of the century.[61] The scientific nature of these recipes for mixing metals meant that they could be codified in text. But it was rather more difficult to express in written form the haptic knowledge required to carry out making processes. Nevertheless, many trade publications gave instructions on different ways of forming small objects, helping uncover more about the techniques used to craft the two rings under study.

Once the gold was mixed, alloyed and formed into ingots, it was manipulated into different shapes from which the various parts of the ring would be made. The band could be made in several ways. One method was to draw metal through perforations in iron or steel to create a thick wire, then beat that wire around a metal cone called a mandrel to form a hoop. An alternative method, called lost wax casting, involved carving out the ring shape in wax, before setting it in a mould made of either sand or gypsum – also known as plaster of Paris – and pouring in molten gold which would burn off the wax mould and set in the negative space it left behind. *The Technical Repository* offered advice on a technique of 'great convenience' which enabled melting and casting to be carried out in one process.[62] This involved cutting a piece of charcoal in two and, in one of those pieces, carving a cavity and the shape of the object to be cast, with 'a slit or channel … leading from the hemispherical cavity … to the mouth of the mould'.[63] The metal was placed in the cavity, and the charcoal pieces were 'firmly bound together with iron binding wire', then heated with the blow-pipe 'until the metal is melted; when, by inclining the charcoal, it flows directly into the mould'.[64] Once cooled, the object was removed from the mould, the branch or 'sprue' left where the metal had run in from the channel was cut off, and a series of files were used to smooth off and polish the rough surface and edges.

The bezel was made separately. First, gold was put through a rolling or 'flatting' mill which 'cannot be dispensed with, where the business is considerable', to

create metal sheet.[65] Then, using a saw, an oval shape was cut out for the back and a rectangular strip was cut and bent around it with pliers to form the outer edge. The two parts were fused with heat to create a small dish-like form into which the hair and crystal would be set. The collet was made in a similar way, sized to fit neatly inside the space, and set aside to be added later. Band and bezel were then soldered together, and the decorative pieces at each side of the bezel were fused over the joints. Similar methods were applied to make the decorative flourishes: melting tiny coils of wire in charcoal to create beads, or bending small strips into a range of shapes. A deft, steady hand, a keen eye and good light were required for each and every stage of bringing these miniature things into being. Crystal and gems were usually bought in from a lapidary who specialized in dealing, cutting and mounting stones. In 1830, the Perth lapidary Robert McGregor sent Keay a bill for £17 17s 11d for supplying stones including amethysts, pebbles, bloodstone, emeralds, garnets, topaz and moonstone; for drilling, setting and repairing stones; and for finished goods including bracelets, lockets and spectacles.[66] In keeping with evidence of subcontracting, this list suggests that the objects moved across firms at different stages of production. It is likely that the hair was worked in a separate area – outsourced to a specialist, as we shall see in Chapter Five – but possibly took place in the same space where the stones were set, to minimize risk of damage as goods were moved around.

Mounting stones was a distinct skill, as is plain in a letter of December 1825 to Keay Snr from his nephew, William Forrester, a jeweller in London's West End. After grumbling about his finances and seeking advice on business problems, Forrester wrote:

> I often wish I had you here I want a friend very much to whom I can open my mind and very often two heads are better than one and Joseph [his younger brother] is such a simpleton in that way he cannot keep his mouth shut he is a very quick mounter but a tolerably good silver chaser.[67]

Joseph's efficiency in mounting was viewed positively by his older brother, but in terms of chasing skill, he clearly fell rather short of expectations. Yet the month after writing to Keay Snr with this critical view, Forrester wrote to the younger, less-experienced Keay Jnr with a more positive (and rather less brutal) evaluation, saying that Joseph 'can now chase very well'.[68] Rather than reflecting a quick and marked improvement in Joseph's ability in what was a notoriously difficult area, this statement shows that skill was a social valuation.[69] Skill was subjective and relative, and was understood not as something that improved in a

linear way, but as something that developed unevenly over time, across different areas of work, and in comparison to the workmanship of others. The difference in presenting this valuation of Joseph's ability to the experienced craftsman and the jeweller-in-the-making may also reflect a degree of encouragement for the development of skill in the latter, effectively pushing Keay Jnr to consider his own workmanship against that of his cousin in London.

Kinship ties were not only important for the transmission of craft skill, but drove innovation through a series of incremental shifts as younger craftsmen attempted to meet the expectations of the more experienced workers who taught and mentored them.[70] In the case of the Keays and Forresters, these ties were familial, but previous studies have shown that kinship links also existed between unrelated individuals in the same trade.[71] Indeed, letters between Caw and Keay Jnr reveal how working within a system of small workshop production fostered an affinity between employers and their artisans. Caw expressed sympathy for workers in a letter to Keay Jnr in December 1841 after a prolonged poor spell, writing: 'it gives me much pleasure to learn that altho' business is very dull in your fair City, that yet your artisans are employed.'[72] Seven years later, after some ups and downs against a wider gradual decline in business, Caw repeated these sentiments: 'Let us live in the hope of soon seeing better times. I pity the manufacturers in our trade – particularly the working men, they are very badly off.'[73] Caw's reference to 'working men' as part of a wider group of manufacturers shows that he understood these different levels of workers as belonging to the same productive class, though he implicitly acknowledged his privileged position as a business owner. Artisans had less security than business owners, who had to prioritize a firm's survival over keeping workers on, though particularly valued workers were often retained during downturns so that the firm could respond quickly if and when business improved.[74] Levels of employment among artisans were undoubtedly read as a barometer of business prosperity by employers like Caw, making his concern for fellow producers lower down the hierarchy inseparable from economic motivations.

The life cycle of jewellery objects is not linear, because of the recyclability of metals and stones. The same is true of the life cycle of the jeweller, with his skills in metalworking adapted to different areas of industry, in different geographical areas, particularly during peaks and troughs in the trade. In 1830, Alexander Cameron, a craft-trained silversmith who was one of the many apprentices trained under Keay, wrote to his former master in Perth. He explained that

he had 'landed in Edinburgh' and following Keay's advice had spoken with Edinburgh silversmith Leonard Urquhart, but

> he [Urquhart] was sorrow [*sic*] that he could not give me any employment + nor did know of any one that could give me any thing to do trade being so very bad at present I was intending to go to Glasgow and some other small towns but Mr Urquhart advised me not to go Glasgow as trade was so very bad.[75]

Following Urquhart's suggestion, Cameron went to Dundee and tried to 'get a job at the Brass Founders … after I had tried [*sic*] all the silversmiths', but was unsuccessful and signed his letter off, with a hint self-pity, as a 'fish dealer'.[76] While fish dealing was a stop-gap for Cameron, mentioned to communicate the extent of his problems to Keay, it highlights a degree of occupational mobility not usually associated with highly-skilled workers. Meanwhile, Urquhart wrote to Keay, telling of how he had advised 'the lad Cameron' in light of the situation, which made it 'impossible for him to get a job here'.[77] Eventually, Cameron carved out an opportunity as a 'watchmaker and jeweller', setting up business on Dundee's High Street and gaining a good reputation.[78] Pleasingly, the 'fish dealers' watch work survives today in museum collections in a rare piece of material evidence that joins the dots on the makers sometimes precarious path. Cameron provides an example of the dynamism of craft skill, as trained silversmiths responded to a decline in demand for silverware by adapting their skills to satisfy increasing demand for jewellery. He moved towns to fill a gap in the market – a reminder that just as boundaries between areas of the trade were mutable, the industry was interconnected through craft networks across different places.

The connections of business owners crossed class boundaries, reaching across the industry and out into the world of wealthy customers. For example, Keay supplied other jewellers with goods, writing in detail about objects and money, as well as discussing bespoke orders with customers. In 1834, a self-confessed 'full Highlander' wrote to order a set of six 'pretty strong' hook-and-eye silver clasps to fix his Highland jacket along with a rough sketch, a 'sort of pattern … rather a coarse piece of work still I expect it will be understood'.[79] It is worth pointing out that aspects of Scotland's geography, topography and transport infrastructure meant that town jewellers were not necessarily easily accessible for rural customers, which created a spatial dimension to the market that required producers to interpret orders for bespoke designs and other goods in this way.[80] Instructions for making goods then had to be communicated by

business owners and masters to apprentices and artisans, as well as to the owners and managers of subcontracted firms, and then a polite letter and bill were sent to the customer with the finished goods. These communication skills were important and show how literacy, both in reading and writing, as well as training in retail and management, was crucial for social mobility among artisans. The increasing need for business acumen and sales skills – which, as we have seen, sometimes constituted a part of the jeweller's apprenticeship – arguably led to a conflicted sense of artisanal identity among producers but can, nevertheless, be considered another area of specialist knowledge.

Applying surface decoration

Engraved decoration was a key feature of nineteenth-century jewellery. A skill closely related to chasing, engraving was applied across both jewellery and silverware, and was usually carried out by specialist workers.[81] Engraved detail increased the play of light on metal surfaces to draw the eye, while inscriptions of names and initials, and messages of love and remembrance gave objects extra layers of meaning, marking ownership and materially embedding traces of social bonds. Engraving, then, was important in making objects visually appealing and in transforming commodities into symbolic personal possessions. A set of silver buttons attributed to Joseph Pearson of Dumfries combines both of these elements (see Plate 1.2). The engraved circles around the outside catch the light and sparkle, framing a flourish of the owner's initials 'NR' in the centre.[82] Once these buttons had been shaped, production moved from hammers and pliers to a set of specialist engraving tools called 'gravers' to create decoration.

An engraver used an arsenal of anywhere between thirty and forty gravers with pointed tips of varying shapes and thicknesses. While these tools changed little over the years, small innovations enhanced the quality of production. For example, the invention of a 'pencil' made of boxwood with an adjustable, flexible point for drawing preparatory lines on metal was considered 'a great improvement' to older steel points and lead pencils used for the same purpose.[83] After the outline was marked on the metal surface, the engraver channelled pressure from the shoulder through the heel of the hand to push the tip of the graver into the metal and, as the tool was steered with one hand and the object turned in the other, a V-shaped ridge was removed in the desired design. With buttons, where a set of identical objects was required, the first piece was done by

hand before candle grease was 'carefully filled into the lettering [and] dampened woven letter-paper is then laid over the lettering, and with a burnisher an impression in grease is printed on the paper'.[84] This 'blackening' process created a transfer which was rubbed on up to two-dozen copies for the engraver to follow. Only the main letters were transferred in this way, 'ornamental dots and points being added to each duplicate by the engraver, eye practice giving him precision in this respect'.[85] We see this clearly in the accuracy of replication in the lettering on Pearson's buttons against the lively little dashes that dance round the edge, clearly done quickly by eye and without the same level of precision.

The ornamental engraving process used to render detailed scrolls, leaves and animal forms was slightly different to letter engraving. This can be seen by comparing the buttons with a brooch made by M. Rettie Sons in Aberdeen, in which sweeping and curling lines were set against a textured background of short dashes to create the effect of movement as the light played on the surface (see Plate 1.3). This fine, layered decoration was a common feature of Victorian jewellery, in keeping with the fashion for elaborate patterning. After the brooch shape was cut out from gold sheet and hammered to form the concave shape, a paper drawing of the engraving design was 'perforated with a fine needle and laid upon the article to be engraved; pumice stone is then beat upon the paper, the design being traced on the plate in fine dots'.[86] Then came specialist gravers 'with [two to six] fine lines cut into the bottom of the tool'.[87] The hand was 'held high, so that the point of the tool touches the plate, the left hand moving it as the design requires'.[88] This was known as 'bright work', produced by 'holding the tool as aforesaid, and wriggling it in short rapid turns' to create a wave effect within the lines that was 'almost imperceptible to the naked eye' but created delicate, bright designs which 'look white on the tinted background of gold or silver'.[89] These tools were 'best adapted' by polishing up on 'a block of wood covered with rough and oil, which imparts a polish to the tool that enables the engraver to cut his work with great brilliancy and beauty of effect'.[90] This advice on preparing tools to heighten quality hints at the many forms of peripheral knowledge required to achieve good workmanship.

The close work and precision involved in engraving put strain on the eyes, which were trained on the point where the tool met the metal through a glass lens. Good light was crucial and trade manuals advised, 'It is important that the light fall on the work, and the eyes be shaded. Attention in this respect will enable the engraver to see better, and not wear out his eyes.'[91] To enhance and focus light, 'Engravers habitually employ a globular glass vessel, filled with

water, which acts as a condenser to concentrate light where it is wanted, and to withdraw it from surrounding parts'.[92] The positioning of globe to flame was key to creating a beam of light that could be directed on to the work and 'a little sulphate of copper, or blue vitriol' was dissolved in the water 'to neutralise the excessive yellowness of common gas-light, and to render it much less irritating to the eyes'.[93] Indeed, it was recognized that 'THERE is, perhaps, no occupation in which the amount and quality of artificial light is more important than it is of that in a watchmaker and jeweller.'[94] As a result, jewellers understood eye conditions and ways to preserve and enhance sight, and this knowledge spilled over into their role as opticians.[95] In this sense, embodied craft knowledge overlapped with anatomical and medical knowledge to create complementary business opportunities.[96]

By the 1870s, it was recognized that 'the sale of jewellery and silverware depends almost entirely upon the ornamentation', therefore new tools were invented to help relieve strain on the engraver's body, and to reduce time and costs.[97] A 'new engraving machine' patented in America in the same decade made 'a very excellent imitation of handwork' and was said to be a device 'of considerable economic value to the jeweller and plate manufacturer'.[98] The graver was fitted into the machine, which was capable of 'delivering 5335 cuts a minute' to create 'fourteen styles of groundwork, claimed to be superior to satin, or pearl, or sand blast finish in depth, durability, and beauty'.[99] Essentially, the machine cut down the pressure applied through the hand, arm and shoulder to reduce time, effort and fatigue, but it was by no means automated. While the simplicity of the device was emphasized by the statement that 'the instrument can be worked by a child', producing good workmanship required adapting existing hand skills to work with the new machine.[100] The engraving machine, then, was not mutually exclusive from craft skill and good workmanship, and was useful in that it had the potential to liberate workers from a proportion of repetitive work, relieve bodily strain, enhance quality and cut costs. While it is impossible to know how many engravers in Scotland adopted the machine, Adam Galbraith of Glasgow proudly demonstrated 'engraving on premises on patent engraving machine' at the city's Scottish Exhibition of History, Art and Industry in 1911.[101]

One of Scotland's most celebrated engravers, David MacGregor of Perth, is an interesting example of how a reputation for good workmanship, often in a specialized area such as engraving, could be the defining feature of a successful maker's career. MacGregor was born in Perth and moved with his parents to

Edinburgh, where he trained as an apprentice during the late 1850s to early 1860s.[102] Census records show that his father was a labourer in 1851 and owned a china shop in 1861, which hints at a degree of economic mobility around the time MacGregor entered his apprenticeship.[103] After training, MacGregor returned to Perth and succeeded to the firm of his aunt, Magdalene Macgregor, a business owner and maker who had carried on the business of her husband, Robert McGregor.[104] It is worth dwelling for a moment to say that widowhood was one mechanism by which a woman could become a business owner in her own right and, despite the hush in the records, many such women were skilled makers themselves. An advertisement from 1870 shows that her nephew, David MacGregor, 'engraver and designer' had gone into business with 'Isaac Constable, Practical Goldsmith and Jeweller' – a useful partnership in that Constable could make objects while MacGregor specialized in applied decoration.[105] MacGregor then ran the business without Constable from 1875 until his death in 1909, and during that time gained a reputation as an exceptional engraver, elevated to the heights of artist-craftsman. Writing about miniature portraits MacGregor engraved on metal objects, *The Herald* commented, 'The likenesses are admirable, but there is an artistic quality about them which has served to "utterly astonish" even the great art critic Ruskin.'[106] According to MacGregor's obituary, he had corresponded with Ruskin, who 'in one of his letters wrote, "I am truly astonished at the rightness, power and brilliance of your work."'[107] As a result of the reputation gained from his work, which led to significant business success, MacGregor died a wealthy man of status, an ex-Lord Provost of Perth with a fifteen-room house in a leafy area just outside town.[108]

Today, MacGregor is best known for his aristocratic silverware, and less so for his feminine jewellery and accessories.[109] Surviving card cases made by his firm are rather on the boundary of what we might term jewellery, but are useful in illustrating how engraving skill was transferred across a range of personal ornaments for the middle market. Card cases contained paper calling cards that were central to middle-class social rituals of the late nineteenth century and, while carried rather than worn on the body, were an important marker of taste and status.[110] MacGregor's card cases were purchased from specialist suppliers and then engraved individually to create small objects of complex craftsmanship. His silverware was also bought from external producers, then engraved in house. One displays a copy of Gainsborough's portrait of the Duchess of Devonshire (Figure 1.5). A note inside tells us that it was gifted by a wealthy Perth business owner to his wife, Agnes Hamilton Coates. This is exactly the type of moneyed

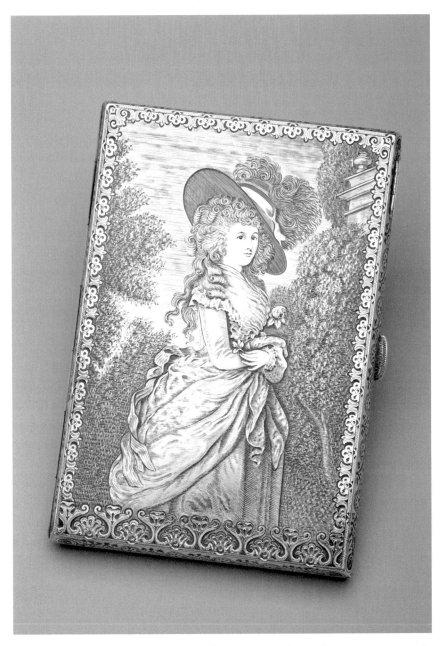

Figure 1.5 Card case with engraving of Thomas Gainsborough's *c.* 1787 *Portrait of Georgiana, Duchess of Devonshire*, Robert MacGregor of Perth, *c.* 1890. Silver, 95 × 64 mm. PMAG, 2967 © Courtesy of Perth Museum and Art Gallery, Perth and Kinross Council.

middle-class customer the likes of MacGregor was able to appeal to with small, highly personalized accessories. Nestled in the palm of the owner's hand during social interactions, thousands of dots, lines and dashes picked up the tones of these women's skin, clothing and jewellery, throwing colour around the mirror-like surface to create the effect of movement and texture.

The tone, depth and accuracy with which the paintings and scenes on MacGregor's card cases were executed suggest that he developed specialized approaches to his craft. The labour that went in to creating this level of ornamentation by hand alone would have rendered the object prohibitively expensive for the middle market, which poses questions about the ways in which technologies and labour-saving devices dovetailed with hand tools in workshop production. For a start, MacGregor's card cases were bought in, rather than made in-house. The accuracy of the engraved images copied from existing portraits hints at the use of photoengraving techniques developed during the mid-nineteenth century – in which silver was a key component – to transfer images via light exposure, rather than tracing marks from paper to metal through the older 'blackening' process. Photographic transfers would have cut down time, reduced costs and produced a more accurate image for the engraver to follow. Furthermore, the adoption of a device like the engraving machine would have facilitated the built-up layers of background texture and depth onto which further layers of hand engraving could then be applied, by either MacGregor himself or his artisans. Together, these types of technologies would have enabled the creation of quality products that displayed elaborate decoration but could be sold profitably as small luxuries to middle-class consumers.

The difficulty of ascertaining whether or not new technologies were employed, and identifying the intersections between hand and machine, speaks to makers' skills in combining old and new methods. But while only fragmentary traces of individual, distinct processes and methods can be unpicked from the overall effects displayed in the final object, there is no doubt that, by the later nineteenth century, makers used a variety of methods to create the high level of ornamentation demanded by the market at a reasonable cost. While narratives about craft, both in the late nineteenth century until the present day, are dominated by ideas about the tension of hand and machine, it is simply the case that this was not seen as an issue among even highly skilled producers like MacGregor. Indeed, Ruskin himself was not against labour saving devices, despite having become a figure strongly associated with a rejection of such innovations, on the basis that they offered advantages for makers and their bodies. Repetitive movement

and pressure wore out skilled hands and joints. This is where the relationship between business – in the sense of the interlinked considerations of time, labour, cost and the depth of the customer's pockets – collides with materiality. The two are often viewed as entirely different realms in the scholarship, but they are inextricably bound, and together were a driving force for the development of both hand skills and new technologies. In this case, improvements to hand tools, new chemical processes and innovative forms of mechanization offered ways of achieving better quality and desired layers of surface effects at lower cost without replacing or diminishing the engraver's skill. It is certainly the case that engraving remained a highly skilled and specialized area of production. Adaptation and innovation, often by small degrees, was the order of the day.

Indeed, it was this very separateness of engraving as an artistic dimension to engraving that enabled some women, such as Elizabeth Kirkwood, to enter the craft. Kirkwood worked as an engraver and enamellist within her family's firm (which survives in Edinburgh today as R. H. B. Kirkwood) during the late nineteenth and into the early twentieth century.[111] Her role as a talented engraver is more often discussed within the context of the Arts and Crafts Movement than the 'industry'. That this is the case is reflective of the ways in which women who were active and respected jewellers in the period have since been overlooked and disregarded in favour of their male counterparts. Their work has been reinserted into the record by historians of the Arts and Crafts Movement, since the 1970s on, providing hugely valuable insights into their work. The outcome, however, is that women like Kirkwood are viewed through the lens of the artist, seen at one remove from the 'workshop proper', when in reality that boundary did not exist or was, at the very least, rather more blurred than it would appear.

That Kirkwood was not only a skilled working jeweller but excelled in her field again underlines the family and kinship dimension to the trade, where the decline of formal apprenticeships that were closed to women opened up opportunities for individuals who had previously been shut out, including those for whom the production of jewellery was a part of their growing up. Children of jewellers had access to and knowledge of the workshop, opening up a path into an area of industry that was becoming valued as a form of artistic and cultural production, as well as a form of skilled manual labour. The engraver's work was closely aligned with aspects of cultural life. Rare surviving pattern books show how specialist engravers, often subcontracted by both small clients and larger firms to apply decoration to their products, built up libraries of designs from museum objects. One such volume from Edinburgh offers a tantalizing look at

how an experienced engraver created a pattern book by tracing representations of archaeological objects in the *Proceedings of the Society of Antiquaries*.[112] As well as scraps of tracing paper laced between the volume's pages are rubbings of completed projects, which were then adapted to a whole host of objects: pendants, watches, medals and silverware. In this sense, antiquarian knowledge was closely linked with hand skill, and hand skill inseparable from the batch production of near-identical objects.

Recovering women's skill

Becoming skilled in jewellery making was an opportunity afforded overwhelmingly to men and possessing this skill was bound with masculinity itself. But women like Magdalene Macgregor in Perth and Elizabeth Kirkwood in Edinburgh show that there were women in Scotland's jewellery craft. There are many others like them, though their names tend to be missing or obscured in the historical record. Looking at the bigger picture, beyond individuals, shows that there was a striking shift in the gender dimension to the trade in the later part of the century. Census data shows that women made up 2.5 per cent of workers in jewellery and silversmithing in 1841, rising to 20 per cent by 1911.[113] Now, this has much to do with census recording which masked women operating in the trade, only acknowledging married women as being attached to occupations from 1871 onwards.[114] Beyond this skewed picture, it is certainly the case that, in a wider British context, women were becoming more visible as producers from the middle of the century. Writing in 1852, Harriet Martineau highlighted women making jewellery in the industrial factory setting in Birmingham:

> Then, there are cutting, and piercing, and snipping machines – all bright and diligent; and the women and girls who work them are bright and diligent too. Here, in this long room, lighted with lattices above the whole range, the machines stand, and the women sit, in a row – quiet, warm and comfortable.[115]

While women were acknowledged as producers by Martineau, the way in which they were likened to the machines – both are 'bright and diligent' – aestheticized process and disguised their movements as labour.[116] The description also reflects the use of women's labour – which was cheaper than men's – in low-grade areas of production, where they tended machinery.[117] The same sort of mechanized production took place in Scotland, including at the Edinburgh factory of

Scottish Vulcanite Co. where jewellery was made from rubber, or gutta percha, to mimic jet, by women who were paid piece rates in a system characterized by the high subdivision of labour.[118] Jewellery chains were made using stamping and 'punching machines worked by girls' before being 'transferred to women who sit at benches', who cut and linked pieces to create: 'ladies' long and Albert chains, necklets, bracelets, gauntlets, buckles, and coronets'.[119] On the whole, however, this type of factory production of jewellery was rare in Scotland.

In contrast to the tending of machines, making jewellery from metals at the bench was a highly skilled and profoundly physical form of work that was generally undertaken by men. Bremner's report describes a system of about thirty 'small masters' in 1860s' Edinburgh employing about 'half a dozen to thirty men each', working from 'dingy, smoke-begrimed places' in 'out-of-the-way lanes in the New Town'.[120] Inside these workshops sandwiched between boulevards of fancy shops retailing luxury goods, the men were 'seated at large tables, round the sides of which are a series of semicircular recesses, each recess being occupied by a workman', where they cut shapes from metal, then soldered the pieces together using a blow pipe to create a range of objects including 'articles of an ornate character'.[121] This description conforms closely to the images discussed in the first section of this chapter, demonstrating that, on the surface at least, the organization of smaller workshops (as opposed to larger factory settings) had changed little from the late eighteenth century. A Select Committee report of 1876 on working conditions underlines the hot, smoky environment:

> The offensive gases are so bad by over breathing, and other causes, that you could hardly stay in the room at all. If you go into a jeweller's workshop, for example, where there are nine or ten men working at a table, with nine or ten blow pipes, you cannot go in for a moment without getting into a most profuse perspiration.[122]

Keeping metals malleable required the workshop to be warm for the duration of the working day. Hammering, cutting, grinding and polishing metals required physical labour, which generated yet more heat. Soldering required workers to blow physically through a metal pipe to direct and control a gas flame on to their work. This type of manual work in busy, smoky, shared workshops was deemed unsuitable for women.

Yet that did not exclude them from the wider business of jewellery. In 1911, 5 per cent of women in the industry owned their own business, compared to 20 per cent of men.[123] Some of those women were like Magdalene Macgregor,

who took on the business when widowed, though she was highly respected as a skilled maker in her own right. That so many in the trade could be categorized as owners reinforces the idea that firms were small, and suggests that a significant proportion of jewellers were prepared to undertake the risks involved in setting up their own business or worked as specialist subcontractors. That they did so was perhaps a response to low pay. As Bremner explained, the manual nature of the work meant that the wages earned by most were 'not higher than those of skilled workmen in other trades which fall under that designation'.[124] He gave detail on the general run of wages: 'Silversmiths and jewellers generally receive from 18s. to 32s. a-week, and lapidaries 24s.; but in exceptional cases higher rates are earned.'[125] These rates are surprisingly low, especially considering that these were still, broadly speaking, apprenticed trades requiring six to seven years training. Recent research has shown that wage rates for manual workers in nineteenth-century Scotland were lower than in England.[126] Still, the figure seems lower than would be expected, even given the fact that, according to Bremner, wages had lately increased while hours had decreased: 'About two years ago the men made a successful movement for the reduction of their hours of labour to fifty-seven a week; but, without any pressure on their part, a considerable advance has been made on the rate of wages within the last few years.'[127] In short, despite the skilled work, jewellers were manual workers and women's participation in this dimension to the craft was minimal.

By looking outside of the patriarchal systems of apprenticeship and the traditional model of the small, shared workshop we see how women did feature in production rather than, or as well as, on the business side. The subcontracting dimension to the industry can throw more light on women jewellers, who remain elusive despite evidence of their rising numbers in the final decades of the century. While production in the smoky workshops like those described by Bremner was dominated by men, we know from directories and other sources that many individuals worked on their own account in small workshops that do not fit this mould, such as garrets and domestic spaces.[128] Indeed, Bremner's report has been discussed as evidence of segregation between the different gradations of working classes in the city, whereby the labour aristocracy or respectable upper-artisans occupied specific areas from which less favoured working-class groups were excluded.[129] By the middle of the nineteenth century – when it was standard to buy supplies, parts and materials from wholesalers in Birmingham – it is likely that many women jewellers were acting as outworkers, assembling jewellery and carrying out

other tasks – such as cleaning, sorting and stringing pearls – that could be done outside of the workshop. And, of course, it was during the final decades of the century that the women of the Arts and Crafts Movement trained through art schools such as Glasgow School of Art began producing jewellery. Uncovering these women and their labour is a thread that runs through the following chapters.

Conclusion

Discussions of head and hand – and their relationship to one another – are now well-explored in the literature of craft, though overwhelmingly considered in relation to the early modern period, with a focus on the eighteenth century up to around 1830. By examining the way things were made and the various facets of knowledge required, this chapter has shown a longer, broader picture, extending those ideas across the modern period. Throughout the long nineteenth century, apprenticeship was the most common starting point in becoming skilled in the craft of jewellery making. While the system became more informal over time, it remained important in terms of learning practical skills and creating a sense of belonging and kinship among producers. Craft skill was passed down from master to apprentice – and between and across producers as they shared knowledge of techniques – and was furthered through the development of new technologies, and through the adaptation and revival of old skills. There was also a strong kinship dimension to the craft throughout, with skill evolving in relation to the work of others within and outside family and social networks. Towards the end of the century, there was a distinct increase in the participation of women as jewellery makers. Whilst women had always been involved, though hidden in the historical record, they were fundamentally excluded in a formal sense. The disintegration of the apprenticeship system along with new forms of learning and producing, together with more transparent sources in the final decades of the century, meant there were more opportunities for women, that they did become more visible as producers, and that evidence (albeit fragmented) of their increased participation and skill survive.

What is clear from all of this is that the materiality of skill was inseparable from the social and cultural dimensions to the craft in a way that crosses temporal boundaries. Chapter Two builds on these ideas, to look more closely at the ways in which jewellers made and re-made older objects to create new things and to fashion an image for themselves and their craft.

2

New-old jewellery: Deconstructing and reconstructing the past

In the galleries of the National Museum of Scotland there is a case displaying charms used in the eighteenth and nineteenth centuries. Among them is a simple but fascinating piece that sends the imagination leaping across vast swathes of time, breaking down the chronological boundaries we impose on objects. It is a nineteenth-century pendant (Figure 2.1). The sturdy gold bail (or suspension loop) suspends a fine hoop of gold which holds a clear oval crystal polished so perfectly smooth by modern tools that the prehistoric flint arrowhead encased within appears almost touchable.[1] That crystal is an exaggerated convex shape, creating a snow-globe effect that magnifies the fine grooves and chips that show clearly the hand of a maker – and their ancient tools – many centuries ago.[2] The slightest movement of the eye changes the way the arrowhead looks inside, making it appear to shift, with different areas coming in and out of focus. The barely-there sliver of gold around the edge of the pendant also holds a transparent crystal back, so that the eye is uninterrupted as it gazes straight through the piece. It gives the sense of looking through a telescopic lens at a shaft of time, the pendant acting as a miniature display case for the repurposed ancient object, then encased itself behind the thick museum-grade glass. Said to have been worn as an amulet, the pendant is just one example of how older objects were reappropriated and recontextualized in the modern period, with ancient objects often associated with magic, embedded with supernatural associations and protective meanings and functions.[3] The piece sits in a case exploring death and belief, protection, the supernatural and the afterlife in modern Scotland. Standing in the gallery today, peering through the gleaming crystal of the pendant at the rough surface of the arrowhead crafted by someone in the prehistoric past, the layers of material and their meanings fire the imagination and make it possible to get a glimpse of lives and makers' hands across time. The layering of multiple uses and meanings across great chunks of human history has ensured that this

Figure 2.1 Prehistoric flint arrowhead mounted in a nineteenth century gold and crystal pendant to be worn as an amulet. NMS, H.NO 75 © National Museums Scotland.

type of 'recycled' jewellery was (and is) the stuff of dreams for curators, collected as both curiosities and miniature time capsules, preserved as evidence of how people perceived and valued the past in the past.

During the long nineteenth century, the work of the jeweller was entangled with layered ideas about the past. If there is one defining feature of nineteenth-century jewellery design, it is a focus on reconstructing, reinterpreting and recontextualizing older objects. Historicism is widely acknowledged as a key facet of nineteenth-century design – in jewellery and a whole raft of other types of goods – particularly later in the century, though it is important to understand that the particular pasts to which jewellers looked shifted across the period.[4] There is a strong sense of chronology to this aspect of design that is often overlooked. In the early part of the nineteenth century, a preoccupation with antiquarianism strongly influenced jewellery design, and classical styles inspired by ancient Greece and Rome were popular. The Victorian era witnessed revivals

of medieval and Renaissance jewellery, as well as 'national' Scottish, Irish, Scandinavian, Assyrian and Egyptian styles inspired by archaeological finds.[5] In the later decades of the century, proponents of the Arts and Crafts Movement looked particularly to the medieval period for inspiration.

Throughout, the interplay of old and new in nineteenth-century jewellery was inextricably bound with the mutable but interlinked concepts of imitation and innovation. The shifting relationship between these two concepts underpinned the design process and shaped the look of things, as well as decisions around the materials and methods employed by the jeweller. In the late eighteenth century, accurate copies of objects made in cheaper materials like paste, which mimicked intrinsically valuable gems, were not seen as shoddy duplicates but often valued more highly than the originals for their inventiveness, viewed as 'an evocation of objects in other forms'.[6] But a growing tension between imitation and innovation was at the centre of Victorian design reform debates.[7] From the 1830s, reformists attempted to resolve this issue by educating the public and implementing new forms of technical education for artisans – a development for which London looked to Scotland, where government design schools were well established in Edinburgh and Glasgow. Additionally, highly debated alterations were made to existing copyrighting legislation in an attempt to protect the intellectual property of designers, encourage innovation and drive production of 'tasteful' goods that could rival work made by France's artisans.[8] Yet copying and adapting older objects remained a standard way of working in many industries.

From the 1870s, key figures in the Arts and Crafts Movement's circles lamented the practice of imitating existing objects as lacking in creativity and devoid of originality. Instead, they harked back to bygone days for inspiration in 'developing appropriate national cultural forms', such as abstracted Celtic patterning.[9] Creative reinterpretation – as opposed to copying – was key. A special jewellery issue of Arts and Crafts journal, *The Studio*, opened with Ruskin's words:

> Never encourage the manufacture of any article not absolutely necessary, in the production of which invention has no share … Never encourage imitation, or copying of any kind, except for the sake of preserving records of great works.[10]

The idea was to take elements of the past and adapt them to make something original. In short, just as particular aspects of the past that captured the popular imagination shifted over time to shape the look and feel of objects, so too did

ideas about the ways in which makers and designers could or 'should' make use of those pasts.

This rhetoric around Victorian design reform and the Arts and Crafts Movement tends to dominate scholarly literature on nineteenth-century design, often obscuring understandings of how producers actually formed, developed and executed their ideas. Of course, all product innovation required adapting and reformulating existing goods to some extent, to make products recognizable and appealing to customers. As Glenn Adamson has argued, late eighteenth-century producers, particularly in 'the provinces', adapted to new markets that opened up as a result of transport improvements and foreign trade by applying their craft skill to rework existing objects, through a process of 'adaptive innovation'.[11] But what has rarely been considered is how, by looking to material and visual cultures of the past in a variety of ways, jewellers not only engaged with ideas about local, national and international histories, but stimulated shifting cultural engagements with – and new understandings of – multiple pasts. Naturally, jewellers in Scotland specialized in making distinctively 'Scottish' jewellery. They looked to older objects as well as to key moments and figures in the Scottish past – and incorporated specific types of materials – to imbue their work with historical meanings and values.

Anthropological studies have argued that touching a museum artefact – which was common practice until the mid-nineteenth century – created a physical link between the hand of the person in the present and 'the traces of the hand of the object's creator and former owners'.[12] Producers and consumers did not exist in separate worlds and, for both groups, these new-old things were portals into a past world that helped them make sense of the present, particularly in the context of narratives about the perceived loss of craft skill and decline in workmanship as a result of industrialization. Against this backdrop, I examine here the different ways in which jewellers engaged with the past and its material cultures, generating new ideas for shifting markets, furthering technologies and shaping perceptions of the past – and of their skill – as they went. By doing so, it is possible to see how (re)making new-old objects enabled jewellers to take imaginative leaps into the past to conceptualize and assert their property of skill as having a history, a provenance and a cultural value. Picking up from the previous chapter, the thread of learning and furthering skills via older objects runs throughout.

Continual adaptation in the heart brooch

During the nineteenth century, the heart-shaped brooch became one of the most recognizably 'Scottish' jewellery designs, having evolved from earlier forms (see Plate 2.1). The representation of the body's vital, central organ was a common symbol of love across cultures, and bubbling with Christian symbolism.[13] The heart brooch design, often with a crown on top, was not exclusive to Scotland. Different styles of heart brooches evolved during the modern period in areas of the Nordic region that shared cultural traditions: Scandinavia, Scotland and the Baltic countries.[14] It also had much in common with the Irish 'Claddagh' ring, which features two hands clasping a crowned heart, said to represent a marriage bond, and a bond with God.[15] While its origins will never be pinpointed exactly, the design was descended from ring-shaped (annular) brooches usually associated with the medieval period and used not just in Scotland, but throughout Britain and Scandinavia. The ring brooch was both decorative and functional: it was fastened by pulling fabric through the centre of the ring and spearing it with the pin to create tension that secured clothing. Engravings from Thomas Pennant's travel writings of the late eighteenth century show women in the Isle of Skye wearing shawls fastened with ring brooches as they work to produce textiles (Figure 2.2). The heart adaptation worked in exactly the same way. Recently, medieval examples of heart brooches have emerged in Scotland, recovered by metal detectorists, showing that some of these early pieces carried religious inscriptions.[16] The earliest known written source for the heart adaptation to the ring brooch dates to the fifteenth century.[17] And by the late eighteenth century, the heart brooch was not only being produced in quantity by jewellers in the north of Scotland, particularly in Inverness, but had made its way across the Atlantic. Scottish traders exchanged thousands of heart brooches for goods such as furs in Nova Scotia, and as jewellers from Scotland emigrated to Canada and Australia, the design was transplanted and evolved into distinctive forms there.[18]

How, then, did a simple, common symbol – or assemblage of symbols – come to represent a distinctively Scottish past? Tracing myths alongside evolving design and use reveals how nineteenth-century jewellers adapted objects and evoked ideas of the past to make meaningful new forms, thus creating a palimpsest on which contemporaries could write and rewrite their own stories about the past. Just as the heart brooch evolved along divergent paths across different geographies, new meanings were associated with it at different points

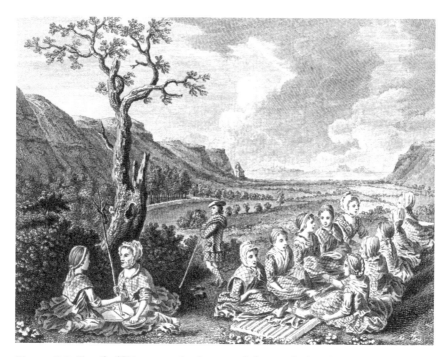

Figure 2.2 Detail of 'Women at the Quern and the Luaghad with a view of Talyskir' showing ring brooches fastening women's shawls, in Thomas Pennant, *A Tour of Scotland and Voyage to the Hebrides, 1772*, Volume 1 (London: Benjamin White, 1776).

in nineteenth-century Scotland according to what best suited the collective imagination. Heart designs in jewellery were linked to key figures in Scottish history: Mary Queen of Scots, Robert the Bruce and his companion James Douglas, and Charles Edward Stuart or 'Bonnie Prince Charlie'. By the late nineteenth century, the form was commonly known as the 'Luckenbooth' brooch, in reference to the demolished 'locked booths' associated with the old centre of Edinburgh's jewellery craft. Thus the heart brooch offers an avenue to explore how distinct jewellery designs that were subject to small changes over time took on multifaceted and mutable historical meanings and became an emblem of the venerability of the jewellery craft itself.

The heart brooch in its modern form has its roots in cultural practices associated with women and children in northern Scotland, exchanged as betrothal gifts and worn or sewn in to clothing as charms to protect babies and breastfeeding mothers.[19] An example in silver from Rosehearty in Aberdeenshire is inscribed 'LOVE' on the back, and is said to have been used as a charm (Plate 2.1). By the end of the eighteenth century, jewellers were making a range

of heart brooches – in quantity – for different levels of the market. A distinctive design emerged with key features that can be seen in a gold example by Inverness jeweller Alexander Stewart, made in the 1790s (see Plate 2.2). It features a heart topped with a looped crown (others display a more solid 'flared' crown), two little bumps or projections on each side of the outside of the heart, a lobed (this was sometimes leafed) section at the tip, and an upside down 'V' chevron inside the open space of the heart creating an outline diamond shape within. The pin was cast separately and then added. On the back is the maker's mark 'AS' and engraved lettering: 'D F sy' and 'M MR'. These inscriptions are common, thought to represent the initials of people who exchanged them as love tokens or betrothal gifts.[20] These marks of the bonds between individuals were always on the back, hidden from sight and kept close to the wearer's body. The crown speaks of power and royalty, but also permanence and immortality – suggesting bonds that transcend time.

A closer look at Stewart's piece shows up some of the maker's decisions around detail, revealing more about the design and production of the piece, as well as its use. For example, in this case the projections at the shoulders of the heart show up clearly an aspect of the design that has been consistently overlooked. These bumps – versions of which are seen on most examples – represent the ends or 'fletchings' of arrows which are piercing through the heart, each one emerging at the opposite side, at the lower projection. The chevron inside the heart is suggestive of those two arrows crossing through the negative space inside the openwork form. This wounded heart design is a remnant of older designs displaying two complete arrows each entering from the upper shoulder and emerging at the opposite bottom section, examples of which survive (see Plate 2.3). Similarly, the crown contains two birds' heads, their beaks pointing outwards, in what is often discussed as a reference to earlier artefacts, such as Pictish metalworks containing decorative birds and animals, thus drawing inspiration from a much longer past. These symbols also hint at aspects of construction: the projections are sometimes remnants of the sprues left when metal cooled in the channels of the mould from which the shape was cast, cut off and then filed down as a decorative feature rather than hidden entirely. The chevron (and to some extent the birds' heads) is also functional in that it makes the piece 'sticky', less vulnerable to loss by creating further points of contact with the garment. The engraved decoration on the front represents the symbolic brilliance emitted from the heart and the physical brilliance from the precious gems that would usually top a crown, and catches the light to draw the eye.

The simple heart and crown motifs could be combined to create an array of designs, allowing for creative experimentation and adaptations for different uses and markets. For example, hearts were doubled up and overlaid, such as a silver example from Stewart (see Plate 2.4). This particular maker's brooches are useful for uncovering the higher end of the market and pinpointing key features, and there are many others like them, but the majority of the hundreds of heart brooches that survive are of lower quality, often made from silver or non-precious metals like pewter. Despite significant variation in materials and workmanship, shared features indicate that Inverness jewellers working in close proximity to one another were making subtle, incremental changes to the design to produce a range of heart brooches, in quantity, for sale along a spectrum of prices to a range of customers. This is the very definition of Adamson's 'adaptive innovation', as makers responded to markets. Those markets stretched from the working classes to wealthy elites, inside and outside of Scotland. Increased luxury consumption of the late eighteenth century saw a blurring of class boundaries across Britain, including in the north of Scotland. Indeed, the pared-down, Grecian-style gowns that dominated women's fashion led a local minister to remark, perhaps somewhat rhetorically, on the difficulties of distinguishing the skilled working classes from the local gentry in 1790s' Inverness, where craftsmen were 'finely apparelled, and their wives, as far as dress is concerned, appear like gentlewomen'.[21] By the late eighteenth century, the heart brooch was also widely available to a range of customers outside Scotland, and became a touristic token or souvenir particularly associated with the north of the country.

The rising popularity of love tokens in the late eighteenth and early nineteenth centuries, in line with the Romantic urge to consume emotional objects, saw the increased production of deeply personal jewellery for women. At the upper end of the market, brooches came in the form of portrait miniatures representing a loved one, often executed by prestigious artists and mounted in precious metals, sometimes set with precious stones.[22] Objects like heart brooches can be understood as more accessible alternatives to the miniature. Recent research has shown that jewellery representing body parts was important in transmitting love and affection – brooches with portraits of eyes, for example, disclosed the heart's sentiments.[23] Marcia Pointon has shown that heart-shaped brooches, particularly those inscribed with messages of love such as 'I fancie non but the[e] alone', created a temporal link between wearers.[24] Pointon describes these memory jewels as having 'quasi-reliquary' status, akin to hair jewellery, worn to aid remembering and thus 'linking a moment of the past to the present of the

consumer'.[25] Heart brooches also undoubtedly travelled on the bodies of women who emigrated to Canada and perhaps functioned as reminders of home, symbols of loss and distant ties.[26] In other words, their mnemonic function operated across time and place, acting as a memory bond between people separated by vast geographical distances.

The heart brooch, then, emerges as a love token which represented one person on the body of another, and symbolized emotional bonds across geographical and temporal distance. At a time when thousands of men were leaving the Highland region for the Americas as British soldiers in the later eighteenth century, the production of Highland dress accessories – clan badges, sporrans, buckles and ring or 'plaid' brooches – that punctuated the military uniforms of Highland regiments stimulated work for local jewellers. It does not require a huge leap of the imagination to arrive at the idea that these same producers fulfilled demand for feminine emotional objects exchanged among a population in flux, including as gifts from men who were leaving to the women in their lives. Indeed, surviving patterns books show that Highland dress accessories included feminine heart brooches among their pages, showing that the two were inextricably bound.[27] This was a product of, or reinforced and given new life by, mass emigration. Existing debates around masculine Highland dress as an 'invented tradition' have long been highly contentious.[28] But as Matthew Dziennik has argued, these debates ignore the agency of local people, who 'constructed their own history with great effectiveness and thereby set the conditions by which the Highlands would be understood' from the mid-eighteenth century on.[29] Following this line of argument, and taking into account the wider production drive for small luxuries to accompany men across Empire, the heart brooch can be seen as a subtle feminine symbol which spoke to the masculine uniform and represented a link between separated individuals. The resulting swell in production cemented the heart's symbolic function as a distinctively Scottish token of love, longing and connection.

The template design set down in the later eighteenth century was still being refashioned a century later, by which point these brooches were popular as souvenirs of Scotland and associated strongly, still, with women and girls.[30] Jewellers in the later decades of the nineteenth century were using examples of objects from around 1800 to create new, fashionable pieces to satisfy contemporary customers. For this they looked to museum collections where older heart brooches had been collected and preserved as examples of folklore,

vernacular customs and historical craft production.[31] Inverness jeweller P.G. Wilson's drawing book of the 1860s shows rubbings or 'impressions' of museum pieces from Inverness Museum and a range of earlier material, mostly dating to around 1800, which had clearly informed new designs.[32] Other Inverness firms worked in exactly the same way, taking rubbings and then elaborating on them to indicate new changes through small design details and sometimes text – such as native pearls or stones studding the crown or engraved decoration. The practice of documenting these older brooches mirrors published sourcebooks like Owen Jones' *Grammar of Ornament*, which offered international producers a visual library of historical representations taken from real examples of architecture, textiles, rare books and stained glass – as well as sculptured stones and crosses and manuscripts – from which to select 'tasteful' patterns for creating new designs.[33] These objects were often early medieval, and labelled 'Celtic', which was often applied with little historical accuracy but provided a useful hook for both makers and consumers looking towards 'ancient' Scotland.[34] Jewellers also looked to Scottish-specific publications such as *Ancient Scottish Weapons*, written and illustrated by curators of the National Museum of Antiquities of Scotland, which contained a full page of illustrations of heart brooches from their collections (see Plate 2.5).[35]

What is particularly interesting here is the way in which jewellers looked to the material culture of the Scottish past in particular to create their own design language. Adapting older objects was fairly standard practice across the jewellery industry – it was not distinctive to Scotland, by any means. William Chapman, a London 'manufacturing goldsmith and jeweller' who supplied the 'chief houses' including Garrard's and Hunt & Roskell's told a Select Committee inquiry into the London School of Design in 1849 that he obtained designs, 'From old examples and engravings of ornament which are published: principally old ones'.[36] Copying old objects, then, was not incompatible with creating new goods. But there are distinctions here, between copying and adapting existing objects and between the continual adaptation of a fairly simple ancient form which carried strong associations of place. Developed during the long nineteenth century as a small luxury located firmly in the world of commerce, but rooted in folklore and vernacular culture of northern, 'rural' Scotland, the power of the heart brooch's ambiguous imagery saw it become a receptacle for both personal and collective memories. Seen in this way, the origins of the style in a distant, abstracted past – bound up with

imagined ideas of a 'timeless' rural Scotland in the popular imagination – gave new objects the ability to act as powerful representations of ties between individuals and of place. And throughout, the design retained its associations with women and children, its magical qualities of protection and its rootedness in the north. By the late nineteenth century the heart brooch was strongly associated with Edinburgh, yet still held on to its rural, romanticized roots in the Highlands.[37] Indeed, through the continual recontextualization of this simple form across a long period, the capital's jewellers created an emblem of their own craft past, which saw the name 'Luckenbooth brooch' appear in reference to historical workshops of the Old Town that we have seen in the previous chapter. It is no coincidence that this name became attached to the design at the point when concerns about the loss of traditional skills in British industry were at their peak, creating and amplifying the cultural value placed on time-tested skills.

The evolution of the heart brooch as a historical style points to the wider transmutation of designs associated with rural people and local histories into distinctively 'Scottish' consumer goods – particularly souvenirs – retailed in urban centres. Significantly though, throughout the form's adaptation across time and place, it carried with it residual meanings that spoke of the Scottish past. In other words, adaptation by small degrees to appeal to shifting markets enabled a distinctive form to carry with it a complex constellation of retained symbolic meanings. It did so not just because jewellers relentlessly reused a successful design template, but because they employed a cultural awareness of visual and material languages of the past to continually reshape a recognized form embedded with layered and mutable historical narratives. In doing so, they transformed it into a symbol of the Scottish jewellery craft itself.

(Re)Invention as originality

From the middle decades of the nineteenth century, jewellers began asserting ownership over their design and skill – over their intellectual property – using two new methods. In the 1840s, they made use of new legislation which enabled them to copyright their designs in the Design Registry.[38] With the opening of the Great Exhibition in London in 1851, they began to make use of international exhibitions to showcase their work. On the face of it, the Design Registry was

a defensive measure to do with legally protecting work from copyists, while exhibitions served the opposite function, to bring them to the attention of as wide an audience as possible. But from a producer's perspective, copyrighting and exhibiting had much in common. Both were tools to assert their property of skill and their status as makers. More often than not, those objects spoke of the historic dimension to their craft, cultivating an image of venerability and tradition that was often enmeshed with the world of the museum.

Among the first designs copyrighted by a Scottish jeweller were two bracelets and a shawl pin by the Aberdeen firm M. Rettie & Sons, made in granite – a locally sourced and notoriously hard stone in which the firm specialized.[39] Few designs were registered in the first years of the new legislation, but those that were overwhelmingly incorporated native minerals and were based on aspects of masculine Highland dress reworked in miniature for wear on the feminine body. For example, James Robertson registered a brooch in the form of a hilted sword with a belt snaking around it, made from blue agates, green bloodstone and red jasper (see Plate 2.6), and another in the shape of a miniature sporran adorned with tear-shaped orange-tinged cairngorms. Both representations are carefully executed with different stones indicated through watercolours, and produced by a London-based agent who appears to have been providing the same service for other jewellers producing similar things in Edinburgh.

It is no coincidence that these objects were made from native materials, shaped in historicist or revivalist designs drawn from ancient dress practices. This was a period which saw the beginnings of mass tourism to Scotland and with it soaring demand for souvenirs, creating a lively, lucrative and competitive market for producers. The miniaturization and feminization of the mainstays of masculine Highland dress, rendered in distinctively Scottish materials, may not have been highly valuable as individual pieces but they were well-made, often cleverly designed objects which commanded a decent price and were intended to be made in batch and sold in quantity. These were innovative little things that straddled the category of souvenir, curiosity and fashion piece. A surviving example of such a piece is a brooch in the shape of a sgian dubh, the small knife worn tucked inside a sock by men in kilt, copyrighted by James Robertson of Edinburgh in 1858 (see Plate 2.7).[40] The high-quality native stones in both sheath and handle are exceptionally well worked, the former unmistakeably agate from Burn Anne in Ayrshire, and mounted in silver adorned with fine engraving.[41] Releasing a small catch at the back, just above the pin, creates a moment of surprise: the tiny blade can be drawn from its stone sheath. On this

scale, that functionality should be seen as a mark of skill in creating a complex, clever design. It is not only playful in its design and form, as a tiny recreation of a weapon, but in its construction and use. Imagine a woman in 1860, drawing a toy-like blade from her brooch, and its playful dimension becomes clear.

Kriegel suggests that international exhibitions provided producers with a means of asserting ownership over their work in a more market-oriented way than copyrighting, though the risk of copyists pillaging ideas from the exhibitions led to further amendments to copyrighting legislation in 1850.[42] Rettie & Sons were one of three top Scottish jewellers who exhibited work at the Great Exhibition of 1851, including pieces of their archaeology-inspired work. The bracelets they had copyrighted previously drew high praise from a production perspective, for the way in which hard and 'uncompromising' and 'comparatively valueless' materials were: 'by dint of labour … elevated into the position of precious stone, and placed among the fancy articles of a jewel case'.[43] But there is a sense from contemporary reports that these objects occupied an aesthetic category all of their own. In a newspaper report, 'A Lady's Glance at the Exhibition', the firm's display is mentioned fleetingly as representing 'the department of the modern antiques of Scotland, in brooches and shawl-pins'.[44] The report pinpoints the location of this new-old work in a case directly adjacent to Irish exhibits including replicas of so-called 'Celtic' archaeological material together with brooches made of Irish gold and gems described as 'rugged in character and heavy of form' but with a 'sturdy antique Druidical dignity of appearance, which renders them scarcely less attractive than the light and modern decorations by which they are immediately surrounded'.[45] Nearby, London jewellers Messrs Garrard displayed an array of precious jewellery including, 'a beautiful tiara of diamonds, with drops composed of fine pearls'.[46] M. Rettie & Sons' jewellery did not fit with either the otherworldly aesthetic of the Irish exhibits or the dazzling spectacle of precious stones, but was innovative in terms of both workmanship and design. Indeed, the fact that these were the ones the firm copyrighted suggests these unusual designs were considered likely to draw attention and be vulnerable to copying, underlining the innovative nature of the firm's work, at least in their own eyes.

The display of newly crafted relics of the Scottish past continued, in Dublin in 1853, Paris in 1855 and again at the International Exhibition in London in 1862. At the latter, Edinburgh's W. Marshall & Co. won a medal for jewellery in 'the ancient Scottish style', described in *The Scotsman* as 'almost as interesting' as the revivalist work of the famous contemporary Italian jeweller, Signor Castellani.[47]

This may seem faint praise, but being measured against Castellani was in itself an accolade, given he was, at the time, the undisputed master of remaking ancient jewellery and the poster boy of Italy's jewellery craft at a point when the country was perceived internationally as a powerhouse of quality production.[48] Even Brydone & Sons' jewellery of human hair harked back to the past with a visual representation of a famous Edinburgh landmark memorializing the historical novelist, Sir Walter Scott: 'in one [piece] is portrayed the Scott Monument … all this is done out of the hair of the late lamented'.[49] The mnemonic properties of the hair itself reinforced the temporal meanings of the piece. Again, the two jewellery firms present at the 1867 Paris exhibition showed distinctively Scottish jewellery. Work was often displayed and described next to Irish jewellery, and sometimes completely misunderstood. An Italian illustration of James Aitchison's work at the Centennial Exhibition in Philadelphia in 1876 depicted a replica of the turreted Lorne brooch – a large and highly decorative round silver brooch dating to *c.*1600 with turrets encircling a central raised charmstone – from the Scottish Highlands among Irish jewellery, and mistakenly referred to it as a ring tree.[50] But Irish and Scottish jewellers were both heavily influenced by archaeological finds – their work mirrored and made sense of each other for international audiences who grouped the objects along visual, cultural and geographical lines.[51]

Meanwhile, copyrighting became a tool employed by more and more of Scotland's jewellers. Often, the protected designs were tied to key events. For example, jewellery pieces produced for royal wedding gifts were often copyrighted because, due to their elevated status as pieces associated with a royal event, they were lucrative for original makers (who often reproduced designs in quantity) as well as for competitor-copyists seeking to cash in on these popular products.[52] And sparked by a gold rush in the Strath of Kildonan in Sutherland, in the north-east Highlands in 1869, a flurry of designs were copyrighted by jewellers in Inverness – the nearest town to the activity and a long-established centre for quality jewellery production. The rush not only led amateur gold prospectors to rural waterways (as we shall see in the following chapter), but stimulated a boom in the Inverness jewellery trade lasting several years and provoked a focused engagement with archaeological finds in the area.[53] In 1869, Robert Naughten of Inverness registered a replica of an eighth-century silver-gilt brooch found in Rogart, north of the town in Sutherland, during the building of the railway (see Plates 2.8 & 2.9). Images of the original appeared in the *Proceedings of the Society of Antiquaries of Scotland*, though it is

likely that Naughten had access to the originals around the time of discovery.[54] He also registered another, adapted from the original's disc shaped terminals. Both designs were represented through photographs in the Design Register.

By copyrighting his remade version of this brooch, Naughten claimed the design of past jewellers as his intellectual property and provided himself with a monopoly on the production of replicas. Through the Registry mark engraved on the back, he physically embedded a further layer of status within the object itself. Alongside that mark, he engraved 'KILDONAN 1869, R. NAUGHTEN, INVERNESS, FROM CELTIC BROOCH *Cadboll, 1869*'. In doing so, he documented the place of origin of the gold (Kildonan) and making (Inverness), as well as his role as the maker or 'remaker' of the ancient object. 'Cadboll' appears there as this was the name given to the original brooches, as two of them were owned by R. B. A. MacLeod of Cadboll.[55] The date, engraved not once but twice, firmly pulls this older object into Naughten's present, fusing the contemporary with the ancient past and marking this piece out as being tied to the gold rush.[56] This kind of copying, to remake originals for modern markets – particularly in native materials – went hand-in-hand with creative endeavour and innovation. The new designs were indisputably clever, from both a craft and a business perspective.

Together, the stamp and inscription bring the materiality of copyrighting practices into sharp relief. Copyrighted jewellery objects carried a physical mark of their status as an 'original' or authentic and, in theory, exclusive design.[57] This was true for other types of objects, to varying degrees, depending on materiality. Domestic hardware might, for example, have carried a mark, while an object produced from a copyrighted fabric design would likely not. In other words, while copyrighting stamps were important to producers, they did not serve a particular role for the majority of end consumers. With jewellery it was different, in that the Registry stamp added another layer of provenance to the established hallmark and maker's mark. Like hallmarking – a form of consumer protection which also marked quality, place and provenance, the copyright mark elevated the prestige of a high-quality or high-status object, like Naughten's Rogart brooches. In others, the stamp took the place of hallmarks, such as on the dirk brooch, to mark out innovation and underline the cleverness of the new design. Copyrighting, then, was a way of appropriating, remaking and reinventing objects of the past and marking these new-old things out as 'of the now': underlining the innovation inherent in playing with concepts of imitation to create new designs.

Copyrighting was, of course, also about protection of highly popular revivalist motifs. We see this, for example, in similar styles of so-called Celtic crosses made by rival firms in Edinburgh, where both Robertson and Westren registered versions of what one termed the 'Iona Cross' with concentric rings behind the intersection. Both jewellers did so not once, but twice: Westren in 1864 and 1871, Robertson in 1868 and 1873.[58] The four pieces show how the same revivalist shapes and motifs of this popular – and highly fashionable – cross design could be combined to create multiple variations. Registering designs protected subtle design features and provided a competitive edge, setting the work of one jeweller apart from other similar designs by competitors. Both the protection and status afforded by copyrighting were important at a point when the business environment was fiercely competitive, when the wider industry was changing rapidly and when the Scottish-Celtic revival saw high demand for the work of Scotland's jewellers.[59]

Jewellers played an active role in making their skill visible, with producers physically demonstrating hand skill in action at exhibitions in Scotland.[60] At the Edinburgh International Exhibition of 1886, jewellers displayed skill and process to tell visitors a story about the life cycle of the object, from ideas and materials to crafted cultural forms.[61] *The Scotsman* reported that, on the stand of David MacGregor of Perth, 'workmen are engaged in making and repairing Scottish jewellery, and occasionally Mr. Macgregor himself may be seen plying his graver' – apparently seeing the business owner at work was particularly noteworthy.[62] That this was the case emphasizes how, by this period, business owners were often seen as middle-class professionals who had a degree of distance from the manual labour carried out by artisans. But among jewellers, the firm's reputation for quality often rested on a respect for the owner's skill.

At the same exhibition, W. Marshall & Co. of Edinburgh mounted a 'very attractive display' of jewellery 'of a very pretty type' set with 'small delicately tinted gems' like that worn in sixteenth-century portraits by Hans Holbein.[63] They were seen next to prints of the original works, enabling consumers to trace a line from inspiration to crafted object. Next to this 'Holbeinesque' jewellery sat Celtic replicas and modern watches, 'as well as the metal from which they are made, and all the several parts in the different stages of manufacture'.[64] By displaying a wide range of goods at different stages of production, the firm highlighted the breadth of its workers' skill and knowledge. Original 'antique' brooches appeared with these new products, submerging the firm's work in a wider narrative of craft ancestry and historical production. Descriptions of other

jewellers' stands in the same report placed the emphasis firmly on workmanship while underlining ideas about historical provenance. There was 'an excellent display' of Scottish jewellery by Messrs James Robertson, 'all of their own manufacture', alongside Highland antiques of the type that 'should appeal to Celtic sensibilities'.[65] Highland clan and regimental jewellery was shown by Messrs R. & H. B. Kirkwood of Edinburgh alongside reproductions of ancient ornaments 'now the treasured heirlooms in several Highland families' including the Lorne, Lochbuie, Glen Lyon and Ballochyle brooches, all of which were large, spectacular brooches from the West Highlands, centred on charmstones and dating to around 1600 (though possibly including reset stones which had been in use for a longer period). M. Rettie & Sons were praised in their local paper for having 'devoted considerable time to the invention' of new designs and for 'displaying great skill of workmanship' in silver crest brooches (markers of ancestry reaching back to the Scottish clan system).[66] In short, firms across the country were displaying a range of old and new goods in such a way as to underline historically inspired invention, ingenuity and quality of workmanship.

At the Glasgow Exhibition of 1888 a 'fine display of jewellery' was situated in a 'gorgeously decorated' location near the central glass dome, again with historical designs and native materials: 'The transverse avenue, which runs south, and which has the original model of Sir John Steell's figure of Sir Walter Scott, is filled with jewellery'.[67] Perth's David MacGregor had a stand showing engraved portraits, silver plate and 'Scottish pearl and cairngorm jewellery … where process of manufacture may be witnessed'.[68] Jewellers from Edinburgh, Glasgow and Kingussie displayed 'capital assortments of Highland ornaments'.[69] John B. Craddock of Glasgow covered his stand 'with nicely finished Whitby jet and Scottish pebble jewellery, which is enhanced in value by the presence of work-folks engaged at their avocations'.[70] This idea that the value of objects was heightened by the presence of jewellers at work clearly shows how the association between makers and the things they made was strengthened when both were seen together, and particularly when people could witness the application of skill and creation of goods.

Living displays have been considered in relation to Scottish, Irish, African and Indian living villages of later nineteenth-century international exhibitions.[71] It is argued that these displays tended to imagine rural people at vernacular crafts in wild landscapes, thus framing them as imperial possessions.[72] Living exhibits were common at Edinburgh in 1886 and Glasgow in 1888, but were dominated by middle-class amateur craftswomen, and rural women from Scotland, Ireland

and India engaged in vernacular crafts.[73] One recent study has argued that exhibition displays of making in rustic 'Irish villages' attempted to personalize production by creating a deeper bond between communities of makers, and between makers and consumers, thus providing an antidote to the negative associations of global trade, namely the proliferation of imported goods.[74] Masculine displays of Scottish jewellers at work were a different case, in that they did not focus on rural, stereotypically feminine crafts, but did correspond with the wider narrative surrounding 'traditional' and 'authentic' skills. And certainly, they were a powerful statement about production carried out at home, during a period when imported goods often carried complex associations including increasing discomfort with imperialism and, more broadly, narratives about the dangers of domestic markets being swamped by mass importation. Seen in this way, jewellers' working displays put hand-work, tools and materials in context for consumers, in order to shape their perceptions of finished objects.

Back on their home turf, jewellers were explicit about their active presence in making, advertising that goods were made in-house and to firmly locate production in a particular place. This was partly to differentiate small producers from retailers in response to wider changes in the industry, namely the rise of ready-made jewellery, which saw some shops stocked entirely with bought-in goods. But it was also a way of emphasizing specialisms in creating historical Scottish jewellery to underline their property of skill and, by extension, their place in a line of past makers. For example, in 1869 Westren placed an advertisement in *The Scotsman* notifying customers that he had 'Just finished' making a range of 'ANTIQUE SCOTCH DESIGNS' set with a variety of Scottish stones.[75] In Inverness, Daniel Ferguson invited 'Tourists visiting the Capital of the Highlands, to [view] his large and varied assortment of JEWELLERY lately made up in his establishment' including 'Ancient HIGHLAND BROOCHES' and a range of other objects which 'For workmanship can rarely be excelled'.[76] Also in Inverness, William Fraser drew attention to 'ANCIENT AND MODERN HIGHLAND BROOCHES In Gold and Silver … *The above in all the Newest Designs, specifically manufactured on the premises for the Present Season*'.[77] The language here, 'ancient and modern' in the 'newest designs', is on first glance utterly paradoxical. But this was not the case by this point, for either producers or consumers. Earlier in the century, jewellers had stressed the newness of London-made products just arrived in their shops, whereas here, words like 'lately' and 'Present Season' were used to emphasize newness in relation to local makers' ability to produce fashionable novelties themselves. Place, design and

workmanship were combined in these messages to create and enhance the value and authenticity of goods in the minds of consumers.

Some firms went further, transforming retail spaces into so-called museums and historical attractions featuring live making and glimpses into the workshop, mirroring living exhibits at international exhibitions in the course of day-to-day business. In 1873, Inverness jeweller P. G. Wilson took out a prominent advertisement in the local directory, encouraging customers along to 'THE GREAT JEWELLERY ESTABLISHMENT', where:

> VISITORS ARE freely admitted to inspect the Shop and Manufactory … the front part of which is fitted up in the style of an Exhibition Room or Museum … The *Press* has described 'the whole as forming one of the finest places of business in the Jewellery and Watchmaking trade in the Kingdom'.[78]

Customers who walked through the door could imagine themselves in a museum gallery, where they could touch objects and also see the workshop (or part of it, at least).[79] This sensory experience underlined local provenance, and linked past and present through both the space and the new-old objects produced and displayed within. Ensconced within this museum-of-sorts, hands-on interactions with Wilson's pseudo-historical artefacts gave customers a visual and tactile experience of production that evoked past craft cultures. This experiential dimension differed, of course, from the museum in that the objects on show could be carried away. They were commercial goods, exchanged for money, and the process by which jewellers embedded them with historical associations should also be seen as savvy marketing. Creating and meeting demand for such products whilst building an image of venerability is something that should be considered a necessary part of the jeweller's repertoire of skills in a commercial, growing and hyper-competitive international market.

Creating copies, shaping histories

Amongst all of this activity, perceptions of old objects themselves were transforming in the minds of makers. Ancient silver objects moved from being viewed by jewellers as intrinsically valuable bullion to culturally valuable specimens of past workmanship. There was, of course, a spectrum of perceptions with many jewellers having a deep respect for the stuff of the past, and often being involved in antiquarian pursuits from the eighteenth century. But for

many, old objects were viewed as bullion, plain and simple: good for melting down to raw materials for producing goods. There are intriguing stories that point to a distinct shift in the minds of jewellers regarding the cultural value of ancient objects, not least one uncovered by recent archaeological detective work involving two nineteenth-century forgeries in the largest and most significant Pictish hoards ever discovered in Britain.[80] The finger points squarely at jeweller Robert Robertson who, on melting some of the originals down as bullion in 1819, later tricked his own replicas back into the hoard in the 1830s, where they went undetected for two centuries.[81] While the reasons for this stunning sleight of hand will never be known, that interaction shows his skill in achieving a level of imitation that tricked experts and a shift in understandings of old things as being of cultural as well as intrinsic value.

Also in the 1830s, there appeared in Ayrshire a piece of jewellery dating to *c*.700 that went on to become the most celebrated example of metalworking ever to be found in Scotland (see Plate 2.10). Throughout the second half of the nineteenth century the Hunterston brooch was the undisputed star of Scotland's material past and became a template for new designs. Its spectre can be seen everywhere in Scottish jewellery from this period. There is a clear timeline to it taking off, underlining the fact that while historicism was key throughout this period, there is a distinct chronology to different types of engagement with the material culture of the past. It was only after the discovery and subsequent popularization of the 'Tara' brooch in Ireland in 1850 that the Hunterston craze began.[82] It was around this time that the making of revivalist jewellery copied or reworked from archaeological finds became popular, in the sense that there was a ready and growing market. The Tara brooch 'opened the eyes of the Victorians to the beauty and sophisticated craftsmanship of early Christian metalwork' and was then copied for commercial markets, and the Hunterston brooch provided Scotland with its very own example of exceptional workmanship from the same period, feeding the 'Celtomania' which then ensued.[83] For that reason, the Hunterston brooch provides a way in to understanding the shifting values placed on the original material as well as the new goods it inspired. Today, it is displayed in the Early People Gallery of the National Museum of Scotland to represent the value of workmanship across a long period of time, during the early medieval and Viking periods. But the brooch is also central to stories of design and industry – and the intersections between museum and craft cultures – in nineteenth-century Scotland.

Through one particular firm's engagement with the Hunterston brooch, viewed through surviving objects and records, it is possible also to explore the intersections between museum and craft further, and to consider how such objects stimulated new and revived skills as contemporary producers deciphered the making processes of past craftsmen to remake objects for sale. That firm, Edinburgh's Marshall & Co., had its roots in the 1790s, was well established by the time of the Hunterston's discovery and became one of the capital's most respected firms.[84] The firm reinterpreted the original Hunterston brooch for commercial markets by fusing the fashion for archaeological jewellery with the trend for native stones. Through the clever placing of swirling patterns in agates and jasper, the firm mirrored the delicate filigree and granulation seen in the original piece at a time when recovering the original techniques and processes was a source of mystery and a notoriously relentless challenge for jewellers across Europe.[85] These new pieces, often made in sets and produced in batch, were unequivocally modern interpretations of the older piece rather than attempts at replication. Yet they showcased particular, if different, skills – not least in stone working – and an element of creativity that gave them a value of their own in the eyes of contemporaries.

It is worth pausing for a moment to consider batch production at this date, usually through lost wax casting which was a long-established method and one which could reproduce intricate, fine details. The first version of the setting would have been made by hand, then a positive – a direct copy – was made in steel. That steel template or 'die' was then used to create multiple versions of the piece in wax – the wax was poured in, left to set and removed, and each one then moulded in plaster. Hot metals (gold, in this case) were poured in through a tree system, melting out the wax (hence 'lost wax' method) and forming the piece, now ready for stones to be set. Around the middle decades of the nineteenth century, vulcanized rubber offered new ways of making precision moulds that could also reproduce fine detail and be continually reused, potentially cutting out the 'lost wax' process. It is thought these rubber moulds were used mainly for one-off reproductions until the twentieth century.[86] Yet the existence of two vulcanized rubber factories in Edinburgh producing gutta percha jewellery, among other things, poses the idea that small jewellery firms were possibly collaborating with large manufacturers to drive batch production with new methods.[87] Lost wax casting, however, remained the method of choice for this type of batch production.

Further evidence of the firm's multifaceted relationship with the Hunterston brooch was documented in a book authored by the firm's owner. Titled *History of Celtic and Scottish Jewellery*, the writing and illustrations were the heavily influenced by earlier antiquarian research and museum publications.[88] A photograph of the original Hunterston brooch appeared on the frontispiece and was discussed in the text as an example of exceptional workmanship: 'The ornamentation of this relic indicates the highest development of the Art.'[89] Like similar publications by established jewellers in London and New York, the Marshall book can be understood as a vehicle for the firm to cement a reputation for knowledge and expertise in both the production and history of jewellery, in this case as it related to the firm's specialism in Scottish jewellery.[90] The book evoked a clear craft past which reached from the Hunterston brooch as the showcase of ancient skill right up to the already longstanding Marshall firm. It inserted the firm into the history of Scottish metalworking and, helpfully, doubled as a catalogue offering a range of jewellery including replicas and novelty objects aimed at the tourist market. Prices for a replica Hunterston brooch varied according to the value of materials and labour, with £6 6s for a version in 'Gold, set with stones and pearls', £1 5s for 'Silver Enamelled' and 17s for plain silver.[91] The combination of historical narrative, discussion of workmanship and promotional material in the book underlines the value of storytelling about a shared and continuing craft past, particularly in the context of contemporary preoccupation with the perceived loss of craft skill. The book was both a passion project by its craftsman-author and a canny piece of marketing that bolstered the jeweller's reputation and standing.

Published writings on the history of the craft appeared for producers themselves, including in widely accessible trade manuals, often framed by the language of discovery and invention. *The Watchmaker, Jeweller and Silversmith* carried regular features such as 'The Goldsmiths' Art. From the Earliest Times' and many others like it.[92] In one report the curator of the South Kensington Museum (now the V&A) George Wallis commented that 'The skill in execution and wonderful subtility [*sic*] of design found in some of these [Celtic] ornaments in Ireland and Scotland cannot be excelled'.[93] Learning to reinterpret and remake these complex objects was discussed as a way of showcasing – and driving – skill and workmanship. The leading producer of archaeological jewellery in Italy, Alessandro Castellani, acknowledged the difficulties of discerning historical techniques: 'We may conclude that [makers of ancient objects] possessed a number of chemical and mechanical processes in common, which are unknown

to us.'[94] He followed that idea up by claiming that jewellers' drive to discover and revive skills to remake these objects for contemporary consumers had led to scientific discoveries, for example in gilding and galvanizing.[95] The electrotyping or electroforming process invented in the 1840s was another breakthrough that combined metals, chemicals and electric charge to produce copies of archaeological objects.[96]

The pinnacle of the Marshall firm's engagement with the Hunterston brooch appears in a letter of 1893 sent from its owner, Thomas Marshall, to the Society of Antiquaries of Scotland. The writing combines both commercial and personal interest, underpinned by a narrative concerned with learning and education. Marshall wrote: 'This Firm has for many years fostered a taste for Celtic art in personal ornament.' He highlighted their publication the previous year of 'a short historical account of Scottish and Celtic Art illustrated which has exited [*sic*] much interest and I believe in its way helped to educate the public taste to the appreciation of the beautiful and characteristic art displayed in the pennanular brooches'.[97] This account of his own role in showcasing historical craftsmanship led in to a significant request: 'I am curious to reproduce in our work the details of ornamentation as nearly as possible in the original spirit as well as made of treatment and it would be of great importance if we have a fine example to put before our workmen.' Indeed, he said: 'It would not only be an education for them but for the public also – this would best be done by obtaining the impression of an example.' By an impression, it is likely Marshall sought to make a copy by obtaining a mould from which he could then cast his own replica. Bold of him, then, to continue on to make a not-so-subtle request for this star object:

> As the Hunterston is one of the finest and most perfect of the brooches I take the liberty of mentioning that one in particular and also of making the suggestion for your kind consideration.[98]

As far as we know, Marshall's request was refused. But the language of Marshall's letter is typical of the period, well-versed in current design reform ideas which centred on educating producers and consumers in matters of taste. And he is careful in couching his request to the keepers of national collections in assurances as to his own understandings of the cultural value of the piece. It goes without saying that the request was motivated by business interests but at the core of this letter is evidence of Marshall's desire to rediscover original methods, both in detail and 'spirit'. Doing so would have required a vast

amount of time and labour, and a high level of skill in a range of techniques. That Marshall wished to employ the finished replica as a training tool in the workshop demonstrates how these older objects were viewed as a potential means of learning skills and enhancing workmanship in a commercial context. Furthermore, Marshall's plan to exhibit the replica would have provided his customers with the opportunity for sensory interaction with the piece. Crucially though, he and his artisans would have engaged with the object on another level entirely, through an embodied understanding of the haptic skills and knowledge of tools and techniques they shared with the original makers. While the physical making of these objects required a range of craft skills, understanding their historical dimension and value was another facet of the jeweller's knowledge.

Producers and consumers did not exist in separate worlds and, for both groups, these new-old things were portals into a past world that helped them make sense of the present, particularly in the context of narratives about the perceived loss of craft skill and decline in workmanship as a result of industrialization. It is possible to see, then, how remaking historical objects enabled jewellers to take imaginative leaps into the past to conceptualize their property of skill as having a history, a provenance and a cultural value. Clearly, both trade publications and individual producers merged contemporary workmanship with ideas of an imagined past. In doing so, they invoked a genealogical dimension to the craft that went beyond the direct transmission of skills passed from masters to apprentices. Of course, the reproduction of archaeological jewellery was driven by the market, but this does not exclude the potential for contemporary makers to have developed an affinity, and a sense of kinship links, with their imagined craft ancestors through shared skills and values. Just as the apprenticeship system shaped the skills and occupational identities of producers, the reproduction of archaeological jewellery can be understood as playing a role in forming skills and shaping perceptions of workmanship, and in fostering a sense of belonging to a world of jewellers that stretched across contemporary makers and back into a distant past. In doing so, they not only deployed but shaped narratives about material cultures of the past. Reproducing historical objects, then, required and furthered a range of processes and techniques, and provided a way for jewellers to intellectualise and historicize their craft and skill.

Learning and the flow of inspiration

Learning from older objects, by studying them closely and thinking through their materiality, was always embedded in a jeweller's formal training. For jewellers, design education in the form of drawing lessons was always peripheral to learning at the bench, but respected firms did engage with design schools. This was the case throughout the period, but particularly so during slow periods in the trade, where apprentices and journeymen who were not necessarily producing at full tilt in the workshop could usefully spend working time learning drawing skills.[99] By the close of the century, art schools looked to working jewellers to train a new strain of designer-craftsperson. From the 1880s, the Glasgow School of Art (GSA), which evolved from the Glasgow Government School of Design, produced some of Scotland's most influential jewellers.[100] GSA students were trained to understand materials and workmanship in a way that enabled them to design across different media and that involved working closely with apprentice-trained jewellers as both teachers and collaborators. This approach, underpinned by school director Fra Newbery's inclusive attitude, was the key to enabling the participation of women jewellers. Jessie Marion King, Ann MacBeth, Margaret Macdonald Mackintosh, Frances Macdonald McNair, Jessie Newbery and Margaret Wilson are today all considered talented jewellers who furthered jewellery design of the Arts and Crafts Movement not just at a Scottish, but at a European level.[101]

In the foreword to a 1913 craft manual, *Educational Metalcraft*, Newbery wrote about how, while there had been much debate about design on paper and the application of design theory, 'little insistence has been made upon practice and upon the need for an excellence of workmanship'.[102] The book itself embodied these principles. It was authored by Peter Wylie Davidson, who trained under the apprenticeship system in Glasgow and became a teacher of jewellery and silversmithing at GSA. Newbery wrote that the skills of craftsmen like Davidson were crucial in producing the 'appropriate design and treatment' to create the 'perfect work of Art', and said that Davidson was:

> possessed of a long and varied experience in the many branches of the metal-worker's art, and is filled with the traditions of the workshop, and he has endeavoured to put into words the theory and practice of those trade methods and processes of which he is a proficient and versatile exponent and instructor.[103]

Newbery explained that the commercial potential of tasteful jewellery design could only be realized when underpinned by the skill of workshop producers, who were trained to make for the market. Indeed, he argued that experimentation with materials, rather than drawing, was the best way to train students to produce successful designs.[104] That the 'traditions' of the jewellery workshop personified in the likes of Davidson were viewed as playing a fundamental role to training and education, to good design and to the success of work in the commercial marketplace says much about the value placed on skill and workmanship at this time. Specifically, it is indicative of the GSA's approach. A pendant designed by Anne MacBeth, Head of Needlework and Embroidery at GSA, and made by Davidson, was featured in his book alongside other pieces by GSA women (see Plate 2.11).[105] An inscription on the back of the surviving piece credits both designer and maker: 'DESIGNED BY ANN McBETH EXE. [executed] by P. & W. A. DAVIDSON'. This form of collaboration enabled the increased participation of women in jewellery production at a time when, despite the progress outlined by the likes of Newbery, stereotypical gender norms meant that middle-class women were still not readily accepted as metalworkers in the traditional sense – in the smoky, sweaty workshop.

There is no shortage of surviving objects containing traces of collaboration and the diffusion of influences between GSA-trained designers and workshop jewellers, as well as the sharing of skills between these groups. For example, a belt buckle designed by GSA-trained Jessie Marion King for London department store Liberty & Co. and made in Birmingham (see Plate 2.12) is similar to a buckle by James Maitland Talbot, an Aberdeen-born Edinburgh jeweller and watchworker (see Plate 2.13). King was a leading figure of the Scottish Arts and Crafts Movement, while Talbot was a workshop producer who – in addition to making his own designs – executed designs in jewellery and silverware for other Arts and Crafts figures, helping them realize designs. He also worked as a teacher of metalwork in the Lynedoch School of Artistic Handicraft, which aimed to bring the Arts and Crafts Movement's social and design principles to the wider public.[106] Both buckles combine swirling curved shapes and bird motifs derived from early medieval (Anglo-Saxon) ornament, with pops of blue featuring in the enamel flowers in King's piece and in the lapis lazuli stones used by Talbot. The historical aesthetic can be seen clearly in the abstracted Celtic designs, but also in surface effects. The hammered surface of King's buckle evokes ideas of age, patina and handwork, while Talbot left a rough finish to the grooves that created the under-and-over effect in his piece, rather than filing

them smooth. These visible signs of the hand emphasized workmanship at a point when machine polishing could produce perfectly smooth, shiny surfaces, thus referencing – even exaggerating – pre-industrial production techniques and their effects. There is an emphasis here on the piece being defined by physical signs of its hand making, with the unfinished-finish evoking ideas about the perceived 'tradition' of workshop production in new design.

While the focus of GSA's influence on European design has often been on pieces designed and sold for department stores such as Liberty, it was also successful in setting students up to cater for the tourist market more usually associated with workshop producers. For example, Euphemia Ritchie met her husband Alexander Ritchie when both were at GSA during the mid-1890s, and the two went on to start a business selling a range of souvenirs in the island of Iona.[107] The island, on Scotland's west coast, was a popular historic site, strongly associated with the advent of Christianity in Scotland when St Columba established an abbey there in the sixth century, and, crucially, with a rich material culture bound up with this history. Iona's long history and the ornate relics associated with it provided both design inspiration and a ready customer base of tourists seeking a visceral experience of the island's past and landscape. The Ritchies' business was named 'Iona Celtic Art', reflecting that most of what they produced was inspired by examples of historical artisanship on the island and in associated material culture. In 1907, *The Art Journal* reported that the Ritchies' work in textiles and metals had its roots in 'a source that is not in the textbook of design, but in individual study of the lovely work that is to be found where … the craftsmen of the great church-building time, wrought out the intricacies of their art'.[108] Alexander Ritchie explained in the 1930s that 'my wife being an expert with the pencil, we began to adapt the Iona designs to silver and have had as much success as I can expect'.[109]

In the late nineteenth century, Iona was a place where visitors sought an otherworldly experience. Tourists described the islands ground as 'hallowed' and 'sacred'.[110] There, one could imaginatively walk the path of saints and encounter the divine in 'sublime' surroundings. Both Catholics and Protestants travelled there in a sort of pilgrimage partly, it has been argued, as a reaction to what was perceived to be the rise of an increasingly secular society.[111] The place offered an 'escape' from the perceived overwhelm and rapid change of modern life for tourists seeking to escape the urban. Intersecting ideas of place and history, and a focus on individual experience, were key for visitors to rural places; tourists of all faiths were able to witness 'the power of nature' and 'immerse themselves

in a deep sense of the past'.[112] Thanks to the Ritchies, many of those visitors left the island with a memento of this deeply spiritual and sensory landscape experience in the form of a new-old silver relic. A surviving photograph shows Euphemia Ritchie of Iona Celtic Art in the doorway of the shop, just inside Iona's nunnery grounds (Figure 2.3).[113] A glass display case on the back of the open door contains brooches, pendants and buckles in Scottish-Celtic revivalist designs, with more of the same on a small shelf under the window. Inside, a large metal plate hangs in the window and smaller objects in cases glint in the light. These goods were framed by the ancient buildings and coastal island landscapes that influenced their design. The lack of physical distance between old and new imbued the goods with local and historical provenance, enabling potential customers to trace a mental line straight from original object to modern pseudo-replica.

As Ritchie had attested, Iona Celtic Art was indeed a successful business around the turn of the century, not least due to its owners' location on the island and the status afforded them by their physical proximity, every day, to

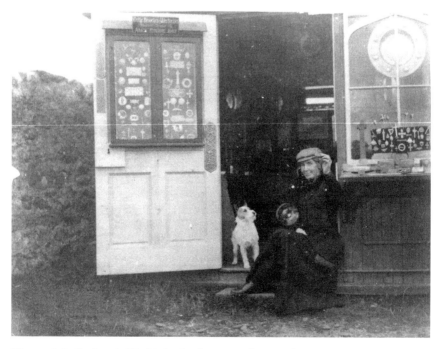

Figure 2.3 Euphemia Ritchie in the doorway of Iona Celtic Art, Iona, *c.* 1900. Black and white photograph. Private collection © E. Mairi MacArthur.

the original stone crosses that became the ultimate icons of the Scottish-Celtic revival.[114] As was standard, however, much of the actual production of Iona Celtic Art's jewellery was carried out in batch on the benches of jewellers in Glasgow, Edinburgh and Birmingham. A pennanular ring brooch designed by Iona Celtic Art – but made in Glasgow by James D. Davidson, and marked by that firm – demonstrates the ways in which different places collided within objects (Figure 2.4). While it was designed in Iona, an island on the west, it was inspired by the Rogart brooch, discovered in the north-east and, as we saw earlier in this chapter, replicated by Naughten in Inverness during the 1860s. Yet the strong lines and stylized form shift the design away from the realm of imitation and replication employed by Naughten towards the creative reinterpretation of older forms typical of Arts and Crafts trained craftspeople such as the Ritchies. It provides evidence of the ways in which knowledge of material and visual cultures of the past was employed to continually recycle old designs to make

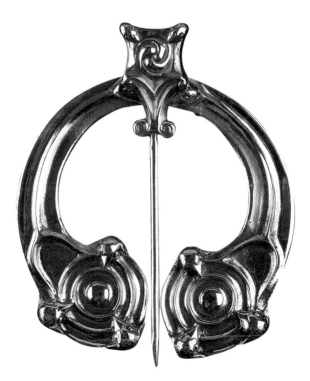

Figure 2.4 Pennanular brooch, designed by Iona Celtic Art and stamped with maker's mark 'JDD', hallmarked in Glasgow, 1902. Silver, 65 mm diameter. L&T, sale 357, August 2012, lot 158. © Lyon and Turnbull.

new products that reflected a particular and historically-situated aesthetic. Furthermore, the brooch was manufactured not in the Highlands but in the industrial powerhouse that was turn-of-the-century Glasgow, in Davidson's small but busy workshop. Either the Ritchies outsourced their work or it had been copied; their designs were so popular at the time that copying was not unusual. Either way, the piece demonstrates the fluidity of concepts of imitation and innovation across supposedly different areas of the jewellery trade. The boundaries said to exist between artist-craftspeople or designers and workshop jewellers were, in reality, something of a myth – and a powerful myth at that, one that suited both producers and consumers of the day.

By the late nineteenth century, archaeological objects and native materials – both of which were unearthed from the ground – shared symbolic significance linked to the temporality of the landscape in the Victorian imagination.[115] While not made of native materials, the historical design of the Ritchies' jewellery, for example, and the association with objects such as stone crosses on the island meant that they were able to act as receptacles of collective memories and harness the spiritual power associated with the landscape. As previous studies have highlighted, the commodity status of souvenirs did not impinge on their ability to act as portals through which the owner could take an imaginary journey back in time, to a particular place.[116] Furthermore, the religious nature of the Ritchies' design is a useful reminder that distinctively Scottish jewellery objects – including those rooted in and borne of ideas of place – were not always tied to concepts of nationhood or 'Scottishness', but were employed to express a multitude of ideas about identity and belonging that spanned spiritual and secular.

Conclusion

Just as the apprenticeship system explored in the previous chapter shaped the skills and occupational identities of producers along genealogical lines, the reproduction and reinterpretation of older objects played a key role in forming skills, driving technologies and shaping perceptions of workmanship among jewellers. This became more marked as the century progressed, in parallel to the disintegration of that formal system of apprenticeship and the shift towards art schools as a new arena which fostered different ways of learning from past makers. Making and remaking new-old things – and the knowledge accumulation required to do so – were central to fostering a sense of belonging to a world of jewellers that

stretched back in time from contemporary makers into a distant past. Instructions and histories of production were written down by makers themselves, and in the second half of the nineteenth century were widely disseminated in trade manuals. Those trade manuals, along with periodicals like that of the Society of Antiquaries of Scotland, also offered producers a practical and intellectual understanding of the history of their craft, thus creating a sense of its rootedness in the past and shaping ideas about the meanings of skill and workmanship.

Beyond the craft, the materialization and commercialization of the Scottish past and landscape were highly successful in shaping an image of Scotland's jewellers internationally. On the world stage, Scottish jewellers were marked out by the 'Scottishness' of the things they made, and discussions of those things focused on their quality and ingenious production, rather than their beauty or intrinsic worth. The cumulative effect was that, internationally, distinctively Scottish jewellery became immersed in narratives of skilled workmanship that were, by extension, also tied to ideas of place. Over time, distinctively Scottish jewellery came to be associated with quality and inventiveness, but simultaneously blurred the boundaries and challenged viewers' understandings of jewellery design. The overall picture was one of quality and small-scale production (which was also equated with authenticity), 'tradition' and venerability.

Historicist and replica objects became manifestations of the venerability of jewellers' skills, in that the temporal dimension of revivalist jewellery was united with an understanding of the craft as old and traditional, at a point when the industrial landscape of Britain was rapidly changing. Through sensory interaction and mental engagement with the materiality of archaeological objects, Scotland's jewellers came to understand themselves as the inheritors, keepers and drivers of craft skills that were practical and physical, and had a cultural value because of their historical dimension. The preoccupation with historicist jewellery was not just about the look of things made for customers – a straightforward case of producers fulfilling demand – but was critical in shaping the many different ways in which jewellers learned and understood their skills, and navigated their identities as producers. In addition, this chapter has pointed to the ways in which the particularities of place bound up with ideas of the past were significant, particularly as the century progressed. Seen wholesale, and with the distance of time, historicist Scottish jewellery has been viewed as an example of national revival. Yet, when viewed more closely, this is a story that was, for both producers and consumers, and to a greater degree than has been considered previously, about

engaging with the local or regional. This overlapped, of course, with the wider phenomenon of national revivals, particularly where jewellers were operating in an international arena. But it is the crossover between the meanings of things that were associated with the past and bound up with specific places and landscapes that has emerged from this chapter as central to the jeweller's practice and to the shaping of designs. These intersecting meanings between place, matter and design are explored closely in the following chapters, starting with precious metals.

3

Silver and gold: Landscape, nature and memory in native precious metals

Throughout human history, precious metals have been bound up with the ways in which we conceptualize the world, build social relationships and mark rites of passage. The physical properties of gold – a rare and untarnishable mineral – have symbolized ideas of preciousness, eternity, permanence and the passing of time since the beginning of the human history.[1] Similarly, silver has been deeply embedded with spiritual and secular meanings. Precious metals were, of course, an index of monetary wealth – with gold bullion used as currency in Britain until 1797 – and continue to underpin the world economic system.[2] Scotland was known to be home to precious metals for many centuries, with a mixture of documentary evidence, myth and folklore tracing a fascination with these materials back to the Roman period.[3] That said, recent research suggests exploitation was patchy until relatively late. Scientific analysis of ancient hoards has shown that native silver was not used in Scotland until the medieval period, with earlier sources imported, first by the Romans, and then continually recycled until Vikings brought new supplies from the first millennium AD.[4] While stories of gold and silver occurring naturally abound across this huge swathe of time, it is fair to say that the making of jewellery from Scottish precious metals, and the appreciation of those metals on the basis of their link to place, is a distinctly modern phenomenon. Yet even in the modern era, exploitation was intermittent and the amounts used by the industry were incredibly small, relative to production as a whole, with jewellers and silversmiths primarily supplied by established and sophisticated international chains of dealers and wholesalers spanning continents.

But from the later eighteenth century, the presence of precious metals in the Scottish landscape created extra layers of cultural meaning in finished objects made from these materials. They presented new technical challenges – and opportunities – for jewellers who used it to fashion miniature luxuries that

simultaneously answered to and generated contemporaries' desire for things made from matter with a known origin, and with ties to particular places. It is precisely the small and specialist nature of jewellery production using these native metals, and the surviving stories of how those metals were hewn from the earth, that makes it possible to engage with questions around the direct links between matter, making and meaning that are otherwise difficult to get at. Bear in mind that, to the naked eye, silver is silver and gold is gold – the origins of the matter are invisible in the finished thing, requiring producers to articulate those origins through design. Given the rarity of these metals in the Scottish landscape, it is possible to examine – albeit through rare and uneven surviving sources – how the origin and sourcing of materials had a direct bearing on the look and feel of the things made from them. Looking through objects and related evidence, I question how the origins and physical state of raw metals played a role in guiding the jeweller's hand and eye to design and make objects in which meanings of place and landscape were rendered readable, visible and tangible for contemporaries.

Seen the other way around, the presence of native metals added a layer of mystery and meaning to the Scottish landscape. In 1798, a topographical guide for travellers highlighted the presence and sporadic exploitation of these rare materials in Scotland:

> Scotland cannot, at present, show many of the precious metals, but considerable quantities, both of gold and silver have, at different periods been obtained from her bowels; and it is more than probable, that the time is not far distant, when, in many counties, these treasures will be again laid open.[5]

The use of the living (feminine) body as a metaphor for the topography and geology of the country, and the imagery of the hidden riches within, conjures a picture of precious metals not just as intrinsically valuable minerals, but as an integral feature of Scotland's landscape and natural world. Aside from geological studies, there has been little scholarly research on native metals in Britain, reflecting the small proportion they represent in terms of world production and the difficulties of differentiating them from materials sourced elsewhere. That said, recent research and exhibitions point to a growing interest in this area. Curated by Helen Clifford, the exhibition 'Gold: Power and Allure' at Goldsmiths' Hall in London explored not only the material but its role as a driving force for craftsmanship, while Neil Clarke's 'Scottish Gold: Fruit of the Nation', at the Hunterian in Glasgow in 2014, marked the

first exploration of Scottish gold finds throughout history.[6] Together, these accompanying catalogues point to a contemporary interest in – and provide valuable insights on – the relationship between landscape, mineralogy and craft.

In this chapter I explore not only the making of jewellery from Scottish gold and silver, but the web of relationships between landscape, memory and nature that were bound up with native metals and things made from them. I examine how Scottish gold and silver stimulated new ways of working at a practical and logistical level and fostered (perhaps, at times, even forced) a deeper, more self-conscious engagement with nature and landscape among jewellers themselves. Landscapes, and the markers within them – from place names to monuments to archaeological sites – were containers for collective memories that linked people, place and environment.[7] Jewellery made of native metals thus enabled collective memories contained within the landscape and ties to place to be materialized in pieces of portable property that were worn to express personal and cultural identities.[8] The structure and focus of this chapter reflects the fairly sporadic nature of the exploitation and use of Scottish gold and silver at particular points in the period, and the rarity of surviving objects known to be made from these precious metals. Up first is silver which, though it was never in high demand, was used to craft high status objects and, picking up a thread from the previous chapter, offers reflections on the links between Scottish materials and the re-creation of older objects.

Gold, as it is wont to do, steals the show here, with a flash of activity surrounding a gold rush in the Highlands, in the county of Sutherland, during the 1860s providing much of the action for the chapter as a whole. The rush was short lived but was undoubtedly the most significant moment for Scottish precious metals in the period, and probably since. The discovery of gold in Sutherland and subsequent diggings fascinated people locally and globally at a point when the transformation of gold supply was impacting on economies and lives and landscapes across the world. What became known as the 'Sutherland gold rush' thus provides a detailed snapshot through which to examine the making, use and perceptions of these materials more widely. Surviving documents and objects provide incredibly rare insights into the complete life cycle of raw metals, from dust and nuggets pulled from mud in remote burns through the jewellers' workshop and on to rural and urban consumers of all classes.

Veins of silver

On display in the Museum of Edinburgh is a small wooden picture frame containing a silver medallion in a bespoke blue silk-lined mount (see Plate 3.1). The words 'Welcome to Scotland G. R. IV, 1822' surround the central circular area of the medallion, which is spliced through diagonally by two strips of unfinished silver resembling ingots, to suggest a St Andrew's cross. A thistle motif is layered on top, its leaves hugging the intersection and masking the joints of the cross. Just looking at the object, the silver could be from anywhere, but nineteenth-century handwriting on the back of the frame tells us that this piece was made of Scottish silver from Leadhills and worn by the Lord Provost of Edinburgh, Sir William Arbuthnot, during King George IV's visit to Edinburgh in 1822. Seen in this context, the design visually represents the transformation of raw matter through the presence of unfinished ingots, with the thistle acting simultaneously as a national symbol of Scotland and a reference to the natural landscape. Together with the textual welcome extended to the King, the piece can be understood as an expression of Scottish sentiment within a British context. The person responsible for having the medallion specially mounted – the white silver against blue silk mimicking the Scottish Saltire – locked in by the frame and marked with its provenance, clearly understood its significance and was aware of the risk of it being melted down and recycled. This intervention, transforming the object from an item of dress to a hybrid object-picture assemblage, has ensured the piece's survival as one of very few objects known to be made from Scottish silver and, in turn, provides an opportunity to explore its life cycle, from landscape to body.

The silver is noted as being from the village of Leadhills in South Lanarkshire, which has played an important role in the story of Scottish metals. Gold from the area was used to form the Scottish crown jewels – the Honours of Scotland – which date to the fifteenth century, though the area is perhaps best known for its lead mines, reflected in the place name.[9] Small amounts of silver were extracted from the ore as a by-product.[10] An account from 1796 records how, in the early eighteenth century, lead miners from Leadhills:

> discovered a very valuable vein of silver, in the glen that separates the Middle-hill from the Wood-hill. It made its first appearance in small strings of silver ore, which being followed, led to a very large mass of that precious ore … When this was exhausted, the silver ore began to appear in smaller quantities … The consequence of which was, that all further researches were at that time laid aside.[11]

The same report goes on to discuss native silver in Alva, Clackmannanshire, which was admired in raw form for 'its beauty; the pure *native virgin* silver being observed to adhere in slender strings to the spar, in a variety of fanciful and irregular forms', and was made into a number of pieces of church silverware.[12] Native silver often went into decorative silverware and its use in church plate – which was most likely to be encountered by the public – is likely to have increased awareness of the presence of the metal in Scotland and shaped associated sacred meanings. The report moves directly from mining in Alva to describe, 'beautiful plantations of trees … a small forest, consisting of many different kinds of trees, such as oaks, elms, ashes, beeches, larches, and pines of different sorts'.[13] The seamless transition from a discussion of raw, inert matter underground to the living trees on the earth's surface underlines the notion that precious metals were understood to be a part of the wider natural world.

So, what did the natural origins of raw silver mean when transformed into Arbuthnot's medal? The royal visit of King George IV was of 'deep emotional significance' for the Scots who were attuned to feelings of national revival, opening up questions about the role of masculine jewellery as symbols of national identity.[14] The activities of Sir Walter Scott and the Celtic Society, which the author founded in Edinburgh in 1820, stirred feelings of Scottish patriotism and promoted the wearing of Highland dress to create a sense of theatre and spectacle at the royal events. Scott's anonymous guide for citizens, *Hints Addressed to the Inhabitants of Edinburgh*, stipulated that those involved in a '*Levee* at Holyrood' where the King would be introduced to magistrates, 'noblemen and gentlemen' were to wear 'any uniform to which they have a right', and those wearing Highland dress were instructed to wear all the accessories.[15] At 'a great entertainment given in the Parliament House by the Lord Provost and Magistrates of Edinburgh' – an elite and exclusively male event – Arbuthnot was seated directly to the left-hand-side of the King, who famously wore full Highland dress.[16]

As Lord Provost, Arbuthnot wore his uniform of ceremonial robes and chains, but it is important to view his clothing within the context of the Highland dress spectacle that surrounded him. Metals and coloured stones punctuated Highland dress, from shoe buckles to kilt pins to buckles and brooches, as well as the sporran, sword and dirk. This male jewellery, which is often overlooked in studies of Highland dress, adorned the body from top to bottom, and was worn as a means of articulating and expressing overtly political and personal ideas about nation and belonging that were tied in with masculinity. Arbuthnot's

medal was designed to condense these meanings, and to fulfil the same symbolic function, marking Scottish difference within a wider British identity. The native silver medal was a marker of custom, tradition and national sentiment at this carefully constructed and meticulously planned event, just like the banquet of 'every kind of Scotch dish … sheep's head, haggis, hodge-podge, etc', and the 'ancient silver basin and ewer for his Majesty's hands after dinner'.[17] The invisible origins of the silver in the medallion – hinted at through its design – added a further layer of symbolic power to the object's visible signs of Scottishness. It was a piece designed and made for this very particular display, a layered assemblage of meanings of geology and landscape, production and nationhood.

Given the number and sheer scale of the events surrounding the royal visit – processions, pageants, dinners, parties and balls – it is difficult to dismiss their effect in generating work for jewellers and silversmiths. Indeed, the visit stimulated a boom in the number of jewellers and firms working in Scotland's capital around that time.[18] This idea is reinforced by receipts in family papers, such as a bill from Edinburgh jewellers Marshall & Sons to the Earl of Breadalbane for seventy medals for £2 18s 4d and the same number of cockades at £3 10s, made specially for the Breadalbane Fencibles Regiment to wear during the festivities.[19] Scott wrote that 'Chieftains' including Breadalbane planned to attend 'with a considerable attendance of their gentlemen followers. And, without doubt, this will add very greatly to the variety, gracefulness, and appropriate splendour of the scene'.[20] It is not clear whether their medals and cockades were made from native silver but fragmentary evidence shows that Breadalbane did indeed have access to precious metals from his own land. A dispute with tenants in 1821 regarding the Earl's broken promises to make improvements shows that lime quarries on his mineral-rich estate near Loch Earn in the southern Highlands were worked from 1810 to 1821 at least.[21] These quarries would very likely have contained silver, possibly as a by-product of other mining activities. Later advice sent to the Duke in 1860 regarding the potential for commercial mining in the area documented 'veins containing very rich silver lead', and others 'containing veins of quartz varying in size … these contain the silver lead in spots and lumps', as well as 'gold in nuggets' and 'specks of gold visible to the naked eye'.[22]

Two surviving objects from the west of Scotland tell a similar story of specially commissioned jewellery attached to royal events. A brooch in National Museums Scotland was, according to the donor, 'struck from the silver in the mine in Ballantyre Farm Hill. When Queen Victoria was at Inveraray Castle [in 1875] she gave each of her Guard of Honour a silver brooch, and my father was

one of them' (see Plate 3.2).[23] The round brooch contains a central monogram with a 'V' framed by two 'R's to signify Victoria R, and is marked on the back with the date, 1875, and the stamp of Edinburgh jeweller, Edmund Millidge.[24] It is identical to another object, in keeping with the oral testimony that several were produced for the group of about forty local men who made up the Guard of Honour during the Queen's visit.[25] Without the donor's testimony, however, there would be no indication that it was of native silver or worn during that visit to Inverary, the seat of the Duke and Duchess of Campbell. And while worn by local, working men, these objects were associated with elites. Like Arbuthnot's medal, these badges were complex markers of power, politics and national identity. To some extent, their self-conscious creation as symbolic objects employed at royal events masks the personal and emotional values contained within them. That said, this particular badge was passed through the family and switched from a masculine piece to be worn as a feminine brooch, highlighting its personal significance. Pieces like this hold on to their stories precisely because they meant something to the individual, in this case tracing a line through a family history to a key moment in Scottish history (the royal visit was well known, and the Queen's daughter, Princess Louise, went on to marry the son of the Duke and Duchess of Campbell).

The rarity of surviving objects known to be made of Scottish silver and corresponding hush in the documentary sources suggests that there was not a particular moment when native silver was in market demand. Very little in the way of advertisements or other sources relating to production of native silver survives, as it does for other Scottish materials. Rather, the making of native silver jewellery was concentrated in one-off specially commissioned pieces. Bremner's 1868 report states that there were no working silver mines in Scotland, and put the total amount of silver obtained as a by-product of lead production at Wanlockhead at around 6000 to 8000 ounces a year – less than a tenth of the total silver production in the UK.[26] Those metals were, for the most part, subsumed into wider supply chains and never marked out as being particularly special in the way that other native materials – both precious and non-precious – were, with stories spun around them to heighten their cultural value and, by extension, the desirability and monetary worth of finished jewellery objects. Given the reputation of Scottish silver, it is perhaps surprising that there is not more evidence. But then, 'Scottish silver' more precisely denoted a geographically defined reputation for the quality craft production of silverware. For those without the knowledge, that created

some ambiguity around whether the material or workmanship was Scottish. Sometimes, the ambiguous 'Scottishness' of workmanship and materials converged, such as in much older examples of craftsmanship and their modern reproductions.

Among the older objects recreated by jewellers and employed as tools of self-fashioning in the later decades of the century were examples reputedly made from native silver. In 1885, Edinburgh jeweller Henry Bruce Kirkwood replicated the sixteenth-century Lochbuie brooch – which evidence suggests was made from silver ore sourced in the Isle of Mull, on Scotland's west coast – by hand and displayed it at the Edinburgh International Exhibition the following year as a showcase of his craft skill (Figure 3.1). The original carries an inscription documenting its life cycle, beginning with: 'The Silver Oar [*sic*] of this Broch [*sic*] was found on the Estate of Lochbuy [*sic*] in Mull and made by a Tinker on that Estate about the year 1500', and then tracing ownership

Figure 3.1 Electrotype replica of the Lochbuie brooch made from the original in the British Museum. The brooch was also copied by R. H. Kirkwood of Edinburgh in 1885 and displayed at the Edinburgh International Exhibition the following year. Silver, rock crystal and pearls, 120 mm diameter x 70 mm. NMS, H.NGD 12 © National Museums Scotland.

through several individuals. Kirkwood painstakingly reproduced the original inscription and added to it, thanking the British Museum for allowing him to replicate the piece and stating that 'This Brooch and the Original in British Museum are the only genuine Lochbuie brooches existing'.[27] This continuation of the object's biography to include the museum and Kirkwood underlines the maker's drive to integrate his skill with historical narratives. There is no evidence that Kirkwood's reproduction was made from, or even included, native silver though each of the turrets was set with a Scottish freshwater pearl. Regardless, the temporal meanings were carried over from old to new, at least as far as the jeweller was concerned. Just as the skill embedded in these older objects gradually came to be perceived and valued on a different level over the century, so too did the significance of the origin of materials. By the late nineteenth century, older objects and native materials shared symbolic significance linked to the temporality of the landscape in the Victorian imagination.[28] New things copying old, and new things made from native materials, both spoke of vast swathes of time, and thus fused past and present. These intersecting meanings between matter and form provide a foundation for understanding jewellery objects made of Scottish gold, which ultimately overshadowed Scottish silver.

Rivers of gold

On 12 September 1869, James Campbell, schoolmaster in the village of Helmsdale in the county of Sutherland in the north-east Scottish Highlands, wrote to his aunt in Perthshire apologizing for neglecting to write for so long, explaining that:

> In fact I have been very much engaged for the last six months. I have been in very good health. You would see and hear of the digging for gold in this Parish. It has not been so productive as it was but there are still many working.[29]

Campbell had been very busy indeed. In 1868 the discovery of gold in the Suisgill and Kildonan Burns that fed the River Helmsdale sparked a rush to the area.[30] Campbell seized the opportunity and set himself up as a gold agent, sourcing gold from diggers and selling it on to Robert Naughten, a jeweller in Inverness, around 70 miles away. In return for gold, Campbell received money, ready-made goods from the jeweller and bespoke jewellery of the native materials he sourced.

Through this connection, he built up a personal collection of jewellery, and acted as a middleman for other non-elite men in the area who commissioned signet rings made of local gold from Naughten. Campbell's letters from the time of the gold rush, which survive in a wet copy letter book, offer a rare look at the transformations of gold – from natural matter as mud and dust in the landscape right through to crafted objects worn to express personal and cultural identities – and reveal insights into complex relationships between producers, consumers and things that are otherwise difficult to get at. The whereabouts of the objects discussed in these letters are a mystery. This absence is testament to both their high monetary value and their place as quotidian possessions of middle-class men rather than dynastic property preserved in private collections. The fact that the letter book of a schoolmaster has survived in the national records is a rarity in itself.

Despite his professional job and comfortable home in the schoolhouse, Campbell – who was at this time a widower in his forties – was always striving to improve his lot. In November 1869 he wrote bitterly about another man in the area whose wealth greatly exceeded his own, assertively underlining his words with what can only be read as a tinge of resentment:

> He has plenty money to furnish the manse. … What a grand thing to have plenty of money and how different from my position who could most comfortably spend in a fortnight all I can earn with all my toil, care and anxiety in a year.[31]

While he was culturally middle-class, working and living in close proximity to the working classes but distinct from them, Campbell was not particularly wealthy. He was also something of an outsider in that he was originally from Perthshire rather than the north-east Highlands, but was involved in various aspects of the community through his positions as the local Poor Law Inspector and First Lieutenant of the local military regiment, the Sutherland Artillery Volunteers. His letters reveal how he was self-consciously shaping an image as a professional man, a military man and a man in need of a wife. The gold rush posed an opportunity for him to make a bit of extra cash and obtain small luxuries to help him fashion this image. He was well placed as a gold agent on the coast in Helmsdale, which was close to the centre of the gold rush activities at the burns around 10 miles inland, up the Strath of Kildonan.

Helmsdale was not linked by rail to Inverness until 1870, making it an example of an area that was relatively isolated from the nearest town, even into the second

half of the nineteenth century.[32] But the village's position on the coast meant that, more widely, it was well connected via a busy port into which herring came and from which wool was exported. The east Sutherland area was doing fairly well, relatively speaking, in economic terms during the late 1850s and 1860s. Living standards were improving and the population had been growing, particularly in comparison to the north and west areas of the county.[33] Helmsdale itself was built to provide fishing employment to people who had been displaced – often forcibly – from the estate's interior to the coast when the landowners implemented large-scale clearances to make way for commercial sheep farming during the early nineteenth century.[34] Those landowners were the Dukes of Sutherland, one of the wealthiest aristocratic dynasties and largest landowners in Western Europe. The Sutherland estate alone covered 1.1 million acres, with many more across other estates across Britain.[35] The clearances took place across Scotland, but what became known as the 'Sutherland clearances' were (and remain) the most notorious, partly because of their scale and partly because of the suffering of those who were displaced.[36] The Sutherland clearances attracted widespread attention and vilification at the time, namely due to deaths linked to the forced removal of families through methods that included burning their homes, and became synonymous with the power imbalance between landed elites and rural populations. Contested collective memories of these events remained deeply embedded in the landscape, and in the identity and historical consciousness of subsequent generations.[37] It is significant, then, that the gold rush was located at what is often viewed as the epicentre of these processes, and tied up with the very same landowners, albeit several generations down the line.

The Sutherland landscape attracted attention of a different sort as a result of the gold rush which, though it turned out to be fleeting, created excitement among local people. Gold was known to be present in the area and had been exploited previously, with some focused activity in 1818, but for various reasons had not led to the level of activity seen in the 1860s. The opening of huge, highly profitable gold fields in Australia and California had recently transformed the global supply of precious metals, generating vast wealth – and the accompanying devastation of unimaginably large tracts of land.[38] It was against this backdrop of riches to be made that people flocked to the burns of Kildonan. Amateur diggers, mainly working people from the surrounding area, attempted to earn extra cash while prospectors travelled across the world in search of huge financial rewards that never really materialized. A newspaper report of February 1869 discouraged working people from travelling to the burns:

Several women are at work every day. Last night two boatloads of men crossed from Cromarty. Poor fellows! I don't think during the whole of to-day they earned 2s amongst the lot of 20. … Snow fell heavily today. … It is pure folly on the part of any one getting 15s weekly to come here till spring, when the streams are low and the nights will allow camping out.[39]

But some large nuggets were found, and according to some estimates experienced prospectors could earn around 10 shillings a day, with a total of 400kg recovered in 1869.[40] The landowner, the 3rd Duke of Sutherland, George Sutherland-Leveson-Gower controlled access to the burns – each digger had to purchase a licence from him at a cost of £1 per month – and refused permission to dig for gold from 1870, bringing an abrupt end to the rush.[41] Despite the short period of the rush, the flurry of activity offers much wider insights.

By sourcing gold for Naughten the jeweller, Campbell was able to acquire a pin, a watch, a watch chain, a compass and a ring for himself, as a well as a silver brooch that was probably meant for a gift. He also earned some extra money from the enterprise. In September 1869 Campbell sent £6 16s 6d worth of gold in a package to Naughten, 'from which you will please deduct balance due to you for my [watch] chain and remit for remainder'.[42] Campbell used his logistical position in Helmsdale as leverage for a discount for ready-made objects: 'My chain was marked 142s [*sic*] but there was no word about discount but I trust you will take a liberal discount off this else I will consider it dear.' In keeping with his authoritative demeanour, he also informed the jeweller of market dynamics, saying that 'There is plenty of gold to be had at £3 10s an ounce but at present at not less … but I am afraid the season for jewellery is about over, so that they will require to reduce this price.'[43] One has to question what the jeweller made of his middleman, valuable as he was, schooling him on fluctuations in demand for his wares. But that Campbell stated that that season was coming to an end in October is interesting, given that the end of the year was a busy spell for jewellers ahead of heightened demand for jewellery around Christmas. Clearly, both men were aware that the majority of jewellery made from this particular gold was aimed squarely at a tourist market, at its peak during the summer.

Campbell bartered with gold diggers in the village or, if necessary, travelled to the centre of the activity at the temporary villages of *Baile an Òr* (Gaelic for 'Town of Gold') and *Carn nam Buth* (the Rock Shop) to get his supply direct.[44] *Baile an Òr* comprised several huts along the banks of the Kildonan Burn, mainly accommodation for workers, trading booths and shops selling necessities like

food, clothing and tools (Figure 3.2).[45] There were other agents and brokers like Campbell, and their tactics were not always appreciated, with buyers and brokers were viewed with suspicion. In May 1869, the *John O'Groat Journal* indicated that they had 'crept out of their holes at last, to the great convenience of those diggers who wish to convert their gold into the common currency of the realm instead of dealing in barter'.[46] Competition among agents combined with unpredictable cycles of supply and informal systems of black market selling meant that Campbell often struggled to get his hands on materials.

The difficulties securing supplies are evident in one of the first objects Campbell acquired of native materials he had sourced himself: a stick pin made from gold and garnets – a deep-red precious crystal that was a by-product of the diggings. Though small, the stick pin was an important part of nineteenth-century masculine dress used to secure a cravat, a symbol of elegant manliness and a means of expressing personal taste as part of the three-piece suit worn by professional men.[47] The pin is first mentioned in a letter to Naughten in September 1869: 'As I have not been able to get garnets I will in the meantime postpone the making of the pin.'[48] He continued to have problems, writing in

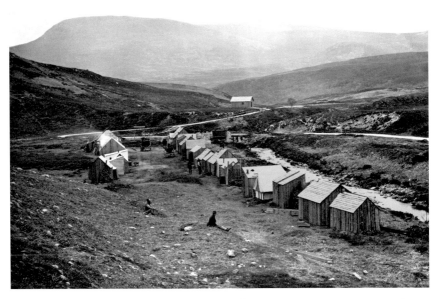

Figure 3.2 The temporary village of *Baile an Òr* next to the Kildonan burn with diggers sitting in the foreground, 1869. Black and white photograph. © The Wick Society Johnston Collection.

November: 'I do not know how many people have promised me garnets but I have as yet got none.'[49] Two days later, still with no stones to have set in his fancy gold pin, he considered going direct to the source: 'I do not know how often I have been promised garnets but as yet I have got none. If I get none before Saturday next I will go to the diggings for them.'[50] Then, success at last: 'Dear Sir, I paid only a glass of beer for the garnets so they will cost you nothing. I have got more since which I enclose … I am very much obliged for your kind offer of a pin & think the design very nice.'[51] While concerned primarily with garnets, Campbell's difficulties document a level of communication and collaboration on matters of supply and design, and suggest the jeweller had sent a sketch or pattern that had met with approval. These sourcing issues highlight the interconnectedness of gold and garnets, both in geological terms and in the way that the rush stimulated demand for other materials. Gold and garnets not only are bedfellows in a natural sense, but are a match that pleases the eye, lending warmth to one another and accentuating colour through the contrast of shining yellow and glinting deep red. Furthermore, while the relative or perceived 'remoteness' of the parish of Kildonan added value to the finished objects, it posed practical challenges for transporting precious materials to jewellers. High value bundled up in small parcels were vulnerable to loss, and travel from the diggings to Kildonan was tricky, particularly at this point, before the railway. As such, the metals were often conveyed through informal channels, carried by trusted friends going into town, in the complete antithesis of established global supply routes.[52]

Perceptions around the rural nature of the Sutherland landscape also show up aspects of environmental consciousness linked to the gold rush and its impact. *The Illustrated London News* posted a correspondent to the area to cover activity, prompting Campbell to subscribe.[53] Reports focused on the diggings but also highlighted fears about the invasion of diggers in the 'solitary wilds of Sutherland' and 'the loss of the sweet grassy haughs along the side of the burns'.[54] This language of loss was partly a reaction to the destruction of landscapes in gold fields abroad but also reflects romanticized notions of the Scottish Highlands as something of a wilderness – a timeless, untouched landscape, somehow 'out of time' – in the popular imagination. These ideas were reinforced by illustrations depicting tiny figures of diggers up to their knees in meandering burns, dwarfed by vast mountainous landscapes stretching into a hazy distance (Figures 3.3 and 3.4). In keeping with contemporary portrayals of the Highlands at large, the images exaggerated the ruggedness of the hilly moorland of the Kildonan area – a

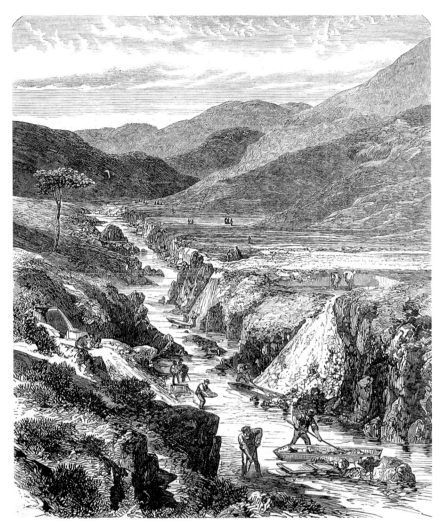

Figure 3.3 'The Kildonan Burn', *The Illustrated London News*, 20 May 1869. © Mary Evans Picture Library.

tame landscape in comparison to the dramatic lochs, forests and steep mountain glens in the north and west Highlands and the mountainous Cairngorms that were cemented as the iconic views of the region.[55] Regular media coverage at a local and national level stimulated demand for Kildonan gold jewellery, both internationally and among tourists to the area. Scottish history and landscape had come to epitomize romantic ideas of past and place from the late eighteenth century, making the Highlands an attractive destination for increasing numbers

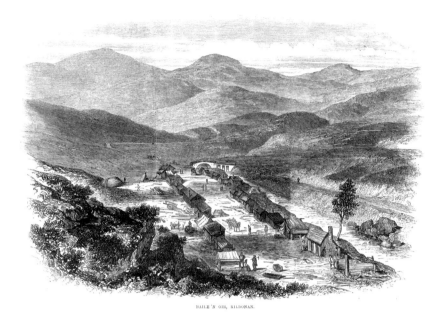

BAILE 'N OIR, KILDONAN.

Figure 3.4 'Baile 'N Oir [*sic*], Kildonan', *The Illustrated London News*, 20 May 1869. © Mary Evans Picture Library.

of middle-class tourists who purchased small luxury souvenirs that evoked emotional and sentimental associations.[56] The gold rush provided visitors to Kildonan with the opportunity to own a precious fragment of this remote landscape, to take home a physical piece of a place bound up with imagined collective memories and personal experience.[57] Concepts of timelessness and eternity associated with gold further increased the power of these commodities to act as mnemonic devices.

Dwelling on these insider-outsider perceptions of landscape for a moment, the writings of another Campbell, this time John Francis, a prolific author, Gaelic scholar and a fount of knowledge on the Scottish Highlands, wrote a tract on the 'Sutherland Gold Diggings' in which he outlined the geological underpinnings of the gold discovery. He is a resolutely local voice amongst writing by newspaper reporters looking inwards. Highlighting the relative flatness of the area concerning the gold rush in comparison to the area further north and west, he wrote: 'A very slight acquaintance with the country itself shows that the greater part of Sutherland is a rolling plateau of no great elevation, above which, to the west and north, pyramidal jagged peaks of strange shape stand singly and line the coasts.'[58] His writing stands out among other sources for the

specificity employed, indicating an understanding of the particularities of place. It is also notable for the expressive ways in which he described mighty geological forces across the wider Nordic region that shaped the Sutherland landscape and the minerals held within it, as well as the use of jewel and jewellery-making metaphors: 'The tallest mountains in Sutherland have ... been carved out of the bent and broken crust of the earth; this particular pattern ... has been graven in crumpled folds of hard rocks ... Whole sets of graving tools have formed a whole series of surfaces'.[59]

He splashes colour across whole tracts of land, painting a picture of how the northern Scottish mountains of 'Clibric, Beinnmòr-Assynt, and others, specked and streaked with snow, stand up like blocks of lapis lazuli above the plateau of copper and silver'.[60] And he put familiar figures from folklore to work to describe geological process:

> If Fionn or the Hrimthursar, the giants of whom Sutherland men and Scandinavians tell tales, were to drag Clibric down to Helmsdale on a sledge, the moving mass would leave a track; and from tracks it is certain that masses of ice far bigger than Clibric did slide to Helmsdale down the glen. ... But the gold problem is in waterworn drift with the gold itself, and it must be dug out of drift'.[61]

He also outlined various methods – collapsing the natural into the man-made – which led the gold to the earth's surface, where 'burns have done a good deal of digging on their own account ... The Kildonan Burn has carved a trench in crystalline Silurian rock from the place where the main diggings are carried on down to the farm-house'.[62] Burns and waterworn drift are expressed as 'natural engines' alongside tools of the trade used by diggers including the 'tin basin' that was used to sort mud, big stones and sand from 'a small heavy stratum [which] remains, in which a lucky man may find a speck or a scale of yellow gold, or a nugget as big as the half of a split pea'.[63] The 'cradle' and 'Long Tom' (which worked to the same principles as the basin, where the heavy ore settled to the bottom to be plucked out) were also described, though the 'long sluice, however, is the best imitation of the burn itself, and the long sluice does most of the work'.[64]

These words point to a way of seeing natural and human energy in retrieving gold as a conjoined or linked process, where the energy of the mountain and weather met the efforts of manual labour and manmade tools. Despite that bigger, joined-up picture around process, he did not neglect also to mention

the human impact on the landscapes. Disturbed mud and silt made its way to the main river 'and spoils the fishing', while the relatively rural area more broadly had found itself full of 'busy wanderers, busily working amongst wandering stones, in quiet burns and grassy straths where deer used to dispute grazing with sheep'.[65] He also stressed the sheer amount of work required to secure a very little amount of gold. 'When such is the nature of the work', he wrote, 'it is no wonder new hands fail to make profit. To wash gold, a man must be skilled in practical hydraulics; to where to seek, he must know the nature of burns; to find the source of the gold, he must be wise in other ways.' He also highlighted how "Experienced Australians" with knowledge of gold mining there had been trying to find 'the source of the branch burn and seek among the Caithness hills, but no gold-mine was found even on "Tom Tiddler's guarded ground", which the diggers invaded in spite of fines and penalties.'[66] This further reference to private land underlines, on the one hand, the power and control that landowners attempted to exert over the search for gold and, on the other, the disregard for it in favour of the informal approach to prospecting that was the reality for diggers on the ground. Looking on the gold rush with the distance of time, it can seem like something which provided opportunities of riches for locals, but in fact there were few who made good money, and most who did benefit in any real way had prior experience in exactly this type of work from gold fields abroad.

Locals were not immune from the desire to own a little bit of luxury fashioned from the precious materials found in familiar yet deeply meaningful landscapes. Take for example, our other Campbell, the schoolmaster: his pin and the Kildonan gold objects he acquired subsequently were valued not just as items of luxury fashion but as objects rooted in ideas of place and home, and as personal mementoes of the buzz of a moment of local pride. There is some indication of what owning an object made from the gold actually meant to him in a letter concerning a ring Naughten had made him, in which he exclaimed, in a rare burst of enthusiasm: 'The ring is beautiful and I am exceedingly proud of it.'[67] The finished pieces were invested with his ties to and knowledge of the local landscape, and his time and labour in seeing the material through from natural to cultural. Moreover, his jewellery drew the eyes of people around him. Impressed by Campbell's ring, other local men commissioned their own, presenting the schoolmaster with further opportunities to arrange production and engage in the creative process of design. In December 1869 Campbell wrote to Naughten: 'An acquaintance here is desirous of getting a ring same as mine

… for which he would provide the gold. What will you charge for making it?'[68] By supplying the jeweller with gold acquired directly from diggers, the customer paid mainly for workmanship.

In a separate exchange between September and October 1869 Campbell acted as middleman for a signet ring commissioned by Reverend James MacPherson, a minister in Golspie, just south of Helmsdale near to Dunrobin Castle, the seat of the Dukes of Sutherland. The letters around MacPherson's ring document various processes, reveal how customers negotiated issues around design and authenticity, and offer further insights into the significance of these small masculine luxuries. After finalizing the decision on a design, or pattern, for MacPherson's ring, Campbell received word that the customer had changed his mind and wanted the object to be copied from another ring belonging to an acquaintance, Mr Keith. Campbell was dismissive of the new design at first and was a little put out when his own design was ultimately abandoned, writing to MacPherson:

> The ring was not begun when I countermanded the order for the first pattern I decided on and now your ring will be made according to your own approval … Mr Naughten likes the design and pronounces it "good" for my own part I would sooner have a shield for a signet ring but this is altogether a matter of taste.[69]

Campbell's disappointment, verging on disapproval, is clear in his writing and amplified in a letter posted to Naughten on the same day. After asking Naughten to engrave MacPherson's initials 'J. M. P.' on the ring, Campbell noted, with a hint of disgruntlement, that he understood 'that the pattern has been changed from what I decided on to the pattern which I sent you with his instructions.'[70] Clearly, schoolmaster and minister had conflicting ideas on matters of design.

The tension around 'good' and tasteful design provides an insight into how small pieces of men's jewellery functioned as highly personal indicators of masculine taste and individuality.[71] The signet ring was a conspicuous symbol of social standing traditionally associated with aristocratic men, engraved with a heraldic device as an expression of the longevity of their standing, but had become a common symbol of a respectable and stylish gentleman throughout Europe by the second half of the nineteenth century.[72] A wide range of patterns were available – typical examples were fairly chunky, with an oval, shield or square bevel engraved with initials or arms.[73] Despite the widespread wearing of the signet ring by the 1860s, the association with elite cultural practices could leave the middle-class man open to the risk of social derision, mocked for having

pretensions to gentility, especially in a small community. These simple but substantial everyday objects could attract the wrong sort of attention, therefore taking advice from trusted and respected acquaintances – such as copying Keith's ring – was one way of navigating issues of style to ensure that the finished object followed wider fashions and was elegant and impressive, but also tasteful and appropriate to the wearer's social position.[74] In this way, the letters around these bespoke objects further our understanding of gendered consumption and highlight how people living in areas that are often considered peripheral were no less desirous of fashioning self identities through small objects of luxury dress than their urban counterparts.

The subtlety of the rings for middling men comes sharply into focus when considered against a decidedly unsubtle piece produced specially for local aristocratic elites. Among the handful of surviving jewellery that can safely be said to contain Kildonan gold, one is a pendant in the shape of a large pectoral cross inspired by ancient stone monuments, with finely engraved Celtic-inspired interlacing swirling around eleven large Scottish pearls (see Plate 3.3). It was made in 1870 for the Duke and Duchess of Sutherland and survives at the family seat of Dunrobin Castle as an ancestral family jewel. The cross is a conspicuous showpiece and the three-dimensional construction gives the illusion of a solid object, when it is in fact constructed from a series of thin panels soldered together to make a hollow – and correspondingly light and wearable – pendant that mimicks cross-shaped reliquaries. Engraved on the back are the words: 'Kildonan', marking the origins of the gold in Sutherland, the source of the pearls in the river glen of 'Glenmoriston' (outside Sutherland, further to the west) alongside the date of creation, '1870'. Taking the gold, design and inscription into account, the cross can be understood as directly translating the Duke's landed property into portable property – it materialized the wealth of the estate in a high-status object, and spoke of long-held held aristocratic ties to and ownership of the county of Sutherland. The cross was a feminine object, and therefore probably worn by the Duchess of Sutherland, Anne Sutherland-Leveson-Gower (nee Hay-Mackenzie), who was Countess of Cromartie in her own right from 1861 and served as Queen Victoria's Mistress of the Robes.[75] Worn by the Duchess, the conspicuous showpiece spoke of gendered power relations – representing male wealth and land ownership on the feminine body – but it was also a fashionable piece that would have marked her taste and style.

The Celtic cross design was in high demand during the Scottish-Celtic revival.[76] The plain cross had long been a popular shape across many forms of Victorian jewellery, but the Celtic style with a ring around the intersection appears to have come into fashion during the 1860s. The pattern book of Inverness jeweller, P. G. Wilson contains a sketch titled 'Iona cross' which corresponds closely to the dimensions of the finished piece.[77] It appears alongside others which are almost certainly adapted from a volume *Sculpted Stones of Scotland*, published in 1867.[78] Wilson's Iona cross, however, appears to be a creative interpretation of a number of stones from different parts of Scotland.[79] This cherry-picking of design elements is unsurprising, and there are further inconsistencies between original source and design sketches with drawings of standing stones from the north-east of Scotland given names from the more 'picturesque' west coast. Producers were less concerned with historical or geographical accuracy than they were with marketability. They chose names to fire consumers' imagination by providing a sense of place, with materials and design converging with locations and landmarks so that the end piece opened up a window on to the very type of landscape that visitors craved.

Wilson was one of the foremost buyers of Sutherland gold, which lends some weight to the notion that he may have made the piece for the landowners. Known in the area simply as 'P. G.', he was mentioned in a humorous song penned by an amateur gold digger from Helmsdale, Sandy Grant:

> I'm off to Kildonan, my fortune for to try,
> I'm off by the first train, so kind friends goodbye!
> To dig the precious metal and sell it to 'P. G.',
> Oh, digging gold you know, what a jolly life for me.[80]

Contemporaries knew exactly who 'P. G.' referred to, due to his participation in the rush. In an advertisement, Wilson stated he was 'well known as the PURCHASER of the SUTHERLAND GOLD' and could make: 'Any Article of Jewellery made to order of the SUTHERLAND GOLD, and sent safe by post to any part of the world.'[81] In March 1869 *The Inverness Courier* reported: 'Since last week, Mr Wilson, Union Street, has bought £19 worth of gold from his agents in Helmsdale, making a total of £147 10s, which he has expended in purchasing the precious metal.'[82] The report went on to discuss another producer:

> Messrs D. C. Rait and Sons, of Buchanan Street, Glasgow, have been active
> purchasers of Sutherland gold from the commencement of the discovery,

and have assayed several specimens officially. These have ranged from 19 to 19¾ carats. Mr Robert Gilchrist, the original discoverer, seems to have been very successful of late at the Kildonan burn, and has supplied Mr Rait with a considerable quantity of gold during the last few weeks.[83]

This reporting on technical details around the volume, prices and composition of gold highlights the commercial interest in the rush, and the connections between diggers and producers outside the Highland region.

The Glasgow jewellers D. C. Rait & Sons operated from an impressive shop on Buchanan Street where they catered to the city's ballooning numbers of wealthy middle-class consumers. A surviving gold cross, engraved with 'D. C. Rait and Sons/Scottish gold' on the back, provides an example of a more commercial version of the landowners' cross, while demonstrating the fashionable appeal of the larger piece (see Plate 3.4). Like the bigger version, it mimicked Celtic stone crosses and was constructed from thin panels, making the most of scarce materials. This much smaller piece could be worn as a pendant or a brooch, a piece of everyday jewellery rather than an aristocratic showstopper. Foliate decoration is engraved on the front – leaves grow down and across each panel around a central daisy, creating sparkle and light and merging the contemporary trends for historicism and naturalism in jewellery design. Indeed, the design combined ideas of Scottish history with motifs drawn from the natural world, linking the native materials back to the landscapes in which they were sourced.

Other pieces made from native gold have surfaced in recent years, including a finely worked piece by a different Glasgow firm, Muirhead and Sons, which speaks a different design language by incorporating a range of Scottish materials (see Plate 3.5). Again, it could be worn as a brooch or a pendant. This one, however, used complementary stones and pearls instead of a distinctively Scottish design to tell a story of landscape. A large oval citrine known in Scottish jewellery terms as a 'cairngorm', linking to the mountain range in which these crystals were found, sits in the centre of the gold setting, framed by four Scottish freshwater pearls. This assemblage of native materials represented a wide geographical area, and communicated visual signs of the landscape so that it was unnecessary for the overall shape or design to scream 'Scottish'. The inscription on the reverse dominates the maker's mark and puts the origins of the gold in 'Sutherland', specifically. The high quality of these materials together with the fine engraved decoration marks this out as an exceptional piece. In addition, tiny beads of gold granulation hug the stone's setting and adorn the outline ellipse shape, descending in size order from the top point and along the shoulders in

a cascade effect. This attention to detail demonstrates how jewellers put these scarce precious metals to best use to make high-end pieces that were coveted by particular groups of consumers who valued the provenance of materials and the links to land embedded within.

It is worth pausing, for a moment, to think about the sourcing and bringing together of these materials from different parts of Scotland, often through informal chains of supply. This required the jeweller to interact with different people who were both out with their usual list of contacts and linked to rural areas rather than urban centres in the cities of Britain and Europe. Decisions on design took place against the backdrop of this self-conscious and undoubtedly, at times, effortful acquisition of materials. The Dunrobin cross, made as a bespoke piece, and these two high-end but more commercial pieces begin to show a spectrum that reflected different areas of the market that jewellers catered for. A flurry of activity from Inverness jewellers in the Design Registers around the time of the gold rush shows up that commercial side, with often elaborate designs invariably referencing the local area and its past. Unsurprisingly, Wilson was one of the first to register a design of Sutherland gold in 1869, which displayed thistles and the 'cat-a-mountain' motif that appeared in Clan Sutherland's crest. Meanwhile, Naughten copyrighted replicas of local archaeological finds to be made in native gold and garnets.[84]

Copyright status and naming practices were important in linking materials to the landscape, particularly in pieces which fitted the stereotypical mould of the souvenir at what we might view as the next level on that spectrum from high-end bespoke to fashionable luxuries to novelties and trinkets. For example, Ferguson Brothers (which operated in Inverness and Edinburgh) advertised their copyrighted designs including: 'THE SUTHERLAND NUGGET PIN OR SCARF FASTENING' (Figure 3.5), 'a most appropriate design for a SUTHERLAND GOLD PIN, being composed of small nuggets, representing a rock, surrounded by a Garter having "Sutherland" or "Kildonan" in enamel or raised gold letters'.[85] In this case, the rawness of the design using natural nuggets emphasized the metal's natural origins while the name of the county left no doubt as to where exactly the nugget was from. They also copyrighted and advertised objects named after the local aristocracy, such as 'THE DUNROBIN GUARD OR SCARF RING' referencing Dunrobin Castle and 'THE GOWER BROOCH', referencing the family name, Leveson-Gower, as well as a design copied from a local archaeological find 'now in the possession of His Grace the Duke of Sutherland'.[86] The list goes on to describe

Figure 3.5 Design for a 'Sutherland nugget pin or scarf fastening', Ferguson Brothers of Edinburgh and Inverness, 1869. TNA, BT43/24/228696. © The National Archives, Kew.

a range of masculine and feminine objects such as the 'KILDONAN LOCKET, Scotch Pearl and Cairngorm Scarf Pins', and 'Any Article of Jewellery, made to order in SUTHERLAND GOLD'.[87] 'Kildonan' and 'Sutherland', then, became recognized terms used to identify products, effectively a system of branding that linked the objects with the parish or county, the estate and the landowner, and by extension with the landscape itself. Notably, these local producers amplified the specific source rather than falling back on the catch-all 'Scottish gold', underlining provenance.

The design of these objects and the names assigned to them in advertisements reinforced the place of origin and linked objects directly to place, enabling owners to emulate elites by possessing a fragment of the landscape. In contrast, the signet rings of Campbell and his acquaintances were more ambiguous – their form did not necessarily tell a story about the materials from which they were made or, as far as we know, explicitly reference place. But their relative simplicity meant they could be worn as everyday objects by local middle-class men in line with wider fashions, glinting on the wearer's hand as a sign of status and style as he went about his everyday life. These wearers were

themselves highly aware of the link to place, having been involved in sourcing the materials, and thus did not require the rings' design to tell a story about the landscape. Nevertheless, the rings conferred upon their owners a sense of ownership over the landscape that surrounded them, and thus constituted a link between person and place. There are other objects linked to the rush via word-of-mouth only, including a well-worn and clearly treasured *piqué pose* mourning brooch of wood (polished to mimic tortoiseshell) with the thinnest sliver of gold arranged in a delicate flower inlay. This low-quality, now-damaged piece clings to the story that it contains Sutherland gold but whether that is the case cannot be determined without scientific testing. Nevertheless the residual memory of the gold rush in the piece is a useful reminder that the discovery enabled local men and women of all classes to get their hands on the precious metal, albeit sometimes in the tiniest of quantities. The ties to place embedded in the materials gave even the most unremarkable of objects a further layer of significance and meaning.

The materials used to form MacPherson's ring were of crucial importance to him, as is evident in Campbell's repeated assurances regarding authenticity. Campbell explained: 'Then the assay stamp is impressed in it this is done before the ring is finished but it will matter little for I can assure you it will be genuine.'[88] Campbell mentioned this again several days later, saying: 'It was to be sent off yesterday to get the "Hall mark".'[89] Anxiety around authenticity was partly created by jewellers as a way of asserting the superiority of their own goods against those of competitors. For example, in an advertisement of 1869 for the aforementioned Sutherland gold ring, Wilson combined persuasive language – and the use of first person to emphasize his personal role in production – with a warning that fellow producers could not be trusted:

> The KILDONAN GOLD seems to be a favourite, and the desire to possess it great; it is of a beautiful colour, and most suitable for the manufacture of jewellery. Every good thing has counterfeits, and the Sutherland Gold excitement offers a temptation to many in the Jewellery trade. I have made a number of articles of the Gold, and the quantity I have purchased will enable me to make to order any article of Jewellery that may be wanted of the SUTHERLAND GOLD.[90]

As well as casting doubt on the goods of other producers with mentions of forgery, the advertisement draws attention to the 'beautiful colour' of native gold. The mention of colour gets at one of the key issues around authenticity.

As a soft metal, gold was usually alloyed with other metals such as silver and copper – though sometimes the natural presence of other minerals made this unnecessary – and the end hue was dependent on that ratio.[91] The suggestion that objects made from Kildonan gold were distinctly beautiful because of the material's origins is indicative of a drive to link the precious metal back to the landscape, to create an added layer of value in the minds of consumers. It also played to concerns around how much native gold, if any, was contained within objects crafted by competitors who could not resist the 'temptation'. Assaying offered an assurance of the ratio of gold to other metals in a piece, but could not give an indication of the gold's origins. A small percentage of native gold could be mixed with gold from other sources, and the customer would never know the difference.[92]

Concerns around authenticity meant that trust in the jeweller was of paramount importance. To return to Campbell's letters, his repeated assurances about the whereabouts of the pattern and finished ring suggest that MacPherson's anxieties went beyond material composition, to issues of security. As with the transportation of raw gold, there were challenges in transporting small objects of financial and sentimental worth out to customers across long distances. The jeweller's physical shop space was key to reputation and customers' trust in the firm and its goods, so it is unsurprising that MacPherson's concerns about authenticity were compounded by the geographical distance between himself and the jeweller. That sense of distance was only increased by Campbell's involvement, which introduced another degree of separation and put the client firmly outside the inner circle of written communications around his commission. Finally though, MacPherson received the rings, prompting Campbell to declare that the new one was, despite his earlier issues with the design, 'the best article I have seen made of Kildonan gold', and a bargain at £2 15s 6d.[93] Further niceties in the same letter indicate that these transactions required a soft touch with regard to payment:

> I am sorry to hear that … bad fever has broken out in your district. … You should not expose yourself needlessly to infection as in carrying out a coffin when others would do that duty equally well if not better. … When you send a Cheque please make it payable to Robert Naughten, Inverness.[94]

Mixing personal sentiment with money matters was a fairly standard way for Victorian men to conduct business, but in this context concern for the customer was important in buoying confidence in what had turned out to be a rather

fraught purchase. Campbell also attempted to communicate the jeweller's credibility and reputation by informing MacPherson that Naughten was 'at present making jewellery of Sutherland gold for the Prince of Wales– and he seems to be proud of the order'.[95] This mention of royal patronage was key to bolstering the customer's trust, quelling any niggling regret or uncertainty. MacPherson could wear his ring confident in the knowledge that it was an appropriate marker of his good taste and individuality, and an authentic piece of his local landscape made by a respected Inverness jeweller. Through close involvement in the transformation of native materials into personal possessions, then, the male consumers documented in Campbell's letters negotiated local, gender and class identities, and attempted to make sense of their present experience in a landscape deeply embedded with collective memories.

Given the small amounts of native metals available relative to wider production, it is important to remember that jewellery of native gold was just one part of the jewellers' stock, but was a distinct area of production with specific challenges. For example, William Fraser of Inverness placed 'JEWELLERY OF SUTHERLAND GOLD' at the top line of an advertisement, above 'CAIRNGORM AND PEBBLE BROOCHES AND BRACELETS' and a variety of 'LONDON-MADE JEWELLERY'.[96] The distinction between objects made of local materials and ready-made goods produced in London raises questions about how the rush affected jewellers' work. The demand for native gold jewellery undoubtedly led to an increase in workshop production as jewellers made objects from scratch and responded to heightened demand. That rise in production is evident not just in the surviving sources employed in this chapter but in clear quantitative evidence in the numbers of firms and jewellers working in Inverness around the time of the rush.[97] Together, those sources point decidedly to the fact that the burst of activity in the burns was mirrored in a boost for jewellers operating in Inverness. And we know that production of Sutherland gold objects was not limited to that town but took place across Scotland's urban centres.

Jewellers across Scotland were thus faced with an unusual set of circumstances that required them to see materials through the complete life cycle and, as such, pushed them to engage with the natural world on a different plane, through the working of materials and the conception and execution of designs using the metals. At the most basic level, they were required to prepare raw gold themselves, melting dust and nuggets down to burn out all the impurities and then alloying with other metals to make workable materials. As highlighted at the beginning of this chapter, usually this part of the process was carried out elsewhere with fine

gold bought in from suppliers and ready to use. But this shift in production and what it entailed cannot be overstated. Mixing raw gold, separating impurities, making decisions on whether to alloy and then seeing that process through was (as discussed in Chapter Two) not necessarily part of even a skilled jeweller's repertoire because it was simply not required the majority of the time. Once the raw materials were made ready for working, jewellers then had to apply head and hand to create objects, either to fit the demands of commissions or to follow wider fashions while articulating the materials' origins in the finished object for the wider market. That meant thinking carefully about designs and constructing a new language with which to convey the matter's origins and associated meanings, and doing so for different types of buyers. Furthermore, this investment in time and labour meant that image-making was important in creating value, ensuring that the final pieces could cut across the fierce competition and command a price which reflected the extra resources required in production. In this sense, the rush presented jewellers with economic opportunities that required them to return to the fundamentals of their craft – and to adapt processes and collaborate with one another as well as with suppliers and consumers – to see objects through from the very beginning to the end piece.

While the Kildonan gold rush came to an abrupt end in 1870, small amounts continued to be used in jewellery. In 1893 Peter Westren released 'The Union Brooch', carrying through the trend for giving particularly notable designs a title, like a miniature artwork (see Plate 3.6). Made in batch, the piece is a veritable feast of Scottish materials comprising a mosaic of native pebbles and crystals couched in a gold garter-shaped setting. It was sold with an accompanying sale card detailing the origins of each material and the landowners' names.[98] At the top of the list is 'Gold from Kildonan, Sutherlandshire – Duke of Sutherland'. The assemblage of materials is worth considering in full. The central shields are of cairngorms from Aberdeenshire and vermillion jasper from Campsie in Lanarkshire, the crown contains pearls from the River Tay in Perthshire and rubies from Elie in Fife and, framing the piece around the outer ring is jasper from Edinburgh and Ayrshire, bloodstone from the Isle of Rum and rubies from the Scottish Borders. Gold from Kildonan was one of many materials contained within the Union brooch, and represented only one part of the Scottish landscape, but it served an important role, conferring status to the stones and gems it enveloped, most of which were not intrinsically valuable. Bringing together

these materials, Westren created a collage of the Scottish landscape embedded in gold from the mainland's northern tip. As well as listing materials' origins, the leaflet outlined the object's commemorative function as a celebration of the Union of Scotland and England in 1707, and the presentation of the design to 'the Duchess of York on the occasion of her marriage of 6 July 1893', thus extending the geographical significance of the object to England and bridging both countries. In a further attempt to put a spotlight on what was clearly a significant piece, a line at the bottom mentioned that Ruskin had 'stated, in his lecture on Geology, that Scotland possesses the most varied and the richest coloured stones found in the world'.

The Union brooch is a cleverly designed object of complex construction, made by skilled hands and accompanied by a sophisticated piece of print advertising that doubled as a certificate of authenticity. That authenticity hinged on the origin of materials, effectively making the piece a geological map of Scotland, rendered in its remarkably diverse mineralogy. The Union brooch has much in common with the silver medal worn by Arbuthnot in 1822. Both tell a tale about the origins of materials in the natural landscape through their design, but rely on written information to articulate the origins of the metals. And, of course, both expressed ideas of Scottish difference within a wider British identity. These are the types of objects that hang on to their provenance and, viewed together, they document the persistence of a narrative of national identity articulated through native precious metals. But seen in the context of the other material transactions in this chapter, local contexts cannot be ignored. Indeed, both objects were accompanied not by references to 'Scottish gold' but to the specific areas of Leadhills and Kildonan. It is important to see the Union brooch as an exemplar of a much wider category of objects which enabled individual owners and wearers to express multifaceted identities that simultaneously spoke of the local, the regional and the national, overarched by the collective memories and romantic ideas embedded within the physical landscape. For some, the particularities of place were resonant in these objects while, for others, landscape specificities and personal links were subsumed into a range of other wider meanings, with the object standing instead for the landscape as an idea, a memory or a figment of the imagination. The rarity of gold found in Scotland, combined with the contemporary yearning for nature, lent objects made from native metals – which were already intrinsically valuable – complex layers of symbolism and cultural value.

Conclusion

The landscape – real and imagined – looms large over the material transformations involved in the production of jewellery from Scottish silver and gold. The temptation is to assign things made of native precious metals to an overarching narrative of national identity, but this chapter has shown that there was a much more complex story at play. Producers made objects speak of their invisible origins by naming them in a way that referenced specific places where matter was sourced, designing them in such a way as to link to the landscape and often inscribing the source into the finished object. There was often a slippage between Scottish silver and Leadhills silver, and between Scottish, Sutherland and Kildonan gold, which reinforces the idea that the materials were layered with national, regional and local associations. The natural origins of native metals imbued finished objects with a symbolic and emotional resonance, requiring jewellers to apply their skills in design, workmanship and marketing to craft narratives of place, nature and landscape onto which consumers then layered personal memories and connections.

In doing so, producers simultaneously satisfied and fuelled contemporaries' desire to connect with nature and landscape. This process required jewellers to forge a deeper connection with landscape and nature themselves, through sourcing and transforming raw matter, designing objects and building images and stories around the finished goods. That kind of engagement – on a practical and cultural level – is rarely seen, and difficult to get at, in relation to modern production but this chapter has shown how looking closely at materials and process can reveal aspects of maker relationships with the natural world that can be applied to other matter and areas of craft. Indeed, the very landscapes that presented economic opportunities, stimulated local fashion trends and gave objects added layers of value and meaning, posed challenges for both producers and consumers. On a logistical level, the path travelled from the rural landscape to the urban workshop and vice-versa, from the jeweller to the country customer, was fraught with problems relating to transport, trust and security. Overcoming these issues involved a level of adaptation and collaboration between producers and consumers that does not fit with dominant assumptions about the essentially commercial nature of supply and retail in Britain during the later nineteenth century.

The values ascribed to and perceptions of Scottish landscape in the popular imagination enhanced and complicated the cultural, and indeed the economic, value of intrinsically valuable precious metals for producers and consumers alike. In turn, the presence of these materials added a layer of mystery, complexity and interest to landscapes already freighted with associations and collective memories. Complicating the picture further still, narratives in international newspapers and other writings clearly point to aspects of environmental consciousness in British culture around the 1860s. The gold rush triggered – or tapped into – contemporary concerns about the impact of human activity on the land and the natural world. The next chapter looks at semi-precious minerals that are often placed at the opposite end of the value spectrum to precious metals, to explore how producers adapted skills and collaborated across branches of their craft to conjure mythical colour worlds through jewellery.

Minerals: Crafting colour worlds in stone

In 1884, John Ruskin addressed the Mineralogical Society at a meeting in Edinburgh, describing Scotland as 'a country which is itself one magnificent mineralogical specimen', a region which presented 'examples of nearly every mineralogical process and phenomenon which have taken place in the construction of the world'.[1] Ruskin had strong Scottish connections and possessed expert knowledge of the country's diverse geology, which provided jewellers not only with silver and gold, but with a range of stones to make colourful jewellery. His reference to the elemental forces that created minerals, and in turn formed the earth itself, provides a useful way of thinking about the intersections between matter and process in the life cycle of jewellery made from Scottish stones known simply as 'pebbles'. During this period, 'pebble' was not used in the modern sense of the word, to denote a waterworn stone on the river or beach, but applied to semi-precious material used in the eighteenth and nineteenth centuries. Ruskin spoke of the beauty, mystery and science of 'pebble,– or crystal' which appeared in 'two main forms … the beautiful conditions of agate, and the glowing colours of the Cairngorm, which have always variegated and illuminated the favourite jewellery of Scottish laird and lassie'.[2] Agates (see Plate 4.1) and cairngorm crystals (see Plate 4.2) – both varieties of quartz, the former a rock associated with lavas in the Lowlands and the latter with granite and metamorphic rock in the Highlands – are at the centre of this chapter. They are considered alongside a range of other stones including jasper, bloodstone and granite, and related materials including glass and enamel. By the time Ruskin gave his speech, pebble jewellery was already considered the quintessential form of 'Scottish' jewellery. The style is mentioned, though never systematically interrogated, in most works on Victorian jewellery design. There is a tendency to focus on how the popular appeal of 'Scotch pebbles' as a direct result of Queen Victoria's influence led to the production of large numbers of goods at varying levels of quality, often made by producers in Birmingham and in the main centre

of agate production in mineral-rich Germany, sometimes from stones imported from South America.[3] While it is certainly the case that stones were sometimes substituted, this narrative of misrepresentation – which has persisted since the early nineteenth century, before Victoria's influence, and often exaggerated even at that time – has obscured the complex story of the interplay between highly-localized geologies and the networks of trade that linked rural landscapes with urban production. There is a much longer and more complex story at play. While native precious metals were exploited only intermittently, pebbles were used by jewellers in Scotland throughout the long nineteenth century, evolving from centuries of use and reuse as charms and amulets, and tied up with the curiosity cabinet – and the museum – as a repository of developing geological knowledge. Pebbles reveal how a shifting cultural engagement with geology and natural history had a direct bearing on jewellery production and consumption, and on perceptions of craft producers and their skills. The very questions of authenticity and cultural value that have rendered this a tangled topic for historical research are worth exploring in their own right.

In the late eighteenth century, James Hutton's theory of 'unconformity', based on the study of geological sites in Scotland led him to the conclusion that the earth was millions, rather than thousands, of years old.[4] Hutton is considered the father of modern geology and was a key figure of the Enlightenment. His theory of 'deep time' overturned scientific ideas about the formation and age of the earth, with profound implications for the ways in which contemporaries understood and appreciated the physical landscape.[5] A century later, when Ruskin addressed the Mineralogical Society, the fields of geology, mineralogy and natural history had entered the popular realm, not least as a result of his own widely read publications on the subject.[6] Ruskin interpreted natural phenomena through theoretical and scientific knowledge, as well as through sensory experience developed from engaging creatively with nature through drawing, writing and painting, and he encouraged his readership to do the same. This intertwining of science and romantically tinged personal experience of the landscape – fuelled by its historical and literary associations – is important in understanding the multifaceted and mutable appeal of pebbles. The enduring fascination with the interlinked physical, geographical and symbolic dimensions to these stones has been documented in writing and cartographic material by professional and amateur geologists from the mid-eighteenth century to the present day.[7] The relationship between the materiality of the stones and the fashionable luxuries made from them, however, is absent from the existing literature.

Unlike precious metals and gemstones such as diamonds, pebbles were not intrinsically valuable and complicate the idea of gems and jewellery as an index of monetary wealth. This is underlined by the use of the word 'pebble', which makes a modern reader think of humble stones made round and smooth by the sea, but was applied in this period to describe crystals and fragments of semi-precious stones found in the wild as well as quarried.[8] The making of jewellery from agates usually started on the coast or hill with a fairly unremarkable, sometimes green-tinged, pockmarked stone (though the greenish skin is soft and wears away quickly on the beach or river).[9] Sliced open and polished, a captivating colour world was revealed, each one different from the next. Thus, pebbles speak of surprise, singularity and process – mineralogical process, the work of elemental forces over long periods of time, and artisanal skill and labour. The relationship between the making and symbolism of pebble jewellery dovetails with recent scholarship on the materiality of colour and coloured objects, which proceed from the fundamental notion that the social and cultural meanings attached to colour vary across social, geographical and historical contexts.[10] Given the slippery meanings of colour, the writings of artists and makers offer important insights and a touchstone for the historian of material culture. For example, contemporary potter Edmund de Waal's study of white through porcelain examines the transformation of muddy matter into luxury crafted objects and, in the process, uncovers ideas about how historical makers were driven to push the limits of their skill – and, in turn, drive innovation – as a result of their fascination with the geological origins and visual effects of their materials.[11] Like porcelain, the value of pebble jewellery was located in the combined effects of colour, luminosity and translucency as well as the craft skill and ingenuity applied to release and enhance these natural effects from raw matter. Crucially, it is important to remember that the makers of such objects had imaginations too – it is possible, here and there in the sources, to glimpse a passion for and fascination with materials which, sometimes, led to the development of both cultural and scientific knowledge. Rather than explore one particular colour, this chapter considers objects made from pebbles that assumed an infinite range of variegated hues.

The chapter begins by examining the rising demand for pebbles from the late eighteenth century, showing how sourcing pebbles relied on a knowledge of geology and landscape, and cutting and slicing the stone required specialist skills and tools, which stimulated both rural trades and a sophisticated lapidary industry in Edinburgh. The second section examines shifts in design and form,

from around the middle decades of the century to understand changing skills and technologies, revealing how the desire for complex pebble mosaics in brooches and bracelets led to close collaboration between lapidaries and jewellers. I explore how issues of scarcity and authenticity together with changing fashions led to a decline in Scotland's lapidary craft, and the parallel development of specialist producers – often highly skilled women – in creating colour through enamels. Throughout, I reflect on the intersections between craft, collecting and cultural engagement with Scotland's geology and physical landscape.

Pebble collecting and the emerging lapidary craft

By the late eighteenth century there was market demand for pebbles as worn objects but, despite Scotland's rich mineralogy, they were not in plentiful supply. Personal networks were crucial to acquiring the right stone for the desired object. On 22 August 1780 Lady Drummond of Blair Drummond wrote to Sir James Grant of Grant, a politician and agricultural improver, seeking 'a Scots Peeble [*sic*]'.[12] She had recently visited the family seat of Castle Grant in Speyside, on the northern edge of what is now the Cairngorms National Park and, as Grant was not at home, she wrote to his Edinburgh address 'to beg a very particular favor [*sic*]' on behalf of a friend, a navy Captain who wished to make a gift to an Admiral, who he had heard:

> express a desire for a Scots Peeble [*sic*] to cut his Crest upon … I could not think of any body more likely to suply [*sic*] me or any one more willing to oblige. If you can procure one it will be doing me a most particular favour, & much oblige me & also my Husband.[13]

After 'promising to write to the Country for a Stone', Grant tried to purchase one at an Edinburgh auction, but the price was too high.[14] Finally, on 26 September, Grant's clerk sent him two pieces of stone with a letter explaining:

> The day before yesterday I acquainted Sandy Lawson as desired, and inclosed [*sic*] are two small pieces of Cairngorm Stones, one of them may be of some use but the other is of no use at all They are all he had. He went only once to the hills this year & he says he made nothing of his travels.[15]

Clearly, sourcing cairngorms could be challenging, as demand was not yet matched with a ready supply. This idea is reinforced in an advertisement in the

Caledonian Mercury in 1780 appealing for 'ANY person possessed of a genuine CAIRNGORUM [*sic*] STONE, fit for a Seal' to offer it for sale.[16]

The request for a 'genuine' stone points to issues of authenticity with regard to place of origin – an aspect that would become particularly contentious as time wore on, and which continues to dominate the narrative around these stones. Writing about his travels in Scotland between 1811 and 1821, Englishman John MacCulloch spoke of these crystals as 'objects of a petty and poor trade among the country people and the shepherds' who demanded 'guineas for what pence will purchase in London'.[17] He was equally withering about the 'jewellers of Edinburgh, who sell Brazil crystal under this pretence [of Scottish origin], at twenty times its value', thereby making a pretty profit from 'elevating them to the dignity of Scottish crystals'. He stated that Scotland did not produce even 'the fiftieth part' of the stones sold as Cairngorms. His account is certainly exaggerated, and underpinned by a general disdain for rural 'Highlanders' – particularly poor ones – whom he gleefully describes, employing the words of a previous traveller, as 'the most impudent extortioners on the face of the earth'.[18] Regardless of the misrepresentation in his account, the point here is that authenticity and provenance were a concern for some purchasers even at an early date. And clearly, the way in which the evolving cultural values being ascribed to these stones impacted on market prices raised eyebrows among some observers.

Both Lady Drummond's letters and the advertisement highlight the use of cairngorms in seals. The seal was a small object engraved with a crest or heraldic device – a symbol of aristocratic status and family ties – used by men and women to stamp the wax seals of letters and usually worn on the body, either as a finger ring, or suspended from a chain on a metal fob. But cairngorms were worn in many forms of jewellery, adorning the bodies of elite men, women and children. In her memoirs, gentlewoman Elizabeth Grant recalled how, when riding in the Scottish countryside around 1800, her father wore full Highland dress – the kilt and plaid with all the usual accessories, including a dagger or 'dirk' studded with native stones – while:

> Mother rode to the ground beside him, dressed in a tartan petticoat, red jacket gaudily laced, and just such a bonnet and feather as he wore himself, with the addition of a huge cairngorm on the side of it.[19]

This self-conscious construction of Scottishness was particularly pronounced among elites when *in* the landscape, engaged in particularly 'Scottish' pursuits, such as hunting, and manifest in more subtle ways when removed from that

backdrop of landed property. For example, in 1810, the thirteen-year-old Elizabeth and her two younger sisters wore cross-shaped pendants made from small faceted cairngorms (see Plate 4.3) at a 'great party' in London hosted by Mrs Charles Grant, wife of the Director of the East India Company. Her memory of the jewels, and their association with the hills, is tied up with a sensory description of fabrics and clothing:

> We got new frocks of soft clear muslin … as our toilettes were completing my Mother entered … holding in her hands three pairs of white kid gloves, and three cairn gorm [sic] crosses dangling to gold chains. Duncan Macintosh had given us the stones which had been found on our own hills and she had had them set for us purposely to wear this evening.[20]

Taken from the family's Highland estate, and worn at an elite gathering in the metropolis, the stones marked the young wearers' long-term links to landed property. Elizabeth wrote that the jewels were admired by an important contact of her father who had an interest in unusual stones, highlighting their rarity, and the attention they drew in light of a contemporary preoccupation with mineralogy.

This ancestral dimension can be seen in other sources. In 1816, Major-General David Stewart of Garth 'wore large round Cairngorum [sic] buttons, richly set', at the first anniversary meeting of the Society of True Highlanders at Inverlochy, while his contemporaries 'had the globular silver buttons of their ancestry'.[21] Both crystal and engraved buttons spoke of lineage and history. Stewart was a key figure in the development of Highland dress, and acutely aware of the symbolic intertwining of ties to land and ties to family embedded in the earthy crystals that punctuated his clothing.[22] As a soldier and, later, colonial administrator, Stewart of Garth was involved with the British imperial project. So too were the likes of Elizabeth Grant's father and the people with whom he mixed. It is notable that these young girls were, through family connections, mixing in social circles that included the head of the East India Company and that their parents chose to display these symbols of Scottish landscape – and of landed property – on their children in this type of setting. Many of the foreign landscapes with which these individuals were familiar through their work and business were key sites for minerals employed in jewellery of the period. Against this material backdrop, Scottish stones spoke explicitly of Scottish landscapes and ties to Britain. The language of minerals was complex, and decidedly international in scope, with jewellery made from

cairngorms functioning both as highly personal possessions and as portable symbols of property.

Rather than marking wealth and status through the brilliant rainbow colour created by precious stones like diamonds, cairngorms spoke of wealth in a muted, discreet way. The stones were inextricably linked to place through their origins, which gave them their name, and through their physical properties. The stone was found in various places in Scotland but named after a single mountain, Cairn Gorm, and associated with the wider mountain range, a massif dominated by warm-hued granite. Raw stones were cut and faceted to create sparkle and bring out their earthy colours, which mirrored the ochres and red-browns of the Cairngorm mountains as they existed in the popular imagination. During the eighteenth and early nineteenth centuries, developing geological knowledge and an appreciation for scenery tied in with Romantic ideologies utterly transformed the ways in which northern Scotland was perceived. As explored by Anne MacLeod, visual depictions were central to both shaping and reflecting these new ways of seeing the landscape.[23] Extending this argument to objects, the visual link between pebbles and the mountains in which they originated is clear in landscape paintings of the early nineteenth century. For example, Sir Edwin Landseer's painting of *Loch Avon and the Cairngorm Mountains* depicts a rocky landscape in muted browns and yellows, the light reflected off the granite face of the mountain and surface of the loch, with glacial hollows – or corries – in deep shadow (see Plate 4.4). The link between the colours assigned to landscapes and pebbles was also made in popular literature, such as in Walter Scott's novel, *Old Mortality*, which describes: 'The stream, in colour a clear and sparkling brown, like the hue of the Cairngorm pebbles, rushes through this romantic region in bold sweeps and curves.'[24] On every level, cairngorm pebbles were understood as fragments of the mountains in which they were sourced. They miniaturized a vast, 'wild' landscape and – whether made into a seal, a brooch or a necklace – transformed the wearer's body into a site of meanings linked to place, functioning as markers of status with embedded associations of ancestry that reached into a distant past.[25] This symbolic potency, and the imbalance of demand and supply, led the stones to command a high price on the market. 'Such', decried MacCulloch, 'is one of the varieties of vanity.'[26]

Like cairngorms, agates could be acquired directly, picked up on the hill or coast by those who knew what they were looking for, or purchased commercially. Pebble jewellery owned by poet Robert Burns – a cravat pin and set of six buttons – offer a way in to exploring both methods of acquisition. The cravat pin

(Figure 4.1) carries an inscription on the back charting the life cycle of the object: 'The Bard found this Stone on Braimar [*sic*] in 1786, Presented TO Mrs Wm Smith by the Widow of the POET BURNS, 1825'. While the mention of Braemar here is surprising, what with it being a fairly unlikely place to find an agate, the fact that the journey and the 'found' nature of the stone was recorded and later memorialized is significant. After being picked up by Burns during his travels, the stone was polished into a convex or 'cabachon' shape to reveal a translucent misty blue with a puff of white, and placed in a textured setting of gold shells, leaves and thistles, which caught the light and framed the pebble with a discreet sparkle. These simple shapes containing suggestions of pictorial landscapes are directly linked to other aspects of the material culture of travel and tourism used in Scotland and elsewhere, such as the 'Gray's Glass' and 'Claude Lorrain'.[27] These portable mirror-devices were held up against landscapes, reflecting the scenery in miniature giving it a painterly filter, transforming views of Scotland into tiny paintings in the hand. After Burns's death, the object passed through

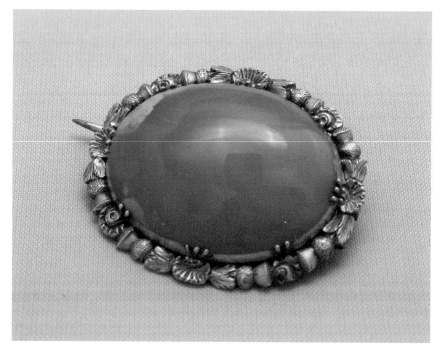

Figure 4.1 Cabochon agate pebble found by Robert Burns in Braemar and set in gold as a cravat pin, *c.* 1787. Gold and agate, 26 × 31mm. DUMFM:1936.2.21 © Dumfries Museum (Dumfries and Galloway Council).

individuals and shifted from being a personal souvenir of the landscape to a relic of an individual. While it is a fairly typical example of a pebble pin or brooch of this date, it has survived with its story about being collected from the wild because of its provenance, its association with the bard.

Similarly, Burns's set of six agate buttons have survived in public collections because they belonged to him, rather than because they are particularly exceptional objects in their own right.[28] Indeed, one cannot be certain they are even of Scottish stones. But in this case, their survival is useful in evidencing how agates were actually put to use in masculine objects and worn by men in Scotland. The spherical polished stones with their variegated, earthy colours and white bands would have stood out against the fabric of a buff- or dark-coloured waistcoat. Additionally, these objects give us a visual on aspects of production detailed in early travel writings. In an early traveller's account of the Hebrides, the Reverend Dr John Walker – Professor of Natural History at the University of Edinburgh from 1779 to 1803 – tells us that demand for agates as worn objects stimulated trades that connected island communities with urban producers:

> The shores of Rum abound with … Agates or Pebbles. These Stones are to be found thrown up by the Sea, in the small bays … Here these Stones might be collected and exported with great Advantage to Places, where they are manufactured.[29]

This is especially interesting as Rum tends to be associated with agates fairly pale in colour, exhibiting subtle warm greys, rather than the brighter examples found in Ayrshire, Perthshire and Angus. Walker went on to write more broadly about the lapidary craft and its recent flourishing in the capital. He described how production began with a specialist stone worker or lapidary in Edinburgh where a body of skilled workers had emerged, with only one lapidary operating around 1780 to, little over two decades later: 'above 30 Workmen closely employed, in cutting Agates, or as they are commonly called Pebbles, for the Birmingham Market'.[30] One man, Walker wrote, could make thirty-six dozen pairs of sleeve buttons each week 'which sell at Birmingham for 15 Pence the Dozen'.[31] Such numbers represented a significant enterprise by the late eighteenth century.

These stones linked rural suppliers in the islands and the countryside of the west and east of the Scottish mainland with urban lapidaries in Edinburgh and distributors in Birmingham, London and further afield. More detail comes from the writings of local church ministers who penned *The Statistical Account*

of Scotland in the 1790s – the first systematic attempt to record knowledge of the country and its people at a national level and a rich historical source – which mentioned the presence and exploitation of pebbles in different parts of the country. In Campsie, Stirling, 'Beautiful pebbles have been found among the rocks, of which a gentleman lately procured as many as, when polished, furnished a set of elegant buttons for a coat'.[32] And 'Pebbles and bloodstones' found on the outskirts of Edinburgh, 'have been cut into very beautiful seals'.[33] Other reports outlined specific locations where different materials were sourced, highlighting that local knowledge was required to find the otherwise elusive spots which turned up the best materials. In Galston near Kilmarnock in Ayrshire, 'the Burn Anne throws up at times some good pebbles, which are supposed to come from the sides of the Mol-mount-hill, where it is said they abound'.[34] Burn Anne would come to be one of the most well-known sites of commercial exploitation of agates for jewellery, its highly colourful stones both revered and easily recognized by an eye attuned to such things. And Kinnoull Hill in Perthshire was already well known by this date, described as having 'been long famous for the number of pebbles found in it consisting of fine agates, onyx, and a few carnelians'.[35]

Written evidence of the craze for pebble collecting permeates contemporary periodicals too. A 1796 report in *The Scots Magazine* documented that while the Scottish landscape contained only small amounts of gold and silver, it boasted a range of gemstones and minerals including amethysts, garnets and 'The *Cornelians,* or Scotch pebbles, are well known, and are no where [*sic*] equalled either in variety or beauty', while '*Jaspers* are to be met almost every where. The spotted jasper, found on Arthur's Seat, is singular and beautiful. It used to be wrought into buttons, which were sold at a high price'.[36] Chalcedony or white cornelian found in Fife was 'equal in colour and hardness to that brought from the East Indies', and granite 'of a very singular appearance' was found nowhere else but near Portsoy and, 'When polished, the figures very much resemble the Hebrew characters'.[37] This short report captures the paradoxical nature of agates' value. While they were not precious, or even particularly rare like cairngorms, different colours and patterns were tied in with particular places, and were deemed to be more beautiful and singular than the same matter found outside the country. As such, they carried a high monetary value when fashioned into small luxuries. The mention of the East Indies implies that Scottish stones were a suitable – even preferable – alternative to imported minerals, which is suggestive of the difficulties of importing luxury materials and goods at a point when the

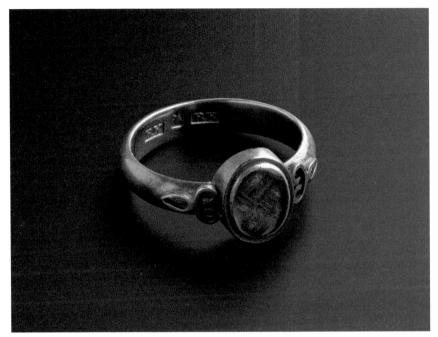

Plate 1.1 Gold and hair ring, Robert Keay of Perth, *c.* 1800–30. Gold, hair and crystal, 19 mm diameter. NMS, H.NJ 167 © National Museums Scotland.

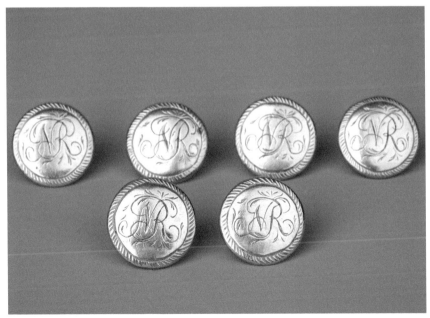

Plate 1.2 Set of six silver buttons engraved 'NR', probably Joseph Pearson of Dumfries, *c.* 1794–1815. Silver, 11 mm diameter. PMAG, 1982.144.1-6 © Courtesy of Perth Museum and Art Gallery, Perth and Kinross Council.

Plate 1.3 Brooch engraved with leaf scrollwork, M. Rettie & Sons of Aberdeen, *c.* 1860–90. Gold and citrine/cairngorm, 38 × 50 mm. AAGM, ABDAG011441 © Aberdeen Archives, Galleries & Museums (Aberdeen City Council).

Plate 2.1 Small heart-shaped brooch of silver (without a crown), with 'LOVE' inscribed on the back, said to have been used as a charm, from Rosehearty in Aberdeenshire, *c.* 1800. Silver, 21 × 17 mm. NMS, H.NGA 110 © National Museums Scotland.

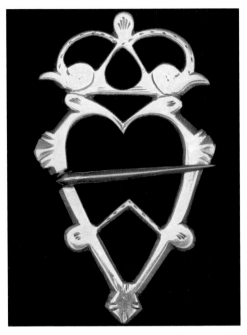

Plate 2.2 Gold heart brooch surmounted by openwork crown of birds' heads, Alexander Stewart of Inverness, *c.* 1796–1800. Gold, 49 × 30 mm. NMS, H.1991.2 © National Museums Scotland.

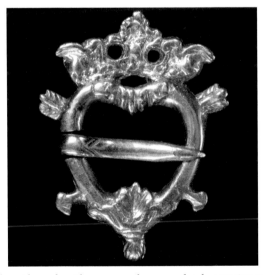

Plate 2.3 Gold heart brooch with crown and arrows clearly entering at the top shoulder and emerging at the opposite side on the bottom, possibly seventeenth century. Gold, 27 × 21 mm. V&A, M.45-1975 © Victoria and Albert Museum, London.

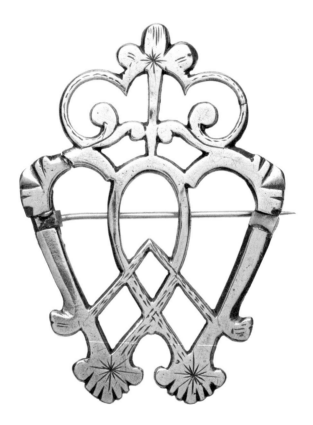

Plate 2.4 Silver double heart brooch by Alexander Stewart of Inverness, *c.* 1800. Silver, 74 × 60 mm. NMS, H.NGA 257 © National Museums Scotland.

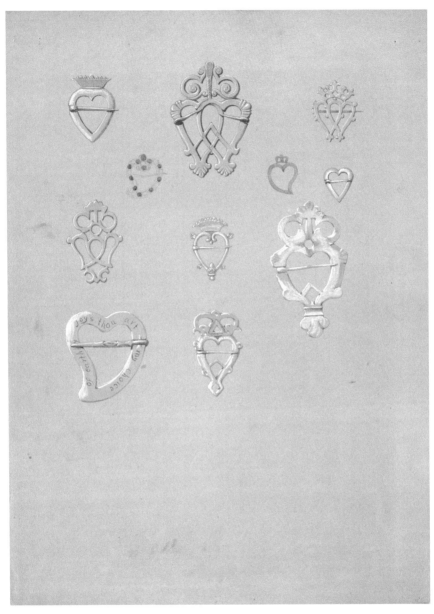

Plate 2.5 Illustrations of heart brooches, in Joseph Anderson and James Drummond, *Ancient Scottish Weapons: A Series of Drawings by the Late James Drummond; With Introduction and Descriptive Notes by Joseph Anderson* (Edinburgh: G. Waterston & Sons, 1881), plate XLV. Pencil with watercolour on wove, buff-coloured card © National Museums Scotland.

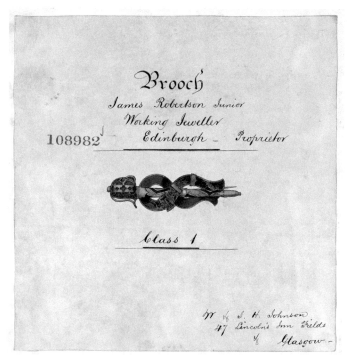

Plate 2.6 Brooch design, James Robertson of Edinburgh, 1857. TNA, BT43/9/108982 © The National Archives, Kew.

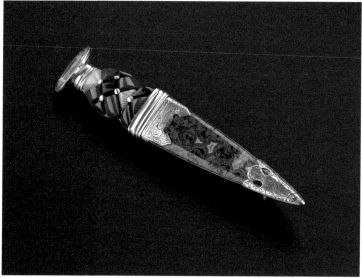

Plate 2.7 Dirk brooch of silver and native stones, including sheath of Burn Anne agate, by James Robertson of Edinburgh, 1858. Silver, agate, jasper, bloodstone and citrine. 97 mm × 19 mm. NMS, H.NGB 80 © National Museums Scotland.

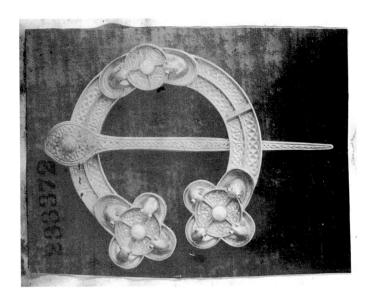

Plate 2.8 Brooch design, Robert Naughten of Inverness, 1869. TNA, BT43/25/233372 © The National Archives, Kew.

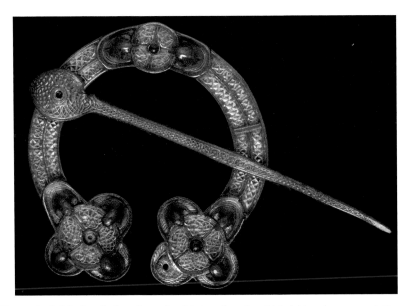

Plate 2.9 Gold-plated silver brooch with interlaced and birds' head ornamentation, from Rogart, Sutherland, eighth century. Gold and silver, 120 mm diameter, pin 193 mm length. NMS, X.FC 2 © National Museums Scotland.

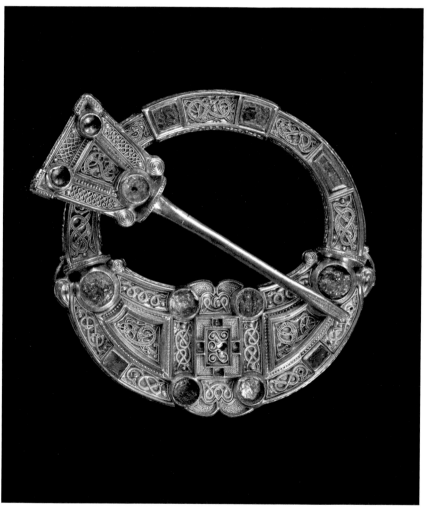

Plate 2.10 Hunterston brooch, *c.* 700 AD. Gold, silver and amber, 122 mm diameter. NMS, X.FC 8 © National Museums Scotland.

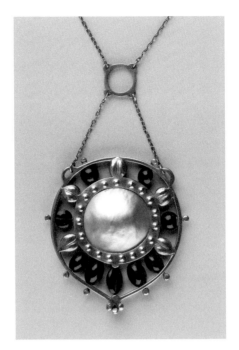

Plate 2.11 Pendant, designed by Ann Macbeth and made by Peter Wylie Davidson, 1905. Silver, amethyst and mother-of-pearl, 60 mm diameter, 320 mm length. AAGM, 0011358 © Aberdeen Archives, Galleries & Museums (Aberdeen City Council).

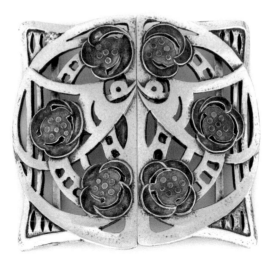

Plate 2.12 Waist buckle by Jessie M. King for Liberty & Co. in London, made by W. H. Haseler in Birmingham, *c.* 1900–08. Silver and enamel, 60 × 60 mm (approx.). GM, E1982.137.2 © CSG CIC Glasgow Museums and Libraries Collections.

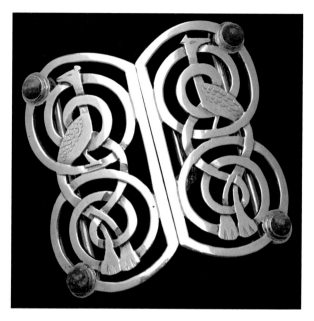

Plate 2.13 Waist buckle, J. M. Talbot of Edinburgh, *c.* 1902–03. Silver and lapis lazuli, 65 × 65 mm. NMS, K.2006.435.2 © National Museums Scotland.

Plate 3.1 St Andrew's Cross and thistle medallion of Leadhills silver worn by Sir William Arbuthnot, Lord Provost of Edinburgh, during the visit of King George IV to Edinburgh, 1822. Silver, 56 × 46 mm (frame 130 × 96 mm). EMG, HH1732/57 © City of Edinburgh Museums and Galleries; Museum of Edinburgh.

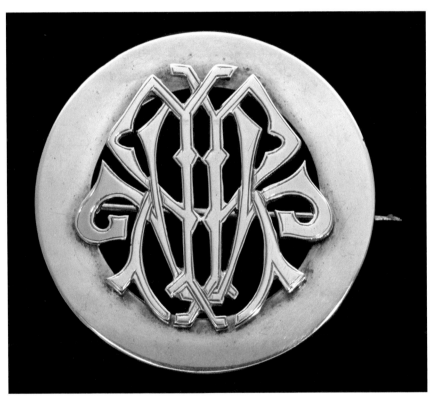

Plate 3.2 Circular silver pin badge or brooch bearing monogram of Queen Victoria, Edmund Millidge of Edinburgh, *c.* 1875. Silver, 65 mm diameter. NMS, SH.2009.5 © National Museums Scotland.

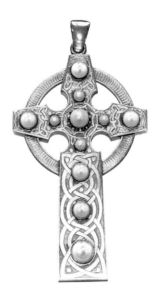

Plate 3.3 Celtic-style cross pendant with ring around the intersection, engraved with interlacing on the front, 1870. Gold and Scottish freshwater pearls, 100 × 70 × 7 mm. © Sutherland Dunrobin Trust.

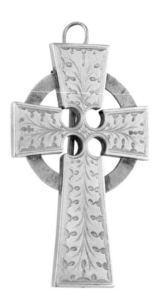

Plate 3.4 Celtic-style cross with engraved foliate decoration, D. C. Rait of Glasgow, *c.* 1869–70. Gold, 48 × 28 × 3 mm. Glasgow Museums, E.2017.3 © CSG CIC Glasgow Museums and Libraries Collections.

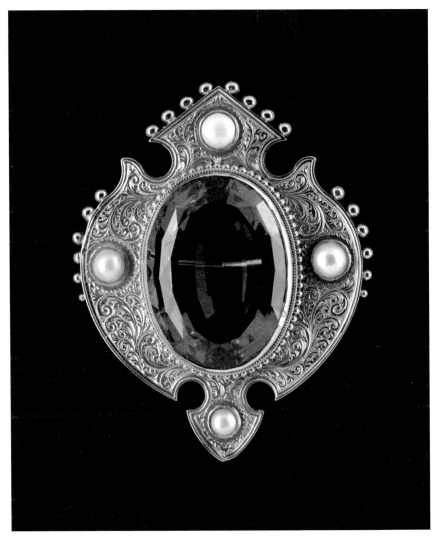

Plate 3.5 Brooch made from Sutherland gold, set with a central 'cairngorm' citrine and four Scottish freshwater pearls, by Muirhead & Sons of Glasgow, *c.* 1869. Gold, cairngorm, pearls, 57 × 46 mm. NMS, X.2018.17 © National Museums Scotland.

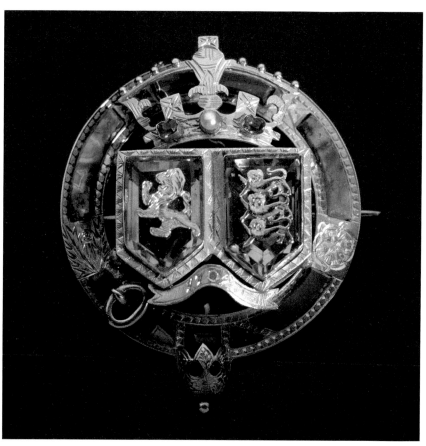

Plate 3.6 'The Union Brooch', Peter Westren of Edinburgh, 1893. Gold, agates, cairngorm, amethyst, garnets and freshwater pearl, 38 mm diameter. NMS, H. 1991.54.1 © National Museums Scotland.

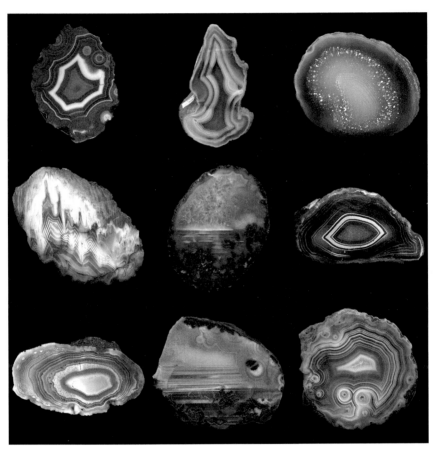

Plate 4.1 Agates from different areas of Scotland, showing the range of patterns and colours created as layers of silica cooled within volcanic rock to form quartz © National Museums Scotland.

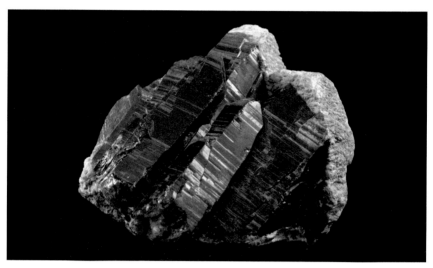

Plate 4.2 Raw cairngorm crystal, a form of quartz (variety: smoky) from Beinn A'Bhuird, in the Cairngorms, north west of Braemar, Aberdeenshire. Matthew Forster Heddle collection, NMS, G.1894.212.293 © National Museums Scotland.

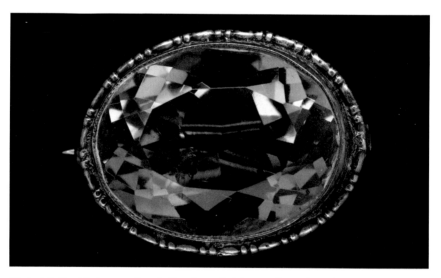

Plate 4.3 Oval 'cairngorm' and silver brooch. The pendants described by Elizabeth Grant of Rothiemurchus would have comprised a series of these small, faceted stones in the shape of a cross. Silver and cairngorm, 22 × 16 mm NMS, H.NGB 209 © National Museums Scotland.

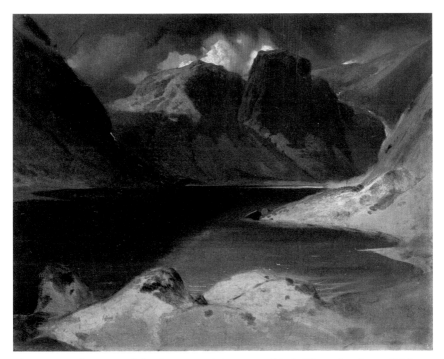

Plate 4.4 *Loch Avon and the Cairngorm Mountains*, Edwin Henry Landseer, 1833. Tate, N05777 © Tate.

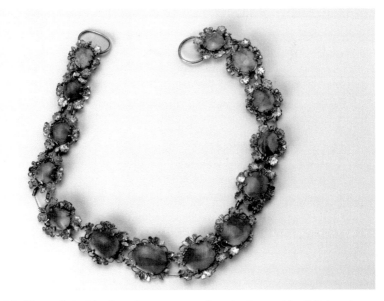

Plate 4.5 Necklace of pinchbeck and agates, part of a suite donated by Edinburgh lapidary and seal engraver David Deuchar to the Society of Antiquaries of Scotland in 1782. NMS, H.NG 93 © National Museums Scotland.

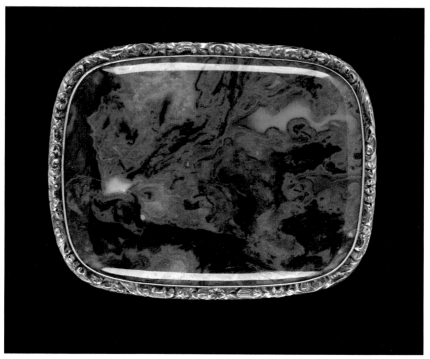

Plate 4.6 Oblong moss agate brooch with rounded corners in a narrow floral frame (with an oblong of woven brown hair inset in the back under glass). Gold and agate, 69 × 53 mm. NMS, H.NGB 109 © National Museums Scotland.

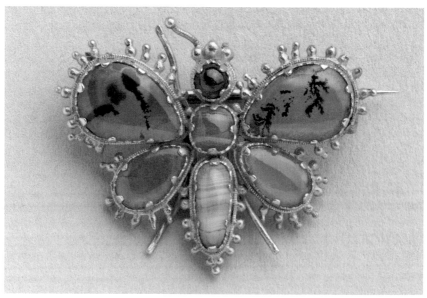

Plate 4.7 Butterfly brooch, mid- to late nineteenth century. AAGM, ABDMS000565. Gold and agates, 22 × 18 mm © Aberdeen Archives, Galleries & Museums (Aberdeen City Council).

Plate 4.8 Plaid brooch presented to Queen Victoria by Prince Albert containing a cairngorm found by the Queen at Lochnagar in 1848. Gold, cairngorm, enamel, seed pearls, garnets. Royal Collection Trust, RCIN 4806 © Royal Collection Trust / © His Majesty King Charles III 2023.

Plate 4.9 Circular brooch with central conical pink granite set in silver, surrounded by Greek key pattern in blue enamel, by M. Rettie & Sons of Aberdeen, *c.* 1886. Silver, granite and enamel, 49 mm diameter. NMS, K.2006.174 © National Museums Scotland.

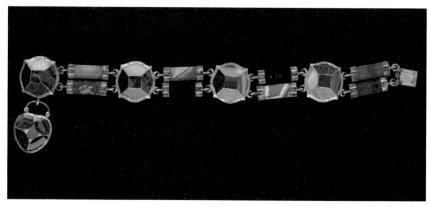

Plate 4.10 Example of a pebble bracelet of gold, set with agates and other native stones, the pendant heart with a window for a hair ornament on the reverse, *c.* 1858. Gold, agates and jasper, 200 mm length. NMS, H.NI 19 © National Museums Scotland.

Plate 4.11 Annular brooch of silver mimicking Hunterston brooch and set with native stones, *c.* 1860s. Silver, citrines or 'cairngorms', agate, bloodstone and jasper, 71 mm diameter. NMS, H.NGB 53 © National Museums Scotland.

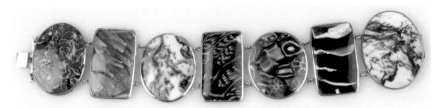

Plate 4.12 Bracelet of imitation pebbles, *c.* late nineteenth century. Glass, gilt metal and enamel. Glasgow Museums, E.1976.1.378 © CSG CIC Glasgow Museums and Libraries Collections.

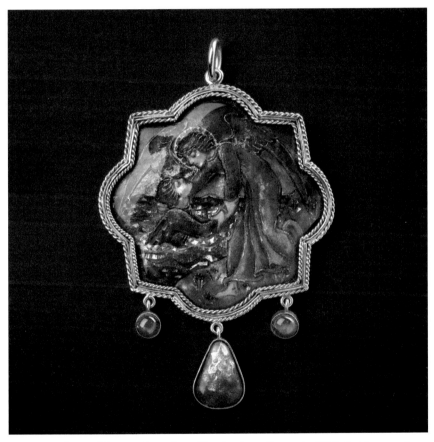

Plate 4.13 'Out of the Deep' pendant, Phoebe Anna Traquair, 1908. Gold, enamel and foil, 65 × 47 mm. NMS, A.1996.16 © National Museums Scotland.

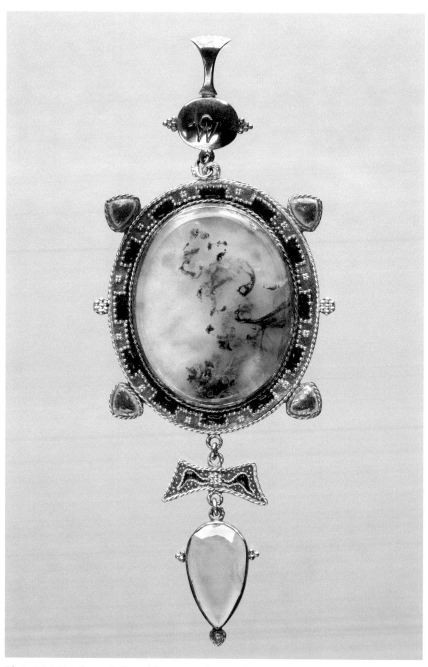

Plate 4.14 Pendant of gilt, gold, agate and enamel, James Cromar Watt, *c.* 1900–10. AAGM, ABDAG011139. Gold, agate and enamel, 74 × 30 × 5 mm © Aberdeen Archives, Galleries & Museums (Aberdeen City Council).

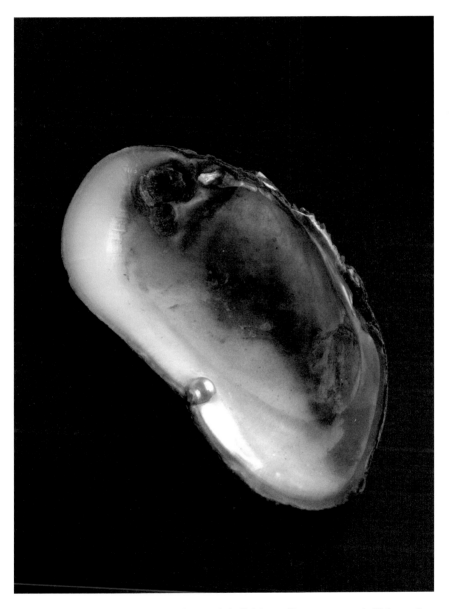

Plate 5.1 Scottish freshwater pearl mussel shell (cleaned) containing a half-formed pinkish Scottish freshwater pearl. NMS, H.QJ 58.1 © National Museums Scotland.

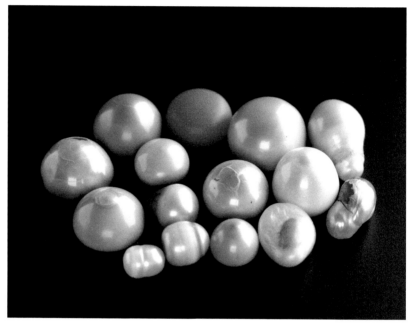

Plate 5.2 Scottish freshwater pearls of different shapes, sizes and colours. NMS, H.QJ 59 © National Museums Scotland.

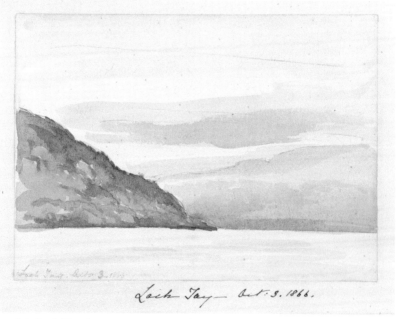

Plate 5.3 *Loch Tay*, Queen Victoria, October 1866. Pencil, watercolour with ink inscription, 127 × 179 mm. Royal Collection Trust, RCIN 980038.bh © Royal Collection Trust / © His Majesty King Charles III 2023.

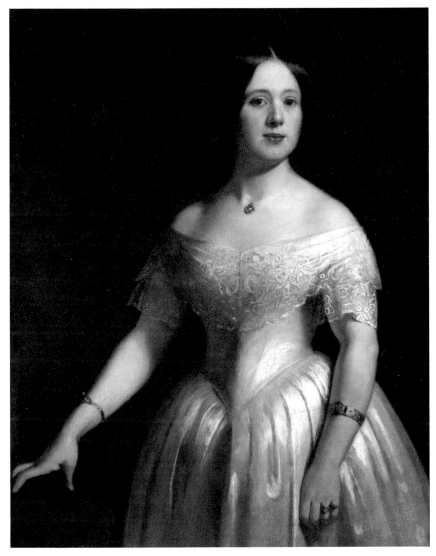

Plate 5.4 *Mary Barclay, nee Rose, the Artist's Wife,* John MacLaren Barclay, 1865. Oil on canvas, 1015 × 796 mm. PMAG, 1992.752 © Courtesy of Perth Museum and Art Gallery, Perth and Kinross Council.

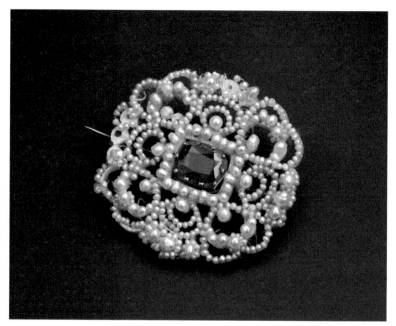

Plate 5.5 Seed pearl and 'Elie Ruby' brooch, *c.* mid-nineteenth century. Scottish freshwater pearls, garnet, mother of pearl, gold wire, 35 mm diameter. NMS, H.1996.5 © National Museums Scotland.

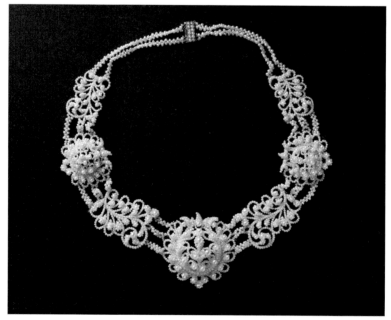

Plate 5.6 Seed pearl necklace belonging to Burella Elizabeth Hardy, *c.* 1850–60. Scottish freshwater pearls, mother of pearl, gold wire, 385 mm length. NMS, H.1992.382.1 © National Museums Scotland.

Plate 5.7 Brooch design, John Davidson of Wick, 1882. TNA, BT44/5/379662 © The National Archives, Kew.

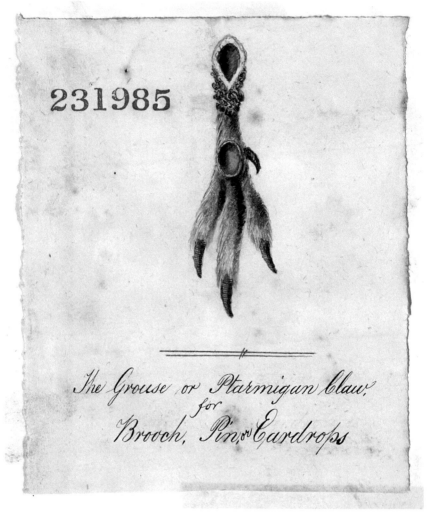

Plate 5.8 Design for 'The Grouse or Ptarmigan Claw for Brooch, Pin or Eardrops', Ferguson Brothers of Inverness, 1869. TNA, BT44/2/231985 © The National Archives, Kew.

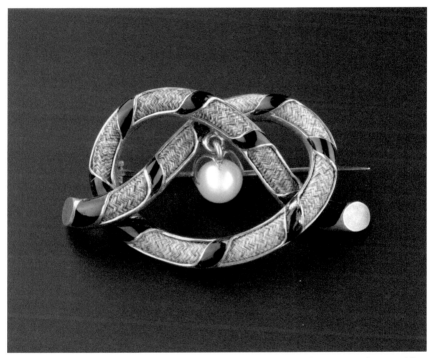

Plate 5.9 'Polharrow Pearl' brooch comprising a Scottish freshwater pearl in a gold open-work claw setting, suspended within a gold and black enamel ribbon-banded 'lover's knot' inset with plaited hair, late nineteenth century. Gold, hair, enamel and pearl, 50 × 30 mm. NMS, K.2001.526 © National Museums Scotland.

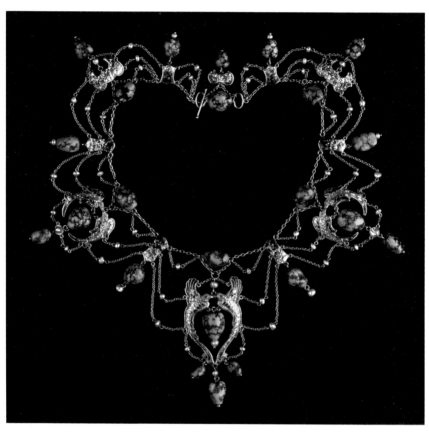

Plate 5.10 Necklace, James Cromar Watt, *c.* 1905–9. Gold, enamel, turquoise and pearls, 410 mm length (main drop 95 mm). AAGM, ABDAG008910 © Aberdeen Archives, Galleries & Museums (Aberdeen City Council).

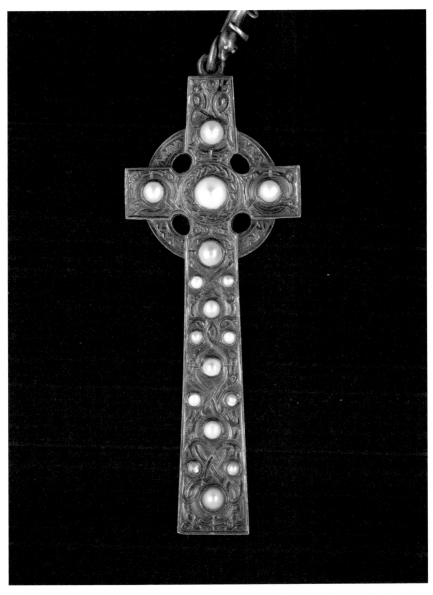

Plate 5.11 Silver pectoral cross by William Robb of Ballater, based on a wheel-headed Celtic cross, engraved with interlace and entwined with gripping beast motifs and set with Tay pearls, *c.* 1905. Silver, Scottish freshwater pearls, 105 × 34 mm. NMS, K.2005.353 © National Museums Scotland.

Plate 5.12 'Edna May' necklace, David MacGregor of Perth, *c.* 1899–1905. Scottish freshwater pearls, peridot, gold and silver, 400 mm length, pendant 12 × 14 mm, drops 39 & 26 mm length. PMAG, 2005.186 © Courtesy of Perth Museum and Art Gallery, Perth and Kinross Council.

French Revolutionary Wars disrupted established supply routes from Asia.[38] It is worth noting that, again, we see subtle but definite imperially tinged rhetoric in relation to these materials, with Scottish examples compared against their foreign equivalents.

Cultural and economic interest collided, generating an area of skilled work that grew throughout the early nineteenth century. Between 1799 and 1829, the number of lapidary firms in Edinburgh rose from three to thirteen, growing at nearly double the rate of the capital's prosperous jewellery industry as a whole over the same period.[39] Lapidaries were specialist workers, often employed within larger firms where they worked alongside jewellers, silversmiths and dealers of minerals, antiques and spirits. While the lapidary craft was fairly new, it is important to consider aspects of dynamism where skills were concerned. Eighteenth-century Edinburgh was home to a body of highly respected producers of watches – a trade that required skills in cutting, slicing and polishing lenses. The increasing specialization and division of labour that came to characterize watchmaking saw a move away from the industry in Edinburgh, where the size of the labour force could not sustain such an enterprise, towards the retail, servicing and repair of timepieces within jewellery firms.[40] It does not require a huge leap of the imagination to question whether the shift away from cutting and polishing crystal for timepieces was linked to rising numbers of lapidaries undertaking the same work to make pebble jewellery.

Indeed, nineteenth-century lapidaries in Scotland often advertised as opticians. There was a high level of crossover, both in terms of skills and tools, in making and polishing convex and concave shapes from hard materials, and framing them in metals for either jewellery or as lenses in spectacles. And the close work involved in making miniature luxuries ensured that lapidaries and jewellers, and engravers in particular, had a detailed understanding of eye conditions, and of measures to help them preserve and enhance their own sight.[41] It is tricky to know exactly how the lapidaries equipment worked, but an image of an opticians' workshop in Diderot's *Encyclopédie* provides a glimpse at tools and techniques involving lathes which turned abrasive discs – or mills – for cutting and polishing stone.[42] In Scotland, as across much of Europe, a hand cranked machine was most probably used: one hand turned a disc charged with abrasive material, and the other held the stone against the mill. The lapidary used the weight of his upper body to push the stone against the mill to cut, grind and polish. Despite the small size of the object being worked, the whole body was

in action and a sharpness of mind was required to work the hard stone without shattering it, or losing fingertips.

An 1819 guide for collectors with accompanying image (Figure 4.2) described 'newly invented' equipment for amateur lapidaries, and provides a closer look at the different mills used:

> It is not very generally known how a piece of Agate or Crystal can be cut into slices, being so much harder than steel; for this purpose the Slitting mill is made of a thin plate of soft iron, the edge of which is armed or charged with Diamond.[43]

Around eight other mills were then used with different edges and abrasive surfaces for cutting, grinding, filing and polishing, and plenty of water was splashed about to keep dust and temperatures down. This new equipment for

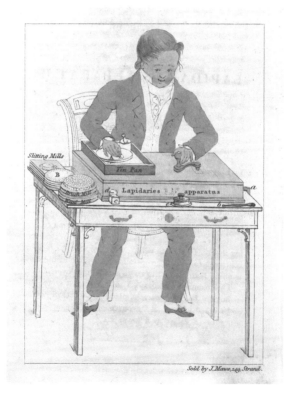

Figure 4.2 Amateur lapidary apparatus in use in a domestic setting, in John Mawe, *Familiar Lessons on Mineralogy and Geology*, 1819.

use at home had been developed as a result of the contemporary preoccupation with collecting:

> The agreeable amusement of collecting Pebbles, Jaspers, Agates, &c. has of late become so fashionable that almost every one who visits the coast has been employed in searching for these pretty productions and forming collections of them; but great disappointment has frequently taken place, owing to the want of a convenient method of cutting and polishing these beautiful substances.[44]

In the accompanying image, a well-to-do man works in a suit – protected by an apron – and dainty shoes at his wooden table and chair, polishing specimens for his curiosity cabinet. We are told this was tough, dirty and physically demanding work, and the man's pink cheeks provide a visual sign of the exertion involved. Although aimed at amateurs and outlining domestic rather than industrial equipment, the guide reinforces the notion that lapidary work was distinct from metalworking, with the divide perhaps most apparent in the elements used in manipulating materials: fire for metals, water for stones.

The collecting of mineralogical specimens was highly fashionable, as a way of building and displaying geological knowledge. Collecting is simultaneously a process of production tied in with memory – a way of holding on to and assembling bits of the past – and a consuming practice which involves acquiring, keeping and passing on objects.[45] Jewellers were also collectors of pebbles and pebble objects, an activity that cut across personal and professional interests, linking their knowledge of the land – and the layers of historical association embedded within it – and the hand skill they applied in the workshop. In 1782, the Edinburgh lapidary and engraver David Deuchar donated a suite of antique pebble jewellery – a necklace, earrings and buckles containing agates in decorative pinchbeck settings (see Plate 4.5) – to the Society of Antiquaries of Scotland, of which he was a member.[46] There are many questions surrounding the set, which is thought to date from the seventeenth century, and the origins of the agate, which are possibly from Germany. That these pieces were in Deuchar's possession, and that as an antiquarian he deemed them worthy of the national collections, indicates that pebble jewellery was of historical value as well as commercial interest at this date. It also raises questions about how older objects influenced the making and design of Scottish pebble jewellery, as knowledge about the sources of native minerals developed in line with the growing interest in geology.

Further evidence reinforces the links between personal and museum collections, and between scientific knowledge and commercial markets. In 1811, Professor Robert Jameson gave an account of the physical properties of cairngorms, which at the time were thought to be topaz rather than quartz, writing that the 'Topaz of Cairngorm … is rock-crystal of various colours, as yellowish-white, clove-brown, wine-yellow, and orange-yellow'.[47] Jameson indicated that the specimens used to arrive at these (flawed) scientific understandings made their way through the hands of producers:

> its true nature was not understood until lately, when its characters were fully exhibited in a fine series of topaz crystals of remarkable size, brought from the upper part of Aberdeenshire to Edinburgh, and now in the possession of Mr White, lapidary.[48]

A cast taken from White's 'topaz crystal' is held in the collections of the Natural History Museum in London.[49] That cast – taken so that a copy of the original stone could reside in the museum collection but White could cut it up to make jewellery (and release its monetary value) – represents the intersections between collecting cultures, geological knowledge, commerce and craft production. Indeed, the hard-won knowledge of the lapidary workshop was key to the development of scientific practice and knowledge. George Sanderson, a lapidary who operated for many years in Edinburgh, worked closely on developing technology around 'thin sections' that are now fundamental to the science of geology, whereby specimen stones are cut finely to around 1mm thickness and glued to glass for viewing through a microscope. Sanderson worked with a geologist named Henry Witham during the 1820s to develop these methods, which were first employed in Edinburgh. Witham, however, rather played up his own role and failed to pay the craftsman due credit when he later published on the breakthrough.[50]

The relationship between the layered meanings of geological specimens and personal jewellery can be explored through a fictional exchange in Susan Ferrier's 1818 novel, *Marriage*.[51] The story tells of an elderly female member of the Highland elite, Lady Grizzy Douglas of Glenfern, who wears a pebble brooch borrowed from her sister when she visits a new acquaintance, the manipulative Mrs Fox – who turns out to be an avid collector of pebbles – at her home in Bath. Grizzy's brooch would have featured a single polished agate – a dark mottled stone – in a light frame setting (e.g. see Plate 4.6). Mrs Fox shows Grizzy her

collection as she talks about her great knowledge of pebbles. Grizzy begins to sense what is coming and feels her throat, where the brooch was fixed, tightening

> 'And, by-the-bye,' exclaimed Mrs. Fox, as if suddenly struck with the sight of the brooch, that seems a very fine stone of yours. I wonder I did not observe it sooner; but, indeed, pebbles are thrown away in dress. May I beg a nearer view of it?'[52]

Mrs Fox is impressed with the stone, which, she says, 'looks quite a different thing in the hand'. Here, the fictional Mrs Fox puts her finger on the idea that the earthy tones, subtle patterns and translucent bands of pebbles look better held up to the light – and passed around in the palm of the hand as a receptacle of knowledge – than backed by clothing fabrics which shut out the light. This is keenly observed, as any reader who had held a thinly sliced agate would have witnessed how the passage of light through such a sliver of stone transformed it entirely, making colours dance and showing up subtle details more vividly. But Grizzy's pebble is a treasured heirloom, a 'lucky stone' passed down from her Grandfather who found it at a key moment in the family's history. Carried on her elite feminine body, the subtle stone in its delicate setting was a discreet but powerful symbol of aristocratic ties to people and place reaching into the past. It was a little memorial of her grandfather, and a microcosm of the Scottish landscape. Under pressure, Grizzy reluctantly concedes that 'a pebble brooch is quite lost as a brooch' and gifts it to Mrs Fox, then leaves feeling physically sick at having given away such a meaningful and emotional object.[53] In a swift transfer of ownership, the stone shifts from personal heirloom to a disembodied specimen for display as a marker of deep time, geological phenomena, and of Fox's knowledge, taste and connoisseurship.

Pebble collecting enabled elite women to engage in the typically masculine field of geology through the consumption of highly visual natural materials linked to feminine jewellery. A pebble collection was an assemblage – a material and visual expression of creativity and knowledge – which required time and skill to create. Inventories and wills show that women displayed pebble collections in private spaces alongside objects that were produced by other women, and represented personal bonds and kinship ties. For example, the Dowager Duchess of Buccleuch listed her pebble collection – a gift from a female relative – alongside other objects gifted, bequest or made by family members and friends, including a set of chairs with embroidery worked by her

daughters and a fire screen embroidered by her mother.[54] Shopping for pebble specimens, too, can be seen as a form of handwork in that sensory engagement with the stones – turning them over in the hand and considering their physical properties – was a process through which the consumer simultaneously applied and built a knowledge of mineralogy and the material world.[55] In the context of the Romantic Movement, which was paradoxically anti-consumerist and generated luxury consumption, collecting pebbles can be seen as neutralizing the negative side of consumerism. Indeed, the evocative power and singularity of each stone made pebbles and pebble jewellery highly sought-after at a point when the emotional and individualistic messages contained within coloured objects were a driving force for luxury consumption.[56] In this way, the collecting of pebbles and the commissioning and wearing of pebble jewellery can be seen as an intellectual pursuit, and as fusing aspects of production and consumption.[57] Seen on a spectrum of production, polished pebble specimens existed somewhere between raw matter and finished objects.

Collaboration in the crafting of pictorial forms

Designing and making pebble jewellery required an understanding of the interlinked physical and symbolic properties of individual stones. Writing in the 1850s, the stonemason turned popular literary geologist Hugh Miller described how: 'Every rock is a tablet of hieroglyphics with its ascertained alphabet; every rolled pebble a casket, with old pictorial records locked up within.'[58] Miller's haptic and visual understandings of stones, obtained through his work as a stonemason, informed the way he expressed the mysterious and imaginative dimension of pebbles for a wide readership. That readership shared this passion for the fields of geology and natural history – areas of knowledge that were, in turn, bound up with ideas about religion and creation.[59] His words encapsulate how the singularity of each stone made it a container of an infinite number of pictures. Through a series of imaginative projections, the wearer or viewer might see hidden textual messages, religious motifs, a misty pool, a pretty cove, or rings in a tree that suggested the passing of time. Individuals assigned their own meanings to pebble jewellery objects, but lapidaries and jewellers shaped encounters with and perceptions of those objects through the way they worked and set materials.

Around the middle decades of the century there was a distinct move towards creating pictures with pebbles by setting small pieces together, rather than imagining pictures within a single polished stone. Designs shifted from simple forms in delicate frames into difficult shapes and elaborate mosaics in complex settings, where multiple pieces were placed to create relationships between colours and patterns. Executing this work – cutting the stones with precision, setting them neatly and creating pleasing colour arrangements – required the skill and labour of lapidaries and jewellers, and a high level of collaboration between the two. Such complex objects featured in contemporary novels, suggesting that they were mainstream enough to be understood by readers. For example, Mary Smith, the main protagonist of Elizabeth Gaskell's 1851 novel *Cranford* (which is set in the 1830s and 1840s) reports that during a trip into town:

> I counted seven brooches myself on Miss Pole's dress. Two were fixed negligently in her cap (one was a butterfly made of Scotch pebbles, which a vivid imagination might believe to be the real insect). [60]

Clearly, Gaskell's contemporary readers were familiar enough with these materials to be able to envisage the way that pebble patterns could mimic butterfly wings. A tiny butterfly brooch provides a useful example of how pebbles were selected and skilfully worked to mimic nature (see Plate 4.7). A garnet stands in for the head, and two pieces of pinkish-white banded agate make up the fleshy thorax and abdomen. The wings are of four small pieces of pale moss agate, the top two containing 'dendritic' tree patterns in darker colours, placed to suggest the mirroring of real butterfly wings. The delicate gold setting is surrounded by minute 'hairs' of gold granulation to complete the simulacra of a little creature. The play of light across the translucent stones and gold setting creates the impression of movement, and of life. This aspect of mimesis can be seen across a range of designs – from green speckled bloodstone moulded into creeping ivy bracelets to variegated jaspers carved into brooches mimicking the shiny iridescence of beetles and lizards – in keeping with the fashion for naturalist jewellery, and reflecting the developments in the scientific knowledge of botany and the animal world explored in the following chapter. There are other examples of butterflies like this, including one made for Cecelia Heddle (daughter of Scottish mineralogist Matthew Forster Heddle) which displays a thorax and abdomen of bloodstone from Rum and agate from Burn Anne respectively, with wings of agate possibly from Perthshire, Angus or Fife.[61]

Ultimately, pebbles were made to fit with all forms of jewellery design, in line with the endless desire for novelty of mid-ninteenth-century consumers. Abstracted geometric designs employed different types of pebbles to create complex colour relationships, producing a kaleidoscopic effect. Designs containing multiple types of stone were visually interesting, and can be understood as alluding to a patchwork of places. Contemporaries had ample information on the origins of different types of stones. As well as knowledge gained through interaction with producers, particularly shopkeepers, who were often skilled at offering layers of information which shaped consumers' perceptions, written material such as Bremner's report linked materials with specific locations:

> Aberdeenshire furnishes agates, beryls, and the famous Cairngorm crystal … Ayrshire furnishes agates and jaspers; Perthshire, bloodstone and a variety of others; Forfarshire, jaspers; and Mid-Lothian, the Pentland pebble and the Arthur Seat jasper.[62]

Regardless of design or form, jewellery containing a combination of these stones can be seen as miniature mosaics of physical landscapes, or portable curiosity cabinets worn on the body. Indeed, Diana Scarisbrick has used the term 'mute travel diaries' to describe Queen Victoria's pebble jewellery.[63]

It is possible to see how pebble jewellery mirrored the topography and geography of parts of Scotland through a brooch presented to Queen Victoria by Prince Albert in 1848 (see Plate 4.8). The high-quality piece contains a raised, faceted cairngorm 'found' by the Queen on the mountain of Lochnagar, near her home at Balmoral Castle (there was speculation, given sourcing challenges, that it had been planted on the mountain's slopes to ensure her success), surrounded by intricately tangled blue and white foliage detail executed in enamel, with Scottish freshwater pearls and pink garnets suggesting flower heads.[64] The design suggests the rocky plateau of the Cairngorm mountains, which give the impression of one single elevated plane, running down into glacier-hewn glens, streams and rivers teeming with wildlife. In this way, the design gave meaning to the earthy-coloured stone which, on its own, did not necessarily speak of its origins. Cairngorms often featured at the centre of agate jewellery. By the middle decades of the century continued scarcity combined with high demand meant that other materials often stood in for the genuine thing. Smoky quartz and citrine imported from South America was sometimes used, as was glass and paste, often enhanced with orange-tinted metallic foils underneath. Like in the

Queen's brooch, enamels as well as agates were commonly used to create colour around cairngorms.

The complex mosaic pebble designs of the second half of the century were valued not solely for the natural stones, but as material manifestations of the skill, ingenuity and creative endeavour of urban craftsmen. These objects required a higher level of labour and dexterity than the simpler cabochon forms seen earlier in this chapter, and thus provided an opportunity for makers to demonstrate skill and innovation. An exhibition report illustrating designs by M. Rettie & Sons in Aberdeen and Muirhead in Glasgow praised the 'solid, yet pretty objects, made from the minerals of the country; the designs and workmanship are generally very good'.[65] Muirhead's circular brooches were said to 'present very ingenious arrangements of Scotch pebbles and other ornamental stones found in Scotland; the bracelet is remarkably effective.' The report hints at the sophisticated knowledge of stones and expert command of tools required to wrap steel-hard granite and agates around curves and gently rounded shapes. Working granite was a specialism among lapidaries in Aberdeen, with jewellery miniaturizing the urban landscapes of the pink and grey 'Granite City' (see Plate 4.9). Just as with the grain lines in fabric or wood, lapidaries had to work with the properties of these stones to avoid them shattering, and to release their colours and patterns to greatest visual effect. Poor workmanship showed up clearly, creating dark gaps that instantly drew the eye where stones and settings did not meet. In this sense, the physicality of individual pebbles shaped the designs created from them, and the quality of work was important to the image and reputation of producers at a point when skilled handwork was perceived as being of particular value, against the backdrop of concerns around the perceived domination of industrial production.

The processes and equipment for working pebbles were much the same at this point as in the eighteenth century (major breakthroughs in electric tools did not come until well into the twentieth century) but the objects themselves are testament to how tools and skills had been developed and refined. Bremner's 1860s' report on the jewellery industry mentions the 'great nicety of manipulation' required to place up to 160 pebble pieces in a single bracelet (see Plate 4.10).[66] Bremner described the making of a pebble brooch in detail, which we can consider against a surviving example – inspired heavily by the Hunterston brooch discussed in the previous chapter – containing small individual pieces of agate, bloodstone and jasper along with cut cairngorms, set in silver (see Plate 4.11). First, the jeweller made the metal back or foundation with spaces or

'apertures' for the pebbles. After these settings were made, the lapidary 'cuts and fixes the pebbles … The stones are first cut with a revolving disc of iron, charged with diamond dust and oil, and roughly shaped with a pair of pincers.'[67] Each small piece of stone was then attached to a wooden stick with a blob of cement on one end, ground to the required shape against the revolving disc or mill, then set in with shellac. At this point 'the lapidary takes the brooch in his hand, and manipulates it on the grinding disc until the stone is reduced to the level of the metal which surrounds it'.[68] It is possible to see in the surviving brooch how the edges of the stone were cut at an angle, tapering up from the setting towards the flat surface, with each edge and corner meeting with razor-sharp precision. Next, the surface of the stones was 'polished on a disc of tin, charged with rotten-stone and water, and the brooch is returned to the jeweller' for finishing.[69] The jeweller would have then set the cut crystals, soldered on findings and passed to a specialist engraver to apply decoration before cleaning and polishing the piece, which was then ready for retail.

Despite the level of skill required, the lapidary's weekly wage was 24 shillings, roughly in the middle of the jewellers' pay scale, which ranged from 18 to 32 shillings a week.[70] These are remarkably low rates of pay for a skilled trade that was structured around a seven-year apprenticeship. Scotland's producers stressed the quality of their work, identifying themselves against what they perceived as shoddy production carried out in industrial districts – often pointing the finger at copyists Birmingham – but rarely mentioned their reliance on outside suppliers and producers. A report on stone cutting in *The Scotsman* in 1884 mentioned that 'pebbles, cut by Edinburgh lapidaries, are used in the manufacture of Scottish jewellery' but that Oberstein in Bavaria, Germany was the undisputed centre of the agate industry.[71] The 'cheapness of labour and a plentiful supply of water' in mountainous Oberstein had allowed the industry to survive despite the rich and plentiful sources of agates being exploited in South America.[72]

Significantly, the report highlighted that 'the ingenuity of the agate-worker was not confined to cutting, carving and polishing his material into all manner of shapes', but extended to 'varying its colour by artificial means' and bringing out subtle patterns by treating with heat, dyes, olive oil, water and honey.[73] Natural changes in the stones, such as exposure to sunlight which 'give a reddish tint to grey-coloured agates', led producers to burn agates and saturate them in acid to create colour.[74] These practices are described in relation to Germany and India with no mention of them taking place in Scotland, though they must have

been employed. Information on dyeing agates in trade publications suggests that jewellers sought to legitimize this practice by submerging it in a much longer history: 'From the earliest ages this practice has been pursued … The moderns, of course, have improved the methods.'[75] But suppliers kept information on dyeing a closely guarded secret: 'Rock crystals … are sometimes apparently stained; but this is a deception from which we would guard our readers.'[76] Despite their hardness, then, these stones were highly mutable. Like the landscapes they represented, their colours and effects could be changed through man-made processes and interventions. *The Scotsman* report ends with folklore about human bodies being 'agatised' into a 'meat board for a banquet of vampires!' and a note that leading Scottish geologist and mineralogist Matthew Forster Heddle had 'found undoubted organic remains of considerable size in agates from Ayrshire and other localities.'[77] This preoccupation with the preservation of human flesh underlines ideas about the temporality and mutability of pebbles, and about their symbolic place somewhere between inert underworlds, the natural living world and the afterlife.

The alchemical processes used to enhance and change the colour of pebbles link them directly to glass production. Isobel Armstrong's study of Victorian glass explores Walter Benjamin's notion that a 'culture of glass' emerged during the middle decades of the century, arguing that increases in production, new techniques and falling prices transformed urban spaces.[78] In Armstrong's words, 'The gleam and lustre of glass surfaces, reflecting and refracting the world, created a new glass consciousness and a language of transparency.'[79] While mainly concerned with larger expanses of glass – namely windows, mirrors and, of course, the Crystal Palace – the study also considers the curved surfaces of lenses to explore ideas of light and images in telescopes, kaleidoscopes (one of the first 'optical crazes'), and dioramas.[80] Pebbles worked in a similar way to these image-creating devices, bending and refracting light to beam miniature worlds into the eye. The play of light within the crystal structure of agates created a sense of shifting layers of hues and effects within the stone that suggested movement, depth and fleeting miniatures of the landscape.[81] Due to cultural ideas around the 'immortality of light' as it was thrown around the universe, these linked 'glassworlds' triggered ideas of deep time and infinity in the nineteenth-century imagination.[82]

So, how did these shifts in making and meaning affect Scotland's lapidary craft? Despite the increasing value placed on the skill and workmanship required to create pebble jewellery, particularly from around the middle of the century,

this specialist craft had entered a period of tumult that was patchy and uneven for several decades and, in the end, terminal. From the 1840s, firm after firm in Edinburgh and elsewhere failed until there were only a handful of lapidaries operating at the beginning of the twentieth century.[83] By the mid-twentieth century, the last professional lapidary firm, Alexander Begbie, has shut up shop. Equipment, materials and tools from Begbie's workshop now held by National Museums Scotland reinforce the notion that the craft was always characterized by small-scale production.[84] Furthermore, that a significant chunk of the workshop was entered into the national collections in the 1950s – from the grinding mill to the tweezers, from the bench to wooden boxes of agates and cut diamonds – is testament to the way in which Begbie's closure was clearly understood to be the end of the road for what had been a thriving and specialist sector in Scotland. Indeed, the closing of that workshop's doors represented the loss of a specialist craft which had changed little from the nineteenth century.

There are several interlinked reasons for the decline in the lapidary craft. Firstly, despite early claims of plentiful supply, scarcity had been an issue with some stones – especially cairngorms – since the 1770s, and the demand for pebbles of all varieties meant that many sources were simply exhausted by the later nineteenth century. Indeed, the increasing difficulties of securing larger pebbles no doubt partly influenced the move towards small pieces set together in complex designs. Secondly, lapidaries' businesses were affected by the invention of the gummed envelope in the 1860s, which saw seals – a mainstay of their business – become a purely decorative object that gradually fell out of fashion.[85] Thirdly, the shift from Victorian fashions characterized by tight, structured bodices with flounces and ruffles towards the pared-down, looser gowns of the Edwardian era played a role in the decline of the lapidary. Pebble jewellery was heavy, making it impractical and aesthetically incongruent with these lighter styles of dress. A typical Victorian-era pebble brooch in a metal setting weighs on average 20 to 30 grams, and a bracelet up to 40 grams, while a plain or enamelled silver equivalent weighs roughly 10 grams. While pebble jewellery continued to be made and worn, it was at odds with the more delicate, ornate designs that characterized fashionable jewellery at the turn of the twentieth century.

A late nineteenth-century bracelet provides a way in to looking at the ways in which scarcity, imitation and shifting fashions brought about shifts in the lapidary trade (see Plate 4.12). From a distance, large agates of different varieties are linked together in a simple gold-coloured metal setting. It is, at a glance,

much like the one on the cover of this book. On closer inspection, it is made from marbled enamel on slivers of glass. This example of imitation of matter raises questions about the parallels between pebble and enamel jewellery. The former was made from coloured and patterned quartz, the latter created through painting surfaces with powdered glass, and firing in a kiln to create layers of colour and pattern. As we have seen, enamel was used to complement and sometimes stand in for pebbles, particularly in the later part of the century. This material crossover is yet more apparent in contemporary publications, such as an essay on Arts and Crafts' jewellery which stated that 'glitter and the vulgar display of affluence are gradually yielding before the higher considerations of beauty of form and colour'.[86] Instead, inexpensive stones were employed, sometimes alongside intrinsically valuable gems, to create interesting colour combinations and:

> since flash and transparence are become of minor esteem, jewels, instead of being cut in facets, are not infrequently polished in their natural shape, *en cabochon,* or 'tallow-cut', as it is called, their irregularities of formation imparting not a little to the boracic richness of the ornaments in which they occur.[87]

Neither cabochon cuts, nor the concept that natural flaws created a value beyond price were new when considered in the context of pebble jewellery. The essay went on to describe how, 'There has, moreover, taken place an extended revival of enamelling, an art which offers abundant opportunities for the exercise of the decorator's skill and fancy'.[88]

Parallels between pebble and enamel jewellery can be seen in the work of Phoebe Anna Traquair, one of Scotland's most significant woman artists. Traquair drew distinctions between her jewellery, which she termed 'little lyrics', and her large-scale 'epic' works like church murals and tapestries.[89] Through both mediums, Traquair created mythical worlds using colour and texture in the late nineteenth and early twentieth centuries. For example, a small gold heart-shaped pendant held by National Museums Scotland contains metallic foils and enamel in a picture of a cherub, wings folded, lying asleep on a bed of flowers. The layering of enamels and foils creates the illusion of depth through colour and pattern, light and shadow. The sense of perspective and depth is seen yet more clearly in another piece which shows an angel, wings outstretched, standing in a grassy flower meadow and leaning over the edge of the sea to kiss a half-submerged mortal, who reaches his face up to return the kiss (see Plate 4.13). The two figures are intertwined, arms clasped together but bodies pulled

apart, creating a circular space between them through which peaked ocean waves rendered in strips of blue foil stretch back into a yellow and blue sunset on the horizon.

Like pebbles, these enamels are characterized by colourful imagined worlds under smooth, glassy surfaces, framed by simple metal borders. They can be understood as painted jewels, made by hand rather than nature.[90] By the 1890s, enamelling had become a popular hobby among the wealthy who – like the pebble collectors encountered earlier in this chapter – had the time and money to engage in such pursuits. Indeed, Traquair learned enamelling from Lady Mary Helen Elizabeth Gibson Carmichael of Castlecraig, who had trained under influential London enameller Alexander Fisher.[91] Elizabeth Cumming explains that enamelling was challenging, but provided makers with an element of surprise and pleasure in colour creation, explaining that people were drawn to the craft because of 'the chemical experiments, the dangers and uncertainties of the kiln and the historic associations (and, not least, the transparent beauty of the fired colours)'.[92] Thus, while the skills and tools required for enamelling were different to those of lapidary work, both processes involved a high level of risk – shattered stones and failed firings ruined potential outcomes – but, when successful, produced similar effects. The materials not only looked similar; the very nature of the materials and the ways in which they behaved during the making process generated shared symbolism and meaning.

The work of James Cromar Watt – an artist, architect and jeweller from Aberdeen who was heavily influenced by Traquair – shows how agates and enamels were used together and interchangeably. Watt was expert at enamelling, but his work also displayed a 'Ruskinian love of stones', linked directly to the Victorian fascination with Scottish pebble brooches and his grandfather's Aberdeen jewellery business.[93] Early exposure to the firm, which specialized in 'granite and other jewellery', may indeed have stimulated Watt's love of stones as well as providing space and tools for learning to make jewellery.[94] He incorporated interesting stones into his work, including native agates, amethysts, granite and Scottish freshwater pearls. He was also a keen antiquarian acutely concerned, as many were, with the perceived loss of craft skills in the 'Age of Industry'.[95] A surviving pendant by Watt made in the first decade of the twentieth century contains a very thin slice of moss agate set into a gold pendant (see Plate 4.14). When light shines in, the gold behind the agate dazzles, lighting it up and illuminating the layers of colour within – a haze of pink appears under the

whispy marbling of dark greenish-blue. The dark swirl in the stone looks like ink dropped on water, as if it has bled into the agate pool from the dark-blue enamel on the gold setting, and it moves as layers of that blue under the surface catch the light and come into view. This geometric enamel detail floats on top of the gold border around the agate, but is separated from it through a fine dotted pattern created through gold granulation. The ancient technique of granulation, which Watt taught himself through workshop experimentation, was the obsession of many a nineteenth-century jeweller seeking to perfect a notoriously difficult skill.[96] Drops at the top and bottom contain enamel, gold granulation, and two pale, milky stones.

The piece documents the shift towards a naturalistic approach informed by the Arts and Crafts Movement's respect for materials, where form was dictated by matter, rather than stones being subject to high levels of intervention to create complex pictorial forms. The way in which Watt manipulated the natural properties of the stone to visually link it to the enamel is useful in considering the relationship between these forms of matter. Neither agates nor enamels were employed to imitate intrinsically valuable gems and, in many ways, they both evaded the moneyed and consumerist associations of precious stones to speak a different language of creativity and connoisseurship. The main difference between these materials was that nature created the layers of colour in agates, while enamel gems were painted by hand. Increasing scarcity and shifting aesthetics, however, meant that agates came to be subject to a series of material interventions, which, combined with consumer uncertainty around imports and imitations, created issues of authenticity. These issues shattered the perception of pebbles as pure, untainted natural forms created by and rooted in the power and mystery of the Scottish landscape. The openly manmade nature of enamels – created through craft process and creative endeavour – also spoke of mysterious processes, and produced similar effects to create imagined colour worlds contained within glass.

Conclusion

Throughout the long nineteenth century, the relationship of colour, pattern and light within and between the many different types of minerals and stones found in Scotland told stories of place, and reflected layers of time, elemental processes and the mutability of the landscape. Pebbles were valued as receptacles of knowledge – the

product of mysterious natural forces and processes – during a period of continual geological discovery, technological change and a shifting cultural engagement with the physical landscape. This interest was manifest in private collecting as well as in the rise of the museum as a repository for both geological specimens and examples of skilled handwork. In other words, knowledge broke off from the workshop and made its way into the laboratory, blurring the lines between craft and science. The subtle shifts in the making, use and meanings of pebbles were closely interrelated.

During the eighteenth and early nineteenth centuries, the interest in geology and mineralogy combined with the availability of materials in the Scottish landscape stimulated rural industries and led to the emergence of a specialist lapidary craft in Edinburgh. Skills and tools were adapted and refined as the meanings of pebbles mutated in the popular imagination, and from the middle of the century lapidaries and jewellers worked in close collaboration to create intricate mosaics and complex pictorial forms. As such, pebble jewellery gained further layers of meaning as material manifestations of skill, ingenuity and creativity. But high demand combined with scarce supplies led to the production of imitation pebbles which eroded the symbolic value of the real thing and, together with wider industry shifts and changes in fashion, saw the lapidary industry shrink towards the end of the century. In this context, there was a distinct overlap with the move towards the use of enamel which, though it had always been partnered with pebbles, became the preferred medium for coloured jewellery. It is important to recognize these links, to understand how the (ultimately terminal) decline of the lapidary craft in Scotland must be viewed alongside the rise of other skills – as part of a dynamic process of skill adaptation rather than a sign of the inevitable obliteration of skilled craft work which dominated the contemporary narrative, and persists today.

Moving from the earth's interior to its surface, and from hard to soft matter, the final chapter explores the links between production, aesthetics and nature through organic materials, namely Scottish freshwater pearls but also linked animal-derived materials including shells and taxidermy.

(Un)Living things: Material afterlives in Scottish freshwater pearls

In the later eighteenth century, it was reported that Scottish freshwater pearl mussels had become extinct. In early travel writings of Scotland, Thomas Pennant wrote in his *Tour of Scotland 1769* that the Perthshire and Loch Tay area had been the centre of the trade in 'Scotch pearling', and that it had been very profitable, but that the sources were now 'exhausted, from the avarice of the undertakers'.[1] Unlike metals and stones, however, the animal origins of pearls meant that living creatures could replenish stocks. Scottish freshwater pearls were used in jewellery prior to and at different points throughout the long nineteenth century. During that time both supply and demand fluctuated significantly, impacting on their values and associated meanings. The freshwater pearl mussel, *Margaritifera Margaritifera*, is found in cold, fast-flowing rivers and streams, mainly northwards from Perthshire, throughout the Highlands and Islands.[2] They are bound up with complex underwater ecologies, often in habitats which include salmon and trout that serve an important role in the mollusc's life cycle, as hosts for their movement within water. The mussels live for 80 to 100 years but only occasionally create pearls, which are formed when the creatures secrete fluid around foreign bodies caught inside their shell, and that fluid then hardens over time into layers of nacre (see Plate 5.1).[3] The resulting pearls emerge complete from beneath the water's surface, but the mussels have to be killed for the jewel to be retrieved. Thus pearls are universally bound with ideas of life and death, fertility and afterlives. Scottish freshwater pearls assume a range of colours with varying undertones – hues range from white and cream to earthy shades of pink, lilac, brown, grey and gold – and are often unevenly shaped (see Plate 5.2).[4] These physical qualities translated into symbolic meanings, in that subtle colourings and irregular shapes imbued pearls with ideas of rarity and difference, and pointed to their natural origins in the animal world. Indeed, specific colours were often associated with particular bodies of water in Scotland

and their environmental variations. The mysticism and enduring appeal of pearls has stimulated a vast literature, which reveals how different cultures across time and place have constructed their own versions of the myth, history and legend of the jewel.[5] The pearl's place in Scotland's folklore, history and culture is useful for exploring its materiality. In folk tales, pearls were (and are) almost always associated with Fin Folk, which included sea creatures like mermaids. In the northern isles, it was said pearls as big as shells were ground to dust and sprinkled over mermaids' tails to give them translucence.[6] By the nineteenth century, pearls carried extra layers of significance because of associations with royalty and Scottish history in high-status objects from the Scottish past. The Kellie pearl, which was found in an Aberdeenshire river in 1621, and was said to be the largest ever uncovered in Britain, is now in the Scottish crown jewels alongside other fine examples of both Oriental and Scottish pearls.[7] In a locket associated with Mary Queen of Scots, smaller pearls in irregular shapes – in colours ranging from off-whites to blue- and purple-tinged silver – surround miniatures said to be of Mary and her son.[8] Of course, these objects were symbols of power and wealth, and were embedded with personal and emotional connections, but they highlight the tangled symbolism, myth and history – as well as aspects of national sentiment – that swirled around the exploitation and use of Scottish freshwater pearls.

Modern understandings of the pearl must be seen against its shifting cultural meanings across time and place. For much of its known history, the pearl has been seen as something precious which links water and land, real worlds and 'otherworlds' but cultural change and crossover have seen its complex layers of meaning evolve. Nicholas Saunders argues that, pre-contact, both Europeans and indigenous Amerindians valued pearls for their beauty and their brilliant effects, and as symbols of 'wealth' and power, but there were differences, and the meeting of cultures shifted the associated meanings of the gem for both groups.[9] Europeans valued pearls as status symbols and embodiments of financial wealth which, when worn on the body, displayed power and riches. Amerindians saw pearls as harnessing the cosmic power of shininess and brilliance that energized the universe – the translucent, lustrous spheres were understood as embodying the shining surface of the watery underworld in which they were created.[10] The economic trade in pearls between these groups led to Europeans associating both pearls and the 'discovered' lands with an element of mysticism and otherworldliness.[11] Across time and place, the layered meanings embedded in pearls have continued to evolve, but retain the natural and otherworldly

associations. These meanings are always tied to their surface effects, to ideas of shininess and brilliance, to their luminosity.[12]

Brilliance appears to be a physical property of shiny things but is, in fact, a consequence of the play of light on a surface – a consequence that has been interpreted in different ways in different time periods and cultures.[13] The colours of pearls were produced through the diffraction of light by the small crystals that formed the jewels' surface, which varied according to many factors, including locality, making it possible for a trained eye to distinguish Scottish freshwater pearls from other varieties (and to speculate on the particular loch or river of origin).[14] In the late eighteenth century, diamonds or 'brilliants' replaced the pearl as the definitive symbol of wealth and status to become the fashionable gem of choice.[15] By the early nineteenth century the pearl had come to be seen, physically and symbolically, as the diamond's 'other'. They were opposites in both a visual and physical sense; lustrous, luminous pearls were soft and fragile while bright sparkling diamonds were renowned for being harder than any other type of natural matter. In popular novels of the period, diamonds had come to be employed as metaphors for moral issues and blurred class boundaries. Their faceted sparkle – which reflected short-term, dazzling flashes of coloured light – was associated not only with eternity, power and status but with conspicuous luxury and the ostentatious display of wealth.[16] In contrast, the veiled brilliance and lustrous sheen of the pearl's unbroken surface spoke of wealth, of course, and of timelessness, but was associated with an 'unshowy' authenticity. One only has to think on 'fortune hunter' Lizzie Greystock's relentless pursuit of a spectacular diamond necklace at the centre of the plot of Anthony Trollope's *The Eustace Diamonds* in contrast to the eponymous Jane Eyre's single, treasured pearl brooch, and a picture emerges of the relationship between a woman's jewels, her social position and her moral values.

That said, pearls always carried a symbolic duality that was dependent on context. They were a highly gendered form of matter, usually associated with feminine energy and fertility. In the context of the eighteenth-century luxury debates, the pearl was a symbol of profane luxury and overt female sexuality on the one hand, and of virtuous love and purity on the other.[17] And while in some nineteenth-century contexts the pearl spoke of vitality, youth and girls' coming-of-age, in others it spoke of death, loss and separation. Many cultures associated pearls with the tears of gods – symbolism that saw them put to use in mourning jewellery alongside human hair, another organic material and one that is considered in this chapter, to act as mnemonic aids.[18] The complex meanings

of pearls, then, oscillated between ideas of life and death. The one constant was that, as a naturally occurring material that originated from a living thing in the landscape, the pearl was always valued as rare, mysterious and precious.

Pearls' links to water and living things set them apart from inert precious matter – metals and stones – created under the ground through geological forces. Thus pearls must be considered separately, on their own terms. This chapter looks at the life cycle of Scottish freshwater pearls, with a focus on how their place as organic matter made by living creatures affected supply and demand, and shaped their making and meanings. The focus is on three key moments when demand and supply of these Scottish pearls converged: the 1830s, 1860s and around the turn of the twentieth century. Each section examines the supply, production and consumption of Scottish freshwater pearls to build up a wider cultural biography that reveals how pearls were symbolically recontextualized across the period as a whole. Other organic materials – including shells, taxidermy and human hair – are also considered, to contextualize the meanings of pearls within a wider and shifting aesthetic of deadness. By examining the relationship between demand and supply alongside materiality and use at specific points in time it is possible to see how, through a cyclical process that was inseparable from the life cycles and stocks of a natural species, producers and consumers continually recreated the meanings of Scottish freshwater pearls.

Pearls and nature's patina in the 1830s

The popularity of Scottish freshwater pearls has always fluctuated with wider fashions and the availability of supply, with cycles of high demand followed by periods of scarcity brought about by the overfishing that resulted from meeting that demand. In the early twentieth century a comprehensive history of pearls across the world reported that the industry in Scotland had lain 'almost dormant' between the late eighteenth century and a so-called 'revival' from 1861.[19] 'Almost' is the key word here. Periods of scarcity did not see demand fall away completely, but did cause shifts in the market. Pearls became even more rare, and were sold second-hand. Inventories of Queen Charlotte's jewellery sold at auction in 1819 after her death the previous year differentiated 'Scotch pearls' from all other varieties, which were described as 'large' or 'fine' rather than in relation to place of origin.[20] That the language of the market made these distinctions underlines how Scottish freshwater pearls were recognized and valued for their particular qualities – set apart because of their place of origin, and by their irregular colours

and shapes. It is true, however, that the very little evidence that survives for the production and consumption of Scottish freshwater pearls in the first half of the nineteenth century is suggestive of a lull in both supply and demand.

Letters in family papers reveal that a specialized micro-industry for pearls remained, however, with fishers and dealers supplying some of Scotland's wealthiest elites. On 1 January 1833 a man named Alpin McAlpine sent two letters to Dalkeith Palace, just outside of Edinburgh – one to Walter Francis Montagu-Douglas-Scott, 5th Duke of Buccleuch and 7th Duke of Queensberry, and the other to Charlotte Anne Montagu-Douglas-Scott, Duchess of Buccleuch and Queensberry. These letters accompanied a parcel of 'presents' containing an ancient Highland sword and one large single pearl for the Duke, and 26 'Scots pearls' for the Duchess.[21] McAlpine was writing from the village of Killin in Perthshire, where locals had been selling pearls to elites from at least the 1780s.[22] Killin was the perfect spot for a pearl dealer – on the banks of Loch Tay where the river meets a huge body of fresh water, right in the centre of the Scottish mainland with access to supplies there as well as further north, and within relatively easy reach of centres of luxury consumption in Edinburgh, Perth and Glasgow. McAlpine was from a modest background. His family were tenants on a Perthshire estate and his father was a servant who had a reputation as one of Scotland's most accomplished fiddle players.[23] This background equipped the pearl dealer with networks of supply in Perthshire and an understanding of local and national cultures, both of which were useful tools for making a living from selling native pearls. Later in life, he was awarded a medal from the 'Celtic Society' on the basis 'that from his boyhood he has ever worn the Highland garb' – a choice of dress which can be understood as reinforcing the Scottishness of his goods.[24] A petition for a pension from the Highland Society of London in 1839 states that McAlpine had:

> devoted his life since his boyhood to the collecting of Pearls and Cairn-grums [*sic*] in the mid-land & Northern Counties of Scotland & that these were distributed amongst many of the Nobility & Gentry in Scotland and not a few in England.[25]

He was experienced, then, at sourcing pearls and other native stones as well as skilled at weaving narratives around these materials.

Analysis of the language of these letters offers insights into the supply, marketing and highly gendered consumption of Scottish freshwater pearls. To the Duke, McAlpine wrote:

I also transmit to your grace a beautiful pearl, one of the greatest Curiosities, ever I met with. The Marquis of Chandos got from me, sometime ago, a pearl of an amazing size, brown in colour, and an inch in circumference, weighing three quarters and forty seven grains which I found in Lord Rae's [*sic*] Country. I took the shell and pearl home in my packet.[26]

In this short description, he gave details of place of origin – Lord Reay's country in Sutherland, on the northern tip of the mainland – along with size, weight and colour. The mention of the shell reinforced the pearl's animal origins. He also alluded to another elite client, the Marquis of Chandos, who was known to Buccleuch – both men served in government at this time. Crucially, he outlined prices:

Robert Allan, Edinburgh received from me the second pearl in my possession, and advertised it in the newspapers as your grace may see from the advertisement included. I received five guineas for each of the above pearls and your grace's pearl is to be the same if accepted.[27]

This mention of Allan's sale of the pearl commercially, evidenced through the enclosed newspaper cutting, was useful in indicating to the Duke that he would be lucky to get his hands on such a thing as well as justifying the price (the market value was clearly dictated by perceptions of rarity). That information also points to the fact that a micro-industry for pearls did indeed remain in operation in a commercial, if highly specialized, sense during this time.

The importance McAlpine placed on provenance can be understood more clearly through the entertaining, if rather overblown, stories he told of the Highland sword sent to the Duke. He wrote that it had belonged to 'Malcom MacGregor one of Rob Roy's servants' and was 'the very sword' used to attack a man who challenged Rob Roy and his party on the road.[28] The mention of Rob Roy, a seventeenth-century folk hero whose story was popularized in Walter Scott's 1817 novel, evoked ideas of Scottish masculinity, heroism and militarism.[29] McAlpine stretched the story yet further into the realm of fantasy, writing that Rob Roy had ordered the servant to, 'beware of taking away his life Cut off one of his ears and let him return home thus mutilated which was done'.[30] The sword was rusted and tarnished – the patinated surface a sign of its age and provenance – but would, McAlpine suggested, look good if japanned. The timing of the letters, several months after Scott's death, shows how McAlpine shaped his narratives to fit with current sentiments and, given that the Buccleuchs were well-acquainted with the author, hints that he personalized those narratives.[31]

In a further letter to the Duke, politely chasing up a reply, McAlpine wrote that he was going to the Highlands and Hebrides to look for pearls and, 'I expect on my return to have the pleasure of exhibiting a variety of them at the Palace of Buccleuch.'[32]

To the Duchess, McAlpine very clearly tailored his words to appeal to feminine sensibilities and fashions:

> I trust that your Grace will accept from one of the most mettled and tired Highlanders in the three Kingdoms, a present consisting of twenty-five pearls, different in colour, size and shape, which constitute one of the greatest curiosities in the three Kingdoms, and which your Grace may challenge any to find their match. Besides the quantity of pearls just mentioned I remit your Grace, a very beautiful and valuable one which I found near my own Residence.[33]

Advice on having the pearls made up in jewellery demonstrates an aesthetic awareness: 'If the smaller ones be set round it [the beautiful, valuable one], it will look very beautiful.' Again, he mentioned place of origin: 'I trust to have [an] abundance of them in my possession, on my return from the Highlands and Hebrides of Scotland.' He named other elites who had purchased his pearls: 'The most Noble the Marchioness of Breadalbane has received the most of my collections for the last twelve years', he wrote, and had worn 'one of the most beautiful headdresses of pearls received from myself' to events surrounding King George IV's visit to Edinburgh in 1822.[34] As in the letter to the Duke, this skilled seller highlighted the rarity, prestige and provenance of the pearls, and imbued them with layers of meaning related to stories of past and place, shot through with a gender dimension.

While the man's pearl was a trophy from the landscape, the woman's was an example of nature's gentle approach to creating variety and beauty in materials that could be crafted into things for wear. Understanding the meanings of pearls against the feminine body is important in uncovering their more subtle associations, and revealing how they were used to express cultural identities. A portrait of the Duchess of Buccleuch dating to the 1840s (Figure 5.1) shows her smiling demurely, her coiffed curls in the latest style falling to just touch her bare shoulders and neck, which is adorned with a necklace of five sparkling stars. A large pearl is nestled in the fur trim of her dark velvet gown, just to the right (as worn) of the point where the V-neck meets at her bust, the roundness of which is indicated through the folds of her gown. The overall look is one of femininity based on a conspicuous but elegant luxury, characterized by sparkling jewels

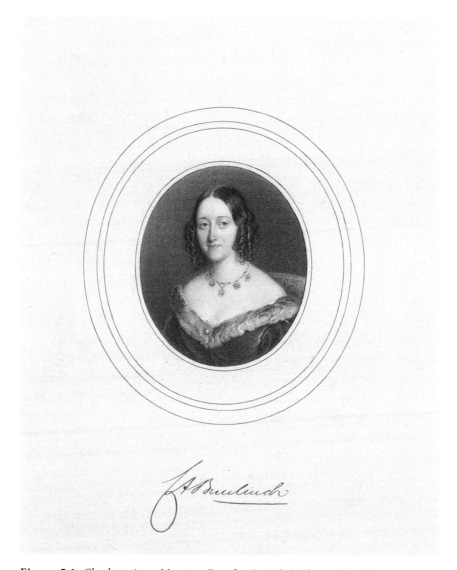

Figure 5.1 *Charlotte Anne Montagu-Douglas-Scott (née Thynne), Duchess of Buccleuch*, Edward Morton after Sir William Charles Ross, published 1843. Lithograph, 400 × 299 mm (paper size). NPG, D32267 © National Portrait Gallery, London.

and the lush and lustrous textures of fur, velvet, hair and pearls. The layering of animal products on her skin – the fur trim and giant pearl – switches the imagination on to rare and fine things originating in the natural world. Whether or not the pearl in the portrait was among those purchased from McAlpine will remain a mystery, but it nevertheless offers a useful way to explore ideas of wear.

On the body of Scottish elite figures like the Duchess of Buccleuch and the Marchioness of Breadalbane, native pearls spoke of land ownership in the Scottish countryside and, by extension, symbolized the wearers' genuine social standing and long-term ties to the aristocracy. Of course, as rare objects available only to those who could afford them, the pearls also signalled the wealth that was tied to landed property. In this sense, native pearls operated in a similar way to the pebble jewellery of the early nineteenth century considered in the previous chapter. Seen in the context of the Scottish stories McAlpine attached to his goods, the pearls hint at a gendered language of national dress. Wearing Scottish pearls was a suitably subtle and feminine way of communicating a national identity, asserting Scottish difference within the wider British aristocracy alongside elite men who expressed these ideas overtly through Highland dress. Certainly, the Marchioness of Breadalbane's pearl headdress, worn during the visit of King George IV, can be understood along these lines. But it is important to keep in mind that while Scottish freshwater pearls were distinctive, their subtle visual differences meant that a trained eye was required to read the pearls as Scottish, and decipher their associated values and meanings. The wearer, of course, provided important context. The presence of unusual pearls on the body of a Scottish aristocrat might give contemporaries clues about the origins of the jewels. Still, viewers would have required specific knowledge about both the materials and the wearer, which suggests that they were appreciated by an elite in-group.

McAlpine's not-so-subtle references to other elite individuals in his letters offer clues as to the types of individuals who could recognize and appreciate Scottish freshwater pearls. By naming these people, he also sought to indicate that he was trustworthy, and to communicate the high demand and exclusivity of his goods in order to raise their desirability and value in the minds of potential customers. It is worth remembering that the early mention of the Marquis of Chandos indicated that customers were not limited only to Scottish elites, but also to wealthy English folk who were part of these elite circles and literate in the meanings of fine, rare things. There is evidence that the pearl dealer did indeed have other elite clients and sourced material to order. In May 1832, he sent a courier with a letter and 'some fine specimens with the prices marked' to Sir Duncan Campbell of Barcaldine saying that he was soon to set off to the Isle of Skye in search of pearls, and asking Campbell to cover the expenses of the trip, thus giving the customer the opportunity to secure any finds of these rare materials in advance.[35] There were close connections between the Breadalbane and Barcaldine Campbells, which suggests that

McAlpine relied, at least in part, on word-of-mouth and reputation among Scottish elites to market his goods.[36] In terms of evidence of consumption, the names in McAlpine's letters reveal a small but exceptionally wealthy group who collected and wore Scottish freshwater pearls of all shapes, sizes and colours.

Existing studies are helpful in understanding how elites read subtle visual clues in high-status objects. Grant McCracken's discussion of the interplay between the physical and symbolic properties of patina is useful in relation to Scottish freshwater pearls, as it pertains to surface effects and degrees of shininess. McCracken argues that patina was important in expressing the long-term ownership of valuable objects.[37] Patinated surfaces – small scuffs and areas of oxidisation on family silver, the tarnished look of polished leather, tiny scratches of use on a fine china dinner service, rust on an old Highland sword – were signs that objects were not new, but had been used, and perhaps passed through generations. As a material sign of age, patina communicated established wealth and acted as a form of 'invisible ink', in that only those able to appreciate how patina was created were able to read it as a sign.[38] Meanwhile, the newly rich gave themselves away by buying and displaying shiny things that were clearly new.[39] Similarly, only those with experience of handling Scottish freshwater pearls and seeing them up close could spot them across a room, discern their origins, and appreciate their rarity and monetary value. Indeed, the subtle colours and distinctive lustre of Scottish freshwater pearls can be understood as nature's patina – a sign of a long period of gestation in specific parts of Scotland – visible only to elite circles made up of individuals who were attuned to the jewels' linked physical and symbolic properties.

As part of an established rural micro-industry, McAlpine had a deep understanding of the pearls' materiality, and knew how to appeal to elite buyers. He embedded narratives of place, landscape and nature in the things he sold, rooting them in local and national histories. And while we can only wonder at the reactions to his verbosity and flair for storytelling, he clearly had a degree of success with these private buyers as well as commercial dealers. His sales patter struck a chord with his wealthy buyers. Though not possessed of the craft skills required in the jewellery workshop, fishers and dealers like McAlpine – the rural working classes – were an integral part of a wider web of supply and retail that was inseparable from urban production.

Spectral symbols in the pearl 'revival' of the 1860s

Evidence relating to a surge in demand for Scottish pearls during the 1860s reveals how rural networks of supply were linked up with jewellers in urban centres. In 1863 *The Scotsman* reported a 'revival' in pearl fishing in Scotland, propelled by the interest of a Mr Moritz Unger, 'trader of diamonds, pearls and precious stones' in Edinburgh, who had carried out a survey of Scotland's rivers and purchased 'as many pearls as could be got'.[40] Jewellery for sale in Unger's shop on the North Bridge included: 'two necklaces composed entirely of Scotch pearls, the brilliancy and colour of which almost rival Orientals', offered at the eye-watering price of £350 for what must have been a truly remarkable example and the other at a more palatable £90.[41] As we shall see, this comparison between Scottish and Oriental pearls would continue throughout the 1860s boom. The renewed interest and corresponding inflated prices encouraged those living near the rivers 'to devote their leisure … to the task of pearl fishing'.[42] Taking exception to this media coverage naming Unger as the saviour of a dying industry, one unnamed pearl fisher wrote to the paper in defence of his trade, highlighting that it had been successful for many years before Unger's interest, enabling him and his 'brother pearl fishers' to earn a respectable livelihood.[43] His response pointed to the fact that specialized, small-scale fishing had continued irrespective of the lack of wider attention up to that point and, perhaps more importantly, also underlines that this was far from an ad hoc activity. It was an occupation for a group of people – one involving experience, knowledge and localized networks – and central to their lives and identities.

Other reports partly attributed the surge in supply to natural conditions, namely a dry summer and resulting low water in 1862, which made it easier to access larger quantities of higher quality pearls in waters usually so deep as to make molluscs inaccessible.[44] And, of course, mussel stocks had likely recovered after many decades of relatively low demand. Regardless of the circumstances, interest generated by the increased availability of Scottish pearls on the market created heightened demand that raised prices and, in turn, further stimulated supply as more were moved to get cold and wet sourcing them in the hope of financial reward. This was a cyclical process whereby the natural environment and complex water ecologies played a role in shaping patterns of consumption and aspects of fashionable dress.

During the 1860s 'revival', it was reportedly difficult for sellers to get a good price for Scottish freshwater pearls in Scotland, compared to the high sums paid for them in London and Paris.[45] The increasing fashionableness of pearls, together with a heightened wanderlust on the part of a growing urban-dwelling middle-class population, meant that Scottish pearls were worth more in the metropolis than they were closer to the source. The jewels reportedly became highly fashionable as a result of patronage by Queen Victoria, who apparently paid forty guineas for one fine example, and other elite women including Empress Eugénie of France and the Duchess of Hamilton.[46] The Queen's visits to Scotland in general, and to the Loch Tay area in particular, played a part in generating a wide interest in pearls from the area. In turn, the pearls put a spotlight on the area and impacted on the ways in which it was seen and understood from the outside by visitors and observers.

Artistic representations of the region, including Queen Victoria's own watercolours of Loch Tay, were executed in pearly tones (see Plate 5.3). Her colour decisions were undoubtedly influenced not only by her own visual interpretation of the area but by what had come before via a genre of picturesque paintings of landscape so well established that the visual material it generated was at the point of ubiquitous.[47] For example, the Queen's ochre-to-purple watercolour of Loch Tay from 1866 mirrored the painting *Loch Tay and Ben Lawers* by her drawing master of two decades, William Leighton Leitch, who was commissioned by the Earl of Breadalbane to document a day out on the water during the Queen's visit in 1844 (the resulting painting was presented to her later, in the 1880s).[48] In both paintings, the water and surrounding landscape is a haze of purples, yellows and dusty browns.

Broadly speaking, Perthshire hills known for their striking summer greens were awash with pearlescent off-whites and greys, ochre-yellows and earthy purple to brown tones in paintings of this period. This use of colour – used far beyond the Queen's art – reflects a broader way of seeing or imagining these particular landscapes in the Victorian imagination. In the same way that the pink-to-red granite of the mountainous Cairngorms region was represented in smoky, ruddy warm reds and browns, the popular scenes of central Scotland and particularly Perthshire – dominated by large bodies of water flanked by the shaggy lower slopes of towering hills above stretching into the distance – were tinted with greeny-yellows and mauves. The material associations of these landscapes have, on the whole, been overlooked in relation to the imagined colour filters through which they were viewed. While it is a stretch to argue

that the presence of pearls in the landscape dictated the palettes employed by artists of the time as they set out to portray such scenery, it is certainly the case that the materialities of place played a complex and often overlooked role in creating associations, representations and perceptions of specific landscapes and their particularities over time. The known presence of rare and valuable gems gave the land colour and meaning. There is no question that the exploitation and use of precious materials in rural areas impacted on the ways in which contemporaries saw, understood and appreciated the physical landscape. In turn, that translated into visual forms of representation, including professional and amateur paintings. As a body of water so bound up with watery gems at this time, Loch Tay and its surrounds were viewed through a pearlescent lens.

Popular publications carried reports of pearl fishing with an emphasis on Scottish history and landscape, underpinning their special qualities through equally romanticized imagery (Figure 5.2). The *Penny Illustrated Paper* gave a potted history in 1867, detailing how, 'The Scottish pearls were, in the Middle Ages, celebrated all over Europe' and were in great demand in the eighteenth century, and followed it up by saying that Unger had 'revived' the trade in pearls

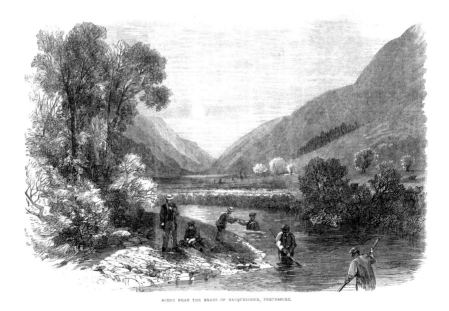

SCENE NEAR THE BRAES OF BALQUHIDDER, PERTHSHIRE.

Figure 5.2 'Pearl fishery near Loch Lubnaig, Perthshire', *Penny Illustrated Paper*, 31 August 1867. © Mary Evans Picture Library.

and Queen Victoria was buying them.[49] This historical overview was embellished with romantic descriptions of rural locations where local people, usually labourers, went seeking the gems in lochs, rich waters and flowing rivers.[50] The engravings and captions that accompany the article provide further evidence of how Scottish pearls were widely associated with rural landscapes embedded with historical associations, rather than purely as a convenient local source:

> The pearl seekers shown in our Engravings are exercising their industry near the picturesque 'Braes of Balquhidder' in Rob Roy's country, and at the outlet from Loch Lubnaig, in the Pass of Leny.[51]

Fishing activity was depicted taking place in deep glens under dramatic skies, where the light reflected off the water like the luminous surface of the pearl. Another image in the same piece shows a burn near the Braes of Balquhidder (Figure 5.3). The full moon hangs like a round pearl in the deep 'V' of the valley, creating light in the sky that picks out the detail of the hills and the figures working in and on the banks of the water. The composition of the image suggests the dressed female form, with the moon representing the brilliant pearl suspended from the neck, above the workings of the trade in the body of

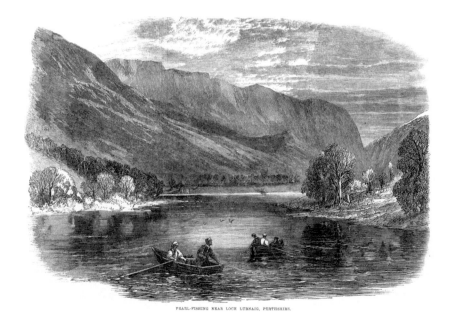

PEARL-FISHING NEAR LOCH LUBNAIG, PERTHSHIRE.

Figure 5.3 'The Scottish pearl fishery: burn near the Braes of Balquhidder, Perthshire', *Penny Illustrated Paper,* 31 August 1867. © Mary Evans Picture Library.

water, conjuring myths about lunar activity linked to water, magic and fertility. Both image and text emphasize the informal nature of the trade – fishing as a Scottish or Highland 'industry' and a facet of a particular way of life in the Highlands – set against the 'professional' pearl industry in 'Eastern seas'.[52]

The difference between Scottish and Oriental pearls was particularly pointed during this period, at a time when there were generally mixed views about the impact of foreign imports on the British economy, as well as the heightened value placed on native materials. Trade publications offer further evidence of the contrast between fishing for 'Scotch' and 'Oriental pearls':

> The diving [for Scottish freshwater pearls] is a comparatively simple process, involving few of the dangers attending the operations of the divers who go down to the bottom of the open sea at a depth of twenty or thirty fathoms, off the coast of Ceylon. The fresh-water mussel-diver has merely to wade into the water, stooping down to collect the precious bivalves.[53]

Retrieving Scottish pearls, then, was not a particularly difficult task, and could be carried out by amateurs. There was, however, a distinction made between the majority and the few skilled divers:

> Some experienced fishers will proceed breast deep into the water, immersing the whole body as they search for the molluscs, and at such times an unlucky step may involve considerable discomfort, if not actual danger.[54]

High prices for pearls were 'sufficient inducement to several persons to devote their energies' to this soggy and potentially dangerous task. Rarer large gems were worth £60 to £80, 'but very few mussels need to be gathered to collect a number of small "seed" pearls, which always find a market if of good colour'.[55] The hierarchy remained: large, white and round were more desirable, and therefore more pricey, than small, bumpy and earthy-toned.

While diving and fishing for pearls was associated with men, preparing pearls for the jeweller was regarded as women's work. This gender distinction was embedded in the 1861 census, in which the male category labelled 'lapidaries or goldbeaters' appeared as a female category labelled 'Pearl Cutter, Worker'.[56] A report from the Paris Exhibition of 1878 highlighted how pearl workers, 'the setters especially, work from home. The polishing, drilling and stringing of pearls is performed by women'.[57] The quotation refers to imitation pearls, which were 'now so admirably made that it almost takes the experienced eye of a jeweller to detect them', but is useful in understanding how pearl work could be done in a domestic setting.[58] Furthermore, the sophistication of imitation

pearls by the later nineteenth century (cultured pearls came later) underlines how the imperfections in Scottish pearls meant they evaded questions of artificiality – natural flaws and irregularities marked them out as natural rather than man-made jewels.[59] These natural pearls required special cleaning, as outlined in trade publication, *The Watchmaker, Jeweller and Silversmith*:

> Soak them in hot water, in which bran has been boiled, with a little salts of tartar and alum, rubbing gently between the hands when the water will admit of it. When the water is cold, renew the operation until the discolouration is removed; rinse in lukewarm water, and lay the pearls in white paper in a dark place to cool and dry.[60]

This gentle, repetitive process could take place in a domestic kitchen using natural products, but required dexterity and a close eye for detail as the worker washed away layers of matter to reveal the pearl's surface by degrees, thus transforming raw materials into shiny supplies for the jeweller.

Once recovered from the water, cleaned and polished, pearls made their way to jewellers, who sold them alongside other native materials, from precious stones to native agates. Prominent Edinburgh lapidary, Sanderson & Son, advertised as 'DEALERS IN GEMS AND PRECIOUS STONES, SCOTCH PEARLS, PEBBLES, MINERALS, &c. &c.' in July 1866.[61] Pearls were often advertised among antiques and paintings, including through Unger who sold pearls and diamonds alongside 'PICTURES (Ancient and Modern), ANTIQUE BRONZES, ENAMELS, CHINA, SILVER WARES, and WORKS of ART of Every Description'.[62] An idea of prices appears in an advertisement for second-hand jewellery sold by Edinburgh jeweller James Aitchison where a fine diamond cluster ring originally worth thirty guineas was on offer at £36 10s while 'a Large Fine SCOTCH PEARL, MOUNTED ON A PIN, in Fine Gold. Cost £8 – will be Sold for £4 4[s]'.[63] Scottish pearls were also tied in with masculine cultures of collecting, as advertised in a sale of possessions belonging to 'an officer going away' in 1869 which included 'Specimens of Scotch Pearls, and an interesting Collection of Oriental and Scotch curiosities, Armour and Antique Weapons', among other animal rarities such as 'Polar Bear Skins', 'Stags' Heads' and even 'Unicorn horns'.[64] These advertisements show how there was both a vibrant second-hand market and that pearls were valued in different ways: as natural gems for jewellers and collectors alike, as pretty things in crafted jewellery objects and as rare animal specimens for the curiosity cabinet.

For the most part, pearls were aimed squarely at women wearers and crafted into women's jewellery. While pearls were often bound with rituals around death, they were also tied in with young women and marriage, because of the associations with life and fertility.[65] This aspect of the pearl can be seen in a portrait of Mary Barclay by her husband, the Perth-born artist John MacLaren Barclay (see Plate 5.4). The portrait was painted in 1865, eleven years after their marriage, when they were living in Perth at the height of the pearl revival. A pearl pendant features in the painting, and though it is impossible to tell whether it was of local origin, the link is nevertheless useful in exploring ideas of wear. The milky pearl is set in the centre of a gold, cross-shaped pendant suspended from a fine gold chain around Mary's neck. While small, the pearl has been carefully painted in, to draw the eye through the whiteness that dominates the image, from Mary's eyes, which meet the viewer directly, across the bare skin of her shoulders, to the lustrous ivory silk and delicate lace of her gown. The cross pendant set with a pearl was highly fashionable during the 1860s, as was the rest of Mary's dress. She is depicted wearing a stylish gold bracelet on each wrist – the left-hand one in a belted garter design with a central panel containing stones (probably Scottish pebbles, commonly found in this popular style of bracelet) – and her fingers are adorned with rings. The off-the-shoulder silk gown with a deep lace flounce is similar to that worn by Queen Victoria on her wedding day in 1840, and whose bridal attire influenced the shift of the pearlescent white wedding dress from fashion to custom and cultural norm.[66] The painted pearl in Mary's portrait, then, fused ideas of fashionableness and style with symbolic associations of purity, love and femininity. And to local people who were attuned to the regional significance, the pearl and its prominence spoke of links to Perth. Surviving objects demonstrate how the materiality of Scottish pearls influenced the ways in which they were set in objects as well as the types of jewellery in which they were put to use. For example, a bar brooch retailed by jewellers R. L. Christie of Edinburgh contains three large bright-white pearls (Figure 5.4). Each one is a slightly different shape with the most spherical set in the middle, between two more oval examples. The jeweller who made the piece would have carefully graded, selected and placed the pearls to ensure they looked their best. Usually, in designs like this, flat or flawed areas of the pearl were turned inward, hidden within the setting. As we have seen in previous chapters, distinctively Scottish jewellery of the Victorian era often included a range of native materials but, as round-shaped gems, pearls did not sit flush with other stones. As such, they were often placed in a prominent position, for instance, on top of a crown

Figure 5.4 Scottish freshwater pearl set bar brooch, probably R. L. Christie of Edinburgh, *c.* 1860s. Gold and Scottish freshwater pearls, 57mm length. Private Collection. L&T, sale 415, August 2014, lot 209 © Lyon and Turnbull.

or in the centre of circular designs. The jeweller was required to make carefully tailored settings, each one bespoke to fit the individual shape of single gems, and to protect them from loss while not damaging the lustrous surface or, given their softness, causing them to crack or break over time. In other words, producing settings – even ones that appeared fairly simple in the finished piece – required a knowledge of pearls themselves as well as metalworking skills in making reliable but suitably delicate (and safe) little homes for each one within the piece.

Intriguing examples pose further questions about the possible role of women in making pearl jewellery, not just in cleaning and polishing pearls but in the construction of pieces which did not require either the training, tools or smoky workshop of the traditional jeweller. Small seed pearls – which were cheaper and more readily available than larger gems – in particular were crafted into jewellery objects without any need for skills in working precious metals. One such object is a brooch with seed pearls from the River Forth in central Scotland set in a naturalistic design around a central faceted garnet from Ruby Bay, a beach near the town of Elie on the coast of Fife, bordering the river's estuary, the Firth of Forth (see Plate 5.5). While the central 'Elie ruby', was cut by a lapidary and set in gold by the hand of someone with the traditional jeweller's skills, the body of the brooch was worked entirely without metals or heat. Each tiny seed pearl was carefully drilled and threaded onto horsehair and silk, then secured on a base painstakingly cut from shell, providing an intricate base which is invisible under the delicate seed-pearl structure that it supports. The brooch fastening is mass produced and secured with the same threading technique used across the pearls. This is a piece, then, that could have been produced in a space that did not adhere to the idea of the jewellers' workshop, including women working at home.

In a necklace of similar construction, hundreds of tiny seed pearls wind their way along three strands and into six areas of swirling decoration representing vines and flowers (see Plate 5.6).[67] These seed pearls may be small but they are fine examples, chosen and graded carefully and combined to impressive overall effect. Again, the fastening was a standard clasp affixed without the use of heat, with two further rows of seed pearls as decoration. Like the brooch, this complex construction could have been carried out with fine hands adept at such work, but not necessarily by a working jeweller in the usual sense of that term. At first glance, the decorative areas in the necklace appear to be standard naturalistic motifs representing foliage and flowers. A second reading brings them into sharper focus: they are boteh or buta, abstracted vegetable motifs and teardrop fig shapes used in Indian printed textiles and mass produced in the west of Scotland as Paisley shawls.[68] Thus the necklace documents the fluidity of visual cultures and aesthetic influences across categories of goods, from textiles to jewellery. The known history of this necklace offers further insights into its significance. It was donated to National Museums Scotland with other pieces of Scottish jewellery – including a garnet ring and a pendant containing dried heather bells – that belonged to an Ayrshire woman, Burella Elizabeth Campbell. These material connections, together with the physical properties of the pearls, lend weight to the statement in the museum's record that the jewels did originate in Scotland though they are a useful reminder that, in some examples, the eye cannot be certain. Campbell was married to an officer of the East India Company, Dr Robert Davidson of Fife, which makes the blending of Indian and Scottish influences interesting in relation to her personal identity. It has been argued that by wearing Indian luxury goods, particularly jewels and clothing, women connected to colonial administration through marriage (known as 'nabobinas') materialized their connection to and place in debates surrounding empire and colonialism.[69] Campbell's necklace dates to a time of heightened political tensions as a result of the Indian rebellion of 1857 – a flashpoint for questions and debates around Britain's role in India and British colonialism in general. In this way, the Scottish-Indian necklace can be understood as both a marker of Burella's identity as a Scottish woman with ties to empire, and an object embedded with a web of connections between people and places. Furthermore, the necklace is a reminder that ideas, influences and objects crossed geographical boundaries and migrated across categories of goods from textiles to jewellery. While Scottish pearls spoke of nature and landscapes 'at home', they could also represent faraway places through design and the personal connections and identities of the wearer.

The visible animal origins of Scottish freshwater pearls and the associated symbolic ideas of life and energy saw them used in jewellery designed to represent living creatures, as well as plants. As with pebbles, the mutable effects of pearls lent themselves to naturalistic jewellery. Indeed, some examples mirror the use of agates' variegated patterning in butterfly wings, with round lustrous pearls standing in for the anatomy of spiders: one pearl for the fused head and thorax and a larger one for the abdomen. While the speckled, variegated effects of pebbles mimicked patterns seen in the animal world, the pearl's animal origins enabled them to stand in for a living thing. Take, for example, a stick pin with the gold talons of an eagle's claw clutching a perfectly spherical pearl in the collections of the Museum of Edinburgh. The pearl represents a creature, or perhaps an egg, snatched by the predatory bird. Seen the other way round, the claw setting was designed to emphasize the animal origins of the pearl. Either way, the design of this object and many others like it reinforces the idea that during the middle decades of the nineteenth century – when materials were used, often playfully, to create clever visual representations of the natural world – the pearl's materiality played a central role in shaping the way in which jewellery was designed and made.

The desire for naturalistic jewellery had its roots in the contemporary drive to understand natural history. That preoccupation with nature can be seen in the founding of the Entomological Society in 1833, and in widely read texts such as Darwin's *Voyage of the Beagle* of 1839, on the flora and fauna of South America, and particularly *On the Origin of the Species*, which proposed theories of evolution that rocked the foundations of knowledge about the natural world after its publication in 1859.[70] These scientific developments quickly entered the realm of popular culture and fashionable consumption, leading the South Kensington Museum to establish an 'Animal Products' collection with objects acquired at the close of the Great Exhibition at 1851.[71] Research on the Great Exhibition has argued that nature's power and industrial strength was put on show through machinery, displayed and celebrated as the source of productive power which, depending on perspective, either belonged to or replaced skilled craftsmen.[72] Nature, then, became something that was valued because of its role in mass-producing luxuries for the growing middle classes, such as the electroplating of silverware, and, in this sense, became a product in its own right.[73] While this argument relates to nature's ability to drive mechanization, it provides a useful way of thinking about the complex layers of meaning embedded in worn things made from animals. Materials like pearls were fragments of rural areas

and imagined 'wild' worlds. But manipulated into jewellery objects they can be understood as symbols of the ability to capture and harness natural energy. In this sense, Scottish freshwater pearls functioned both as wonders of the natural world and as material expressions of humans' power over nature.

The significance of the natural aspect of native pearls can be explored further through the wider fashion for jewellery made from other organic materials from the 1860s on. For example, shells offered a cheaper form of natural matter for making jewellery, but were linked to pearls in that they were made under the water by living creatures.[74] Miniature cowrie shells, known as Groatie Buckies in the north of Scotland and widely considered there to bring luck, were put to use in jewellery in brooches and stick pins. A jeweller in Wick on the northern tip of the Scottish mainland combined the two when in 1882 he copyrighted a flower-type design for a brooch containing six Groatie Buckies set like petals around a central pearl, inside a circular metal setting with the words 'Souvenir John O'Groats' (see Plate 5.7). This particular design is a typical souvenir and declared as such on the piece itself, but other examples from the 1860s onwards show individual cowries adorning brooches and pins. The delicate patterning of the shell's ribbed surface, and its rounded shape and variegated dusky-pink colour, offered a similar aesthetic to pearls but were available at a fraction of the price. As products of sea creatures, pearls and shells were simultaneously embedded with ideas of living things and void of life. Both were materials of water: one freshwater; the other always found in the sea. Both carried associations of rarity along with mystical or supernatural properties, but only the pearl was considered precious and carried a monetary value linked to that status. Though not necessarily easy to come by, these delicate little cowries were more easily sourced than pearls. Picked up on the beach, they were known to be present in particular coastal spots. Finding one required looking closely at the shore, often on hands and knees, by people enjoying the seaside or, as was also clearly the case, collecting them for commercial use by jewellers like Davidson.

The desire for wild things extended to parts of dead animals. In 1869, Inverness jewellers Ferguson Brothers copyrighted a design for 'The Grouse or Ptarmigan Claw, for Brooch, Pin or Eardrops' (see Plate 5.8).[75] The ptarmigan was – and is – a rare white grouse that inhabited Scotland's mountains and was hunted for sport.[76] The copyrighted design is fairly typical in that the claw was usually speared with a stud as a way of affixing the setting on the back. That stud was usually set with a Scottish stone, usually a Cairngorm or amethyst – something linking it to the Scottish mountain environment. They were worn by men and women as

lucky charms, and often commissioned as trophies of a successful shoot. The bird's high altitude habitat and its white winter plumage suggested rarity and a hunter's skill not just in shooting but in navigating the snowy mountainscape to make such a kill. The ptarmigan brooch was essentially the low-brow version of pieces such as a necklace of deer's teeth set in gold, gifted by Prince Albert to Queen Victoria after a Scottish shoot.[77] The use of birds in jewellery was not confined to Scotland, and has a long and rich history but in this period took on new meanings. A famous example by top London jewellers Harry Emanuel saw rows of tiny stuffed hummingbirds set in precious metals as necklaces and earrings, sometimes sold as a set.[78] The hummingbird's glossy, gem-tone plumage shone like precious jewels, but the furry white claw of the ptarmigan operated in an altogether different aesthetic category.[79] Hummingbird jewellery was associated with the 'discovery' of and excitement around the development and dissemination of knowledge about species and environments of South America. Meanwhile, ptarmigans were tied in with ideas of the hilly Scottish landscape as an area of natural diversity and rare species that doubled as a playground for elite pursuits such as hunting and shooting. Taxidermy jewellery was not treasured like objects made from precious materials but functioned as trophies of human power and knowledge linked to the animal world. These objects were not without an element of appreciation and wonder relating to specimens of the living world in difficult or hard-to-reach places, but they were resolutely about humans conquering and controlling the natural and animal world (via science or leisure, or both).

The stuff of the human body, too, provided a key material for jewellery throughout the long nineteenth century, with hair used to memorialize individuals and cement social bonds. As another 'unliving' material, hair had strong mnemonic properties and was often used alongside pearls. In mourning jewellery, hair spoke of an individual while pearls stood in for watery tears. Both symbolized aspects of liminality between this world and 'otherworlds' or the afterlife and, more broadly, of separation and memory. Set together, hair and pearls augmented and amplified each other's mnemonic properties. Numerous examples contain both materials, in an infinite range of forms. One example displays a pearl from Polharrow Burn in the Scottish Borders, suspended within a piece dominated by a thick braid of plaited hair set in a gold and black enamel 'lover's knot' symbolizing eternal bonds (see Plate 5.9). In thinking through the symbolic links between these different types of organic matter it is possible to glimpse a range of makers of jewellery who were not trained through

apprenticeship: pearl fishers and cleaners, hair workers and taxidermists. As we have seen, pearl workers were often women. Similarly, specialist hair work could be done from home and evidence shows that women ran specialist firms, such as Mrs Millar, 'hair artist and jeweller' on George Street in central Edinburgh.[80] Of course, complex subcontracting networks within the jewellery trade were of little interest to most and deliberately disguised from consumers. This was work done by hands that left no trace in the form of marks and stamps hammered into metals, and little in the way of documentary records, making it difficult to link specific makers to objects. But the Polharrow brooch is exactly the kind of piece which holds stories of women's work – outsourced from the jeweller's bench – embedded and disguised within highly crafted precious metals. Taxidermy, too, was associated with feminine handwork, carried out in domestic settings (as well as professionally, usually by men, in commercial workshops). Indeed, books and magazines aimed at women and girls offered instructions on such matters, providing technical guidance on preparing animal parts for accessories such as jewellery and hat ornaments.[81]

The use of these different types of organic matter in jewellery begins to reveal a complex and shifting aesthetic of deadness that was tied in with ideas of loss and memory. In the context of these other materials, it is possible to see how Scottish freshwater pearls fitted with the desire for rural, natural things, and functioned as spectral symbols of an imagined world 'lost' or irrevocably changed in the perceived upheaval caused by industrialization and urbanization. The connections between the living world and imagined otherworlds gave these organic jewels the power to act as deeply sentimental objects, and to function as memory devices linking life, death and afterlife.[82] Furthermore, seen against these other organic or 'soft' forms of matter, it is possible to understand how the 1860s craze for Scottish freshwater pearls originating in the countryside created work in jewellery making outside the male-dominated urban workshop.

Scottish freshwater pearls into the twentieth century

After the sustained period of high demand for Scottish freshwater pearls during the 1860s, the depletion of mussel stocks became a concern, and brought about yet further shifts in the way pearls were perceived and used. An 1889 report repeated the sentiments expressed by Pennant over a century before: 'Unfortunately, the business of pearl-seeking is one that requires the killing of

the goose which lays the golden egg, and therefore the extinction of the Scottish stock of *Mya Margaritifera* [sic] is only a work of time'.[83] Another report of the same year demonstrated how Scottish pearls were embedded with historical associations, highlighting that Julius Caesar was drawn to Britain for pearls in 55 BC; that the twelfth-century Alexander I, King of Scots, was said to have the best pearl collection in the world, and that the gems appeared in two fourteenth-century sources, including a poem entitled, 'The Parl', and a Trade Charter of the Paris Goldsmiths.[84] These symbolic associations with the past were amplified in the context of the threat of loss – loss both of natural sources of Scottish freshwater pearls and of the cultures of craft associated with their transformation from natural to cultural. The concern around extinction must also be seen in the light of growing concerns for the preservation of wildlife and natural beauty, with the founding of the Royal Society for the Protection of Birds in 1889 as just one mark of what had been a growing movement for some time.[85]

Despite the repeated fears of extinction, mussels in Scotland's lochs and rivers continued to provide materials for jewellery into the twentieth century, though evidence suggests attitudes towards pearl fishing were changing. For example, in 1907, an Aberdeen man named R. Webster was interdicted for:

> trespassing on the estates of Aldbar and Kindrochat, and particularly from removing mussels or other shellfish from the Lower South Esk and the Blaikie Mill Lade, and from fishing for pearls in the said river and lade.[86]

Webster had 'been warned and failed to desist from his operations' because 'Shellfish were thrown in heaps on the banks of the river, and in the hot weather they caused a smell. The operations also disturbed the salmon in the stream'.[87] All in all, the report highlighted how 'the pearl fishing was getting somewhat of a nuisance'.[88] The unpleasant smell of rotting shellfish and the relationship between pearl production and salmon stocks is a further reminder of pearl mussels' place in a fragile ecosystem. More widely, the report highlights inherent tensions around the ownership and use of the land as a resource for the production of luxury goods, and as a site of leisure and pleasure. While wearers of pearls associated them with wide open spaces in Scotland, the nature of supply impacted on the experience of those who wished to spend warm days enjoying encounters with wildlife in the countryside.

As stocks and attitudes shifted, so too did the use and meanings of pearls in jewellery. One such change was the increased demand and appreciation for flawed specimens, or pieces which showed a subtle range of colours and shapes

that could not be mistaken for anything but natural gems. The emphasis on natural imperfections was a particular feature of the Arts and Crafts Movement. Contemporary writings provide evidence of the aesthetic value of unusual natural materials such as fossilised shells and 'pearls undeveloped in the shell and misshapen, which nevertheless are peculiarly useful for decorative jewellery'.[89] Surviving artefacts from the turn of the century show that this Arts and Crafts aesthetic influenced the production of pearl jewellery at all levels of the market. James Cromar Watt let tiny silver-tinged seed pearls into the chain of an elaborate necklet containing enamel birds in lush greens and rough turquoise stones in a celebration of natural beauty (see Plate 5.10). The fashion for imperfect natural materials together with the place dimension of freshwater pearls provided commercial opportunities for jewellers across Scotland operating at different levels of the market. In Aberdeen, A. & J. Smith sold a necklace of a single row of Scottish pearls where a large pink-tinged central pearl in an almost heart shape was flanked by smaller pearls with large areas of brown calcification. This was a marked shift from earlier pieces where flaws and flat edges were carefully tucked away in settings. A stylized 'spray' brooch with high-quality lustrous pearls in cream to gold to peach tones around dark green tourmalines, carefully arranged to mimic a floret bouquet, was retailed by W. Marshall & Co. in Edinburgh. Similar examples containing lower quality pearls with imitation diamonds also appeared on the market – a reminder that, while imperfections were valued as markers of nature, the quality and monetary value of pearls remained closely interlinked. Lustrous, shiny pearls were incorporated into high-quality objects while lower-grade matt examples were put to use in cheaper pieces. Well-known makers such as William Robb of Ballater in the Cairngorms region very deliberately chose and set pearls within distinctively Scottish designs, and in such a way as to emphasize their natural origins. A pectoral cross by Robb of *c.*1905 features engraved gripping beasts slithering their way around sixteen pearls (see Plate 5.11). The gems have been carefully graded so that the biggest and whitest dominates at the centre of the cross, with the four studded around all of similar size and a slightly pinkish hue, then variegated peach and pinkish hues running down the centre line to a baby-pink one at the bottom. Tiny seed pearls interspersed between are of a similar size and whitish hue. The effect is one of balance and harmony employed to emphasize difference and variation between the pearls, showing a sensitive understanding of pearls as coloured matter, and as symbols of life and afterlife that fitted with the ancient symbolism of the cross and beasts inspired by archaeological objects and carved stones in the landscape.

Perth was always most closely associated with the quality production of pearl jewellery, partly because of its established craft reputation as well as its location on the banks of the River Tay. The town's reputation in this area became so embedded in the local mindset that a charitable publication of 1907 containing 'literary gems' and 'favourite verses and mottoes' was entitled *Tay Pearls*, a play on the idea of pearls of wisdom.[90] Businesses built their reputations around specialisms in these locally sourced materials. In an advertisement of 1899 David MacGregor & Co. drew particular attention to 'Choice specialities of own Design and Manufacture' including 'ARTISTIC JEWELLERY IN TAY PEARLS'.[91] In 1903, an advertisement emphasized the renowned engraving side of the business and announced new stock for 'the Christmas season', highlighting that 'a speciality of this excellent stock are the numerous articles of jewellery set with perfect Tay pearls'.[92] A surviving necklace by the firm is rare in that its complete biography, and thus details of its original owner and the personal meanings she ascribed to it, are known. It contains tiny freshwater pearls sourced from the River Tay, let into a fine chain of silver and 15 carat gold at the centre of which, worn at the throat, is a faceted lime-green peridot (a highly fashionable stone at this time, probably imported from Egypt) framed with larger, finer, creamy-toned pearls. Two smaller pearl and peridot terminals are suspended from the pendant (see Plate 5.12). The cool but vibrant green stone, warm gold and luminous pearls create an earthy, muted palette that reflected the natural Arts and Crafts aesthetic.

It belonged to a popular young woman, Rhoda Pullar, who married into the well-known and wealthy Pullar family, owners of a successful dyeworks that employed thousands of people locally in the 1890s.[93] A positively gushing newspaper report from 1904, after Rhoda gave birth to a son, described her as 'deservedly popular ... one of the most charming ladies it is possible to imagine ... the community esteem and respect her'.[94] The piece was known as the 'Edna May' necklace, a name applied to this style featuring a pendant with suspended terminals, influenced by the glamorous actress and singer, Edna May Pettie, who had her heyday around 1900. The delicate, girly, 'Edna May' necklace would have marked Pullar out as a stylish and wealthy woman, and the Tay pearls would have been instantly identifiable to local people around her in what was a fairly small city. Reports of fashionable weddings in Perth around this time were punctuated with reports of young brides wearing pearl jewellery, often with information about the design and accompanying stones.[95] This is suggestive of the strong association between pearls, young women, marriage – and by extension the expectation of fertility and new life – at this time, as well as a local culture highly

attuned to pearls and their attendant meanings. Later, Rhoda gifted this piece to a friend with links to the pearl trade who, in turn, saw that it entered the local museum's collections.[96]

Local jewellers advertised pearl jewellery with detailed descriptions of the materials they were placed alongside – usually gold metals and cool, earthy-coloured stones – providing colourful images in the reader's mind. In 1904, A. & G. Cairncross advertised their Christmas specials including: 'fine gold necklaces and pendants set with silver pearls, or pearls and turquoises, or again amethysts and pearls', the latter combination popular on account of another influential woman, this time Queen Alexandra, who had been 'reviving a new reign of life to the amethysts'.[97] The mention of 'silver pearls' partly explains this use of blue, green and purple. Cool-coloured stones set off pearls that were on the greyish side of off-white – as Scottish freshwater pearls often were – whereas warmer tones could make them look dull. This colour matching was an important part of the jeweller's repertoire when making pearl pieces. Yellow metals were often used, lending warmth to silver-toned pearls and cool stones. Seen the other way round, the pearls' lustre was enhanced by this blending of coloured materials. The careful consideration of colour in the making of pearl jewellery points to aspects of the makers' skill and knowledge in creating desirable objects. Visual sensitivity and a knowledge of materials was required to grade and sort pearls along the lines of colour and shape, and to set them in such a way that their imperfections were enhanced to create an overall effect that was appealing to the eye. This was a specialism and a skill in its own right. It required time and practise and a learned sensory knowledge of materials.

While jewellers were skilled in adapting designs to enhance the physical properties of lower-grade pearls, there was always a demand for superior specimens and a continued fascination with their origins. Particularly good finds appeared in the newspapers, such as a 'MAGNIFICENT EARN PEARL' discovered in the River Earn in Perthshire and exhibited in the Perth shop of Mr A. F. Dalgleish in 1906: 'The pearl is of a brilliant hue, weighs 21 ½ grains, and is almost perfect in form.'[98] In 1902 a newspaper report outlining 'Some Valuable Finds' observed that 'There are probably few industries more interesting or exciting than pearl fishing, and the lordly waters of the River Tay have long been noted as being the resting place of many rare and valuable pearls.'[99] This allusion to death through the mention of 'resting place' demonstrates the continued association between pearls and ideas about afterlives. The same report described pearls of 'transparent white, pink and salmon' (an interesting link between

colour and the fish found in the same environments) and mentioned that 'some magnificent examples have recently been exhibited in the window of Mr R. F. Macaulay, jeweller, Scott Street, Perth … of the well-known pea size, and perfect in colour and symmetry'. It was noted that rising prices demonstrated 'the value in which some of these beautiful specimens of the deep are held' and that their rarity meant that 'European Royalties' were 'continually forming necklets of them, although on account of their rarity it often takes many years to complete such an ornament to the fair sex'.[100]

The long process of creating these stranded pearl necklaces meant that some nineteenth-century examples were not completed until the inter-war period. In 1935, a local newspaper reported that 'a remarkable pearl necklace', forty years in the making, and 'containing 79 beautifully graded gems, all from the bed of the River Tay' was displayed in the premises of A. & G. Cairncross.[101] The report put the value of the necklace was put at £1200, and explained that it had taken four decades of 'patient search and matching to complete'. The story of the piece was traced back to the river, decades previous:

> Pearl fishers with their little glass-bottomed boxes have been searching the bed of the Tay since about 1894 for the gems which go to make up the necklet. As the years have passed many of the gems included have been displaced as more perfect pearls were brought in, until now the necklace has assumed almost perfect proportions.[102]

This emphasis on order and proportion indicates that the pearls were graduated by size, with the largest ones at the centre, but there is no mention of colour. The age and life cycle of the piece is discussed in detail, with its history teased out back to the first half of the nineteenth century:

> Some of the gems may be more than 100 years old, for when they were acquired 40 years ago they had already been over half a century in the shell of the fresh-water mussel.[103]

Layered on to this double-sided fascination with the necklace as a result of its age and flawlessness was a comment that rooted the overarching value of the piece in place. This 'collection of gems strung on a slender thread' was described as 'one of the most remarkable pearl necklets in the country, for the pearls, everyone of them, have come from one river–the Tay'.

This story of the Tay necklace encapsulates all of the various stages of the pearls' transformation from natural to cultural. The focus is on the skill and expertise of the jeweller in sorting and grading pearls according to weight,

size, and shape to achieve symmetry and balance in pursuit of perfection. The long gestation period inside the mussel was matched by the slow process of assemblage and adaptation over many decades. The finished necklace can be understood as an important marketing device in that it represented the jeweller's fount of knowledge in Scottish freshwater pearls and, in turn, materialized the strong and long-standing ties between the firm and the local area. The report emphasized the long life cycle of the necklace and rooted its beginnings firmly in the nineteenth century, referencing the dominant narratives that emerged around them during that period. In this sense, the necklace offers a way of thinking about the processes by which a distinctly nineteenth-century desire for native materials came to define the identity of particular firms and shaped the reputation of the jewellery craft in different towns at the time and for generations to come. The rarity and preciousness (inseparable from monetary value) of pearls gave meaning to particular places, and not just to scenic 'rural' landscapes but to towns associated with established specialisms in the production of pearl jewellery. The reputations of individual firms and jewellers in various towns orbited around interlinked aspects of materiality, place and specialist skill. Indeed, the proximity of pearl sources and, in turn, the development of craft specialisms in Perth can be understood as playing a key role in shaping the skills and knowledge of individual jewellers – and their relationships with their materials – in a way that continued across the period. Perth, and indeed the Cairncross business, firmly remains the home of Scottish pearl jewellery to this day. The report itself nodded to the future with a mention that, having finally achieved perfection, 'pearl experts at Cairncross's have begun another necklace; but it's a mere youngster. It has only been on the "go" for seven years'.[104]

Conclusion

This chapter has examined the ways in which producers and consumers perceived the interlinked physical and symbolic properties of Scottish freshwater pearls at different points during the nineteenth century, when supply and demand converged. Scottish freshwater pearls were always employed as markers of wealth, power and status. Their animal origins – which were visible in their imperfections – meant that they were associated with landscape, nature and wildlife, and evoked ideas of wide open spaces, of the passing of time, and of life and afterlife. They were imbued with personal, poignant stories and the emotions

of individuals. As such, they were worn on the body as jewellery to express layered and complex cultural identities. By submerging analysis of production and use in the context of cultural change, this chapter has demonstrated how the meanings of pearls migrated as they moved through geographic and symbolic space on the journey from landscape to body, and mutated across time, in subtle but distinct ways. The material and symbolic transformations of pearls, when seen against the backdrop of cycles of demand and supply, underline the value of a methodology that embraces the ephemeral, the personal and the emotional meanings of things in the study of nineteenth-century craft.

Furthermore, this chapter has illuminated hitherto unrecognized connections between people, places and objects. It has uncovered links between tenants on Scotland's estates and the aristocratic landowning elite that fall outwith the boundaries of existing historical studies, showing rarely seen interactions across class boundaries. It has revealed producers who would otherwise be absent from the historical record, to glimpse the fishers in rural lochs and women who participated in pearl work at home. It has demonstrated the importance of local materials to provincial jewellery firms that built and sustained a reputation for their expertise in this specialist area. And it has highlighted a plethora of skills, from sourcing and retrieving pearls from the water to the delicate work transforming them into ready materials for the jeweller, and from the visual sensitivity required to grade pearls and match colours to the technical and cultural knowledge necessary to design and make fashionable, desirable consumer goods.

The continual recontextualization of these Scottish freshwater pearls draws attention to the evolving processes by which native matter was transformed into meaningful crafted jewellery objects through the interactions between producers and consumers. The regenerative properties of pearls meant supply and demand were interlinked with meaning in a way that we do not see with non-organic matter, whereby periods of relative scarcity were followed by flashpoints of high demand. While overfishing was to blame for periods of scarcity, environmental conditions and natural processes – from dry summers to wider river ecologies – dictated availability for the consumer but, crucially, also shaped the reputations of jewellers and localized sectors of the jewellery craft. Perth was, and remains, a prime example, even today when the endangerment of Scottish freshwater mussels has seen a ban on all pearl fishing. In that sense, the long nineteenth century was a period that cemented the relationship between natural, local landscapes and the image and skills of jewellers in the surrounding area.

Conclusion

'Quite a different thing in the hand': Making as historical process

In Montrose Museum, on the north-east coast of Scotland, there is a large wooden box containing a remarkable collection of stones. Put together by collector and antiquarian Lord Francis Gray of Kinfauns Castle, the collection comprises 875 slivers of polished stone including 'moss agate, cloud agate, onyx, cornelian, avanturine, jasper, eye agate, heliotrope, woodstone, rock crystal, green stone garnet, green opal, and chalcedony'.[1] This assemblage of geological specimens was gathered, sliced up and polished during the early nineteenth century. Sitting in the museum's gallery at a small wooden desk some two centuries later, I spent a day inspecting the hundreds of neatly filed slices of perfectly smooth stone. This process is akin to sorting through slides or glass negatives, squinting at each image and holding it up to the light to reveal the detail. There is an ebb and flow to this kind of material research. Some of the specimens appear from the box in a series where, much like a camera capturing movement in a series of frames, near-identical slices cut from the same stone show molten silica rushing through air bubbles in the rock, converging into rainbows that soar through dark skies, blooming like algae in murky water, bursting into dark flecks like speckled eggs. Others are surprising one-offs. As I peered at each one, I was reminded of the words of the acquisitive Miss Fox in the novel *Marriage,* when she highlights (as discussed in Chapter Four) how pebbles look much better 'in the hand', viewed as specimens rather than as worn jewellery.[2] In doing so, she put her finger on key elements of the relationship between raw matter, mineralogical specimens and crafted objects displayed on the human body.

The story behind Lord Gray's agates further underlines aspects of transformation on the spectrum from natural to cultural. In 1935, *The Scotsman*

reported on the rediscovery of the collection, which had effectively been lost in a 'safe place' in the museum's store for decades, explaining:

> Most of these stones were much more highly prized then than now as Highland jewellery … and the Museum was unable to afford a curator to guard them properly. They were accordingly kept in the strong-room, and presumably were taken out only for the inspection of connoisseurs. In time they were neglected, and ultimately forgotten.[3]

The life cycle of this collection is important in understanding the key parameters of this book, and stretches across the time period considered herein. Its biography begins during the heyday of pebble collecting during the Romantic era, collected by an elite man living in a large castle in Perthshire at the foot of Kinnoull Hill, which was itself considered a productive source of interesting stones. That these museum objects were displayed and then hidden due to risk from thieves underscores the craze for pebble jewellery – as well as the high value and (linked) relative scarcity of authentic, quality specimen-jewels – during the middle decades of the nineteenth century. By the time they were excavated from the strong-room in the 1930s, 'pebble-mania' was well and truly over, but an appreciation for the strength of the collection remained strong and, in addition, its historical value was recognised. Like the flashpoints in the collection's biography, this book hovers around temporal touch points, focusing in and out to give a sense of change and continuity over the long nineteenth century rather than marching through a strict chronology. Those points of focus are guided by the material, honing in where objects and surviving records throw light on jewellers' ways of learning and working, and on the culture that saw the stuff of Scotland's landscapes become a key driver for jewellery making that encompassed a range of skills.

<p align="center">*</p>

The picture that emerges shows up in sharp relief how Scotland's jewellery craft evolved during the period. The jewellery industry as a whole – and the specialist craft sector located therein – grew and adapted during the long nineteenth century.[4] There were also significant shifts in the gender dimension to the workforce, with a higher participation of women by the turn of the twentieth century. And while jewellery making in Scotland's towns was always characterized by small-scale workshop production, it was enmeshed with, but identified itself against, industrial centres in Birmingham and London, as well

as further afield. This overview of the industry alone tells us that this was not a period of shrinkage and decline, or of the loss of skill. Yet there is much more to the story. Peaks and troughs throughout the period point to a high level of dynamism across different arms of the trade at different points in time and, crucially, show up the importance of locality to production.

The genealogical nature of the jeweller's skill created a body of producers that were bound together not just by techniques, materials, tools and markets but by a culture of making and a collective – though complex and mutable – understanding of what it actually meant to be a jeweller. The apprenticeship system created layered ties between masters and apprentices, but knowledge was also shared in a horizontal way, among fellow makers. And while the formal apprenticeship system gradually fell away, it was replaced by more informal, market-led approaches to learning, including the copying and reworking of historical pieces and museum objects. In this way, jewellers came to understand their skill and workmanship as having a historical value that reached beyond formal intergenerational learning mechanisms into a distant craft past materialized by older objects. It is impossible to separate jewellers' engagement with that craft past from the growing consumer demand for jewellery of a historical design aesthetic – this was a circular process whereby jewellers both shaped and responded to demand. Both makers and consumers were embedded in a culture that was preoccupied with ideas of the past at a time of profound change. Notions of the history and venerability of the jewellery craft became more explicit in the second half of the century. It was in this context that forms like the heart brooch, which was commercialized in the late eighteenth century and continually recontextualized thereafter – and was always tied in with aspects of memory – came to take on further layers of temporal meaning, transformed into an emblem of the history of jewellery production in Scotland. The heart brooch, or 'Luckenbooth' as it has been known since the late nineteenth century, remains a popular souvenir of Scotland.

The historical dimension to design that characterized nineteenth-century jewellery internationally somewhat obscures the innovation that came about from the adaptation, reworking and replicating of existing pieces. By stamping design registration marks on their goods, producers materially embedded objects with a mark of originality and authenticity while asserting ownership of their skill and intellectual property. In doing so, they also created an extra layer of marketability in a volatile and highly competitive business environment. Furthermore, the analysis here shows how separating groups of producers

along the lines of their training, with apprentice-trained workshop producers as the old guard and art-school educated designer-makers as the innovators, not only masks commonalities, but obscures understandings of the way in which education in jewellery making was linked across different settings and evolved over time. Workshop jewellers trained through apprenticeship received drawing lessons in design schools that were established early on in Edinburgh and Glasgow (in comparison to later institutions in London). Those same workshop jewellers collaborated with artists and indeed taught them in art schools towards the end of the period.

During the second half of the century – a period which saw a deepened respect for craft skill and a more open, less secretive approach on the part of producers – it is possible to see how jewellers articulated ideas about their workmanship more explicitly. Distinctively Scottish jewellery displayed at international exhibitions, for example, were seen as curious and worthy of comment because they were innovative and ingenious. Through their design, these objects demonstrated a command of materials, tools and technology that stimulated a discussion about the skill, knowledge and creativity of artisans and business owners. Complex designs executed in difficult materials and copies of ancient objects became a way to both drive and showcase workmanship. The changing meanings and values of workmanship brought about shifts in how producers saw themselves and their skill, and how consumers engaged with ideas about production. Thus, through the things they made, jewellers forged an image of their craft that was rooted in ideas of inherited skill, history and quality. The relationship between the craft and older material cultures – and between makers and museums – was key.

<p style="text-align:center">*</p>

Looking through Lord Gray's agate collection today, it is not hard to understand why, during the 1840s, these geological specimens were removed from display in the museum, lest they be pilfered for jewellery. Historians and curators are trained, of course, to recognize and think deeply about matters of subjectivity, to avoid value judgements, to be aware of bias and seek to adjust for it. But it would be dishonest to the point of bizarre to deny that these were – and are – aesthetically interesting objects, things of beauty and wonder that provoke a human response. They are snapshots of mountain-building, of the inner lives of volcanoes and glaciers, of the dark workings of the underland. They represent deep time captured and frozen in your hand. They present and display miniature

pictures. Every day, earth scientists at National Museums Scotland post an image of a Scottish agate on social media. Responses from across the world show how they capture the imagination, with viewers commenting on the pictures they imagine within each stone. People who have looked at the bracelet on the cover of this book volunteered information on what they see in the stones: rock pools, iridescent oily puddles, aerial images of cloudy skies with mountain tops peeping through, contour lines on a topographical map.

Recognizing the ways in which the use and perception of this type of material shifts over time – including today – is important. Ways of seeing and understanding natural materials are and always have been historically contingent, thus opening a window onto the wider cultural context. The production of jewellery using native materials – precious metals, pebbles and Scottish freshwater pearls – came to represent an area of specialist craft knowledge during the nineteenth century not through coincidence, but because of particular social and cultural shifts. A clear pattern can be detected, with these native materials moving away from being associated mainly with elites during the late eighteenth and early nineteenth centuries. Those wealthy, often landed, individuals sought to materialize long-held aristocratic ties to and ownership of the land through these materials, worn on the body. Materializing those landed links on the body also shifted the gaze from imperial and colonial connections, and this particular aspect of the identity work performed by forms of native matter is one which opens up new avenues for future research. The move to a much wider market from around the 1840s did have much to do with the oft-cited royal influence of Queen Victoria, yes, but this was just one of many factors at play. More widely, that shift reflected growing middle-class markets, the demand for novelty, the embracing of new and non-precious materials, and the wider democratization and proliferation of jewellery. And overarching all of this was the development of geological knowledge and the 'opening' up of Scotland – specifically the Highlands – to a wider audience from the later eighteenth century onwards.[5] Where previously, the area had been regarded as 'wild' in the negative sense of the word, from the eighteenth century and through the nineteenth, the north of Scotland came to mean something new to those outside seeking (imagined) visions of an untouched, rugged landscape that encapsulated ideas of timelessness. These materials were fragments of that landscape. In this sense, jewellers played as much a part in shaping ideas of a wild and majestic Scotland as the high culture of Lord Byron's poetry, Felix Mendelssohn's *Hebrides Overture* and Edwin Landseer's picturesque paintings.[6]

The 1860s was undoubtedly a key moment for native materials with the Sutherland gold rush, a new level of achievement and collaboration in working pebbles, and the so-called pearl 'revival'. The exploitation of this raft of natural materials at this particular point in time was, again, not coincidental. Against their earlier use by elites, it is possible to see how the growing middle classes sought to assert ownership of and an emotional attachment or sense of belonging and connection to particular places and landscapes. This was true of locals and visitors to the areas with which different materials were associated, and indeed people who consumed imagined ideas of Scotland from a distance. Seen as part of the longer story, then, the desire for native materials in the second half of the century was not simply a simple case of royal influence and the emulation of elites. It was about a nuanced and shifting cultural preoccupation with the handmade, with landscape and nature, and with past and place that had also do with contemporaries' drive to seek a material and experiential antidote to a rapidly changing world marked by industrialization and urbanization. Linked to this, the turn to native materials in the later nineteenth century was influenced by questions around the British colonial project, the impact of the exploitation of foreign landscapes in pursuit of jewellery materials, and of the perceived impact of the proliferation of foreign goods on the domestic economy. The desire to make visions of Scotland (real and imagined) tangible through jewellery is visible in other areas of culture at this time, for example in artistic depictions of the landscape, in the popularization of scientific ideas through romantic literary geology, the urge to travel and the development of the museum. All of this was intrinsically linked to the dynamism and evolution of the jewellery craft and its various, interwoven strands. While the 1860s was the meeting point where demand for various types of native matter came together, and intersected with a shift in the meanings of workmanship, it is possible to see the more subtle developments over the longer view as these ideas ebbed and flowed in line with wider economic, social and cultural changes.

Despite the industrial and commercial developments during the nineteenth century – and indeed partly as a result of those very developments – local materials and makers outside the main production centres played a critically important role in shaping the cultural meanings of things. It is abundantly clear that the meanings of native materials were inextricably linked to the landscapes in which they were sourced. The ways in which place of origin was articulated in finished goods varied across materials, revealing how the interlinked physical properties and symbolic associations of matter had a direct bearing on how objects were

made and perceived. These findings refute the idea of industrialization as the destroyer of craft and show that it was, in fact, the driving force behind a deeper engagement with hand skill and nature that is perhaps more commonly associated with producers of the early modern period. In tapping in to a cultural desire to engage with the landscape, jewellers played a role not just in maintaining skills but in actively driving the emergence of new and revived areas of craft knowledge. One of the key themes to emerge in this book is the part jewellers played in producing knowledge not just in terms of craft, but in the areas of antiquarianism, geology and natural history. Through jewellery objects, both producers and consumers could interact in a sensory way with local archaeological finds, connect with scientific and romantic ideas about geology and mineralogy, and engage physically and emotionally with the landscape and nature.

Coming back to the present, then, the way we see materials and making now is important. As an object-based study, this book has relied on many a museum collection. Thankfully, evidence of this craft has been preserved, though of course what has survived has been dictated by the shifting interests and agendas of collectors and curators, not to mention the shifting roles and collecting remits of museums. The documentary records help illuminate that which does exist and spotlight the gaps left by now-absent objects. There is great value in working across collections. That is certainly true for the scientific and the social, where insights between natural specimens such as stones or pearl shells can be linked to the jewellery created from them. But it is also the case for collections over time, from ancient objects that stimulated new designs and methods seen in modern collections right up to the present. National Museums Scotland recently added to its collections a ring of Scottish gold from a source discovered deep inside the mountain of Beinn Chuirn in the 1980s. In 2018, that gold vein was finally transformed into commercial products by Edinburgh's Hamilton & Inches Ltd., a company founded in 1886. This newly-mined native gold commanded a higher price because of its rarity and its associations with the Scottish landscape, and now has its own hallmark, certified by the Incorporation to authenticate its source in the Loch Lomond and Trossach's National Park.

Mirroring events during the 1860s Sutherland gold rush, this new chapter for native gold in the twenty-first century stimulated wide press coverage. It generated a collection of goods designed with an eye to the physical and natural environment of the area surrounding the source, from rugged hillsides to waterfalls. It also ignited debates on the environmental impact of such activities – particularly given its location in an area of protected national

park – and the effects on the land itself and the surrounding ecologies. Rather than seeing this as history repeating itself, I would argue that these two 'moments' for Scottish gold are part of the same, longer narrative documenting environmental thinking across the period. Scientists have, in recent decades, proposed that we are now living in the Anthropocene – a new geological epoch in which the geological record has been altered by humans.[7] Some propose the roots of that epoch lie in exactly the period covered by this book, during the rise of industry from the late eighteenth century.[8] Objects like those of Scottish gold that materialize aspects of environmental thinking across this period can, and indeed should, be used to explore the shifting relationship between humans and nature.[9] That relationship was and is bound up with production and consumption. Breaking down the boundaries between collections in this way – specifically by looking through matter and its transformation into consumer goods – can illuminate hitherto unrecognized connections between people and places, and present useful ways of understanding the historically contingent ways in which we engage with the material and natural world.

<div align="center">*</div>

This book set out to open up new ways of looking at the history of material culture by exploring the neglected area of Scotland's jewellery craft during the long nineteenth century, with a focus on the relationship between materials, making processes and the social and cultural meanings of things. The material, visual and symbolic dimensions to jewellery have been addressed throughout by employing a 'craft-based reading' that draws together social, cultural and economic history methods with frameworks drawn from art, design and dress history. Employing this interdisciplinary framework to explore materiality, both the making and wearing of jewellery have been considered as embodied cultural practices throughout. The book looks at the skill of jewellers, the culture of the workshop and ways of learning and making things. It traces materials from their origins in the Scottish landscape through the jewellery workshop and on to the bodies of wearers.

In doing so, this book has presented new methodologies for the study of craft production, by taking a material culture approach that places artefacts firmly in the context of their culture. It builds on studies of materiality to show how the physical and symbolic qualities of matter did not just shape the making and meaning of objects, but had a direct bearing on the skills, identities and perceptions of jewellers. It shows how the mutable meanings of matter in

finished objects were inseparable from the historically contingent values of skill and workmanship. As such, it makes the case that studies of materiality in history must involve a sustained analysis not just of matter and meaning, but seek to deepen understandings of the processes by which things were made – the stage in between and the people who transformed materials from natural to cultural. It also demonstrates the value of taking place and landscape into account, both in relation to the origins and journeys of materials and the locations of different stages of production. As well as throwing light on a hitherto understudied aspect of Scotland's industry – one that was small in size but culturally significant – this study has paved the way for uncovering the links between rural areas and urban production more widely. That is important in providing a corrective to areas of historical enquiry that are dominated by a focus on heavy industry, and in urban centres. More broadly, it complicates the underlying assumption that places which are often considered provincial or rural were peripheral not just geographically but culturally, to show how the materials, trades and consumers in Scotland's countryside played an important role in shaping urban production.

Jewellery is an arc between the landscape and the embodied rituals of daily life. As such, peering into the workshop at the jeweller's craft reveals how contemporaries navigated wider changes and assigned cultural values through the things they made and the ways in which they adorned their bodies. In 1810, the Aberdeen jeweller James Gordon bequeathed to George Roger, his brother-in-law, business partner and former apprentice:

> all my wearing apparel and body linen, a silver watch made by Hugh Gordon, Aberdeen No. 534 which was my Brother Francis's … my Fathers [*sic*] old watch, my Cornelian signet ring with my crest engraved on the stone and my Brother Franc's [*sic*] age on the hoop of it, an antique plane [*sic*] ring.[10]

This fragment of evidence is a useful reminder of the personal and the poignant often hidden within now-lost or -absent objects. It reveals the social dimension to the craft through the multi-stranded master-apprentice, business and family ties between the two men. It underlines the personal temporalities embedded in jewellery objects which, like skills and businesses, were passed down through individuals. It highlights the relationship between clothing and jewellery in the construction of the gendered body, and points to the use of small luxury objects to express cultural identities. Gordon's carnelian signet ring for example, acted as a mark of wealth and status, was an important tool for carrying out the day-to-day business of jewellery and, through the

inscription inside, hidden against his skin, materialized emotional bonds to his brother. Overarching all of this, the list acts as a reminder that the people who made up Scotland's jewellery craft did not operate in a vacuum but were part of their wider culture – they were consumers and wearers of jewellery, too – and were highly attuned to the multifaceted meanings of the things they made and sold. The scholarly study of how raw materials were transformed into deeply meaningful jewellery objects for wear on the body is one that will continue to evolve, as the present continues to shape the way we see the past. By placing producers in cultural context, this book reveals how attending to the materiality of even the smallest of objects can offer new and multifaceted insights into the wider transformations that marked Scotland and Britain during the long nineteenth century.

Notes

Introduction

1 George Smith, *The Statistical Account of Scotland*, Galston, Ayrshire, Volume 2 (Edinburgh: William Creech, 1792), 78.

2 Among the works that have informed this book on these wider changes are: Roderick Floud and Paul Johnson (eds), *The Cambridge Economic History of Modern Britain, Volume 1: Industrialisation, 1700–1860* (Cambridge: Cambridge University Press [hereafter CUP], 2004); Roderick Floud and Paul Johnson (eds), *The Cambridge Economic History of Modern Britain, Volume 2: Economic Maturity, 1860–1939* (Cambridge: CUP, 2004); Alan Kidd and David Nichols (eds), *The Making of the British Middle Class?* (Stroud: Sutton Publishing, 1998); David Cannadine, *Aspects of Aristocracy* (London & New York: Penguin, 1994).

3 Work in this area spans social and economic studies from the 1970s to very recent cultural approaches: Raphael Samuel, 'Workshop of the world: Steam power and hand technology in mid-Victorian Britain', *History Workshop* 3 (Spring, 1977): 6–72; Stana Nenadic, *Craft Workers in Nineteenth Century Scotland: Making and Adapting in an Industrial Age* (Edinburgh: Edinburgh University Press [hereafter EUP], 2021).

4 Glenn Adamson, *The Invention of Craft* (London: Bloomsbury, 2013), xv–xvi.

5 Frank Trentmann, 'Materiality in the future of history: Things, practices, and politics', *Journal of British Studies* 48, no. 2 (2009): 283–387.

6 See Ulinka Rublack, 'Matter in the material renaissance', *Past & Present* 219 (2013): 41–85.

7 T. R. Marshall, *History of Celtic and Scottish Jewellery* (Edinburgh: W. Marshall & Co., 1892); Harry Emanuel, F. R. G. S., *Diamonds and Precious Stones: Their History, Value and Distinguishing Characteristics*, second edition (London: John Camden Hotten, 1867); George Frederick Kunz, *The Curious Lore of Precious Stones* (Toronto & London: J. B. Lippincott Company, 1971 [1913]); George Frederick Kunz and Charles Hugh Stevenson, *The Book of the Pearl: Its History, Art, Science and Industry* (New York: Dover Publications, 2001 [1908]).

8 *The Scotsman*, 6 April 1868.

9 David Bremner, *The Industries of Scotland: Their Rise, Progress, and Present Condition* (Edinburgh: A. & C. Black, 1869), 115.

10 Nenadic, *Craft Workers in Nineteenth Century Scotland*, 212–13.

11 See: Adrian W. B. Randolph, 'Performing the bridal body in fifteenth-century Florence', *Art History* 21, no. 2 (June, 1998): 182–200; Jane Fair Bestor, 'Marriage transactions in Renaissance Italy and Mauss's essay on the gift', *Past & Present* 164 (1999): 6–46; Tessa Storey, 'Fragments from the "life histories" of jewellery belonging to prostitutes in early-modern Rome', *Renaissance Studies* 19, no. 5 (2005): 647–57; Marcia Pointon, 'Material manoeuvres: Sarah Churchill, Duchess of Marlborough and the power of artefacts', *Art History* 32, no. 3 (June, 2009): 485–515.

12 Arjun Appadurai (ed.), *The Social Life of Things: Commodities in Cultural Perspective* (Cambridge: CUP, 1986).

13 Arjun Appadurai, 'The thing itself', *Public Culture* 18, no. 1 (December, 2006): 15–22; Trentmann, 'Materiality in the future of history', 288.

14 Pointon, 'Material manoeuvres', 491–5.

15 Marcia Pointon, 'Materializing mourning: Hair, jewellery and the body', in Marius Kwint, Christopher Breward and Jeremy Aynsley (eds), *Material Memories: Design and Evocation* (Oxford & New York: Berg, 1999); Christiane Holm, 'Sentimental cuts: Eighteenth-century mourning jewellery with hair', *Eighteenth-Century Studies* 38, no. 1 (Fall, 2004): 139–43.

16 Marcia Pointon, *Brilliant Effects: A Cultural History of Gem Stones & Jewellery* (New Haven & London: Yale University Press [hereafter YUP], 2010), 2.

17 Ibid.

18 Jean Arnold, *Victorian Jewelry, Identity and the Novel: Prisms of Culture* (Farnham: Ashgate, 2011), 2.

19 See: John Plotz, 'Discreet jewels: Victorian diamond narratives and the problem of sentimental value', in John Plotz (ed.), *Portable Property: Victorian Culture on the Move* (Princeton: Princeton University Press, 2008), 24–44. See also: Stefanie Markovits, 'Form things: Looking at genre through Victorian Diamonds', *Journal of Victorian Studies* 52, no. 4 (Summer, 2010): 591–619.

20 Igor Kopytoff, 'The cultural biography of things: Commoditization as process', in Appadurai (ed.), *The Social Life of Things*, 64–91; Alfred Gell, *Art and Agency: A New Anthropological Theory* (Oxford: Oxford University Press [hereafter OUP], 1998), 80–1.

21 For a key work in the 'turn' to materiality and a summary of the field, see: Trentmann, 'Materiality in the future of history'. For an exemplary work in this area, see: Rublack, 'Matter in the material renaissance', 41–85.

22 This approach is informed by: Marius Kwint, 'Introduction: The physical past', in Kwint, Breward and Aynsley (eds), *Material Memories*, 1–16. See also: Marius Kwint, 'Introduction: Commemoration and material culture', *Journal of Victorian Culture* 10, no. 1 (2005): 96–100.

23 Marcia Pointon, 'Women and their jewels', in Jennie Batchelor and Cora Kaplan
 (eds), *Women and Material Culture, 1660–1830* (London & New York: Palgrave
 Macmillan, 2007), 16.

24 John Styles, *The Dress of the People: Everyday Fashion in Eighteenth-Century
 England* (New Haven & London: YUP, 2007), 97–107. For the later period and
 an American perspective, see: Vicki Howard, 'A "Real Man's Ring": Gender and
 the invention of tradition', *Journal of Social History* 36, no. 4 (2003): 837–96. For
 a discussion of the need to address jewellery as a form of dress see: Peter McNeil,
 '"Sparks Set in Gold": A new history of jewellery', *Art History* 36, no. 4 (2013): 867;
 Susan North, 'The fusion of fabric and gem: The Costume Society symposium
 2005', *Costume* 40, no. 1 (2006): 1–7; Roland Barthes, 'From gemstones to jewellery',
 in Roland Barthes, *The Language of Fashion* (Oxford & New York: Berg, 2006),
 60–9.

25 Matthew Dziennik, 'Whig tartan: Material culture and its use in the Scottish
 Highlands, 1746–1815', *Past and Present* 217 (November, 2012): 120.

26 Diana Scarisbrick, *Scottish Jewellery: A Victorian Passion* (London: Five Continents
 Editions, 2009); Rosalind K. Marshall and George R. Dalgleish, *The Art of Jewellery
 in Scotland* (Edinburgh: Scottish National Portrait Gallery, 1991); Jane Perry,
 Traditional Jewellery in Nineteenth-Century Europe (London: V&A Publishing,
 2013), 20–40.

27 Judy Rudoe, 'The invention of tradition in Scotland', in Charlotte Gere and Judy
 Rudoe, *Jewellery in the Age of Queen Victoria: A Mirror to the World* (London:
 British Museum Press, 2010), 454–61.

28 Ibid., 7.

29 An exception to this, and a book that has informed my approach throughout is:
 Shirley Bury, *Jewellery, 1789–1910* (Suffolk: ACC Art Books, 1999).

30 Alan McKirdy and Roger Crofts, *Scotland: The Creation of its Natural Landscape, a
 Landscape Fashioned by Geology* (Perth: Scottish Natural Heritage, 2010 [1999]), 5.

31 See: Karin Hofmeester, 'Shifting trajectories of diamond processing: From India
 to Europe and back, from the fifteenth century to the twentieth', *Journal of Global
 History* 8 (March, 2013): 25–9; Jack Ogden, *Diamonds: An Early History of the King
 of Gems* (New Haven & London: YUP, 2018), 317–22.

32 Stana Nenadic, 'Romanticism and the urge to consume in the first half of the
 nineteenth century', in Maxine Berg and Helen Clifford (eds), *Consumers and
 Luxury: Consumer Culture in Europe, 1650–1850* (Manchester: Manchester
 University Press [hereafter MUP], 1999), 215.

33 Iain Mackinnon and Andrew MacKillop, 'Plantation slavery and landowernship
 in the west Highlands and Islands: Legacies and lessons', Land and the Common
 Good: A discussion paper series on land reform in Scotland (Community

Land Scotland, November 2020), https://www.communitylandscotland.org.
uk/plantation-slavery-and-landownership-in-the-west-highlands-and-islands-
legacies-and-lessons/ [accessed 20 December 2020].

34 Simon Schama, *Landscape and Memory* (London: HarperCollins, 1995).

35 Ibid., 7.

36 Charles W. J. Withers, 'Landscape, memory, history: Gloomy memories and the
nineteenth-century Scottish Highlands', *Scottish Geographic Journal* 121, no. 1
(2008): 29–44.

37 James Hunter, *On the Other Side of Sorrow: Nature and People in the Scottish
Highlands* (Edinburgh: Mainstream, 1995), 12–17. The starting point for this is
taken from T. C. Smout, *The Highlands and the Roots of Green Consciousness,
1750–1990* (Edinburgh: Scottish National Heritage, 1993) and later published in
T. C. Smout, *Exploring Environmental History: Selected Essays* (Edinburgh: EUP,
2011).

38 Anne MacLeod, 'The idea of antiquity in visual images of the Highlands and islands'
(Unpublished PhD thesis: University of Glasgow, 2006); Anne MacLeod, *From
an Antique Land: Visual Representations of the Highlands and Islands 1700–1880*
(Edinburgh: John Donald, 2012); Viccy Coltman, *Art and Identity in Scotland: A
Cultural History from the Jacobite Rising of 1745 to Walter Scott* (Cambridge: CUP,
2020).

39 For a case study approach, see: Annie Tindley and Heather Haynes, 'The River
Helmsdale and Strath Ullie, *c.* 1780–*c.* 1820: A historical perspective of societal and
environmental influences on land management', *Scottish Geographical Journal* 130,
no. 1 (2013): 35–50. See also: For work on these ideas in relation to the eighteenth
century, see Fredrik Albritton Jonsson, *Enlightenment's Frontier: The Scottish
Highlands and the origins of Environmentalism* (New Haven & London: YUP, 2013).
See also: Wendy Parkins and Peter Adkins, 'Introduction: Victorian Ecology and
the Anthropocene', *19: Interdisciplinary Studies in the Long Nineteenth Century* 26
(2018): 1–15.

40 See also: John Bonehill, Anne Dulau-Beveridge and Nigel Leask (eds), *Old Ways,
New Roads: Travels in Scotland 1720–1832* (Edinburgh: Birlinn, 2021).

41 Anthony Cooke and Ian Donnachie, 'Aspects of industrialisation before 1850', in
Anthony Cooke, Ian Donnachie, Ann MacSween and Christopher A. Whatley
(eds), *Modern Scottish History 1701 to the Present: Volume 1: The Transformation
of Scotland, 1707–1850* (East Linton: Tuckwell Press, 1998), 133; T. M. Devine,
'Scotland', in Floud and Johnson, *The Cambridge Economic History of Modern
Britain*, Volume 1, 399.

42 Devine, 'Scotland', 400.

43 For more on this argument, see: Stana Nenadic, 'Industrialisation and the Scottish people', in T. M. Devine and J. Wormald (eds), *The Oxford Handbook of Modern Scottish History 1500–2000* (Oxford: OUP, 2011), 406.

44 For an introduction to these works, see: Glenn Adamson (ed.), *The Craft Reader* (Oxford: Berg, 2010).

45 Samuel, 'Workshop of the world', 9.

46 Ibid.; E. P. Thompson, *The Making of the English Working Class* (Harmondsworth: Penguin, 1968 [1963]).

47 See: Janice Helland, Beverly Lemire and Alena Buis (eds), *Craft, Community and the Material Culture of Place and Politics, 19th–20th Century* (Farnham: Ashgate, 2014).

48 For more on the global interconnectedness of different arms of metalworking trades, see: Sarah Laurenson and Stana Nenadic, 'Metal and jewellery', in Stana Nenadic (ed.), *A Cultural History of Craft in the Age of Industry* (London: Bloomsbury Academic, forthcoming 2023).

49 Giorgio Riello, 'Strategies and boundaries: Subcontracting and the London trades in the long eighteenth century', *Enterprise and Society* 9, no. 2 (June, 2008): 243–80.

50 Francesca Carnevali, 'Golden opportunities: Jewelry making in Birmingham between mass production and specialty', *Enterprise & Society* 4, no. 2 (2003): 272–98; Francesca Carnevali, 'Fashioning luxury for factory girls: American jewelry, 1860–1914', *Business History Review* 85 (Summer, 2011): 295–317. See also: Dario Gaggio, 'Pyramids of trust: Political embeddedness and political culture in two Italian gold jewelry districts', *Enterprise & Society* 7, no. 1 (March, 2006): 19–58; Maxine Berg, *The Age of Manufactures, 1700–1820: Industry, Innovation and Work in Britain* (London: Routlege, 1994); Philip Scranton, *Endless Novelty: Specialty Production and American Industrialisation, 1865–1925* (Princeton: Princeton University Press, 1997). For the seminal work on 'flexible specialization', see: Charles F. Sabel and Jonathan Zeitlin, 'Historical alternatives to mass production', *Past and Present* 108 (August, 1985): 133–76.

51 Bremner, *Industries*, 131.

52 Ibid.

53 Ibid.

54 For more on the craft production of silver in these towns, see: George Dalgleish and Henry Steuart Fothringham, *Silver: Made in Scotland* (Edinburgh: National Museums Scotland [hereafter NMS], 2008); Ian Finlay, *Scottish Gold and Silver Work* (London: Chatto & Windus, 1956); Gerard P. Moss and Anthony D. Roe, *Highland Gold and Silversmiths* (Edinburgh: NMS, 1999).

55 See: Joanna Mundy, *A History of Perth Silver* (Perth: Perth Museum and Art Gallery, 1980).

56 There is a wealth of published research on Glasgow's urban development, including: T. M. Devine and Gordon Jackson (eds), *Glasgow: Volume 1, Beginnings to 1830,* (Manchester: MUP, 1995); W. Hamish Fraser and Irene Maver (eds), *Glasgow, Volume 2: 1830–1912* (Manchester: MUP, 1996).

57 Louise Miskell and William Kenefick, '"A flourishing seaport": Dundee harbour and the making of an industrial town, *c.* 1815–1850', *Scottish Economic & Social History* 20, no. 2 (2000): 189; William Kenefick, 'Growth and development of the port of Dundee in the nineteenth and early twentieth centuries', in Christopher A. Whatley, Bob Harris and Louise Miskell (eds), *Victorian Dundee: Image and Realities* (Edinburgh: EUP, 2011), 30–1.

58 For middle-class consumption in Glasgow see: Stana Nenadic, 'The middle ranks and modernisation', in Devine and Jackson (eds), *Glasgow*, 282. For Dundee see: Charles McKean, '"Not even the trivial grace of a straight line"', in Whatley, Harris and Miskell (eds), *Victorian Dundee*, 7.

59 For example: Pamela H. Smith, *The Body of the Artisan: Art and Experience in the Scientific Revolution* (Chicago & London: University of Chicago Press, 2004), 4; Joan Lane, *Apprenticeship in England, 1600–1914* (London: Routledge, 1996), 12, 37, 164.

60 John Rule, 'The property of skill in the period of manufacture', in Patrick Joyce (ed.), *The Historical Meanings of Work* (Cambridge: CUP, 1987), 104. See also: Anne Montenach and Deborah Simonton (eds), *A Cultural History of Work in the Age of Enlightenment* (London: Bloomsbury Academic, 2020).

61 Ibid.

62 Eric Hobsbawm, 'The making of the working class, 1870–1914', in Eric Hobsbawm (ed.), *Worlds of Labour: Further Studies in the History of Labour* (Frome & London: Butler & Tanner Limited, 1984), 194–213.

63 Geoffrey Crossick, 'Past masters: The artisan in European history', in Geoffrey Crossick (ed.), *The Artisan and the European Town, 1500–1900* (London: Routledge, 1997), 11.

64 James Farr, 'Cultural analysis and early modern artisans', in Crossick (ed.), *The Artisan and the European Town*, 56.

65 For an overview of this weakening of guild power in relation to goldsmiths, see: John Forbes, 'Search, immigration and the Goldsmiths' Company: A decline in its powers', in Ian Anders Gadd and Patrick Wallis (eds), *Guilds, Society & Economy in London 1450–1800* (London: Institute of Historical Research, 2002), 115–27.

66 Incorporation, http://www.incorporationofgoldsmiths.org/ [accessed 22 August 2021].

67 Dalgleish and Fothringham, *Silver,* 17.

68 Ibid., 18.

69 Smith, *The Body of the Artisan,* 44.

70 Crossick, 'Past Masters', 13.

71 Ibid., 4.

72 Clive Behagg, 'Secrecy, ritual and folk violence: The opacity of the workplace in the first half of the nineteenth century', in Robert Storch (ed.), *Popular Culture and Custom in Nineteenth-Century England* (London: Croom Helm, 1982), 154–79.

73 Ibid., 171, 174. See also: Adamson, *The Invention of Craft,* xx.

74 Anthea Callen, *Angel in the Studio: Women in the Arts and Crafts Movement, 1870–1914* (London: Schott, 1979); Tony Lesser Wolf, 'Women jewelers of the British Arts and Crafts Movement', *The Journal of Decorative and Propaganda Arts* 14 (Autumn, 1989): 28–45; Elizabeth Cumming, *Phoebe Anna Traquair, 1852–1936* (Edinburgh: Scottish National Portrait Gallery, 1993); Janice Helland, 'Frances Macdonald: The self as Fin-de-Siècle woman', *Woman's Art Journal* 14, no. 1 (1993): 15–22; Janice Helland, *The Studios of Frances and Margaret Macdonald* (Manchester: MUP, 1996); Jude Burkhauser, *Glasgow Girls: Women in Art and Design, 1880–1920* (Edinburgh: Canongate, 2001); Elizabeth Cumming, *Hand, Heart and Soul: The Arts and Crafts Movement in Scotland* (Edinburgh: Birlinn, 2006); Zoe Thomas, *Women Art Workers and the Arts and Crafts Movement* (Manchester: MUP, 2020).

75 Annette Carruthers, *The Arts and Crafts Movement in Scotland: A History* (London & New Haven: YUP, 2013), 73, 149, 166.

76 Crossick 'Past Masters', 1–2.

77 For the key works on consumption, see: Neil McKendrick, 'Introduction', in Neil McKendrick, John Brewer and John Harold Plumb (eds), *The Birth of a Consumer Society: The Commercialization of Eighteenth-Century England* (London: Europa Publications Ltd, 1982), 1–6; Mary Douglas and Baron Isherwood, *The World of Goods: Towards an Anthropology of Consumption* (London: Routledge, 1996); Daniel Miller, *Material Culture and Mass Consumption* (Oxford: Wiley, 1997); Maxine Berg, 'Consumption in the eighteenth and early nineteenth centuries', in Floud and Johnson (eds), *The Cambridge Economic History of Modern Britain*, Volume 1, 357–87.

78 Maxine Berg, *Luxury and Pleasure in Eighteenth-Century Britain* (Oxford: OUP, 2005), 13; Jan de Vries, *The Industrious Revolution: Consumer Behaviour and the Household Economy 1650 to the Present* (Cambridge: CUP, 2008). See also: Maxine Berg, 'The rise and fall of the luxury debates', in Maxine Berg and Elizabeth Eger (eds), *Luxury in the Eighteenth Century* (Baskingstoke: Palgrave Macmillan, 2003), 7–27.

79 See: Helen Clifford, 'Concepts of invention, identity and imitation in the London and provincial metal-working trades, 1750–1800', *Journal of Design History* 12, no. 3 (September, 1999): 252–3; Helen Clifford, 'A commerce with things: The value of precious metalwork in early modern England', in Berg and Clifford (eds), *Consumers and Luxury*, 147–69.

80 Kate Smith, *Material Goods, Moving Hands: Perceiving Production in England, 1700–1830* (Manchester: MUP, 2014); Kate Smith, 'The potter's skill: Perceptions of workmanship in the English ceramic industries, 1760–1800' (PhD thesis, University of Warwick, 2010). On the haptic in relation to craft tools, see: Kate Smith, 'How to? Historical perspectives on tool use', in Ethan Lasser (ed.), *The Tool at Hand* (Wisconsin: The Chipstone Foundation, 2013), 20–5.

81 Pamela H. Smith, 'Making and knowing in a sixteenth-century goldsmith's workshop', in Lissa Roberts, Simon Schaffer and Peter Dear (eds), *The Mindful Hand: Inquiry and Invention between the Late Renaissance and Early Industrialization* (Amsterdam: KNAW Press, 2007), 20–37.

82 Adamson, *The Invention of Craft*, xv–xvi. For a similar argument on craft in relation to industrialization, see: Paul Greenhalgh, 'The history of craft', in Peter Dormer (ed.), *The Culture of Craft* (Manchester: MUP, 1997), 20–52.

83 Ibid.

84 Richard Sennett, *The Craftsman* (London: Penguin, 2009). See also: Christopher Frayling, *On Craftsmanship: Towards a New Bauhaus* (London: Oberon Masters, 2011).

85 Lara Kriegel, *Grand Designs: Labor, Empire and the Museum in Victorian Culture* (Durham & London: Duke University Press, 2007).

86 The approach to recovering production is informed by: Ludmilla Jordanova, *The Look of the Past: Visual and Material Evidence in Historical Practice* (Cambridge: CUP, 2012), 66–74. The method in reading objects is adapted from: Valerie Steele, 'A museum of fashion is more than a clothes-bag', *Fashion Theory* 2, no. 4 (November, 1998): 327–35. Steele's methodology is developed from: Jules David Prown, 'Style as evidence', *Winterthur Portfolio* 15, no. 3 (1980): 197–210; Jules Prown, 'Mind in matter: An introduction to material culture theory and method', *Winterthur Portfolio*, 17, no. 1 (1982): 1–19.

87 For more on this approach see: Karin Dannehl, 'Object biographies: From production to consumption', in Karen Harvey (ed.), *History and Material Culture: A Student's Guide to Approaching Alternative Sources* (London: Routledge, 2009), 133.

88 See: Glenn Adamson, 'The case of the missing footstool: Reading the absent object', in Harvey (ed.), *History and Material Culture*, 192–207; Viccy Coltman, 'Material

culture and the history of art(efacts)', in Anne Gerritsen and Giorgio Riello (eds), *Writing Material Culture History* (London: Bloomsbury, 2015), 17–32.

89 'Editorial Introduction', *The Journal of Modern Craft* 1, no. 1 (March, 2008): 6.

Chapter 1

1 Sennett, *The Craftsman*, ix.

2 Ibid.

3 David Pye, *The Nature and Art of Workmanship* (London: Herbert, 1995), 2.

4 Dugald Stewart, *Elements of the Philosophy of the Human Mind* (London: T. Tegg, 1843), 122.

5 Adamson, *The Invention of Craft*, 127. For more on design schools, see: Celina Fox, *The Arts of Industry in the Age of Enlightenment* (New Haven & London: YUP, 2009); Nenadic, *Craft Workers in Nineteenth Century Scotland*, 70.

6 Ibid.

7 Sarah Laurenson, 'Materials, making and meaning: The Jewellery craft in Scotland, *c.* 1780–1914' (Unpublished PhD thesis: University of Edinburgh, 2017), 43–6.

8 Frayling, *On Craftsmanship*, 79–80.

9 For more on this argument and the case for looking past the rhetoric, see: Adamson, *The Invention of Craft*.

10 See: Rule, 'The property of skill in the period of manufacture', 99–118.

11 See: Bert De Munck and Hugo Soly, '"Learning on the shop floor" in historical perspective', in Bert De Munck, Steven L. Kaplan and Hugo Soly (eds), *Learning on the Shop Floor: Historical Perspectives on Apprenticeship* (Oxford & New York: Berghahn Books, 2007), 4; Christiane Eisenberg, 'Artisans' socialisation at work: Workshop life in early nineteenth-century England and Germany', *Journal of Social History* 24, no. 3 (Spring, 1991): 507–20.

12 Denis Diderot and Jean Le Rond d'Alembert, *Encyclopédie ou Dictionnaire Raisonné des Sciences, des Arts et des Métiers* (Paris: Briasson, 1751–75).

13 Riello, 'Strategies and boundaries', 257.

14 Ibid., 260.

15 Maxine Berg, 'Small producer capitalism in eighteenth-century England', *Business History* 35, no. 1 (1993): 17–39; Carnevali, 'Golden opportunities', 277.

16 John Souter, *The Book of English Trades: And Library of the Useful Arts: With Seventy Engravings* (London: Richard Phillips, 1818), 210–16.

17 Ibid., 216. For more on these structures, see: Berg, 'Small producer capitalism in eighteenth-century England', 17–39; Carnevali, 'Golden opportunities', 277.

18 There has been very little scholarly work on apprenticeships as a form of learning in Scotland, but existing work on the migration patterns of apprentices shows that the records are uneven and incomparable between towns and guilds over time: Ian D. Whyte and Kathleen A. Whyte, 'Patterns of migration of apprentices into Aberdeen and Inverness during the eighteenth and early nineteenth centuries', *Scottish Geographical Magazine* 102, no. 2 (September, 1986): 82. For an overview of recording methods, see: Henry Steuart Fothringham, 'Scottish goldsmiths' apprentices', *The Silver Society Journal* 14 (2002): 79.

19 See: Jane Humphries, 'English apprenticeship: A neglected factor in the first Industrial Revolution', in Paul David and Mark Thomas (eds), *The Economic Future in Historical Perspective* (Oxford: OUP, 2003), 73–102; David Mitch, 'The role of education and skill in the British Industrial Revolution', in Joel Mokyr (ed.), *The British Industrial Revolution: An Economic Perspective*, second edition (Boulder & Oxford: Westview Press, 1999), 241–79; Keith Snell, 'The apprenticeship system in British history: The fragmentation of a social institution', *History of Education* 25 (1996): 303–21.

20 For more on the European picture of a gradual decline and weakening of guilds from 1500, with some survivals past 1800, see: Sheilagh Ogilvie, 'The economics of guilds', *Journal of Economic Perspectives* 28, no. 4 (2014): 169–92.

21 Joan Lane, *Apprenticeship in England, 1600–1914* (London: Routledge, 1996), 12, 37, 164.

22 Adam Smith, *An Inquiry into the Nature and Causes of the Wealth of Nations* (Oxford: Clarendon Press, 1880 [1776]), 128.

23 Ibid., 129–30.

24 Ibid., 130.

25 Discharged indentures were not recorded until 1821 and, even after this date, details are sketchy.

26 National Records of Scotland (hereafter NRS), GD1/482/9, Miscellaneous small collections of family, business and other papers: Records of the Incorporation of Goldsmiths of Edinburgh; Glasgow Goldsmiths Company, 1582–1850; Minute Book, 1805–1820, 296.

27 NRS, GD1/482/10, 235.

28 Ibid. Ages of apprentices are not recorded in all periods; therefore, these dates are used for analysis because they give the most accurate and consistent data.

29 NRS, GD1/482/26, Bundle of indentures and a letter, 1786–1876.

30 Lane, *Apprenticeship in England*, 242.

31 NRS, GD1/482/6, Minute Book, 1768–1790, 227.

32 Ibid., 149.

33 Apprenticeship contracts failed for many reasons including business changes, illness, death and problematic personal relationships: Stana Nenadic, 'The rites, rituals and sites of business, 1650–1820', in Siobhan Talbott and Caitlin Rosenthal (eds), *The Cultural History of Business in the Age of Enlightenment* (London: Bloomsbury, forthcoming), 5–6.

34 NRS, GD1/482/10, 239.

35 Ibid.

36 NRS, GD1/482/9, 53–4.

37 Ibid., 241.

38 Nenadic, 'The rites, rituals and sites of business, 1650–1820', 6.

39 NRS, GD1/482/9, 203.

40 Ibid.

41 Munck and Soly, 'Learning on the shop floor', 5.

42 NRS, GD1/482/9, 203.

43 Ibid., 204.

44 Kate Smith, 'The potter's skill: Perceptions of workmanship in the English ceramic industries, 1760–1800', (PhD thesis, University of Warwick, 2010), 225; Brian Moeran, 'Materials, skills and cultural resources: Onta folk art pottery revisited', *The Journal of Modern Craft* 1, no. 1 (2008): 44.

45 Eisenberg, 'Artisans' socialization at work', 510.

46 Aberdeen City and Aberdeen Archives (hereafter ACAA), DD747, Papers of James Gordon, goldsmith of Aberdeen, 1767–1835: George Roger's indenture, 1766.

47 Ibid. Contract between James Gordon and George Roger, 1777.

48 See: Ben-Amos and Ilana Krausman, 'Failure to become freemen: Urban apprentices in early modern England', *Social History* 16, no. 2 (1991): 155–72.

49 'Robert Keay I', Incorporation, http://incorporationofgoldsmiths.org/evoke/customer/2593/view_form [accessed 8 August 2021].

50 'Robert Keay II', Incorporation, http://incorporationofgoldsmiths.org/evoke/customer/172/view_form [accessed 8 August 2021].

51 NRS, CS280/44/24, Court of Session: Bill Chamber, Processes in concluded sequestrations under 1838 Act, 4 Series, 1839–1879: Concluded Sequestrations, 1st/2nd Divisions, 4th Series, 1858: Robert Keay, Perth, Jeweller Silversmith, 1858, 1.

52 NRS, NG1/1/29 Board of Manufactures – General and Manufacturing records, 1727–1930: Minutes of meetings of the board and its committees, 1727–1907, 21 January 1795–19 December 1798, 29, Memorial from Giacomo Visconti, 11 March 1795.

53 NRS, GD1/482/9, 106.

54 PKCA, MS24/15, Bill from John Blackwood Caw, Edinburgh to Robert Keay, Perth, November–December 1834.

55 PKCA, MS24/135, Letter from Caw, Edinburgh to Keay, Perth, 14 October 1848.

56 PKCA, MS24/15, Note from Caw, Edinburgh to Keay, Perth, November 1834.

57 Pye, *The Nature and Art of Workmanship*, 2.

58 T. Gill, *The Technical Repository; Containing Practical Information on Subjects Connected with Discoveries and Improvements in the Useful Arts*. Illustrated by Numerous Engravings, Volume 2 (London: T. Cadell, 1822), 98. For earlier 'hints' as to combining metals and salts, see: Godfrey Smith (ed.), *The Laboratory, or, School of Arts: Containing a Large Collection of Valuable Secrets, Experiments, and Manual Operations in Arts and Manufactures* (London: H.D. Symonds et al., 1799), 411.

59 PKCA, MS24/135, Letter from Caw, Edinburgh to Keay, Perth, 14 October 1848.

60 Ibid.

61 For example: 'Colouring metals', *The Watchmaker, Jeweller and Silversmith,* 1 June 1875, 6.

62 Gill, *The Technical Repository*, 99–100.

63 Ibid.

64 Ibid.

65 Souter, *The Book of English Trades*, 215.

66 PKCA, MS24/4, Bill from Robert MacGregor, Perth to Keay, Perth, 24 November 1830.

67 PKCA, MS24/2, Letter from William Forrester, London to Keay, Perth, 10 December 1825.

68 PKCA, MS24/2, Letter from Forrester, London to Keay, Perth, 6 January 1826.

69 See: Smith, *The Potter's Skill,* 250.

70 Chris Evans and Göran Rydén, 'Kinship and the transmission of skills: Bar iron production in Britain and Sweden 1500–1860', in Maxine Berg and Kristine Bruland (eds), *Technological Revolutions in Europe: Historical Perspectives* (Cheltenham, UK and Northampton, MA: Edward Elgar, 1998), 198.

71 Smith, *The Potter's Skill*, 242.

72 PKCA, MS24/41, Letter from John Caw, Edinburgh to Keay, Perth, 13 December 1841.

73 PKCA, MS24/111, Letter from John Caw, Edinburgh to Keay, Perth, 13 January 1849.

74 Robert Q. Gray, *The Labour Aristocracy in Victorian Edinburgh* (Oxford: Clarendon Press, 1976), 88–90; R. J. Morris, 'The labour aristocracy in the British class struggle', *Refresh: Recent Findings of Research in Economic and Social History* 7 (Autumn, 1988): 1–4.

75 PKCA, MS24/5, Robert Keay elder and younger papers, 1790–1857: Letter from Alexander Cameron to Robert Keay, 9 April 1830.

76 Ibid. Letter from Alexander Cameron, Dundee to Robert Keay, 9 April 1830.

77 Ibid. Letter from Leonard Urquhart to Keay, 11 June 1830. Note that Urquhart mistakenly dated his April letter to June.

78 *The Dundee Directory for 1837–8*, 14.

79 PKCA, MS24/8, Letter from Charles Gibson, Pitlochry to Keay, Perth, 10 September 1834.

80 See Chapter Three for more on the logistical challenges of high value goods across tricky topographies.

81 Chasing was more likely to be applied to silver goods than jewellery. See: Bremner, *Industries*, 124.

82 'Joseph Pearson', Incorporation, http://incorporationofgoldsmiths.org/evoke/customer/6939/view_form [accessed 9 August 2020].

83 'Engraving', *The Watchmaker, Jeweller and Silversmith,* September 1884, 42.

84 Ibid.

85 Ibid.

86 Ibid.

87 Ibid.

88 Ibid.

89 Ibid.

90 Ibid.

91 'Artificial light', *The Watchmaker, Jeweller and Silversmith,* 1 June 1875, 18.

92 Ibid.

93 Ibid.

94 Ibid.

95 Laurenson, 'Materials, making and meaning', 49, 201.

96 'Lenses', *The Watchmaker, Jeweller and Silversmith,* 1 February 1890, 200.

97 'A new engraving machine', *The Watchmaker, Jeweller and Silversmith*, 5 June 1876, 4.

98 Ibid.

99 Ibid.

100 Ibid.

101 *The Scottish Exhibition of History, Art, and Industry. Official Catalogue* (Industrial Section), (Glasgow: Dalross Limited, 1911).

102 *Evening Telegraph and Post,* 7 April 1909; *Courier,* 8 April 1909.

103 Census of Great Britain, 1851; Census of Scotland, 1861.

104 'David MacGregor', Incorporation, http://incorporationofgoldsmiths.org/evoke/customer/4047/view_form [accessed 16 August 2021]. Note changed spelling – it is common for Scottish surnames to change over time and between branches of the same family.

105 *Perthshire Advertiser and Strathmore Journal,* 6 January 1870.

106 *The Herald,* 5 November 1888.

107 *Evening Telegraph and Post,* 7 April 1909.

108 Census of Scotland, 1901.

109 Dalgleish and Fothringham (eds), *Silver,* 135–9.

110 John H. Young, *Our Deportment, Or the Manners, Conduct and Dress of the Most Refined Society …* (Detroit & St. Louis, Cincinnati & Chicago: F. B. Dickerson & Co., 1881), 76.

111 Cumming, *Hand, Heart and Soul,* 167–8; Carruthers, *The Arts and Crafts Movement in Scotland,* 166.

112 Incorporation of Goldsmiths of the City of Edinburgh, Pirnie pattern books, *c.* 1897–*c.* 1960, n. p.

113 Laurenson, 'Materials, making and meaning', 56.

114 Prior to 1871, married women were categorized under the domestic class.

115 Harriet Martineau, 'An account of some treatment of gold and gems', *Household Words* 12, no. 31 (1852): 63.

116 See: Catherine Waters, *Commodity Culture in Charles Dickens's Household Words: The Social Life of Goods* (London: Routledge, 2008), 89.

117 Carnevali, 'Golden opportunities', 278.

118 Bremner, *Industries,* 372–3.

119 Ibid., 372.

120 Ibid., 123.

121 Ibid., 128.

122 British Parliamentary Papers, *Report of the Commissioners Appointed to Inquire into the Working of the Factory and Workshops Acts, with a View to Their Consolidation and Amendment; Together with the Minutes of Evidence, Appendix, and Index,* Volume 2, C.1443-I (1876), 63.

123 Census of Scotland, 1911.

124 Bremner, *Industries,* 129.

125 Ibid. These wage rates Bremner cited are lower than the 28 to 30 shillings outlined fifty years earlier, in Souter, The Book of English Trades, 216 which probably reflected the situation in London. Low pay in Scotland may also partly explain the draw of London for Edinburgh-trained jewellers.

126 For detail see: Clive H. Lee, 'Scotland, 1860–1939: Growth and poverty', in Floud and Johnson (eds), *The Cambridge Economic History of Modern Britain,* Volume 2, 434–7.

127 Bremner, *Industries,* 129.

128 Laurenson, 'Materials, making and meaning', 52–62.

129 Gray, *The Labour Aristocracy in Victorian Edinburgh,* 95.

Chapter 2

1 Charm consisting of a leaf-shaped flint arrowhead set in an oval crystal container bound with gold, and with a suspension loop, National Museums Scotland, H.NO 75.

2 Matthew Knight, Dot Boughton and Rachel E. Wilkinson (eds), *Objects of the Past in the Past: Investigating the Significance of Earlier Artefacts in Later Contexts* (Oxford: Archaeopress, 2019), 9.

3 Hugh Cheape, 'Charms against witchcraft: Magic and mischief in museum collections', in Julian Goodare, Lauren Martin and Joyce Miller (eds), *Witchcraft and Belief in Early Modern Scotland* (Basingstoke: Palgrave Macmillan, 2008).

4 See: Nenadic, *Craft Workers*, 4, 173–7. For replicas and copies, see: Julie Codell and Linda K. Hughes (eds), *Replication in the Long Nineteenth Century: Re-makings and Reproductions* (Edinburgh: EUP, 2018).

5 See: Gere and Rudoe, *Jewellery in the Age of Queen Victoria*, 330–461; Julia Farley and Fraser Hunter (eds), *Celts: Art and Identity* (London: British Museum Press, 2015), 244–6.

6 Maxine Berg, 'From imitation to invention: Creating commodities in eighteenth-century Britain', *Economic History Review* 55, no. 1 (2002): 3; Clifford, 'Concepts of invention, identity and imitation in the London and provincial metal-working trades, 1750–1800', 253.

7 Frances Collard, 'Historical revivals, commercial enterprise and public confusion: negotiating taste, 1860–1890', *Journal of Design History* 16, no. 1 (January, 2003): 35–48.

8 See: Kriegel, *Grand Designs*, 84.

9 Pat Kirkham, 'Mackintosh and his contemporaries', *Journal of Design History* 1, no. 2 (January, 1988): 147.

10 Charles Holme (ed.), '*Modern Design in Jewellery and Fans*; Special Winter Number of "The Studio" A.D. 1901–1902' (London: The Studio, 1902), 3.

11 Adamson, *The Invention of Craft*, 22.

12 Constance Classen and David Howes, 'The museum as sensescape: Western sensibilities and indigenous artifacts', in Elizabeth Edwards, Chris Gosden, Ruth Phillips (eds), *Sensible Objects: Colonialism, Museums and Material Culture* (London: Bloomsbury Academic, 2006), 202.

13 For more on the symbolism of the heart, see: Sally Holloway, *The Game of Love in Georgian England: Courtship, Emotions & Material Culture* (Oxford: OUP, 2019), 29–31; Lyndsay McGill, 'Scottish Heart Brooches: A Re-evaluation of the Luckenbooth', *Proceedings of the Society of Antiquaries of Scotland* 151 (2022): 223–234.

14 Perry, *Traditional Jewellery in Nineteenth-Century Europe*, 77, 21.

15 Ida Delamer, 'The Claddagh ring', *Irish Arts Review Yearbook* 12 (1996): 181–7.

16 McGill, 'Scottish Heart Brooches', 5.

17 Marshall and Dalgleish, *The Art of Jewellery in Scotland*, 41.

18 George Dalgleish, 'Aspects of Scottish-Canadian material culture', in Peter E. Rider and Heather McNabb (eds), *Kingdom of the Mind: How the Scots Helped Make Canada* (Montreal: McGill-Queens University Press, 2014), 128.

19 For the chronology in relation to evolving geographic specificity, see: McGill, 'Scottish Heart Brooches'.

20 Marshall and Dalgleish, *The Art of Jewellery in Scotland*, 41.

21 Robert Rose, George Watson and Alexander Fraser, *The Statistical Account of Scotland*, Inverness, Inverness, Volume 9 (Edinburgh: William Creech, 1793), 628.

22 Marcia Pointon, '"Surrounded with Brilliants": Miniature portraits in eighteenth-century England', *The Art Bulletin* 83, no. 1 (March, 2001): 54–5.

23 Sally Holloway, 'Romantic love in words and objects during courtship and adultery *c.* 1730 to 1830' (Unpublished PhD thesis: Royal Holloway, 2013), 80. See also: Hanneke Grootenboer, *Treasuring the Gaze: Intimate Vision in Late Eighteenth-Century Eye Miniatures* (Chicago: University of Chicago Press, 2013).

24 Marcia Pointon, 'Intriguing jewellery: Royal bodies and luxurious consumption', *Textual Practice* 1, no. 3 (1997): 494.

25 Pointon, '"Surrounded with Brilliants"', 55.

26 Dalgleish, 'Aspects of Scottish-Canadian material culture', 125.

27 NMS, H.1994.15.1-29, 'Volume of pencil drawings for Highland dress accoutrements, possibly from Mackenzie, a jeweller of Inverness, *c.* 1890–1900'.

28 The most contentious of these essays is: Hugh Trevor-Roper, 'The invention of tradition: The Highland tradition of Scotland', in Eric Hobsbawm and Terence Ranger (eds), *The Invention of Tradition* (Cambridge: CUP, 1983), 15–42.

29 Dziennik, 'Whig tartan', 119.

30 Gere and Rudoe, *Jewellery in the Age of Queen Victoria*, 458.

31 See: 'Purchases for the museum', in *Proceedings of the Society of Antiquaries of Scotland*, 1 December 1884, 10. Marshall and Dalgleish, *The Art of Jewellery in Scotland*, 41.

32 See: Peter Wilson's drawing book: Inverness Museum and Art Gallery, INVMG.1973.062.

33 John Kresten Jespersen, 'Originality and Jones' The Grammar of Ornament of 1856', *Journal of Design History* 21, no. 2 (June, 2008): 143; Owen Jones, *The Grammar of Ornament* (London: Day & Son, 1856).

34 For a detailed discussion of the often liberal and unspecific use of the word 'Celtic', see: Farley and Hunter (eds), *Celts*.

35 Joseph Anderson and James Drummond, *Ancient Scottish Weapons: A Series of Drawings by the Late James Drummond; with Introduction and Descriptive Notes by Joseph Anderson* (Edinburgh: G. Waterston & Sons, 1881), 24.

36 British Parliamentary Papers, Report from the Select Committee on the School of Design; Together with the Proceedings of the Committee, Minutes of Evidence, Appendix, and Index, no. 576 (1849), 155.

37 Marshall and Dalgleish, *The Art of Jewellery in Scotland*, 41.

38 Kriegel, *Grand Designs,* 52–85.

39 The National Archives (TNA), BT43/1/78454, BT43/1/78456 and BT43/1/78632.

40 TNA, BT 43/10/114233, James Robertson, Registered design for a 'Skeandhu' brooch, 16 July, 1858.

41 For more on Burn Anne, see: Introduction.

42 Kriegel, *Grand Designs,* 84.

43 Great Exhibition, 1851, *The Art Journal Illustrated Catalogue: The Industry of All Nations, 1851* (London: Virtue, 1851), 219.

44 'The great exhibition', *Illustrated London News,* 6 September 1851.

45 Ibid.

46 Ibid.

47 *The Scotsman*, 12 August, 1862.

48 Jack Ogden, 'Revivers of the lost art: Alessandro Castellani and the quest for precision', in Susan Weber Soros and Stefanie Walker (eds), *Castellani and Italian Archaeological Jewelry* (New Haven & London: YUP, 2004), 185.

49 Ibid.

50 Gere and Rudoe, *Jewellery in the Age of Queen Victoria,* 460.

51 Elizabeth McCrum, 'Irish Victorian jewellery', *Irish Arts Review* 2, no. 1 (Spring, 1985): 18–21. For the reception of archaeology at international exhibitions, see: Amara Thornton, 'Exhibition season: Annual archaeological exhibitions in London, 1880s–1930s', *Bulletin of the History of Archaeology* 25, no. 2 (2015): 1–18.

52 See, for example: Illustration of a brooch copyrighted by G. M. Crichton of Edinburgh alongside 'Old Norse' jewellery in, Robert Dudley, *A Memorial of the Marriage of HRH Albert Edward Prince of Wales and HRH Alexandra Princess of Wales … The Various Events and the Bridal Gifts …* (London: Vincent Brooks, Day & Son, 1867).

53 For more on archaeological engagement in Ireland, see: Tara Kelly, 'Products of the Celtic Revival: Facsimiles of Irish Metalwork and Jewellery, 1840–1940' (Unpublished PhD thesis: Trinity College Dublin, 2013); Tara Kelly, 'Specimens of modern antique: Commercial facsimiles of Irish archaeological jewellery, 1840–1868', in Stephen Walker (ed.), *The Modern History of Celtic Jewellery 1840–1980* (Andover & New York: Walker Metalsmiths, 2013), 23–33.

54 See: Illustration of three 'Rogart' brooches discovered in Sutherland during the building of the railway, and displayed at an exhibition in 1871, in *Proceedings of the Society of Antiquaries of Scotland* 8 (1868–70), 305–10, plate XVI.

55 Cadboll is, confusingly, a place in Easter Ross, not in the county of Sutherland where the pieces were found (Rogart) or the gold was sourced (Kildonan).

56 In a remarkable survival, Naughten's Design Registry paperwork for his new versions of the brooch survives in the pattern book of his fellow producers, the ever-watchful Fraser, Ferguson & MacBean.

57 For discussions on the creation of concepts of authenticity, see: Sally Foster, 'Replication of things: The case for composite biographical approaches', in Julie Codell and Linda K. Hughes (eds), *Replication in the Long Nineteenth Century*, 23–45.

58 See: TNA, Design Registry: Peter Westren of Edinburgh, 1864, BT43/1/175929; James Robertson of Edinburgh, 1870, BT43/2/242076; Peter Westren of Edinburgh, 1867, BT43/2/209417; James Robertson of Edinburgh, 1871, BT43/2/259054. For more on replication of the Iona Cross, see: Sally Foster and Sian Jones, *My Life as a Replica: St John's Cross, Iona* (Oxford: Windgather Press, 2020), 92, 94.

59 For more on the business environment for small firms, see: Nenadic, 'The small family firm in Victorian Britain', 88–90.

60 For more on international exhibitions in Scotland, see: Stana Nenadic, 'Exhibiting India in nineteenth-century Scotland and the impact on commerce, industry and popular culture', *Journal of Scottish Historical Studies* 34, no. 1 (2014): 67–89.

61 *Edinburgh International Exhibition of Industry, Science and Art, Edinburgh, 1886* (Edinburgh, 1886).

62 *The Scotsman*, 15 October 1886.

63 Ibid.

64 Ibid.

65 Ibid.

66 *Aberdeen Weekly Journal*, 5 May 1886.

67 *The Scotsman,* 23 April 1888.

68 *The Scotsman,* 5 July 1888.

69 Ibid.

70 Ibid.

71 Janice Helland, 'Benevolence, revival and "fair trade": An historical perspective', in Helland, Lemire and Buis (eds), *Craft, Community and the Material Culture of Place and Politics*, 125–42; Stana Nenadic, 'Gender, craftwork and the exotic', in Deborah Simonton, Marjo Kaartinen, and Anne Montenach (eds), *Luxury and Gender in European Towns, 1700–1914* (London: Routledge, 2015), 150–67. See also the chapter on 'Human showcases', in Paul Greenhalgh (ed.), *Ephemeral Vistas: the Expositions Universelles, Great Exhibitions and World's Fairs, 1851–1939* (Manchester: MUP, 1988), 82–111.

72 Lara Kriegel, 'The pudding and the palace: Labor, print culture, and imperial Britain in 1851', in Antoinette M. Burton (ed.), *After the Imperial Turn: Thinking with and through the Nation* (Durham, NC: Duke University Press, 2003), 237–8.

73 Nenadic, 'Gender, craftwork and the exotic', 150–67.

74 Helland, 'Benevolence, revival and "fair trade"', 125–6, 134–7.

75 *The Scotsman*, 30 July 1869.

76 *The Inverness Directory, 1873–74.*

77 Ibid.

78 Ibid.

79 Classen and Howes, 'The museum as sensescape', 201. For a similar approach to eighteenth-century workshop tours, see: Smith, *Material Goods, Moving Hands*, 49–60.

80 Alice Blackwell, Martin Goldberg and Fraser Hunter, *Scotland's Early Silver: Transforming Roman Pay-Offs to Pictish Treasures* (Edinburgh: NMSE, 2018), 84–93.

81 Sally Foster, Alice Blackwell and Martin Goldberg, 'The legacy of nineteenth-century replicas for object cultural biographies: Lessons in duplication from 1830s Fife', *Journal of Victorian Culture* 19, no. 2 (2014): 149.

82 For more on the Tara brooch, see: Susan Young, *The Work of Angels: Masterpieces of Celtic Metalwork, 6th–9th Centuries AD* (London: British Museum Publications, 1989), 77; Kelly, *Products of the Celtic Revival*, 69–73.

83 Farley and Hunter, *Celts,* 244.

84 For more on the history of the firm, see: Laurenson, 'Materials, making and meaning', 88–90.

85 For detail on the difficulties of recreating ancient detailed granulation in filigree, see: Ogden, 'Revivers of the lost art', 185.

86 Jack Ogden, *Age and Authenticity: The Materials and Techniques of Eighteenth and Nineteenth Century Goldsmiths* (Birmingham: National Association of Goldsmiths, 1999), 7.

87 Bremner, *Industries,* 363.

88 Marshall, *History of Celtic and Scottish Jewellery.*

89 Ibid., 11.

90 For example: Emanuel, *Diamonds and Precious Stones*; Kunz, *The Curious Lore of Precious Stones*; Kunz and Stevenson, *The Book of the Pearl.*

91 Marshall, *History of Celtic and Scottish Jewellery*, 21.

92 'The goldsmiths' art. From the earliest times', *The Watchmaker, Jeweller and Silversmith*, 5 July 1875, 27.

93 George Wallis, 'Jewellery', *The Watchmaker, Jeweller and Silversmith*, 5 October 1878, 45.

94 Alessandro Castellani, 'Antique jewellery and its revival', *The Watchmaker, Jeweller and Silversmith*, 5 January 1878, 154.

95 Ibid., 155.

96 'The electrotyping process', The Metropolitan Museum of Art, http://www.metmuseum.org/metmedia/video/collections/esda/electrotyping-process [accessed 8 August 2021].

97 Society of Antiquaries of Scotland (SAS), UC 17/467 Internal Manuscripts: Letter from Thomas R. Marshall, Edinburgh to the Council of the Society of Antiquaries of Scotland, Edinburgh, 8 February 1893.

98 Ibid.

99 Laurenson, 'Materials, making and meaning', 89–90.

100 See: Wolf, 'Women jewelers of the British Arts and Crafts Movement', 40–5.

101 Ibid.

102 Fra Newbery, 'Foreword', in Peter Wylie Davidson (ed.), *Educational Metalcraft: A Practical Treatise on Repoussé, Fine Chasing, Silversmithing, Jewellery, and Enamelling, Specially Adapted to Meet the Requirements of the Instructor, the Student, the Craftsman, and the Apprentice* (London & New York: Longmans, Green & Co., 1913), n. p.

103 Ibid.

104 Carruthers, *The Arts and Crafts Movement in Scotland*, 266.

105 Davidson, *Educational Metalcraft*, 40, 43.

106 Ibid., 89.

107 E. Mairi Macarthur, *Iona Celtic Art: The Work of Alexander and Euphemia Ritchie* (Isle of Iona: New Iona Press, 2008), 21.

108 *The Art Journal* (London: William Clowes & Sons, Ltd, 1907), 318.

109 MacArthur, *Iona Celtic Art*, 23.

110 Katherine Haldane Grenier, '"Public acts of faith and devotion": Pilgrimages in late nineteenth century England and Scotland', in Ailsa Clapp-Itnyre and Julie Melnyk (eds), '*Perplext in Faith': Essays on Victorian Beliefs and Doubts* (Newcastle upon Tyne: Cambridge Scholars Publishing, 2015), 153. For emotional responses to historic sites in England, see: Peter Mandler, '"The wand of fancy": The historical imagination of the Victorian tourist', in Breward Kwint and Aynsley (eds), *Material Memories*, 131–2.

111 Grenier, '"Public acts of faith and devotion"', 155, 162.

112 Katherine Haldane Grenier, '"Missions of benevolence": Tourism and charity on nineteenth-century Iona', in Benjamin Colbert (ed.), *Travel Writing and Tourism in Britain and Ireland* (London & New York: Palgrave Macmillan, 2012), 117.

113 Ibid., 22.

114 Foster and Jones, *My Life as a Replica,* 17.

115 For similar ideas about the perceptions of matter that came out of the ground, as applied to archaeology, see: Nicolas Saunders, 'The cosmic earth: Materiality and mineralogy in the Americas', in Nicole Boivin and Mary Ann Owoc (eds), *Soil,*

Stones and Symbols: Cultural Perceptions of the Mineral World (London: UCL Press, 2004), 123–42.

116 Esther Leslie, 'Souvenirs and forgetting: Walter Benjamin's memory-work', in Kwint, Breward and Aynsley (eds), *Material Memories*, 116, 118. For Benjamin's ideas on commodities as modern relics, see: Walter Benjamin, 'The work of art in the age of mechanical reproduction', in Hannah Arendt (ed.), *Illuminations* (London: Penguin, 2015), 211–44.

Chapter 3

1 Helen Clifford, 'Gold and the rituals of life', in Helen Clifford (ed.), *Gold: Power and Allure* (London: The Goldsmiths' Company, 2012), 127.

2 Timothy Green, 'London – the world's gold market', in Clifford (ed.), *Gold: Power and Allure,* 76.

3 Neil D. L. Clark, *Scottish Gold: Fruit of the Nation* (Glasgow: Neil Wilson Publishing Ltd in conjunction with The Hunterian, University of Glasgow, 2014).

4 Blackwell, Goldberg and Hunter, *Scotland's Early Silver*, 3–6.

5 *The Traveller's Guide; or, a Topographical Description of Scotland and of the Islands Belonging to It* (Edinburgh: J. Fairburn, 1798), 3–4.

6 Clifford (ed.), *Gold: Power and Allure*; Clark, *Scottish Gold.*

7 Withers, 'Landscape, memory, history', 29–44.

8 These ideas are guided by: Plotz, *Portable Property*, 24–44; Susan Stewart, *On Longing: Narratives of the Miniature, the Gigantic, the Souvenir, the Collection* (Durham, NC: Duke University Press, 1992), 70–9.

9 See: Clarke, *Scottish Gold*, 21–7.

10 For more on David Allan's romanticized depictions of this industrial activity, see: Mike McKiernan, 'David Allan, lead processing at Leadhill, pounding the Ore *c.* 1786', *Occupational Medicine* 66, no. 5 (July, 2016): 349–50.

11 John Duncan, *The Statistical Account of Scotland, Alva, Stirling*, Volume 18 (Edinburgh: William Creech, 1796), 141.

12 Ibid.

13 Ibid., 145.

14 B. C. Skinner, 'A contemporary account of the royal visit to Edinburgh, 1822', *Book of the Old Edinburgh Club* 31 (1962): 65.

15 Walter Scott, *Hints Addressed to the Inhabitants of Edinburgh, and Others, in Prospect of His Majesty's Visit by an Old Citizen* (Edinburgh: Bell & Bradfute, 1822), 16.

16 Ibid., 26.

17 Ibid., 27.

18 Laurenson, 'Materials, making and meaning', 44. For a similar spike in demand
 for textiles, see: Sally Tuckett, 'Weaving the nation: Scottish clothing and textile
 cultures in the long eighteenth century' (Unpublished PhD thesis: University of
 Edinburgh, 2010), 41, 199.

19 NRS, GD112/74/652/16, Papers of the Campbell Family, Earls of Breadalbane
 (Breadalbane Muniments), 1306–20th century: Additional Papers from the
 Taymouth Estate Office, 1428: Accounts relating to Breadalbane's expenses in
 Edinburgh during visit of George IV, mostly clothing bills, 1822: Bill from Marshall
 & Sons, 13 August 1822.

20 Scott, *Hints*, 16.

21 NRS, GD112/18/1/5/21, Papers Relating to Mines and Minerals, 1628–20th
 century: Papers concerning limequarries of Lochearn and gold and silver mines
 there, 1810–60.

22 NRS, GD112/18/1/5/21, Report of the Lochearnhead Mines Gold and Silver,
 Perthshire made by George Henwood Sept 1860. Pyrite or 'fool's gold' has since
 been noted in the area, raising questions as to the veracity of these earlier reports
 on the presence of gold. Today, Scotland's only commercial gold mine operates in
 the Breadalbane area.

23 Kate Mackay, 'A new perspective on the Coille-Bhraghad silver mines', *Paragraphs:
 The Neil Munro Society Journal* 30 (Winter, 2011): 13–14. For more on this source,
 see: Stan Lockhart, 'Coille-Bhraghad silver mines, Inveraray', *Paragraphs: The Neil
 Munro Society Journal* 29 (Spring, 2011): 10–11.

24 See: 'Millidge & Son', Incorporation, http://incorporationofgoldsmiths.org/evoke/
 customer/3932/view_form [accessed 17 April 2015].

25 Mackay, 'A new perspective on the Coille-Bhraghad silver mines', 13–14.

26 Bremner, *Industries*, 118.

27 Another modern electrotype replica is held by National Museums Scotland,
 H.NGB 12.

28 For similar ideas about the perceptions of matter that came out of the ground, as
 applied to archaeology, see: Saunders, 'The cosmic earth', 123–42.

29 NRS, GD1/970/3, Miscellaneous small collections of family, business and other
 papers: Papers of James Campbell, Schoolmaster at Helmsdale, 1852–1913: 3, Letter
 to an unnamed aunt, 2 September 1869. For a contemporary report on the geology
 of the area in relation to gold, see: J. M. Joass, 'Notes on the Sutherland gold-field,
 with an introduction by Sir Roderick I. Murchison, Bart., K.C.B, F.R.S, V.P.G.S',
 Proceedings of the Geological Society 67 (June, 1869): 314–26.

30 Clark, *Scottish Gold*, 33–8.

31 NRS, GD1/970/3, 43, To Robert Naughten, 27 November 1869.

32 Jon Thomas and David Turnock, *A Regional History of the Railways of Great Britain: The North of Scotland*, Volume 15 (Penryn: Atlantic British Publishers, 1989), 247.

33 Annie Tindley, *The Sutherland Estate, 1850–1920* (Edinburgh: EUP, 2010), 19–21.

34 Tindley and Haynes, 'The River Helmsdale and Strath Ullie, *c.* 1780–*c.* 1820', 46.

35 For an overview of the earlier consolidation of the Sutherland estate with large areas of land in England, see: Eric Richards, *The Leviathan of Wealth: The Sutherland Fortune in the Industrial Revolution* (London: Routledge, 2006).

36 James Hunter, *Set Adrift Upon the World: The Sutherland Clearances* (Edinburgh: Birlinn, 2015); T. M. Devine, *The Scottish Clearance: A History of the Dispossessed, 1600–1900* (London: Penguin, 2019).

37 Withers, 'Landscape, memory, history': 39. For more on the clearances and memory, see: Hunter, *On the Other Side of Sorrow*, 23–7.

38 Green, 'London', 78–9.

39 *The Herald*, 13 February 1869.

40 Clark, *Scottish Gold,* 34.

41 Ibid., 36.

42 NRS, GD1/970/3, 15, To Robert Naughten, 28 September 1869.

43 Ibid., 20, 2 October 1869.

44 Ibid., 32, 6 November 1869.

45 Clark, *Scottish Gold,* 34.

46 *John O' Groat Journal*, 27 May 1869.

47 For more on the Victorian democratization of the three-piece suit, see: Christopher Breward, *The Suit: Form, Function and Style* (London: Reaktion Books, 2016), 20. Also known as a 'boutonniere', the stick pin evolved into the tie pin during the twentieth century. For more see: Umberto Angeloni, *The Boutonniere: Style in One's Lapel* (New York: Rizzoli International Publications, 1999).

48 NRS, GD1/970/3, 15, To Robert Naughten, 28 September 1869.

49 Ibid., 33, 06 November 1869.

50 Ibid.

51 Ibid., 36, 11 November 1869.

52 For detail on the relationship between topography and transport, see: Sarah Laurenson, 'Material landscapes: The production and consumption of men's jewellery during the Scottish gold rush of 1869', *History of Retailing and Consumption* 2, no. 2 (July, 2016): 129–42.

53 For letters renewing subscription, see: Ibid., 117, 22 June 1870; 127, 9 September 1870; 153, 1 December 1870.

54 *Illustrated London News,* 20 May 1869.

55 For more on the deliberate alteration and exaggeration of Scottish scenery since the late eighteenth century, see: Schama, *Landscape and Memory*, 467–8.

56 Nenadic, 'Romanticism and the urge to consume', in Berg and Clifford, *Consumers and Luxury,* 215. So eager were these tourists to experience the sublime in untouched landscapes that they barely registered the poverty, famine and evictions experienced in the Highlands.

57 See: Kwint, 'Introduction', in Kwint, Breward and Aynsley (eds), *Material Memories,* 1–16.

58 John Francis Campbell, *Something from the Gold Diggings in Sutherland,* (Edinburgh: Edmonston and Douglas, 1869), 2.

59 Ibid., 4.

60 Ibid., 5.

61 Ibid., 9.

62 Ibid., 17.

63 Ibid., 19.

64 Ibid., 12.

65 Ibid., 25.

66 Ibid., 21.

67 NRS, GD1/970/3, 52, To Robert Naughten, 9 December 1869.

68 Ibid., 50, 8 December 1869.

69 Ibid., 21, 2 October 1869.

70 Ibid., 20, 2 October 1869.

71 For more on urban men's consuming practices in the later nineteenth century, see: Christopher Breward, *The Hidden Consumer: Masculinities, Fashion and City Life 1860–1914* (Manchester: MUP, 1999).

72 Diana Scarisbrick, *Rings: Symbols of Wealth, Power and Affection* (London: Thames and Hudson, 1993), 167–8.

73 Ibid.

74 Similarly, invoking custom and tradition was key to legitimizing new practices in men's jewellery: Howard, 'A "Real Man's Ring"', 838–40.

75 Eric Richards, 'Gower, George Granville Leveson-, first Duke of Sutherland (1758–1833)', in Matthew and Harrison (eds), *ODNB* online.

76 See also Chapter Two.

77 Drawing book of P. G. Wilson, Inverness Museum and Art Gallery, INVMG.2000.041.

78 John Stuart, *Sculptured Stones of Scotland,* Volume 2 (Aberdeen: Spalding Club, 1867). Many thanks to Sally Foster for directing me to this source.

79 Possibly incorporating the 'Ederton' and 'Barrochan' standing stones in an earlier volume of the same publication Ibid., Volume 1 (Aberdeen: Spalding Club, 1856).

80 Jack Saxon, *The Story of the Kildonan Gold Rush of 1868* (Caithness: Caithness Field Club, 1992), n. p.

81 *Inverness Courier,* 28 October 1869.

82 Ibid., 11 March 1869.

83 Ibid.

84 See Chapter Two.

85 *Inverness Courier,* 28 October 1869.

86 Ibid.

87 Ibid.

88 NRS, GD1/970/3, 16, To James MacPherson, 28 September 1869.

89 Ibid., 21, 2 October 1869. Unfortunately, there is no record of the ring in the surviving records of the Incorporation of Goldsmiths of the City of Edinburgh.

90 *Inverness Courier,* 16 April 1869.

91 See Chapter One.

92 Many thanks to Dr Helen Clifford for her insights into mixing native gold with recycled and imported gold in Wales.

93 NRS, GD1/970/3, 28, To James MacPherson, 23 October 1869.

94 Ibid., 23 October 1869.

95 Ibid., 45, 30 November 1869.

96 *Inverness Courier,* 2 September 1869.

97 Laurenson, 'Materials, making and meaning', 48–9.

98 NMS, H.1991.54.2 Advertising card for the 'The union brooch', 1893.

Chapter 4

1 John Ruskin, 'On the distinctions of form in silica', in E. T. Cook and Alexander Wedderburn (eds), *The Works of John Ruskin* (London: George Allen, 1906), 373.

2 Ibid., 374.

3 Scarisbrick, *Scottish Jewellery*, 18–19; Gere and Rudoe, *Jewellery in the Age of Queen Victoria*, 454–81.

4 John E. Gordon and Matt Baker, 'Appreciating geology and the physical landscape in Scotland: From tourism of awe to experiential re-engagement', *Geological Society, London, Special Publications* 417 (January, 2015): 25.

5 Ibid., 27–30.

6 Jeremy Burchardt, *Paradise Lost: Rural Idyll and Social Change Since 1800* (London & New York: I.B. Tauris, 2002), 123.

7 Matthew Forster Heddle (au.) and John George Goodchild (ed.), *The Mineralogy of Scotland* (Edinburgh: David Douglas, 1901); H. G. Macpherson, *Agates* (London: The Natural History Museum, London & National Museums Scotland, Edinburgh, 1989); Roy E. Starkey, *Crystal Mountains: Minerals of the Cairngorms* (Bromsgrove: British Mineralogy Publications, 2014); Nick Crawford, *Scottish Pebble Jewellery: It's*

[*sic*] *History and the Materials from Which It Was Made* (Kingsdown: Lapidary Stone Publications, 2008).

8 I am grateful to Dr John Faithfull of the Hunterian for his discussions on the changing usage of the word 'pebble' in scientific and popular contexts.

9 Macpherson, *Agates*, 5.

10 See: Andrea Feeser, Maureen Daly Goggin and Beth Fowkes Tobin (eds), *The Materiality of Color: The Production, Circulation and Application of Dyes and Pigments, 1400–1800* (London: Routledge, 2012). This chapter is also underpinned by: Diana Young, 'The colours of things', in Christopher Tilley et al. (eds), *The Handbook of Material Culture* (London: Sage, 2006), 173–85; Diana Young, 'Mutable things: Colours as material practice in the northwest of South Australia', *Journal of the Royal Anthropological Institute* 17, no. 2 (June, 2011): 356–76.

11 Edmund de Waal, *The White Road: A Pilgrimage of Sorts* (London: Chatto & Windus, 2015).

12 National Records of Scotland (NRS), GD248/58/1/1, Papers of the Ogilvy family, Earls of Seafield (Seafield Papers), *c.* 1205–1971: Grant Correspondence: Many letters on local politics, Aug–Dec 1780: Letter from Lady Agatha Drummond Home to Sir James Grant, Edinburgh, 22 August 1780.

13 Ibid.

14 Ibid. Grant's efforts are noted in his own hand on the original letter.

15 NRS, GD248/58/1/94 Letter from James Grant, the clerk, Castle Grant, to Sir James Grant, 26 September 1780.

16 *Caledonian Mercury*, 3 May 1780.

17 John MacCulloch, *The Highlands and Western Isles of Scotland*, Volume 1 (London: Longman, Hurst, Rees, Orme, Brown and Green, 1824), 405.

18 Ibid.

19 Andrew Tod (ed.), *Elizabeth Grant of Rothiemurchus: Memoirs of a Highland Lady* (Edinburgh: Canongate, 1988 [1911]), 108.

20 Ibid., 145–6.

21 *Inverness Journal and Northern Advertiser*, 19 July 1816, 4.

22 For more on Major-General David Stewart of Garth and Highland dress, see: Rosie Waine, *Highland Style: Fashioning Highland Dress, c. 1745–1845* (Edinburgh: NMSE Publishing Ltd, 2022), 77–83. There are examples of military garments with cairngorm buttons, such as a tartan mess waistcoat coat in the collections of National Museums Scotland (M.1970.1.3).

23 Anne MacLeod, 'The Highland landscape: Visual depictions, 1760–1883', in Martin MacGregor and Dauvit Broun (eds), *Mìorun Mòr nan Gall, 'The great ill-will of the Lowlander'? Lowland Perceptions of the Highlands, Medieval and Modern* (Glasgow: University of Glasgow, 2009), 129, 147. See also: MacLeod, *From an Antique Land*, 33.

24 Walter Scott, *Old Mortality* (Harmondsworth: Penguin, 1975 [1816]), 171.

25 For more on souvenirs, see: Stewart, *On Longing*, 70–9.

26 MacCulloch, *The Highlands and Western Isles of Scotland*, 405.

27 Viccy Coltman, 'Portable knick-knacks or the material culture of travel', in Bonehill, Beveridge and Leask (eds), *Old Ways, New Roads*, 174.

28 The set of six agate buttons worn by Robert Burns. National Trust for Scotland, 3.4004.a-f.

29 Margaret M. Mackay (ed.), *The Rev. Dr. John Walker's Report on the Hebrides of 1764 and 1771* (Edinburgh: John Donald, 1980), 197.

30 Ibid., 199.

31 Ibid.

32 James Lapslie, *The Statistical Account of Scotland*, Campsie, Stirling, Volume 15 (Edinburgh: William Creech, 1795), 328.

33 Sir John Sinclair, *The Statistical Account of Scotland*, Penicuik, Edinburgh, Volume 17 (Edinburgh: William Creech, 1796), 625.

34 George Smith, *The Statistical Account of Scotland*, Galston, Ayrshire, Volume 2, (Edinburgh: William Creech, 1792), 78.

35 Lewis Dunbar, *The Statistical Account of Scotland*, Kinnoull, Perth, Volume 18 (Edinburgh: William Creech, 1796), 560.

36 'Topography and natural history of Scotland', *The Scots Magazine, or, General Repository of Literature, History and Politics* 58 (Edinburgh: James Watson & Company, 1796), 43–4.

37 Ibid. This material, known as 'graphic granite' with a distinctive texture resembling ancient text from Portsoy was probably widely known about after Hutton described it in his writings.

38 Timothy Green, 'London – the world's gold market', in Clifford (ed.), *Gold*, 77.

39 Laurenson, 'Materials, making and meaning', 205.

40 Ibid., 84–5.

41 Ibid., 49–50.

42 See: 'Lunetier', in Denis Diderot and Jean Le Rond d'Alembert (eds), *Encyclopédie ou Dictionnaire Raisonné des Sciences, des Arts et des Métiers*, Volume 6 (plates) (Paris, 1767). For more detail on this images, see: R. Charleston, 'Wheel-engraving and -cutting: some early equipment', *Journal of Glass Studies* 6 (1964): 83–100; R. J. Charleston, 'Wheel-engraving and -cutting: Some early equipment – II water-power and cutting', *Journal of Glass Studies* 7 (1965): 41–54.

43 John Mawe, *Familiar Lessons on Mineralogy and Geology … to Which Has Been Added a Practical Description of the Use of the Lapidary's Apparatus* (London: John Mawe, 1826 [1819]), 103.

44 Ibid., 102.

45 See: Russell W. Belk, 'Collecting as luxury consumption: effects on individuals and households', *Journal of Economic Psychology* 16, no. 3 (1995): 477–90.

46 Rosalind K. Marshall and George R. Dalgleish, *The Art of Jewellery in Scotland*, 42.

47 Robert Jameson, 'On the topaz of Scotland', in *Memoirs of the Wernerian Natural History Society* 1 (Edinburgh: The Wernerian Natural History Society, 1811), 446.

48 Ibid., 447.

49 Starkey, *Crystal Mountains,* 18.

50 See: Henry Witham, *Observations on Fossil Vegetables, Accompanied by Representations of Their Internal Structure as Seen through the Microscope* (Edinburgh: W. Blackwood, London: T. Cadell, 1831). Witham's account was later disputed, with more emphasis on Sanderson's role, in: William Nicol, 'Observations on the structure of recent and fossil coniferae', *Edinburgh New Philosophical Journal* 16 (1834): 137–58.

51 Susan Ferrier, *Marriage* (Oxford: OUP, 1997 [1818]), 377.

52 Ibid., 379.

53 Ibid., 380.

54 NRS, GD224/131/9, Papers of the Montague-Douglas-Scott Family, Dukes of Buccleuch, 1165–1947: Family Correspondence and Testamentary Papers, Etc, 1707–1848: copy will and codicils of Elizabeth, Dowager Duchess of Buccleuch and Queensberry, 25–6, 28. For more on elite women, collecting and craft, see: Freya Gowrley, 'Gender, craft and canon: Elite women's engagements with material culture in Britain, 1750–1830' (Unpublished PhD thesis: University of Edinburgh, 2016), 211.

55 Kate Smith, 'Sensing design and workmanship: The haptic skills of shoppers in eighteenth-century London', *Journal of Design History* 25, no. 1 (2012): 3.

56 Nenadic, 'Romanticism and the urge to consume', 209.

57 Marina Bianchi, 'Collecting as a paradigm of consumption', *Journal of Cultural Economics* 21, no. 4 (1997): 275–89.

58 Hugh Miller, *The Cruise of the Betsey, or a Summer Holiday in the Hebrides, with Rambles of a Geologist, or Ten Thousand Miles Over the Fossiliferous Deposits of Scotland*, ninth edition (Edinburgh: William P. Nimmo, 1872 [1857]), 149.

59 Simon J. Knell and Michael A. Taylor, 'Hugh Miller: Fossils, landscape and literary geology', *Proceedings of the Geologists' Association* 117 (2006): 87.

60 Elizabeth Gaskell, *Cranford* (Leipzig: B. Tauchnitz, 1867 [1851]), 139.

61 Hamish H. Johnston, *Matthew Forster Heddle: Mineralogist and Mountaineer* (Edinburgh: National Museums Scotland Enterprises, 2015), copyright page.

62 Ibid.

63 Charlotte Gere, *Love and Art: Queen Victoria's Personal Jewellery* (London: Royal Collection Trust, 2012), 12.

64 Ibid., 14.

65 G. W. Yapp, 'Scotch pebble, amber, and granite work', in *Art Industry Metal – Work …* (London: Virtue, 1878).

66 Bremner, *Industries*, 128.

67 Ibid.

68 Ibid.

69 Ibid. 'Rotten-stone' is a natural abrasive used for polishing.

70 Ibid., 129.

71 *The Scotsman*, 7 July 1884.

72 Ibid.

73 Ibid.

74 Ibid.

75 *The Watchmaker, Jeweller and Silversmith,* 5 December 1877, 130.

76 Ibid.

77 *The Scotsman*, 7 July 1884.

78 Isobel Armstrong, *Victorian Glassworlds: Glass Culture and the Imagination 1830–1880* (Oxford: OUP, 2008), 1.

79 Ibid.

80 Ibid., 255, 261.

81 For more on colour as a way of representing movement in anthropological theory, see: Young, 'Mutable things', 363–71.

82 Armstrong, *Victorian Glassworlds*, 255.

83 For detail on the number of firms and workers, see: Laurenson, 'Materials, making and meaning', 217.

84 A large number of objects from Alexander Begbie's workshop are held by NMS, mainly under accession lot H.QVA.

85 Bremner, *Industries*, 130.

86 Aymer Vallance, 'Modern British jewellery & fans: British section', in Holme, (ed.), *Modern Design in Jewellery and Fans*, 1.

87 Ibid.

88 Ibid.

89 Cumming, *Phoebe Anna Traquair*, 36; Carruthers, *The Arts and Crafts Movement in Scotland,* 164–5.

90 See: Karin Leonhard, 'Painted gems. The color worlds of portrait miniature painting in sixteenth- and seventeenth-century Britain', *Early Science and Medicine* 20, no. 4–6 (December, 2015): 439.

91 Henry H. Cunynghame, *European Enamels* (London: Methuen and Co., 1906), 173. For more on Lady Gibson Carmichael see: Katherine Prior, 'Carmichael, Thomas David Gibson, Baron Carmichael (1859–1926)', in Matthew and Harrison (eds), *ODNB* online.

92 Cumming, *Phoebe Anna Traquair*, 36.

93 Cumming, *Hand, Heart and Soul*, 150. See also: Carruthers, *Arts and Crafts Movement in Scotland*, 285; Aberdeen Art Gallery, *A Vivid and Individual Art: Enamels by James Cromar Watt* (Aberdeen: Aberdeen Art Gallery, 1992), 4–5.

94 For evidence of this firm, which was successful and operated branches in London and Edinburgh, see: Laurenson, 'Materials, making and meaning', 220.

95 Carruthers, *Arts and Crafts Movement in Scotland*, 15. See also: James Cromar Watt, *Examples of Greek and Pompeian Decorative Work* (London: B. T. Batsford, 1897).

96 For Watt's practice-based research, see: AAGM, ABDAG008643, Examples of granulated gold work, James Cromar Watt, *c.* 1880–1900.

Chapter 5

1 Thomas Pennant, *A Tour of Scotland 1769*, fourth edition (London: Benjamin White, 1776), 88.

2 Ann Skinner, Mark Young and Lee Hastie, 'Ecology of the freshwater pearl mussel', in *Conserving Natura 2000 Rivers Ecology Series no. 2* (English Nature: Peterborough, 2003).

3 W. H. Dall, 'Pearls and pearl fisheries', *The American Naturalist* 17, no. 6 (June, 1883): 582–3.

4 Fred Woodward, *The Scottish Pearl in Its World Context* (Edinburgh: Diehard, 1994), 11.

5 See: Kunz and Stevenson, *The Book of the Pearl*; Kirstin Joyce and Shellei Addison, *Pearls: Ornament and Obsession* (London: Thames & Hudson, 1992); Beatriz Cadour-Sampson and Hubert Bari, *Pearls* (London: V&A Publishing, 2013).

6 Ernest Marwick, *The Folklore of Orkney and Shetland* (Bristol: Batsford, 1975), 26.

7 Kunz and Stevenson, *The Book of the Pearl*, l61; Clarke, *Scottish Gold*, 66.

8 For more on Mary Queen of Scots and pearls, see: Kunz and Stevenson, *The Book of the Pearl*, 453.

9 Nicholas Saunders, 'Biographies of brilliance: Pearls, transformations of matter and being, *c.* AD 1492', *World Archaeology* 31, no. 2 Special Edition: The Cultural Biography of Objects (October, 1999): 247.

10 Kunz and Stevenson, *The Book of the Pearl*, 163.

11 Ibid., 253.

12 For historical studies on light and surface effects, see: Grant McCracken, *Culture and Consumption: New Approaches to the Symbolic Character of Consumer Goods and Activities* (Bloomington: Indiana University Press, 1998), 31–43; Mikkel Bille and Tim Flohr Sørensen, 'An anthropology of luminosity', *Journal of Material Culture* 12,

no. 3 (2007): 263–84; Nicholas P. Maffei and Tom Fisher, 'Historicizing shininess in design: Finding meaning in an unstable phenomenon', *Journal of Design History* 26, no. 3 (2013): 231–40. On pearls specifically, see: Saunders, 'Biographies of brilliance'; Natasha Eaton, 'In search of pearlescence: Pearls, empire and obsolescence in South Asia', *Journal of Material Culture* 21, no. 1 (2016): 29–58.

13 Maffei and Fisher, 'Historicizing shininess in design', 231. See also: Antje Krause-Wahl, Petra Löffler and Änne Söll (eds), *Materials, Practices, and Politics of Shine in Modern Art and Popular Culture* (London and New York: Bloomsbury, 2021).

14 Woodward, *The Scottish Pearl in Its World Context,* 11.

15 For an interesting discussion of pearls and diamonds, see: Pointon, 'Intriguing jewellery', 504; Pointon, 'Material manoeuvres', 489.

16 See: Arnold, *Jewelry, Identity and the Novel*, 11.

17 See: Pointon, 'Intriguing jewellery', 506.

18 Kunz and Stevenson, *The Book of the Pearl*, 35; Pointon, *Brilliant Effects*, 301.

19 Ibid., 163.

20 Pointon, 'Intriguing Jewellery': 497.

21 NRS, GD224/1040/83/3/1–5, Papers from the Secretary's Office: Accounts, Financial and Miscellaneous Papers, 1386–1922: Letters from Alpin McAlpine, Killin to Walter, Duke of Buccleuch, 1833.

22 NRS, GD112/29/76/1, Miscellaneous Receipts, 1545: Receipt by John Deor, 'Merchant in Killin' to Lady Glenorchy for £16 paid for 'Scots pearls sold and delivered', 11 January 1765. The pearls were purchased from a number of individuals in Killin and Callander.

23 NRS, GD112/11/1/4/99/1, Letter from James Bruce of Kinnaird, Kinnaird House, to the Hon Colin Campbell of Carwhin, 26 March 1786. Alpin McAlpine's father was also named Alpin McAlpine.

24 NRS, GD112/11/10/6/3, Petitions from Tenants and Others, 1716–1862: Petition of Alpine McAlpin, Killin, 1839. The letter most likely refers to the Royal Celtic Society, founded in 1820.

25 NRS, GD112/11/10/6/3, Petition of Alpin McAlpin, Killin, 1839. The Highland Society of London was founded in 1816. There is no surviving record of McAlpine in the Society's manuscript collection: NLS Dep. 268, Records of The Highland Society of London: Box 5, Correspondence & c.

26 NRS, GD224/1040/83/1, Letter from Alpin McAlpine, Killin to Walter, Duke of Buccleuch, 1 January 1833.

27 Ibid.

28 Ibid.

29 Walter Scott, *Rob Roy* (Oxford: OUP, 1998 [1817]).

30 NRS, GD224/1040/83/2, Letter from Alpin McAlpine, Killin to the Duchess of Buccleuch, 1 January 1833.

31 For more on these personal connections to the Buccleuch family, see: Robert Mayer, *Walter Scott and Fame: Authors and Readers in the Romantic Age* (Oxford: Oxford University Press, 2017), 30–2.

32 NRS, GD224/1040/83/3, Letter from Alpin McAlpine, Killin to Walter, Duke of Buccleuch, 30 January 1833.

33 NRS, GD224/1040/83/2.

34 Ibid.

35 NRS, GD170/2515/1, Papers of the Campbell Family of Barcaldine, 1539–1961: Letter from Alpin Macalpin to Sir Duncan Campbell of Barcaldine, 1st b.t., 1832–1833, 1 May 1832. Note the spelling of McAlpine/McAlpin varies across sources.

36 For detail on the Breadalbane and Barcaldine connections, see: Stana Nenadic, *Lairds and Luxury: The Highland Gentry in Eighteenth-Century Scotland* (Edinburgh: John Donald, 2007), 21.

37 McCracken, *Culture and Consumption*, 32.

38 Ibid., 35.

39 Ibid.

40 'Pearl Fishing in Scotland', *The Scotsman*, 7 December 1863.

41 Ibid.

42 Ibid.

43 'The Scotch Pearl Fishery: A Pearl Fishes [sic]', *The Scotsman*, 14 December 1863.

44 Kunz and Stephenson, *The Book of the Pearl*, 163.

45 Ibid.

46 Ibid.

47 See: John Bonehill and Nigel Leask, 'Picturesque prospects and literary landscapes', in *Old Ways, New Roads*, 147–65.

48 See: William Leighton Leitch, *Loch Tay and Ben Lawers*, 1844. Pencil, watercolour and bodycolour, 25.0 × 38.0 cm. RCIN 919663.

49 'The Scottish Pearl Fishery', *Penny Illustrated Paper*, 31 August 1867.

50 Ibid.

51 Ibid.

52 Ibid.

53 *The Watchmaker, Jeweller and Silversmith*, 5 October 1878, 52.

54 Ibid.

55 Ibid.

56 Census of Scotland, 1861.

57 British Parliamentary Papers, *Report of Her Majesty's Commissioners for the Paris Universal Exhibition of 1878, to the Queen's Most Excellent Majesty,* Volume 1, C.2588 (1880), 250.

58 Ibid.

59 For cultured pearls, see: Kiyohito Nagai, 'The history of the cultured pearl industry', *Zoological Science* 30, no. 1 (December, 2013): 783–93.

60 *The Watchmaker, Jeweller and Silversmith*, 1 October 1887.

61 *The Scotsman*, 4 July 1866.

62 Ibid., 6 August 1866.

63 Ibid.

64 *The Scotsman*, 14 December 1863.

65 Pointon, 'Women and their jewels', 12; Pointon, 'Intriguing jewellery', 499.

66 Edwina Ehrman, *The Wedding Dress: 300 Years of Bridal Fashions* (London: V&A Publishing, 2011), 65. For more on pearls and weddings in the period, see Ibid., 23, 85.

67 For similar objects, see: Clare Philips, *Jewels and Jewellery* (London: V&A Publishing, 2000), 78.

68 Stana Nenadic and Sally Tuckett, *Colouring the Nation: The Turkey Red Printed Cotton Industry in Scotland c. 1840–1940* (Edinburgh: NMS, 2013), 72–3.

69 The 'nabobina' was a term used for the female relations of male East India Company employees known as 'nabobs'. For more on the relationship between nabobinas and luxury goods in the context of imperial debates, see Tillman W. Nechtman, 'Nabobinas – luxury, gender and the sexual politics of British imperialism in India in the late eighteenth century', *Journal of Women's History* 18, no. 4 (Winter, 2006): 8–30.

70 Gere and Rudoe, *Jewellery in the Age of Queen Victoria*, 225.

71 Ibid.

72 Iwan Rhys Morus, 'Manufacturing nature: Science, technology and Victorian consumer culture', *The British Journal for the History of Science* 29, no. 4 (December, 1996): 429.

73 Ibid., 432.

74 For more on shells, see Gere and Rudoe, *Jewellery in the Age of Queen Victoria*, 237–40.

75 Design for 'The Grouse or Ptarmigan Claw for Brooch, Pin or Eardrops', Ferguson Brothers of Inverness, 1869. TNA, BT44/2/231985.

76 For an interesting discussion of a Landseer painting of the 1830s depicting dead, bleeding ptarmigan in a snowy Cairngorm landscape, see: Richard Ormond (ed.), *Monarch of the Glen: Landseer in the Highlands* (Edinburgh: National Galleries of Scotland, 2005), 56.

77 Gere and Rudoe, *Jewellery in the Age of Queen Victoria*, 244.

78 Ibid., 226–9.

79 For an innovative study on materiality of coloured objects using bird feathers, see: Amy Buono 'Crafts of color: Tupi Tapirage in early colonial Brazil', in Feeser, Goggin and Tobin (eds), *The Materiality of Color*, 235–46.

80 *The New Edinburgh, Leith and County Household Directory, 1868–69*, 136.

81 Talia Schaffer, 'Women's work: The history of the Victorian domestic handicraft', in Kyriaki Hadjiafxendi and Patricia Sakreski (eds), *Crafting the Woman Professional in the Long Nineteenth Century: Artistry and Industry in Britain* (London: Routledge, 2016), 35. For earlier examples, see: Deborah Lutz, *The Brontë Cabinet: Three Lives in Nine Objects* (London: W. W. Norton & Company, 2015), 55.

82 For hair jewellery and memory, see Pointon, 'Materializing mourning', 19–57; Pointon, *Brilliant Effects*, 297; Holm, 'Sentimental cuts', 139–43; Gere and Rudoe, *Jewellery in the Age of Queen Victoria*, 120–7; Shu-chuan Yan, 'The art of working in hair: Hair jewellery and ornamental handiwork in Victorian Britain', *The Journal of Modern Craft* 12, no. 2 (2019): 123–39. For a Scottish and collecting perspective on hair jewellery, see Margaret Hunter, 'Mourning jewellery: A collector's account', *Costume* 27, no. 1993 (1993): 9–22.

83 J. G. B., 'Scottish pearls', *The Graphic*, 10 May 1889.

84 A. W. C. H., 'Scottish pearls', *Northern Notes and Queries* 4, no. 14 (1889): 82.

85 These issues had their roots in earlier concerns around land reform and animal rights, but had become a focus in relation to fashion during the 1890s: Hilda Kean, *Animal Rights* (London: Reaktion, 1998), 114–15.

86 *Aberdeen Daily Journal*, 21 June 1907.

87 Ibid.

88 Ibid.

89 Vallance, 'Modern British jewellery & fans', 1.

90 *The Evening Telegraph and Post*, 19 December 1907.

91 *Leslie's Directory for Perth and Perthshire, 1899–1900*, 8.

92 *The Evening Post*, 15 December 1903.

93 John McG. Davies, 'Pullar, Sir Robert (1828–1912)', Matthew and Harrison (eds), *ODNB* online.

94 *The Evening Post,* 11 May 1904.

95 There are numerous examples, including: *The Courier*, 7 July 1904 and 16 July 1908.

96 This information was provided by the donor, who wishes to remain anonymous.

97 *The Evening Post*, 13 December 1904.

98 *The Evening Telegraph,* 12 July 1906.

99 *The Evening Post*, 13 October 1902.

100 Ibid.

101 *The Courier and Advertiser*, 1 October 1935.

102 Ibid.

103 Ibid.

104 Ibid.

Conclusion

1 *The Scotsman*, 25 January 1935.

2 Ferrier, *Marriage*, 377.

3 The *Scotsman*, 25 January 1935. For more on Lord Gray's antiquarian impulse, see: Megan J. Coyer and David E. Shuttleton, *Scottish Medicine and Literary Culture, 1726–1832* (Leiden: Brill, 2014), 218.

4 Laurenson, 'Materials, making and meaning', 35–65.

5 For more on these ideas in relation to the visual, see: McLeod, *From an Antique Land*, 174–6.

6 Patrick Watt and Rosie Waine, *Wild and Majestic: Romantic Visions of Scotland* (Edinburgh: NMSE, 2019), 68–9.

7 Natural History Musuem, 'What is the Anthropocene?', online: https://www.nhm.ac.uk/discover/what-is-the-anthropocene.html [accessed 10 December 2021]; Simon L. Lewis and Mark A. Aslin, 'Defining the Anthropocene', *Nature* 519 (2015): 171–80.

8 Jeremy Davies, *The Birth of the Anthropocene* (California: University of California Press, 2018); Andreas Malm, *Fossil Capital: The Rise of Steam-Power and the Roots of Global Warming* (London: Verso, 2016).

9 Lotte Isager, Line Vestergaard Knudsen and Ida Theilade, 'A new keyword in the museum: Exhibiting the Anthropocene', *Museum & Society* 19, no. 1 (2021): 88–107.

10 ACAA, DD748/3/3.9a-b, James Gordon's will, 28 May 1810.

Bibliography

Manuscript sources

Aberdeen City and Aberdeenshire Archives (ACAA)

DD747, Papers of James Gordon, goldsmith, of Aberdeen, 1767–1835.
DD748, Goldsmiths of Aberdeen, 1740–1886.

Incorporation of Goldsmiths of The City of Edinburgh

Pirnie pattern books, *c.* 1897–*c.* 1960.

National Library of Scotland (NLS)

Dep. 268, Records of The Highland Society of London.

National Records of Scotland (NRS)

Court of Session

CS280/44/24, Court of Session: Bill Chamber, Processes in concluded sequestrations under 1838 Act, 4 Series, 1839–1879: Concluded Sequestrations, 1st/2nd Divisions, 4rth Series, 1858: Robert Keay, Perth, Perthshire, Jewellers silversmith, 1858.

Family papers

GD1/482, Miscellaneous small collections of family, business and other papers: Records of the Incorporation of Goldsmiths of Edinburgh; Glasgow Goldsmiths Company, 1582–1850.
GD1/970, Miscellaneous small collections of family, business and other papers: Papers of James Campbell, Schoolmaster at Helmsdale.
GD112, Papers of the Campbell Family, Earls of Breadalbane (Breadalbane Muniments), 1306–20th century.
GD170, Papers of the Campbell Family of Barcaldine, 1539–1961.
GD224, Papers of the Montague-Douglas-Scott Family, Dukes of Buccleuch, 1165–1947.
GD248, Papers of the Ogilvy family, Earls of Seafield (Seafield Papers), *c.* 1205–1971.

Manufacturing Records

NRS, NG1/1/29, Board of Manufactures – General and Manufacturing records, 1727–1930.

PERTH AND KINROSS COUNCIL ARCHIVES (PKCA)
MS24, Robert Keay elder and younger papers, 1790–1857.

SOCIETY OF ANTIQUARIES OF SCOTLAND (SAS)
UC 17/467 Internal Manuscripts: Letter from Thomas R. Marshall, Edinburgh to the
 Council of the Society of Antiquaries of Scotland, Edinburgh, 8 February 1893.

THE NATIONAL ARCHIVES (TNA), KEW
UK Board of Trade Design Register

Official publications

Census of Great Britain, 1851, *Population Tables II. Ages, Civil Condition, Occupations,
 and Birth-Place of the People: With the Number and Ages of the Blind, the Deaf-
 and-Dumb, and the Inmates of Poorhouses, Prisons, Lunatic Asylums, and Hospitals,*
 Volume II (London: George Edward Eyre and William Spottiswoode, 1854
 [reprinted by Shannon: Irish University Press, 1970]).
Census of Scotland, 1861, *Population Tables and Report, Ages, Civil or Conjugal
 Condition, Occupations, and Birth Places of the People in Scotland: With the Number
 and Ages of the Blind, the Deaf-Dumb, and the Inmates of Poorhouses, Prisons,
 Lunatic Asylums, and Hospitals,* Volume II (Edinburgh: Murray and Gibb, 1864).
*Report from the Select Committee on the School of Design; Together with the Proceedings
 of the Committee, Minutes of Evidence, Appendix, and Index,* no. 576 (1849).
*Report of the Commissioners Appointed to Inquire into the Working of the Factory and
 Workshops Acts, with a View to Their Consolidation and Amendment; Together with
 the Minutes of Evidence, Appendix, and Index,* Volume II, C.1443-I (1876).
*Report of Her Majesty's Commissioners for the Paris Universal Exhibition of 1878, to the
 Queen's Most Excellent Majesty,* Volume I, C.2588 (1880).

Newspapers and periodicals

Aberdeen Daily Journal (Aberdeen)
Aberdeen Journal (Aberdeen)
Aberdeen Weekly Journal (Aberdeen)
Art Journal (London)

Athenaeum (London)
Caledonian Mercury (Edinburgh)
Courier (Dundee)
Courier and Advertiser (Dundee)
Evening Post (Dundee)
Evening Telegraph (Dundee)
Edinburgh Advertiser (Edinburgh)
Graphic (London)
The Herald (Glasgow)
Illustrated London News (London)
Inverness Courier (Inverness)
Inverness Journal and Northern Advertiser (Inverness)
John O'Groat Journal (Wick)
Memoirs of the Wernerian Natural History Society (Edinburgh)
Northern Notes and Queries (Edinburgh)
Penny Illustrated Paper (London)
Perthshire Advertiser and Strathmore Journal (Perth)
Proceedings of the Geological Society (London)
Proceedings of the Society of Antiquaries of Scotland (Edinburgh)
The Scots Magazine, or, General Repository of Literature, History and Politics (Edinburgh)
The Scotsman (Edinburgh)
The Studio (London)
The Watchmaker, Jeweller and Silversmith (London)

Contemporary printed sources

Anderson, Joseph and Drummond, James. *Ancient Scottish Weapons: A Series of Drawings by the late James Drummond; with Introduction and Descriptive Notes by Joseph Anderson* (Edinburgh: G. Waterston & Sons, 1881).

The Art Journal Illustrated Catalogue: The Industry of All Nations, 1851 (London: Virtue, 1851).

Bremner, David. *The Industries of Scotland: Their Rise, Progress, and Present Condition* (Edinburgh: A. & C. Black, 1869).

Campbell, John Francis. *Something from the Gold Diggings in Sutherland* (Edinburgh: Edmonston and Douglas, 1869).

Cunynghame, Henry H. *European Enamels* (London: Methuen and Co., 1906).

Dall, W. H. 'Pearls and pearl fisheries', *The American Naturalist* 17, no. 6 (June, 1883): 597–87.

Davidson, Peter Wylie. *Educational Metalcraft: A Practical Treatise on Repoussé, Fine Chasing, Silversmithing, Jewellery, and Enamelling, Specially Adapted to Meet the*

Requirements of the Instructor, the Student, the Craftsman, and the Apprentice (London & New York: Longmans, Green & Co., 1913).

Diderot, Denis and d'Alembert, Jean Le Rond. *Encyclopédie ou Dictionnaire Raisonné des Sciences, des Arts et des Métiers* (Paris: Briasson, 1751–75).

Drummond, James. *Ancient Scottish Weapons, a Series of Drawings* (Edinburgh: G. Waterston & Sons, 1881).

Dudley, Robert. *A Memorial of the Marriage of HRH Albert Edward Prince of Wales and HRH Alexandra Princess of Wales … The Various Events and the Bridal Gifts …* (London: Vincent Brooks, Day & Son, 1867).

Dunbar, Lewis. *The Statistical Account of Scotland*, Kinnoull, Perth, Volume 18 (Edinburgh: William Creech, 1796), 540–62.

Duncan, John. *The Statistical Account of Scotland*, Alva, Stirling, Volume 18 (Edinburgh: William Creech, 1796), 125–48.

Dunlop, Jocelyn and Denman, Richard D. *English Apprenticeship and Child Labour. A History. With a Supplementary Section on the Modern Problem of Juvenile Labour* (London: T. Fisher Unwin, 1912).

Edinburgh International Exhibition of Industry, Science and Art, Edinburgh, 1886 (Edinburgh, 1886).

Emanuel, Harry F. R. G. S. *Diamonds and Precious Stones: Their History, Value and Distinguishing Characteristics,* second edition (London: John Camden Hotten, 1867).

Ferrier, Susan. *Marriage* (Oxford: Oxford University Press, 1997 [1818]).

Gaskell, Elizabeth. *Cranford* (Leipzig: B. Tauchnitz, 1867 [1851]).

Geikle, Archibald. *The Scenery of Scotland Viewed in Connexion with Its Physical Geology* (London: Macmillan, 1865).

Gill, Thomas. *The Technical Repository; Containing Practical Information on Subjects Connected with Discoveries and Improvements in the Useful Arts.* Illustrated by Numerous engravings, Volume 2 (London: T. Cadell, 1822).

Heddle, Matthew Forster (au.) and Goodchild, John George (ed.). *The Mineralogy of Scotland* (Edinburgh: David Douglas, 1901).

Holme, Charles (ed.). 'Modern Design in Jewellery and Fans; Special Winter Number of "The Studio" A.D. 1901–1902' (London: The Studio, 1902).

The International Exhibition of 1862: Official Catalogue of the Industrial Department, British Division, Volume 2 (London: Truscott, 1862).

International Exhibition of Industry, Science and Art, Glasgow 1888. *The official Catalogue*, second edition (Edinburgh: Constable, 1888).

Jameson, Robert. 'On the Topaz of Scotland', *Memoirs of the Wernerian Natural History Society* 1 (1811): 445–53.

Jones, Owen. *The Grammar of Ornament* (London: Day & Son, 1856).

Kunz, George Frederick. *The Curious Lore of Precious Stones* (Toronto & London: J. B. Lippincott Company, 1971 [1913]).

Kunz, George Frederick and Stevenson, Charles Hugh. *The Book of the Pearl: Its History, Art, Science and Industry* (New York: Dover Publications, Inc., 2001 [1908]).

Lapslie, James. *The Statistical Account of Scotland*, Campsie, Stirling, Volume 15 (Edinburgh: William Creech, 1795), 312–86.

MacCulloch, John, *The Highlands and Western Isles of Scotland*, Volume 1 (London: Longman, Hurst, Rees, Orme, Brown and Green, 1824).

Marshall, T. R. *History of Celtic and Scottish Jewellery* (Edinburgh: W. Marshall & Co., 1892).

Martineau, Harriet. 'An account of some treatment of gold and gems', *Household Words* 12, no. 31 (1852): 59–70.

Mawe, John. *Familiar Lessons on Mineralogy and Geology: Explaining the Easiest Methods of Discriminating Metals, Earths, and Rocks … to Which Has Been Added a Practical Description of the Use of the Lapidary's Apparatus* (London: John Mawe, 1826 [1819]).

Miller, Hugh. *The Cruise of the Betsey, or a Summer Holiday in the Hebrides, with Rambles of a Geologist, or Ten Thousand Miles over the Fossiliferous Deposits of Scotland*, ninth edition (Edinburgh: William P. Nimmo, 1872 [1857]).

Nicol, William, 'Observations on the structure of recent and Fossil Coniferae', *Edinburgh New Philosophical Journal* 16 (1834): 137–58.

Pennant, Thomas. *A Tour of Scotland 1769*, fourth edition (London: Benjamin White, 1776).

Pennant, Thomas. *A Tour of Scotland and Voyage to the Hebrides, 1772*, Volume 1 (London: Benjamin White, 1776).

Rose, Robert, Watson, George and Fraser, Alexander. *The Statistical Account of Scotland*, Inverness, Inverness, Volume 9 (Edinburgh: William Creech, 1793), 603–5.

Ruskin, John. 'On the distinctions of form in silica', in Cook, E. T. and Wedderburn, Alexander (eds). *The Works of John Ruskin*, Library Edition, Volume XXVI (London: George Allen, 1906), 373.

Scott, Walter. *Hints Addressed to the Inhabitants of Edinburgh, and Others, in Prospect of His Majesty's Visit by an Old Citizen* (Edinburgh: Bell & Bradfute, 1822).

Scott, Walter. *Old Mortality* (Harmondsworth: Penguin, 1975 [1816]).

Scott, Walter. *Rob Roy* (Oxford: Oxford University Press, 1998 [1817]).

The Scottish Exhibition of History, Art, and Industry. Official Catalogue (Industrial Section) (Glasgow: Dalross Limited, 1911).

Sinclair, John. The *Statistical Account of Scotland*, Penicuik, Edinburgh, Volume 17 (Edinburgh: William Creech, 1796), 597–628.

Smith, Adam. *An Inquiry into the Nature and Causes of the Wealth of Nations* (Oxford: Clarendon Press, 1880 [1776]).

Smith, George. *The Statistical Account of Scotland*, Galston, Ayrshire, Volume 2 (Edinburgh: William Creech, 1792), 71–83.

Smith, Godfrey (ed.). *The Laboratory, or, School of Arts: Containing a Large Collection of Valuable Secrets, Experiments, and Manual Operations in Arts and Manufactures …* (London: H.D. Symonds et al., 1799).

Souter, John. *The Book of English Trades: And Library of the Useful Arts: With Seventy Engravings* (London: Richard Phillips, 1818).

Stewart, Dugald. *Elements of the Philosophy of the Human Mind* (London: T. Tegg, 1843 [1829]).

Stuart, John. *Sculptured Stones of Scotland,* Volume 1 (Aberdeen: Spalding Club, 1856).

Stuart, John. *Sculptured Stones of Scotland,* Volume 2 (Aberdeen: Spalding Club, 1867).

Tod, Andrew (ed.). *Elizabeth Grant of Rothiemurchus: Memoirs of a Highland Lady* (Edinburgh: Canongate, 1988 [1898]).

The Traveller's Guide; or, a Topographical Description of Scotland and of the Islands Belonging to It (Edinburgh: J. Fairburn, 1798).

Trollope, Anthony. *The Eustace Diamonds* (London: Penguin Classics, 2004 [1868]).

Vallance, Aymer. 'Modern Design in Jewellery and Fans; Special Winter Number of "The Studio" A.D. 1901–1902' (London: The Studio, 1902), 1–10.

Watt, James Cromar. *Examples of Greek and Pompeian Decorative Work* (London: B. T. Batsford, 1897).

Witham, Henry. *Observations on Fossil Vegetables, Accompanied by Representations of Their Internal Structure as Seen through the Microscope* (Edinburgh: W. Blackwood, London: T. Cadell, 1831).

Yapp, G. W. (ed.), 'Scotch pebble, amber, and granite work', in Art Industry Metal-Work, Illustrating the Chief Processes of Art-Work Applied by the Goldsmith, Silversmith, Jeweller, Brass, Copper, Iron and Steel Worker Bronzist, etc etc. (London: Virtue, 1878).

Young, John H. *Our Deportment, or the Manners, Conduct and Dress of the Most Refined Society; Including Forms for Letters, Invitations, Etc., Etc. Also, Valuable Suggestions on Home Culture and Training.* Compiled from the Latest Reliable Authorities (Detroit, San Louis, Cincinnati & Chicago: F. B. Dickerson & Co., 1881).

Post office directories

The Dundee directory for 1837–8 (Dundee: James Chalmers, 1837).

The Inverness Directory, 1873–74 (Inverness: Advertiser Office, 1873).

The New Edinburgh, Leith and County Household Directory. 1868–69 (Edinburgh: Ballantyne & Co., 1868).

The Post-Office Perth Directory for 1866–67 (Perth: C. G. Sidey, 1866).

Object and art collections

Aberdeen Art Gallery and Museum (AAGM)

British Museum (BM)

Museums & Galleries Edinburgh

Glasgow Museums (GM)
Inverness Museum and Art Gallery (IMAG)
National Galleries Scotland (NGS)
National Museums Scotland (NMS)
National Portrait Gallery, London (NPG)
National Trust for Scotland (NTS)
Perth Museum and Art Gallery (PMAG)
Royal Collections Trust
Sutherland Dunrobin Trust
Tate, London
Timespan, Helmsdale
Victoria & Albert Museum, London (V&A)
Wick Society

Secondary sources

Books

Aberdeen Art Gallery. *A Vivid and Individual Art: Enamels by James Cromar Watt* (Aberdeen: Aberdeen Art Gallery, 1992).

Adamson, Glenn. *Thinking through Craft* (Oxford: Berg, 2007).

Adamson, Glenn (ed.). *The Craft Reader* (Oxford: Berg, 2010).

Adamson, Glenn. *The Invention of Craft* (London & New York: Bloomsbury Academic, 2013).

Angeloni, Umberto. *The Boutonniere: Style in One's Lapel* (New York: Rizzoli International Publications, 1999).

Appadurai, Arjun (ed.). *The Social Life of Things: Commodities in Cultural Perspective* (Cambridge: Cambridge University Press, 1986).

Arendt, Hannah (ed.). *Illuminations* (London: Penguin, 2015).

Armstrong, Isobel. *Victorian Glassworlds: Glass Culture in the Imagination, 1830–1880* (Oxford: Oxford University Press, 2008).

Arnold, Jean. *Victorian Jewelry, Identity and the Novel: Prisms of Culture* (Farnham: Ashgate, 2011).

Auerbach, Jeffrey A. *The Great Exhibition of 1851: A Nation on Display* (New Haven & London: Yale University Press, 1999).

Barthes, Roland. *The Language of Fashion* (Oxford & New York: Berg, 2006 [1953]).

Batchelor, Jennie and Kaplan, Cora (eds). *Women and Material Culture, 1660–1830* (London & New York: Palgrave Macmillan, 2007).

Berg, Maxine. *The Age of Manufactures, 1700–1820: Industry, Innovation and Work in Britain*, second edition (London: Routledge, 1994).

Berg, Maxine. *Luxury and Pleasure in Eighteenth-Century Britain* (Oxford: Oxford University Press, 2005).

Berg, Maxine and Bruland, Kristine (eds). *Technological Revolutions in Europe: Historical Perspectives* (Cheltenham, UK and Northampton, MA: Edward Elgar, 1998).

Berg, Maxine and Clifford, Helen (eds). *Consumers and Luxury: Consumer Culture in Europe, 1650–1850* (Manchester: Manchester University Press, 1999).

Berg, Maxine and Eger, Elizabeth. *Luxury in the Eighteenth Century* (Baskingstoke: Palgrave Macmillan, 2003).

Blackwell, Alice, Goldberg, Martin and Hunter, Fraser. *Scotland's Early Silver: Transforming Roman Pay-Offs to Pictish Treasures* (Edinburgh: NMSE, 2018).

Boivin, Nicole and Owoc, Mary Ann (eds). *Soil, Stones and Symbols: Cultural Perceptions of the Mineral World* (London: UCL Press, 2004), 123–42.

Bonehill, John, Dulau-Beveridge, Anne and Leask, Nigel (eds). *Old Ways, New Roads: Travels in Scotland, 1720–1832* (Edinburgh: Birlinn, 2021).

Breward, Christopher. *The Hidden Consumer: Masculinities, Fashion and City Life, 1860–1914* (Manchester: Manchester University Press, 1999).

Breward, Christopher. *The Suit: Form, Function and Style* (London: Reaktion Books, 2016).

Burchardt, Jeremy. *Paradise Lost: Rural Idyll and Social Change since 1800* (London & New York: I.B. Tauris, 2002).

Burkhauser, Jude (ed.). *Glasgow Girls: Women in Art and Design, 1880–1920* (Edinburgh: Canongate, 2001).

Bury, Shirley. *Jewellery, 1789–1910* (Suffolk: ACC Art Books, 1999).

Cadour-Sampson, Beatriz and Bari, Hubert. *Pearls* (London: V&A Publishing, 2013).

Callen, Anthea. *Angel in the Studio: Women in the Arts and Crafts Movement, 1870–1914* (London: Schott, 1979).

Cannadine, David. *Aspects of Aristocracy* (London & New York: Penguin, 1994).

Carruthers, Annette. *The Arts and Crafts Movement in Scotland: A History* (New Haven & London: Yale University Press, 2013).

Clapp-Itnyre, Ailsa and Melnyk, Julie (eds). 'Perplext in Faith': Essays on Victorian Beliefs and Doubts* (Newcastle upon Tyne: Cambridge Scholars Publishing, 2015).

Clark, Neil D. L. *Scottish Gold: Fruit of the Nation* (Glasgow: Neil Wilson Publishing Ltd in conjunction with The Hunterian, University of Glasgow, 2014).

Clifford, Helen (ed.). *Gold: Power and Allure* (London: The Goldsmiths' Company, 2012).

Codell, Julie F. and Hughes, Linda K. (eds). *Replication in the Long Nineteenth Century: Re-makings and Reproductions* (Edinburgh: Edinburgh University Press, 2018).

Colbert, Benjamin (ed.). *Travel Writing and Tourism in Britain and Ireland* (London & New York: Palgrave Macmillan, 2012).

Coltman, Viccy. *Art and Identity in Scotland: A Cultural History from the Jacobite Rising of 1745 to Walter Scott* (Cambridge: Cambridge University Press, 2020).

Cooke, Anthony, Donnachie, Ian, MacSween, Ann and Whatley, Christopher A. (eds). *Modern Scottish History 1701 to the Present: Volume I: The Transformation of Scotland, 1707–1850* (East Linton: Tuckwell Press, 1998), 130–54.

Coyer, Megan J. and Shuttleton, David E. *Scottish Medicine and Literary Culture, 1726–1832* (Leiden: Brill, 2014).

Crawford, Nick. *Scottish Pebble Jewellery: It's [sic] History and the Materials from Which It Was Made* (Kingsdown: Lapidary Stone Publications, 2008).

Crossick, Geoffrey (ed.). *The Artisan and the European Town, 1500–1900* (London: Routledge, 1997).

Cumming, Elizabeth. *Phoebe Anna Traquair, 1852–1936* (Edinburgh: Scottish National Portrait Gallery, 1993).

Cumming, Elizabeth. *Hand, Heart and Soul: The Arts and Crafts Movement in Scotland* (Edinburgh: Birlinn, 2006).

Dalgleish, George and Fothringham, Henry Steuart (eds). *Silver: Made in Scotland* (Edinburgh: National Museums Scotland, 2008).

Dalgleish, George and Maxwell, Stuart. *The Lovable Craft: 1687–1987* (Edinburgh: National Museums Scotland, 1987).

David, Paul and Thomas, Mark (eds). *The Economic Future in Historical Perspective* (Oxford: Oxford University Press, 2003).

Davies, Jeremy. *The Birth of the Anthropocene* (California: University of California Press, 2018).

De Munck, Bert, Kaplan, Steven L. and Soly, Hugo (eds). *Learning on the Shop Floor: Historical Perspectives on Apprenticeship* (Oxford & New York: Berghahn Books, 2007).

Devine, T. M. and Jackson, Gordon (eds). *Glasgow: Volume I, Beginnings to 1830* (Manchester & New York: MUP, 1995).

Devine, T. M. and Wormald, Jenny (eds). *The Oxford Handbook of Modern Scottish History, 1500–2000* (Oxford: Oxford University Press, 2011).

De Vries, Jan. *The Industrious Revolution: Consumer Behaviour and the Household Economy 1650 to the Present* (Cambridge: Cambridge University Press, 2008).

De Waal, Edmund. *The White Road: A Pilgrimage of Sorts* (London: Chatto & Windus, 2015).

Donnachie, Ian and Whatley, Christopher (eds). *The Manufacture of Scottish History* (Edinburgh: Polygon, 1992).

Dormer, Peter (ed.). *The Culture of Craft* (Manchester: Manchester University Press, 1997).

Douglas, Mary and Isherwood, Baron. *The World of Goods: Towards an Anthropology of Consumption* (London: Routledge, 1996).

Edwards, Elizabeth, Gosden, Chris and Philips, Ruth (eds). *Sensible Objects: Colonialism, Museums and Material Culture* (London & New York: Bloomsbury Academic, 2006).

Ehrman, Edwina. *The Wedding Dress: 300 Years of Bridal Fashions* (London: V&A Publishing, 2011).

Farley, Julia and Hunter, Fraser (eds). *Celts: Art and Identity* (London: British Museum Press, 2015).

Feeser, Andrea, Goggin, Maureen Daly and Tobin, Beth Fowkes (eds). *The Materiality of Color: The Production, Circulation, and Application of Dyes and Pigments, 1400–1800* (Farnham: Ashgate, 2012).

Finlay, Ian (au.) and Fothringham, Henry Steuart (ed.). *Scottish Gold and Silver Work* (Stevenage: Strong Oak Press, 1991).

Floud, Roderick and Johnson, Paul (eds). *The Cambridge Economic History of Modern Britain, Volume 1: Industrialisation, 1700–1860* (Cambridge: Cambridge University Press, 2004).

Floud, Roderick and Johnson, Paul. *The Cambridge Economic History of Modern Britain, Volume 2: Economic Maturity, 1860–1939* (Cambridge: Cambridge University Press, 2004).

Fox, Celina. *The Arts of Industry in the Age of Enlightenment* (New Haven & London: Yale University Press, 2009).

Foster, Sally and Jones, Sian. *My Life as a Replica: St John's Cross, Iona* (Oxford: Windgather Press, 2020).

Fraser, W. Hamish and Maver, Irene (eds). *Glasgow, Volume 2: 1830 to 1912* (Manchester: Manchester University Press, 1996).

Frayling, Christopher. *On Craftsmanship: Towards a New Bauhaus* (London: Oberon Masters, 2011).

Gadd, Ian Anders and Wallis, Patrick (eds). *Guilds, Society and Economy in London* (London: Institute of Historical Research, 2002).

Gell, Alfred. *Art and Agency: A New Anthropological Theory* (Oxford: Oxford University Press, 1998).

Gerard P. Moss and Anthony D. Roe. *Highland Gold and Silversmiths* (Edinburgh: NMS, 1999).

Gere, Charlotte. *Love and Art: Queen Victoria's Personal Jewellery* (London: Royal Collection Trust, 2012).

Gere, Charlotte and Rudoe, Judy. *Jewellery in the Age of Queen Victoria: A Mirror to the World* (London: British Museum Press, 2010).

Gerritsen, Anne and Riello, Giorgio (eds). *Writing Material Culture History* (London & New York: Bloomsbury Academic, 2015).

Goodare, Julian, Martin, Lauren and Miller, Joyce (eds). *Witchcraft and Belief in Early Modern Scotland* (Basingstoke: Palgrave Macmillan, 2008).

Gray, Robert Q. *The Labour Aristocracy in Victorian Edinburgh* (Oxford: Clarendon Press, 1976).

Greenhalgh, Paul. *Ephemeral Vistas: The Expositions Universelles, Great Exhibitions and World's Fairs, 1851–1939* (Manchester: Manchester University Press, 1988).

Grootenboer, Hanneke. *Treasuring the Gaze: Intimate Vision in Late Eighteenth-Century Eye Miniatures* (Chicago: University of Chicago Press, 2012).

Hadjiafxendi, Kyriaki and Sakreski, Patricia (eds). *Crafting the Woman Professional in the Long Nineteenth Century: Artistry and Industry in Britain* (London: Routledge, 2016).

Harvey, Karen (ed.). *History and Material Culture: A Student's Guide to Approaching Alternative Sources* (London: Routledge, 2009).

Helland, Janice, Lemire, Beverly and Buis Alena (eds). *Craft, Community and the Material Culture of Place and Politics, 19th–20th Century* (Farnham: Ashgate, 2014).

Hobsbawm, Eric J. *Worlds of Labour* (Frome & London: Butler & Tanner Limited, 1984).

Hobsbawm, Eric J. and Ranger, Terence (eds). *The Invention of Tradition* (Cambridge: Cambridge University Press, 1983).

Holloway, Sally. *The Game of Love in Georgian England: Courtship, Emotions & Material Culture* (Oxford: Oxford University Press, 2019).

Hunter, James. *On the Other Side of Sorrow: Nature and People in the Scottish Highlands* (Edinburgh: Mainstream, 1995).

Hunter, James. *Set Adrift Upon the World: The Sutherland Clearances* (Edinburgh: Birlinn, 2016).

Johnston, Hamish H. *Matthew Forster Heddle: Mineralogist and Mountaineer* (Edinburgh: National Museums Scotland Enterprises, 2015).

Jonsson, Fredrik Albritton. *Enlightenment's Frontier: The Scottish Highlands and the Origins of Environmentalism* (New Haven & London: Yale University Press, 2013).

Jordanova, Ludmilla. *The Look of the Past: Visual and Material Evidence in Historical Practice* (Cambridge: Cambridge University Press, 2012).

Joyce, Kirstin and Addison, Shellei. *Pearls: Ornament and Obsession* (London: Thames & Hudson, 1992).

Joyce, Patrick (ed.). *The Historical Meanings of Work* (Cambridge: Cambridge University Press, 1987), 99–118.

Kean, Hilda. *Animal Rights* (London: Reaktion, 1998).

Kwint, Marius, Breward, Christopher and Aynsley, Jeremy (eds). *Material Memories: Design and Evocation* (Oxford & New York: Berg, 1999).

Kidd, Alan and Nichols, David (eds). *The Making of the British Middle Class? Studies of Regional and Cultural Diversity Since the Eighteenth Century* (Stroud: Sutton Publishing, 1998).

Knight, Matthew, Boughton, Dot and Wilkinson, Rachel E. (eds). *Objects of the Past in the Past: Investigating the Significance of Earlier Artefacts in Later Contexts* (Oxford: Archaeopress, 2019).

Krause-Wahl, Antje, Löffler, Petra and Söll, Änne (eds). *Materials, Practices, and Politics of Shine in Modern Art and Popular Culture* (London & New York: Bloomsbury Academic, 2021).

Kriegel, Lara. *Grand Designs: Labor, Empire and the Museum in Victorian Culture* (Durham & London: Duke University Press, 2007).

Lane, Joan. *Apprenticeship in England, 1600–1914* (London: Routledge, 1996).

Lasser, Ethan (ed.). *The Tool at Hand* (Wisconsin: The Chipstone Foundation, 2013).

Lutz, Deborah. *The Brontë Cabinet: Three Lives in Nine Objects* (London: W. W. Norton & Company, 2015).

MacArthur, E. Mairi. *Iona Celtic Art* (Iona: The New Iona Press, 2003).

McCracken, Grant. *Culture and Consumption: New Approaches to the Symbolic Character of Consumer Goods and Activities* (Bloomington: Indiana University Press, 1998).

MacGregor, Martin and Broun, Dauvit (eds). *Mìorun Mòr nan Gall, 'The great ill-will of the Lowlander'? Lowland Perceptions of the Highlands, Medieval and Modern* (Glasgow: University of Glasgow, 2009).

Mackay, Margaret M. (ed.). *The Rev. Dr. John Walker's Report on the Hebrides of 1764 and 1771* (Edinburgh: John Donald, 1980).

McKendrick, Neil, Brewer, John and John Harold Plumb (eds). *The Birth of a Consumer Society: The Commercialization of Eighteenth-century England* (London: Europa Publications Ltd, 1982).

McKirdy, Alan and Crofts, Roger. *Scotland: The Creation of Its Natural Landscape, a Landscape Fashioned by Geology* (Perth: Scottish Natural Heritage, 2010 [1999]).

MacLeod, Anne. *From an Antique Land: Visual Representations of the Highlands and Islands, 1700–1880* (Edinburgh: John Donald, 2012).

Macpherson, H. G. *Agates* (London: The Natural History Museum, London & National Museums Scotland, Edinburgh, 1989).

Malm, Andreas. *Fossil Capital: The Rise of Steam-Power and the Roots of Global Warming* (London: Verso, 2016).

Marshall, Rosalind K. and Dalgleish, George R. *The Art of Jewellery in Scotland* (London: Scottish National Portrait Gallery, 1991).

Marwick, Ernest. *The Folklore of Orkney and Shetland* (Bristol: Batsford, 1975).

Mayer, Robert. *Walter Scott and Fame: Authors and Readers in the Romantic Age* (Oxford: Oxford University Press, 2017).

Mokyr, Joel (ed.). *The British Industrial Revolution: An Economic Perspective*, second edition (Boulder and Oxford: Westview Press, 1999).

Montenach, Anne and Simonton, Deborah (eds). *A Cultural History of Work in the Age of Enlightenment* (London: Bloomsbury Academic, 2020).

Mundy, Joanna. *A History of Perth Silver* (Perth: Perth Museum and Art Gallery, 1980).

Nenadic, Stana. *Lairds and Luxury: The Highland Gentry in Eighteenth-Century Scotland* (Edinburgh: John Donald, 2007).

Nenadic, Stana. *Craft Workers in Nineteenth Century Scotland: Making and Adapting in an Industrial Age* (Edinburgh: Edinburgh University Press, 2021).

Nenadic, Stana and Tuckett, Sally. *Colouring the Nation: The Turkey Red Printed Cotton Industry in Scotland c. 1840–1940* (Edinburgh: National Museums Scotland, 2013).

North, Michael and Ormrod, David (eds). *Art Markets in Europe, 1400–1800* (London: Routledge, 1998).

Ogden, Jack. *Age and Authenticity: The Materials and Techniques of 18th and 19th Century Goldsmiths* (Birmingham: National Association of Goldsmiths, 1999).

Ogden, Jack. *Diamonds: An Early History of the King of Gems* (New Haven & London: Yale University Press, 2018).

Ormond, Richard (ed.). *Monarch of the Glen: Landseer in the Highlands* (Edinburgh: National Galleries of Scotland, 2005).

Perry, Jane. *Traditional Jewellery in Nineteenth Century Europe* (London: V&A Publishing, 2013).

Philips, Clare. *Jewels and Jewellery* (London: V&A Publishing, 2000).

Pointon, Marcia. *Brilliant Effects: A Cultural History of Gem Stones and Jewellery* (New Haven & London: Yale University Press, 2010).

Plotz, John. *Portable Property: Victorian Culture on the Move* (Princeton: Princeton University Press, 2008).

Pye, David. *The Nature and Art of Workmanship* (London: Herbert, 1995).

Richards, Eric. *The Leviathan of Wealth: The Sutherland Fortune in the Industrial Revolution* (London & Toronto: Routledge & Kegan Paul Ltd & University of Toronto Press, 2006).

Rider, Peter E. and McNabb, Heather (eds). *Kingdom of the Mind: How the Scots Helped Make Canada* (Montreal: McGill-Queens University Press, 2006).

Roberts, Lissa, Schaffer, Simon and Dear, Peter (eds). *The Mindful Hand: Inquiry and Invention between the Late Renaissance and Early Industrialization* (Amsterdam: KNAW Press, 2007).

Rodger, Robin H. and Slatterly, Fiona. *Perth Silver* (Perth: Perth Museum and Art Gallery, 2001).

Saxon, Jack *The Story of the Kildonan Gold Rush of 1868* (Caithness: Caithness Field Club, 1992).

Scarisbrick, Diana. *Rings: Symbols of Wealth, Power and Affection* (London: Thames & Hudson, 1993).

Scarisbrick, Diana. *Scottish Jewellery: A Victorian Passion* (London: Five Continents Editions, 2009).

Schama, Simon. *Landscape and Memory* (London: HarperCollins, 1995).

Scranton, Phillip. *Endless Novelty: Specialty Production and American Industrialization, 1865–1925* (Princeton: Princeton University Press, 1997).

Sennett, Richard. *The Craftsman* (Harmondsworth: Penguin, 2009).

Simonton, Deborah, Kaartinen, Marjo and Montenach, Anne. *Luxury and Gender in European Towns, 1700–1914* (London: Routledge, 2015).

Smith, Kate. *Material Goods, Moving Hands: Perceiving Production in England, 1700–1830* (Manchester: Manchester University Press, 2014).

Smith, Pamela H. *The Body of the Artisan: Art and Experience in the Scientific Revolution* (Chicago: University of Chicago Press, 2004).

Smout, T. C. *The Highlands and the Roots of Green Consciousness, 1750–1990* (Edinburgh: Scottish National Heritage, 1993).

Smout, T. C. *Exploring Environmental History: Selected Essays* (Edinburgh: Edinburgh University Press, 2011).

Soros, Weber Susan and Walker, Stephanie (eds). *Castellani and Italian Archaeological Jewelry* (New Haven & London: Yale University Press, 2004).

Starkey, Roy. *Crystal Mountains: Minerals of the Cairngorms* (Bromsgrove: British Mineralogy Publications, 2014).

Stewart, Susan. *On Longing: Narratives of the Miniature, the Gigantic, the Souvenir, the Collection* (Durham, NC: Duke University Press, 1992).

Storch, Robert (ed.). *Popular Culture and Custom in Nineteenth-Century England* (London: Croom Helm, 1982).

Styles, John. *The Dress of the People* (New Haven & London: Yale University Press, 2007).

Thomas, Jon and Turnock, David. *A Regional History of the Railways of Great Britain: The North of Scotland*, Volume 15 (Penryn: Atlantic British Publishers, 1989).

Thomas, Zoe. *Women Art Workers and the Arts and Crafts Movement* (Manchester: Manchester University Press, 2020).

Thompson, E. P. *The Making of the English Working Class* (Harmondsworth: Penguin, 1968 [1963]).

Tilley, Christopher et al. (eds). *The Handbook of Material Culture* (London: Sage, 2006).

Tindley, Annie. *The Sutherland Estate, 1850–1920* (Edinburgh: Edinburgh University Press, 2010).

Walker, Stephen (ed.). *The Modern History of Celtic Jewellery, 1840–1980* (Andover & New York: Walker Metalsmiths, 2013).

Waters, Catherine. *Commodity Culture in Charles Dickens's Household Words: The Social Life of Goods* (London: Routledge, 2008).

Watt, Patrick and Waine, Rosie. *Wild and Majestic: Romantic Visions of Scotland* (Edinburgh: NMSE, 2019).

Whatley, Christopher A., Harris, Bob and Miskell, Louise (eds). *Victorian Dundee: Image and Realities* (Edinburgh: Edinburgh University Press, 2011).

Woodward, Fred. *The Scottish Pearl in Its World Context* (Edinburgh: Diehard, 1994).

Young, Susan. *The Work of Angels: Masterpieces of Celtic Metalwork, 6th–9th Centuries AD* (London: British Museum Publications, 1989).

Articles, chapters and essays

Adamson, Glenn. 'The case of the missing footstool: Reading the absent object', in Harvey, Karen (ed). *History and Material Culture: A Student's Guide to Approaching Alternative Sources* (London: Routledge, 2009).

Appadurai, Arjun. 'The thing itself', *Public Culture* 18, no. 1 (December, 2006): 15–22.

Barthes, Roland. 'From gemstones to jewellery', in Barthes, Roland. (ed.). *The Language of Fashion* (Oxford & New York: Berg, 2006), 60–9.

Behagg, Clive. 'Secrecy, ritual and folk violence: The opacity of the workplace in the first half of the nineteenth century', in Storch, Robert (ed.). *Popular Culture and Custom in Nineteenth-Century England* (London: Croom Helm, 1982), 154–79.

Belk, Russell W. 'Collecting as luxury consumption: Effects on individuals and households', *Journal of Economic Psychology* 16, no. 3 (1995): 477–90.

Ben-Amos, Ilana Krausman. 'Failure to become freemen: Urban apprentices in early modern England', *Social History* 16, no. 2 (1991): 155–72.

Benjamin, Walter. 'The work of art in the age of mechanical reproduction', in Arendt, Hannah (ed.). *Illuminations* (London: Penguin, 2015), 211–44.

Berg, Maxine. 'Small producer capitalism in eighteenth-century England', *Business History* 35, no. 1 (1993): 17–39.

Berg, Maxine. 'From imitation to invention: Creating commodities in eighteenth-century Britain', *Economic History Review* 55, no. 1 (2002): 1–30.

Berg, Maxine. 'The rise and fall of the luxury debates', in Berg, Maxine and Eger, Elizabeth (eds). *Luxury in the Eighteenth Century* (Baskingstoke: Palgrave Macmillan, 2003), 7–27.

Berg, Maxine. 'Consumption in the eighteenth and early nineteenth centuries', in Roderick Floud and Paul Johnson (eds). *The Cambridge Economic History of Modern Britain, Volume 1: Industrialisation, 1700–1860* (Cambridge: Cambridge University Press, 2004), 357–87.

Bestor, Jane Fair. 'Marriage transactions in Renaissance Italy and Mauss's essay on the gift', *Past & Present* 164 (1999): 6–46.

Bianchi, Marina. 'Collecting as a paradigm of consumption', *Journal of Cultural Economics* 21, no. 4 (1997): 275–89.

Bille, Mikkel and Sørensen, Tim Flohr. 'An anthropology of luminosity', *Journal of Material Culture* 12, no. 3 (2007): 263–84.

Bonehill, John and Leask, Nigel, 'Picturesque prospects and literary landscapes', in Bonehill, John, Dulau-Beveridge, Anne and Leask, Nigel (eds). *Old Ways, New Roads: Travels in Scotland 1720–1832* (Edinburgh: Birlinn, 2021), 147–65.

Brooks, Christopher. 'Apprenticeship, social mobility and the middling sort, 1550–1800', in Barry, Jonathan and Brooks, Christopher (eds). *The Middling Sort of People: Culture, Society and Politics in England* (Basingstoke and London: Palgrave Macmillan, 1994), 52–83.

Brown, Bill. 'Thing theory', *Critical Enquiry* 28, no. 1 (Autumn, 2001): 1–22.

Brown, Stewart J. and Fry, M. 'Preface', in Brown, Stewart J. and Fry, M. (eds). *Scotland in the Age of Disruption* (Edinburgh: Edinburgh University Press, 1993), viii–xi.

Buono, Amy. 'Crafts of color: Tupi Tapirage in early colonial Brazil', in Feeser, Andrea, Goggin, Maureen Daly and Tobin, Beth Fowkes (eds). *The Materiality of Color: The Production, Circulation, and Application of Dyes and Pigments, 1400–1800* (London: Routledge, 2012), 235–46.

Burns, R. W. 'Bain, Alexander (1810–1877)', in Matthew, H. C. G. and Harrison, Brian (eds). *Oxford Dictionary of National Biography* (Oxford: Oxford University Press, 2004 [online edition]).

Butler, Richard W. 'The history and development of royal tourism in Scotland: Balmoral, the ultimate holiday home?', in Long, Phil and Palmer, Nicola J. (eds). *Royal Tourism: Excursions Around Monarchy* (Bristol: Channel View Publications, 2008), 51–60.

Carnevali, Francesca. 'Golden opportunities: Jewelry making in Birmingham between mass production and specialty', *Enterprise & Society* 4, no. 2 (2003): 272–98.

Carnevali, Francesca. 'Luxury for the masses: Jewellery and jewellers in London and Birmingham in the 19th century', *Enterprises et Histoire* 46 (April, 2007): 56–70.

Carnevali, Francesca. 'Fashioning luxury for factory girls: American jewelry, 1860–1914', *Business History Review* 85 (Summer, 2011): 295–317.

Charleston, R. J. 'Wheel-engraving and -cutting: Some early equipment', *Journal of Glass Studies* 6 (1964): 83–100.

Charleston, R. J. 'Wheel-engraving and -cutting: Some early equipment - II water-power and cutting', *Journal of Glass Studies* 7 (1965): 41–54.

Cheape, Hugh. 'Charms against witchcraft: Magic and mischief in museum collections', in Goodare, Julian, Martin, Lauren and Miller, Joyce (eds). *Witchcraft and Belief in Early Modern Scotland* (Basingstoke: Palgrave Macmillan, 2008), 227–48.

Classen, Constance and Howes, David. 'The museum as sensescape: Western sensibilities and indigenous artifacts', in Edwards, Elizabeth, Gosden, Chris and Philips, Ruth (eds). *Sensible Objects: Colonialism, Museums and Material Culture* (London: Bloomsbury Academic, 2006), 199–222.

Clifford, Helen. 'A commerce with things: The value of precious metalwork in early modern England', in Berg, Maxine and Clifford, Helen (eds). *Consumers and Luxury: Consumer Culture in Europe, 1650–1850* (Manchester: Manchester University Press, 1999), 147–69.

Clifford, Helen. 'Concepts of invention, identity and imitation in the London and provincial metal-working trades, 1750–1800', *Journal of Design History* 12, no. 3 (1999): 241–55.

Clifford, Helen. 'Gold and the rituals of life', in Clifford, Helen (ed.). *Gold: Power and Allure* (London: The Goldsmiths' Company, 2012), 124–35.

Collard, Frances. 'Historical revivals, commercial enterprise and public confusion: Negotiating taste, 1860–1890', *Journal of Design History* 16, no. 1 (January, 2003): 35–48.

Coltman, Viccy. 'Material culture and the history of art(efacts)', in Gerritsen, Anne and Riello, Giorgio (eds). *Writing Material Culture History* (London & New York: Bloomsbury Academic, 2015), 17–32.

Coltman, Viccy. 'Portable knick-knacks or the material culture of travel', in Bonehill, John, Dulau-Beveridge, Anne and Leask, Nigel (eds). *Old Ways, New Roads: Travels in Scotland 1720–1832* (Edinburgh: Birlinn, 2021), 166–79.

Cooke, Anthony and Donnachie, Ian. 'Aspects of industrialisation before 1850', in Cooke, Anthony, Donnachie, Ian, MacSween, Ann and Whatley, Christopher A. (eds). *Modern Scottish History 1701 to the Present: Volume I: The Transformation of Scotland, 1707–1850* (East Linton: Tuckwell Press, 1998), 130–54.

Crossick, Geoffrey. 'Past masters: The artisan in European history', in Crossick, Geoffrey (ed.). *The Artisan and the European Town, 1500–1900* (London: Routledge, 1997), 1–40.

Dalgleish, George. 'Aspects of Scottish-Canadian material culture: Heart brooches and Scottish pottery', in Rider, Peter E. and McNabb, Heather (eds). *Kingdom of the Mind: How the Scots Helped Make Canada* (Montreal and Kingston: McGill-Queens University Press, 2006), 122–36.

Dannehl, Karin. 'Object biographies: From production to consumption', in Harvey, Karen (ed.). *History and Material Culture: A Student's Guide to Approaching Alternative Sources* (London: Routledge, 2009), 122–38.

Davies, John McG. 'Pullar, Sir Robert (1828–1912)', in Matthew, H. C. G. and Harrison, Brian (eds). *Oxford Dictionary of National Biography* (Oxford: Oxford University Press, 2004 [online edition]).

De Munck, Bert and Soly, Hugo. '"Learning on the shop floor" in historical perspective', in De Munck, Bert, Kaplan, Steven L. and Soly, Hugo (eds). *Learning on the Shop Floor: Historical Perspectives on Apprenticeship* (Oxford & New York: Berghahn Books, 2007), 3–34.

Delamer, Ida. 'The Claddagh ring', *Irish Arts Review Yearbook* 12 (1996): 181–7.

Devine, T. M. 'Scotland', in Floud, Roderick and Johnson, Paul (eds). *The Cambridge Economic History of Modern Britain, Volume 1: Industrialisation, 1700–1860* (Cambridge: Cambridge University Press, 2004), 388–416.

Dziennik, Matthew. 'Whig tartan: Material culture and its use in the Scottish Highlands, 1746–1815', *Past & Present* 217 (November, 2012): 114–47.

Eastop, Dinah. 'History by design: UK Board of Trade Design Register', in Gerritsen, Anne and Riello, Giorgio (eds). *Writing Material Culture History* (London & New York: Bloomsbury Academic, 2015), 113–20.

Eaton, Natasha. 'In search of pearlescence: Pearls, empire and obsolescence in South Asia', *Journal of Material Culture* 21, no. 1 (2016): 29–58.

'Editorial Introduction', *The Journal of Modern Craft* 1, no. 1 (1 March 2008): 1–6.

Eisenberg, Christiane. 'Artisans' socialization at work: Workshop life in early nineteenth-century England and Germany', *Journal of Social History* 24, no. 3 (Spring, 1991): 507–20.

Evans, Chris and Rydén, Göran. 'Kinship and the transmission of skills: Bar iron production in Britain and Sweden 1500–1860', in Berg, Maxine and Bruland, Kristine (eds). *Technological Revolutions in Europe: Historical Perspectives* (Cheltenham, UK and Northampton, MA: Edward Elgar, 1998), 188–206.

Farr, James. 'Cultural analysis and early modern artisans', in Crossick, Geoffrey (ed.). *The Artisan and the European Town, 1500–1900* (London: Routledge, 1997), 56–74.

Forbes, John. 'Search, immigration and the Goldsmith's Company: A decline in its powers', in Gadd, Ian Anders and Wallis, Patrick (eds). *Guilds, Society & Economy in London, 1450–1800* (London: Centre for Metropolitan History, 2002), 115–27.

Foster, Sally, 'Replication of things: The case for composite biographical approaches', in Julie Codell and Linda K. Hughes (eds). *Replication in the Long Nineteenth Century: Re-makings and Reproductions* (Edinburgh: Edinburgh University Press, 2018), 23–45.

Foster, Sally, Blackwell, Alice and Goldberg, Martin. 'The legacy of nineteenth-century replicas for object cultural biographies: Lessons in duplication from 1830s Fife', *Journal of Victorian Culture* 19, no. 2 (2014): 137–60.

Fothringham, Henry Steuart. 'Scottish goldsmiths' apprentices', *The Silver Society Journal* 14 (2002): 79–86.

Gaggio, Dario. 'Pyramids of trust: Political embeddedness and political culture in two Italian gold jewelry districts', *Enterprise & Society* 7, no. 1 (March, 2006): 19–58.

Gordon, John E. and Baker, Matt. 'Appreciating geology and the physical landscape in Scotland: From tourism of awe to experiential re-engagement', *Geological Society, London, Special Publications* 417 (January, 2015): 25–40.

Green, Timothy. 'London: The world's gold market', in Clifford, Helen (ed.). *Gold: Power and Allure* (London: The Goldsmiths' Company, 2012), 74–83.

Greenhalgh, Paul. 'The history of craft', in Dormer, Peter (ed.). *The Culture of Craft* (Manchester: Manchester University Press, 1997), 20–52.

Haldane Grenier, Katherine. '"Missions of benevolence": Tourism and charity on Nineteenth-century Iona', in Colbert, Benjamin (ed.). *Travel Writing and Tourism in Britain and Ireland* (London & New York: Palgrave Macmillan, 2012), 114–31.

Haldane Grenier, Katherine. '"Public acts of faith and devotion": Pilgrimages in late nineteenth century England and Scotland', in Clapp-Itnyre, Ailsa and Melnyk, Julie (eds). *'Perplext in Faith': Essays on Victorian Beliefs and Doubts* (Newcastle upon Tyne: Cambridge Scholars Publishing, 2015), 149–67.

Helland, Janice. 'Benevolence, revival and "fair trade": An historical perspective', in Helland, Janice, Lemire, Beverly and Alena, Buis (eds). *Craft, Community and the*

Material Culture of Place and Politics, 19th–20th Century (Farnham: Ashgate, 2014), 125–42.

Helland, Janice. 'Frances Macdonald: The self as fin-de-siècle woman', *Woman's Art Journal* 14, no. 1 (1993): 15–22.

Hobsbawm, Eric J. 'The making of the working class, 1870–1914', in E. J. Hobsbawm. (eds). *Worlds of Labour* (Frome & London: Butler & Tanner Limited, 1984), 194–213.

Hofmeester, Karin. 'Shifting trajectories of diamond processing: From India to Europe and back, from the fifteenth century to the twentieth', *Journal of Global History* 8 (March, 2013): 25–9.

Holm, Christiane. 'Sentimental cuts: Eighteenth-century mourning jewelry with hair', *Eighteenth-Century Studies* 38, no. 1 (Fall, 2004): 139–43.

Howard, Vicki. 'A "Real Man's Ring": Gender and the invention of tradition', *Journal of Social History* 36, no. 4 (Summer, 2003): 837–56.

Humphries, Jane. 'English apprenticeship: A neglected factor in the first Industrial Revolution', in David, Paul and Thomas, Mark (eds). *The Economic Future in Historical Perspective* (Oxford: Oxford University Press, 2003), 72–102.

Hunter, Margaret. 'Mourning jewellery: A collector's account', *Costume* 27 (1993): 9–22.

Isager, Lotte, Vestergaard Knudsen, Line and Theilade, Ida. 'A new keyword in the museum: Exhibiting the Anthropocene', *Museum & Society* 19, no. 1 (2021): 88–107.

Jespersen, John Kresten. 'Originality and Jones' The Grammar of Ornament of 1856', *Journal of Design History* 21, no. 2 (June, 2008): 143–53.

Kelly, Tara. 'Specimens of modern antique: Commercial facsimiles of Irish archaeological jewellery, 1840–1868', in Walker, Stephen (ed.). *The Modern History of Celtic Jewellery 1840–1980* (Andover & New York: Walker Metalsmiths, 2013), 23–33.

Kenefick, William. 'Growth and development of the port of Dundee in the nineteenth and early twentieth centuries', in Whatley, Christopher A., Harris, Bob and Miskell, Louise (eds). *Victorian Dundee: Image and Realities* (Edinburgh: Edinburgh University Press, 2011), 29–44.

Kirkham, Pat. 'Mackintosh and his contemporaries', *Journal of Design History* 1, no. 2 (January, 1988): 147–8.

Knell, Simon J. and Taylor, Michael A. 'Hugh Miller: Fossils, landscape and literary geology', *Proceedings of the Geologists' Association* 117 (2006): 85–98.

Kopytoff, Igor. 'The cultural biography of things: Commoditization as process', in Appadurai, Arjun (ed.). *The Social Life of Things: Commodities in Cultural Perspective* (Cambridge: Cambridge University Press, 1986), 64–91.

Kriegel, Lara. 'The pudding and the palace: Labor, print culture, and imperial Britain in 1851', in Burton, Antoinette M. (ed.). *After the Imperial Turn: Thinking with and through the Nation* (Durham, NC: Duke University Press, 2003), 230–45.

Kwint, Marius. 'Introduction: The physical past', in Kwint, Marius, Breward, Christopher and Aynsley, Jeremy (eds). *Material Memories: Design and Evocation* (Oxford & New York: Berg, 1999), 1–17.

Kwint, Marius. 'Introduction: Commemoration and material culture', *Journal of Victorian Culture* 10, no. 1 (2005): 96–100.

Laurenson, Sarah. 'Material landscapes: The production and consumption of men's jewellery during the Scottish gold rush of 1869', *History of Retailing and Consumption* 2, no. 2 (July, 2016): 129–42.

Laurenson, Sarah and Nenadic, Stana. 'Metals and Jewellery', in Nenadic, Stana (ed.). *A Cultural History of Craft in the Age of Industry* (London: Bloomsbury Academic, forthcoming 2023).

Lee, Clive H. 'Scotland, 1860–1939: Growth and poverty', in Floud, Roderick and Johnson, Paul (eds). *The Cambridge Economic History of Modern Britain, Volume 2: Economic Maturity, 1860–1939* (Cambridge: Cambridge University Press, 2004), 428–55.

Leonhard, Karin. 'Painted gems. The color worlds of portrait miniature painting in sixteenth- and seventeenth-century Britain', *Early Science and Medicine* 20, no. 4–6 (December, 2015): 428–57.

Lewis, Simon L. and Aslin, Mark A. 'Defining the anthropocene', *Nature* 519 (2015): 171–80.

Leslie, Esther. 'Souvenirs and forgetting: Walter Benjamin's memory-work', in Kwint, Marius; Breward, Christopher and Aynsley, Jeremy (eds). *Material Memories: Design and Evocation* (Oxford & New York: Berg, 1999), 107–22.

Lockhart, Stan. 'Coille-Bhraghad silver mines, Inveraray', *Paragraphs: The Neil Munro Society Journal* 29 (Spring, 2011): 10–11.

McCrum, Elizabeth. 'Irish Victorian jewellery', *Irish Arts Review* 2, no. 1 (Spring, 1985): 18–21.

McGill, Lyndsay. 'Scottish heart brooches: A re-evaluation of the Luckenbooth', *Proceedings of the Society of Antiquaries of Scotland* 151 (2022): 223–234.

Mackay, Kate. 'A new perspective on the Coille-Bhraghad silver mines', *Paragraphs: The Neil Munro Society Journal* 30 (Winter, 2011): 13–14.

McKean, Charles. 'Not even the trivial grace of a straight line', in Whatley, Christopher A., Harris, Bob and Miskell, Louise (eds). *Victorian Dundee: Image and Realities* (Edinburgh: Edinburgh University Press, 2011), 1–28.

McKendrick, Neil. 'Introduction', in McKendrick, Neil, Brewer, John and Plumb, John Harold (eds). *The Birth of a Consumer Society: The Commercialization of Eighteenth-Century England* (London: Europa Publications Ltd, 1982), 1–6.

McKiernan, Mike. 'David Allan, lead processing at Leadhill, pounding the ore *c.*1786', *Occupational Medicine* 66, no. 5 (July, 2016): 349–50.

MacKillop, Andrew. 'Grant, Sir James, of Grant, eighth baronet (1738–1811)', in Matthew, H. C. G. and Harrison, Brian (eds). *Oxford Dictionary of National Biography* (Oxford: Oxford University Press, 2004 [online edition]).

Mackinnon, Iain and MacKillop, Andrew. 'Plantation slavery and landowernship in the west Highlands and Islands: Legacies and lessons', *Land and the Common Good: A Discussion Paper Series on Land Reform in Scotland* (Community Land Scotland, November 2020).

MacLeod, Anne. 'The Highland landscape: Visual depictions, 1760–1883', in MacGregor, Martin and Broun, Dauvit (eds). *Mìorun Mòr nan Gall, 'The great ill-will of the Lowlander'? Lowland Perceptions of the Highlands, Medieval and Modern* (Glasgow: University of Glasgow, 2009), 128–57.

McNeil, Peter. '"Sparks set in gold": A new history of jewellery', *Art History* 36 (2013): 867–70.

Maffei, Nicholas P. and Fisher, Tom. 'Historicizing shininess in design: Finding meaning in an unstable phenomenon', *Journal of Design History* 26, no. 3 (2013): 231–40.

Mandler, Peter. 'The wand of fancy: The historical imagination of the Victorian tourist', in Kwint, Marius, Breward, Christopher and Aynsley, Jeremy (eds). *Material Memories: Design and Evocation* (Oxford & New York: Berg, 1999), 125–42.

Markovits, Stefanie. 'Form things: Looking at genre through Victorian diamonds', *Victorian Studies* 52, no. 4 (Summer, 2010): 591–619.

Mason, John. 'The Edinburgh school of design', *Book of the Old Edinburgh Club* 27 (1949): 67–96.

Miskell, Louise and Kenefick, William. '"A flourishing seaport": Dundee harbour and the making of an industrial town, *c.* 1815–1850', *Scottish Economic & Social History* 20, no. 2 (2000): 176–98.

Mitch, David. 'The role of education and skill in the British Industrial Revolution', in Mokyr, Joel (ed.). *The British Industrial Revolution: An Economic Perspective*, second edition (Boulder & Oxford: Westview Press, 1999), 241–79.

Moeran, Brian. 'Materials, skills and cultural resources: Onta folk art pottery revisited', *The Journal of Modern Craft* 1, no. 1 (2008): 35–54.

Morris, R. J. 'The labour aristocracy in the British class struggle', *Refresh: Recent Findings of Research in Economic and Social History* 7 (Autumn, 1988): 1–4.

Morus, Iwan Rhys. 'Manufacturing nature: Science, technology and Victorian consumer culture', *The British Journal for the History of Science* 29, no. 4 (December, 1996): 403–34.

Nagai, Kiyohito. 'The history of the cultured pearl industry', *Zoological Science* 30, no. 1 (December, 2013): 783–93.

Nechtman, Tillman W. 'Nabobinas – luxury, gender and the sexual politics of British imperialism in India in the late eighteenth century', *Journal of Women's History* 18, no. 4 (Winter, 2006): 8–30.

Nenadic, Stana. 'The small family firm in Victorian Britain', *Business History* 35, no. 4 (1993): 86–114.

Nenadic, Stana. 'The middle ranks and modernisation', in Devine, T. M. and Jackson, Gordon (eds). *Glasgow: Volume 1, Beginnings to 1830* (Manchester: Manchester University Press, 1995), 278–311.

Nenadic, Stana. 'Romanticism and the urge to consume in the first half of the nineteenth century', in Berg, Maxine and Clifford, Helen (eds). *Consumers and Luxury: Consumer Culture in Europe, 1650–1850* (Manchester: Manchester University Press, 1999), 208–27.

Nenadic, Stana. 'Industrialisation and the Scottish people', in Devine, T. M. and Wormald, Jenny (eds). *The Oxford Handbook of Modern Scottish History, 1500–2000* (Oxford: Oxford University Press, 2011), 405–22.

Nenadic, Stana. 'Exhibiting India in nineteenth-century Scotland and the impact on commerce, industry and popular culture', *Journal of Scottish Historical Studies* 34, no. 1 (2014): 67–89.

Nenadic, Stana. 'Gender, craftwork and the exotic', in Simonton, Deborah, Kaartinen, Marjo and Montenach, Anne (eds). *Luxury and Gender in European Towns, 1700–1914* (London: Routledge, 2015), 150–67.

Nenadic, Stana. 'The rites, rituals and sites of business, 1650–1820', in Siobhan Talbott and Caitlin Rosenthal (eds). *The Cultural History of Business in the Age of Enlightenment* (London: Bloomsbury, forthcoming 2017/18).

North, Susan. 'The fusion of fabric and gem: The costume society symposium 2005', *Costume* 40 (2006): 1–7.

Ogden, Jack. 'Revivers of the lost art: Alessandro Castellani and the quest for precision' in Soros, Weber Susan and Walker Stephanie (eds). *Castellani and Italian Archaeological Jewelry* (New Haven & London: Yale University Press, 2004).

Ogilvie, Sheilagh. 'The economics of guilds', *Journal of Economic Perspectives* 28, no. 4 (2014): 169–92.

Parkins, Wendy and Adkins, Peter. 'Introduction: Victorian ecology and the Anthropocene', *19: Interdisciplinary Studies in the Long Nineteenth Century* 26 (2018): 1–15.

Plotz, John. 'Discreet jewels: Victorian diamond narratives and the problem of sentimental value', in Plotz, John (ed.). *Portable Property: Victorian Culture on the Move* (Princeton: Princeton University Press, 2008).

Pointon, Marcia. 'Intriguing jewellery: Royal bodies and luxurious consumption', *Textual Practice* 1, no. 3 (1997): 493–516.

Pointon, Marcia. 'Materializing mourning: Hair, jewellery and the body', in Kwint, Marius, Breward, Christopher and Aynsley, Jeremy (eds). *Material Memories: Design and Evocation* (Oxford & New York: Berg, 1999), 19–57.

Pointon, Marcia. '"Surrounded with Brilliants": Miniature portraits in eighteenth-century England', *The Art Bulletin* 83, no. 1 (March, 2001): 48–71.

Pointon, Marcia. 'Women and their jewels', in Batchelor, Jennie and Kaplan, Cora (eds). *Women and Material Culture, 1660–1830* (London & New York: Palgrave Macmillan, 2007), 11–30.

Pointon, Marcia. 'Material manoeuvres: Sarah Churchill, Duchess of Marlborough and the power of artefacts', *Art History* 32, no. 3 (June, 2009): 485–515.

Prior, Katherine. 'Carmichael, Thomas David Gibson, Baron Carmichael (1859–1926)',
 in Matthew, H. C. G. and Harrison, Brian (eds). *Oxford Dictionary of National
 Biography* (Oxford: Oxford University Press, 2004 [online edition]).

Prown, Jules. 'Mind in matter: An introduction to material culture theory and method',
 Winterthur Portfolio 17 (1982): 1–19.

Prown, Jules. 'Style as evidence', *Winterthur Portfolio* 15 (1980): 197–210.

Randolph, Adrian W. B. 'Performing the bridal body in fifteenth-century Florence', *Art
 History* 21, no. 2 (June, 1998): 182–200.

Richards, Eric. 'Gower, George Granville Leveson-, first Duke of Sutherland
 (1758–1833)', in Matthew, H. C. G. and Harrison, Brian (eds). *Oxford Dictionary of
 National Biography* (Oxford: Oxford University Press, 2004 [online edition]).

Riello, Giorgio. 'Strategies and boundaries: Subcontracting and the London trades in
 the long eighteenth century', *Enterprise and Society* 9, no. 2 (June, 2008): 243–80.

Rublack, Ulinka. 'Matter in the material renaissance', *Past & Present* 219 (May, 2013): 41–85.

Rudoe, Judy. 'The invention of tradition in Scotland', in Gere, Charlotte and Rudoe,
 Judy (eds). *Jewellery in the Age of Queen Victoria: A Mirror to the World* (London:
 British Museum Press, 2010), 454–61.

Rule, John. 'The property of skill in the period of manufacture', in Joyce, Patrick (ed.). *The
 Historical Meanings of Work* (Cambridge: Cambridge University Press, 1987), 99–118.

Sabel, Charles F. and Zeitlin, Jonathan. 'Historical alternatives to mass production', *Past
 & Present* 108 (August, 1985): 133–76.

Samuel, Raphael. 'Workshop of the world: Steam power and hand technology in mid-
 Victorian Britain', *History Workshop* 3 (Spring, 1977): 6–72.

Saunders, Nicholas. 'Biographies of brilliance: Pearls, transformations of matter and
 being, c. AD 1492', *World Archaeology* 31, no. 2 Special Edition: The Cultural
 Biography of Objects (October, 1999): 243–57.

Saunders, Nicholas. 'The cosmic earth: Materiality and mineralogy in the Americas',
 in Boivin, Nicole and Owoc, Mary Ann (eds). *Soil, Stones and Symbols: Cultural
 Perceptions of the Mineral World* (London: UCL Press, 2004), 123–42.

Schaffer, Talia. 'Women's work: The history of the Victorian domestic handicraft', in
 Hadjiafxendi, Kyriaki and Sakreski, Patricia (eds). *Crafting the Woman Professional
 in the Long Nineteenth Century: Artistry and Industry in Britain* (London: Routledge,
 2016), 25–42.

Skinner, Ann, Young, Mark and Hastie, Lee. 'Ecology of the freshwater pearl mussel',
 Conserving Natura 2000 Rivers Ecology Series no. 2 (Peterborough: English Nature,
 2003).

Skinner, B. C. 'A contemporary account of the royal visit to Edinburgh, 1822', *Book of
 the Old Edinburgh Club* 31 (1962): 65–170.

Smith, Kate. 'Sensing design and workmanship: The haptic skills of shoppers in
 eighteenth-century London', *Journal of Design History* 25, no. 1 (March, 2012): 1–10.

Smith, Kate. 'How to? Historical perspectives on tool use', in Lasser, Ethan (ed.). *The Tool at Hand* (Wisconsin: The Chipstone Foundation, 2013), 20–5.

Smith, Pamela H. 'Making and knowing in a sixteenth-century goldsmith's workshop', in Roberts, Lissa, Schaffer, Simon and Dear, Peter (eds). *The Mindful Hand: Inquiry and Invention between the Late Renaissance and Early Industrialization* (Amsterdam: KNAW Press, 2007), 20–37.

Smith, Pamela H. 'In the workshop of history: Making, writing, and meaning', *West 86th* 19, no. 1 (March, 2012): 4–31.

Snell, Keith. 'The apprenticeship system in British history: The fragmentation of a social institution', *History of Education* 25 (1996): 303–21.

Steele, Valerie. 'A museum of fashion is more than a clothes-bag', *Fashion Theory* 2, no. 4 (1998): 327–36.

Storey, Tessa. 'Fragments from the "life histories" of jewellery belonging to prostitutes in early-modern Rome', *Renaissance Studies* 19, no. 5 (2005): 647–57.

Styles, John. 'Product innovation in early modern London', *Past & Present* 168 (August, 2000): 124–69.

Thornton, Amara. 'Exhibition season: Annual archaeological exhibitions in London, 1880s–1930s', *Bulletin of the History of Archaeology* 25, no. 2 (2015): 1–18.

Tindley, Annie and Haynes, Heather. 'The River Helmsdale and Strath Ullie, *c.* 1780–*c.* 1820: A historical perspective of societal and environmental influences on land management', *Scottish Geographical Journal* 130, no. 1 (2013): 35–50.

Trentmann, Frank. 'Materiality in the future of history: Things, practices, and politics', *Journal of British Studies* 48, no. 2 (2009): 283–307.

Trevor-Roper, Hugh. 'The invention of tradition: The Highland tradition of Scotland', in Hobsbawm, Eric and Ranger, Terence (eds). *The Invention of Tradition* (Cambridge: Cambridge University Press, 1983), 15–42.

Whyte, Ian D. and Whyte, Kathleen A. 'Patterns of migration of apprentices into Aberdeen and Inverness during the eighteenth and early nineteenth centuries', *Scottish Geographical Magazine* 102, no. 2 (September, 1986): 81–92.

Withers, Charles W. J. 'The historical creation of the Scottish Highlands', in Donnachie, Ian and Whatley, Christopher (eds). *The Manufacture of Scottish History* (Edinburgh: Polygon, 1992), 142–56.

Withers, Charles W. J. 'Landscape, memory, history: Gloomy memories and the 19th-century Scottish Highlands', *Scottish Geographic Journal* 121, no. 1 (2008): 29–44.

Wolf, Tony Lesser. 'Women jewelers of the British arts and crafts movement', *The Journal of Decorative and Propaganda Arts* 14 (Autumn, 1989): 28–45.

Yan, Shu-chuan. 'The art of working in hair: Hair jewellery and ornamental handiwork in Victorian Britain', *The Journal of Modern Craft* 12, no. 2 (2019): 123–39.

Young, Diana. 'The colours of things', in Tilley, Christopher et al. (eds). *The Handbook of Material Culture* (London: Sage, 2006), 173–85.

Young, Diana. 'Mutable things: Colours as material practice in the northwest of South Australia', *Journal of the Royal Anthropological Institute* 17, no. 2 (June, 2011): 356–76.

Unpublished PhD theses

Gowrley, Freya. '*Gender, Craft and Canon: Elite Women's Engagements with Material Culture in Britain, 1750–1830*' (University of Edinburgh, 2016).

Holloway, Sally. '*Romantic Love in Words and Objects during Courtship and Adultery c. 1730 to 1830*', (Royal Holloway, 2013).

Kelly, Tara. '*Products of the Celtic Revival: Facsimiles of Irish Metalwork and Jewellery, 1840–1940*' (Trinity College Dublin, 2013).

Laurenson, Sarah. '*Materials, Making and Meaning: The Jewellery Craft in Scotland, c. 1780–1914*', (University of Edinburgh, 2017).

MacLeod, Anne Margaret. '*The Idea of Antiquity in Visual Images of the Highlands and Islands*', (University of Glasgow, 2006).

Smith, Kate. '*The Potter's Skill: Perceptions of Workmanship in the English Ceramic Industries, 1760–1800*' (University of Warwick, 2010).

Tuckett, Sally. '*Weaving the Nation: Scottish Clothing and Textile Cultures in the Long Eighteenth Century*' (University of Edinburgh, 2010).

Online sources

Community Land Scotland
https://www.communitylandscotland.org.uk/

Incorporation of Goldsmiths of the City of Edinburgh
http://incorporationofgoldsmiths.org/

The Metropolitan Museum of Art
https://www.metmuseum.org/art/collection

The Natural History Museum, London
https://www.nhm.ac.uk/discover/what-is-the-anthropocene.html

Index

workshop
 conditions 49, 78, 50
 dynamics 21–51
 hierarchies (*see also* masters) 24–9, 39
 in relation to shop 24–6, 71
 representations of 24–8
 social and cultural dimensions of 23–8, 38–9
 spaces 23–8, 160
 training in (*see also* apprentices) 23–8, 75, 77–8, 176
 windows 24, 26

CHAPTER 4

I HAVE A DREAM

L et's rewind about two years before I head for America. I'm tucked up in bed at home in Edinburgh and having the strangest dream ever. I'm walking on a long, straight road with large blocks of houses on either side that seem to go on forever. It's night time in my dream and there are thousands of lights twinkling through the darkness from the windows of all these apartment blocks.

In the dream, I feel like I'm walking along a path to greatness and this never-ending road was leading me to some kind of personal nirvana.

Suddenly, the man who is undoubtedly the world's greatest boxer, Sugar Ray Robinson, appears on the road beside me and says: "You need to go to New York. This is where you need to be. You should walk this way because you need to learn your boxing craft from the best."

When I woke up, I could remember the dream quite vividly and thought it was a bit strange, although some dreams can be like that. I put it down to watching too many videos of the old boxing greats and filling my head with stories from the ring in books and magazines.

Now, fast forward to when I'm actually in New York and making my way to the Starrett City Boxing Club for the first time. And this is where it really gets spooky.

I'd called the gym the day before and had spoken to the legendary Jimmy O'Pharrow who had started the club. Better known as Jimmy O,

he was an old school boxing trainer, who still ran the gym and coached fighters. He'd told me to come along the following night and so I get a bus from my apartment to Pennsylvania Avenue, which is close to the gym.

I'm striding along when suddenly the dream I'd had two years previously flashes into my mind and I get the incredible sensation that I've been on this road before. I look around and sure enough, what I'm seeing in front of me is exactly the vision I had in the dream.

My pace slows as I remember more about the dream – the long, wide road, the rows and rows of apartment blocks of The Projects on either side and the banks of lights from the apartment windows. The only thing missing was Sugar Ray giving me a pep talk.

It was such a surreal experience, but it gave me a renewed confidence and belief that coming to New York was the right thing to do. It was almost as if some higher power had destined that I should come to Brooklyn and the Starrett City Boxing Club to bring me closer to achieving my ambitions. I stick my chest out a little bit further and hold my head a few inches higher, as I pick up my walking pace and become even more excited about getting to the gym.

I'd phoned the Starrett City Boxing Club the second day I'd been in the apartment, as I'd just about got my head around the two guys being shot the night before.

I didn't think it would be the great man himself, Jimmy O, who would answer the phone, but I thought it was pretty cool I was talking to him. The gym must get lots of phone calls from guys who say they want to be a boxer and ask if they can train at Starrett City. I reckon a lot of them chicken out at the last minute and don't turn up. But when I told Jimmy I'd come all the way from Scotland to train at his gym, he must have thought I was serious about it.

After the usual chat about kilts, bagpipes and hunting trips on heather-clad hills to catch a haggis, Jimmy says: 'Come on down tomorrow night and we'll see what you've got and you can decide if you want to work with any of our trainers or, more to the point, if they want to work with you.'

Training at a boxing club in America is a lot different from back home in Scotland. When I first started boxing, coaching was more of a group activity and the trainer is shouting to everyone: 'All right

lads, hit the bag and hit it hard.'

But in America, you either approach a boxing trainer in a gym to give you individual coaching, or the trainers approach you if they think you've some potential, and you pay them a fee for coaching. These guys are always on the lookout for the next big thing and they will approach a young boxer they think can make it to the top, and while the boxer is raking in the cash as a professional fighter, the trainer will get his cut.

As well as the obvious ability to box, the trainers are also looking out for saleability. Is the young boxer good-looking and marketable? Will lots of people want to see him box and will he sell plenty of tickets to his fights? Basically, if a trainer thinks he can make money out of you, then he'll want to train you.

The closer I get to the boxing club, the more nervous and excited I become. This is what I'd always wanted to do and I'd been planning for this moment a long time. I'm about to find out how good a boxer I really am and if these American trainers rate me.

In hindsight I probably could have made a better impression walking into the gym, as I was carrying my boxing gear in a black bin bag. I didn't have a holdall like everyone else, but at the time I thought walking in with my gear in a bin bag would make people take notice and remember me.

This was all part of the Rambo persona I was cultivating. Wow, look at this kid coming all the way from Scotland on his own to live in the hood and he turns up carrying his kit in a bin liner. He must be a bit crazy. That's the kind of image I was trying to get across.

I stand in front of the big brown-painted metal double doors of the gym and give one side a push. The door opens with a screech of metal on metal and then slams shut behind me. Seems the hinges hadn't seen a squirt of WD40 in a long time.

As I walk in I have the eye of the tiger, looking like I'm ready for all-comers. With more than just a hint of swagger I walk down the ramp into the gym, not wanting anyone to think I was afraid or intimidated, but instead I was super-confident.

As the view of the gym opens up in front of me, I can see two boxing

rings and a myriad of punchbags large and small and most of all people – lots of them.

I hear the cacophony of noise you get in every gym in the world. Leather thudding on leather as the heavy bag takes a pounding; the rhythmic smack –like helicopter rotor blades whirring – of the speed bag bouncing off its wooden platform; the slap of skipping ropes clipping the floor; the squeak of boxing boots on canvas and trainers shouting encouragement to their charges as they put them through their paces. Add in the smell of sweat and leather and as boxers will tell you, when you walk into any boxing gym, it feels like you've come home.

Chest puffed out and with the bin bag over my shoulder like Santa delivering presents on Christmas Eve, I walk towards the desk where Jimmy O is sitting. As I reach the desk, the noise quickly subsides and everyone in the gym stops what they're doing and turns round to look at me.

It was like a scene from a Hollywood cowboy movie. You know, the one when the gunslinger walks into the saloon bar looking for his next target practice with these darned rustlers, there's a hush as the piano player suddenly stops tinkling his ivories, poker players drop their straight flush cards onto the table and the bartender keeps pouring the bourbon into a glass until it overflows.

I knew they were checking me out and thinking this white guy must have lost the map – and his marbles – to end up in a boxing gym in East New York instead of a yoga class in Cobble Hill, which is a trendy and posh part of Brooklyn.

I'd travelled thousands of miles to get here and I wasn't going to bottle it now. I didn't want to appear arrogant, but I stood tall and faced everyone in the gym and took a minute to look round the place, almost as if I owned it. I wanted to let them know that Stephen McGhee, a wee laddie from Scotland, was here to show them what he had in him and he wasn't afraid of anything. And to be honest, if I hadn't caused that kind of reaction walking into the gym, I would have been disappointed.

Eventually, I turn to Jimmy O and say: 'I called about training here.'

And when he hears my accent he replies: 'Ah, so you're the kid from

Scotland.' And smiles broadly as he adds: 'You not wearing your kilt today?'

'I've left the kilt at home,' I tell him. 'It's a bit cold in New York at this time of year for that, especially when you're a real Scotsman and don't wear anything underneath the kilt.'

That makes him laugh, then he asks me if I know the Scottish boxer Ken Buchanan, who was the former undisputed world lightweight champion in the early 1970s and topped the bill at New York's famous Madison Square Garden, with the legendary Muhammad Ali on the undercard. I tell Jimmy O I had never met Ken Buchanan, but I was impressed that he knew about him and it proved to me these guys really know their boxing history.

I pay my $40 a month fee to join the boxing club and head towards the lockers in the far corner of the gym. You could tell this place had history and character as there was a mural of Jimmy O on the right-hand wall along with photographs of boxers, posters for fights, newspaper clippings and boxing championship belts hanging from the wall.

I get my boxing boots out the bin bag, put them on and tape my hands with boxing wraps ready for some shadow boxing in front of the mirrors along the left-hand wall. I'm right among these guys now and I need to impress them straight away. I do a bit of stretching then start shadow boxing, going through combination punches as fast as I can because I know people – especially the trainers – are watching me to see what I can do.

After several minutes of shadow boxing and imagining I was fighting for a world title, I could see in the mirror there was someone behind me watching all my moves.

I stop and turn round to see who it is. It's one of the boxing trainers – a big Black guy, at least six foot three inches tall and with long dreadlocks. He introduces himself as Tyrone Venning and shakes my hand. 'How you doing? You from the UK?' he asks.

'Yeah, I'm from Scotland.'

'You fancy doing some work with me? I'd like to see what you got,' he says.

'Sure, that would be great.'

He nods for me to carry on shadow boxing and I can see he's analysing every movement, feint and punch I'm making, but he doesn't say a word.

Then he suggests I get my gloves on and start working on the heavy bag. I'm thinking: 'Wait till this guy sees me on the bag. I'll show him how amazing I am.'

I thought he'd be impressed, as back in Edinburgh people would be blown away by how hard I could hit the bag. So, I take my stance, crank up the aggression to almost overload and start leathering the bag, trying to knock seven shades of shit out of it. Again, Tyrone is studying me and after a few minutes he tells me to take a breather before I get back to business.

After another few minutes, Tyrone stops me and starts to tell me what I'm doing wrong. And it's not just a tweak here and there, he's telling me I need to go back to the basics and change the habits of my boxing lifetime. If ever I had an inflated idea of how good a boxer I was, well Tyrone certainly burst that bubble and my ego was splattered all over the gym floor.

'You've got all this aggression and power, but you're too tense and too wound-up,' he says. 'You're telegraphing your punches and I reckon an opponent will know you're about to throw a punch just by the look on your face. And your feet – man, you're not even moving them in the right direction. You're not holding your arms in a position to defend yourself properly and you need to relax. There's too much tension in your arms and you're wasting all your energy. When you get into the ring for a fight you're going to get tired pretty damn quick.'

I couldn't have been more stunned than if he'd landed a haymaker square on my jaw. Although I appreciated his advice and grudgingly accepted that he was probably right, I was still a bit peeved. After all, back home everyone had been telling me what a good boxer I was, but probably my biggest mistake was that I believed them. 'F**k me, am I doing anything right?' I ask myself.

There was, however, some sugar coating and Tyrone softens the blow when he tells me: 'You've got something though. I'd like to work with you. If you want me to train you, come back on Monday and I'll turn you

into a proper boxer.'

When I arrived back at the gym on the Monday, Tyrone had a new piece of equipment that would turn me into a champion – a stick. And I don't mean giving me a hard time verbally. He started by taping lines out on the floor for me to practise my footwork and if I got it wrong he would whack my shins with this stick of his.

And when he was holding the pads for me to hit, if I got the combination punches wrong, he would hit me over the head with the pads. Tyrone was in his 50s, more than double my age, but he was fast with these slaps around my head. I had fought guys back in Scotland who weren't as quick as Tyrone to throw a punch.

I paid Tyrone $20 a week to train me and it was worth every cent. I was going four or five times a week and I reckon Tyrone really did think I had some potential and he could eventually make some serious money out of me, because I certainly got my $20 worth out of him. He was a former light heavyweight professional boxer and I got to know him well. Often, he would give me a lift back to my apartment.

The next stage in my boxing development would be my first spar and it wasn't just my credibility that would be on the line. Tyrone didn't want to be someone who picked losers to train.

One day I walked into the gym for what I thought would be just another few hours of training, until Tyrone announced I would be taking part in a sparring session. I'd watched the boxers sparring at the Starrett City gym and they took it a lot more seriously than back home in Scotland where it's more about helping each other out to refine your skills. But here, it was more intense, as if it was a real boxing match and you were expected to beat your opponent.

I shadow box for a few minutes to warm up and then I put my groin and head guards on. Tyrone wraps my hands with tape before the gloves go on. Then to my surprise, Tyrone rubs Vaseline on my face. This is getting serious, as the professional attention to detail is what normally only happens when you're about to go into the ring for a real boxing match.

A crowd starts gathering around the ring to watch the sparring session and I could detect a palpable sense of anticipation. I'm beginning to

wonder what I've let myself in for as Tyrone gives me the big pep talk.

'You're ready for this, Stevie. Stay calm. Keep hitting him with those jabs. Jab, reload and jab again. Just remember everything I've told you.'

I climb into the ring and look across at the other corner, and for the first time I see who my opponent is. He's a big guy, taller and heavier than me and his trainer is giving it big licks about how he should knock me all the way back to the Royal Mile, in Edinburgh.

I'm thinking I've walked onto the set of the wrong movie. This is undoubtedly a mismatch in terms of weight class. Looking back, I wonder if the sparring session was deliberately set up like this to see how I would stand up to a bigger boxer and if I really was as good as my ego and braggadocio would suggest.

There's no referee in the ring, just the boxers and the trainers in the corners ready to jump in if the fight gets out of hand. I hear someone shout: 'Time to work, gentlemen. Time to work.' And the buzzer sounds to start a sparring session like I'd never experienced before.

I move into the centre of the ring wondering how all this is going to pan out, but there are no niceties like the boxers touching each other's gloves. Instead this guy charges at me like a bull and unloads a barrage of punches on me. He's throwing everything at me – including the kitchen sink – and I'm on the ropes trying desperately to defend myself with my arms and gloves.

I push myself off the ropes, but only manage to stumble into volley after volley of punches. I can see the anger and aggression in his face and can tell this certainly ain't going to be the tippy-tappy, bounce around the ring showing off the nifty footwork sparring session I'm used to.

Now I'm pinned in the corner as punch after punch bounces off my arms as I desperately try to stop any of the blows landing on my face, head or body.

Tyrone's shouting: 'Get out the corner! Get out the corner!' And I'm thinking: 'F**k's sake, Tyrone. You try and get out the corner!'

Eventually, I barge, or should that be stumble, my way into the middle of the ring, but the punches are still raining down on me. Three rapid hits to the body and then a couple of dull ones to the head, pause for a

second to see me suffer, and repeat over and over again. Boy, am I taking a beating here and it's as if I'm frozen to the spot and have forgotten that boxing requires two people to punch each other, as I've still not thrown a glove that's landed on my opponent. Never mind throwing punches, if it goes on like this, Tyrone will have to throw in the towel.

My opponent even used one of my own favourite moves – a switch-hitting hook – to land a hefty blow to my chin and that had me bouncing off the ropes and back into the corner. That's a move you make when you're leading with your left hand and your left foot, then you suddenly change to lead with your right foot and at the same time swing a right hook at your opponent. But thankfully, as he unloaded even more culinary equipment along with the aforementioned kitchen sink on me, the buzzer went for the end of the round.

When I got back to the corner, I expected Tyrone was going to give me – as we say in Scotland – a right good shericking, which is a verbal ear bashing. But he was very calm, even after seeing his protégé being used as a punchbag.

'Just relax,' he says.

'Relax?' I think. 'If I have to go through that again I'll be so relaxed I'll be lying on the canvas with Tyrone wafting smelling salts below my nose to bring me round after getting knocked into next week.'

'He's tired now,' Tyrone continues. 'You'll get him this round. Start using your jab. Move forward, jab and hit, move back. Forward, jab and hit. You can take him now.'

Sure enough, when I came out for the second round I immediately hit him with a flurry of jabs and punches and he wasn't hitting back. The more punches I threw, the more confident I became and when I landed a hard punch to his head, it became obvious I had rocked him. And just like a pro when you need some time to recover from a big hit, he grabbed me with both his arms like he was hugging a long-lost friend. I knew I had hurt him.

Tyrone's shouting from the corner: 'Get away from him and start jabbing. Jab, jab, jab.' And that's exactly what I did and before long he's in the corner. I hit him with a barrage of punches using every ounce of energy I had. Bam, bam, bam! I landed punches on his body, then to his

head and even more to his body. I could sense he was wilting.

The crowd watching are going crazy and every time I'd land a punch, there would be shouts of: 'Yessss! Go on, kill him! F**k him up!'

And Tyrone is just as bad, screaming: 'More jabs, more jabs. Jab and reload. Hit the body. You got him now!'

I unleash one more frenzy of punches on the guy before he flops to the canvas and goes down on one knee, holding on to the ropes with one of his arms to stop himself completely keeling over.

The boy's trainer is going apeshit shouting: 'What the f**k you doing? Get up, get up!' But the guy just shakes his head and stays on his knee. He's had enough and I've won.

Tyrone jumps into the ring and hugs me. 'You did it, Stevie boy. You did it!' he shouts in my ear. I was exhilarated and it felt like winning that sparring session was the biggest achievement in my life so far.

When the session was over, there was no hug from my opponent, or respectful recognition that I had been the better boxer. He went his way and I went mine. That's just how it is at the Starrett City gym.

Winning that battle was like I'd flicked a switch, as the boxers and trainers from the gym who had been watching now looked at me differently. I could feel a new respect. They had warmed to me, had accepted I was a genuine boxer and now I was one of them. When I climbed out the ring they crowded round me saying how well I'd done. One of the guys had filmed the session on a small video camera and he played the fight back to me.

That day kind of summed up my whole experience of my time in New York. People were sceptical of me turning up out of nowhere on my own, but when I would go on to prove I wasn't some shyster or scam merchant, show them I wasn't going to disrespect them or their culture and appreciate anything they do for me, their attitude towards me would change.

Tyrone took me home from the gym and he was well hyped-up. In the car, he was telling me how he would take me on the next stage of my boxing career. He told me he reckoned I could make it as a professional boxer and how he had lots of contacts that could help me achieve that dream.

And he knew I could sell tickets and make money. 'Man, you being from Scotland and all. You'll be Slick Scottish Steve and with that cute face of yours, everybody will love you and you'll sell loads of tickets for your fights.'

I was on a high and whatever Tyrone said I just agreed with him.

The next time I was in the gym, everyone gave me a nod of recognition or wanted a word with me. It was great that I could talk to these guys about boxing, big fights and the old boxers from years gone by. It's not that my knowledge of the noble art inside the squared circle particularly impressed them, all those guys from the gym knew their stuff and because I did too, I was accepted as one of their own.

The gym's population was made up of all ages, shapes and sizes. There were young hungry boxers with stars in their eyes – and not always from getting punched – who dreamed of fame and fortune from becoming a champion boxer.

There were the trainers who had been former pros and good journeymen boxers, but had never made the dizzying heights of the fight game to set them up for life. They had knowledge and experience in abundance and were chasing fame and money through the young men they were hopefully guiding to boxing glory.

Then there were the old timers who had become shambling wrecks with hardly enough spare change in their pocket to get the bus home. These guys had given their lives to boxing, but boxing had become the unfaithful wife who had abandoned them for a younger man, as they got older and could no longer make it in the ring. All that was left for these old guys was the comfort and warm feeling a boxing gym gave them and the people there who could understand what they had gone through.

These old boys gave so much to boxing and for many, boxing took all they had to offer along with their health, money and relationships. But they were content that at least boxing had given them a gym to go to and a place they would call home.

And of course, there was me.

I trained hard with Tyrone in the weeks after that sparring session and I managed to get rid of the bad habits I'd picked up boxing in Scotland.

Not only did he have me working out in the gym, he had me pounding round a running track that bordered an American football field just off Linden Boulevard, in East New York.

And if I thought he was a hard taskmaster making me sprint and run longer distances the way I was facing, he would have me running backwards as well. At first, I thought that was really bizarre and weird that he would tell me not to look over my shoulder as I ran as fast as I could in reverse. But when I thought about it, moving backwards and forwards is a big part of boxing and I was developing different sets of muscles.

I also did a lot of road running around the streets of The Projects, in Flatbush – usually at two or three o'clock in the morning. Lots of people I knew thought I was crazy running in these areas, as many would be wary of being on these streets no matter what time of day it was.

I loved running through these streets at night and I suspect psychologically it was proof to myself that I was brave enough to survive living in the mean streets of the city. However, I had to use my stamina and running ability to get me out of one dangerous situation.

It was about 2am, and I was running round the streets of Flatbush when I stopped to look inside a laundromat. Bizarrely, there was a small group of people inside watching the Braveheart movie on a TV screen fixed to the wall. I thought how ironic this was that I had come all the way from Scotland, only to see a film about my homeland on a TV screen in a Brooklyn laundromat in the early hours of the morning.

Unfortunately, while I was watching the screen from the sidewalk and having a wry smile to myself, someone else was looking at me. Further up the street a group of Bloods were hanging around an ATM and when they saw me, they started running towards me. I heard the sound of their feet pounding on the road and I quickly realised that a sharp exit was called for.

I took to my heels and ran like the proverbial bat out of Hell. They weren't gaining on me, but I could still hear them running after me. They weren't going to give up on their prey. I knew there was a cemetery nearby, so I took a sharp left towards the graveyard and with a leap that an Olympic high jumper would be proud of, jumped over a wall and hid among the gravestones.

I stayed there for a few minutes until the sound of the hunting pack of Bloods had gone and I knew they had given up trying to find me. Then it was back over the wall and sprinting away in the opposite direction.

Although as a boxer I knew I could handle myself if it ever came to fisticuffs in the street, I never flaunted my pugilistic prowess other than in the gym and boxing ring. But much to my chagrin, the same couldn't be said for Cass and Mayor. They were forever telling people what a great boxer I was and this would inevitably lead to some would-be Mike Tyson wanting to have a go at me. They were also constantly on at me to take part in boxing matches and said they could make money by betting on me to win. If it would make them a few dollars, they would have had me fighting sleep. And I was so gung-ho at that time I would have done that as well.

I was hanging around The Junction one day with a friend I'd met through Cass, called Ricky B. He bumped into a couple of guys he knew and when I was being introduced Ricky told them I was a boxer.

Now, one of them obviously fancied himself as a bit of a boxer and to be honest, almost all the guys in Brooklyn would tell you they'd been boxing at some time or other.

Before you could say seconds out, round two this guy has moved round in front of me with a challenge: 'Boxer, yeah? Why don't you throw me a fair one, then?'

I turn to Ricky and say: 'What the f**k is a fair one?'

He replies: 'It means have a bit of a friendly spar or a dummy fight.'

'No, you're OK,' I say to the guy who, having seen my choirboy face, obviously fancies his chances with me. 'I keep my boxing for the gym.'

'Come on, let's see what you got. I've done a bit of boxing, so go on, throw me a fair one.'

'No, I'm fine.'

Then he starts moving his shoulders from side to side and slapping me on the side of the head. 'Come on. Let's see what those little hands of yours can do. Don't think they can do much.'

'Don't touch me,' I reply. But I know full well that this isn't going to end

with just a bit of banter, and this guy's not going to back down. Ricky shows how he's not really cut out for the diplomatic corps or negotiating stand-offs between warring factions as a United Nations envoy, when he chimes in: 'Go on Stevie. Show him what you've got. Give him one of your best shots.'

This just serves to wind the guy up and he carries on slapping me on the shoulders and side of the head. He's spoiling for a fight and there's nothing I can say to change his mind, so I raise my fists and take up a boxing stance.

His eyes change and he becomes even more aggressive. He has another slap at me and I feint a left jab to his midriff, but as soon as he drops his hands to defend his body and I've got a clear shot at his face, I throw a peach of a punch with my right hand that lands square on his jaw. You could hear the crack of the punch landing on his face several blocks away and he immediately crumples to the ground.

He's lying face down on the sidewalk and there's silence for a few seconds. But Ricky's getting excited. 'Man, what a punch,' he says. 'You've knocked him out cold. F**k me, that was awesome. Can't wait to tell everyone.'

The now groggy, would-be challenger is helped up off the ground by his friend, who decides Saturday night – or any night for that matter – isn't the night for fighting and doesn't say a word.

Ricky and I head off before the guy gets to his feet to stagger home like a drunk with a full bottle of liquor in his pocket weighing him down on one side. Ricky's still enthusiastically going on about me knocking the guy out with one punch. I'm just grateful I didn't break my hand.

I was coming to the end of my three-month visa and I would soon be heading back to Edinburgh. I said my temporary farewells to my new 'family' and friends in Brooklyn, but with the words of Arnold Schwarzenegger in The Terminator movie: 'I'll be back!'

However, the American immigration officials might have something to say about that.

<div style="text-align:center">

CHAPTER 5

IT'S A RAP

</div>

It must be the most bizarre venue a rapper has ever performed in and the crowd – well, you couldn't exactly call it a sell-out. All the same, I put in a performance to be proud of.

I was rapping for the right to be allowed back into America and the audience was three stern-looking immigration officials, who had the power to decide my fate.

After my first 90-day visa waiver period had expired I'd come back to Scotland for just a week and in early January 2011, I headed back to New York on another visa waiver hoping to get another three months in the States.

I'd landed in Newark Airport and at the immigration booth the official there made the usual enquiries.

'How long are you planning to stay in America?' she asks.

'Three months,' I reply.

'Do you have any family or friends in this country?'

'No family, but I've a few friends here?'

'Where will you be staying?'

'I'll probably be staying in Flatbush and East New York with friends for

a while until I find a place to stay on my own.'

'What will you be doing during your stay in America?'

'I'll be boxing and doing music.'

That last reply obviously put the tin lid on it, as the immigration official stopped writing and looked at me with no little dubiety in her eyes. 'Come with me, sir,' she says.

I'm led into what looks like a courtroom. There are three podiums at one end and rows of seats in front of these podiums. I'm told to take a seat alongside three other people already in the room – a Chinese couple and a guy from Africa. We look at each other apprehensively and, without saying a word, know that the next hour or so would see us either being allowed to stay in the Land of the Free, or unceremoniously frogmarched onto the next plane home.

The guy at the middle podium is obviously the main man here and he's flanked by two other officials. After a while, he nods and gestures for me to come forward and stand in front of them.

He looks at me, exhales wearily and asks: 'Now Mr McGhee. Why exactly do you want to enter the United States of America?'

'I've been out here before and I'm training to be a boxer. I'm also a rapper and I've been writing and recording music as well. I've made lots of friends here and they've been looking after me.'

'But why are you saying you're going to stay in East New York and Flatbush? I've lived in Brooklyn and I know what these areas are like and they ain't no tourist hot-spots.'

'I know what you're saying, but I've lived there before and I'm fine. That's where all my friends are from.'

'OK, I might come back to that, but you know you're not allowed to undertake any paid work. So how are you going to provide for yourself and survive if you can't earn any money?'

'I've got savings and my family will be sending me money, so I don't need to work.' I knew that was what he needed to hear.

The official leaned over the podium and stared at me as if he was trying to look through my eyes and into my mind to see what I was really

thinking. 'Are you telling us the truth today, Mr McGhee? Have you really got enough money to keep you without having to earn a living?'

'Honestly, sir. I don't need much. I don't drink, I don't do drugs and I don't smoke. I'm training to be a boxer, so I keep myself fit.'

He almost breaks into a smile as he says: 'Come off it – you're from Scotland and you don't drink? You got to like a drink. Do they not call whisky Scotch after you Scotch people?'

'No, I can truthfully say I don't drink and I'm a clean-living person.'

'Anyway, what kind of music did you say you do?'

'I'm a rapper.'

That produces a stifled guffaw from the guy and he turns to the other two officials, points at his piece of paper and says to them: 'Does this guy know what he's doing? I know this place where he says he's going to stay and it's a crazy neighbourhood. This is a real bad area and I wouldn't even go there.'

Then he turns to me. 'So, you're a rapper are you? Get out of here! There's no way you're a rapper. First you're a boxer, then a Scotsman who doesn't drink and now you're a rapper. It doesn't make sense.'

I was getting frustrated and I tell him: 'I am a rapper. You want me to rap for you? I'll show you.'

I go into performance mode and launch into this rap that I'd written about America. I'm giving it the full Monty, with a repertoire of the hip hop hand gestures like the Mos Def Wave, Slim Shady Chop, Ninja Star and a few moves of my own. And it doesn't take me long to get into top gear, as I start spitting bars:

In this Confederate State of American life

I'm a resident busy being the president

Of this benevolent deafening Thomas Edison light shooting like venison heroin and a terrorist

Never competitive just better at imperative tasks that are eminent gang bang you're celibate

Wearing this game like a snap back my heads in it

Warring with my words like Anne Frank I'm selling it

Life is like lettuce I relish this blessed with intelligence

Bitterness stems from evidence that you never lived

Reminiscing about things that you've never did

Sedative living sleeping is your nemesis.

When I end my impromptu rap there's an awkward silence where the applause should have been, so I go into a spiel about how America is supposed to be the land of opportunity and I want to grab that opportunity. I also tell them that the last time I was here, the experience had changed me and made me a more mature person.

The three immigration officials start laughing and the main man says: 'OK, OK. That's enough. And as a matter of interest have you been talking to the girls out here?'

'I've spoken to one or two.'

'I'm sure you have and I bet they really like your accent.'

I can feel tension disappear and he says: 'Alright, Mr McGhee I'm going to let you enter the country this time. But if you ever come back to the US, make sure you've got a proper visa that lets you stay longer, or else we'll just send you right back.'

And as I turn to walk out the door, he adds: 'Hopefully, I'll see you on TV sometime. Good luck with everything.'

I breathe a sigh of relief and quickly head for the airport exit doors before they change their minds. Waiting for Cass to come and pick me up outside the main doors of Newark Airport, I feel like I've just escaped from prison. I say to myself: 'I've done it again. I've beaten the system and I'm free!'

I stayed with Cass in his flat above his dad's realtor office in Flatbush for a few weeks, and it wasn't long before I was back in the old routine of boxing training and regular visits to Fletch's studio recording my rap songs. It was in his studio that I came up with my new hip hop moniker, Stevie Creed, and the guys who were there that day thought it was spot on.

I'd been looking for another name for myself the more I realised I wanted to become a serious rap artist, and I knew hip hop performers had their own street names. I also knew that when you are in the music business image is very important and the first time someone hears your name mentioned you'd want them to remember it. So, Stevie McGhee had to become Stevie something or other.

Up till then they had called me everything from Stevie Scotland, Braveheart, after the movie and Choir Boy, because of my baby-face looks. Then, because of the colour of my skin, I'd either be Milk Bread – what they called a white loaf of bread – or Vanilla Boy. It was all done in good humour with not a hint of racism, and sometimes in a conversation I'd even refer to myself as a honky, which always got a laugh.

We'd just finished recording one of my tracks and we were sitting around shooting the breeze about why I had come to America. I told them that I believed in myself that I could make it either as a boxer or a rapper.

Fletch started talking about boxing and mentioned that he liked the Apollo Creed character in the Rocky movies and the Assassins Creed video game that was really popular at the time.

They got back to talking about me believing I could be a success in the States and Fletch said: 'If that's what you think, then that's what you should aim to do. That's your belief, that's your creed Stevie. You got Stevie's creed to see you through.'

As soon as the words came out of his mouth I knew we'd hit on the name I'd been searching for.

'That's it,' I said loudly. And they all turned to look at me as if I'd just discovered the cup I'd been drinking coffee from was, in fact, the Holy Grail goblet that Jesus was said to have drunk from at the Last Supper.

'I've got my new name. You know I've been looking to call myself something else when I'm rapping and Stevie Creed is perfect.'

It was one of those light bulb moments and I thought the name represented me, everything I was doing and why I was in America. Fletch had stumbled on the phrase Stevie's creed – my belief that despite coming to a foreign country on my own and all the risks involved in that,

I was going to survive and prosper.

Everyone in the studio thought it was a great name and it summed me up perfectly. From that day on I was known in the hood as Stevie Creed and if I was being introduced to friends of Cass and Mayor, they would say this is Stevie Creed, he's a rapper and a boxer from Scotland. Even back home, the name has stuck and to this day some people I've known since then think my real name is Stevie Creed.

I've never officially changed my surname to Creed by deed poll, as you have to do in the UK if you want to give yourself a new name, but since I've done some crazy shit in my time – you just never know.

And it wasn't long after that I was given the additional sobriquet of The Brooklyn Scotsman. Cass and I were sitting in his dad's realtor's office and he was describing what I was like when he first met me.

'Man, you would walk about like you had a pipe up your ass. You looked so militant and angry,' he says. 'You didn't have enough swag, but you got your shit together now, brother. You're starting to get a bit of swag, you act like you've been indoctrinated into the streets and you understand how things move here. We've adopted you, the whole neighbourhood has adopted you and you're part of our family. You're from Scotland, but you're also from Brooklyn now. You're now our very own Brooklyn Scotsman.'

And he was right. I had been adopted by Cass, Mayor and his family along with lots of other people I'd met during my relatively short time living in Brooklyn.

I thought The Brooklyn Scotsman was another great name for me and it meant so much to me that these people who had been complete strangers a few months ago had accepted me as one of their own. And the name also described perfectly who I was and what I was trying to achieve at the time.

Now that I was Stevie Creed, The Brooklyn Scotsman, my determination to become a rapper grew even more and the names were another part of my hip hop armoury. Especially in Brooklyn, where you could close your eyes, throw a stone and it would likely hit someone who could rap, I knew there were unsigned and unknown artists who were better rappers than the acts who made the charts each week. And I also quickly recognised

that I had to stand out.

The last thing I wanted to become was a culture vulture trying to copy the Black hip hop acts. I needed to create an image and persona that was genuinely me. What I was going to promote was that I was, first and foremost, a Scottish rapper with a distinct Scottish accent, and that I had a very unusual story to tell about what had happened to me since I came to live in Brooklyn.

I reckoned that would certainly make me stand out from the crowd, since there didn't seem to be many people as crazy as me, coming all the way from Scotland to live in the hood, trying to be a champion boxer and a hip hop star at the same time. Brooklyn might have had a plethora of rappers, but as much as I searched high and low, I couldn't find another Scotsman with a penchant for pugilism and a proclivity for hip hop.

With this surge in my enthusiasm for rap, I wrote even more about my experiences in America and I wanted to use my story to encourage people to talk about humanity, not be afraid to try something new and take a leap of their own faith into the unknown and to question the stereotypes and perceptions they have of other people.

I wanted people to listen to my music and come away questioning themselves. Are they sure they don't hold racist views and do they realise what racism is? Do they simply believe what they're told in the media about people, and judge them without finding out for themselves or experience what they are going through?

We all make those mistakes and have misconceptions. I certainly did when I went to the States, but it didn't take me long to realise how much I'd been influenced by society's stereotyping of Black people, and I was soon challenging the false impressions of the good people who had befriended me.

The saying about not judging someone until you have walked a mile in their moccasins is very apt. Many people assume this is an old Native American proverb, but it actually comes from a poem, called Judge Softly, written in 1895 by American poet, preacher and suffragist, Mary Torrans Lathrap. A verse from the poem reads:

Just walk a mile in his moccasins

Before you abuse, criticize and accuse.

If just for one hour, you could find a way

To see through his eyes, instead of your own muse.

I only wish the cops I encountered, the night I went to Manhattan with Cass and a couple of his friends, had learned that particular verse off by heart and understood its meaning. We were driving along, having just crossed the East River from Brooklyn into the city, when two police officers in their squad car pulled us over for no apparent reason.

We hadn't been breaking the speed limit and I can only suspect the blue lights were flashing in Cass's rear-view mirror because the officers saw a car full of Black people driving in the city. What happened next brought home to me the meaning of white privilege.

Strange as it may seem, the first time I was in America I never ventured out of Brooklyn, so during this visit, Cass said he would take me on a tour of Manhattan in his car. With Cass driving, I joined him and three of his friends on the journey across the East River and into the city.

Only a few minutes after driving into Manhattan, Cass spots a police car following us and it's not long before the patrol car is right behind us and its roof lights are flashing, which means Cass has to pull into the side.

The patrol car pulls in behind us and two white officers get out and walk towards us. One of them taps on the driver's side window and Cass rolls it down.

'What are you gentlemen doing tonight?' the cop asks.

'We're just taking my boy from Scotland here to see the sights in Manhattan. He's never been in the city before,' Cass replies.

Then there are more questions from the officer, like where Cass was from, where he was planning to drive to and what he'd be doing later that night. After Cass answers all the questions, I thought it would be a case of 'OK, guys. On your way and drive safely.'

But the cops aren't letting up. 'Licence and registration, please.' And after Cass produces the documents, we're all told to step out the car.

We're told to stand in a line facing the front of the car, but very quickly one of the cops asks me to step to the side and motions for me to stand yards away from the other guys.

He starts talking to me and I can see he's intrigued, asking where I was from in Scotland and where I'm staying while I'm in America. When I tell him I'm staying with Cass, in Flatbush, but I'm about to move into an apartment in Linden Boulevard, in East New York, I can see he's bemused that a white boy is living in these areas.

'Why are you with these people?' he asks me.

'They're my friends and I've come to America to visit them,' I reply.

While my conversation with the cop is very civil, the demeanour between the other officer and Cass and the other guys definitely changes as soon as I'm separated from them. The cop's questioning is certainly a lot more aggressive and degrading than before.

'Alright. Can you tell me what you're really doing in Manhattan?' he asks with a sneer in his voice. The obvious implication being that he didn't believe their answers first time around.

One by one, each of them is told to turn and face the cop before he starts his body searches. It takes me a few moments to realise what's going on and that Cass and his friends were being treated a lot differently from me. I wasn't being quizzed in the hostile manner they were and I wasn't being frisked by a cop.

I had a weird sickening feeling as I watched the scene unfold. My friends were being treated like they were inferior to the cops. I should have intervened and said something, but I was still quite young and inexperienced about what it's like for Black people living in New York. That's why it took me a few minutes for my brain to compute that Cass and his friends were being treated like that because they were Black and as a white boy, I wasn't. If the same thing happened today, I'd certainly be more aware of what was happening and I'd be right in there to say something to support my friends.

The cop searching Cass and his friends found nothing untoward and the incident ended with Cass getting a ticket as they claimed Cass had been speeding.

After the cops drove off, I felt embarrassed, ashamed and a coward because I froze and didn't intervene and say something to the cops to stop the way my friends were being treated.

Cass and the rest of the guys didn't mention that I'd been treated differently during the incident, and shrugged it off as if it was just another day for a young Black guy coming into Manhattan. Back in the car, I'm still trying to understand how I'd managed to drive around Brooklyn many times in a car full of Black guys and never been stopped once by the cops, but as soon as we get into Manhattan, we're pulled over straight away.

This was just another example of white privilege that I was learning about and how the friends who were looking after me were treated differently just because they were Black.

That incident was a wake-up call for me. I had seen programmes on TV and read about the slave trade in years gone by, and about how Black people are still discriminated against in the 21st century. But when you have first-hand experience of white privilege it really drives home the message that racism still exists in society today, and something has to be done to eradicate it.

While I was living in Brooklyn, Cass and Mayor introduced me to guys who had been in jail for violent crimes and even murder. At first when I met them, I would think they were some of the nicest people in the world. But it was only after they had left our company that I'd be told they had been in jail for these crimes.

Very quickly getting over the shock of having spent time chatting away to a murderer, I would ask what the background to their story was. Only then would I realise there was always more to the story than meets the eye, and I would start to understand how they got themselves into a situation where someone sadly ends up dead.

Once again Craigslist became compulsory reading and I found someone looking to rent out a room in the house they were staying in. I moved into a room on Linden Boulevard, East New York across the road from The Projects, and shared it with a New York cop, Malik Williamson. He was a good guy who was always warning me to be careful when I went out running round the streets. And he had first-hand experience of

what it's like to be a victim of street crime. Yes, even the cops got robbed in East New York.

Malik told me he was robbed at gunpoint in an alleyway in Brooklyn and although he had his police firearm in the holster he was wearing at the time, he couldn't draw it in time to defend himself. His only option was to hand over all his money and his wallet.

But he was quite sanguine about the whole episode. 'It was just my time,' he says.

'But you're a cop,' I reply.

'Yeah, but getting robbed is going to happen to you at sometime or other.'

Crime and violence were never too far away on the streets of East New York, Flatbush and Brownsville where I was living and hanging out. The friends I'd made were always looking out for me and they even offered me a gun that I could carry around with me in case I was being robbed or threatened. On several occasions they tried to hand me a gun, or said they would get me one. One of my friends even handed me a flick knife and said it was a present from him.

'Just hold on to this. You're going to need it sometime,' he said.

I always refused the offer of a gun and I didn't carry the knife when I was out and about. I reckoned that if I couldn't talk my way out of trouble, or a right hook wouldn't do the trick, I'd take to my heels and run like the proverbial wind – or a stiff breeze, depending on how fit I was – to get away from danger.

I also trusted my luck and fortuitous fate on occasions to keep me safe. I was coming back from seeing Cass one evening on the B6 bus from Flatbush to Linden Boulevard and I normally got off at the bus stop close to the house. I'd been at the gym in the morning and had been hanging around with Cass all day, so I was feeling tired and I couldn't wait to get home, put my feet up and relax for a while.

But a few stops before mine, the bus broke down and trundled to a halt. Despite the driver turning the engine over time and again, it just wasn't for catching and taking us on the rest of the journey. Finally, we were told the bus wasn't going any further and we'd have to get off and walk.

I was mightily pissed off at having to take shanks's pony for the rest of my trip home and started trudging along the road, muttering under my breath. But my indignation soon faded when I was only a hundred yards from my apartment and I saw two groups of Bloods and Crips battling each other right outside my building. It was like a scene from the Braveheart movie, or the Battle of Bunker Hill during the American War of Independence.

What I witness stops me in my tracks. There are more than 100 gang members involved and they look like two armies who had run headlong into each other and were engaged in bloody hand-to-hand combat.

I'm horrified to see people punching, kicking, slashing and stabbing each other, and the injured lying on the road. They're going at it hammer and tongs trying to kill each other, so I decide it's time for a sharp exit, as I don't fancy getting caught up in the melee. During my time in New York I've certainly developed an aversion to knives and guns – especially when they are being pointed at me.

I quickly head back the way I came, and decide to visit a friend's house about a half-mile away until the Battle of Linden Boulevard is over. On my way there I realise how lucky I am that the bus had broken down. I would have been getting off the bus at the exact spot and the exact time the fighting broke out and would have been in the middle of the carnage.

There was another occasion when, for no reason, I decided to take a different route walking home from the gym. Normally I would take a shortcut through a park, but one day I took the long way round and I later discovered that at the time I was taking the detour, someone was shot and murdered on the same path I would have been walking on if I'd gone my usual route. Spooky, eh? Or is someone really watching over me?

If there was, they must have taken their eye off the ball, or were looking the other way a few times. That's when I'd be the victim of attempted robberies, and there were occasions when I was robbed and had no choice but to hand over whatever money I had on me at the point of a gun.

New York may be the city that never sleeps and it seems neither do the Brooklyn bandits who prowl the streets looking to liberate money,

watches, jewellery and phones from innocent and unsuspecting night owls on their way home. I was caught a few times during my late-night jogging sessions, or when I was coming back from a night out.

I was also robbed once when I came out of the subway at The Junction, in the early hours of the morning. While I was on the train I noticed this one guy was being aggressive and shouting at the other passengers. I sensed he could be dangerous, as he was acting either unhinged or out of his skull on drugs, so I moved carriages to make sure I never got involved in his shenanigans.

The next time I see him is when I get out onto the street and it quickly becomes obvious he's following me. I didn't want to walk straight to where I was staying, so I took a detour, as it's not a good idea to let guys like that know where you live.

He begins shouting at me to turn round, but I keep walking. 'Where the f**k you going?' he yells. 'You got money?'

Finally, I turn round and he pulls one of those small snub-nose pistols out of his coat pocket. Now that I can get a close-up look at him I can tell he's one of these guys who hasn't felt the cascade of hot water from a shower over his head for quite a while and has probably been living on the street.

The guy was very aggressive in demanding I give him money and my phone. And, to accentuate his point, he kept jabbing the gun into my chest. I didn't know if the gun was imitation or a real firearm, or if it was loaded. But I wasn't taking any chances as I was convinced this one was a wacko, and very dangerous into the bargain.

'Look man, I don't want any problems. Just take whatever money I've got,' I say and hand over my wallet which only had a few dollars in it and an old mobile phone I used for listening to music when I was out running. Goodness knows why he took that from me, because it was ancient and no one would want to be seen dead using such an old-fashioned cell phone.

But the pièce de résistance from this madman was that after he grabbed my wallet and was about to run off, he threw half a sandwich at me. Bizarre as it may seem, whether he had bought the sandwich or someone had given it to him, this roaster – as we Scots describe someone like him

– thought he would leave two slices of rye bread with corned beef and pastrami as his calling card. And I don't even like pastrami!

I'd been told that you were more likely to be robbed by a teenager than an adult. These teenagers are desperate to prove themselves and make their mark in the hood, while the older generation sit back and chill out smoking doobies, or as we call these joints at home – wacky baccy. They're quite happy letting the young Turks do all the dirty work and take the rap if they get caught.

I'd been approached several times by youths in their early to mid-teens demanding money from me, but usually I would just swat them away with the threat of a slap on the chops, or a boot up the backside. That is, if they weren't carrying a gun.

But even I was shocked when a good friend, Josh Valentin, from Brooklyn told me a story about the day a kid on a bicycle, who looked like he was only about seven years old, pulled a gun and tried to rob him. Josh had grown up in East New York and was very street-wise. He had gone to college and made a lot of money as a businessman in network marketing. He was in is early 20s at the time and was coming home from work one day when this youngster walked up to him and demanded: 'Give me your wallet.'

Josh laughed and thought that instead of playing cops and robbers, the boy just wanted to play robbers, so he replied: 'Beat it, kid. Stop bothering me.'

The boy disappeared and Josh thought he'd never see him again. But a few minutes later the kid comes hurtling up the road on a bicycle waving a gun in the air shouting: 'Give me your motherf****n' money! Give me the money now!'

Josh takes one look at this boy and starts running away, as the lad pedals like mad trying to catch up with him. Even to this day, Josh tells how embarrassed he was being chased through his own neighbourhood by a gun-toting seven-year-old on a bicycle.

I also found myself in some weird and wonderful situations during that second stint living in Brooklyn. One day, I decided I needed a haircut when I was on my way back from a nearby running track I used for stamina training to help in my boxing.

The first barber's shop I passed was on Pennsylvania Avenue, so I jauntily walked in and was immediately hit by a weird scene. The place was dark and the air was thick with cigarette smoke. It also seemed very busy, but no one was getting their hair cut.

I stand in the middle of the barbers and say: 'Hi – alright guys! Just want to get my hair cut.'

Everyone stops speaking and turns to look at me. The guy that turns out to be the barber gives me an evil stare and says curtly: 'Sit down here then,' and points to a chair.

He doesn't ask what style I want or how much I want off the top and sides. He just plugs in an electric razor and starts roughly mowing through my thick head of hair. Normally, a hairdresser would have started with a pair of scissors to take off the longer locks, but this guy just got stuck in with the electric razor and it was quite painful. No chance of a New Age Indian head massage along with a short back and sides from this Brooklyn coiffeur.

And there was none of the usual barber's chat about football, ice hockey or baseball games, or if you were going somewhere nice that evening. I thought when they heard my accent there would be lots of questions about where I came from and what I was doing in Brooklyn. But no, nothing and I thought that was a bit odd. Certainly, the customer service skills needed brushing up on, if you'll pardon the pun.

Since I'm getting the silent treatment as my hair's being cut, I'm looking in the mirror at what's going on behind me and I notice an older guy sitting in a wheelchair with one leg up on the foot rest. Every minute or so, people were coming into the barber's shop and handing this guy bundles of money and walking back out again. Sometimes as they walked out he would shout something to them about not being late the next time.

In the time I was in the barber's chair he must have been given thousands of dollars that he'd stuff into a pocket at the side of his wheelchair. And if I thought that was strange, it got even stranger when I noticed he had a gun in a holster fitted to the other side of the wheelchair.

The barber hadn't spoken a word to me the whole time I was getting my haircut and I've no idea why I was being treated like a butcher at a vegan convention. Even when he'd finished and I was handing him a $10

bill, he just stared at me. And then without a word, he put his hand in a jar and pulled out a key ring with the name Black Success Barber's Shop and handed it to me.

I don't know if it's me, or if there's something in the air in Brooklyn, but I couldn't even go to the barbers without it being a hair-raising experience.

Although rap music was taking up a lot of my time and I'd regularly be in Fletch's studio recording my material, boxing was still the main reason I was in Brooklyn. I was training hard with Tyrone most days of the week and he suggested it was time I got myself some experience of fighting in real boxing matches.

Getting on the boxing bill at Madison Square Garden was still just a dream, but as I made my way along the long road to turning pro, I needed some experience of the real thing. So, I decided to take the chance to fight in boxing matches known as smokers, which are unofficial boxing bouts. Sure, they had referees in the ring and judges to award points, but some of the fights were complete mismatches.

These smokers may have been unlicensed, but they were certainly a licence to print money for some people, with the amount of betting on the outcome of the fights that went on.

The fights attracted huge crowds who packed into boxing gyms, function rooms and community halls all over New York that had been kitted out with a ring for a night of boxing madness. The atmosphere is incredible at these boxing matches, as the boxers would be desperate to show up well and get on the next rung of the ladder as they reach for the dizzying heights of pro championship boxing.

And they would bring along lots of family and friends who would make an incredible din as they shouted and screamed at every punch their boy landed on his opponent. And even if you weren't family, if you had $100 on one particular fighter to win, you'd be shouting for him just as loud as the boxer's mother was yelling.

My first smoker was at a venue in The Bronx and as I was about to step into the ring I was nervous, although I had trained hard and thought I was ready for this.

As I stoop to go through the ropes and onto the canvas, there's nothing

but the usual hubbub of noise from the crowd of around 200 waiting for the fight to start. But when my opponent comes into the ring there's a huge cheer from his fans and before the bell goes, his mother is screaming: 'F**k him up! F**k him up! Come on baby, hit him hard!' They got even more wound up and their screams got even louder every time he landed a punch on me.

My game plan was to knock this guy out, but the noise and the animosity towards me from the boy's supporters made me angry, which is the last thing you want to be in a boxing match. It made me more desperate to chase the knockout, but it also made me too tense and that big knockout punch I was desperate to unload never came. The fight went the distance and I won on points, but if I'd stayed calm I reckon I could have got the knockout victory I wanted.

My second smoker took place in Brooklyn. This time I was fighting a guy who was in the same light welterweight class, but a bit taller than me. He was one for moving about the ring too much and that tires you out. I played it cute and waited for him to come within my range and I'd hit him with jabs to the body.

We're well into the first round and he's moving towards me. I bide my time and land a beaut of a punch under his short rib. Now, if you can land a hard punch on that sweet spot, your opponent isn't coming back up off the canvas anytime soon. It's an almost paralysing blow and can be more devastating than a headshot.

He's hit the deck and although fully conscious, he can't move and he's counted out. I'm in my corner, but I can see the agony etched in his face until the excruciating pain from the blow subsides and he can get to his feet. However, by then it's too late and I've won by a knockout.

My third was also in Brooklyn and again the place was packed with people and there was food and drink on tables for everyone. It was like one giant birthday party, only with boxing instead of a game of pass-the-parcel or musical chairs.

Before I got into the ring my opponent's brother was trying to put me off by getting inside my head. He comes over to me and says: 'My brother's going to f••k you up. You've no chance.'

'Fair enough,' I reply. 'Whatever you say. But let's wait until the fight's

over before you decide who's going to be doing the f*****g up.'

'Big talk. So, you gonna put your money where your mouth is? I'll bet you 100 bucks my bro will take you.'

'You're on,' I reply.

I go to the changing room, delve into my bag and bring out $100. I then hand it to another guy who was there and had agreed to hold the money for both wagers until the fight was over and either of us would collect our winnings. But as I'll soon find out, I've not even got into the ring and I've been hit with a sucker punch.

I won the fight on points after dropping the boy onto the canvas with a good left hook. I was really chuffed to have won my third fight and after taking the pats on the back and congratulations from people in the crowd and getting my gloves and tape off my hands, I went to collect the money I'd won in the bet.

I look all around the hall, in the changing rooms and even the gents' toilets, but the boxer I'd just defeated, his brother and the guy holding the money were nowhere to be found. Talk about snatching defeat from the jaws of victory.

My fourth fight was also in Brooklyn and it was a pretty straightforward victory on points. This time, I kept my money in my pocket because as far as I was concerned all bets were off.

CHAPTER 6

MY SCOTTISH SURVIVAL KIT

It wasn't exactly like a scene from the Braveheart movie, but considering the amount of times people tried to rob me, I could well have been yelling: 'They may take our wallets, but they'll never take our freedom!'... or something along those lines.

I've a lot to thank Mel Gibson for after his portrayal of William Wallace in the Hollywood blockbuster film about Scots warriors battling it out with the English. When I was living in America, many people thought we Scots were all as fierce and brave as Wallace and his battling clansmen. I certainly didn't do anything to disavow them of that notion, as the more they thought of me as a mad Scot always ready for a fight, the better.

Being Scottish, with my broad accent, aggression and audacious attitude, along with the perception some Americans have about the Scots, certainly got me out of a few scrapes. It didn't always work, but more often than not a bit of the Celtic courage and bravado got me through situations unscathed if I was being threatened, and may have even saved my life at times.

Being Scottish, more than being white, was what made me stand out when I was living in America and what drew people towards me and made them want to look out for me.

77

The people in Brooklyn – particularly those from a Black culture and background – seemed to find a common bond with me because of my heritage.

Many Scots came to America as immigrants to start a new life in a foreign land and both had to struggle to survive. Both Scots and Black Americans had to fight against tyranny – the African Americans against slavery and as portrayed in the Braveheart movie, the Scots were fighting for their freedom against the English.

They perceived Scots to be very loyal, like Black people are to their own culture and also both are proud of their heritage. You would see lots of cars in Brooklyn with bumper and window stickers of Haitian and Jamaican flags, just like you would see the Saltire flag or Lion Rampant stickers on cars in Scotland.

Sometimes I would think people noticed my accent before the colour of my skin and the way I spoke was a real bonus when I came to live in Brooklyn. I'm sure out of all the different accents and dialects the Brooklynites were hearing, a Scots accent wasn't one of them, so that set me apart from other white guys and got me noticed.

Many people outside of Scotland think that when Scots have a normal conversation we sound aggressive, and I played up to that idea when I first lived in Brooklyn. I didn't try to come across as aggressive and intimidating when I was speaking – although to some people, I may have done at times – I was just trying to be assertive and have some authority in my voice.

Everyone seemed to love the accent and it was a great hit with the girls I'd come across in bars or even on the subway train.

It's not the first time I'd be within earshot of a girl I'd taken a fancy to and I'd pretend to be talking to someone on my mobile phone just so she would hear my accent. Now, that was a great conversation starter.

'Oh honey, I love your accent,' they'd say when they heard me on my phone – allegedly. 'Where are you from?'

'I'm from Scotland. Just moved to New York and I'm not sure where I'm supposed to be going. I wonder if you could help me out and give me some directions – preferably to where you stay...'

Corny, yes, but you get the picture.

Some, let's say, less travelled folks would ask me what language I was speaking when they heard me talking and some would compliment me for being able to speak such good English when I came from Scotland.

It got so ridiculous that sometimes I'd be asked if we had cars and electricity in Scotland. They obviously thought the Braveheart movie was an up-to-date documentary and in the 21st century, the Scots still roamed the hillsides in kilts, faces painted with woad and claymore in hand, looking for a square go with anyone who had an English accent.

And when people asked what it's like where I stayed in Edinburgh, I'd show them a photograph of Edinburgh Castle and they would gasp: 'Wow, man! You live in a castle?'

I'd string them along for a few minutes, but even when I told them I didn't actually live inside Edinburgh Castle and it just happened to be in the same city where I came from, they were still mightily impressed.

I'd also play along with the Scots warrior image they had of folks in my home country, and when we'd talk about the latest shooting in the hood I'd pretend it was no big deal since worse happened back home.

'You think these shoot-outs are bad, well you should see what goes on at our football matches with gangs of hooligans trying to kill each other,' I would say. 'Most weekends you would go to a gang fight and a game of football would break out.'

They thought I was crazy, so I just rolled with that perception and pretended nothing fazed me and I would never back down from confrontation. Sometimes a Scots accent spoken with authority and a steely stare can face down a six foot three, built like a brick shithouse guy from the hood, who thinks he can intimidate me because of my baby-face good looks.

Once, Mayor got first-hand experience of how on edge I could be. I'd fallen asleep in the realtor's office and when he came in, he tried to waken me by shaking my shoulders. I must have been having a dream because without knowing what was really happening, I jumped up, grabbed Mayor and threw him against the wall.

'Yo man. Chill. You're one crazy son of a bitch,' he said. And after that, he had yet another story to tell of the mad Scotsman who had come to live in Brooklyn.

Many times, the Latin motto of some Scottish Army regiments would be my watchword: 'Nemo me impune lacessit' – meaning 'no one provokes me with impunity', or as some Scots would say: 'Wha daur meddle wi' me?' And I would certainly utilise the fearlessness, courage and guile us fighting Scots are famous for on the battlefield, but this time on the streets of Brooklyn.

It was during my first three-month stint in America and I was walking back to my apartment in Foster Avenue weighed down carrying two heavy bags of shopping – one in each hand.

I'm trudging along when I see half a dozen Crips coming towards me and as they get closer, they put their bandanas over their faces. I'd seen gang members do this before and it usually meant they were about to get up to no good and didn't want anyone to recognise them. I'd no doubt they wanted to rob me.

In case I would have to fight my way out of this situation, I stopped walking and placed the bags on the sidewalk to free my hands so I could defend myself. I quickly decide the odds of me beating the shit out of all of them in the next few minutes were pretty long and I'd have to come up with another ruse to escape the confrontation.

Now they are only a few feet away and they stop in front of me. Before they can say anything, I whip out my UK driver's licence from my inside pocket and hold it up in front of me like I'd seen all good hero cops do in the movies. At this point, I knew they could easily pull a gun on me at any second, but I walk into the middle of the gang and look each one of them in the eye.

'Good afternoon, gentlemen. My name's Detective John Kimble and I'm on secondment from the Scottish Police Force to the NYPD and I'm working undercover in this neighbourhood,' I tell them in a commanding voice.

I could see the confusion on their faces after they hear a strange accent like mine on the streets of Flatbush, and even more puzzling for them was that they couldn't quite understand why a cop from Scotland should be working undercover and then blowing his cover by telling them what he was doing.

'I was wondering if any of you have information on the sale of narcotics in this area,' I continue. 'I understand this neighbourhood is rife with drug

dealers and we're cracking down on them. Be sure you can talk to me in confidence and there's a reward for any information that leads to an arrest.'

They're now looking at each other and shrugging their shoulders. None of them know how to react – should they shoot me, stab me, rob me, or just run away and put the whole experience down to a bad trip on drugs.

And it's just as well for me none of them remembered the Arnold Schwarzenegger film, Kindergarten Cop, because Detective John Kimble was the main character in the movie. I have no idea why the name John Kimble came into my head, but I'm glad it did.

I realise I'm on a roll and I'll be able to talk my way out of this. 'What are you gentlemen doing tonight? Are you up to much?' I ask. 'And are you sure you haven't seen anyone acting suspiciously in the area?'

'No, no – we ain't seen shit. We cool, man,' one of them replies.

'Alright, then. But keep your eyes peeled, as this seems to be a dangerous area with a lot of gang members roaming around. You gents take care of yourselves and stay safe. I'll see you around and when I do, remember you haven't met me and you don't know who I am.'

I step back from the group, grab my two shopping bags and carry on walking past them along the road towards my apartment. The gang stand motionless and I can hear murmurs coming from them. Then one of boys says: 'Who the f**k was that dude and did that really just happen to us?'

Another time, while I was staying in Linden Boulevard, I had to utilise some of the Scots cunning and chutzpah to get myself out a spot of bother.

I'm heading for the local shops when again, a group of half a dozen Crips gang members are walking towards me. I see the tell-tale sign that there's a good chance they're going to try to rob me when the teenagers pull their blue bandanas up over their noses to hide their faces.

I'm only a few yards away from them when I slow down, put my hand in my jacket pocket and make the shape of a gun with my fingers pushing up against the material. The Crips have stopped moving and are staring in my direction, trying to look as menacing as they can to frighten me. One of them pulls his tracksuit top to the side of his body, so I can see he has a gun tucked into his waistband.

But as I get closer to them, their demeanour changes when they notice

what they think is a gun bulging in my pocket and me ready to pull the trigger. As far as they can see, it looks like I've got a gun and they've got to gamble whether it's worthwhile getting shot trying to rob someone for a few dollars. My little trick works a treat and I march through the gaggle of gang members with more than just a hint of a swagger and every one of them remains statue-still.

When I get round the corner and out of sight, I take my hand out my pocket, still in the shape of a gun, and pretend to blow smoke from the barrel of my imaginary firearm.

It's always a good feeling to get one over on the robbers when they threaten you and demand money – especially as I didn't have a lot of cash in the first place. One trick I played on them was to fill an old wallet with Monopoly money I'd bought on eBay and the next time I was being robbed, my plan was to act scared and immediately hand over the wallet with the Monopoly notes.

I'd been carrying the old wallet with the fake cash around with me for a couple of months when it came in handy one night when I was coming home from a house party.

I'm walking past The Projects and suddenly two guys appear as if from nowhere. One of them points a gun at me, then his partner in crime utters the ubiquitous words you hear in such a scenario: 'Hey motherf****r! Gimme your money!'

'No problem,' I reply. 'Don't want any trouble. You can take my wallet.'

I pull the old wallet bulging with Monopoly money from my jacket pocket and hand it over to the guy. He sees the thickness of the notes folded inside the wallet and thinks he's hit the jackpot. With a smile on his face he turns to his accomplice, shows him the wallet and the pair of them run off through a darkened outdoor basketball court and disappear into the night.

I would love to have seen their faces when they realised the wallet was full of Monopoly money and the thick wad they thought was made up of tens and $20 bills weren't worth a dime to them.

There's a rather impolite saying we have in Scotland to celebrate a triumph over an adversary – no matter how minor the victory. You utter it with feeling and fervour and it goes like this: 'Get it right up ye!'

Well, that's what I was saying to the two guys who tried to rob me at gunpoint after they'd legged it thinking they'd got away with a small fortune in cash. Perhaps they could put an offer in for Trafalgar Square, Piccadilly, or Mayfair with the Monopoly money they stole from me.

One of the rites of passage for teenagers in Scotland – and probably the world over – is trying to get served in pubs or get into nightclubs when they are under the legal age for drinking alcohol. Back home, you were supposed to be 18 before you could drink in bars and for those who haven't quite reached that ripe old age, the trick was to get a false ID card of some kind that gave a date of birth that made you older than what you really were.

Well, here I am in America, 19 years of age and still not old enough to legally drink in bars, as you were supposed to be 21 before having a taste of beer, wine or liquor. So, I'm thinking that if I've travelled to New York and lived on my own in the hood, I'm old enough to get married, become a soldier and go to war, then why shouldn't I be able to get into bars and clubs? Time for some good old Scottish subterfuge with a dodgy ID card.

I'd been talking to Cass about this and he'd been saying it was time I was frequenting the local nightclubs and meeting some girls.

'Leave it with me,' he says. "I'll get you some fake ID that says you're over 21.'

Sure enough, the next day he turns up with an ID card and hands it to me. 'You can use this,' he tells me.

I look at the photo on the ID card and there's a picture of a Black guy staring back at me.

'F**k's sake Cass! I can't use this,' I blurt out to Cass. 'This ID card is for a Black guy and I certainly won't get away with pretending that's me.'

'Not a problem,' he answers. And with a straight face tells me: 'Just tell the guys on the door that you got a suntan when you had the photo taken and I'll say you're my cousin from Scotland.'

If I were to look anything like the guy in the photo I would have had to lie on a sunbed and not move for about a month.

Apparently, Cass got the ID card from a guy living in Queens and to bolster his argument that I would get away with using the fake ID, he

says: 'You worry too much, man. These guys on the door don't care and they don't look too hard at the ID cards anyway.'

A few nights later, Cass and I are waiting in line to get into a club when the doorman stops me and asks to see proof that I'm 21 and old enough to get inside. I go into my pocket, pull out the fake ID and hold it in front of him trying to cover the photo with my thumb. But he takes it out my hand, looks at the photo, then looks at me and says: 'Come on, man. What the f**k is this? This don't look anything like you.'

Before I can say anything, Cass interrupts and tells the doorman: 'Hey, man. What you mean? Of course it's the same guy. He's my cousin come all the way from Scotland and he's a rapper.'

That was my cue and I launch into a rap song in front of the guy. Then with the rest of the queue getting restless, the doorman shakes his head, hands me back my fake ID and tells me to get inside. 'And don't dare say to anyone that I saw you and asked for ID.'

I wasn't drinking all that much because I was still training at the boxing gym, but when I did try to get served in bars I would always try to divert their mind away from what age I was by chatting to the barman. As soon as anyone heard my accent they would invariably ask about where I came from and what I was doing in Brooklyn. And it wouldn't be long before he was pouring me a vodka and Coke.

But the real fun and games were when you went to a block party, which is held outside in the street with tables groaning with food and drink placed on the sidewalk. There would be a DJ blasting out the beats to the crowds milling around on the street, and these crazy shindigs would run from early afternoon into the small hours of the next day.

It seemed like anything goes at these block parties, and I was at one with Fletch when we saw two people having sex on the fire escape of a building as everybody stood watching and cheering on the street below.

'Betcha they don't have street parties like this back in Edinburgh,' Fletch says.

You're damn right, I thought. Even my Auntie Jeannie's Hogmanay Hootenanny with ginger wine, black bun, shortbread from a tartan tin and Jimmy Shand's accordion tunes on the record player wouldn't quite cut it in the hood.

CHAPTER 7

THE HEIGHT OF FASHION

I'm shadow boxing and doing my very best Rocky Balboa impersonation in front of a wall mirror in the world-famous Gleason's Boxing gym, in Brooklyn. It had been an ambition to train at the gym at least once in my life and here I am with no top on, bare-chested, showing off my six-pack, pecs and guns and giving it laldy with jabs, hooks, uppercuts and combinations, battering lumps out my imaginary opponent.

Suddenly I feel a tap on my shoulder and there's a woman standing behind me. 'Do you have representation?' she asks.

I thought she must be some kind of boxing manager or promoter so I reply: 'No, I'm boxing solo just now, so I don't have a manager.'

'I'm not talking about boxing,' she says. 'I'm involved as an agent in the fashion industry and I was wondering if you'd ever done any modelling?'

Now this has come from left field and it's the last question I expect to be asked working out at Gleason's. I think quickly on my feet and immediately go into bullshit mode.

'Not too much. I'm just getting my portfolio together,' I reply, hoping that I sound like I know what I'm talking about, but in reality I hadn't a

clue about male modelling.

I must have got past that first hurdle because the lady goes on: 'We've got New York Fashion Week coming up and they're always on the lookout for models. I think you've got the look that people would like. I can set you up with an audition, if you like.'

She introduces herself as Andrea Ramirez, gives me her business card and suggests I give her a call and she'll fix me up with an audition to do modelling work.

Now this really is something, although I had no idea if she was suggesting I could do a fashion photo shoot, or be a fashion model on the catwalk. The bizarre conversation I'd just had certainly gave my confidence and ego a boost.

I turn, strike a pose and look in the mirror and say to myself: 'Aye, right enough, you could well be a model. You're not so bad looking after all, with a face more than just a mother would love...'

I was on my third trip to America having spent a year back in Scotland working in a call centre for utilities company, Scottish Water. My previous two trips to the States had completely emptied my bank account, and I had to spend all that time back at home saving up to finance another three-month stint in the hood.

I'd arrived back in America in July, 2012 and, as well as renewing old acquaintances, I was going to the Starrett City gym again and visiting Fletch in his studio to record new material.

This time round my living conditions were a bit more civilised, as the apartment I was renting from Airbnb was the nicest I'd stayed in and I had the luxury of it having a real bed. The apartment was owned by a Jamaican photographer, Wade Phillips, and I had the upper level consisting of a living room, kitchen, bathroom and bedroom with Wade living in the apartment below me. I had also splashed out to buy a proper sports holdall instead of walking around carrying my boxing gear in a black bin bag. Now, that's what you call going up in the world.

During the previous two visits to America there had been too much going on for me to pay Gleason's a visit. Coming to Brooklyn on my own had been like I was an alien that had been dropped onto planet Earth and

left to find my own way. New York is one of those places where there is so much happening and so many opportunities, I hadn't expected to have been sucked in by all the craziness that I'd experienced. But I'd promised myself that this time, I'd make the boxing pilgrimage.

I didn't expect to work with a trainer during this visit to Gleason's and I was more like a tourist visiting a landmark, which it most certainly is in the boxing world. I paid my $20 to get into the gym for a day and soaked up the history of the place before I started shadow boxing.

I felt quite proud of what I had achieved in making it to Gleason's and thought back to my first day in Brooklyn walking into the Galaxy Motel. I had survived on my own in the hood and it certainly wasn't a Camp America scenario where young adults from Scotland go to work for a few months at a time. Nothing wrong with Camp America, but there's a measure of protection there for you and plenty folks who will help you settle in a foreign country.

I had turned up in Brooklyn not knowing a soul and had to make connections, friends and create my own network, so I could navigate the streets, culture and lifestyle, as well as earning the respect of people living in the hood. I had very quickly matured into an adult and grown as a person over the past couple of years.

So, here I am in the world-famous Gleason's gym and one of first things I notice is there's a photoshoot going on in one of the four boxing rings in the gym. I knew that lots of films, TV shows and adverts had been filmed there, but the boxer strutting and posing for the camera looked like he was a young prospect that his manager was getting readied for a promotional push.

It was interesting to watch what was going on and I took it all in, hoping that one day they'd be taking my photo in the ring for my next big fight. However, the way things panned out that day with the mystery lady interrupting my shadow boxing to suggest I could be a fashion model, I was going to be seen through a camera lens in a rather different setting.

I called Andrea the following day and told her I was definitely interested in some modelling work, and she promised to call me back when she had sorted out an audition for me. True to her word, a few hours later she was back on the phone telling me I had an audition for a runway fashion

show the next day. She gave me the time and place where the audition was being held, but kept the bombshell news until last. 'Just take your portfolio along with you as they'll want to see your photos,' she said.

I didn't ask any questions because I'm acting as if I know what I'm doing as the professional model that she thinks I am. 'That's really cool. Thanks very much for the opportunity and I'm really looking forward to it,' I tell her.

I was both excited and nervous at the chance to become a male model. But it didn't take long for the panic to set in, as I didn't have a single photograph of myself that could remotely be described as me modelling, never mind a whole portfolio of pictures.

I did, however, have a fashion photographer living in the apartment below me and when I told Wade my predicament of being the only wannabe male model in the country without a portfolio, he said he would take a set of photographs of me in the apartment.

Wade was a huge help. Not only did he take the photographs, but he also told me how I should stand and pose like a real model. At first, he just laughed at my efforts at trying to become the new David Gandy, Lucky Blue Smith, or Sean O'Pry.

'You look so uncomfortable, stiff and awkward standing there,' he says. 'Relax, man. You look like one of those mannequins they have in Bloomingdales or Macy's. No, that's not fair on the mannequins 'cos they look more alive than you do,' he laughs.

Wade then gives me a crash course in deportment and how a model should pose for photographs. 'Shift your weight to your back foot, face away, but turn your head towards me, then tilt your head and for f**k's sake smize. You never seen Tyra Banks on America's Next Top Model?'

After Wade finished taking photographs he chose the best dozen or so and loaded them onto a USB stick. Since the audition was the next day I had to find a 24-hour photographic shop and get A4 prints to put into a faux leather folder that cost me all of $2 from a store near where I stayed.

The only printer I could find open late at night was in Manhattan, so it was a mad dash on the 2 Train across East River to get my prints. But not before Wade showed me how I should walk on the fashion runway. Now,

I thought walking was easy and all you had to do was put one foot in front of the other, but as I was to find out, there's a lot more to it than that when you're modelling. Before I left for the city he made sure I spent half an hour on YouTube watching video footage of male models strutting their stuff on the catwalk.

I still had to type up my information sheet for the audition and I did that when I returned from Manhattan. All they want to know is quite straightforward, but when it came to saying what height I was, I reckoned I should add a few inches for good measure. I'm really only five foot ten inches, but I typed that I was six foot one. And if anyone looked at me quizzically after reading my sheet, then I would just stand on my tiptoes.

I could hardly sleep that night thinking about how I would have to wing it and try to pass myself off as a model. The only modelling I'd ever done up to that point was building plastic Airfix model aeroplanes when I was a kid.

The next day, I find myself walking along Manhattan's 22nd Street, plucking up the courage to make my way into the building where the auditions are being held in a fourth-floor studio. I feel a mixture of excitement and fear, but at the same time a sense of satisfaction that I was achieving something and I was going to Manhattan with a purpose and, no matter what happened at the audition, I would get the chance to meet new people and make new contacts, who might be able to help me.

Wade had told me that I should wear very plain clothes to the audition – jeans and a white T-shirt – as I was to become a walking mannequin that someone else would hang their own style of clothes on. 'You can't have your own personality or style. They want to look at you and be able to easily visualise how they can mould you into what they want.'

As I approach the doorway, I can see a group of Adonis-like guys standing around chatting. At this point, the fear really takes over and I walk past them, head down, pretending I don't even notice their presence on the sidewalk.

I turn a corner around the block and stop. It's like there are two wee guys standing one on each of my shoulders. One is whispering in my ear: 'Who are you kidding Stevie boy? Whatever makes you think you can be a model? Don't go in. They'll clock you straight away and you'll

just embarrass yourself and end up walking back out that door and never dare to cross the Brooklyn Bridge again.'

I'm just about to carry on walking away when suddenly, the other wee guy is shouting: 'F**k's sake, Stevie. Get a grip. You know you can do this, so don't be such a tosser. Get yourself up there and put on a show for these people. You can be whoever you want to be and if you need to be a male model today, then go and be a male model. You've come through all sorts of shit to get where you are today, so pretending you're a male model is a doddle.'

I take the advice of the latter wee guy and steel myself to go to the audition. Inside the building, I'm sharing the elevator with a six-foot-three guy with dreads and tattoos all over his body. And this boy looked like a real model.

'How you doing man?' he asks, and introduces himself as Kevin Wallace.

'Yeah, OK. Will know better once this audition's over and I get the gig,' I reply.

He laughs at that and it's amazing how you can bond with someone in such a short elevator ride. Little did I know that a few years later Kevin would have become a very successful model with his face on billboards all across the USA.

We walk out the elevator and push open the doors into a dance studio. I'm amazed at how many people are crammed inside and there is such a hubbub with everyone talking you can hardly hear yourself think. There must have been about 150 people in the room, although it looked like hundreds more, as everyone's reflection appeared in the floor to ceiling mirrors that line one side of the room.

As Kevin and I squeeze past groups of people chatting, I'm giving out an air of nonchalance, as if this is just another routine audition and I've brought my big pal Kev along to show him the ropes.

We make our way over to the far end of the studio, where a man and a woman are sitting at a table with a video camera set up to film on the table top, and we hand over our portfolios.

I then take one of the seats that are lined up in rows and while I'm

waiting to be called, another modelling candidate walks through the door and sits beside me. We start chatting and he seems a nice enough guy, although doesn't look anything like the other male models there. He's called Joey Kingery and is originally from Iraq, but now lives in Washington DC.

I'd noticed Joey walked rather strangely in big, clumpy shoes and was the same height as me. I smile to myself, as I've now got competition for the somewhat vertically challenged model role. Joey is wearing shorts, has a bushy black beard, a huge mop of curly hair that hasn't seen the inside of a barber's shop in quite some time and is wearing a colourfully-patterned shirt and an 80s-style tank top jumper.

After a few minutes, the guy at the table stands up, claps his hands and shouts: 'Right everyone – thanks for coming. We're just about to start and when we call you, walk forward towards the table, strike a pose and spell out your name, then tell us where you're from and give us your cell phone number.'

As each model was called, they'd do their catwalk saunter up to the table and when they said where they were from, I soon realised this was a big deal as people had travelled hundreds or even thousands of miles from across America to be at the audition. And they knew what they were doing when it came to deportment and doing the runway shuffle.

I'm starting to get worried about making a fool of myself when it was my turn, especially in front of some really good-looking girls who I'd planned to give a few good ol' Stevie Creed chat-up lines to when the audition was over.

But these moments of self-doubt never seem to last long, as something always comes over me and I get the 'f**k it!' attitude. I'm not going to die here, the worst that can happen is that someone says no to me getting a modelling job. And since I was never a model in a month of Sundays, that's no big deal. I also told myself that since I'd never see these people again it didn't matter if I made a complete fool of myself.

When my name is called, I get out the chair and with head held high, chest puffed out and shoulders swinging, strut my way towards the table. I stop in front of the man and woman, give them the James Bond 007 stare and say: 'My name's Stevie. Stevie McGhee. And that's S-T-E-V-I-E

M-C-G-H-E-E. I'm from Scotland and I've no idea what my cell number is because I just got a phone when I came to New York a few weeks ago and I can't remember what it is.' As I finish my spiel, I decide to ham it up, so I put one hand on my hip and half-turn side-on and give them the raised eyebrow.

The accent has certainly caught the attention of the pair behind the desk and also some of the models in the room, and there are a few giggles coming from behind me.

But the guy behind the desk is not impressed and he just stares at me with what can only be described as a withering look of disdain. If looks could kill, I'd have dropped dead on the spot.

On the other hand, the woman seems to have taken a shine to me, as I could see her covering a smile with her hands, so the guy wouldn't notice. She's still got a sly grin on her face when she tells me to go back to my seat.

After everyone has been seen, there is a hiatus while the pair at the table choose the models they want for the fashion show, so I mingle and talk to as many people as I can. After half an hour we're asked to stand in lines like toy soldiers and those whose names are called out have to take one step forward. By this point I reckoned I'd had my fun and just wanted the whole thing to be over, as I didn't expect to be chosen.

Much to my surprise my name is called and as I step forward the guy says: 'We really like your look.' It takes me all my time not to burst out laughing at the idea that he hasn't a clue I had never modelled before and I really have no idea what I'm doing. But then there's that old saying about not looking gift horses in the mouth, so I nodded my head in thanks and played along with it.

We're told to expect an email in the next few days telling us the fashion show is going to be held in the famous Waldorf Hotel, in Manhattan in two weeks' time and a couple of days before that, we would have to attend a fitting of the clothes we would be wearing.

I'm standing on the sidewalk after we'd all left the audition and it's hard for me to take in that I've been chosen to take part in a catwalk show, during New York Fashion Week. But, at the same time, I was excited and decided I'd share the good news with my mother.

Walking down 22nd Street I call her on the mobile and tell her I've been chosen to be a model in a fashion show.

'That's amazing,' she says. 'Maybe you should concentrate on that instead of boxing.'

My mum seemed more excited about me being able to walk in a straight line, pause, turn and come back the way I came than anything else I'd done. Never mind going to America on my own, staying in Brooklyn and making friends who support me, training as a boxer and recording my hip hop music – her boy's going to be a model and that's what she'll tell the neighbours.

The fitting session in another dance studio in Manhattan, two days before the fashion show, was a bit weird to say the least. Especially, as I had no idea what to expect. All the male models were told to strip down to their boxer shorts and stand in line.

Then the designer whose clothes we were going to model walks up and down the line with his arms folded, stopping to inspect each of us standing there half naked. I felt very uncomfortable with this guy staring at me and it got worse when he started grabbing my shoulders and moving me into different stances.

I was almost for hooking him as he turned me around for the umpteenth time, but I thought I'd better control the urge to lash out, as this may well be de rigueur in modelling and I didn't want to spoil my chances of getting on the catwalk as a fashion model.

One of the outfits I was told I'd be wearing at the fashion show was a full-length half-dress-half-coat type thing with a hood made of silk. With the hood up, it went from my head to my ankles and it felt like I was in fancy dress as Obi-Wan Kenobi from Star Wars. I was also given some vests with some unusual designs on them to wear and at the end of the fitting session I was just glad I hadn't been thrown out. To be honest, if they'd asked me to dress up as a marshmallow, I'd probably have gone along with it I was that keen to get the modelling gig.

The night before the fashion show I couldn't sleep, as I was feeling a mixture of excitement and nerves. I had no idea what I was letting myself in for, but it was a fantastic opportunity to meet new people and who knew where being a model in a fashion show was going to take me.

The show was due to start at 7pm, but we had been asked to be at the hotel for 3pm. It was pandemonium when we were shown to a room backstage with dozens of models getting their hair and make-up done. Thankfully, my make-up didn't take long as they gelled my hair and put some foundation on my face.

In another room, all the clothes being shown were on rails and there were lots of girls running around in their underwear. For some reason, that was my favourite room to hang about in as I waited for my big moment on the catwalk. I was in my element with lots of new people to meet and get chatting to. And it wasn't just idle chitchat either.

The day before the show I'd had a sit-down with a clothing company owner, Eman Awuro. Not one to let the facts get in the way of a good story I could tell about my modelling 'career', ever since I'd managed to get the fashion show gig, I'd been applying for different modelling jobs on websites like Craigslist.

Eman had called me and we met in his office on 7th Avenue, or as it's better known, Fashion Avenue, as that's where New York fashion was born in the Garment District of Manhattan.

He looked really cool with his dreadlocks and shades on and definitely had a bit of a swagger about him. Eman explained he was involved in a fashion brand, called Fourfront and he had an upcoming event to promote a new range of Gilekos – Greek style designed waistcoats you pull over your head – in a Manhattan nightclub he had hired the following week.

His father had very recently died and Eman hadn't got the time to organise models for his show until now and this was him getting round to it. We were getting on great and when I told him I was also a rapper and had been recording while I was in America, he said he knew people in the hip hop music business.

My heart soared when I heard this, as it's exactly what I'd hoped my incessant urge to meet new people would achieve – getting to know someone, who knew someone's cousin twice removed, whose neighbour was a big wheel in the music business.

As well as agreeing to model in his show, he was grateful when I offered to recruit models for him when I was at the fashion show in The Waldorf

the following day. Eman gave me a bundle of his business cards and I promised I would get half a dozen or so models to give him a call.

So when the next day came, amongst all the chaos while everyone was getting ready, or hanging around waiting to go on the catwalk, I was scouting all the male models to see to approach for this other fashion show.

I would sidle up to them and get them to move to the side so we could have a chat on our own and I'd say in almost a surreptitious whisper: 'Just keep this between us, but there's a fashion show coming up next week that I'm recruiting models for. I think you'd be ideal for it.' And handing them one of Eman's business cards I'd say: 'Give this guy a call. He'll sort you out with all the details.'

As soon as they thought I was some kind of modelling agent I became their best friend – for that day, anyway. I spoke to about a dozen models and gave them all Eman's business card. It made me feel really good about myself that I'd managed to achieve something out of the first few times I'd ever been in Manhattan.

But back to the fashion show at the Waldorf. When I was called to one of the fitting rooms backstage, a fashion designer was waiting for me and after giving me the once over said: 'Yes, yes, yes! I've got another idea for you. Just you wait till you see this outfit.'

He dressed me in white shorts, white polo shirt, a cream-coloured sleeveless tennis-style jumper and black Converse trainers. I'm just about to leave the fitting room and head for the area behind the curtain when he hands me a tennis racket.

'What am I supposed to do with this?' I ask.

'You're on first leading the way. So, walk along the runway, then along to your left then to the right, come back to the centre and pose with the tennis racket. Now, on you go. You'll be fabulous!'

I'm now behind the curtain and I can see no one else has been given a tennis racket and I've no idea what I'm going to do with it at the end of the runway. Momentarily, it crosses my mind that I could pretend it was a guitar and play it like Keith Richards of the Rolling Stones, or Bruce Springsteen, taking it closer to home. I decide that might not go

down too well, so I shrug my shoulders and say to myself that I'll think of something when I get there.

The DJ turns the music volume up loud and it's almost time for my big moment. Just before I step out from behind the curtain I feel the vibrations of the music thumping through the floor and I glance out a window to my right. We're several floors up and I can see the criss-cross streets of Manhattan and skyscrapers in the distance. 'You've come a long way,' I say to myself. 'Not bad for a daft wee boy from Edinburgh on a mad adventure living on his wits.'

'Okay, time to go,' someone shouts and the curtain is pulled back slightly to let us walk out onto the catwalk. The first thing I see are hundreds of people seated in row upon row down the sides and at the front of the runway, and then the camera flashes are almost blinding me. I remember to look straight ahead and not at the photographers and the audience below me.

'Walk, walk, walk,' I keep telling my legs hoping they will remember how you get from point A to point B. 'Left, then right, left then right,' as if I'm having to learn how to walk all over again.

Halfway down the catwalk, I remember I'm holding this tennis racket and I still have to decide what I'm going to do with it while I pose. When it comes to that point I nonchalantly put the tennis racket over my right shoulder, swivel on my left heel one way and then the other.

Then it's about-turn and head back up the runway to let someone else have the limelight. My first modelling appearance only took about 30 seconds, but it was exhilarating – that feeling when you've been nervous or afraid about something and you realise you've just gone and done it and overcome these fears.

I modelled a few other outfits during the show including the Obi-Wan Kenobi dress-cum-flowing-robe, and I just hope no one noticed my red neck with the embarrassment of wearing that.

After the show there was a small huddle of fashion writers and bloggers waiting to interview the designers and even some of the models. It must have been the accent that attracted the girl who was doing a piece for her blog. I just gave her a load of the usual spiel after she'd asked where I was from.

It was almost like the lyrics from a rap song: 'I'm from Scotland, out here living the dream as long as I can. I'm loving it in the US of A and they call me The Brooklyn Scotsman.' I still didn't know a lot about fashion and modelling, so I just had to bullshit. I was getting quite adept at that.

Both Kevin and Joey were modelling at the fashion show and we had arranged to go out on the town afterwards. We're standing in the street outside and I notice this blonde woman hanging around looking at everyone coming out of the hotel. She was showing off her more than ample bosom, wearing a skirt so short the manufacturer must have run out of material and a cowboy hat. At least her head was covered.

She waves at Joey and he goes across to talk to her. When he comes back to where I'm standing he says: 'She wants to give us $5000 to take part in a gangbang with her that's going to be filmed.'

'Away and behave yourself,' I tell him. 'That's going to be nothing but a sleazy porn movie.'

'So what? It's a lot of money. We should do it.'

'Not a chance. These things always come back to haunt you years later. There's no way I'm going to get involved in a porn movie.'

Kevin then tells us he's got an address of an apartment where there's a party going on tonight, so we jump into a cab and head for the Upper East Side. When we come out of the elevator in the apartment block there are these Wall Street type guys with the expensive suits and the minted with cash look about them. They are just hanging about the corridor and looking completely out of their heads on drugs.

We squeeze past them and push open the door of the apartment, which was slightly ajar and what a sight befell our eyes as they almost pop out of our heads. Everybody was naked, drinking, snorting cocaine off the glass coffee table and generally re-enacting the decadence that preceded the fall of the Roman Empire.

In a bedroom there were four or five naked people tangled up with one another and it was hard to see who was actually doing what to someone else. Before I could even get myself a drink two girls grab my arms and pull me into another bedroom. I didn't put up too much of a protest because, as they say, two's company – three's an orgy!

97

When I came out the room the next morning, the apartment was littered with bodies and there was one girl, who had obviously snorted too much of the Colombian marching powder, whose nose had been bleeding as she slept.

It was weird seeing these people, especially the guys, as I felt a lot more of a man than they were. They make obscene amounts of easy money and just blow it all on drink and drugs. There doesn't seem to be much more to their life than that hedonistic cycle. Me, on the other hand, I might not have their wads of cash and fancy clothes, but any money, success and riches coming my way will have been hard earned.

On the night of Eman's fashion show, the scene inside the nightclub wasn't quite as frenetic as the last show I was involved in. I had managed to successfully recruit five guys plus myself to model the Gilekos. We were going through what was going to happen during the show a few hours before it was due to start. I don't know if Eman was saying this to get some excitement going with the models, but he tells us there could be a few music celebrities and rappers coming to the show.

That's when the alarm bells go off in my head. I need to get some of my songs burned onto CD, so I can hand the discs to these music people and try to get a deal. Fortunately, I have three tracks on a flash drive, some blank CDs and sleeves in my bag. I'd have to find somewhere to burn the tracks.

Eman had started doing the fittings with the models and I rush over to him. 'I need to go out for an hour or so.'

'What do you mean? I need you here for the show.'

'I'll be back in time. I just need to get some CDs burned.'

And before he could say anything else, I high-tail it out the nightclub door with no idea where I'd find a computer to burn the discs. I head into Chinatown and there seems to be nothing but offices on the streets I'm running down. I'd burst into offices and plead with people to let me use their computer, but they all tell me to get out and some even threaten to call the cops.

Eventually I got to an office where there's a Chinese accountant sitting behind a desk. I gave him my usual spiel about coming from Scotland

trying to find fame and fortune.

'I'm not being disrespectful, but I need to get some songs burned onto half a dozen CDs.' The guy just looks at me with astonishment.

'I'm a rap artist and I've come to America with nothing and this could be my big break. I'm doing a fashion show a mile or so down the road, but I need to get this music onto these CDs. All I can spare is $20, but you can have that if you let me use your computer.'

Good on the guy, because he could have thought I was just out for the day and had to be back in the psychiatric ward for dinner, but he said I could use one of his computers.

I ran back to the nightclub and made it just in time to get a fitting for the outfits I was wearing in the show that night. The show went well and Eman was delighted. But the promise of music moguls in the audience never materialised and I ended up giving my newly-burned CDs with my music to the chef and the barman at the nightclub along with Eman and a few of the models. You never know where these people could end up.

When the fashion show was over, a rather bizarre incident took place. I was standing on the sidewalk with some girls who had been at the show, when a random guy drove up in a fancy SUV, stopped beside us and started chatting through his open car window. Then amazingly, he handed one of the girls $200 in cash and said: 'Take this and I'll meet you all in the bar on the corner down the road in ten minutes.'

We went there, bought a round of drinks with his money before he appeared and then he spent the next hour telling us all about his marital problems.

It was a really weird situation to find myself in with a complete stranger handing over that amount of money and trusting us not to do a runner. I wish everyone in New York had been as generous as this guy!

After the second fashion show, I advertised myself as a model on Craigslist and I got a few phone calls. They were mainly from photographers who wanted to expand their own portfolios, but since I would also get a set of prints I wasn't complaining. I did a few photoshoots including one at the Starrett City gym I'd organised to get the use of when it was closed.

I had to be careful though and one incident gave me food for thought when it came to me deciding if I was going to pursue a full-time career as a fashion model. I'd got a phone call from a guy who claimed he was a fashion photographer. He said he would send me money to buy a return train ticket to Boston.

At first I thought that was great and there would be plenty of people in Boston I could network with and who knows what would come of that. The train fare money arrived and a day later the guy texts me asking 'And can you tell me what your erect penis size is?'

Errr, thanks, but no thanks and I'm keeping the train fare money for you being so pervy.

I very soon decided that fashion modelling wasn't for me, as I saw for myself how you are treated like a piece of meat and you can't have your own opinion, or personality. I also got the feeling that some people in the fashion industry just want to control you to give them a feeling of power. Some young fashion models will put up with that, as they reckon that's a fair price to pay for the chance to see themselves on the electronic billboards in Times Square.

But it wasn't for me. Although, the Obi-Wan Kenobi gear would be ideal for the dancing on a Saturday night.

CHAPTER 8

LIGHTS, CAMERA, ACTION!

I n the midst of utter pandemonium, I'm doing my own version of the famous Hollywood movie The Great Escape and carrying off a not too bad impression of Steve McQueen into the bargain. And, like McQueen and his fellow POWs captured by the Germans, I too need to make my escape.

A dozen models and dancers rush in and out of a tiny room in the photographic studio, as they get their hair and make-up done to take part in a video shoot for one of my music tracks, Feeling Alive.

I'm resplendent in a tartan kilt, until suddenly I need to make myself scarce rather pronto. The studio manager has just discovered I'd somewhat understated the amount of people who would be using the premises; I wasn't delivering on my 'we won't disturb anyone' pledge since the noise from the ghetto blaster playing music is almost deafening and I'm nowhere near ready to vacate the premises at the

agreed time, as we're way behind in getting everyone's make-up done.

His neighbours have also called the cops about the disturbance we're causing and that I'm being filmed and interviewed standing on the building's fire escape that apparently should only be used for escaping from fires. Maybe the clue is in its name and I should have realised that.

There's steam coming out the studio manager's ears, as he's charging in and out of the rooms shouting: 'What in Hell's name is going on here and where's the Scottish guy called Stevie that I hired the place to – the one who's wearing a kilt? I've got the neighbours and the cops on my back. Where is Stevie 'cos I'm going to sue the ass off him. He said there would only be two or three people here.'

I could hear him shouting from down the hallway and decide it's time to make a sharp exit. But I need to get out the building without the manager catching me – and that means resorting to a cunning disguise, since he's seen me wearing a kilt on the fire escape when he was on the sidewalk below.

The choreographer for the video shoot, Kristopher Allen, better known as Krizal Lips because of the lips tattoo on his neck, has brought along some costumes in case we need them. One of the outfits was a pimp suit – white baggy tracksuit with diamond Argyle pattern designs, white flat cap, chunky gold chain and a pair of sunglasses. He rummages through his bag, finds the clothes and I make a quick change out of my kilt and into this weird gear that some character from the 70s would wear.

'This guy's looking for someone wearing a kilt,' says Krizal Lips. 'He'll never recognise you dressed like that.' And he was right because my own mother wouldn't recognise me in this garish garb.

I pop my head into the room where the hairdressers and make-up artists are and tell them to round everyone up and let's get out of here. Now that I'm disguised as a pimp, I sneak down the stairs, out into the street and, like the Pied Piper, I'm followed by all these girls dressed in skin-tight spandex leggings as we march towards Union Square, in Manhattan, where filming of scenes for the video is due to take place.

I had managed, or should I say Krizal Lips organised for hair stylists and make-up artists to work on the dancers in the video shoot – for free, of course. He came up with a plan to suggest to the Empire Beauty School, in Manhattan that they should run a competition to find the top four students, and the prize would be the chance to work on my music video. He knew some of the staff at the beauty school and suggested we pay them a visit. Krizal Lips also designed and printed a poster for the shoot that made me out to be some kind of UK rap star on the cusp of fame and fortune to hand out at the school.

We visited the school, met with teachers and some of the students, who totally bought into the competition idea. Looking back, I know it sounds ridiculous they agreed to do the make-up for free, but Krizal Lips was on good form, selling them the idea that I was the next big thing, and his idea worked.

I'm supposed to be in my kilt all through the video, which was being shot in several outdoor locations in the city. The first scene is on the street where I come across a homeless person – in reality an actor I'd press-ganged into service for the video – who is sitting on the sidewalk holding a piece of cardboard with the words 'Feeling Depressed' written on it and begging for money. Instead of handing him a few dollars, I put a CD of the track Feeling Alive into a beat box by his side and when the track begins playing the guy starts smiling, pulls out a marker pen and scores out the word 'Depressed'.

So far, so good, as this scene was filmed before everyone has descended on the photographic studio and all Hell breaks loose.

But now I'm disguised as a pimp, I film the scenes of me rapping with dancers busting their moves all around me in Union Square. The way I was dressed made me look like I had just come out of a time machine, but when I look back at the video now, the vibe it created worked well.

However, there was one more hitch before we could start shooting the video. When we tried to turn on the ghetto blaster to give us the soundtrack to dance to, we discovered the batteries were done. Someone was dispatched to buy more batteries, but they came back with the wrong size, so that caused more delay while we had to wait for these to be swapped for the correct size.

The hiatus did mean more and more people were gathering round to watch what was going on and we ended up with around 300 people in Union Square watching – and waiting – for someone to shout 'action'.

And plenty action there was with the videographer Jon Edwards filming us as he whizzed around Union Square on a skateboard. It was a rather novel and, more to the point, less expensive way of filming on the move, instead of using a traditional camera dolly you usually find on film locations.

Despite the earlier commotion at the studio and the roasting hot sun, the shoot goes well and everyone has lots of fun. Especially me, as I was surrounded by a group of good-looking girls gyrating in skin-tight spandex. It's a tough job, but someone's got to do it.

A few days after our exploits in Union Square, we visit Pier 55 on the Hudson River and also Times Square, in Midtown Manhattan, filming more scenes for the Feeling Alive video. This time I'm in Highland dress and the kilt is swinging to the hip hop beat.

As you can imagine, a kilted rapper surrounded by a group of three Black Krump hip hop dancers, called Nuu Knynez performing some amazing moves caught the attention of the tourists and the locals, who quickly form a large circle around us when we are in Times Square.

We're just about to start filming when a FedEx delivery guy – who is friendly with one of the Krump hip hop dancers performing in the video – walks by. The FedEx guy stops to talk to his friend and it turns out he's a dancer as well. So he asks if I mind if he joins in to be part of the video during his lunch break. The more the merrier is my motto, so it was a case of fill your boots and let's see what moves you got.

Unfortunately, the pride of NYPD law enforcement also saw what we were doing and came over to bring a halt to the proceedings.

Apparently, you don't need a permit to use a hand-held camera to film in Times Square, but you do need permission if you want to plonk a tripod on the street or sidewalk. You probably won't be surprised to learn that we didn't have a permit and we were indeed using a rather large tripod, so it was a case of the cops calling 'cut' and we had to stop filming.

Fortunately, we got enough footage before two police officers called a

halt, but what happened next was another real eye-opener to the systemic racism that can be found in America.

As soon as the cops arrived on the scene they made a beeline for the Black hip hop dancers and totally ignored the rest of us who were white. Even though I was the obvious centre of attention and had been cavorting around Times Square wearing a kilt, the two cops only questioned the dancers. It wasn't the first, or the last, time I'd witnessed Black people being discriminated against by the authorities and being suspected of being up to no good because of the colour of their skin.

I felt bad about not intervening on behalf of the hip hop dancers, but since I was in America on the visitor visa waiver scheme, the production assistant helping me organise the video shoot, Chelsea Roach – who was a friend of Krizal Lips – bundled me into the back of a cab and we drove to her house in Manhattan. She didn't want me getting involved with the authorities in case it affected my visa waiver and I'd be deported back to Scotland.

However, in his own inimitable style Krizal Lips distracted the cops from their questioning of the hip hop dancers with an Oscar-winning performance of a man with a bad stutter trying to apologise for an oversight in not having the proper permit to film in Times Square. His stuttering routine seemed to work and the cops let everyone off with a warning.

Now, this guy Krizal Lips was to become a big part of my life as he helped me a lot putting together my music videos. He's the craziest man I've ever known and I met him after he saw an advert I'd placed in Craigslist for dancers to appear in the first of my music videos.

Feeling Alive had been the third music video filmed during this particular sojourn to America in the summer of 2013, after I'd done a deal with a New York videographer, Jon Edwards, to do a package of three videos for $1000. I had three tracks I wanted a video for – Ballerina and Feeling Alive, which had been recorded and produced by a friend, known as Sean Tha Don, at his studio, in Edinburgh and The More I Dream, which was recorded in studios in Brooklyn and Manhattan.

I wanted to make videos that showed I was in New York as a way of

announcing to the folks back home, and to everyone else for that matter, that I was here to launch a solo music career as a hip hop artist. It was also the sign that my boxing ambitions had fallen by the wayside, as my music had become more important to me.

I also managed to squeeze in a fourth music video during this visit to America. This one was filmed by Paradox for a track called Stalker that I had previously recorded back home in Edinburgh. The video didn't cost me any money, as Chelsea directed the video as a favour and it was shot in her Manhattan apartment.

The More I Dream track featured New York singer, Monet on the chorus of the song, and she had already recorded her vocal part. But to finish the track, I still had to record my vocals on the verses. I couldn't believe my luck when I persuaded well-known engineer and producer, Steve Sola – who had mixed, produced and engineered for rap acts like Mobb Deep, 50 Cent, Mariah Carey, Mary J Blige and Eminem – to record my vocals.

I had been looking for a name producer and recording engineer to work on my track and if I was going to have to bullshit someone to get them to do it for a pittance, it may as well be one of the best in the business.

I went online and found a phone number for Steve Sola's Plaintruth Recording Studios, in Fulton Street, Manhattan, and called him up. I got straight through to the man himself and immediately went into motormouth mode, telling him how I'd come from Scotland to stay in Brooklyn and I was aiming to become the biggest hip hop star in the world. I also buttered him up by telling him how much I admired his work and I would be honoured if he would work his mixing desk magic on my track.

I don't know what sealed the deal, but he agreed and said: 'Why don't you come in for a couple of hours and we'll see how it goes.' I must have been his act of charity that week because when I told him I didn't have much money, he said he would only charge me $40 an hour. His usual clients probably wouldn't have got any more than the click track that helps you keep in time for that price.

I was excited about meeting Steve Sola, never mind getting him to work on the track. He's worked with some of the greatest names in hip hop and

as well as getting his expertise, I would soon find out if he thought I was any good or send me home with a pat on the head and a sugar lump.

On the day I was to meet Steve Sola, I'm walking around outside his recording studios going over the lyrics in my head, as I don't want to record my vocals reading them off a lyric sheet. I want to show him I'm a real pro who memorises the words to songs.

I record a few takes and Steve shows why he's so successful at his craft. He's a perfectionist and he makes me repeat vocal lines until they are spot-on. It takes me an hour to get the vocals right and I spend another 45 minutes talking to him about the music business.

Steve said he was impressed by not only the song, but also the way I performed it. I also reckon he was more than a little surprised that what he heard had come out of a white boy from Scotland. He said he would like to work with me again, which was an amazing compliment to get from him and I was doing heel clicks à la Fred Astaire all the way along Fulton Street after I left the studio.

The video for The More I Dream had Monet and me walking around the streets of a hip area of Williamsburg and the not-so-hip East New York performing the track. There was a block party going on while we were filming on a street in East New York and the local rapscallions thought we were filming a porn movie and kept asking if they could get a part in the film. They started coming on to Monet, who was quite shocked at this kind of unwanted attention, as she lived in a rather gentrified area of Brooklyn and didn't have a lot of experience of places like the hood. I thought she was quite brave to put up with it and carry on filming.

Although, I'd said in the Craigslist advert that I was looking for dancers to appear in a music video for my song, Ballerina, in reality, I would have welcomed anyone to be in the video. I was desperate to have as many people in the video as I could. Of course, being able to move your arms, legs and body in time to the music would be an added bonus.

I hadn't realised how much I had to do to make this video happen. As well as finding dancers, I had to get a choreographer, make-up artists and hairstylists, hire a room for several rehearsals and then a dance studio for the shoot itself.

Not an easy task for someone like me who is doing all this for the first time and has very little money to spend, as I was renting a room in an apartment in the Vanderveer Projects, in Flatbush. The cash I had saved from working back home in Edinburgh for the past ten months was running out faster than Usain Bolt sprinting home with a fish supper before his chips got cold.

This was never going to be a big-budget MTV blockbuster video costing millions of dollars, but I was determined to make it look like it was, using all the guile and cunning I had to get people to do things for me and of course, with a little help from my friends.

The advert in Craigslist asked people to come along to a dance studio in Williamsburg for the first rehearsal, which was five weeks from when the video was due to be filmed. At the time everyone was supposed to be there, I stood in the middle of the studio waiting for my troupe of dancers to arrive. I walked up and down, constantly looking at my watch and then my phone to see if anyone has texted me to say they were held up in traffic, but they were on their way.

I waited and waited, but after half an hour I was still on my own because no one had turned up. Suddenly the door opens and in walks a guy who introduces himself as Quinnel Sylvester, but says everyone calls him Que.

'Are you a dancer?' I ask, more in hope than expectation.

'No, man. I'm a rapper,' Que replies.

Ah, well, I thought. Just what the world needs – another rapper when I'm desperate for dancers. But Que's appearance was a real stroke of luck for me, as we became friends after we'd chatted for a while. He'd heard about me coming from Scotland and we played each other's tracks as we sat in the empty dance studio.

My disappointment at no one turning up was tempered by meeting Que and his promises to do everything he could to help me. My plan of action was to take out some more adverts in Craigslist and print A4 leaflets to distribute, asking if dancers wanted to be in Stevie Creed's latest music video.

I also started haunting dance studios in Manhattan, handing out the

leaflets to dancers, pinning the leaflets to notice boards and leaving them on seats. I also waited in corridors and lobbies for classes to start and finish, so I could meet and chat up the girls as they were coming and going, and try to persuade them to be in the video. I phoned girls I had met in Brooklyn and at the fashion shows I'd been involved in during my previous stay in America. Even if they had no experience, I'd still ask if they fancied being a dancer for a day.

I had a week before the second rehearsal, so I was pulling out all the stops to make sure I wasn't going to be the only person being filmed in the video and I would be surrounded by plenty of dancers.

I may have had a plan to get myself some dancers, but I still hadn't recruited a choreographer to tell them what to do. Enter Krizal Lips. He'd seen one of my adverts in Craigslist and called me offering his services as a choreographer, which is one of his many talents. When I answered the phone, he was hyper and wouldn't stop talking about what he could do for me. We arrange to meet in a café just off Times Square the following day.

We met on the sidewalk outside the café and I don't think Krizal Lips had stopped talking since we spoke on the phone. He was carrying on from where we left off and was chuntering on at 100 miles an hour, words shooting from his mouth like bullets coming from Gerard Butler's machine gun in the Olympus Has Fallen movie. He couldn't stand still and was constantly moving around the sidewalk.

'Yes, yes, yes. We're going to make this video. It'll be the best music video you've ever seen, Stevie. Just you wait and see. I've listened to the track you sent me and I've got some great moves for it. They're all in my head, but I'll get them onto the dance floor – don't you worry,' he says.

Krizal Lips has brought a female dancer, Taylor Nicole, he was currently managing, along with him and there's an older man hovering around as well. 'This is my bodyguard,' says Krizal Lips, introducing me to the guy. Turns out he's Taylor's father. He might have been security for the choreographer, but somehow I reckon he was also there to look out for his daughter.

I'd sent Krizal Lips a couple of tracks – Ballerina and Feeling Alive – and he starts listening to them on headphones as we're speaking and

his head is bobbing up and down. Then he plays the music through the phone's speaker and starts dancing on the sidewalk to the track, showing me the moves he wants to use on the video.

We're inside the café now and Krizal Lips fires off another verbal volley: 'Stevie, Stevie, listen to me, man. Your music's great. This is crossover. You're rapping. You're singing. You got the look and we'll get you the girls to go with that. You're from Scotland, you've got the accent and you've got stories to tell. We can market you in so many different ways and you got worldwide potential.'

I'm quickly coming to the conclusion that this guy may well be the one that did fly over the cuckoo's nest, but I don't care. He likes my music and wants to help me with the video. I was happy to meet anybody and he was another connection in New York I didn't have before. He might appear to be a bit wild and eccentric, but he's also exciting to be around, as he's got amazing energy and gets very animated and enthused about anything he's involved in. Never mind the madness – we could all do with a bit of that in our lives from time to time – this boy will do for me.

Krizal Lips says Taylor is happy to be in the music video and he'll try to bring some more girls along for the second rehearsal the following week. I'm on the 2 Train back to Brooklyn and the weight on my shoulders is a little bit lighter after meeting Krizal Lips and he's agreed to do the choreography for the video. Maybe this madcap plan of mine to do an MTV-style video on a shoestring might just get pulled together after all.

I redouble my efforts to recruit dancers for the video and on the day of the second rehearsal all I can do is hope and pray people will turn up. I'm mightily relieved when there are more than a dozen dancers, who had bought into my enthusiasm and believed me when I had told them we were heading for the big time and they should hitch their wagon to my star.

While we were waiting for Krizal Lips to arrive, I went round every one of the girls, spoke to them and thanked them for coming along. They knew they weren't getting paid for appearing in this video, but after I had painted this picture of me being a big-time rapper from the UK about to

break America, dropped some names like Steve Sola so hard it almost shattered the floor, they believed it might be plain old bread and butter today, but there would be lashings of jam tomorrow.

The reality was that I didn't have enough money to pay them, as much as I would have wanted to. Still, everyone seemed very excited about doing the video and where it might take all of us and I promised they could use the video, along with still photographs from the shoot, in their portfolio.

I was telling everyone about the amazing choreographer who was going to be working with them when the door flies open and Krizal Lips makes his entrance.

He's wearing shorts, a sleeveless T-shirt and has a bandana tied around his head like the Karate Kid. After pausing in the doorway, he walks in, opens his arms wide and says: 'How are we all doing? We're going to do this and it's going to be great. So, let's go, troops. Let's go.'

He then skips to the middle of the dance studio, does a front flip, but instead of landing on his feet he clatters to the floor, landing on his back with a thud. Ouch! But acting as if almost breaking his back is what he meant to do all along, he gets to his feet, pirouettes and introduces himself. 'Hi! I'm Krizal Lips.'

He then starts making karate noises, as he goes through a series of pseudo karate moves he's created. He gets the girls to follow all his moves and while I'm getting the ghetto blaster ready to play my track, he's telling the dancers: 'I do lyrical dance choreography. If Stevie here sings that he's screwing the label, we're screwing the label with our dance moves. If he says he's from the UK, we're making a sign that he's from the UK.'

I play the track several times and within ten minutes Krizal Lips has got the girls, let's say, sweating rather more than just gently perspiring as ladies do. I'm amazed he's put all these moves together and how energetically he makes the dance steps move along with the track. I stand back, watch him at work and say to myself: 'Good luck with this one, girls. Rather you than me.'

I was no expert and I had no idea what made good choreography for

a music video, but what he had the girls doing for the Ballerina track looked great to me. We even had a real ballet dancer, a girl called Azama Bashir, among the volunteers. She would be dressed in a black tutu and doing some traditional ballet steps in the video alongside the other girls performing Krizal Lips' own dance moves.

The rehearsal lasted two hours and despite Krizal Lips' eccentricities and working the girls like Trojans, they seemed to enjoy it and they all agreed to come back for a further three rehearsals.

The more time I spent with Krizal Lips the more I thought he was crazy, but in a loveable way and that he'd be able to get me into places and meet people who could help my career. He even got me an interview with an immigration lawyer who advised me to find a sponsor and apply for a work visa so I could stay in America.

He would also take me round different clubs and bars to introduce me as a 'rap star from the UK' and get them to agree to host post-video shoot parties. But probably the biggest thing he did for me was to get me a session with one of Hollywood's acting coaches, Bob Luke. The list of actors he has worked with was like a who's who of movie stars, and Bob was on-set acting coach for The Cosby Show and films Dogboy, Ransom and Music of the Heart to name but a few. He also coached Sarah Michelle Gellar, who starred in Buffy the Vampire Slayer, Scooby Doo and Scream 2.

I visited Bob at his apartment in Manhattan and he started by asking lots of questions about my background. He then gave me a script to read from and we traded lines for a short time before he gave me advice on how to react to what someone else is saying and not just read the reply from the script.

He was very good at getting his point across and when I was reading a lengthier passage from the script, he pretended to fall asleep as he sat in his chair opposite me. When I saw this and stopped reading he suddenly 'awoke' and explained he was making the point that I should be more animated when I'm reading my lines, and it was boring the way I had been delivering the words in the script.

I also think he was trying to see if he could get a reaction from me and find out if I really did have it in me to be an actor. His sleep act certainly

worked and I quickly realised that you don't just say words when you are acting – you have to live them and become the person who's speaking. It also brought out the competitive side of me and I performed a lot better as I continued with the script. Bob amplified this point when he said: 'Don't just read the words. Put yourself in that room, or in that place and add a bit of emotion to what you're saying.'

At the end of the session he was quite complimentary, saying I had got better after he had given me some coaching, I had a good look and that I could probably get acting work. He told me that although I didn't have any formal acting training, I had something that other young actors might not have and that was real-life experience.

'You've got a lot of things going for you,' he told me. 'You've got life experience, which you can use to recall the emotions you felt in different situations. Use your experiences if they're relative to the part you're playing and think back to how you felt then and use the same behaviour pattern in your acting as you did in real life. That's how you can make your acting more believable. That's an advantage you could have over other actors, and a leveller when you walk into a room and are up against trained actors in an audition.'

This was one of the most productive hours I'd spent so far in New York and as well as learning a huge amount from Bob, he also gave my confidence a boost.

Everything was coming together for the Ballerina video shoot and I even recruited two boys aged about 12, who were identical twins, to act as security guards escorting me into the dance studio for the video. They were dressed in black suits, wore shades and had the security earpiece and mic headset just like the real thing.

I was dressed in tartan trews, white shirt, black waistcoat and pink bowtie and wore a tartan flat cap for the video. I'd got the idea when I was working in a kilt shop on Edinburgh's Royal Mile the last time I'd been back home. I thought being The Brooklyn Scotsman, I should wear something tartan and I hadn't seen too many rap artists wearing tartan trews and a tartan bunnet in their music videos.

I've got the ballet dancer in the black tutu; a Russian model in the shortest of shorts, wearing a bra underneath an open leather jacket and

high heels; the Nuu Knynez hip hop dancers, who also appeared in the Feeling Alive video leaping around; plus a dozen other male and female dancers doing their stuff, as I rap and sing the Ballerina track. I love every minute of it and all the stress of putting it together disappears, as the first beats of the song filled the dance studio.

Now it was on to the Feeling Alive video and you already know the drama that went on to get that one done.

By this time, Krizal Lips is almost a constant companion and he's working on the choreography for Feeling Alive. He's really bought into what I'm trying to do and says he sees me like a little brother – he's almost ten years older than me – he wants to look after. He even took me to meet his mother, who he still lived at home with, in a city called Newburgh, in Orange County, New York State, just over an hour's drive from Manhattan.

And his phone calls were something else. He can certainly talk for America and often I would put my phone on the table and do something else. By the time I got back to the phone, he's still talking and has no idea that I haven't been listening to what he's saying.

We never had any written agreement about payment for anything he did for me – which was a lot. Every now and then he would say: 'We'll do a deal, Stevie. We'll start our own company. I'll get a contract drawn up for us to sign.' But that particular piece of paper never materialised, as I reckon he was so caught up in the idea and the creative process of making my music videos and promoting his new best pal.

The day before the Feeling Alive video shoot I still didn't have any outfits for the girl dancers and I was starting to fret ever so slightly. But I needn't have worried, as I've got Krizal Lips who'll come to the rescue. I'm with him and Chelsea in Manhattan talking about the video shoot when I tell them I still need to get some outfits for the girls.

'Come with me,' he says. 'I know the very man to sort us out.'

He explains that he knows a guy that's normally found standing beside a van with tinted windows not far from the bright lights of Times Square and within an hour he can get anything you want. Apparently, he just clicks his fingers and one of his minions dashes off to fulfil the

order within the allotted timeframe.

Krizal Lips assures me that everything is legal and above board with this guy – whose nickname is Lightning because he can get what you want so quickly – as he has contacts everywhere in New York and if you've got the money, he'll get whatever you're looking for.

As the three of us walk along the street, sure enough there's the van with a guy looking very chilled leaning against it.

'My man,' says Krizal Lips. 'How you doing? I want you to meet a friend of mine, Stevie. He's from Scotland and he's a rapper. He's cool, man.'

Lightning shakes my hand and seems like a nice guy as we make small talk.

Then Krizal Lips gets down to business. 'Hey man, you're the best,' he says. 'You can get your hands on anything, yeah? We're shooting a music video tomorrow and we need about a dozen costumes for the girl dancers. Something sexy – you know what I mean?'

The guy turns round and looks at another guy who's standing behind him and has heard the conversation. He snaps his fingers and points to the other side of the street. Without a word being said, the other guy runs across the road and heads along the street.

He tells tells us to come back in an hour and as we walk away, I turn to Krizal Lips. 'This is not happening,' I say. 'There's no way anyone is going to come up with a dozen costumes in such a short time.'

How wrong I was. An hour later we're walking back towards where the van was parked and your man is still leaning nonchalantly against its side.

'Did you manage to get anything for us?' I ask.

He doesn't say a word. He just pushes himself off the van, goes to the back doors, opens them and lying inside are a dozen bright metallic blue spandex leggings and black tops.

I was amazed and was more than happy to give the guy the $100 he asked for. I walk back down the street with an armful of tops and leggings that fitted so tight on the dancers' legs they looked like they

were painted on.

Now I've got four videos ready to be unleashed on the world and surely now I'm on my way to fame and fortune. Well, I was certainly on the road, but there would be more than just a few bumps on the way and I would make the return journey almost penniless.

CHAPTER 9
LIVING IN A CRACK DEN

I could swear the rat has a swagger as it wanders under the big gap at the bottom of my door and saunters around my room. It's late at night and I'm sitting on my bed writing lyrics in the room I'm renting in Flatbush when suddenly my unwelcome visitor makes an entrance.

The rat ambles along the skirting board towards me, sniffing at the floor and then lifting its head to look at me as if to say: 'Don't mind me. You just carry on with whatever you're doing.'

I quickly pull my legs up onto the bed and can feel my heart pounding like an Amtrak train thundering along from coast to coast. I'm terrified of this horrible creature with a long tail that sends shivers down my spine just looking at it and worst of all, it's only a few feet away and getting closer. I've been billeted in some pretty unpleasant places in my time, but a rat – that's a whole new level of shit to deal with.

I've no idea what to do to get rid of the rat, so I gingerly stretch my arm over the side of the bed and grab a suitcase, pulling it towards me. I start banging on the lid of the suitcase making as much noise as I can

to frighten the audacious rodent, but it totally ignores the racket I'm making and carries on wandering around making tiny clicking noises, as its claws pitter-patter on the wooden floor.

I decide my next line of attack is to stand up on the bed and throw the suitcase at the rat. That's when I discover I'll never get signed as a pitcher for the New York Yankees, as I miss the target and the suitcase bounces a couple of feet to the side of the rat and ends up at the far end of the room. There goes my last piece of ammo.

Despite the suitcase bouncing across the floor, the rat hardly moves and just stares at me again. That rodent dude must have been on some heavy-duty wacky baccy because he just seems to be chilling out no matter how much I try to frighten it away. I'm desperately thinking what my next move is going to be when the rat slowly turns and I can almost hear him say: 'See ya later, bud' as he swaggers back out underneath the door the way he came in.

I had arrived back in Brooklyn in August 2014 for another three months, after almost a year back home delivering Dominos pizzas in Edinburgh to get enough money for my next sojourn to the States. When it comes to wages, you don't get much dough topping up your bank account by delivering pizzas (see what I did there) and I had less money saved than for previous stays.

But things were starting to happen for me on the music front, as my Ballerina track was getting noticed by radio station DJs around the country. I was also planning to do a show in Manhattan with me headlining and having the rappers and musicians from Brooklyn I'd met and become friends with also on the bill.

I'd also become really friendly with a rapper from Brooklyn, called Paradox – or to give him his Sunday name, Lloyd Gonzales. I'd met Paradox the previous year when he came along to one of the dance rehearsals for a nosey and we'd hit it off straight away.

Before I flew to America, I'd asked Cass if he could find me somewhere to stay and he suggested a room in an apartment, in Flatbush. Cass had been living in that apartment when I first came to America and I'd stayed there with him for a couple of weeks in 2011. With that in mind, I thought it must be a decent place to stay.

I suppose it depends on your definition of decent, but when I get to Brooklyn I soon realise the place has gone downhill since Cass had lived there.

Cass picks me up from JFK Airport and drives me to the apartment at The Junction and pulls up outside the building. We head for the door at the side of a shop front and as soon as he opens it I could smell a horrible mix of dampness, weed and gas that was escaping from somewhere. I later discovered the smell of gas was coming from a leak in the cooker I was supposed to use.

We walk up the wooden stairs that are rotting and there are holes in the plasterwork on the wall. When we get to the landing at the top of the stairs, there are three rooms for tenants and a communal kitchen and bathroom. The place looks really decayed and run-down, but so are a lot of other places in Brooklyn that people put up with because that's just the way it is.

Cass points to a room and says this is where I'm going to be staying. My heart sinks even more because the door doesn't have a handle or a lock on it and worse still, the wood on the door has rotted and there is a huge gap about a foot high right along the bottom. I only had about three quarters of a door to the room I'm to live in after someone had taken their size tens and kicked in the bottom panel of the door.

Cass has to bend down and put his hand into the gap along the bottom to open the door, which only stays closed because the door jams into the edge of the frame when you push it hard enough.

I didn't want to complain to Cass since he's been good enough to find me a place to stay and I was only paying $500 a month which, believe it or not, is cheap for renting a room in New York.

I was willing to put up with the state of the place because I felt I was lucky to be in America for another three months chasing my dreams and, in any case, I wasn't planning to spend a lot of time in the room.

All I really needed was a bed and a roof over my head. Which is just as well, because that's all I had – the room had nothing but a single bed and a mattress. No table, no chairs, no wardrobe or chest of drawers and not even a pillow to rest my weary head on. At least the walls were newly painted white, although there was a strange tennis ball-sized hole

in one of the walls. I console myself that this is a bit of an upgrade from a previous place I'd stayed in the first time I came to America. That time, I didn't even have a bed and I slept on the floor with folded curtains as a mattress.

After Cass left, my first port of call was the Target department store at Flatbush Junction to buy some pillows and bedding. Little did I know the Target store would soon become a second home for me and I would regularly head over to the store to use their bathroom, as the one in the apartment wouldn't pass many hygiene tests and there always seemed to be someone using it.

My flatmates were a pair of Haitian ladies who shared a room and the third room was where a Jamaican guy, called Dred, was staying. I never did find out what his full name was.

Let's just say Dred was a bit of a character, as he regularly walked around the apartment in his bare feet wearing only a pair of pyjama bottoms.

However, other visitors to the apartment were not so welcome. Apparently, there used to be a crackhead living in one of the rooms, who had been evicted after he'd turned the place into a community centre for crack cocaine addicts getting high, puffing away at their pipes and long, thin glass tubes filled with the tiny off-white pieces of cocaine rock.

Although the junkie who stayed there had been thrown out, all his crackhead mates still came around the apartment to get high every other day and since there was no lock on the outside door either, there was nothing to stop them coming inside. They would sit, or lie, on the stairs and landing outside my room depending on how out of it they were. I would have to step over their bodies as I was coming and going, or manoeuvre around them when they were smoking their crack cocaine.

Cannabis seemed to be everywhere in New York and sparking up a joint was as common as the pssssssschhh sound of a can of lager being opened back home. If it kept everyone in their happy place and they wanted to smoke the ganja, then that was fine by me. And selling cannabis in Brooklyn is like having a newspaper delivery round in Scotland – lots of people do it and even more people smoke it.

But the crack cocaine was something else entirely and you could see the damage it does to people both psychologically and physically.

When the crackheads had their fix they were on Planet Euphoria, but they could be really nice people in a weird way. They would talk to me about how much pain there was in the world and how people should treat and love each other better. Think back to the peace and love heyday of Haight-Ashbury, in San Francisco in the Sixties, where flower power and hippy culture began, and our Flatbush crackheads would fit in nicely.

Some of them were also very talented and resourceful and could turn their hand to many different skills to make money to feed their drug habit. But when the cash for coke ran out and they were desperate for a fix, that's when they became aggressive when they were asking you for money.

I wasn't having much luck with my accommodation during some of my visits to America, having stayed in a whorehouse motel, people getting murdered outside my flat and now this latest apartment being used as a crack den.

That first night I found it hard to get to sleep because the heat was almost unbearable, the mosquitos were out in force and there was constant loud music filtering into my room from the J'Ouvert Festival and West Indian Day Parade going on outside in the street.

I got up to close the window, hoping to keep both the mosquitos and the racket from the parade from invading my room. The curtains had been drawn when I had first arrived and when I pulled them back I couldn't believe my eyes because there wasn't a window there – just a rectangular opening in the wall to the outside world where a window used to be.

The next day I asked Cass about the lack of a window and he explained that the crackhead who was evicted had been living in the room next to mine and when he was getting kicked out, went off on one and punched a hole in the wall. He then ripped the window and its frame from the wall and ran off with it under his arm.

I asked him to help me get the landlord to do something about the room not having a window, as apart from the mosquitos swarming in and eating me alive, any opportunist thief could easily climb to the roof below the first floor where the room was and climb in to steal anything I had.

I didn't want to make too much of a fuss with Cass, as I still felt obliged

to him for finding me this place, but I was getting a bit miffed at the state of it. And I certainly didn't want anyone getting into my room, so I wanted the landlord to fit a glass window.

Unfortunately, that never happened. Instead of a new frame and window being fitted, my friend Paradox came round and taped a black refuse sack over the space where the window should have been. At least it stopped the mosquitos getting into the room, but it also stopped any natural light coming in as well. In the meantime, I was sleeping with my passport, debit cards and all the cash I had tucked into my boxers.

After the rat had sauntered into my room, I also asked Cass to help me get the gap at the bottom of my room door repaired. But Cass being the laid-back guy that he is was rather sanguine about the whole incident and says: 'I knew that would happen. Rats and all kind of shit will turn up here. You got to get that covered up man or that mother******g rat will be back to pay you another visit.'

Cass did help me close the gap at the bottom of the door, but his revolutionary solution was to cut a length of cardboard from a cereal box and attach it to the bottom of the door with brown packaging adhesive tape.

Before I came to Brooklyn that year, I had been eating well at home, since mums like to feed their boys well, especially when the prodigal son returns home. I had also been visiting the gym several times a week, lifting weights and my body had bulked up with muscle quite a bit. I was the biggest I'd ever been and lots of people in the hood commented on my size.

I was trying to keep the costs of this trip to America to a minimum, so I was rationing how much food I was eating, so it wasn't long before the lack of proper eating would see me shrink.

I only ate once a day and more often than not my fine dining experience would be a submarine sandwich, or some macaroni and vegetarian chicken from the Ital Fusion restaurant and takeaway, at The Junction. The staff at the Ital had got to know me well from my previous stays in Brooklyn and they were very generous with their portions.

Whatever I had bought for the $5 a day I would generally allow myself to spend on food and a fruit juice, I would take over to the Target store

and sit at one of the tables in their food court.

I was hardly ever away from the Target store, as I would spend as little time as possible in the crack den and would sit at one of the food court tables for hours on end taking advantage of the free Wi-Fi, reading articles and watching videos about the music business on my phone.

Along with crackheads, mosquitoes and the odd rat wanting to share my lodgings, I also had to endure the pungent smell of gas in my room for a few days. Little wonder I didn't want to hang about the apartment too much. I could also have fed myself a lot cheaper by cooking rice and pasta in the kitchen, but you couldn't use the cooker because it didn't work and I was soon going to find out why.

The source of the gas smell was only discovered to be coming from the cooker after I'd complained bitterly to the landlord. It was horrendous. Even though my room wasn't next to the kitchen, the smell of gas was stifling and I made a slit in the plastic refuse bag that made do for a window to let some air in.

I was getting less reluctant to complain about the flat by this time, as I was getting angry about the state of the place. When I called the landlord, I told him in no uncertain terms that I wanted something done about the gas leak.

'If you don't do something we're all going to die in here,' I said. 'These crackheads are sitting on the stairs lighting their pipes. If that gas gets ignited, this place will blow up and it'll be like Hiroshima.'

Give the landlord his due, he did come round the next day and turn the gas off at the point it got to the cooker.

Drama was never far away on the streets of Flatbush and I got caught up in a shoot-out as I was leaving the Target store one afternoon.

I've just stepped out of the store and onto the sidewalk when I hear a woman screaming: 'Get down! Get down! They're shooting. Everybody get down.' No sooner had she shouted the warning, I hear the firework-like crack of two gunshots that seem to come from across the other side of the street. People start screaming and rushing into shop doorways, or kneeling down behind parked cars. I take a step back and jam myself against one of the pillars at the entrance to the Target store and visually

sweep up and down the street to see where the gunfire is coming from.

Another two shots are fired and this time I guessed they were coming from my side of the street. I put my head round the pillar to my right and I see one of the shooters about 20 yards down the street from me. It's like something out the movies and the guy is crouched behind the back of a car pointing a handgun over the trunk in the direction of the other side of the road.

He looks like he's just a teenager and is oblivious to the panic going on all around him. It seems like he's only interested in killing whoever he's shooting at across the street.

The guy fires another two shots and when I look across the street, I see the second shooter has taken a bullet and he's lying on the sidewalk writhing in agony. I reckon he didn't stand much of a chance, as he didn't have much cover in front of the Modell's Sporting Goods store as he fired his gun.

As soon as the guy on my side of the street knows he's hit his target, he vanishes from the scene. My mind is still trying to process what has just happened and very quickly I can hear a police helicopter in the sky above me. It's flying in circles above the streets of Flatbush, looking for the gunman who had escaped.

The sound of the helicopter's rotor blades and the wailing sirens of the approaching police cars and ambulance getting louder and louder is strangely comforting and makes me feel a lot safer. I walk across the street to where a crowd has gathered around the gunman who had been shot. I look between the people in front of me and see that the guy is now lying still and there's blood seeping across the front of his shirt.

It's strange when you witness something like this in real life because it's not like the movies when the hero immediately reacts and leaps into action to save the day. When you're actually there when it's all happening, it takes time for your brain to register what exactly is going on and then you have to decide what you're going to do to keep yourself safe.

I only stayed at the other side of the road for a few minutes, as I didn't want any involvement with the NYPD. Although I hadn't done anything wrong, I didn't want my name to be on any police record even as a witness. I was always afraid of being deported, or not being allowed back

into America by the immigration authorities the next time I turned up at JFK or Newark on a visa waiver.

And I didn't want some immigration officer looking through the glass at me saying: 'Ah, so you're the tourist who likes to spend their holidays living in a violent area of Brooklyn and getting caught up in gun battles on the streets. A bit strange, don't you think, Mr McGhee? Think we should look a bit more into what you're doing when you come to visit our country.'

So I quickly took leave of the crime scene, and headed back into the Target store to find a window seat in the food court that overlooked the street below and watch what was going on from a safe distance.

It wasn't just on the streets that I had a close encounter of the violent kind. One time it happened a few yards away from my room in the apartment. Who needs Netflix to bring some high drama into your life?

I was in my room just about to head out to my usual perch in the food court at the Target store when I hear people screaming and arguing with each other in the kitchen and the sound of pots and pans falling from shelves onto the floor.

Suddenly, after a few minutes of this rumpus, I hear a different kind of scream. The kind you hear when someone has been hurt badly and they are in a lot of pain. Then everything goes silent. Something tells me this is not a run-of-the-mill row and I come out my room to see what's happened.

I look through the kitchen door and see one of the Haitian women lying on the floor and at first I thought she'd been decked by a punch. But when I walked into the kitchen and looked more closely I could see a long-bladed knife sticking out of her belly. Most of the knife blade is embedded in the woman's stomach and the front of her dress is turning a deep crimson colour as blood seeps out of the wound.

The poor woman was alternating from sobbing loudly and shouting: 'Oh my God! Oh my God! Help me, somebody help me.'

I must have been getting used to crazy things happening, as I wasn't in shock and my brain was quick to process what I was seeing.

The first thing that comes into my mind is to get the emergency services

in to save her and, as I turn round, I see Dred standing in the landing staring into the kitchen. I shout for him to call the ambulance, which he does on his cell phone and I kneel down to look at the woman on the floor. I didn't want to pull the knife out in case that caused more blood to pour from her body, but I tried to reassure her that she would be OK as help was on the way.

As soon as the ambulance crew arrive and are treating the woman, I disappear. Again, just like the shooting outside Target, I don't want to be caught up in any police investigation. I make myself scarce for a couple of days, cadging a couch to sleep on with friends until the dust settles and I can go back to the apartment without being quizzed by the cops.

It wasn't all mad mental shootings and stabbings in Flatbush, as there are many really good people living and working in the area, along with some odd characters, who would always make you smile.

One of these worthies was a guy called Bucket Man who would tour the shops and takeaway restaurants pretending to clean their windows. He was a lovely person without a bad bone in his body. He'd carry a bucket and a cloth around with him – although the bucket never had any water in it – and visit the many businesses on The Junction.

He never charged any money and no one ever told him to get out their premises. Some of the takeaways would give him food for his services of wiping the windows with a dry cloth.

The first time I saw him on his 'rounds' I asked him his name and he replied: 'I'm the Bucket Man! Just call me the Bucket Man. How you doing, man?'

From then on I'd always ask how he was getting on cleaning windows and he'd reply: 'Yo man! They're all getting done. Peace and love, bro. Peace and love.'

And while Bucket Man was cleaning windows, my bank account was just about to be cleaned out after I lost all my savings in a business deal that went disastrously wrong.

CHAPTER 10

FROM PARTY TIME TO PENNILESS

Just when I think everything is falling into place with the stars and planets aligning in my favour, the sky comes crashing down on top of me.

I've just lost $1000 of my money in a business deal that went disastrously wrong, leaving me with just a few crumpled dollar bills and some loose change in my pocket.

For legal reasons I can't say too much about what happened, or who was involved, but needless to say my hopes and dreams of making the big time as a rap artist turned into a nightmare and I was left living on a 75-cents cream cheese bagel a day, or scrounging a meal off friends to survive.

I'd been looking forward to my 2014 sojourn to America for months, as I was buzzing that my song and music video Ballerina were getting a positive reaction. At the time, the song was being well received by radio stations and club DJs and I was going to Atlanta to promote the track.

Ballerina was a track that showed a temporary change of direction in

my music. Up till then I had been writing and recording straight up and down rap music, but this song turned out to be a crossover track into dance music as well as hip hop. I kind of fell into the dance genre with Ballerina during the recording of the track with my producer, Sean The Don.

Sean's got to take the credit for letting the crossover vibe creep up on me to make the song more commercial than my previous material. He brought more of the melody and music out in me during the recording, as he got me to experiment with different music genres and had me sing more as well as rapping on the song.

It was a new, enjoyable, fun and creative experience for me doing something different with my music and lyrics. By the time we did the final mix, I knew the song had an appeal outside my usual hip hop market. A straightforward rap track is OK for audiences to stand there and bob their heads, but you could certainly dance to Ballerina as well. Someone even suggested the track sounded like a gay party anthem, which is fine by me.

Back then, the script was that before a track is officially released on vinyl, CD, download or for streaming, a new artist would try to have the song played on as many radio stations and in clubs as possible. That way you create a buzz about the track along with the artist.

It all started with the plan that both my friend and fellow-musician, Paradox would accompany me when I headed for Atlanta, Georgia and I would go round the radio stations and clubs to promote the song and perform a show there.

So, a few weeks after I'd arrived back in Brooklyn, Paradox and I head for Atlanta on one of the infamous Chinatown buses that runs from Manhattan to various cities in America. It's the cheapest way of getting there by public transport, costing only $44 for a one-way ticket for the 800-mile journey that takes about 16 hours.

It's not exactly business class and it's fair to say all human life is travelling with you on the bus as it rumbles along the highway. There are either lots of young mothers with children or, scarily, guys who are just out of jail on board for the journey south to the capital of the state of Georgia and they've all got a story to tell.

My first time in Times Square and honest, that cop car being there has nothing to do with me!

With Ricky B on Pennsylvania Avenue in East New York. This was the road I saw in my dream, before I went to the America. (Photograph by Herve Tennessee)

The young team on Pennsylvania Avenue – from left, Kevin Wallace, Karl Louinis, me, Mayor, Cass and, Ricky B. (Photograph by Dimitri Mais)

Baby faced brawler in the Starret City Boxing Club. (Photograph by Joe Nunez)

Boxing training at the Starret City Boxing gym was hard graft. (Photograph by Joe Nunez)

Strutting my stuff on the runway in Manhattan during New York Fashion Week.

With my two bodyguards for the Ballerina video shoot. (Photograph by Herve Tennessee)

The Ballerina music video shoot in Manhattan. (Photograph by Herve Tennessee)

Attracting some attention in Times Square with some of the coolest guys I've ever met, the NUU Knynez hip hop dancers in the Feeing Alive video shoot. (Photograph by Herve Tennessee)

Me in disguise and dressed like a pimp in Union Square during the Feeling Alive video shoot. (Photograph by Herve Tennessee)

Getting questioned by cops in Times Square during the Feeling Alive video shoot. (Photograph by Herve Tennessee)

Opening scenes from the Feeling Alive video. (Photograph by Herve Tennessee)

With the hardest working Haitian in Atlanta, club promoter, Ron Du – what a guy! (Photograph by Paradox)

Surrounded by beautiful girls on a rooftop in Manhattan during filming of the Feeling Alive video. (Photograph by Herve Tennessee)

On Ron Du's balcony in Atlanta. (Photograph by Paradox)

With Krush, third from left in his basement during the My Throne video shoot, which was the day I met Douglas Adam Ferguson, back row centre, for the first time and we filmed 18 hours straight.

My two brothers from another mother – Mayor, left and Cass right. (Photograph by Douglas Adam Ferguson)

I spent many days and nights coming in and out of this subway station. (Photograph by Christopher Cook)

Rockin' my sporran on Flatbush Junction. (Photograph by Christopher Cook)

With my boxing trainer Tyrone Venning, middle, and professional boxer, Julian Sosa. (Photograph by Garry Torrence)

In the moment on stage at Stramash gig in Edinburgh. (Photograph by David Macara Brown)

Just before we hit the nightclubs in Atlanta. (Photograph by Garry Torrence)

I carry my life on my back with this tattoo I had done of Edinburgh Castle, the Brooklyn Bridge and the Statue of Liberty. (Photograph by David Wilkinson)

Here I am with three of the most influential people in my life pictured in Times Square, Manhattan. From left, Immy Perez, Douglas Adam Ferguson, me and Sean The Don.

I'm sitting in an aisle seat across from a guy and we strike up a conversation. We're having a general chitchat when he reveals he's not long been released from prison for murdering his father. Now, there's a conversation stopper for you.

He tells me his father used to beat him with the flex from an iron and lock him in a room feeding him nothing but baked beans. And he reveals the denouement to this particular tale by casually telling me: 'So I just murdered him.'

What are you supposed to say to that? I just mumble: 'Oh, right. Fair enough then, chief,' and turn to speak to Paradox sitting on the other side of me as if I'd something of earth-shattering importance I can't wait a second longer to tell him.

There was another guy on the bus who was sleeping for the first few hours of the journey and I could see he had eyeballs tattooed on his eyelids. When he woke up, I said to him: 'Cool tattoos you've got there. Never seen any like that before.'

He looked at me and replied with a growl: 'Yeah, because the mother******s need to know I sleep with my eyes open.'

Who exactly the mother******s were he was referring to I don't know, as I didn't want to ask in case I was one of them.

The bus journey got even more bizarre when halfway to our destination and in the blackness of night, the driver pulls into a layby that's bordered by a dense forest in the middle of nowhere. There's the hiss of the air brakes and a similar sound as the door of the single-decker bus opens, just before the driver leaps out of his seat and disappears into the forest. A minute later, a different guy appears from out of the forest, jumps into the driver's seat and with a vroom, vroom we're off on our journey again.

When we arrive in Atlanta, we head for the Sheraton Hotel where we were staying for a couple of nights with the hotel bill being picked up by the person I'd got involved with in the ill-fated business deal.

I'd just come from living in a crack den and now I was going to be in the relative lap of luxury with a real bed, en suite shower and bathroom, a real glass window and no rats strolling under a gap in the door. I look at

Paradox, shrug my shoulders and think I'll just strap myself in and enjoy the ride while it lasts.

While we were there, the Sheraton was hosting a music business conference for record company executives, producers and artists. I'm introduced to some people in the business and it was confirmed I'd be headlining a show in a club across the road from the hotel the following night. I wasn't sure how influential the people I was being introduced to actually were, but at the time I just pressed the flesh and hoped for the best.

The gig the following night turned out to be just about OK. I was told there would be big-time music executives in the club and the rapper Waka Flocka Flame's mother, Debra Antney, who ran a music management company with some decent names on her roster, would have a table at the front near the stage.

I've no idea if she was there or not, but I was the last to perform and spent the night trying to make myself heard above all the noise in the club by shouting at whoever I was talking to. I also had a few Jack Daniel's and Coke – purely for medicinal purposes, you understand, since I was becoming hoarse with having to raise my voice.

By the time I took to the stage to perform my four songs, the place was pretty raucous and my vocals weren't the best they'd ever been. Just the same, I seemed to go down quite well with the crowd.

Since we were only booked into the Sheraton for two nights, Paradox introduced me to one of his friends from Brooklyn, who now worked and lived in Atlanta. His name was Rondu Montfleury, who is from Haitian descent and is, among many other things, a music promoter organising for hip hop acts to get gigs in the city's big clubs and venues. He's into anything and everything, even organising the security on the doors of the clubs and if any big name wants to be seen in Atlanta, Rondu is their man.

As for Rondu himself, he's a real hustler and party animal. Whatever Rondu might do, he does it all night long, as I was to find out to the expense of my liver and a daily visit to Hangover Central.

We stayed in Rondu's apartment for a few days and he promised to show Paradox and me the Atlanta nightlife. He'd have three parties a

night that he'd organised going on and we would flit from club to club, sashaying past the doormen with nothing but a nod as the passport to getting in, while there would be a queue of people round the block waiting to be allowed entry to the club.

I'd be chatting up the girls – only stopping to down either a glass of complimentary champagne or triple shots of JD and Coke – and then it was on to the next club for more of the same.

At that time, the home of hip hop had shifted from New York to Atlanta and the city had even developed its own genre of music, called Southern Hip hop, or Trap. The music business in Atlanta was awash with an ocean of cash – mainly from the drug cartel known as the Black Mafia Family.

These guys were like the Pablo Escobars of the hip hop world, investing huge amounts of money into rap artists and the music industry in Atlanta. They were using the music business as one giant washing machine and tumble dryer to launder all their mega-millions of drugs cash. And of course, every drugs lord needs a bit of R&R, so Atlanta became the city of perpetual partying.

While Rondu was taking Paradox and me on the nightly rounds of clubs and shows, I was introduced to some big names in the hip hop scene. Guys like Travis Scott, Jermaine Dupri and Ludacris all got to meet Stevie Creed – Scotland's gift to hip hop who was about to take over the world. Well, maybe it wasn't quite like that and more of me telling them how brilliant I thought they were and asking if I could buy them a drink. And one or two of them perhaps thinking: 'Gonna get the f**k out my face, man. Who are you anyway?'

I thought I could party and drink like an apprentice sponge, but I was struggling to keep up with Rondu and all the girls who wanted to buy me a drink when they saw I was with him. It's 4am on one of his marathon sessions and Rondu tells me to meet him outside the club where he would pick me up in his fancy sports car, a Chevrolet Camaro.

I'm having trouble walking in a straight line and can't wait to crash out in Rondu's apartment to get some sleep. But when he roars up in the car, he shouts: 'Come on, my Scottish bro. We're on to the next club.'

Rondu eventually calls it a night, or should that be a day since the sun is already up at around 6.30am, and gets a takeaway pizza to eat on the

way home. We get to the apartment and Rondu immediately heads for his bedroom and falls asleep on top of the bedcovers. He says: 'See you guys in the morning,' and within seconds he's snoring like the three-litre turbo-charged engine in his sports car.

I crash out on the couch and the next thing I know it's only 9am and Rondu's full of beans, kicking the couch telling me: 'Time to get up, man. Don't be so lazy. It's another day full of opportunities. We need to do this. You want to take over the world? Well, get your ass into gear and let's go and do that.'

I groan and try to clear the fuzziness from my head and by the time I get up off the couch, Rondu is on his third phone call pitching for people to appear on TV shows, organising parties and being a life coach to some guy who's having woman trouble.

Rondu gets called the Haitian King and describes himself as 'the hardest working Haitian in the entertainment industry'. I'd certainly not argue with that and running his own company, Do U Entertainment, he's a force of nature and never stops working. But, just now and again, someone needs to take his Duracell batteries out so other people can get a rest.

Now it was time to head back to Brooklyn and undergo another journey on the Chinatown bus. This time, the inevitable calamity happens as we're speeding along the highway. One of the passengers notices everyone's bags and cases were spilling out the side of the bus and bouncing along the road in our wake like a scene from an old Hollywood silent movie, with cars behind us swerving to avoid hitting the cases. The door to the luggage compartment hadn't been closed properly and the vibration of the bus's engine along with the bumps in the road had caused the door to fly open.

One of the passengers rushes to the front of the bus and shouts at the driver: 'Stop the bus! Stop the bus! Our bags are falling out the bus and they're all over the road.'

At first, the driver shrugs his shoulders and carries on, but after more people crowd to the front of the bus shouting at him, he pulls over and stops at the side of the road. Passengers quickly pile out the bus and run back up the road to rescue their bags and cases.

We have a saying in Scotland when we return from holiday, which is we're back to 'auld claes and porridge'. That translates to back to wearing your old work clothes and eating porridge instead of the high life you'd been living on vacation. Well, for me it was all of that and living in the squalor of the crack den.

During the next two or three weeks, my spirits were kept high with a regular stream of emails telling me about the different radio stations around the country who were playing the Ballerina track. I was getting airtime in Atlanta, Miami, Chicago and also on the west coast of America from the radio stations that played mainly pop and dance music.

The biggest boost I got was when I was told to have a look at the Music South pop and dance charts, based on airplay in the southern states of America, which had Ballerina in at Number 5. Taylor Swift was at Number 1, but I was above artists like Sam Smith, Pink and Pitbull.

It was really exciting seeing my name in among the music stars for the first time. I was starting to get carried away with myself and dreaming I was on the road to stardom. I'd fantasise about appearing on TV talk shows describing how I had started as a 12-year-old boy selling CDs of my songs to pals around my school back home in Edinburgh, but now I was on the cusp of fame and fortune.

The news that I had charted also provided momentum for me, as I was trying to organise a hip hop show in Manhattan's famous Pyramid Club, where I would headline and the support acts would be the rappers I had met during my time in Brooklyn. It was my way of thanking them and giving them something back for all the help they had given me.

I chose the Pyramid Club, in the East Village, as it certainly has a big reputation and history with both Nirvana and Red Hot Chilli Peppers playing their first New York City concerts there and Madonna appearing at her first AIDS benefit at the club.

I've never used a promoter to put on a show for me, as I like to organise the whole kit and caboodle myself. For me, it's all about ownership and being responsible for making things happen and that includes finding the money to finance the gig. You put your money where your mouth is, give it your best shot and see what you can make out of it at the end of the day.

I've always used my own money, whether it comes to paying for recording studios, hiring venues, promoting gigs or designing and printing Brooklyn Scotsman T-shirts and hoodies. I'm not afraid to drop some dosh in the toaster and see what pops up. It's one sure way of finding out if you've got what it takes.

I enlisted a good friend I had from Brooklyn called Krush to help me pull the show together. His real name is Jimmy Alexander and Cass had introduced me to him. He's a guy that likes to get things done and is a Jack-of-all-trades and a master of quite a few of them into the bargain. I met him through recording in his basement studio and very soon I realised that Krush can turn his hand to almost anything. He's a DJ, a music producer, he's worked as a studio engineer, selling real estate and if you want your house painted and decorated, Krush is your man. And he has street cred by the bucket-load.

From the get-go, Krush bought into what I was trying to achieve and was always very supportive. And it wasn't just me, as he'd helped many other young rappers along the way.

Krush was going to be one of the DJs for my Pyramid Club show and he also volunteered to come with me to meet the venue manager to negotiate a deal to hire the place.

We're in an office in the club's basement and the manager is sitting behind a desk, Krush is sitting across from the desk and I'm standing up, poised to perform my party piece about how big this show is going to be, how there will be hundreds of people there spending a fortune at his bar.

At first the manager says it will cost me $600 to hire the venue for the night.

'No way I can pay that,' I tell him. 'You'll make plenty money out of the show. Remember, it's going to be on a freezing cold Tuesday night in November and I doubt the place will be full if there's nothing on to attract people. I can guarantee I'll fill this place. This is a completely unique show. I'm a rapper from Scotland, I'm living in Brooklyn and I'm getting airplay all over the country. Shows like this don't happen every week.'

I'm giving it to him rapid fire, not letting him get a word in edgeways and I finish by saying I can only pay $400 to hire the club. Then, with a theatrical flourish to bring even more urgency to the proceedings and

put a bit of pressure on the guy, I pull $100 out of my pocket, wave it about in front of him and place the dollar bills on the desk in front of him.

'Agree $400 and that's a $100 deposit you can have right now,' I tell him.

He looks at the notes fanned out in front of him, but says nothing. My final gambit is to grab them back off the table, stuff them in my pocket and say: 'I understand if you're telling me you're not willing to or can't negotiate a fairer price, but I can't go any more than $400. Thanks for your time, but we'll just have to leave.'

Just as Krush is pushing the chair back to get up, the manager says: 'OK, OK. I can do $400 if you leave the deposit with me now.'

Krush was well impressed that I had pulled off the deal and I was excited as well. But on the train ride back to Flatbush, it gradually sinks in that what I'd just done was probably the easy part – now I'd have to put a show together. The doubts start to creep in and I realise that although I know lots of people in Brooklyn, I'll have to persuade them to make the journey into Manhattan for the show. Have I just jumped in at the deep end without a lifebelt? I sure have, but there's only one thing for it and that's I'd better learn to swim pretty damn quick.

I push these doubts to the back of my mind and, like I always do, think positive and get my finger out my ass and start pulling the show together. I was throwing quite a bit of money at the project to make sure everything was the best it could be.

While I'm organising the show, I'm told I need to go back to Atlanta and then travel to Miami, Florida to promote the Ballerina track while it's fresh in people's minds. I invest $1000 of my own money with someone who was going to organise the promotional trip for me and pay for a consignment of Brooklyn Scotsman T-shirts and hoodies that were going to get made for me to use as a promotional tool.

My money was running out and the $1000 would empty my bank account. But I thought back to when I first rolled up at the Galaxy Motel and all that had happened since then. No point in getting this far and turning back now and although it was just four weeks to the Pyramid Club gig, I again got the Chinatown bus along the interstate highway south.

Just like the last time, Paradox was with me, but this time we were staying in a motel rather less salubrious than our previous billet in the Sheraton.

On the drive to the motel, this individual tells us we were due to leave for Miami first thing in the morning and there were several radio stations wanting to interview me and play the Ballerina track. I was also to pick up the Brooklyn Scotsman merchandise of hoodies and T-shirts that would be ready the next day.

Both Paradox and I are excited about the prospect of heading to the rather warmer climes of Florida and wonder if we should have looked out our old Crocket and Tubbs pastel-shade shirts and jackets with the sleeves rolled up to our elbows.

The following morning we're up bright and early waiting to be picked up at 7am. But long story short, no one appears and after several hours of pacing up and down the motel room and numerous unanswered phone calls, it becomes apparent that I wouldn't be going to Miami. There's nothing else for it but to get back on the New York-bound Chinatown bus – flat broke and utterly deflated, as I'm now a grand down.

Paradox even had to pay for the motel room – as we'd been told the bill would be settled for us that morning – and my ticket for the Chinatown bus.

It was a pretty sombre trip back after the excitement of looking forward to promoting the track at a host of radio stations. It was only after several hours on the road that it dawned on me that I also didn't have any of the merchandise.

However, now back in Brooklyn, I keep myself busy organising the show and that slowly lessened the feeling of disappointment about what happened in Atlanta.

Fortunately, I had paid my rent in advance, but after searching through the pockets of jackets and trousers hoping to find dollar bills and loose change I collected the sum total of $10. I didn't want to call home and ask for money from my parents, as I had got myself into this dire situation and it was up to me to get out of it. I was also embarrassed at not being able to feed myself properly, didn't want to admit failure and discovered that pride comes before hunger as well as a fall.

I was living day to day and trying to make the little money I had last as long as possible since I had a couple of weeks left before I had to fly back to Scotland. The highlight of my existence would be my daily meal of a cream cheese bagel washed down by a dollar can of Arizona Iced Tea, which on most days was all I had to eat and drink. Of course, sitting in the warm food hall in Target with my bagel watching the world go by The Junction was a welcome respite from my sad state of affairs.

For the same reasons I didn't ask my parents for help, I didn't want to tell Cass just how desperate my situation was. Although now, I would immediately accept any invitation he gave me to visit his or his mum's house, as I knew there would always be a plate of rice and chicken on offer.

As well as sitting in the crack den writing lyrics and meeting people who would be involved in the Pyramid Club show, I would spend hours riding on the subway with a Metro card I'd previously bought. I'd get off every few stations and listen to street performers on the platform, chat to them for a while and then get on the next train that pulled into the station. Sitting on the subway train as it rumbles its way from Brooklyn to Manhattan and back, I feel pathetic and embarrassed, as I'm wondering where my next meal is coming from and feeling afraid for what might happen to me.

But I have to keep myself busy and on the move so I can forget about the pangs of hunger stabbing through my stomach. The more I can think about other things, the less my brain is telling me to get something to eat.

Even though I was at my lowest ebb, I kept reminding myself that I was a fighter and that I shouldn't give up. It was almost as if I was punishing myself for getting into this sorry state.

I'd done this before to myself a few years previously when I was boxing. I'd gone into a fight, but hadn't trained and prepared properly. When I got into the ring, my opponent absolutely hammered me from the first bell. In between one of the early rounds I realised that I'd been arrogant and over-confident about beating this guy and I wasn't as tough after all.

When the bell went for the next round, I came out into the centre of the ring and really just let the guy hit me for the rest of the fight. I didn't get

knocked out, but there wasn't enough room on the judges' scorecard to mark all the points he'd won.

It wasn't just the money I'd shelled out for the Atlanta and Miami promotional tour that was getting me down. I was in a foreign country on my own and living in a crack den with hardly any money. I'd not only lost $1000, but I might also have lost the chance to make it in the music business.

I had a great track in Ballerina that people liked and it's only once in a very long while you create that little bit of magic and everything falls into place. I believe I would have been on my way to that success if the promotional tour in Atlanta and Miami had happened and I wondered if I'd ever get to that position again.

But while I'm still hungry in Brooklyn, with no money and having a cream cheese bagel a day to survive, feeling sorry for myself isn't going to be an option, as very soon a tragedy that puts everything into perspective strikes my good friend, Cass.

CHAPTER 11

TRAGEDY STRIKES

C ass holds the half-empty whisky bottle by the neck and makes a rattling noise as he drags it along the metal shutters that cover a shop's window and door.

It's only been a few hours since his five-month-old son, Nico, tragically died in hospital the day after Cass couldn't get the boy medically examined, when it was mistakenly thought he wasn't covered by health insurance.

I'm with Mayor and Karl, Cass's brother, walking alongside the distraught young dad, as we wander the streets aimlessly trying and failing miserably to console him after the devastating loss of his child. The sound of my good friend sobbing his heart out will haunt me forever. The world could have been coming to an end, but Cass is in such a state he wouldn't have noticed. His world had already ended with the death of his son.

I'd never felt so useless in my life. I'd hugged him – held him tight for longer than normal – but could only find the few platitudes to say that everyone utters in a situation like that. For someone who spends

so much time writing lyrics, even I couldn't find the right words that would ease the pain for Cass. Probably there aren't any right words to say and the best I could do was just be there with him and his family.

Earlier that morning, I had been out with Cass in his car and we were going over what tracks he would perform during his set at the Pyramid Club. He also told me what had happened the day before when he and his partner, Carmeline Paul, were worried about Nico and wanted him medically examined. They thought there was a problem with his breathing, as he was making a strange sound every time he took a breath.

I could tell Cass was angry and no wonder, when he told me what happened.

'We went to a place where we could get Nico examined, but they thought we didn't have proper health insurance for him,' he said. 'I kept telling them Nico was covered, but they said according to their records he wasn't. We had to leave and get in touch with the insurance company to get it sorted out.'

Cass was waiting to hear back from the insurance company and was heading home to see how Nico was. We agreed to meet up later that night at 7pm and Cass said he would pick me up in his car so we could head to Paradox's studio to rehearse some songs.

Seven o'clock comes and goes, but I'm not surprised because Cass has a reputation for always being late. He can be very frustrating – especially when you are standing outside an airport for an hour waiting for him to pick you up – but that's just the way he is.

By 9pm I start phoning and texting Cass trying to find out what has happened to him, but he doesn't get back to me. I phone Mayor as well, but I can't get a hold of him either. Eventually, after lots of calls and texts, I phone Karl and he answers his phone.

I had no idea what had happened and I was angry with Cass. There's being fashionably late to live up to your reputation and then there's being a pain-in-the-ass late. As far as I was concerned in that moment Cass was the latter.

As soon as Karl says hello I jump in: 'Where the f**k's Cass? You seen

that brother of yours? He should have picked me up hours ago.'

What Karl said next was like getting a punch in the stomach and it took my breath away. 'Cass is with me, just now. We're at the hospital and Nico is dead. We're all just about to head back to Cass's house.'

It takes quite a few seconds for my brain to process exactly what Karl has just told me. When it eventually did sink in, I didn't even think to ask what had happened and all I said to Karl was that I'd head straight over to Cass's. My first reaction was that I should be with my friend after hearing this awful news about his baby son.

When I got to Cass's home Karl tells me that Nico had been in his cot that afternoon and when someone had gone to check on him they realised he had stopped breathing. The boy was rushed to hospital where the staff there tried to resuscitate him, but by that time it was too late and the boy was gone.

Cass was in a desperate state, beside himself with grief and he wanted to get out of the house for a while. Mayor, Karl and I said we would go with him and we headed to a nearby liquor store where Cass bought a bottle of whisky. We walked around for a while swigging from the bottle and then we got in Cass's car and just drove around for a couple of hours.

By the time we got back to the house, lots more relatives had arrived and it was mentioned that some of them needed a place to sleep, as they had travelled a long way and were staying until Nico's funeral was held.

They needed somewhere to stay so I said they could have the room I was living in. I would have done anything to help Cass and his family in these tragic circumstances, so late that night I went back to the apartment and packed my belongings into a suitcase and a rucksack.

I called Paradox, told him what had happened to Nico and that I was moving out of the crack den. I didn't want to impose on Paradox by asking if I could stay at his house, as he was living with other members of his family and didn't have any spare beds. When he asked me if I had somewhere to stay that night I told him I had, but could he do me a favour by letting me leave my suitcase and bag at his place.

Paradox came to pick me up in his car and after dropping off my stuff at his house, I left and started walking the streets. I was bewildered by what had happened that day and it took me a while to get my head together and decide what I was going to do now that I was officially homeless.

It was about 2am and I headed for the Flatbush Avenue subway as fortunately, I still had a valid Metro Card that would let me ride the trains. It's October and although New York isn't exactly in the grip of winter, it can get more than a little parky to say the least. But down in the subway, either on a train or on a platform, you'll find an escape from the biting cold wind.

I rode the train to Manhattan and got off at 34th Street, and what I experienced in the next few hours took me from the depths of despair to a strange feeling of elation as I mixed with the poor homeless souls you don't see in the New York tourist brochures.

I don't want to go up onto the street in case I never get back onto the subway with my Metro Card, so I wander up and down the platform for a few minutes. A train pulls in and a few people get off and head for the stairs. But one guy, clutching an armful of A4 sheets of paper, hangs around the platform with obviously nowhere to go.

Just as I'm about to pass him he drops the papers on the ground and hurriedly bends down to gather them up again. I notice there's a hospital name on the headed notepaper, but as he stands back up I'm horrified to see that his trouser legs have either been cut or torn and there are large areas of his leg covered in what looked like a bad case of gangrene.

It was a sickening sight and when he sees me looking at his wounds, the guy tells me he's been discharged from hospital, as he can't afford the medical bills. He holds out the sheaf of papers inviting me to read them, but I shake my head with a murmur: 'No thanks, mate. You're alright – I believe you.'

I don't know if he was homeless, why his trousers were torn, or why he would be wandering around the subway at that time of night. But one thing's for sure – the guy was in dire need of medical treatment and he should have been in a hospital bed and not on a subway platform.

One look in his eyes and you can tell here is a broken man standing before me.

Seeing the state he was in made me think how lucky we are in the UK to have a National Health Service because someone in his position would always get the medical treatment he needed.

Not long after, I came across another man who wandered onto the platform whose life had dealt him the worst ever hand. He was wearing what was once a smart suit, which he no doubt wore with pride. But now the suit was crumpled and dirty. We got chatting and his story was harrowing to say the least.

He and his wife apparently had a good life in New York until she was struck down with cancer. He explains that after a long battle against the disease with radiotherapy and chemotherapy, his medical insurance wouldn't cover his wife's hospital bills any more and he used all his savings and took out loans to pay for further treatment in the hope it would save her life.

Sadly, the woman succumbed to the cancer and she died. Not only had this guy lost his wife to cancer, the disease had sucked all the money he had and he couldn't afford his mortgage, so he ended up living on the streets.

Once again, another person's tragic misfortune was a salutary lesson in how lucky I really was.

The subway station at 34th Street is well known as a haunt for street performers, no matter what time of day or night it is, and it wasn't long before I heard someone singing, another person slapping away on the bongo drums and a guy playing the bucket drums further up the platform.

These are plastic buckets turned upside down and you can get different sounds depending on where you hit the bottom of the base of the bucket with drumsticks.

I wander up the platform to be closer and I sit down on the platform stairs, listening to the bucket drummer for a while. We eventually start chatting about how he came to be playing paradiddles, flams and drags on plastic buckets in the middle of the night on the subway. It was

quite a sobering tale he had to tell and it took my mind off my own predicament.

He had been a successful professional musician making good money and living the rock 'n' roll lifestyle, which was to be his downfall. The drugs took hold of his life and he became addicted. The sorry downward spiral ended with him losing all of his band and session work and, not being able to afford the rent on his apartment, he became homeless.

Realising that the subway was now his home and workplace was a scary thought and it made me realise how different a world I was used to living in back home. The guy had been homeless for several months, barely making enough money to feed himself from the quarters and dollar bills people would give him for entertaining them with his drumming skills on plastic buckets. And after watching him rattle those sticks on the makeshift snares and tom-toms I was in no doubt he was a fine drummer.

After about half an hour talking to the bucket drummer, I had a strange sense that something special was happening to me. Instead of feeling sorry for myself, I had a weird sense that something magical was happening here and that what I had been going through in the last 24 hours was meant to happen. It would teach me how to overcome obstacles and deal with the difficult situations life throws at you.

Talking to the guy gave me strength, as when he was telling me his back story he never once complained and I thought that if he can survive, why should I complain when I've only been homeless and on the streets for just a few hours.

The subway is open and trains run 24 hours a day, so even at 3am there are quite a few people around. A couple of girls walk onto the platform to wait for a train and when they hear our bucket drummer playing, they start humming and singing along with him. They sound great and I join in rapping some off-the-cuff lyrics.

I feel elated that I'm part of this impromptu 34th Street subway concert and it's a snapshot in time I want to savour, as these few magical moments will never happen again.

When the train pulls into the platform, the two songbirds hop on

board leaving us with a smile, a wave and an amazing memory. It's not long after that the bucket drummer bids me farewell and departs saying: 'Nice talking to you, bro.'

The adrenalin has kept me going for hours, but tiredness is kicking in and I need to get some rest. I lay down on one of the benches that line the middle of the two platforms and very quickly fall asleep.

I only get a few hours rest when I'm abruptly woken by someone shaking my shoulders. I look up and there's a police officer hovering over me gruffly ordering me: 'Move on.' There were no questions asking what I was doing sleeping in the subway, or if I was OK. Just a simple instruction to get myself off the platform and pronto.

By this time, the subway is gearing up for the hordes of people going to work and I got the train back to Brooklyn and wandered around The Junction talking to people I knew. I went into the Ital Fusion takeaway restaurant and spoke to the guys behind the counter. I tell them about losing all my money, Cass's son dying and having to leave the apartment across the road from them. I wasn't looking for sympathy, but they knew I was in a predicament and guessed I was short of money since I hadn't ordered any food.

'You OK?' one of them asked.

'Yeah, I'm fine.'

'You had something to eat this morning?'

'No. I don't really feel like anything.'

I probably didn't look my best after spending the night on a subway platform and they saw through my bravado. Without another word, one of the guys spoons a huge portion of macaroni and cheese into a carton and hands it to me. 'This is on us,' he says.

'Thanks a lot. You've no idea how much I need this,' I reply.

Clutching the box full of much-needed sustenance, I head for my favourite bolthole – the Target store. I park myself at a table in the food hall and spend several hours in there eating the food and, bizarre as it may seem, watching YouTube motivational business videos on my phone.

It's a trait of mine that I want to be learning all the time. Even when I watch a movie, I'm always working out how the film was shot, how the plot develops and how the actors play their parts. Just because I was homeless, I wasn't going to change the habit of a lifetime and with some time on my hands, I was going to use it and increase my knowledge.

It's the evening of my first official day as a homeless person and I'm again wandering around the streets of Flatbush wondering where I'm going to sleep that night. Apart from subway platform benches being on the hard side, I didn't want to have the cops continually moving me on, which would draw attention to myself being in New York as a visitor on a visa waiver scheme with nowhere to stay.

An old girlfriend from a couple of years previously, Camira Martin, came into my mind and I thought I would chance my luck and give her a call. Since I had plenty of spare time on my hands I thought back to what had happened to me and what I'd achieved during my time in Brooklyn. I couldn't help but have a chuckle when I recalled how we had met and some of the high jinks we'd got up to going out on dates.

I had been genuinely looking for directions to the apartment where a rapper I had met in Fletch's studio lived, when I stopped Camira in the street and asked her how to get there. I was doing the lost puppy act and she said she would walk with me to the apartment as she was going that way.

While we were walking, we got chatting and I got her phone number. But before she carried on to where she was going, I asked if she fancied going out together and she agreed.

And what a date that turned out to be. We went into Manhattan and did the rounds of a few bars. We'd had quite a few vodkas that night and neither of us were feeling any pain. It's late, it's dark, and as we were strolling along the side of the East River I saw lots of small boats that tourists hire to go out onto the river being tied up to a pontoon. I asked the guy in charge of the boats if we could hire one, but he said they were closed for the night.

I whisper to Camira: 'We need to go out on one of these boats. Keep walking on and once he's gone, we'll double back.'

After about 20 minutes we pass the boats again and there's no sign of the guy. 'C'mon, let's untie one of the boats and we'll have a sail on the East River,' I said to Camira.

'Are you crazy? We can't do that.'

But she had hardly finished the sentence when I jumped into one of the boats and beckoned her to get in. She's giggling as I grab her hand and pull her into the boat. I quickly tug at the cord of the small outboard engine and it roars into life and we cast off.

We head out into the river and I'm doing a passible impersonation of Captain Jack Sparrow from the Pirates of the Caribbean movies. We're having a great time until, suddenly, shouts pierce the night air.

'What the f**k do you think you're doing?' howls the boat guy who has re-appeared. 'Get back here or I'm calling the cops.'

I'm still tipsy and think this is a hoot as I rev the engine to make the boat go faster along the shoreline trying to get away from the raging boat guy. I make matters worse by trying to be smart and frighten Camira by standing up and rocking the boat from side to side. Then there are two almighty splashes as we both fall out the boat and into the water. The outboard is still running and the boat shoots away from us.

Hitting the cold water immediately sobers me up and I shout to Camira: 'Swim for the shore! Swim for the shore!'

Luckily, the river was calm that night and we were quite close to the shore. Both of us made it to a jetty where some other boats were moored and we climbed up a ladder, out the water and onto dry land.

We are dripping wet as we run to the nearest subway station to get back to Brooklyn and away from the scene of our nautical crime. Looking back, it was one of, if not the most stupid jape I got up to in my time in America. There's no doubt we both could have drowned that night.

Camira and I were more than just friends. We were in a traditional boyfriend-girlfriend romance and at one point we even spoke about getting married. At the time, I still wanted to pursue a boxing career and fancied my chances entering the famous Golden Gloves tournament. However, without a resident's visa I couldn't enter and there was more

chance of me getting a visa if I was married to an American girl.

Camira and I had grown close and at the time we probably did love each other. But I fudged the question of whether I wanted to marry Camira, as I knew that even if I did, there would be no guarantee I would get a resident's visa.

I'd heard stories about immigration officials following couples who had got married to find out if their relationship was genuine. I'd no doubt that when it came to applying for the visa, both Camira and I would be put through the Guantanamo Bay detention camp version of the Mr and Mrs or The Newlywed game shows on television.

Although I certainly had strong feelings for Camira, I was still quite young and not sure what love was, where life was going to take me and if I was ready to settle down to a future with the white picket fence bordering the front garden. Those were the reasons from my perspective, but I also thought it wouldn't be fair on Camira to get her to buy into the lifestyle I was hoping to have – touring and performing all over the world.

It was only a few weeks until I was due to fly back to Scotland, so I stalled on telling Camira if I wanted to marry her and during the time I was back in Edinburgh, we drifted apart.

When I eventually returned to Brooklyn again, I did speak to Camira from time to time, but we never rekindled the relationship we once had. That was my fault, as I'm not great at keeping in touch and there would be long periods – in this case more than a month – when I wouldn't be in contact with her.

It was a big ask for me to turn up out the blue and ask to stay with her for a few nights and as I wandered around Flatbush, I wondered what kind of reception I'd get when I phoned Camira. Well, there was only one way to find out, so I dialled her number.

'Hi sweetheart. It's me, Stevie. How you doing?'

A few seconds of awkward silence.

'Sorry I've not been in touch, but you'll never believe what's happened to me. I've been in Atlanta and I lost all my money.'

'Mmm-hmm…' she says.

'So…I was wondering if I could come and see you.'

'Mmm-hmm…' I can almost feel the chilly blast of her wrath coming down the phone at me and I'm starting to get the impression this is Camira's phrase of the day.

But she relents and says: 'OK. I take it you still remember where I stay after all this time without a word from you?'

Ouch!

I walk to her apartment and knock on her door. She opens it and I spread my arms wide to give her a hug, but she just turns and heads into the lounge. I close the door and follow her in.

'How you been? What's been happening? I'm really sorry I've not been in touch.'

Well, talk about light the blue touch paper and stand well back as she launches a verbal volley at me.

'You don't call me. You don't text. You just vanish off the face of the earth and go ghost on me. Now, out of nowhere you turn up and say you want to see me. Why are you here? What do you really want?'

'I want to see you,' I reply.

'Bullshit! You're only here because you've nowhere else to go. I don't believe you.'

Now, I'm the worst person to have an argument with because I don't get emotional about it. The problem I have with that though, is when I don't get het up and shout back, the other person thinks I'm being a smart-arse.

And talk about adding fuel to the fire.

'I think we've established that I could maybe have done things differently,' I tell her. 'But, do you think we can move on from that? I admit it. You're right, but you don't have to keep telling me. I'm a smart cookie and I know what I'm like.'

That just encourages Camira to carry on having a go at me: 'You been

running around with someone else? You got side chicks?' she asks accusingly.

Trying and failing miserably to inject a bit of humour to diffuse the argument, I reply: 'Not really, I've only a couple of side chicks.'

Seeing that my attempt at humour went down as well as Will Smith turning up at a Chris Rock Appreciation Society Annual Dinner, I quickly put my hands up in surrender and said I was only kidding. In hindsight, it probably wasn't the cleverest thing to say to her.

I thought that I would have to calm her down, or else I'd be back sleeping in the subway.

'Look, I'm really sorry for not keeping in touch and I know I'm in the wrong here,' I tell her.

'I've had to move out of the apartment and I've nowhere to stay. Please, Camira. I slept on the subway last night and I've nowhere else to go. And anyway, I really do want to see you.'

I pause for a few seconds then tell her more of what's happened: 'You remember Cass? Well, his baby son died yesterday. Everybody's been in a terrible state and I left my apartment so some of his relatives can stay there until after the funeral.'

That news shocked her into calming down a little. I took my opportunity and played the sympathy card.

'I didn't really want to put this on you and I look and feel like shit. I've been kicking about the streets and have hardly had any sleep. I'm really embarrassed.'

The tide has turned and she replies: 'You're an idiot. Why didn't you just call or text me last night. You're so stubborn. You always have to do everything yourself.'

I grab both her arms and pull her towards me. 'You look so sexy when you're angry,' I tell her.

'You look a mess. If you're going to stay here tonight, you better get a shower.'

The next morning, I thanked her for letting me stay and said I would

try to find somewhere else to lay my head that night. Although Camira had relented and let me stay I wasn't quite sure I had been fully forgiven. I did, however, promise to keep in touch although I suspect Camira took that pledge with a lorry-load of salt.

That day, I went to see Paradox and told him what I'd been up to the past couple of nights. He said he'd make room for me in his home and I was to stay with him for the next two-and-a-half weeks before I was due to fly back to Scotland. He also weighed in with some money for me, so that when I wasn't eating in his house, I could gorge myself on the ubiquitous cream cheese bagel a day.

When I moved in to stay with Paradox I heard that Cass was struggling to come to terms with his son's death and that he might even be suicidal. He called me and very quickly I realised what I'd been told about his state of mind wasn't far from the truth.

For the past two days he'd been drinking heavily, aimlessly driving around the streets and was talking about 'dancing with the devil' and 'ending it all'.

I persuaded him to meet up with me that night and he came to pick me up in his car. He told me he'd written lots of song lyrics in the past couple of days and had recorded himself rapping them on his phone. I was shocked when he played them to me as they were like suicide notes that rhymed and I'd never heard him so angry.

He told me that they'd gone back to the place where Nico had initially been refused a medical examination and they admitted that a mistake had been made and the baby did have insurance cover after all.

As you can imagine, Cass was furious and he confronted the staff there. He told me that their reply was: 'Sorry, we made a mistake.'

We both cried as we sat in the car and when Cass started driving around Flatbush he tells me: 'I'm done with this life. Everything I was doing was for my son and now he's gone. What's the point of living anymore.'

I knew Cass was teetering on the brink, but I didn't really know what would pull him back from the black, black hole he was tumbling into. But I had to try something.

'You know there's no words I can say to make things different,' I said. 'And it's not like I can imagine what you're going through. I don't really know how you feel because something like this has never happened to me. But you've got to understand that there are lots of people who love you and they need you to be here. And you've a responsibility to keep Nico's memory alive and do him justice.'

There's a pause and I'm desperately thinking what else I can do or say. I thought the best thing I can do is give Cass something to focus on and get him to commit to. Although the Pyramid Club gig would be the last thing on his mind, I felt if I could get him to perform there, I would be giving him a direction and something to occupy his mind and replace the dark thoughts he was having.

I hesitated and was having a debate with myself whether I should mention it. Surely that would be the weirdest thing ever if I were to suggest he do the gig? But I could see he was close to giving up on life.

'I know this may seem a strange thing to say after what happened to Nico, but I need you to do the Pyramid Club,' I blurt out. 'We can make the show all about Nico. You can do it for your son and it will be in his memory. He gave you lots of memories and no one can take that away.'

Thankfully I seemed to have got through to Cass and he said he would perform at the Pyramid gig.

The next two weeks went by in a flash of phone calls, emails and posters promoting the show. But the gig almost never happened after a last-minute hitch with the venue.

I'm in a car with Mayor, Cass and Karl crossing the Brooklyn Bridge on the way to the Pyramid Club for the show when my phone goes. It's Chelsea Roach – who had been a great help organising the gig and handling ticket sales – and as soon as I answered, I could tell she's panicking about something.

'The manager says he's not letting anyone into the club until he gets paid the $300 he says you still owe him for the venue hire,' she says. 'And there's a big queue outside the club, but they're stopping people getting in.'

'Don't worry,' I reply. 'I'll sort it when I get there. We're not far away.'

The easy bit was saying I would get it sorted, but I didn't have 300 cents to my name, never mind $300. After having been quite excited and animated on the car journey from Brooklyn, I went quiet as I was thinking how I was going to persuade the manager to wait until after the show when he would get his money from the ticket sales.

The other guys noticed the change in my demeanour and they looked at each other. 'What's up, Stevie?' asks Mayor.

'Nothing to worry about. I'll sort it when we get to the Pyramid Club.'

I reckoned my best plan of attack was to get to the club and speak to the manager. I thought I would be able to use my abundant wit, charm and repartee to get him to agree to wait until after the show to get his money. But as I was soon to find out, I had run out of these talents by the time we got there.

I see there's a decent queue of people snaking round the side of the club waiting to be allowed in. We park across the street and I ask Cass, Mayor and Karl to wait in the car while I speak to the club manager.

Straight away I went into Stevie Creed bullshit mode, telling him how much money he is going to make at the bar tonight and that he'd definitely get his $300 after the show when I had collected all the ticket money.

'C'mon dude. Cut me some slack,' I tell him. 'I don't have the money just now, but you'll definitely get paid after the show.'

But my pleas fell on deaf ears. 'No, I want the money now,' he says. 'Just pay me my money then we'll let people in and you can start the show.'

I walk out of his basement office, head upstairs and out on to the street. The guys in the car are watching me as I walk towards them. As soon as I get in the car they know all is not well.

'What's wrong? What's the problem? And why's everybody queuing outside?'

'I'm f****d,' I tell them. 'The guy in the club says he's not letting anyone in until I pay him the $300 I still owe him. I don't have that kind of money just now. I was going to pay him after the show from the ticket

money. I don't know how I'm going find that kind of money. Looks like the gig is cancelled.'

I've got my head in my hands and Mayor goes into his pocket and pulls out a wad of money, nudges me and says: 'I got you, bro. Here's $300.'

As he hands me the money, I say to him: 'Are you serious? I can't take that from you.'

'Sure you can. We're family. If one of us is struggling, we're going to help him out. You'd do the same. So here, take it. I've always believed in you, Stevie. You're going to be great. Now move it and give these people waiting here a show they'll remember.'

I was blown away by this act of generosity and kindness and I'd gone from the depths of despair to ecstasy that the show would go ahead after all. Mayor told me he understood just how much I was struggling for money and he didn't want the money repaid. He's never mentioned the money he gave me since then, but I'll make sure that one day he'll get it back.

I had three hip hop support acts performing that night – Paradox, a group from East New York called 800 Foreign Side, and a rapper called Sly Cooper – along with an R&B singer, Kyron Dupont, and Krush was on the decks doing his DJ duties.

The place was almost full and there was a fantastic energy in the club during the show. Cass did a few tracks with me as a duet and he dedicated the night to Nico. I was so pumped with adrenalin I jumped into the crowd at one point in my performance.

There were even Bloods and Crips gang members there that night, but there was no sign of trouble between them. The Crips boys were there to support 800 Foreign Side and the Bloods were there to see other acts.

There's a guy from Brooklyn who calls himself Da Product DVD, who makes films of street gangs and their culture for his internet channel. He was at the show mainly to film 800 Foreign Side, but he ended up filming my performance as well. Then we went outside and I did a freestyle rap for him to film and later broadcast.

One of the 800 Foreign Side rappers performing in my show that night was Ether Da Connect, who has gone on to have an amazing solo career in hip hop with millions of music video views.

I was buzzing when the show was finished and I told Cass, Mayor and Karl I'd make my own way back to Brooklyn, as I had to stay behind to make sure everything was cleared up at the club.

After I left the club, I took some time out and treated myself to a luxury meal of a big Tuna Hero sandwich that cost all of $6 at a corner store and sat on a bench in East Village eating it.

As I ate the sandwich and watched the night owl people going back and forth, I went through a whole gamut of emotions. I was exhausted, I was hungry, but I was happy. Not just for me, but happy for the people who had supported me from the first time I stepped off a plane at Newark Airport and rocked up at The Galaxy Motel. The people from Brooklyn who had adopted me as one of their own had seen their faith in me repaid with my first headlining show in Manhattan.

I also took time to think about what I had achieved. I had created the songs and the music that people had come out to hear and they had enjoyed that night. I had lost all my savings in the Atlanta escapade, leaving me penniless and living on meagre rations. I was distraught when Nico died and then had to endure sleeping in a subway.

None of these things had stopped me achieving what I had set out to do. The help of people who'd been with me since day one had given me belief, encouragement, shelter, food and money. I wasn't rich and famous, nor was my face on a giant electronic billboard in Times Square, but the show that night was confirmation that I was on the right track.

The next day, people I'd meet in Flatbush were raving about the show and all they wanted to know was when and where the next one was being held.

I only had a few days left before I had to fly back to Scotland because my 90-day visa waiver was going to expire. The one regret I did have is that I wasn't going to be in Brooklyn for Nico's funeral. Apparently, Haitian funerals, especially when a child has died, take a long time to organise and by the time Nico was laid to rest, I was back in Scotland.

I might have returned home, but before I even stepped off the plane at Edinburgh Airport, I was planning how I would get enough money to return and shoot even more hip hop videos as The Brooklyn Scotsman. And ironically, it would be with a Black filmmaker in New York, whose white grandfather came from Scotland of all places.

CHAPTER 12

JUST ANOTHER STEVIE CREED SITUATION

There's only so much a man can take. Three topless beauties with an American flag painted across their boobs standing behind me and I'm supposed to ignore them?

The half-naked girls parading around Times Square, Manhattan are also wearing the skimpiest of bikini bottoms and as I'm sure you'll appreciate, this sight for sore eyes is bound to make anyone lose concentration – even though they're in the middle of shooting a hip hop video.

The guy filming me is getting as frustrated as I was, but for a different reason. And in my case it was three reasons. He can see that I'm more interested in the trio of semi-starkers girls jumping around, their ample bosoms bouncing in the faces of men now sporting a grin as wide as the Holland Tunnel.

These girls call themselves The Desnudas – desnuda is the Spanish word for naked – and they make their money from tips as they pose and pout having their photographs taken with tourists.

'Stevie! Focus on your moves. Concentrate on the music or we'll

never get this done,' says filmmaker Douglas Adam Ferguson, who is an extremely experienced movie and TV cameraman. He's patently not used to such amateur-night behaviour from someone who just can't take his eyes off these girls while the camera is rolling.

I try to put the image of the girls out my mind and concentrate on the dance moves for the track, My Throne, but their image is tattooed onto my brain. Douglas – or Doug as everyone calls him – has got the camera rolling and I decide that if I can't ignore them, I'll just have to join them. The track blares out and I start dancing closer to the girls, desperate to get them in the shot.

I'm jumping about in front of them and the girls look quizzically at each other wondering what on earth is going on. At one point, I even give them one of those exaggerated winks before I bust some more moves.

As far as I was concerned, it was a cheap way of getting some glamour in my video and perpetuating the tight-fisted Scotsman image, as I never even gave them a tip.

This was just part of the fandango that I had to go through to record a music video during my next visit to Brooklyn that began in March 2015. This time, my aim is to finish off the song My Throne that I'd started recording in Edinburgh, with my producer Sean The Don, and then get a video recorded for the track.

I was lucky enough that Steve Sola remembered he'd liked the previous song of mine he'd recorded, The More I Dream, and he agreed to complete the recording of my latest track.

I had the concept for the video that there would be five other rappers guesting on the track, and they would be filmed along with me in their own Brooklyn neighbourhoods – South Jamaica, Queens, also known as The Southside, the Marcy Projects in Bedford-Stuyvesant and Flatbush. The five were Cass, Ddot NuuWorld, Eddie Hizpanik, Black Suit and Slyy Cooper. I would mainly feature in the shots filmed in Manhattan and all of us would be vying for the song title accolade My Throne.

I came across, Doug on Craigslist when I was looking for a videographer and I emailed him the My Throne track. After I'd spoken to him on the phone, he bought into the song and video idea big time. I was very

animated on the phone and he was hooked on my enthusiasm. By the end of the conversation he was almost as hyped up as me and I was blown away by how much he liked the track and wanted to be involved.

Because I was so busy organising the final recording session for My Throne and then bringing all the rappers together for the video shoot, I didn't actually meet Doug until the first day of filming. However, we had lots of phone conversations before the shoot and bonded quickly. Doug is a few years older than me and he's become a really close friend and to this day, we've got a fantastic relationship.

It's a bizarre way of describing him, but Doug looks like a big Black Scottish guy at well over six foot tall, built like an armoured tank and hands like shovels. And so he should look like a Scotsman, as his grandfather, Samuel Ferguson, came with his parents to America from Edinburgh – ironically, the same city where I'm from – in 1932 when he was only four years old.

When he had grown up, grandad married a Black woman and their daughter, Patricia – Doug's mum – married a Black man and that's how we can go from a white Scotsman to a Black American living in Dyker Heights, Brooklyn in a couple of generations.

Doug loves talking about his ancestors and the fact they came from Scotland. When the Ferguson family emigrated from Scotland to America they decided to settle in a town called Ferguson, Missouri because they mistakenly thought that's where all the Fergusons stayed and the place was named after the family name. However, no one else with the Ferguson moniker was anywhere to be found as Samuel and his parents settled down to live among a big Black population.

Samuel engaged with the Black culture in his early years and became an accomplished Delta blues-style guitarist. In his late teens, he came to New York and tried to make a living as a musician. But the blues hadn't yet become popular with white people, and the sight of him playing the blues didn't quite cut the mustard for the Black population in places like Harlem, where Samuel would play.

He had to give up his dream of being a professional musician and ended up working as a debt collector for big stores like Macy's, and then as a truck driver for the notorious Harlem gangster, Bumpy Johnson. By

this time, Samuel's brother, Saul, had joined him in New York and he made a living collecting debts for the Mafia.

It's a great story and there must be great lyrics for a song in there somewhere!

Doug himself is big and muscular and he worked as a bouncer at the famous Tunnel nightclub in New York when he was a teenager. And his boss at the time was none other than Hollywood actor, Vin Diesel, who was the head of security at the club before he hit the big time in the movies.

He had a tough upbringing living in the Bronx and he would talk about how he would see dead bodies – people who had been gunned down or stabbed – lying in the street as he walked to school. But he's made a great career for himself as a filmmaker and I've nothing but admiration for his talents.

The first part of the My Throne video was being shot at the Marcy Projects on a Saturday morning and everything went to plan, apart from us running late, even though we'd only just completed the first scenes for the video.

Being known as The Brooklyn Scotsman, there was no way I was going to miss filming scenes for my music video at the New York Tartan Day Parade being held that same day, Saturday, April 11.

Everyone involved in the shoot and all the equipment was loaded into four cars as we headed from Brooklyn to Manhattan. The traffic was horrendous and I was getting more and more frustrated as the minutes ticked by and we were making very slow headway into the city. When we did eventually get there, it took ages to find a place to park and the Tartan Day Parade had long started making its way along Sixth Avenue.

When we do get a parking space, I jump out the car with Doug on my tail lugging his camera gear. When I get onto Sixth Avenue, the parade has almost passed and there are just a few pipe bands still to go by. I run along the sidewalk, which is packed with people, hoping to get the chance to somehow jump into the middle of the parade between a couple of bands, so Doug could film me.

There are still a few bands coming towards me, bringing up the rear of the parade. But between the crowds lining the sidewalk and New York's finest standing on duty every 100 yards or so, there's no chance I'm going to be able to invade the parade to be filmed rapping among the massed pipes and drums.

Time for a Plan B – find someone in a kilt with a set of bagpipes in his hands who's not marching down the middle of Sixth Avenue. I spot a piper with all the Highland gear on standing at the side of the road playing for the crowds. I nod to Doug to follow me and signal for him to get his camera rolling. I jump in front of this piper and start rapping and moving around the guy while he's still playing. I don't know if he was oblivious to me prancing around him, or if he liked the idea of being filmed with someone he must have thought was an absolute nutter, but the guy just kept playing.

When you're filming a music video you normally have the track blasting at you from speakers so you can lip sync. No such luxuries here. All I had was someone holding a mobile phone that was playing the My Throne track as close to me as possible without being in the shot.

With the pipes playing and the general noise of the crowd, I can hardly hear the track and I only manage to catch a few bars of the music. I have to count the beat in my head and remember the rhythm, as I try to keep in time. It was probably the most bizarre way ever of recording a music video. I wonder if Eminem, Jay Z, or Kanye West ever had to put up with this kind of shit!

After we got shots with the piper we ran ahead and tried to catch up with some of the bands at the back of the parade. I'd arranged for some teenagers from a dance school in New Jersey to meet up with me on Sixth Avenue, so they could be in the video as well, and I called their teacher on her mobile.

The dancers are waiting for me further down Sixth Avenue and when Doug, a few others helping out and I race past the parade to meet them, there were still some bands at the end of the parade coming towards us. I told the kids just to dance and do their stuff as close to the pipe bands as they could get and Doug would film them.

When I look back at the video, I'm amazed that it actually worked out

so well and after all my efforts in the midst of the madness, you could say I deserved to be top of the hit parade – albeit, the Tartan Day Parade.

But we weren't finished, and there was hardly time to draw breath before we were back in the cars heading to Southside Jamaica Queens for the next part of the shoot. On the way there, my phone was constantly ringing with people calling me to confirm arrangements for the other video shoots I'd organised later that day. But one call I got turned out to be really bizarre and ended with me being told there was a guy with a shotgun looking for me.

I had contacted goodness knows how many people to appear as dancers, or just to stand around looking cool, at the various locations that day and this woman comes on the phone and says:

'Hi Stevie. I'm just calling about the video shoot you're doing in Southside today. You spoke to me on the phone and I said I'd come along. Are you there yet?'

'We're not far away,' I reply. 'We've been filming in Manhattan and the traffic on the way over is horrendous. But we won't be long.'

'That's OK. I'm not there myself yet and I've got my kids with me in the car, but I wanted to make sure the shoot was going ahead.'

'It sure is. Thanks for agreeing to be in the video. That's really good of you.'

I don't have the chance to end the call when I hear the voice of an angry-sounding man butting in.

'What the f**k's going on? I don't believe this shit. This ain't no f****n' video shoot. You're conning us, 'cos this shit ain't happening.'

I could hear the woman in the background saying: 'Yes, it is. It is happening.'

The call ends abruptly and the others in the car who had heard bits of the conversation are asking what was going on. 'I've no idea what that was about. It's all a bit strange. The girl was really nice then this guy starts shouting at me,' I tell them.

Five minutes later the woman calls me back. 'Hi. That's us at the basketball court you told us to go to. Are you here yet?'

Once again Mr Angry grabs the phone. 'Yo, mother*****r – what's going on? You ain't no rapper. You're just a f****n' con artist, man.'

She gets the phone back and says: 'I'm sorry about that.'

By this time, I've got the phone on loudspeaker so everyone can hear this guy ranting and raving. And he didn't disappoint. We could hear him shouting at the woman: 'Who the f**k is this Stevie Creed? He ain't coming.'

Then he turns his ire on me. 'Yo man. I'm going to f**k you up big time. You said you're coming and you ain't here.'

Ddot is sitting in the car beside me and she shouts through the phone: 'Who the f**k is this talking like that?'

To which the guy replies: 'And who the f**k are you talking to me like that? Nobody talks to me like that, mother*****r,' before hanging up on me again.

It takes us another 20 minutes to get to the basketball court and there's a small group of people waiting for us to start filming. As we're getting out the car one of the guys in the court shouts: 'Hey, any of you Stevie Creed?'

Everyone turns to look at me and I reply: 'That'll be me then. What's the problem?'

'There was a guy in a do-rag with a shotgun and he says he's looking for you.'

'What?'

'Yeah, man. He looked pretty pissed and he says he was going to f****n' smoke you.'

'When was this and where is he now?' I ask, quickly scanning the basketball court and the surrounding streets in case I was going to have to hit the deck to avoid a hailstorm of buckshot peppering my ass.

And I breathe a sigh of relief when he says: 'He left five minutes ago.'

I can only assume it was the same guy in the car who had been shouting at me and he thought I was either a conman or I was trying to have my wicked way with his wife, or girlfriend.

After everything had calmed down we got on with the video shoot and thankfully there were no more interruptions from angry young men wanting to shoot me.

I'd never met the woman and had previously only spoken to her once on the phone to tell her about the video shoot. Ironically, later that night she messaged me and started hitting on me. Let's just say my phone was out of battery before I could reply.

After the Southside shoot, we piled into the cars again and headed for Krush's basement recording studio to do some filming, and then it was back to Manhattan to shoot some scenes outside a nightclub.

It was an amazing day and a baptism of fire for Doug as he got a taste of the rather eventful life of Stevie Creed. 'I've never been through a day like that before,' he tells me, as we were packing up after filming outside the Manhattan nightclub. 'Nothing's simple and straightforward with you, Stevie. You could have everything planned, but something is going to happen, or go wrong. I couldn't believe it when we turned up for a shoot and there's been a guy with a shotgun looking for you. What happened today was just another Stevie Creed situation. Someone needs to make a documentary about your life.' And how prophetic did that statement turn out to be?

I'm staying with Paradox during this trip to America, so my domestic arrangements are far more stable than previous times. And it was great to share the excitement of the release of my first album, The Brooklyn Scotsman, with my 'family' from the hood.

I wasn't sure if it was going to be released on the music streaming channels while I was in the States, or if I would be back home in Scotland, but it was rather apt that I'd be in the US when it did become available for download.

During this trip to America, I was spending a lot of time with the friend I'd told you about, Josh Valentin, who had come from a really hard background in East New York and had worked tirelessly to become a successful businessman.

At the time, he was involved with an enterprise called World Ventures, which offered discounted holidays through a membership scheme. He was making the long drive from New York to Kansas City and asked if I

wanted to join him on the road trip.

We were driving along when I started getting messages on my phone from people saying they had downloaded my Brooklyn Scotsman album. I was so elated I could have taken off and flown all the way to Kansas City.

There are 12 tracks on the album that had been recorded the previous year, either in Edinburgh or when I was in America, and I felt it was a culmination of everything I had experienced over the past five years.

It was as if everything had finally come together and I now not only had a body of work out there that people could hear, but also that I could tour and do shows with. I also hoped it would give me respect from my peers and other hip hop artists, as well as start to build a fan base far outside Brooklyn and Edinburgh where people already knew me.

I never thought I would make a lot of money from the album, as these days an artist doesn't make huge amounts from music streaming. The riches, if you're lucky enough, come from touring, merchandise and appearing on television shows and movies.

I felt proud because I knew people would be listening to my songs on their phones, at home or in their cars. Certainly, if you were anywhere within listening distance of Josh, he'd let you hear the album and tell you they were listening to the next big thing in hip hop. 'And by the way, this is Stevie Creed here with me,' he'd say.

Back in Brooklyn, the troops loved the album and I hope they felt part of it, because without them, the album would never have happened. But the biggest buzz I got was when I was standing at Flatbush Junction and someone walked by playing the My Throne track from the album on his phone. He didn't have headphones on, so he was playing the song through the phone's speaker.

Seeing a complete stranger listening to my song made me believe I was right to go through all the hassle and heartache of the past few years and I was producing music that people wanted to hear. I'm a firm believer that if you can sell ten donuts, you can sell 10,000 donuts because there is a market for your product. The difference when someone you don't know listens to your music is that they have taken a conscious decision to buy, stream or download your album instead of me pushing the songs and telling them they should listen.

I reckoned The Brooklyn Scotsman album let me tell the stories of my life both in Scotland and America. But there was one song on the album that seemed to have caught a lot of people's imagination and got me the most feedback. That track was Traffic Life and it dealt with darker issues of alcohol and drug abuse rather than the more light and upbeat songs, like Ballerina and Feeling Alive.

I had recorded a video for the song the last time I was home in Edinburgh and much of it was filmed in the Moredun housing scheme where its residents have seen their fair share of poverty, violence, drink and drug addiction.

The song is about a young boy whose mother is addicted to drugs and his father is an alcoholic and like many teenagers being brought up in these circumstances, the lad falls into – or can't escape – the same traps that destroyed his parents.

Traffic Life is an observation that life is like watching traffic go round and round seeing the same cars and that's what the boy in the song represents. I've seen the same tragic life stories happening time and time again and seemingly not a lot being done to break that cycle of poverty, deprivation and addiction. It's like an unintended legacy of hopelessness passed on from parent to child.

I was sent a private message on Facebook by a guy from New Jersey who had been homeless and was having a hard time with mental health issues. Just like the boy in the song, his parents had addiction problems and he was in a bad place, admitting to me that he had 'reached such a dark place in my life and I was thinking about ending it all'. But after listening to Traffic Life and seeing the video, it made him realise he wasn't alone and not the only person in the world who was suffering mental health issues and it was OK to feel like he was. The song had helped him deal with his problems and he abandoned all thoughts of suicide.

The guy had written a lengthy message about the issues he was facing and it hit home to me that music and lyrics can have a deeper effect than just the casual enjoyment of listening to a few banging tunes.

Traffic Life also caused a stir with my old boxing coach, Brad Welsh back home in Edinburgh. I hadn't heard from him for ages and surprisingly,

he had no idea I was a rap artist, thinking I was still going over to the States to train as a boxer.

Brad grew up on the Moredun housing scheme where the video for Traffic Life was shot and when he saw the video online, not only was he gobsmacked to see his old stomping ground featuring in a hip hop video, he was shocked to discover the teenage boxer he trained and mentored was the writer and rapper on the track. That revelation made him get back in touch with me while I was in America, we rekindled our friendship and he helped me organise shows in Edinburgh after that.

But back in Brooklyn, being able to record in Fletch's basement studio several times a week was a great learning experience for me as I was still honing my craft. Despite spending lots of his own time with me in the studio, Fletch never charged me a cent. If he had been charging me I would owe him thousands of dollars. Thanks to Fletch, I've got many hours experience of working in a studio and that has been invaluable.

I was writing lyrics all day long, creating lots of new songs and I needed somewhere to record them. Fletch knew a lot about the music industry and he helped me decide who I was as an artist and develop my own hip hop character and sound.

I will always appreciate what Fletch did for me and I've often wondered why he spent so much time on me in such a selfless way. He always said he believed in me and thought I would make it big in the music business, although he never once hinted about him being involved or getting some payback if I ever did. I also think he respected me for having the courage to come all the way from Scotland to Brooklyn to live on my own when I was still a teenager.

Fletch also taught me some good lessons about surviving in the hood and what life is like for people living there. He was involved in a bizarre incident when police arrested him and he spent the weekend locked up in a police cell for opening his garden gate and walking up the path to his own house.

I had been due to record in Fletch's studio when earlier in the day I met Mayor, who told me Fletch had been arrested and was being kept in police custody. I couldn't believe it as Fletch is like a choirboy compared

to some of the other guys in the hood and had never been in trouble with the law before.

When I meet up with Fletch the following week I get the full story from him. 'I heard you got arrested. What happened?' I ask him.

'I was just opening my gate to my house last Friday when the cops thought I was breaking in, so they arrested me. They wouldn't believe me when I said I lived there and before I knew it, I was in a cell in the police precinct. I didn't get out until Monday.'

'That's crazy. You going to sue them for wrongful arrest?'

'No man, I'll not be suing anyone. I don't have the money for lawyers to do that.'

Fletch's wife had gone to the precinct that night, but it appeared no one seemed too bothered that an innocent man was being held in a police cell.

'By the time they got the paperwork sorted out and realised I was only going into my own house, it was Monday and they let me go,' Fletch explains. Adding: 'That's just the way it is in the hood. Not worth complaining about and I don't want more trouble coming to my door.'

However, I later found out that Fletch did get some compensation for his wrongful arrest.

Releasing The Brooklyn Scotsman album brought me to the attention of record companies in America and I spoke to several people from different labels. But I was always left asking myself the same question – what can they do for me that I can't do for myself?

Up till then I had written songs, produced and recorded an album, released and promoted my music, organised video shoots, created a website and performed in live shows. I had built up a network of people throughout New York that I trusted and who believed in what I was trying to achieve. These people were willing and very able to help me achieve all these things.

I wasn't sure if signing with a record label at this stage in my career was the right thing, as I had got to where I was under my own steam. Why should I sign away a large chunk of my future earnings to a record

company who would only do what I'd already been doing myself? It was the right decision at the time and I was able to have full creative control of my music.

By the summer of 2015 I was back in Scotland to keep on the right side of American immigration law, as my 90-day visa waiver period had come and gone. I got a job working in a Slater Menswear store in Edinburgh, to build up my cash reserves. But I wasn't going to let the musical grass grow under my feet, and I hatched a plan to promote a major gig in my hometown with me headlining and performing with a live band, which I'd never done before.

Never one to do things by half, I hired one of the biggest club venues in Edinburgh, the Liquid Rooms, which holds around 850 people. Some of my friends thought I was crazy and told me: 'We know you're good, Stevie. But you know what Edinburgh folk are like. They're not going to pay money for tickets and come out to a gig unless it's someone really famous.' Talk about never being a prophet in your own hometown.

But I wasn't to be deterred even though I was risking a lot of my own money. I was paying £1000 for the venue hire and would have to raise another £500 for rehearsal space along with posters and flyers advertising the gig. Every week a big part of my wage from Slater's would go towards financing the show, called Stevie Creed – The Brooklyn Scotsman Homecoming Concert.

I had the venue and I had the plan on how I would promote the show, now all I needed was to find other artists to perform on the night and recruit a live band to back me in my headline spot.

I was seeing a girl at the time, a singer called Kaya Oledzka, who had come to Scotland from Poland to study at the Academy of Music and Sound, in Edinburgh. She said she would help me put together a band from students she knew at the Academy. First, she got me a drummer, then guitarist and a keyboard player. I was almost there, but I still needed a bass player and you can't have a rapper without a bassist.

I was on the lookout for support acts when I came across a band called The Fed Peasants, who were a slightly left-field pagan folk group. They were certainly different from what I had been used to, but I thought I'd put them on the bill just for the Hell of it.

When I went to a flat they were all staying in to meet them, I was giving them the Stevie Creed spiel about the show being the biggest and best hip hop gig Scotland's ever seen. I also gave them a bundle of tickets to sell and told them they could keep the proceeds if they agreed to play that night.

But it wasn't just a band I was getting that day, as I took a shine to their bass player who looked like a 70s Bohemian with flowery-patterned shirt, massive collar, bow tie, Zapata moustache and hair down to his shoulders. His name was Oliver Sentence and as it transpired, he was pretty good on the bass to boot. So much so, he's still the bass player I use anytime I need a band.

It's only five days until the show on Thursday, November 19 and I was starting to get a bit concerned about not having a bassist for my backing band. Hip hop is made on drums, bass and keyboards and not having a bassist on the night would be nuts.

While I was being introduced to The Fed Peasants band, I mentioned I was looking for a bass player and your man pipes up: 'I'm the bass player and I'm not doing much right now.'

'You fancy doing the show?' I ask him.

'Yeah, sure.'

'That's great. But you know you've only got five days to learn the material.'

Give the boy his due he did just that.

In the run-up to the show I was using every trick in the book to sell as many tickets as I could. I'd visit dozens of pubs and tape posters promoting the gig to the walls above the urinals. Everywhere I went I would tell people about the show and I always had a bundle of tickets I could make appear from my inside pocket as if by magic if they showed even a scintilla of interest in going.

When I was working at Slater's and I'd sold someone a suit, I'd always work the show into the conversation and hand them a flyer along with their new outfit as they walked down the stairs. My final words to the customer would always be: 'And how many tickets would you like?'

In hindsight this was a bit naughty, but I'd deliberately turn up at other band's gigs and before they'd even started playing, I'd be going round the tables shaking people's hands and giving it: 'Hi, how are you?'

'Who the f**k are you?'

'I'm Stevie Creed. The Brooklyn Scotsman.'

'Aye, so what?'

'Listen man, I've got a great show coming up at the Liquid Rooms. It's going to be an amazing night. Here's a flyer…oh even better, here's a couple of tickets. Only a tenner each – you want them?'

The Liquid Rooms is one of the best-known club venues in Edinburgh and it was Brad Welsh who suggested it for my homecoming show. I've no doubt the phone call he made to the bosses there smoothed the way for them agreeing to hire the venue to me. Brad also organised the show's after-party in the city's Opal Lounge – another well-known haunt of all the beautiful people – with no charge for the venue and lots of free drink thrown in for good measure.

By the time I'd pulled together the acts for the night, I reckoned everyone would be getting a good night's entertainment for their tenner. I had well-known Edinburgh rappers Immy Perez and Madhat McGore performing sets, an indie rock band called Wonderboy and our pagan folkies, The Fed Peasants. I also had DJ Pryzmat, who was well known on the circuit, doing his stuff on the decks in between acts.

And since there's no show without Punch, I topped the bill with my new live band with Kaya and Lianna Hamilton on backing vocals. I also invited singer, Marie Gould, to join me on stage for the Traffic Life song.

I also had dancers on stage with me after I'd met one of the top dance teachers in Edinburgh, Ashley Jack, and persuaded her to do the choreography and bring along some of her top pupils on the night.

Our rehearsals had gone very well and the band was pretty tight by the time the gig came around. But on the day of the first rehearsal I had to pull off a real con job with all these musicians. I had brought them together, it was my show and, quite rightly, they're standing there with their instruments looking at me as if to say: 'Right, Stevie. What you want us to play?'

I had never worked with a live band before. I'd been thrown out of music class at school and now these people, who have been playing for years and are studying for music degrees, are expecting me to tell them what to play. At first, I hadn't a clue what I was doing, but I got a kick from the challenge of having to lead these musicians. I busked it big time and got by because even though I might not know every chord or sequence they're playing, I know what sounds right and I know how to perform my stuff on stage. While I was in America, I learned how to motivate people and to lead them to where I want to go.

I'd been so caught up trying to fill the Liquid Rooms. I was frantically trying to sell tickets and was giving other people bundles of tickets they could sell for me. Every performer was given tickets to sell to their fans with the promise they could keep the money for the first 20 they sold. All I wanted to do was break even, but I didn't have a clue how many tickets had been sold and what the crowd would be like on the night.

But even with all this going on I was having an amazing time. There was lots of energy from everyone involved in the show, I had a new girlfriend in Kaya and seeing everything come together made me feel invincible.

On the day of the show I was late for the sound check, as Kaya and I were in bed having a long and detailed dialectic about whether a chorus in one of my songs should have an E minor chord in it. Well, believe that if you like…

We were using the Liquid Rooms' own PA and light systems along with their technicians for the show and when I eventually got to the club these guys were not very happy bunnies. They thought I'd simply be singing to backing tracks and no one had told them there were other acts on the bill, each with their own instruments and needing their own PA set up on stage. They were going to have a busy old night.

It's the usual Stevie Creed situation, as Doug would say. I'm going at 100 miles an hour organising the band, the support acts and placating the club's sound engineers, who are threatening to walk out, according to the manager in charge of the club that night. I manage to calm everyone down, which I thought was pretty good going for someone who hadn't a clue about the technical specs needed by a sound engineer for a gig.

There are two screens either side of the stage that would show the

artists performing but, at the last minute, we realise that instead of two projectors hanging from the ceiling there is only one. This means we could only project onto one of the screens.

Not to be outdone by such trivial hindrances, my good friend Ash Arya, who was helping me out on the night operating the laptop that sent the visual signals to the projectors, leapt into action. Well, he jumped on top of a table, and started tying a film projector he had brought with him in case of such emergencies to a pole that led up to the club's balcony area.

Ash is balancing on his tiptoes on top of the table as he wraps electric cable round and round the pole and the projector, holding it in place so we could have a display of the concert on the second screen.

I'd obviously forgotten to hire a health and safety advisor that night because while Ash is doing his mountaineering act, the club's lighting guy runs over and shouts: 'What the f**k are you doing? If the projector comes off that pole it could kill someone and that someone could be you because you'll be sitting underneath it.'

'It's not going anywhere. We'll be fine,' Ash replies, and the lighting technician turns and walks away shaking his head.

The gig was due to start at 7pm and go on till 10pm and, amazingly, we had everything organised for the start of the show. I'm backstage in the Green Room when the first support act, Wonderboy, goes on. When they come back in, I ask them: 'Is there anyone out there?'

'It's OK actually. The place is starting to fill up,' they tell me.

I ask the same question when the Fed Peasants finish their set and come backstage. 'It's getting really busy out there,' they report.

Before the third act goes on, I come out of the Green Room and go backstage. Although I can't see out front, I can hear a welcome hubbub of noise building and I know then that I've managed to pull a good crowd.

I'm buzzing, especially as people in the Edinburgh music scene who had been saying I'd never fill the place were coming into the Green Room to congratulate me. I could feel a great vibe coming through from the almost sell-out crowd to backstage and I was pumped up like never before for my performance.

I'm wearing the kilt, a sleeveless white shirt and a Brooklyn Scotsman hoodie when I bound on stage and I'm immediately hit by a feeling of euphoria. All I can see is a sea of faces in the first few rows and a mass of bodies behind them. The place is packed.

I'd done everything else to get us here and now I just wanted to put on a great show for the people who had come to see me. After I got to the mic, I thanked everyone for coming, took off my hoodie and threw it into the crowd before launching into the first song.

The show seemed go by like a flash, but it was a fantastic experience that will stay with me forever. It wasn't just the fact I was performing in front of a big crowd that made me feel so good about it. It's because I was headlining, all these people had come out after seeing my name on a flyer or poster and I had taken a huge risk that had paid off. Later on, I would reflect on the other skills I had to learn in double-quick time – putting together the acts, promoting the gig, working out the logistics and having to hustle, hustle, hustle to sell tickets.

After the gig, everyone headed for the Opal Lounge for a celebratory drink or five. The next day my back was really sore with all the people who had been slapping it to congratulate me on the show.

I was so hyped with the success of that Liquid Rooms gig I did another one there a few months later, on April 23, 2016. To be honest, although there was a decent crowd in, the show, called Stevie Creed – Seduction was a bit of an anti-climax for me.

I wasn't in a good place personally, as I was having a rollercoaster relationship with Kaya, who was still in the band, and when it came to the performance, I had a bad throat infection and felt really ill going on stage. I gave it my best shot, but I knew I didn't get the same positive vibe that night as I did from the first gig.

But as they say, the show goes on and I was soon planning and saving money for another trip to America, another gig in Brooklyn and recording a new album with Doug, the would-be Scotsman.

CHAPTER 13

GET BACK IN
THE HOLE

I'm just realising that Douglas Adam Ferguson would have made an excellent drill sergeant. Not for the first time since I've been staying with him on this next trip to America, Doug's giving me a severe dressing down. He's telling me in no uncertain terms that I should buck up my ideas, or any dreams I have of making it in the music business would become nothing but wishful thinking on my part. And the big chap doesn't mince his words either, as he reads me the Riot Act.

'You need to get your shit together,' he says. 'You want to spend the rest of your life working in a menswear store measuring chests, waists and inside legs? Or do you want to make something of your music?'

He doesn't let up and goes on: 'You're not focussed on anything. You're not writing songs, you're not recording – in fact, you're doing the square root of f**k-all with your life just now. If you want to be a success in music, it's going to take a lot of work on your part and I don't see much graft going on from where I'm standing.'

And you know what – he was spot on.

I'd returned to the States in May 2016 with the idea of putting on a

show in Brooklyn with a live band, which was something I'd never done in America. I'd enjoyed performing with a band in the two Liquid Room shows and thought I could recreate that same vibe when I was in New York. There was also a very loose suggestion that I could record another album while I was there this time around.

Although nothing was set in stone about recording the album, my producer in Scotland, Immy Perez, came to New York a few days earlier than me for a holiday and was also staying with Doug. But just in case there was work to be done on this new album, he'd brought some of his recording equipment with him.

I hadn't written any lyrics for months, as I was concentrating on organising the Liquid Rooms shows, and by the time I'd got to America my mind was in a very low, dark and uninspired place. My relationship with Kaya was disintegrating, and not in a very nice way, with accusations of people being used and recriminations flying around before I left for America.

Looking back, it was a case of no matter how much I loved her and didn't want her to be with anyone else, we weren't right for each other. Sometimes you just have to let someone go if it's not going to work out in the long-term and get on with the rest of your life.

I just wasn't in a good place and my life seemed to have taken a wrong turn and was heading up a blind and very dark alley.

A couple of months before I'd come to New York, Doug flew over to Scotland for the second Liquid Rooms gig. Even then he noticed something had gone awry with me. 'There's something not right with you,' he told me one night during his trip to Edinburgh. 'You're not the Stevie I met back in New York and you're distracted. You're definitely not in a happy place just now.'

I knew everything he was saying was true, but I was so down, I never really listened to him.

I reckon he was hoping that a change of scenery and being back in the hood with the Brooklyn crew would shake me out of my lethargy and drag me out of the rut I was in. But when I got to America and he realised I hadn't written any new material, I knew he was disappointed in me. It was time for the shock treatment to get me back on track and Doug was the man to send a few thousand volts through my body and spark me back into action.

The sleeping arrangements didn't exactly help when I arrived at Doug's two-bedroom apartment. Immy had already commandeered a blow-up mattress that was in the second bedroom and I was to sleep on a tiny two-seater couch that was also in the room. Even calling it a two-seater was a bit of a stretch.

'Look at the size of that couch,' I moan. 'Where the f**k am I going to put my legs? It's way too small for me to sleep on.'

Doug and Immy are in hysterics at the thought of me trying to sleep with my legs dangling over the end of the couch.

'I've got the solution,' Doug says, with the flourish of someone who's just unlocked the mysteries of quantum physics. And he proceeds to pull a chair over and place it at the end of the couch. 'There you go – sorted,' he says and the pair of them burst into howls of laughter again.

I'd be out and about with Doug and Immy and they'd be laughing and joking, even poking fun at me, trying to get a reaction, but I wasn't in the mood for joining in the banter. I'd a face like a Hallowe'en cake left out in the rain.

Doug had obviously decided that enough was enough and the quicker I got back into the rhythm of writing and recording new material the better I was going to feel about myself. He also recognised there was a danger of me losing all the momentum I had built up if I didn't get some new material out there for people to hear.

'Tomorrow, Stevie boy, we're starting this new album of yours,' Doug announces. 'So sharpen your pencil, 'cos you've got a lot of lyrics to write.'

The next day Immy sets up his gear in Doug's living room and all three of us listen to beats and instrumentals and suggest different song titles, or experiences I had gone through that I should write about.

Doug's rallying call to me was: 'There are lots of people who can rap or string words together in fancy ways. But you're different and better than them because even though you're still young, you've lived a remarkable life so far and had some amazing experiences that no one else has had. You're a storyteller, so go and tell your stories in the lyrics to your songs, because only you can do that.'

It wasn't long before we had a list of potential song titles and ideas that

told the stories of what I'd been through. The titles that jumped out at me and were the first I worked on were Galaxy Motel, East New York and Young Lion. After all that had happened to me in the past few years, I wasn't short of material to write about.

The next stage in the writing was a tad draconian. Doug banished me to the bedroom with my laptop and told me not to come out until either I'd finished the first song, or I was dying of dehydration or malnutrition. Although I suspect the food and water bit was an afterthought.

It was the best medicine to get rid of my melancholy and lethargy because once I get in the creative zone I just keep writing and writing for hours on end. I could hear Doug and Immy laughing and carrying on in the living room, but that didn't bother me and I could feel the big, black clouds slowly disappear from inside my head.

Doug called my bedroom 'the hole' and any time I'd come out, he'd be shouting at me: 'Back into your hole, Stevie. Back to the hole!' and the pair of them would be laughing like hyenas.

When I'd finish a song, I'd come out and play them a backing track with me rapping the lyrics. But Doug was a hard taskmaster and he'd say things like: 'First verse is good. Second verse is so-so, but the third verse really sucks. Back to your hole. You know you can do better.'

When that happened, I'd be raging and have a right tirrivee as I stomped back into the bedroom muttering: 'Basturts! They'd never be able to take that kind of criticism of anything they did.'

But I'd calm down and realise being so harsh on me was for my own good and Doug was only trying to get the best out of me.

My life in lyrical lockdown goes on for almost two weeks with my only release being to record the finished songs in the living room. It was tough going as the heat in New York that summer was horrendous and, stuck in that bedroom writing lyric after lyric, it felt as if I was melting.

My night times were just as big a nightmare as I hardly got a full night's sleep with the foghorn sound of Immy snoring. He's the loudest snorer I've ever come across and not even putting rolled up paper tissues in my ears or wearing noise-cancelling headphones could block out the sound. And the worst thing is, for a rapper and music producer, Immy can't even snore in tune.

As time went on, tensions started running high between all three of us as we remained in Doug's apartment and hardly ventured outside. There was one particular blow-up between Doug and Immy when they had a disagreement about some vocals on a track that ended with Doug storming out the apartment.

With the song Young Lion, Doug suggested we should get an actor and singer he knew from Philadelphia, Dwayne Alistair, to sing the chorus. We emailed the song's backing track to him, so he could load it onto his computer with the same recording software we were using. He was then able to add his vocals to the track before sending it back to us for Immy to do the final mix.

When the track with Dwayne's vocals arrived a few days later, the three of us sat and listened to his vocals on the chorus and realised he had changed the melody slightly. But Doug's giving it: 'Yeah, man. Dwayne's put some real soul on there. That's really good. What you think, Immy?'

Immy leans back in his chair, strokes his chin and says: 'Afraid it doesn't do it for me. I hate it.'

Doug huffs as he bounces out his chair in a rage and slams the door on his way out of the apartment. Perhaps Immy was a bit harsh in his criticism because there's no denying Dwayne can sing, and even when you hear him speaking on TV and films you can tell he's got a deep timbre that makes for a very listenable voice.

When it came to me doing the vocals for the Galaxy Motel track, I wasn't nailing the vocals properly. The song has very sexual lyrics and I couldn't quite create the sultry, smooth, laid-back vibe we were looking for. But after quite a few takes that were all for the delete button, Immy comes up with a novel idea to get me in the right mood – he plays a porn film on his phone and holds it up in front of me to see while I'm singing the track. I nailed it in the next take.

We managed to get the basis of eight songs recorded before Immy had to head back to Scotland, and I stayed on to organise a live gig I had always planned to do. However, my home comforts when it came to sleeping arrangements were still something to be desired.

I had been looking forward to sleeping on the blow-up bed once Immy had gone back home. But only hours before he was due to head for the

airport, he was carrying on and dived onto the airbed causing a loud bang as he burst it. My hopes of a good night's sleep on a comfortable mattress were deflating as quickly as the air out of the blow-up bed. The tear in the bed was so big it couldn't be repaired, so it was back to the Barbie and Ken-size couch with a chair extension for my legs.

However, after my tough love fortnight from Doug, I was back to a bit of form and raring to go with the live gig.

Doug had introduced me to a rapper turned music promoter, Chris Carr, who runs the annual Brooklyn Wildlife Summer Festival, which goes on for a week in August. Chris agreed to put on a gig with me headlining at a venue called The Paper Box, which is a music complex for concerts, rehearsal space and a recording studio.

Now it's down to organising the show and as per usual, I just throw myself wholeheartedly into the project. The next thing after finding someone to promote me is putting a band together. Cue scouring Craigslist for musicians looking for work, the Facebook pages of local bands, calling people I had previously been introduced to and generally hustling for contacts in the local music scene. I first recruited a drummer, then a keyboard player and a bassist.

I also got back in touch with Monet, who agreed to do backing vocals along with another girl singer I'd met called Summer Malia. Dwayne also agreed to make the 200-mile round trip to sing on the Young Lion song, and that gave me an extra jag of enthusiasm that he was willing to do that.

I managed to persuade the musicians making up the band to perform for free. I was very honest and upfront with them saying I didn't have any money to pay them, but they would benefit from the experience and exposure. I didn't promise them jam tomorrow, but I did say that I would return the favour sometime in the future – and I'll certainly do that.

The Paper Box gig was called Saturnalia, which is the name of the ancient Roman festival in honour of their mythical God, Saturn. Back in the day, Saturnalia was a time of general fun and merriment for the toga-clad Romans and that's what we recreated at The Paper Box, on Friday, June 24, 2016.

It was a packed show and, apart from myself headlining, the support

acts were Paradox, Raze, DJ Dr Hollywood, Parnitash and Coe, Synapsie, Mike Wray, Merk, Julian Anthony, Dwayne Alistair and the promoter himself, Chris Carr, also did a set.

I really enjoyed the show as people like my old boxing trainer, Tyrone, came along, as did many people like Cass, Mayor and Chelsea who had supported me so much over the years. It was almost like a Stevie Creed old pals' reunion and, of course, I did the gig resplendent in the kilt, which had now become the de rigueur Brooklyn Scotsman outfit.

Gigs in New York have a different vibe to what you get from the audience in Scotland. When I did the Liquid Rooms, people were jumping about the venue, but in Brooklyn the audience nod their head to the beat, listen closely to your lyrics, absorbing every word. The audience act in a different way to your music, but it is also satisfying to know that people are actually listening to the words.

I was happy with my performance and how my music had got a good reaction from the crowd. I had just come off stage when a total stranger came up to me and said: 'That was amazing. When I heard you were a Scottish rapper I thought you'd be a gimmick, but you're the real deal, man.'

And the guy who ran the Paper Box, who was also a big muso, was also very complimentary. 'You rock, Stevie,' he says. 'That was a damn good show you put on there.'

During this trip, Doug also filmed a music video for me using a live version of a song I'd written, called One Shot, that had been recorded during one of the Liquid Rooms shows. Part of the video was shot in a well-known boxing gym started by now-retired NYPD cop, Pat Russo, and supported by famous boxing trainer, Teddy Atlas. The gym is called the Atlas Cops and Kids gym, in Flatbush, and as well as providing some serious training for boxers, there is a big emphasis on getting youngsters off the streets, keeping them out of trouble and into boxing as a sport they can enjoy.

I would loved to have filmed the video in the Starrett City Boxing Club, but by this time the gym had closed and many of the boxers and trainers, including Tyrone Venning, had moved to the Cops and Kids place.

I was also filmed doing roadwork, running through the streets of the

Vanderveer Projects – now known as Flatbush Gardens – and around Coney Island. And it was a real shock to the system when I had to pound the pavements, jogging and sprinting around the streets.

Doug had suggested I might want to put in some training sessions to get in shape before the video was filmed. I told him that wasn't necessary since I was still as fit as I used to be when I was regularly in the ring. I soon found out how wrong I was.

It was only a few minutes after he shouted 'Action!' and I started running at full pelt round the Vanderveer Projects, that I could feel a burning in my chest and I started panting instead of lip-syncing the lyrics to the song. I very quickly realised I wasn't as fit as I thought I was and I was nowhere near enough in shape for boxing and the training that goes with the sport. Thankfully, I had just enough in the tank to get away with the running scenes for the camera, but I was a million miles away from being fit enough to be a boxer.

Since I'd heard Tyrone had moved to the Cops and Kids Gym, I hoped he would be able to smooth the way for me to use the place to film part of the music video. Time for me to pay him a surprise visit.

I walk into the gym and it feels like I'm a prodigal son returning home with the same sights, sounds and smells I'd always known when I was boxing. I take a few minutes to look around, but nobody seems to notice I'm there and all the boxers and trainers carry on with their workouts.

I can't see Tyrone anywhere, so I say to the first guy I come across as I walk into the heart of the gym: 'I'm looking for a big Black guy with a beard and he's called Tyrone. You seen him?'

The guy looks me up and down before turning to the assembled posse of pugilists and shouting in almost a scornful way: 'Listen up guys. We got a white boy here asking for a Black guy called Tyrone.'

Everyone bursts out laughing and I suddenly realise there must be a Black man called Tyrone on every street corner in Brooklyn.

I look sheepish as I introduce myself and he coldly explains he's a boxing trainer at the gym and he's called Aureliano Sosa. I immediately recognise his name, as he's a former professional fighter and is one of the top boxing trainers in Brooklyn. He tells me Tyrone is due in later and if

I want, I can wait for him to arrive.

It isn't the friendliest welcome I've ever had, but I try to engage Aureliano in conversation. He quickly warms to me when I tell him about my boxing career as a teenager and how I'm now a hip hop artist going back and forth to New York from my home in Scotland.

It turns out that Aureliano's son, Julian, is also a young boxer and a rapper just like me. It's not long before he's quizzing me about the music business and what his son should be doing to make his way in hip hop. He tells me his son's rap name is Julian Anthony and I offer to put the boy on the bill for the Paper Box show. He takes me up on that offer and that's how Julian ends up on the bill putting in a storming set.

By the time Tyrone turns up, Aureliano and I are getting on like a house on fire. We're now best buddies and I get a tour of the gym and an insight into all the young boxers that look like they could make it to the big time.

It was great to meet up with Tyrone again and when I explain I want to use the gym to film part of my music video he very quickly sorts that for me.

In the gym part of the video, I'm a boxer again, being filmed in the ring sweating buckets doing pad work with Tyrone, shadow boxing and walloping a punch bag as hard as I can. I looked the part in the video, but that's as far as it went. Thankfully the camera doesn't show me blowing out my backside as I go through the high tempo training in the video. Think I'll stick to being a rapper.

While I was staying with Doug, I volunteered to help him on a film project he was working on in New Jersey. It was a small-budget web series called The Devil's Work and I asked if I could tag along and watch the filming process over a weekend. Doug agreed so long as I made myself useful and that's how I ended up being a boom operator. We started filming at 6am and by the end of the day I had aching arms after having to hold a giant pole with a microphone on the end to record the actors' dialogue. I wasn't getting paid any money, but the food on set was quite good. It certainly made a change from the cream cheese bagel a day I lived on during a previous visit to America.

I even talked my way into getting a small part in front of the camera. The producers still hadn't cast a character who was being interviewed for

a job working for the Devil and negotiating to bring the souls of dead people to Hell.

Doug suggested I would be good for the part and told them not to even bother giving me a script. 'Just give him a prompt, roll the cameras and let him ramble on. Steve'll be hilarious 'cos that boy can sure talk for Scotland.'

They agreed and the scene starts with me being asked: 'Why do you think you'd be good for this position?'

It was a case of wind me up and let me go. And off I went ad-libbing with great gusto: 'I wanna let you know, Sandra, I'm not a nine to five guy. I'm 24/7. I'm like Scarface. I'm like Al Capone. You give me this job and I won't be standing in the corner. I'll be all around the world. I'll be moving these souls left, right and centre. I'm a street hustler and I'll be round and round the block. That's what I'll be doing all day, every day.'

The actor playing Sandra sitting in front of me has to dig her thumbnail into her finger to stop herself laughing. But I'm on a roll and undaunted I continue: 'You know what? I'm deadly serious. United we stand, divided we fall. We come together, we can change the world.'

At that the director yells 'cut' and everyone bursts out laughing. 'You gotta keep that in,' shouts Doug over the hilarity. 'He might not be Oscar-winning material just now, but Stevie sure as Hell is great entertainment value.'

I've never seen the finished episode, but I hope they did keep it in. I reckon I would have made a great soul catcher.

It wasn't long before I was heading back to Scotland, but it was a different Stevie Creed stepping off the plane at Edinburgh Airport to the one that had left a couple of months earlier. That trip was one of the defining periods of my life. And a big hat tip to Doug for recognising that I was at a low ebb and for dragging me back to being the old focussed and enthusiastic Stevie Creed.

Goodness knows what I'd be doing with my life if it weren't for Doug and his tough love regime in the sweltering heat of New York that summer. I've always been ambitious and had lots of drive to achieve my dreams, but sometimes you just need someone to give history a nudge, or in my case a good boot up the arse!

CHAPTER 14

FRINGE BENEFITS

You'll have gathered that I like everyone to have a blast when I'm in the studio or filming one of my music videos. That was certainly the case when I was shooting a video for a song I had written called Preach. I made sure everything went literally with a bang. When it came to creating the video's dramatic storyline and visuals, I had one of those mad moments when I thought it would be a great idea to blow up a car. And that's exactly what we did.

I had been driving my trusty old dark blue Fiat Punto for years, but it had seen better days and was heading for the scrapyard in the sky. I decide to give the old girl one last hurrah and feature the jalopy getting blown up and ending her days in an inferno for the video.

The song Preach was inspired by a weekly blog I did on Instagram called The Sunday Sermon. Not surprisingly, I posted this tome of arrant nonsense every Sunday and I'd kept it going since 2015. It was a way for me to keep my profile up on social media, have some fun and a rant at the same time and most importantly, take the Mickey out of myself.

My Brooklyn buddy, Doug, thought the blog was hilarious and he

dubbed me 'Preacher Creed'. Anytime he was in my company Doug would read out the latest Sunday Sermon with the same gusto you get from these American evangelistic preachers you see on TV.

He'd also say: 'You sound like a preacher when you start your bullshit to get people to do things for you. You're like the padre in the hood. The guy who's bringing his hip hop religion to the people and you've got all your acolytes doing your bidding.'

It became a running joke and the Preacher Creed appellation caught on with people who knew me. So much so, Doug wanted me to get a licence to be able to marry people in America, so I can officiate at his wedding to his fiancée, Laura Douthit. 'I want to be married by Preacher Creed,' he's always saying.

It's November 2016 and I want to make the Preach video as dramatic as I can, so I come up with a storyline that I'm a preacher, dressed in dog collar and full-length black coat, who kidnaps someone to baptise them by fully immersing them in the sea. I'm then filmed driving around on a quad bike with a shotgun over my shoulder before the Fiat Punto gets blown up. Bet you wouldn't have wanted to see inside my head when I came up with that narrative.

I've a good friend who also worked in Slater's, Michael Retout, who knew a farmer called Mick Cross, and he persuaded him to let us use one of his fields when we were blowing up the car. Mick's farm was near Berwick-upon-Tweed, which is over the border in England, but only slightly over an hour's drive from Edinburgh.

Michael had done a bit of acting before, so he agreed to play the part of the hostage and by the end of the scene, he was so cold, he wished he hadn't. The baptism scene was shot on The Holy Island of Lindisfarne, which is a few miles down the coast from Berwick. It's one of these islands that you can get to by car at low tide, but if you don't make it back by high tide, you're stuck there until the tide goes out again.

The videographer and director, Keir Siewart, has his shoes and socks off and is already in the water with his trousers rolled up to his knees. He starts filming as I come into the shot. Resplendent in my vicar's garb, I've tied Michael's hands with a rope and drag him across the beach to

the water's edge. He's struggling to get free, but stumbles several times as I pull on the rope.

Now, the North Sea is cold at the best of times, but in November it's absolutely freezing. I pull him into the water and we go deeper and deeper into the sea until it's up to our chests. It's so cold, Michael is shivering uncontrollably and screaming 'Ahhhhh!' and we're worried he's having a panic attack. But I'm right in character, put all thoughts of the freezing cold out of my mind and continue undaunted in my role as the mad preacher. Keir shouts: 'For f**k's sake hurry up and put his head under the water.'

I then push Michael's head under the sea for about ten seconds so we can get a good shot of me doing a total submerged baptism. As soon as I pull Michael's head to the surface, I let him go and we make a dash through the water onto dry land to get rubbed down with a towel and try to get some heat into our bodies. I've got to give a hat tip to Michael for putting up with that freezing cold North Sea water and going through with the scene. I'm sure John the Baptist didn't have to put up with water that cold when he was baptising his followers in the River Jordan.

Word of our music video being filmed on Holy Island had obviously got round as there were about 30 people standing on the beach watching these bizarre scenes. But no one could hang around, as the tide was coming in and it wasn't long before everyone was making a mad dash off the island.

Now it's on to the farm and getting footage of me as a shotgun-toting preacher careering about on a quad bike, which was great fun, but not half as crazy as the next scene when the car was blown up. This was supposed to be the preacher getting rid of the car he had used to kidnap his victim and stow him in the boot before baptising him in the sea. Again we had a big audience, who quite sensibly were standing well back, but were obviously enjoying the spectacle.

I organised for someone who knew about such matters to set the explosives inside the car, which had been spray-painted with graffiti and we'd stuck Brooklyn Scotsman posters on it. When it came to filming the scene, I, along with Mick and some of his friends, get the nod and we take aim and fire off a volley of shotgun rounds at the car. It sounds like

a 21-gun salute, or everybody in Edinburgh setting off fireworks at the same time on Guy Fawkes Night.

Then all of a sudden there's a loud boom, which startles everyone, and within seconds the car bursts into flames and very quickly becomes an inferno. After the initial shock everyone is clapping and cheering.

It was an amazing sight and I could see the steering wheel melting through the flames. We stay to watch the fire burn itself out and then we pack up the film gear before heading back to Edinburgh.

A few days later I heard that someone had called the police after seeing the plume of thick black smoke that eventually came from the car after the intense heat from the flames had died down. Fortunately, we had left by then and it was down to Mick and his pals to explain why a burnt-out and charred Fiat Punto was sitting in the middle of one of his fields.

While everyone thought the video for Preach was fantastic, I wasn't happy with my vocals on the track. I'd done dozens of takes in the studio and I didn't think any of them were good enough. This was especially frustrating, as Doug had done a great job of reading one of my Sunday Sermons for the track's intro. And I had recruited a new female vocalist, Jamei-Lee Lister, to join the band and she did a fantastic job singing the chorus and dressing up as a nun on the video.

After months of trying and failing to nail a vocal performance that I thought would be good enough, I decided Doug and Jamei-Lee had done such a fabulous job I would only use their performances on a shorter version of Preach. No point in me spoiling a good track with some poor vocals. In the end, my only input was to chant: 'Preach, preach, preach…' on the song.

Jamei-Lee was an amazing find for me a month before we did the Preach video. I first heard her sing when a video of her performing popped up on my Facebook newsfeed and I couldn't believe she wasn't already snapped up by a record company and had her own band.

She was singing her version of Chandelier, originally sung by Sia and after the third or fourth time in a row listening to Jamei-Lee, I thought: 'Who the Hell's that? How come I've never heard of her before? She's got an amazing voice.' Even just listening to that one song I could tell she had soul and didn't just perform a song – she lived it. Very few performers

can touch your soul when they sing, but I quickly realised Jamei-Lee was one of them.

I messaged her straight away and she agreed to travel the few miles from her home in South Queensferry to meet up with me in the centre of Edinburgh. I sent Jamei-Lee the backing track for Preach, so she could get an idea of the musical direction I was going in, and suggested that when we met up, she could try out some vocals on the track at Sean The Don's studio.

I pick her up in my car outside a Starbucks café in Edinburgh and almost immediately we hit it off. We drove to the coastal town of Musselburgh on the Firth of Forth and had something to eat before we went to the studio. It didn't take me long to realise Jamei-Lee had a warm personality and was very easy to get along with.

Sean's not easily impressed, as he's recorded some really good singers in his time. But as soon as Jamei-Lee starts her vocals, he looks at me and says: 'F****n' Hell! Where did you find this one? She's amazing.'

I knew there and then that I had to get Jamei-Lee in the band and when I told her about the Preach video and that I had some gigs lined up in the early part of 2017, she agreed to join our happy band of hip hoppers.

Early in 2017, a music promoter from Edinburgh called Gavin Hogg wanted me to help him organise a show in the Jam House, a popular live music venue in the city. We booked the club for Friday, May 26 and got busy promoting the show. There was a lot of interest and everything was going well until the venue contacted us at the beginning of May to say the gig would have to move to the following Friday, June 2. They claimed they had just realised that another band had booked the same date we had been given, but a year before us.

We weren't happy, but there wasn't a lot we could do about it apart from contact people who had bought tickets to tell them of the new date for the show and get updated posters printed with the new date.

But worse was still to come when, ten days before the rescheduled gig, the club sent me an email saying we would have to start the show at 11pm instead of the 7pm start we'd been advertising, as there was another event being held in the club earlier in the evening.

I was raging, as we had put together a show with six acts on the bill and if we started at 11pm the show wouldn't finish until around 3am. The late start also wouldn't have suited many of the people who had bought tickets, so I decide to tell the Jam House where they could stick their gig and I would find another venue. That sounded like a great idea at the time and it certainly made me feel a lot better within myself, but finding a new venue for a gig in ten days instead of the show going ahead at the Jam House could have got me into a right pickle.

However, my sister Alison's partner, Alan Reid, knew the people who ran The Voodoo Rooms – another well-known live music venue in Edinburgh – and they agreed to host the show on the same night, June 2. It meant another print run of new posters and flyers, but the place was packed and it was a great sell-out gig with support acts Immy Perez, Irie Yoyo, Eloquent, The Honey Farm, rappers Chris Wood and Fizzy Boy, along with DJ Beef.

Providence is a wonderful thing, especially when it opens lots of new doors for you and sometimes I think serendipity is my middle name. A few days before the Voodoo Rooms gig, I had gone along to meet the guys who run the Twelve 50 YouTube TV channel in Edinburgh. I was giving them a copy of the One Shot music video, which they were going to feature.

While I was in the studio there was some general chitchat and moaning from a few rappers who were there about the lack of venues that would put on a hip hop show. I tell them I've got a show at The Voodoo Rooms and they'd be welcome to come along. I was also introduced to a guy, Garry Fraser, which turned out to be rather fortuitous.

Garry tells me that he performs unaccompanied spoken word and I suggest he can make a guest appearance at the Voodoo Rooms show. Not only did he do that, but he was knocked out by the crowd's reaction to the gig and it gave him an idea for an upcoming project he was involved in.

Garry was the director and co-writer of a TV drama series that was about to start filming in the Edinburgh area. It was called The Grey Area and had been commissioned by the BBC for their new BBC Scotland channel.

The drama is a gritty tale of violence and drug addiction on a deprived housing estate and the main character, Mikey, uses hip hop music to escape the world he is living in.

A few days after The Voodoo Rooms show, Garry asked if we could meet as he wanted me to set up another hip hop show at the venue, with me headlining, to be filmed for scenes in The Grey Area. He also offered me a small speaking part playing a rapper called Robbie.

Although I'd never done any professional acting before, I was confident I could wing it – and as you've probably gathered, it wouldn't have been the first time I'd done that in my life.

When I met up with Garry he brought his Grey Area co-writer, Garry Torrance, with him. He was also involved in the programme, as producer and cinematographer. Neither of us knew it at the time, but Garry Torrance would go on to play a major role in the next part of my career.

I did the gig that was filmed for the drama series in October that year, and I also spent a couple of days on set filming my part. It was a great experience and I even got a mention in the credits of the series.

I was still working in Slater's throughout that year, but I was eagerly pursuing my parallel career in hip hop music. Doug also made an appearance back in Edinburgh to film yet more footage he wanted for the music video to the Galaxy Motel track, which also featured R&B and soul singer, Garnett Boldin. I hired an apartment in the city and staged a mad party with lots of booze and girls for Doug to film.

All my colleagues in Slater's knew my background and how I'd gone to America as a teenager, and they were very supportive of what I was trying to achieve with my music. One day in December of that year, I was chatting to a girl, Ellie Graves, who worked beside me and totally out of the blue she says: 'You should do your story on stage. It would make a brilliant theatre show because you've got a remarkable story to tell.'

Ellie likes her theatre and she goes on to talk about the world-wide hit show, Hamilton, which is a hip hop musical based on the life of one of America's founding fathers, Alexander Hamilton. She goes on: 'When it comes to rapping you're the real deal. You can perform on any stage and you've got your own story to tell. You should go for it. I'd come and see your theatre show.'

Well, at least I'd have one person in the audience, thanks to Ellie. A minute after she'd mentioned doing a theatre show of my story, the proverbial light bulb went on in my head. 'Ellie's right,' I thought. 'I could do a show like that. What a challenge that would be and if there's anyone up for a challenge, then it's me.'

Ellie had planted the seed, and I spent a few days thinking about how I would nurture that seed and bring the idea to fruition. I remembered a couple of years previously the assistant manager at Slater's, Sandy Bisset, had introduced me to a guy called Liam Rudden, who is an award-winning theatre show writer and director, as well as the arts and entertainment editor of the Edinburgh Evening News paper.

Slater's is a great place to work if you are into celebrity spotting, as it's the go-to place for a smart new suit. Sandy was always shouting me over so he could introduce me to people in the music, entertainment and media business and he'd tell them I was destined for great things as a hip hop artist.

Liam had written an article in the paper when I was doing the Liquid Rooms show back in 2015 and I'd also sent him the One Shot video the following year. Not long after my conversation with Ellie, Liam messaged me out of the blue on Facebook asking if I had done any acting and suggesting we meet up for a chat.

We're sitting in the Alexander Graham Bell pub in Edinburgh and I tell Liam I had only done a little bit of acting. But that doesn't put Liam off and he says he might have a part for me in one of his shows.

We also get round to talking about me chasing an American dream as a boxer and a rapper and he seems very interested in my tales of derring-do.

'I've got this crazy idea of doing a show based on everything that's happened to me,' I tell him, wondering what his reaction is going to be.

'Yeah, that might work,' he replies. 'You've certainly got plenty of material and you're definitely a bit of a showman. That should get you through this even if you don't have a lot of acting experience.'

Liam asks me to write a script for a one-man theatre show of my story

and I tell him I'll get on the case right away. It doesn't take me long to put together a script, which I email to him. We meet up again in January 2018 after the Christmas and New Year celebrations, and, by this time, Liam has been busy with the red pen cutting back on the amount of narrative so we could make room for my music and hip hop songs in the show.

Now we're getting somewhere and Liam says he would take on the director's role. We agree there's no other name for the show than The Brooklyn Scotsman.

The next question is where would this new show be performed, and Liam suggests putting it on during the 2018 Edinburgh Festival that coming August.

I didn't have any spare money to hire a theatre, but Liam had a friend, fellow theatre director Derek Douglas, who was creating and managing his first theatre venue in an old Masonic Hall in Hill Street, during the Fringe that year. Derek was hiring the building for a month and kitting it out with a stage and seats for the audience.

Liam, the guitarist in my band, Stuart Gentleman and I have a sit-down with Derek and he agrees a deal that would give me 60 per cent of the ticket money and he would get 40 per cent. Now we're all set for a 23-night run of The Brooklyn Scotsman show at the Hill Street Theatre.

By this time it was too late to be listed on the official Festival Fringe programme, and Liam warns me that I'm going to have to hustle like never before to promote and sell tickets for The Brooklyn Scotsman. But first I have to put a band together who could commit to the full run of shows. Stuart was right up for it, especially as he had been pushing me to go ahead with the show as soon as it had been mooted.

Jamei-Lee was next and was as excited as me at the prospect of putting on a show at the Fringe. It was a huge commitment on her part to agree to do the whole run as she had a young son, Calvin, to look after, and would have to recruit a babysitter – usually her mother, Mary – every night for almost a month.

The Slater's connection came to my rescue when I was looking for a drummer. One of the guys who worked there was a drummer, who

also played a bit of keyboard and guitar. So the aptly named Simon Drummond completed the band for the show.

When it came to rehearsals I spent most of the time on the music, rather than my own acting performance, as the songs had to be restructured for a stage show. By the time it came to opening night, I'd only done one complete run-through with Liam, but from the reviews we got I reckon I got away with that.

Jamei-Lee joined me in the promotional push to sell the show, which is no easy task as there are more than 3500 shows during The Fringe and all of them are vying for the attention of the paying public. It seems that every nook and cranny in Edinburgh has some kind of performance going on during the festival.

But we gave it a right good shot and put a poster up on anything that was flat and would take wallpaper paste, dropped flyers into pubs and Jamei-Lee would hand out flyers to people on the train journey from South Queensferry to Edinburgh. She also went round slipping a poster into the newspaper billboards outside newsagents' shops. It got to the point where I think even the dogs on the streets knew about The Brooklyn Scotsman.

The run of shows went really well for me both financially and critically as we got some very good reviews. That was a hectic month for me as I was still working in Slater's during the day and doing the show at night. I even managed to squeeze in a show at Stramash, a live music venue in Edinburgh, which has a capacity of 900.

We filled the place that night after one of the Brooklyn Scotsman shows, and I had the full band with me. I decided to give the band a name – Linden Boulevard – after one of the places I'd lived when I was in Brooklyn. It was a great gig for us, and the excitement of performing every night at the theatre carried on and was intensified in front of such a big crowd.

I also issued the eight-track album, In Creed We Trust, to coincide with The Fringe shows and to make as much of the publicity as possible to promote my music.

The small Hill Street Theatre that had been created in one of the rooms of the Masonic Lodge was regularly full and, with everyone crammed in,

it made for a great atmosphere. But there were two occasions when only one person was in the audience.

The first was when a man from England had come to see the show for a second time, as he had enjoyed the performance so much when he first saw it. The second time I played to a single member of the audience was when an American woman came along. But whether it was an audience of one person, or 1001 people watching, I would still give it my all in the performance.

I even had some celebrities come along to the theatre to see the show thanks to Sandy Bisset. Former glamour model-turned actress, Linda Lusardi and her actor and talent agent husband, Sam Kane, were in the audience one night. Sandy had known Sam and Linda from a few years back when they would regularly visit Edinburgh and would come into Slater's. Sandy had kept in touch with the famous couple and when they told him they were coming back to the city for the festival, Sandy was adamant they should see The Brooklyn Scotsman.

Sam had told him: 'We'll do that, but I'll be harsh and if I don't think the show's any good, I'll say so.'

Just before I'm due to start a performance one night, Liam comes backstage to tell me Sam Kane and Linda Lusardi are sitting in the front row. No pressure then, they're only two of the best-known faces in the British entertainment industry sitting only a few feet away from me and they'll be close enough to see the whites of my eyes.

It didn't really spook me that they were there. Although it made me slightly more nervous, their presence gave me an extra edge for the performance.

Now and again I would sneak a look at them to see how they were reacting to my performance and if they were enjoying the show. They seemed really engaged with what I was doing on stage and were laughing at the right places. At one point, talking about my experiences in the New York fashion industry, I tell the audience: 'In a world where being beautiful is all that matters, I still managed to come across some of the ugliest people.' I glance at them and I can see Linda looking at Sam, nodding her head in agreement and laughing.

I had bought new T-shirts from Primark for that show and while I

was on stage I realised I hadn't taken the tag off the top I was wearing. I got the impression that Linda had noticed, so I ripped the tag off and threw it to her and ad-libbed a few lines about her keeping the tag as a souvenir.

When the show finished I was packing up and Liam came backstage to tell me Sam and Linda wanted to talk to me in the bar. They were sitting in the corner and, after the introductions, Linda says: 'What an amazing story you have to tell. I can't believe you did all that. Going out to America at such a young age and then everything happening to you.' She adds: 'I could tell you really are a boxer because when you're doing those scenes, it was all so real.'

Sam chimes in: 'This has to be a movie. You've got the story, you've got the looks and you've got the music. You got everything tied up in one package.'

'I really appreciate you coming along and thanks for what you're saying,' I reply. 'It's been a lot of hard work getting to this point and I spent so much time on the music, I only had one rehearsal with the director, Liam.'

'Only one rehearsal?' Sam says. 'That's amazing. I told Sandy that if I thought the show's not very good, I'd be brutally honest. And I am being honest when I say I was blown away by what I saw tonight.'

Again, he says my story should be turned into a movie and goes on to say he's an agent for an actor who had been in Peaky Blinders, Jack Rowan, who he says would be ideal to play the part of me in a film.

I was on a high as we said goodbye. That was the point when I realised my story might actually have the potential to turn into something really big and have some value. My next assignment after the run of The Brooklyn Scotsman shows was to write a movie script and it took me a few weeks to finish it.

This was the first time I had attempted to write a movie script and, although I put my heart and soul into it, my efforts at a screenplay left a lot to be desired. That is par for the course with me, as one of my biggest strengths is my ignorance because I don't know what I don't know and I'm never afraid to try something new. And neither am I afraid of criticism or being humiliated.

Although making a movie of my story was still just an idea, with my efforts at writing a script, I now had something tangible to use if that opportunity ever did arise.

A month after the Fringe shows, one of the guys I'd got to know during filming for the Grey Area TV series, Garry Torrance, asked me to meet up with him to sign some forms so I could get paid before the series was due to be broadcast the following year, in February 2019.

He asks how The Brooklyn Scotsman had done at The Fringe and apologised for not being able to see one of the shows.

'It went very well,' I tell him. 'Sam Kane and Linda Lusardi came along and Sam suggested my story could be turned into a movie. I've written a script, but haven't let anyone see it as I'm not sure how I want to take it forward.'

'That's interesting,' he replies. 'I've got my own production company and I wouldn't mind having a read of what you've written. I'm always looking for ideas and scripts that I could take to people I know at the BBC.'

I thought that since he had his own company he would be hungry for success, and I quite liked the way he worked on The Grey Area, so I let him read the script.

A month later we meet up again and Garry asks if I ever thought of doing a documentary about my life. 'You need about £3m to £4m to do a movie, but you can get a documentary done for about £100,000,' he says, and admits: 'I don't have the contacts at the big movie studios to raise millions, but I reckon I could get enough from the likes of the BBC to film a documentary about you. With all the archive video footage of yourself in America it's a no-brainer to do a documentary, and that's a great way to get your music to a wider audience and the real story about Stevie Creed out there.'

I agree to do the documentary with Garry and his company, Intryga Films, and it's not long before he's got the good news that the BBC has agreed to commission a documentary about me going to America as a teenager trying to make it as a boxer and eventually coming back as a hip hop artist. Best of all, they want to fly me to America and film me in my old haunts with guys like Cass, Mayor and Doug as well. Garry

also says he wants to follow me around filming me as I organise a show in Brooklyn, go back to Atlanta where I'd lost all my money and record another album in America with Immy Perez and Sean The Don flying over to help with production.

For the first part of 2019, I'm working on the documentary and Garry is filming me in and around Edinburgh. I also decide to do another run of The Brooklyn Scotsman at the Hill Street Theatre during the Festival Fringe, which will also feature in the documentary.

I'm on a real high and I take a mad notion to get a huge tattoo across the width of my back and shoulders that symbolises the Brooklyn Scotsman with icons of both Scotland and New York. The tattoo shows a picture of Edinburgh Castle alongside the Brooklyn Bridge, and the Statue of Liberty holding a microphone. Talk about sacrificing for your art. It was agony and every stroke of the tattoo artist's needle on my skin was like getting stung by a thousand bees. The tattoo is so big and there is so much shading it took many visits to the tattoo parlour and months to complete.

While everything seems to be jogging along nicely and you're on cloud nine, life always seems to find a way of bringing you back down to earth with a crash. I got a phone call from a friend asking if I'd spoken to Brad Welsh that day. 'I was speaking to him yesterday,' I reply. 'Why? What's happened?'

'There's rumours doing the rounds that he's been shot.'

I found it hard to believe, but I checked the latest news on my phone and, sadly, the rumours were true. It was being reported that he was killed by a gunman on his own doorstep. I was shattered, and, apart from losing a good friend who had helped me both in boxing and with my music, there was the shock of finding out he'd been shot dead outside his own front door with his wife and daughter inside the house, in Edinburgh's West End.

Brad's funeral didn't take place until early in June with around 1000 people attending, including celebrities from the world of sport and entertainment, and Brad's love of Hibernian Football Club marked by his green-coloured coffin.

I put on a black suit to go to the funeral, but on my way there my

trousers ripped and I had to rush back to the house to put on a new pair. The only trousers I could find were maroon – the colours of Hibs' city rivals, Heart of Midlothian Football Club. I was mortified that I'd turned up at Brad's funeral wearing the club colours of the team he most loved to beat. Worse still, the next day's Daily Record newspaper coverage of the funeral had a photograph of me walking beside Trainspotting author, Irvine Welsh, sporting my maroon trousers in all their glory. Brad would have laughed his socks off and never let me forget what I'd done. Sorry, mate!

Eventually in May 2021, the hitman who killed Brad was convicted of murder and jailed for a minimum of 28 years.

But an even bigger shock was on its way. On Sunday, June, 16 I was walking along the front at South Queensferry in the shadow of the famous Forth Bridge and the Forth Road Bridge, with a girl I'd been seeing at the time. I'd never spent any time in South Queensferry – or The Ferry, as it's known locally – apart for dropping Jamei-Lee off at her home there after a rehearsal or a recording session.

I haven't looked at my phone for a while, but when I do I notice several missed calls from Jamei-Lee's mum, Mary. I call her back and when she answers I know immediately that something is wrong. She can hardly get the words out, as she is crying and all I can hear her say is: 'Jamei-Lee's dead.'

My world stopped there and then and all I can think to say is: 'Can I come and see you? I'm in The Ferry just now. I won't be long.' I was so shocked, I didn't even ask what had happened.

I explain to my friend and she heads back to Edinburgh while I walk the short distance to Mary's flat. On the way there I kept thinking about how Jamei-Lee was so hyped up about the second run of The Brooklyn Scotsman shows and the documentary being filmed. We'd been rehearsing together with the band only a few days earlier, and she was talking about how it felt like the band was a family that had got back together again.

I also had a weird feeling thinking that the one and only time I've spent a few hours in The Ferry is the day I get a call to say Jamei-Lee has died. But I was grateful for this terrible twist of fate as I was able to see Mary

so quickly and give her whatever comfort I could.

When I get to Mary's flat I give her a hug and learn that Jamei-Lee had been found dead in her home that morning with no apparent explanation. I spend time telling Mary how much I thought of Jamei-Lee, and recall some of the stories about her taking a blanket out of my car to give to a homeless person in Edinburgh city centre and how she preferred to walk about in her bare feet during band rehearsals.

By this time, Mary's family begin to arrive and I leave, unable to comprehend, in even the tiniest way, the emotional torture she is going through. All I could say was that I'd be there for her and her family if they needed anything.

I was privileged to give the eulogy at Jamei-Lee's funeral, and I told a packed crematorium, and lots of people standing outside listening on the PA system, that whether it was performing with Linden Boulevard, or in The Brooklyn Scotsman at The Fringe, I was supposed to be the star of the show. But the reality was that I wasn't, because Jamei-Lee shone the brightest and she was the real star.

Jamei-Lee was my rock and as loyal as the day is long. And, if I ever had any doubts about anything I was doing, she'd be the one to reassure me I'd be fine, so long as I went on stage and told my story with as much feeling and emotion as I could. She was very well summed up on the front of the order of service at her funeral with the words 'Life is a song and she sang it out loud.'

I'm writing this on what would be Jamei-Lee's 28th birthday and I've not long posted on YouTube a compilation of various videos featuring Jamei-Lee, as she brilliantly sings one of the most personal songs I've ever written, called Save Me. I only hope that one day, I can come close to her brilliance.

For a few days after Jamei-Lee died, music, performing and doing the show at The Fringe was the furthest thing from my mind. But the more I thought about her, the more I realised I should stop feeling sorry for myself.

Jamei-Lee would have given me her own version of my Sunday Sermon telling me I should carry on. And she would have been right. She played such a big part in getting me to this point it would have been a disservice

to her not to carry on with The Brooklyn Scotsman show and do it in her memory.

Every night, during that second run in the theatre, we told the audience we were dedicating the performance to Jamei-Lee, and there was always a photograph of her on the stage as part of the props for the show.

I had a long discussion with Liam about how we were going to do the show without Jamei-Lee on vocals. It didn't feel right replacing her with another singer. Thankfully, we had recorded some of the previous year's show and we used part of these recordings of Jamei-Lee singing in the second run. I also sang some of her parts and it felt like she was there on the stage with me every night.

I made sure every performance was the best I could make it and we had another successful run of shows. One of the performances was being filmed for the documentary and I was particularly hyped up for that one, especially as some of Jamei-Lee's family were in the audience that night.

There were some lighter moments during this run of shows, like the night the fire alarm went off after someone put some pies in the oven in the kitchen and forgot about them. Fortunately, this happened before we went on stage, but when I arrived at the theatre all I could see was smoke billowing out the kitchen.

There was another night when the boys in blue turned up at the theatre after a show to ask if anyone had seen, or knew anything about, a prostitute having sex with a client on the building's fire escape. This particular fire escape was only a few feet away from where I was performing on stage, but thankfully with a stone wall in between. Some of the neighbours had complained to the police, but when the cops asked me if I'd seen anything I had to say: 'Sorry, mate. I was kind of busy being a boxer and rapper in New York at the time.'

Jamei-Lee called herself the Paradoxical Pixee and, as only she would do, spelled Pixee with a double-e. As a lasting tribute to her, I had an image of a pixie added to the tattoo on my back. Well, as I've already alluded to, Jamei-Lee always did have my back.

Losing both Brad and Jamei-Lee in such a short time made me realise how fragile life is. Although I would have said both were invincible spirits, they were here one day and the next they were gone. We can't

decide when we'll come into this world and we don't know when we'll die, but how we can be a positive influence on others while we're here and after we're gone is the true legacy we should want to leave.

CHAPTER 15

BACK IN THE OLD ROUTINE

W e've a saying in Scotland for when something unbelievable happens. That's when you exclaim: 'You couldnae make it up!' Another more sophisticated way of describing it is to say: 'The truth is stranger than fiction.' Whichever way you want to define it, I experienced one of those amazing moments when I was in New York to film the documentary.

It took me back to the days when I was living in the crack den and a group of itinerant rappers from Queens came to see me and one of them ended up sleeping on my floor. These guys were very talented, but were homeless and had no money. They would flit around from one recording studio to the next, or other rappers' homes, finding a space on the floor to crash out. I enjoyed having them visit me, as we would spend all day and night swapping beats and bars and I learned a lot from them.

Fast-forward five years and the documentary director, Garry Torrance, wants to film me making a music video in New York. He'd been told by one of the two American camera crew he'd hired that there was a guy who rented out his basement apartment in Greenpoint, Brooklyn and it was kitted out with a jacuzzi, a bar and a pole for strippers and pole

dancers to strut their stuff. It was an ideal venue for a song I'd written called Body Language.

Garry hires the flat from the guy, called Rain Palmer, we get ourselves a sexy model to cavort around in the jacuzzi with me, and Garry films the video. He said I could use the footage for the music video and it was like killing two birds with one stone – I was getting another music video done and filming some scenes for the documentary at the same time.

I hadn't met Rain Palmer until he walked into the apartment as we were about to start filming. 'Hi, I'm Stevie. Nice to meet you,' I say.

'How you doing?' he replies.

While we're talking we're looking at each other as if we're both having a déjà vu experience. However, nothing else is said.

After we finish the shoot and get dried off, Rain tells me that although he's an actor, he's also a rapper and he starts freestyling a rap for me. Very quickly I realise he's very good and I join in the rap session which Garry films.

I'm in the car with Garry as we head back to the apartment in Bedford-Stuyvesant where we are staying and I mention to him that I thought Rain looked familiar, but I couldn't quite place where I'd seen him before.

'You're right,' says Garry. 'I think I've seen him somewhere before as well. He's an actor and he's heading out to LA in the next few days. Maybe we've seen him on TV in shows like The Wire or CSI because I recognise his face from somewhere.'

Back in the apartment, I message Rain to thank him for letting us use his place for the video shoot and I also ask if he has a brother, or a cousin, who calls himself Sun Zeus. That was the name of the rapper that slept on my floor a few years previously and the more I thought about it, the more I reckoned Rain looked a bit like him.

It only takes a minute for the reply from Rain to come back. 'Sun Zeus – yeah, that's me,' he says.

You could have knocked me down with a half-smoked doobie. I get right back to him. 'Do you not remember how you slept on my floor when I was living in a crack den in Flatbush about five years ago? We

used to rap together and you were with a guy called Malik.'

'Shit, man! I thought I recognised you,' he replies. 'I was so out of my mind back then, but it's all starting to come back to me now,'

'This is amazing. It's like some crazy spiritual shit that's brought us back together after all this time. We need to record a track together. How you fixed for time before you go to LA?'

'Yeah, I'm right up for that. Monday's good for me.'

'Brilliant. I'll send you a backing track I have and bring over some recording equipment we've got with us. We can write lyrics together and then lay down some vocal tracks.'

Although this is all happening at 2am, I rush through to Garry's room and bang on his door to waken him. 'Wait till you hear this,' I tell him excitedly. 'You know you were saying you thought you recognised the guy from the house we were filming in earlier? Well he's one of the rappers that slept on the floor of my room when I was living in the crack den.'

'That's f****n' crazy,' Garry says. 'I knew I'd seen him somewhere before. It must have been in one of those old videos you took on your phone from years ago that you showed me.'

And he was right. I'd lots of old footage from the various times I'd stayed in America and I remember filming these rappers who had been staying in the crack den.

When I told Garry I was going over to Rain's to record a track, he immediately thought that would make some great scenes in the documentary. We had a great time recording and writing a song, which is called Hard To Believe and Garry got some great footage.

We had a long conversation and I could only admire Rain for coming such a long, long way from his days sleeping on studio floors, or anywhere he could get a roof over his head, to where he was now. Rain's very talented, has great charisma and is a sociable guy who would endear himself to anyone. He may well have had a few lucky breaks to get into acting, but he made his own luck and was persistent enough to get where he is today.

Coming back to New York to film for the documentary was a bit like

THE BROOKLYN SCOTSMAN

Groundhog Day for me when it came to getting through immigration with my visa waiver. My flight had already been delayed for seven hours and when I flew into JFK Airport I was asked the usual questions at the immigration booth.

'Hello, sir. What's the reason for your visit to the United States?' I'm asked.

'I'm visiting friends for Thanksgiving,' I reply.

'How long are you staying for?'

'I'm here for three months.'

'Thanksgiving is in a few weeks, so what else are you going to be doing all this time and have you a return flight booked?'

'I'm going to be here over Christmas as well, and I've got a flight back to the UK booked.'

Then the questioning gets a little more aggressive. 'Why do you need to spend three months in the US if you're just visiting friends? What are you actually going to be doing all that time and what are you going to do for money?'

'Just like I said, I'm visiting friends and I've got money saved up.'

'Come with me, sir.'

I'd been in this movie before and I thought I'd be taken into another room, some other immigration officer would ask me the same questions and when I gave them the same answers I'd be let into the country.

The room has six podiums and seats lined up in rows for the travellers wanting to get into America. I take a seat and my phone is constantly vibrating, as Garry – who had arrived a few days earlier – and Mayor are waiting outside to pick me up. They've called so many times I thought I'd better answer and tell them what's happened. But, as I pull the phone from my pocket, an officer seated at one of the podiums looks at me and abruptly says: 'Put your phone away,' and points to a sign on the wall I hadn't noticed that forbids the use of mobile phones.

After 20 minutes my name gets called and I stand in front of one of the podiums and an immigration officer asks me the same questions as his colleague did half an hour or so earlier. I give him exactly the same

answers, but this guy is taking the questioning a bit further.

'I see you've been in America before,' he says. 'In fact, you've been here quite a lot before. I also see from your record that you've been pulled in by immigration for questioning before. So, tell me – who are you staying with this time?'

I hadn't mentioned that, as well as seeing friends, I was going to be filmed for a BBC documentary, in case immigration would class that as working and not allow me into the country on my visa waiver. And because of that, I didn't want to give the address of the apartment I would be staying in, as Garry would also have given that address when he arrived on a visa classing him as a working journalist.

My mind is racing and I can imagine the immigration guys pondering: 'OK, we've had a journalist fly in from Scotland and now we've got another guy also flying in from Scotland a few days later staying at the same address, and he says he's just visiting friends. Think there's more to this than meets the eye...'

Neither did I want to say I was staying with Doug because that's where Immy Perez and Sean The Don would be staying before starting work on the new album and they would be giving immigration his address. I tell the officer that I'm staying with Cass and give his address. Then the conversation gets a bit complicated and my story starts to unravel.

'So you're staying with this gentleman called Cass. Is he picking you up today?'

'No, his cousin, Mayor, is.'

'So you're actually staying with Mayor? Do Cass and Mayor live in the same house?'

'No, they stay in different houses. Cass was supposed to pick me up, but my flight was delayed for seven hours and now he's at work, so Mayor is picking me up instead.'

The immigration officer is looking perplexed and tells me to sit back down and I begin to realise this isn't going well at all. I'm left sitting for half an hour before being called back to the podium.

'This is all a bit strange,' he says. 'I'm not convinced you're telling the

truth. Do you have this Mayor's cell phone number so I can call him?'

I give him Mayor's number and he tells me to sit down again before he walks out the room. I'm dreading what Mayor is going to say to him because he won't know that I've told immigration that I'm staying with Cass and to confuse matters more, Mayor will probably just tell him I'm staying at an apartment in Bedford-Stuyvesant. Now, Hannibal Smith from the hit 1980s TV show, The A-Team always said he liked it when a plan comes together, but my plans to get into America were definitely going awry.

The officer eventually returns and asks me to follow him to another interview room. It's a small room with just a table and two chairs either side and I now know I'm definitely in trouble. I'd never had to go this far to get into America any other time I'd arrived at the airport. I'm thinking that I'm going to be sent home and wondering what will happen to the documentary. Will it be scrapped because they can't film me in America, which is the main part of my story? Will I never be allowed back into America? Will I be sent to Guantanemo Bay, given an orange jumpsuit and never be seen or heard of again? All these and even more outrageous scenarios were going through my head.

I sit down and the officer is facing me. He hesitates for a few seconds then says: 'I don't think you're being totally straight with me. I called your friend Mayor and he doesn't really confirm your story. Quite clearly you haven't come to America for three months just to see your friends.'

I don't know what to say because I've no idea what Mayor has told him. For some unknown reason I take my phone from my pocket to show him the text messages from Mayor asking where I am and saying that he's waiting outside the airport terminal to pick me up.

The officer takes the phone out of my hand and starts looking through my messages and I think I've just dug my own grave. If he looks through the messages, emails and photos on my phone he'll find out about the documentary. He stops at one of the text messages and asks: 'Who's Garry? And where does he live?'

My heart misses yet another beat before I reply: 'He's a friend of mine and he's staying in Brooklyn. I'm going to be seeing him as well.'

The official takes a deep breath, exhales slowly and takes a long hard

look at me before saying: 'I'm going to give you one last chance to be honest with me. Why are you visiting America?'

I clear my throat and begin: 'Well, actually I do a bit of music and I sometimes work with artists in America. We collaborate in writing songs.'

'What kind of music do you do?'

'It's mainly hip hop.'

'Do you perform in Scotland?'

'Yes, I've got my own band and I've had my own theatre show at the Edinburgh Fringe.'

'Are you going to be working with people in New York?'

'I suppose it depends on how you define working, but I'm only collaborating with other artists. I'm not going to earn any money when I'm in America. I know I can't do that.'

'But you know even if you're just collaborating, you should have a visa.'

I'm worried he's setting me up for the killer blow that he's sending me back home and as we all know, desperate situations require desperate measures. I go into my spiel about coming to America as a teenager and how being in his country has helped me develop as an artist and grow as a person. It's the same speech I've made before when immigration officials had my future in their hands and were deciding whether to let me into the country. Only this time, I had some new ammunition.

'I was born in Scotland, but America is my spiritual home,' I tell him. 'I love this place so much, I even got a tattoo of the Statue of Liberty and the Brooklyn Bridge on my back. Do you want to see my tattoo?'

'No thanks. That won't be necessary,' he replies.

But I stand up, pull my top off over my head and turn round to show him the tattoo across my back.

After a few seconds he says: 'Yes, sir. That is indeed some very interesting artistry.'

I put my top back on and sit down. The officer says nothing for a minute then tells me to go back into the interview room with all the podiums.

A few minutes later the official comes back into the room and asks me to come to the podium. 'Thank you for being so honest with me,' he says. 'You know yourself you've been called in by our officers in the past, but I'm going to let you through. Make sure if you ever want to return to America you'll need a proper visa even if you're only going to be collaborating with other artists.'

I thank the officer and only the Roadrunner could have been faster getting out of the airport. Outside the terminal building I call Garry to tell him I've been allowed into the country. But since they had already left the airport, thinking I wasn't being allowed in, he had to send an Uber car to pick me up.

When I was on the phone to Garry he said: 'We thought you'd been sent home. That's three and a half hours you've been in there.'

When I get back to the apartment and meet up with Garry, he tells me about the phone conversation Mayor – who was half-asleep at the time – had with the immigration officer: 'The guy tells Mayor he's from US Immigration and asks if he knows a Stephen McGhee? Mayor tells him he does. Then the official starts asking lots of questions like where he'd met you. Mayor told him on a road at Flatbush Junction because you were living in a whorehouse hotel and you wanted to get your own apartment.'

Garry continues: 'Then he asks Mayor if he knows where you're staying and he tells him about the place in Bed-Stuy. From what I heard of the phone call the officer seemed to think you were staying with Cass, but Mayor told him you had your own place to stay.'

No wonder the officer was bamboozled by my story and it's just as well the name on my passport was Stephen McGhee and not Stevie Creed. All he'd have to do is put the name Stevie Creed into Google and he'd have seen my music videos and promotions for the shows I'd done in Brooklyn and Manhattan, albeit not having earned any money from them. I know I can talk a good game, but I'd only be talking all the way to the departure lounge if he'd done that.

My first full day back in Brooklyn was spent meeting up with the musicians I had contacted when I was back home that I wanted to make up the band. I hired a bass player, Clinton Greenlee; drummer, Beza

Gebre; guitarist, Drew Anello and keyboard player, Carlisio Keys and yes, that is his real name. I also had Monet, who had featured on The More I Dream track, joining the band on vocals.

I'd been looking forward to the following day, as that's when I was going to be filmed visiting my old haunts in Flatbush. I pop into the Ital Fusion restaurant and takeaway, at The Junction, where I'd found much sustenance for the little money I had when I stayed in the crack den across the road. It had been so long since I'd seen them, the guys in there were shocked to see me and thought I'd disappeared off the face of the earth.

Along with the camera crew, I was waiting across the road from the crack den for Cass and Mayor to arrive and be interviewed for the documentary. I was chatting to one of the camera guys when I saw this man come out of a door with bin bags and start sweeping the sidewalk. It was Ernest, Cass's father, and there was much hugging and back-slapping when he realised it was me shouting his name from across the road.

Par for the course, Cass was more than an hour late turning up, but we filled the time by getting Ernest in front of the camera and being interviewed by Garry.

On another day, the documentary crew were filming in and around Flatbush and getting drone shots of the area, and I was due to catch up with them along with Cass and Paradox. I got on the Express bus in Bedford-Stuyvesant heading for Flatbush having bought my ticket before I got on. I'm sitting next to the door and, about two stops further on, four Metropolitan Transportation Authority inspectors get on the bus and ask to see everyone's tickets. The bus driver waits until the inspectors are finished checking everyone has a ticket.

As one of the inspectors stands in front of me, I go into my pocket to pull out my bus ticket. I'm fumbling with a handful of crumpled dollar bills, as I knew my ticket would be among them, when the ticket falls onto the floor of the bus and a gust of wind catches it and blows it out the door.

The inspector has seen what happened, but still asks to see my bus ticket.

'You know I had a ticket and it's just blown out the door,' I tell him.

'Can I see your ticket, sir?'

'You know I don't have my ticket anymore.'

'Off the bus then, sir.'

'What?'

'If you haven't got a ticket, and quite clearly you don't, then please get off the bus.'

I've no option other than to do what he's telling me and, as the bus drives off, the inspector starts filling out a form that he hands me. It says I've got to go to a courthouse in Manhattan and pay a $60 fine for riding on a bus without a ticket.

I'm speechless and as I'm reading the citation the inspector says: 'That's an unusual accent you've got there. Where you from?'

'Scotland.'

'That's cool. When you going back home?'

'I'm going back in January.'

'Well then, don't worry about this as you'll be back in Scotland before the deadline for paying the fine. They're not going to chase you all the way to Scotland.'

The inspector waits at the bus stop and when the next bus comes along he gets on along with me, gives me a nod and a smile and says to the driver: 'He's good. He's got a ticket.'

I'm so taken aback by what's happened that I don't make a fuss about getting a $60 fine for not having a $3 ticket that I actually did have in the first place. I reckon these inspectors have a quota of fines to meet every day and I was just one more towards meeting his target.

With a documentary team in tow, meeting up with all the people who had helped me over the years, like Cass, his dad Ernest, Mayor, Doug, Fletch and Tyrone and all the others was like a triumphant homecoming. But these guys said they weren't surprised and seeing me being filmed was no big deal for them. They were simply proud of me and were happy they had played a part in my incredible journey so far.

Cass summed it up when he said: 'We knew something like this would

happen to you. It's just another step forward for you. When you say you're going to do something it usually gets done.'

That was the biggest compliment these special people could have paid me. From the very first time we met they believed I would achieve my dream and they still did. I was well made up.

Being around Cass again reminded me of who I am, what I used to be, the hard times I'd gone through and how far I'd come since we first met.

Garry filmed me in all my usual haunts when I stayed in Brooklyn, and I did get a bit emotional at times when I thought about everything that had happened to me. But there was a shock when we got to the Galaxy Motel. Not only was it not a whorehouse anymore, it wasn't even a hotel. It had been turned into a drop-in centre for mothers and their children.

As I walked towards the building, it looked exactly like it did when I first arrived in Brooklyn, but when we got inside the hotel, I could see the reception desk was gone and the layout was completely changed. It was all a bit surreal and slightly disappointing that what made the Galaxy Motel so famous – or should that be infamous – no longer existed.

After filming around Brooklyn and Manhattan, Paradox joined Garry and me on a flight to Atlanta. Times had indeed changed. This was another world to the one I was living in when I had to get the Chinese Bus. There were three reasons for us going. The first was to film for the documentary, second was to promote the Galaxy Motel track at a radio station and third, simply to have a good time in what is the party capital of America.

We arrive on a Friday and the following day I'm a guest on Highly Unique Radio, which has a good reputation for featuring and breaking new hip hop talent. The promotional visit goes well and the girl, Mandy, from the radio station even agrees to come out clubbing with us.

As I mentioned in an earlier chapter, Atlanta is a drugs haven for everyone in the narcotics chain, from the people who use the city as a hub when drugs are brought in from Mexico, to the mega-rich drug barons, dealers on the street and the users themselves.

The further up the chain you are, the more money you have to throw around buying yourself all manner of decadence. Even the strippers and

hookers act like big-time businesswomen and can earn up to a $250,000 a year.

There were lots of trap houses – homes where drugs are openly sold outside the front door – close to where we were staying in an Airbnb apartment. All this had spawned a new hip hop culture and a style of music, called trap music, which has a constant heavy bass drum and snappy snare sound. But it wasn't just the bass drum that was heavy.

One night, Paradox was driving our hired car with Garry, Garnett Boldin and his manager, Kevin Green – who had driven from Virginia to meet up with us for a few days – and myself as passengers when we got lost. Paradox stops the car to find his bearings and immediately some real heavy-looking guys appear at the front doors of a few of the trap houses in the street, staring at us and making sure we can see they're carrying guns.

'F**k's sake Paradox!' I say. 'What are you stopping for? Let's get out of here before we get shot.'

Needless to say, when Paradox realises the danger we are in he quickly puts the car in gear and drives off like he's in the Indianapolis 500.

No visit to Atlanta would be complete without a night on the town courtesy of Rondu Montfleury and he organises for us to get into one of the biggest nightclubs in Atlanta, called Opium.

My old buddy from Brooklyn, Que Sylvester, had moved to Atlanta and we met up for our big night out. There was quite a team assembled and the Stevie Creed Crew, including Garry, Paradox, Que and a cousin he brought along for the ride, Garnett and his manager, Kevin, Mandy from the radio station and the man himself, Rondu, who was working at the club that night, were all set for a party.

I'd started wearing my sporran with my jeans during this visit to Atlanta as a fashion accessory and that certainly got me noticed. I was wearing it when we went to Opium and what an attraction it was for the girls who all wanted to touch the black and white fur sporran.

The girls are asking what I'm wearing and what I use it for. 'It's called a sporran. It's a great place to keep your money and phone along with the necessities in life, like your condoms,' I tell them.

'Ooooh! That's really cool. Where can I buy a sporran like yours?'

I'm thinking that I might have found a new market here to sell sporrans and I was planning to bring a consignment over from Scotland and start a new trend of wearing a sporran with your jeans.

Rondu comes through to see us in the lounge bar and says: 'Yo! What's happenin', Mr Scotland? Follow me and I'll take you to the VIP area.'

Garry's got his film camera with him and that's another attraction for the clubbers, who all want to be filmed. 'Hey, cameraman – come and shoot some scenes with us,' they're shouting.

Rondu grabs me and takes me to the DJ podium in the club and gets the guy to shout out my name. I must have been an unusual spectacle as I'm probably one of only two white guys in the club and certainly the only one wearing a furry sporran.

As the night goes on, the drink is flowing like the Chattahoochee River through Atlanta and our antics are getting more and more outrageous. I end up on top of a table dancing and then a couple of Black girls ask if I want to be the filling in an Oreo biscuit. 'I've never heard of that one before,' I tell them. 'But hey-ho, there's always a first time, so show me what an Oreo is.'

At that the two girls start twerking with one in front of me and the other behind. With the two Black girls on the outside and a white guy in the middle, we're just like a human Oreo. The things you do when you've had a drink or ten.

When the club was about to close around 3am the house lights came on, and suddenly we heard a loud scream over the music that's still blasting out. Then there's the sound of smashing glass, shouting and people being thrown onto tables and chairs that are being smashed.

A fight has broken out between two rival gangs and it's mayhem. One woman is being dragged along the floor, there are bottles being thrown across the VIP area, guys charging at each other brandishing broken table legs as clubs. It was something out of a Wild West movie – absolute mayhem.

Que, who has been chaperoning Garry as he filmed around the club, grabs him and shouts: 'C'mon, we'll need to get the f**k out of here.'

But Garry shrugs him off and goes straight into the thick of the action filming the melee. It takes a few minutes for the security staff to jump in and stop the fighting, but just as calm seems to have been restored, there's the sound of gunshots coming from the club's entrance.

Cue more wild screaming and a stampede as the clubbers desperately try to find a way out of the club and to safety. Elvis has certainly left the building –along with everyone else.

We meet up on the sidewalk outside the club and Garry says: 'That was one crazy night. I got some great footage, but I almost got killed getting it.' To which Rondu replies with his usual understated nonchalance: 'Yeah, that's Atlanta for you, man. It can get a bit wild sometimes.'

After the madness of Atlanta, it was time for some serenity and four days living in a cabin in the Catskill Mountains. Trees, rivers and the sound of birdsong surrounded us as we got to work recording a new album that was being filmed as part of the documentary.

I was there with Doug and Garry, along with Immy and Sean, who had flown in for the writing and recording session. We brought our recording gear to the cabin and got down to work with the ever-present Garry filming over our shoulders. It was good to get away from the hustle and bustle of the city and have space to think. Immy and Sean sat opposite each other in the cabin and it was like a contest to see who could come up with the best beats.

While everyone else was indoors, I spent many a long hour sitting in the car outside the cabin writing lyrics. The first reason I did this was to get some time on my own to concentrate. The second was that I rap the lyrics out loud when I'm writing a song, and that would have been a real pain in the ass for Doug, Immy and Sean if I did that in the house while they were working on producing the tracks.

We were there for four days and got the basics of the album recorded. It was unrealistic that we would get the album completed, but we made a good start and certainly provided enough footage for Garry and the documentary.

While I was in the Catskills, Doug encouraged me to write a song about the incident involving the cops who pulled over Cass's car when we were driving in Manhattan. That was the time I was told to stand aside while

two cops gave my Black friends a hard time. It was months later that I realised I'd written a lyric that was to become prophetic in a terrifying way.

While I was back in Scotland waiting for the documentary to be broadcast I, along with the rest of the world, was shocked to see the video clip of a Black man, George Floyd, being arrested by white cops in Minneapolis. George Floyd was killed when one of the police officers restrained him on the ground by continually kneeling on his neck for up to nine minutes.

The horrific incident sparked massive worldwide protests against racism and it made me think about the Black people who adopted me as one of their own and helped me survive when I first came to America as a teenager.

I also hope both the documentary and this book shine a spotlight on what it's like to be a Black person in America today and break down the stereotypical image that many white people have of a Black neighbourhood in New York. There are good and bad white guys in the world, just like there are good and bad Black guys. There are plenty good Black guys in Brooklyn and they certainly changed my life for the better.

What happened to George Floyd brought back memories of the institutional racism I had witnessed when I was in America. As I've already described in this book, I have seen cops in New York totally ignore me because I was white, while Cass and my other Black friends were pulled over, questioned and body-searched when we were driving into Manhattan.

And there was the time the police targeted my Black hip hop dancers' friends instead of me when I was the main protagonist, while we were illegally filming a music video in Times Square.

I was even more horrified when I saw the video of the cop kneeling on George Floyd's neck and realised I had written lyrics eight months earlier about the Manhattan car incident, which frighteningly told of a similar scenario of a cop forcing a Black man's head onto the road.

The song, produced by Immy Perez, is called T.H.U.G. and that stands for The Hate U Give and the lyrics in one of the verses reads:

Feeling the embarrassment because you have a Glock

Being a good Samaritan standing on the block

My friend's leg's dragging as they grab him like a dog

Protect and serve, the badge is a paradox

Fear of death's frozen both legs

Power trip grips lead, stands on my bro's neck

Feel like a fake friend watch me crumble

A white elephant in this concreed jungle.

Although none of my friends were forced to lie down on the road while they were being questioned during the Manhattan incident, I was told police officers commonly use this tactic to restrain people.

A lot of Black people have died being arrested or in police custody, but the big difference with George Floyd's death was that someone captured the incident on film and the clip went viral around the world for everyone to see how Black people are sometimes treated.

After writing and recording in the Catskills, it was back to Brooklyn and organising the show that Garry was also going to be filming. I wanted to do the show somewhere in Flatbush as a thank you to the people there and give local artists a chance to perform. There's a lot of musical talent in Flatbush, but not a lot of music venues for them to play. It would have been easy for me to find a music venue elsewhere in Brooklyn that's known for putting on live music, but I was adamant I was putting the show on at the heart of the community I owe so much to.

At first I thought about doing the gig in Brooklyn College, which is in Flatbush, but I didn't have the contacts there to make it work in a short time, as I only had a few weeks to pull the show together. Then I had the crazy idea of doing the show in the Atlas Cops and Kids gym, using a boxing ring as the stage. The guys there were up for it, but the gym was just about to close for refurbishment, so that idea was knocked on the head and hit the canvas.

I decided to stage the show in a bar and restaurant called the Juicy Box, on Nostrand Avenue, Flatbush after Paradox had suggested it as a venue. The date for the gig was going to be on Saturday, November 9, which was

only a couple of weeks away. I only had two rehearsals with the band and any worries I had about them not being ready for the gig were quickly dispelled. These guys were the ultimate professionals and after only two hours they had picked up on the tracks. They were so good their motto could have been: 'You whistle it and we'll play it!'

I did my usual posters and flyers to promote the show, and spoke to everyone who gave me a second glance as they passed by to tell them about the show. Although the Juicy Box had its own PA system, it wasn't big enough for a show the size I was putting on. We had to bring a lot of our own equipment into the venue and only hours before the gig was due to start, we were rushing around electrical stores buying cables for the sound system.

It was a small venue, with a capacity of slightly more than 100, but the place was packed for the show and the audience created a great atmosphere. I had ten different acts performing and I took on the role of master of ceremonies for the night before I did my headlining set sporting my furry sporran on top of my jeans, of course. Everyone seemed to love the music and I just hoped the show looked good when people saw the documentary.

I stayed with Doug for a few weeks after Garry, Immy and Sean had gone home and I got back to Scotland in early 2020 – in time for the coronavirus pandemic to turn everyone's life upside down. That stopped me finishing off the album we'd started in New York, to be called Concreed Jungle; halted any shows I wanted to do; put an end to plans for a third run at the Edinburgh Festival Fringe and then a tour round the UK.

However, coronavirus didn't stop the documentary – The Brooklyn Scotsman – being broadcast on the BBC Scotland television channel and quite unusually, being repeated a further four times.

That BBC documentary was a huge boost to my profile with coverage of my story in the local and national media.

But how Garry got more than 100 hours of film edited down to 58 minutes is beyond me.

It's just as well you've been able to read all my stories in this book, because you'd never have known about them, as there were far too many to be included in the documentary.

Thanks for allowing me to share my adventures with you and I hope it might even inspire someone who has a dream to go out there, never give up and make that dream a reality. But I would advise staying away from whorehouses, crack dens and the stick-up merchants on the way.

I like to think I got where I am today thanks to the words in my pocket, a punch like a rocket and a swagger that shows I'll keep going against all the odds. Of course, I couldn't have done it without the love and support from my adopted Brooklyn family, who had my back at all times.

Now I'm off to plan the next stage of my hip hop odyssey with a new album called Concreed Jungle being released in 2022 and as they say in the hood: 'Laters, man. Laters...'

ACKNOWLEDGEMENTS

Firstly I want to thank Norman Macdonald for all the hard work he has put into this book with me. He has gone over and above the call of duty for this project and I will be eternally grateful to him for helping me complete a book I am very proud of.

I want to thank my hard-working mother and father, Elizabeth and Alastair for creating me and being the best parents any son could ask for. Also my sister Alison and her fiancé Al for always supporting my shows in Edinburgh and anything I choose to do.

Sandy Bisset and all the incredible people at Slater Menswear who've supported me and whose unwavering encouragement is something I will never forget.

Liam Rudden for taking a chance on a day dreaming suit salesman and giving him a life changing opportunity to perform at the Edinburgh Fringe and for encouraging me to pursue my acting career.

I want to thank my brothers from another mother, Cass and Mayor for being my first friends in New York City and The Louinis family for taking me in. Their kindness and loyalty is the reason I am still here today and have such an incredible story to tell.

I want to thank Ramon Fletcher for opening his Brooklyn studio to me and telling me that Scottish people can rap.

Sean Tha Don for being the guiding light in my musical career and always supporting my creative ideas.

Douglas Adam Ferguson for being my big brother, creative counsellor and always willing to support me and my crazy ideas. He opened his home to me along with his incredible wife, Laura. They are both two people who I call family and will always keep close to my heart.

Ian Rankin for taking the time to read my book and his words of encouragement. Some of your heroes don't live up to your expectations. Ian Rankin has surpassed mine. A true legend.

Linda Lusardi and her husband Sam Kane for coming to my Fringe show and convincing me I had a bigger story to tell. They have supported this book and they are two of the kindest souls I have ever met.

I want to thank the late Bradley Welsh and Tyrone Venning for teaching me the art of boxing, coming to my shows, and always pushing me to succeed.

Immy Perez is one of the most influential people in my career. He has always been there for me through thick and thin. Everybody needs their right hand man and Immy is mine. He has made so many sacrifices in his life to help my career and I would not be the artist or performer I am today without him.

KC for starting this crazy rap journey with me. Jason Singh and Steve Sola for supporting my music and lending assistance to my album *Concreed Jungle*.

Timoy Riley for helping KC and me get into the rap game.

I want to thank all the incredible musicians I have been fortunate enough to have worked with in my live shows. They all really helped me bring my music to life and put on a show like no other.

Jamei Lee Lister for being a guiding angel in my life and always watching over me.

Thank you to the self proclaimed hardest working Haitian Ron Du for showing me Atlanta like no one else could, opening his home to me and always giving me words of encouragement.

Garry Torrence for believing in my story and doing an incredible job

on my BBC documentary. Thank you for handling my story with respect and not being afraid to go into the trenches with me. He also taught me a lot about the art of filmmaking and he is a director I truly admire.

Krizal Lipz for being the best dance choreographer anyone could have asked for.

Q Sylvester for being my loyal friend and sticking with me ever since that first empty dance rehearsal in Brooklyn. Thank you for believing me and never wavering in your confidence in our vision.

Josh Valentin for being my life guru and teaching me about business.

Paradox for giving me a roof over my head in Brooklyn when I was really in trouble. He helped me in many endeavours and always supported my career.

Kaya Oledzka for believing in me and helping me figure out this music game. Thank you for everything you have done for me and all your tremendous support.

Chris Walker for always being my creative consultant and designing my website, posters, album artwork and logos.

Keir Siewert for shooting many incredible music videos for me.

Chelsea Roach for helping me on my music video shoots in New York, letting me film in her apartment and giving me advice on my acting career. She has always been a great supporter.

Everyone who helped or participated in my video shoots. From great directors, cast, crew, and editors. Teamwork makes a vision come to fruition.

Camira Martin for giving me a safe haven in NYC and teaching me about balance in life.

And three special people for the next chapter of my life – Stuart Gentleman, Jesse Rae, and Craig James Moncur. Watch this space....

There are so many people who helped me along the way and they are all the reason I am able to call myself "The Brooklyn Scotsman".